Photoshop CS4
Channels & Masks
one-on-one™

Also from Deke Press

Adobe Photoshop CS4 One-on-One
Adobe InDesign CS4 One-on-One
Adobe Photoshop CS3 One-on-One
Adobe InDesign CS3 One-on-One

Upcoming titles from Deke Press

Adobe Illustrator CS4 One-on-One

Photoshop CS4
Channels & Masks

one-on-one™

DEKE McCLELLAND

deke™
PRESS
O'REILLY®

BEIJING • CAMBRIDGE • FARNHAM • KÖLN • SEBASTOPOL • TAIPEI • TOKYO

Photoshop CS4 Channels & Masks One-on-One

by Deke McClelland

This title is published by Deke Press in association with O'Reilly Media, Inc., 1005 Gravenstein Highway North, Sebastopol, CA 95472.

O'Reilly Media books may be purchased for educational, business, or sales promotional use. Online editions are also available for most titles (*safari.oreilly.com*). For more information, contact O'Reilly's corporate/institutional sales department: 800-998-9938 or *corporate@oreilly.com*.

Managing Editor:	Carol Person	**Cellular Ombudsmen:**	Suzanne Caballero, Dan Brodnitz
Associate Editor:	Susan Pink, Techright	**Design Mastermind:**	David Futato
Organizeuse:	Toby Malina	**Video Producer:**	Max Smith
Content Contributors:	Tim Grey, David Futato, Colleen Wheeler	**DVD Management and Oversight:**	Tanya Staples
Indexer:	Julie Hawks	**DVD Graphic Design:**	Angela Buraglia
Technical Editor:	Ron Bilodeau	**Live-Action Video:**	Jacob Cunningham, Scott Erickson, Loren Hillebrand
Production Coordinator:	Chris Meredith	**Video Editors:**	Jacob Cunningham, Paavo Stubstad
Manufacturing Manager:	Sue Willing		

Print History:

December 2008: First edition.

Special thanks to Michael Ninness, Lynda Weinman, Bruce Heavin, Jehf Jones, David Rogelberg, Sherry Rogelberg, Stacey Barone, Kevin O'Connor, John Nack, Addy Hoff, Jeff Tranberry, Steve Weiss, Derrick Story, Betsy Waliszewski, Sara Peyton, Denise Elia, Rachel James, Dennis Fitzgerald, Karen Montgomery, and Tim O'Reilly, as well as Megan Ironside, Danny Martin, Val Gelineau, Bryan O'Neil Hughes, Zorana Gee, and the gangs at iStockphoto.com, PhotoSpin, and Adobe Systems. Extra special thanks to our relentlessly supportive families, without whom this series and this book would not be possible. In loving memory of Marjorie Baer.

This book was typeset using Adobe InDesign CS3 and the Adobe Futura, Adobe Rotis, and Linotype Birka typefaces.

ISBN: 978-0-596-51615-4 [C] RepKover™ This book uses RepKover,™ a durable and flexible lay-flat binding.

To my first cousin,
twice removed, Clyde.
Tough break about Pluto.

And my father, he of the first
sealed, rechargeable lead-acid
battery. Seek ye, in the red
mountains and arid plains,
New Mexican truth.

CONTENTS

PREFACE. How One-on-One Works xi

LESSON 1. How Channels Work 3
 What Are Channels? 5
 The Mechanics of RGB Primaries 5
 The Single-Channel Grayscale Image 9
 Working with Lab Color 11
 The Mechanics of CMYK Inks 18
 Editing in the Multichannel Mode 21
 Duotones, Tritones, and Quadtones 28

LESSON 2. How Masks Work 37
 What Are Masks? 39
 Creating and Saving Alpha Channels 40
 Loading Masks and Putting Them to Use 48
 Modifying a Mask 56
 Combining Masks 61

LESSON 3. Selection Essentials 69
 The Automated Selection Tools 71
 Making the Most of the Magic Wand 72
 Using the Quick Selection Tool 85
 Using the Magnetic Lasso 90
 Refining a Selection Outline 93
 Selection Calculations 104
 Transforming and Warping Selections 113

LESSON 4. **Color Range and Quick Mask** **123**
 As Close to Automatic asMasking Gets 125
 Using the Color Range Command 125
 Smoothing Edges and Remaking Corners 131
 Refining a Selection with Quick Mask 136
 Pasting an Image into a Mask 147

LESSON 5. **Everyday Channel Masking** **151**
 One Big, Hairy Project 153
 Making a Mask from a Channel 154
 Finessing the Smooth Contours 160
 Creating a Silhouette Effect 166
 Blending Hair and Sky 173
 Setting the Image in a $3000 Frame 182

LESSON 6. **Blends and Composites** **187**
 When in Doubt, Blend 187
 Blending a Scanned Logo 190
 Working with Blend Modes 203
 How Add out-brightens Multiply 209
 Luminance Blending 219
 Using Blending to Reconcile Images
 that Really Don't Go Together 223

LESSON 7. **Masking Layers** **235**
 The Many Kinds of Layer Masks 235
 Creating a Jet of Motion Blur 237
 Masking an Adjustment Layer 243
 Masking Translucent Objects 249
 Assembling the Perfect Group Photo 258
 Employing a Knockout Mask 267

LESSON 8. **Specialty Masks** **273**
 Six Specialized Selectors 275
 Smoothing with a Luminance Mask 276
 Adjusting Skin Tones with a Corrective Mask 283
 Changing the Color of an Image
 Element with a Color Mask 287

Sharpening with a Density Mask 296
Blurring a Background with a Depth Mask 300
Correcting an Archival Photo with an Edge Mask 304

LESSON 9. **Channel Mixing and Other Tricks** **313**
Channel Mixer, I Am Your Father 315
Mixing a Custom Black-and-White Image 316
Swapping Channel Mixer for Black & White 322
Extreme Channel Mixing 325
The Professional's Approach to Red-Eye 337

LESSON 10. **Calculations (a.k.a. Channel Operations)** **349**
The Lore of the Chop 351
Blue Screen Calculations 352
Using the Add and Subtract Modes 365
Curves, Dodge, Burn, and Paint 374
Multiply, Minimum, Blur, and Apply Image 389

LESSON 11. **The Pen Tool and Paths Palette** **397**
Vector-Based Shapes 399
Drawing a Free-Form Polygon 400
Adding and Deleting Anchor Points 404
Converting a Path to a Selection or a Mask 408
Control Handles, Smooth Points, and Cusps 411
Vector Masks, Shape Layers, and Layer Masks 414
Editing Character Outlines as Paths 422

LESSON 12. **Masking the Tough Stuff** **429**
Calculations, High Pass, and Arb Maps 431
Masking and Compositing Light Hair 432
Capturing and Enhancing a Flame 442
Mastering Advanced Calculations 445
Creating a High Pass Mask 449
Masking with Arbitrary Maps 452

INDEX. **461**

PREFACE

HOW ONE-ON-ONE WORKS

Welcome to *Photoshop CS4 Channels & Masks One-on-One*, another in a series of highly visual, full-color titles that combine step-by-step lessons with three hours of video instruction. As the name *One-on-One* implies, I walk you through using channels and masks in Photoshop just as if I were teaching you in a classroom or corporate consulting environment. Except that instead of getting lost in a crowd of students, you receive my individualized attention. It's just you and me.

I created *One-on-One* with three audiences in mind. If you're an independent graphic artist, designer, or digital photographer—professional or amateur—you'll appreciate the hands-on approach and the ability to set your own pace. If you're a student working in a classroom or vocational setting, you'll enjoy the personalized attention, structured exercises, and end-of-lesson quizzes. If you're an instructor in a college or vocational setting, you'll find the topic-driven lessons helpful in building curricula and creating homework assignments. *Photoshop CS4 Channels & Masks One-on-One* is designed to suit the needs of beginners and intermediate users. But I've seen to it that each lesson contains a few techniques that even experienced users don't know.

Read, Watch, Do

Photoshop CS4 Channels & Masks One-on-One is your chance to master Photoshop under the direction of a professional trainer with more than twenty years of computer design and imaging experience. Read the book, watch the videos, do the exercises. Proceed at your own pace and experiment as you see fit. It's the best way to learn.

Figure 1.

Photoshop CS4 Channels & Masks One-on-One contains twelve lessons, each made up of four to six step-by-step exercises. Every lesson in the book includes a corresponding video lesson (see Figure 1) on the accompanying DVD, in which I introduce the key concepts you'll need to know to complete the exercises. Best of all, every exercise culminates in a real-world project that you'll be proud to show others (see Figure 2). The exercises include insights and context throughout so that you'll know not only what to do but, just as important, why you're doing it. My sincere hope is that you'll find the experience entertaining, informative, and empowering.

All the sample files required to perform the exercises are on the DVD-ROM at the back of this book. The DVD also contains the video lessons. (This is a data DVD, not a video DVD. It won't work in a set-top device; it works only with a computer.) Don't lose, destroy, or otherwise harm this precious DVD-ROM. It is as integral a part of your learning experience as the pages in this book. Together, the book, sample files, and videos form a single comprehensive training experience.

Figure 2.

One-on-One Requirements

The main prerequisite to using *Photoshop CS4 Channels & Masks One-on-One* is having Photoshop CS4 or Photoshop CS4 Extended installed on your system. You may have purchased Photoshop CS4 as a stand-alone product or as part of Adobe's Creative Suite 4 (see Figure 3). You *can* work through many of the exercises using an earlier version of Photoshop, but some steps will not work as written. All exercises have been fully tested with Adobe Photoshop CS4 but not with older versions.

Photoshop CS4 Channels & Masks One-on-One is cross-platform, meaning that it works equally well whether you're using Photoshop installed on a Microsoft Windows–based PC or an Apple Macintosh.

Any computer that meets the minimum requirements for Photoshop CS4 also meets the requirements for using *Photoshop CS4 Channels & Masks One-on-One*. Specifically, if you own a PC, you need Windows XP with Service Pack 3, or Windows Vista (Home Premium or better) with Service Pack 1. If you own a Mac, you need Mac OS X version 10.4.11 or higher.

Regardless of platform, your computer must meet the following minimum requirements:

- 512MB of RAM

- 2GB of free hard disk space (1GB for Photoshop, 500MB for the *One-on-One* project files, and the remaining 500MB for Photoshop's scratch disk files)

Figure 3.

- 16-bit color graphics card that supports OpenGL 2.0 (as do most modern cards, including those from market-leader nVidia)
- Color monitor with 1024-by-768 pixel resolution
- DVD-ROM drive
- Broadband Internet connection for extras

To play the videos, you need Apple's QuickTime Player 7.2 or later. If you don't have it, see the facing page to find out how to get it.

Finally, you'll want to install the *One-on-One* lesson files, color settings, and keyboard shortcuts from the DVD-ROM that accompanies this book, as explained in the next section.

One-on-One Installation and Setup

Photoshop CS4 Channels & Masks One-on-One is designed to function as an integrated training environment. So before embarking on the lessons, I ask that you install a few files onto your hard drive:

- QuickTime software (if it isn't already installed)
- Lesson files used in the exercises (500MB in all)
- *One-on-One* Creative Suite color settings
- Custom collection of keyboard shortcuts called dekeKeys
- An extension that adds a custom palette to Photoshop

I'll also have you change a few preference settings. These changes are optional—you can follow along with the exercises in this book regardless of your preferences. Even so, I advocate these settings for two reasons: First, they make for less confusion by ensuring that you and I are on the same page, as it were. Second, some of Photoshop's default preferences are just plain wrong.

All files (except QuickTime) are provided on the DVD-ROM that accompanies this book. To install the files, follow these steps:

1. *Insert the* **One-on-One DVD.** Remove the DVD from the back cover of the book and place it in your computer's DVD drive. Then do one of the following, depending on your platform:

 - On the PC, Windows may ask you what action you'd like to perform on the disk. Scroll down the list and click **Open folder to view files using Windows Explorer**. Otherwise, go to My Computer, find the DVD, and double-click it.

 - On the Mac, double-click the DVD icon located on your computer's desktop.

Figure 4 shows the contents of the DVD. Although this screen shot happens to come from a Mac, you'll see the same five files and folders on a PC, albeit either in list form or with different icons.

Figure 4.

2. ***If necessary, get QuickTime.*** If your computer is already equipped with QuickTime (as all Macs are), skip to Step 3. Otherwise, double-click the file *PsCM videos.html* on the DVD to open the *Photoshop CS4 Channels & Masks One-on-One* page in your default Web browser. In the bottom-left corner of the screen you'll see a link to *www.apple.com/quicktime*, magnified in Figure 5. Click the link to open a new window to Apple's QuickTime site. Follow the on-screen instructions to download and install the software. After you finish installing QuickTime (and restarting your system, if you are asked to do so), proceed to the next step.

To view the training videos, QuickTime 7 must be installed. For a free download, visit www.apple.com/quicktime.

Figure 5.

3. ***Copy the lesson files to your desktop.*** Return to your computer's desktop (called the Explorer under Windows, the Finder on the Mac). Inside the window that shows the contents of the DVD, locate the folder called *Lesson Files-PsCM 1on1*. This folder contains all the files you'll be using throughout the exercises in this book. Drag the folder to the desktop to copy it, as you see me doing in Figure 6.

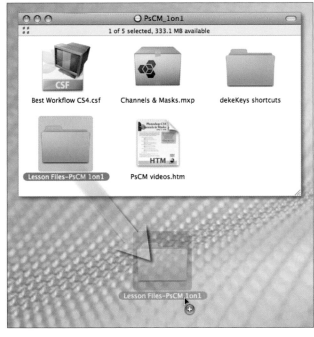

You don't absolutely *have* to copy the folder to the desktop; you can put it anywhere you want. But be advised, if you put the folder somewhere other than the desktop, I leave it up to you to find the folder and the files it contains.

Figure 6.

4. ***Copy the color settings to your hard drive.*** On the DVD, locate the Adobe color settings file called *Best workflow CS4.csf.* Copy this file to one of two locations on your hard drive, depending on your platform and operating system. (Note that, in the following, user indicates your computer login name.)

- Under Windows Vista, the location is
 C:\Users\user\AppData\Roaming\Adobe\Color\Settings

- Under Windows XP, it's
 C:\Documents and Settings\user\Application Data\Adobe\Color\Settings

- On the Mac, choose **Go→Home** and copy the color settings to the folder *Library/Application Support/ Adobe/Color/Settings*

If you can't find the AppData or Application Data folder on the PC, it's because Windows is making the system folders invisible. Choose **Tools→Folder Options**, click the **View** tab, and turn on **Show Hidden Files and Folders** in the scrolling list. Also turn off the **Hide Extensions for Known File Types** and **Hide Protected Operating System Files** check boxes and then click the **OK** button.

5. *Start Photoshop.* If Photoshop CS4 is already running on your computer, skip to Step 6. If not, start the program:

- On the PC, go to the **Start** menu (⊞ under Windows Vista) and choose **Adobe Photoshop CS4**. (The program may be located in the **Programs** or **All Programs** sub-menu, possibly inside an **Adobe** submenu.)

- On the Mac, choose **Go→Applications** in the Finder. Then open the *Adobe Photoshop CS4* folder and double-click the Adobe Photoshop CS4 application icon.

6. *Change the color settings to Best Workflow.* Now that you've installed the color settings, you have to activate them inside Photoshop. Choose **Edit→Color Settings** or press the keyboard shortcut, Ctrl+Shift+K (⌘-Shift-K on the Mac). Inside the **Color Settings** dialog box, click the **Settings** pop-up menu and choose **Best Workflow CS4** (see Figure 7). Then click the **OK** button. Now the colors of your images will match (or very nearly match) those shown in the pages of this book.

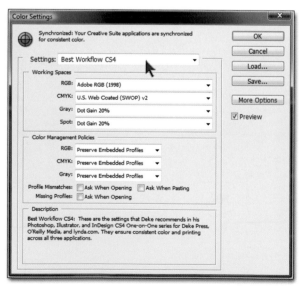

Figure 7.

If you own the full Creative Suite 4 package, you'll need to synchronize the color settings across all Adobe applications. Launch the Adobe Bridge by choosing **File→Browse in Bridge**. Inside the Bridge, choose **Edit→Creative Suite Color Settings**. Locate and select the **Best Workflow CS4** item in the scrolling list. Then click **Apply**. Now all your CS4 applications will display consistent color.

7. *Install the dekeKeys keyboard shortcuts.* Return to the desktop level of your computer and open the *dekeKeys shortcuts* folder on the DVD. There you'll find two versions of my custom dekeKeys keyboard shortcuts, one for the Mac and one for the PC. Double-click the file that corresponds to your platform. Photoshop will spring to the foreground. (If you get a message asking if you want to

save the changes to your preexisting shortcuts, click **Yes**, give the shortcuts a filename, and click **Save**. But more likely, you won't see any message.)

8. ***Confirm the dekeKeys installation.*** To confirm that the dekeKeys shortcuts have installed successfully, choose **Edit→Keyboard Shortcuts** and do the following:

 • Confirm that the **Set** option at the top of the **Keyboard Shortcuts** dialog box reads **Photoshop Defaults (modified)**, meaning that some sort of shortcuts shift has occurred.

 • Set **Shortcuts For** to **Application Menus**.

 • Click the ▶ triangle to the left of the **File** entry to view the commands in the File menu.

 • Scroll down to the command name **Place** (between Revert and Import). If it lists the shortcut Alt+Shift+Ctrl+D (or Option-Shift-⌘-D), you're looking at dekeKeys.

9. ***Save the dekeKeys shortcuts.*** Click the disk icon (🖫) to the right of the **Set** option to save the modified shortcuts. Name the new shortcuts "dekeKeys CS4" (or your own name if you plan on customizing them further) and click the **Save** button, as in Figure 8. Then click **OK** to complete the process. You now have shortcuts for some of Photoshop's best masking functions, including Color Range, Gaussian Blur, and High Pass.

10. ***Install the Channels & Masks palette.*** I've created a special extension that adds a palette to Photoshop CS4 that gives you quick access to most of the tools and commands you'll work with over the course of this book. To install it, simply double-click the *Channels & Masks.xmp* file on the DVD. This launches the Adobe Extension Manager, which will bring up a license agreement for the extension. Accept the agreement and the extension is installed.

11. ***Quit and restart Photoshop.*** You have to reload Photoshop to load the palette. So return to Photoshop. Press Ctrl+Q (⌘-Q) to quit the program, then relaunch it as described in Step 5.

12. ***Open the Channels & Masks palette.*** Choose **Window→Extensions→Channels+Masks** to bring up the palette. (The first time you bring it up, there may be an Adobe-created message

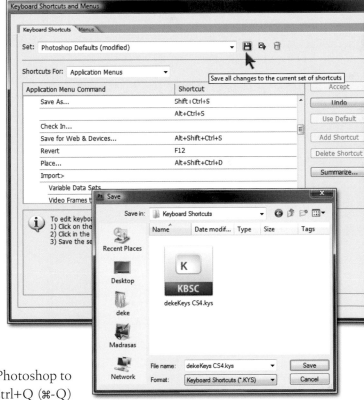

Figure 8.

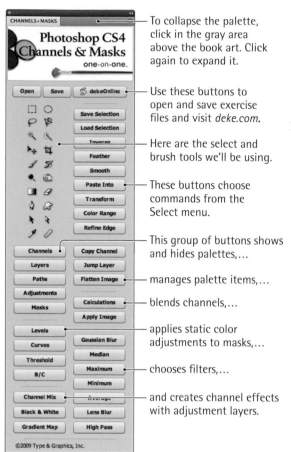

To collapse the palette, click in the gray area above the book art. Click again to expand it.

Use these buttons to open and save exercise files and visit *deke.com*.

Here are the select and brush tools we'll be using.

These buttons choose commands from the Select menu.

This group of buttons shows and hides palettes,...

manages palette items,...

blends channels,...

applies static color adjustments to masks,...

chooses filters,...

and creates channel effects with adjustment layers.

Figure 9.

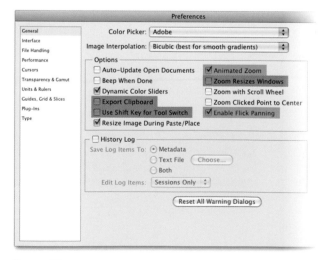

Figure 10.

asking you to close the panel to enable its functionality, or even restart Photoshop again. Do as it says.) You can see the Channels & Masks palette in all its tallness in Figure 9. The palette gathers everything you'll regularly use into one convenient place. However, I don't want the palette to be a crutch, so this book also details how to access all these functions without using this palette.

13. *Adjust a few preference settings.* To minimize confusion and maximize Photoshop's performance, I'd like you to modify a few preference settings. Choose **Edit→Preferences→General** (that's **Photoshop→Preferences→General** on the Mac) or press Ctrl+K (⌘-K). And then make these changes:

• Photoshop lets you copy big images. And when you switch programs, Photoshop conveys those copied images to the system. Problem is, that takes time and the operation often fails. Best to avoid this problem and the associated delays by turning off the **Export Clipboard** check box.

• Turn off the **Use Shift Key for Tool Switch** check box. This makes it easier to switch tools from the keyboard, as we'll be doing frequently over the course of this book.

• Check to make sure both the **Animated Zoom** and **Enable Flick Panning** check boxes are available and on. If they're dimmed, you either have a system that is incompatible with the graphics acceleration standard OpenGL or need to update your graphics card driver.

• If you use a Mac, turn off **Zoom Resizes Windows**. (On the PC, it's off by default.) In Photoshop CS4, the Zoom commands and the zoom tool share the same window resizing behavior, and trust me, you don't want the zoom tool resizing the window. I've highlighted this and the preceding check boxes in Figure 10. Red means turn the option off; green means turn it on.

• Click **Interface** in the left-hand list. Or press Ctrl+2 (⌘-2 on the Mac). This switches you to the next panel of options.

• Set all **Border** options in the top-right area of the dialog box to **None**. This makes for less confusion when gauging the boundaries of an image.

• By default, every image opens in a tabbed window, thus permitting you to switch between images just by clicking

a tab. I like the tabbed interface, but if you don't cotton to it, you can disable it by turning off **Open Documents as Tabs**. In other words, I'm not recommending you turn off the option; I'm just letting you know it's there. Hence the yellow highlight in Figure 11.

- Click **File Handling** in the left-hand list or press Ctrl+3 (⌘-3) to switch panels.

- Notice the pop-up menu labeled **Maximize PSD and PSB File Compatibility**? Unless you're a video professional or you spend a lot of time trading layered images between Photoshop and Lightroom (a separate program from Adobe), this option is best set to **Never**.

- Unless you work with a group that employs Adobe's Version Cue technology, turn off the **Enable Version Cue** check box, highlighted red in Figure 12.

- Click **Cursors** in the left-hand list, or press Ctrl+5 (or ⌘-5) to switch panels.

- Turn on the **Show Crosshair in Brush Tip** check box. Highlighted green in Figure 13, this option adds a + to the center of every brush cursor, which helps you align the cursor to a specific point in your image.

- Click **Units & Rulers** in the left-hand list, or press Ctrl+7 (or ⌘-7) to display another panel of options.

- Set the **Rulers** pop-up menu to **Pixels**, which I've highlighted green in Figure 14 on the next page. As you'll see, pixels are far and away the best unit for measuring digital images.

Your preferences now match those of the loftiest image-editing professional. Click **OK** to exit the Preferences dialog box and accept your changes.

14. *Quit Photoshop.* You've come full circle. On the PC, choose **File→Exit**; on the Mac, choose **Photoshop→Quit Photoshop**. Quitting Photoshop not only closes the program but also saves the changes you made to the color settings, keyboard shortcuts, and preference settings.

Congratulations, you and I are now in sync. Just one more thing: If you use a Macintosh computer, the system intercepts a few important Photoshop keyboard shortcuts, which you'll want to modify according to the following tip. If you use a PC, feel free to skip the tip and move along to the next section.

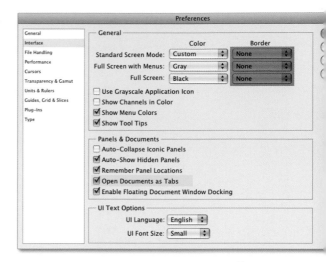

Figure 11.

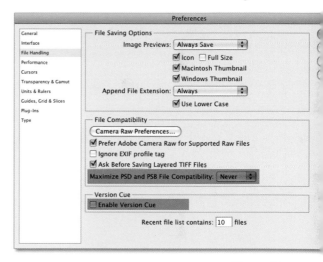

Figure 12.

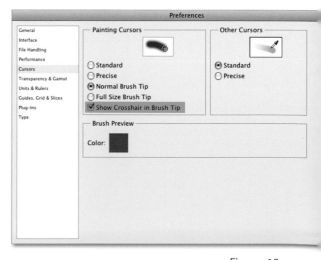

Figure 13.

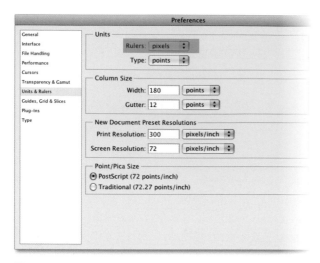

Figure 14.

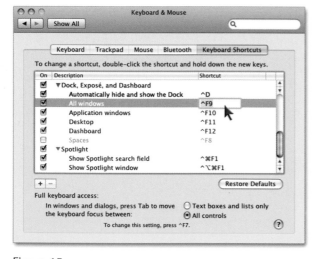

Figure 15.

Adobe intends for the function keys to display or hide common palettes. Meanwhile, pressing ⌘ and Option with the spacebar should access the zoom tool. But in recent versions of OS X, these keys tile or hide windows according to Apple's Exposé or invoke search functions via Apple's Spotlight. (Apple's newest aluminum keyboards map these to iTunes and volume controls; you need to hold the FN key on these keyboards to override these mappings, even after making the following fixes.) To rectify these conflicts, choose **System Preferences** from the menu. Click **Show All** at the top of the screen, click the **Keyboard & Mouse** icon, and click the **Keyboard Shortcuts** button. Scroll down the shortcuts until you find one called **All Windows**. Click the **F9** shortcut to highlight it. Then press Control-F9 (which appears as **^F9**, as in Figure 15). After that, reading down the list, replace F10 with Control-F10, F11 with Control-F11, and F12 with Control-F12. Next, click ⌘**Space** and replace it with ⌘-Control-F1; click ⌥⌘**Space** and replace it with ⌘-Control-Option-F1 (which shows up in reverse order as ^ ⌥⌘**F1**). Finally, click the ⊗ in the top-left corner of the window to close the system preferences. From now on, the palette and zoom tool shortcuts will work according to Adobe's intentions, as well as the directions provided in this book.

Playing the Videos

At the outset of each lesson in this book, I ask you to do something most books don't ask you to do: I ask you to play a companion video lesson from the DVD-ROM. Ranging from nine to twenty minutes apiece, these video lessons introduce key concepts that make more sense when first seen in action.

Edited and produced by the trailblazing online training company lynda.com, the video lessons are not traditional DVD movies. They're much better. A standard DVD movie maxes out at 720-by-480 nonsquare pixels. This DVD has no such restrictions. My movies play at resolutions of 1280-by-800 pixels (see Figure 16), more than twice the resolution of a DVD movie and just shy of 1080p HDTV. The result is a high-quality, legible screen image, so that you're never squinting in an attempt to figure out what tool or command I'm choosing. And thanks to lynda.com's considerable experience supplying movies over slow Internet connections, every movie plays smoothly. This is video training at its finest.

800 pixels tall

1280 pixels wide

photo istockphoto.com/JJRD

Figure 16.

To watch a video, do the following:

1. **Insert the One-on-One DVD.** The videos reside in an invisible folder called *videos*. If you can find it, you can copy that folder (which weighs in at 900MB) to your hard drive and play the videos inside QuickTime. But that's by no means necessary, nor do I encourage it. I designed the videos to play from a simple HTML interface directly from the DVD, as these steps explain.

2. **Launch the video interface.** Open the DVD and double-click the file named *PsCM videos.htm* to open the *Photoshop CS4 Channels*

Figure 17.

& *Masks One-on-One* page in your default Web browser, as pictured in Figure 17.

3. ***Click the link for the video lesson you want to watch.*** The left side of the page offers a series of seventeen links, each of which takes you to a different video. Click one of the five bold items to watch a live-action segment from your cordial host, me. The indented links take you to one of the twelve video lessons that accompany the twelve lessons in this book. You can watch the video lessons in any order you like. However, each makes the most sense and provides the most benefit when watched at the outset of the corresponding book-based lesson.

4. ***Watch the first introductory video.*** Click the **Channels, Masks, and Selections** link to watch the first welcoming message. It explains a bit more about how the book and video lessons work with each other. Plus, it permits me to accost you with some brightly lit, personal-training love.

5. ***Watch the video at your own pace.*** Use the play controls under the movie to play, pause, or jump to another spot in the movie. You can also take advantage of the following keyboard shortcuts and hidden tricks:

- Click inside the movie to pause it. Double-click to send the movie playing again.

- You can pause the video also by pressing the spacebar. Press the spacebar again to resume playing.

- I don't know why you'd want to do this, but you can play the video backward by pressing Ctrl+← (⌘-← on the Mac). Or Shift-double-click in the movie.

- Drag the circular playhead (labeled in Figure 18) to shuttle back and forth inside the movie. Or just click in the timeline to move to a specific point in the video.

- Press the ← or → key to both pause the movie and go backward or forward one frame.

- Press Ctrl+Alt+← (or the simpler Option-←) to return to the beginning of the movie.

- Use the ↑ and ↓ keys to raise or lower the volume.

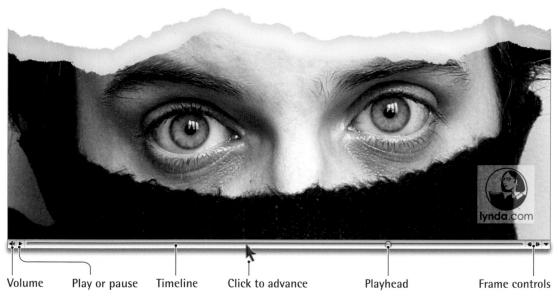

| Volume | Play or pause | Timeline | Click to advance | Playhead | Frame controls |

Figure 18.

Here's a really weird one: Press Alt (Control on the Mac) and drag in the frame controls in the bottom-right corner of the window (labeled in Figure 18) to change the playback speed.

That last technique is an undocumented trick dating to the early days of QuickTime. It's hard to predict how far you need to drag to achieve a particular speed, but with a little bit of experimenting, you can fast-forward over the tedious stuff (when will I stop yammering?) or slow down the really useful information that otherwise goes by too fast.

PEARL OF WISDOM

One final note: Unlike the exercises inside the book, none of the video lessons include sample files. The idea is, you work along with me inside the book; you sit back and relax during the videos.

Structure and Organization

Each of the lessons in the book conforms to a consistent structure, designed to impart skills and understanding through a regimen of practice and dialog. As you build your projects, I explain why you're performing the steps and why Photoshop works the way it does.

Each lesson begins with a broad topic overview. Turn the page, and you'll find a section called "About This Lesson," which lists the skills you'll learn and directs you to the video-based introduction.

Next come the step-by-step exercises, in which I walk you through some of Photoshop's most powerful and essential image-manipulation functions. A DVD icon (like the one on the right) appears when- ever I ask you to open a file from the *Lesson Files-PsCM 1on1* folder that you installed on your computer's hard drive. To make my directions crystal clear, all command and option names appear in bold type (as in, "choose the **Open** command"). The first appearance of a figure reference appears in colored type. More than 800 full-color, generously sized screen shots and images diagram key steps in your journey, so you're never left scratching your head, puzzling over what to do next. And when I refer you to another step or section, I tell you the exact page number to go to. (Shouldn't every book?)

To make doubly sure there are as few points of confusion as possible, I pepper my descriptions with the very icons you see on screen, critical icons like 👁, *fx*, ✂, and ✋. So when I direct you to add a layer to your document, I don't tell you to click the Create a New Layer icon at the bottom of the Layers palette. (The only time you see the words *Create a New Layer* is when you hover your cursor over the icon, which is impossible to do if you don't know where to hover your cursor in the first place.) Instead, I tell you to click the ⬓ icon, because ⬓ is what it is. It has meant hand-drawing nearly 400 icons to date, but for you, it was worth it.

PEARL OF 🔘 WISDOM

Along the way, you'll encounter the occasional "Pearl of Wisdom," which provides insights into how Photoshop and the larger world of digital imaging work. Although this information is not essential to performing a given step or completing an exercise, it may help you understand how a function works or provide you with valuable context.

More detailed background discussions appear in independent sidebars. These sidebars shed light on the mysteries of color, bit depth, resolution, and other high-level topics that are key to understanding Photoshop.

A colored paragraph of text with a rule above and below it calls attention to a special tip or technique that will help you make Photoshop work faster and more smoothly.

Some projects are quite ambitious. My enthusiasm for a topic may even take us a bit beyond the stated goal. In such cases, I cordon off the final portion of the exercise and label it "Extra Credit."

EXTRA ⭐ CREDIT

If you're feeling oversaturated and utterly exhausted, the star icon is your oasis. It's my way of saying, you deserve a break. You can even drop out and skip to the next exercise. On the other hand, if you're the type who believes quitters never prosper (which they don't, incidentally), by all means carry on and you'll be rewarded with a completed project and a wealth of additional tips and insights.

I end each lesson with a "What Did You Learn?" section featuring a multiple-choice quiz. Your job is to choose the best description for each of twelve key concepts outlined in the lesson. Answers are printed upside-down at the bottom of the page.

FURTHER INVESTIGATION

Finally, every so often you'll come across a "Further Investigation" marker, which includes information about further reading or video training. Oftentimes, I refer you to the lynda.com Online Training Library, which contains tens of thousands of movies, more than a thousand of them by me. And all available to you, by subscription, every minute of every waking day.

Just to be absolutely certain you don't feel baited into making yet another purchase, I've arranged a special time-limited back door for you. Go to *www.lynda.com/dekeps* and sign up for the 7-Day Free Trial Account. This gives you access to the *entire* Online Training Library, including all the movies in my "Further Investigation" recommendations. But remember, your seven days start counting down the moment you sign up, so time it wisely.

Then again, if you find the service so valuable you elect to subscribe, we're happy to have you. You'll be happy, too.

The Scope of This Book

I and my extensive team have done our best to assemble the most comprehensive and comprehensible book on channels and masks ever written. Here's a quick list of the topics and features that I discuss:

- Lesson 1: How channels work, including the three color models (RGB, Lab, and CMYK); single-channel grayscale images; and multichannel images (including spot colors)

- Lesson 2: How masks work, including converting selection outlines to masks, converting masks back to selections, and viewing masks and composite images simultaneously

- Lesson 3: Core selection techniques, including the automated selection tools, the Refine Edges command, and selection calculations

- Lesson 4: Using the Color Range command and the quick mask mode, including ways to use the two features in tandem

- Lesson 5: Channel masking, including building a mask from a color channel, creating silhouettes, and masking complex details, like hair

- Lesson 6: Blending and compositing, including the Layer palette's 25 blend modes (featuring "The Fill Opacity Eight"), advanced luminance blending, and ways to seamlessly blend foregrounds and backgrounds

- Lesson 7: Layers and masks, including transparency masks, layer masks, clipping masks, adjustment layers, knockout layers, and ways to mask translucent objects such as glass

- Lesson 8: Specialty masks, including luminance masks, corrective masks, color masks, density masks, depth masks, and edge masks

- Lesson 9: Channel mixing, including ways to create high-impact black-and-white photos with Channel Mixer, Black & White, and Gradient Map adjustment layers, and a professional take on eliminating red-eye

- Lesson 10: Channel operations, including ways to blend channels and assemble complex masks with Calculations and Apply Image

- Lesson 11: Paths and the Pen tool, including how to draw with the pen tool, convert paths to selections or masks, employ vector masks and shape layers, and edit type as path outlines

- Lesson 12: Advanced masking techniques that employ advanced calculations, the High Pass filter, and arbitrary maps to separate hair, flames, and feathers from similarly colored or busy backgrounds

To find out where I discuss a specific feature, please consult the index, which begins on page 460.

Note that this book does not address the most basic features of Photoshop and assumes that you have a working knowledge of the product and an interest in taking a very deep dive into the topic of channels and masks. I've worked hard to make sure the steps contain all the details required to take on this large and involved topic, but you'll do better if you possess an intermediate skill set, including the ability to navigate inside the program by zooming, panning, switching between images, and working with tools, commands, and palettes.

FURTHER INVESTIGATION

If your goal is to learn Photoshop from the ground up, please consult my general guide to the program, *Adobe Photoshop CS4 One-on-One*. It covers the gamut of Photoshop functionality, including everything you need to know to take on the information in this book.

I now invite you to turn your attention to Lesson 1, "How Channels Work." I hope you'll agree that *Photoshop CS4 Channels & Masks One-on-One*'s combination of step-by-step exercises, real-world insights, and video introductions provides the best learning experience of any training resource on the market. As lofty as that may sound, that was our goal.

I LOVE CHANNELS and masks for three reasons. First, they're as old as the hills. Not only were both made available in the very first version of Photoshop, they predate Photoshop and even personal computers by years, one might even argue decades. And yet they remain every bit as relevant and indispensable as the day they were invented.

Second, they permit you to merge different images into a seamless work of art. Take Figure 1-1 on the right. We start with the Parthenon, remove it from the Acropolis of Athens, posit it against a brown map, and blend map and blue sky with a hint of white mist. The moment you see the final *composition*—the term given to a multilayered file that contains many photos, graphics, and effects, often mingling to form a single continuous image—you know what you're seeing is not real or even possible. But that's part of the fun. And its credible execution sells you on the authenticity of its conceit. The fact that it required perhaps 15 minutes of work to pull off is pure bonus.

But the biggest reason I love channels and masks is that, despite many efforts, masking has yet to be successfully automated. It is often difficult work, it involves secret knowledge of some of Photoshop's most labyrinthine features, and—as you'll learn over the course of this book—no two jobs are the same. Which can make for a challenging but secure career.

Because it involves seeing photographs and other imagery in a way that computers simply can't, masking relies on the pluck and talent of the compositor. By which I mean, not to put too fine a point on it, you.

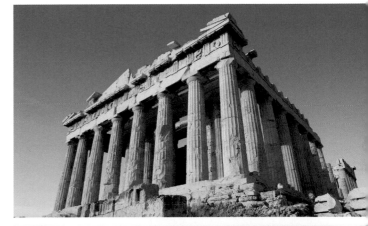

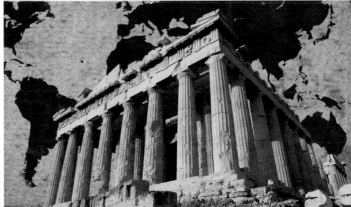

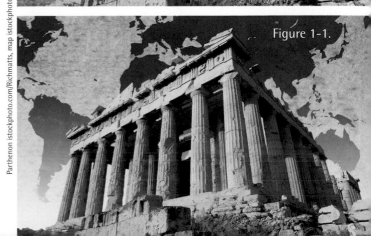

Figure 1-1.

Parthenon istockphoto.com/Richmatts, map istockphoto.com/zoomstudio

ABOUT THIS LESSON

Project Files

Before beginning the exercises, make sure you've copied the lesson files from the DVD, as directed in Step 3 on page xv of the Preface. This should result in a folder called *Lesson Files-PsCM 1on1* on your desktop. We'll be working with the files inside the *Lesson 01* subfolder.

This lesson introduces you to the way that channels work and demonstrates how three to four grayscale images may ultimately blend together to form a full-color composite photograph. Over the course of these exercises, you'll learn how to:

- Explore the mechanics of an RGB image page 5
- Create a single-channel grayscale image page 9
- Enhance the saturation of an image in Lab page 11
- Convert an image to a CMYK image and find out how CMYK works page 18
- Edit an image in the multichannel mode. page 21
- Add spot colors to a quadtone image and modify its channels in the multichannel mode . . . page 28

Video Lesson 1: The Channels Palette

What the Layers palette is to layers, the Channels palette is to channels and masks. (Compare this to the Masks palette, which is a minor support palette that we won't be looking at until Lesson 7.) The Channels palette is where you find and modify color-bearing channels, save and load masks, blend channels to create selections and effects, and more.

To see this palette in action—and gain a few insights you'll need to complete the exercises in the book—watch the first video lesson. Insert the DVD, double-click the file *PsCM Videos.html*, and click **Lesson 1: The Channels Palette** under the **Channels, Masks, and Selections** heading. This 14-minute, 21-second movie touches on the following shortcuts:

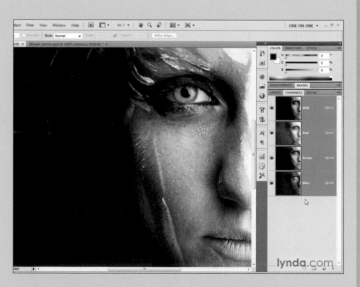

Operation	Windows shortcut	Macintosh shortcut
Assign large thumbnails to palettes	right-click below last item	right-click below last item
Collapse a palette group	click to the right of the tab	click to the right of the tab
Display File info dialog box	Ctrl+Shift+Alt+I	⌘-Shift-Option-I
Switch between channels	Ctrl+3, Ctrl+4, Ctrl+5	⌘-3, ⌘-4, ⌘-5
Switch back to the full-color composite	Ctrl+2	⌘-2
Display Interface preferences	Ctrl+K, Ctrl+2	⌘-K, ⌘-2

What Are Channels?

Here's the idea: Photoshop is at its heart a grayscale image editor. So rather than seeing a full-color image, the way you do, Photoshop sees no fewer than three grayscale images, working together but ultimately unique. These grayscale images are called *channels*, and like TV or radio channels, they are independent bands of information that you can switch to at will. Virtually every tool and command in Photoshop affects each channel separately. The fact that Photoshop blends the channels on-the-fly to produce a full-color preview is strictly a favor to you.

Labeled in the Channels palette in Figure 1-2 (which you get to by choosing Window→Channels) the *color-bearing channels* contain nothing but *luminance*—that is, brightness—information, from black to white with incrementally lighter shades of gray in between. By assigning a primary color value to each of the color-bearing channels, Photoshop is able to blend the full-color image that you see on screen and in print.

A *mask* is a specific variety of channel. Rather than conveying information about the color of the image, it conveys selection or transparency information. After saving a selection as a mask, you can bring the entire weight of Photoshop to bear on making that selection as accurate as it needs to be, down to isolating individual strands of hair. And that's just the beginning. Understanding and embracing the machinations of masking is perhaps the most sure-fire way to boost the quality of your work in Photoshop.

This lesson is all about channels. The next is all about masks. The remaining lessons are all about making you the best photographic manipulator you can possibly be.

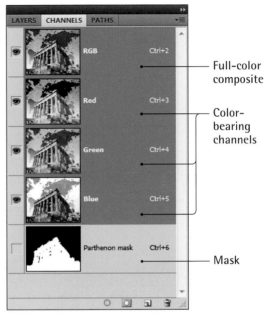

Figure 1-2.

The Mechanics of RGB Primaries

In this and the next few exercises, we're going to review the various color models supported by Photoshop. Why begin with such an arcane topic? Because an image's color model—whether it's RGB, Grayscale, Lab or CMYK—directly affects the channels housed in the Channels palette. In turn, those channels define the color values contained in the image. (For a complete explanation of color models and other channel modes, see the "Photoshop's Eight Channel Modes" sidebar on page 12).

Let's start things off with a look at the most common color model, RGB, which is the one most likely to be in force when you first open an image in Photoshop. *RGB* stands for the primary colors of light: red, green, and blue. As such, it is the color model employed by computer monitors, televisions, projectors, and other devices that emit light. It's also the color model used by digital cameras and scanners, which capture the light that gets reflected off people and other real-world objects.

In the following steps, I invite you to watch the first of 12 video lessons that I've created specially for this book. This video explains how to mix and match channels in Photoshop, an essential concept to understanding this and future exercises. Then I'll walk you through a layered file that diagrams how RGB channels interact.

1. *Open an RGB photograph.* Open *Painted couple.jpg*, located in the *Lesson 01* folder inside the *Lesson Files-PsCM 1on1* folder, which you should have copied from the DVD in the back of this book. Pictured in Figure 1-3, this is the RGB image as it was captured by photographer Sophia Tsibikaki of iStockphoto.

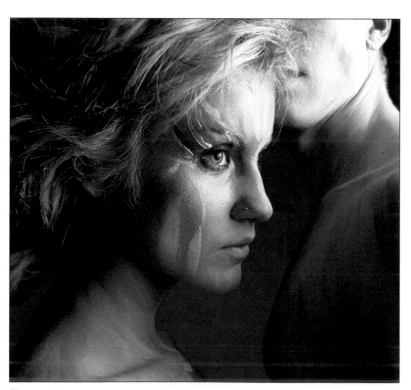
Figure 1-3.

2. *Bring up the Channels palette.* Choose **Window→Channels** to display the **Channels** palette, which contains just four items, the full-color RGB image and each of the independent channels, Red, Green, and Blue.

3. *Familiarize yourself with the Channels palette.* If you haven't done so already, now is a great time to watch Video Lesson 1, "The Channels Palette" (which I introduce on page 4). In the video, I admonish you to sit back and relax, but you may find it useful to sit up and work along with me in this sample file (which hails from the same photo shoot as the image in the video). As I do in the video, I recommend that you enlarge the thumbnails inside the Layers, Channels, and Paths palettes.

4. *Open the RGB diagram.* Now open *RGB revealed.psd*, also found inside the *Lesson 01*

folder. As witnessed in Figure 1-4, this image appears to be the image colorized in a deep scarlet red. Meanwhile, if you look at the Channels palette, you'll see normal brightness in the Red channel and nothing but black in the Green and Blue channels. Upshot: This is what the image would look like if it had a red channel and nothing else.

5. *Go to the Layers palette.* To provide insight into how Photoshop blends RGB channels, I've relegated each of the color channels from the *Painted couple.jpg* image to independent layers. To see those layers, choose **Window→Layers** or press the F7 key, the shortcut for the **Layers** palette. As witnessed in Figure 1-5, the image contains an empty Background layer, a visible Red layer (as indicated by the ◉ icon), and hidden layers for Green and Blue.

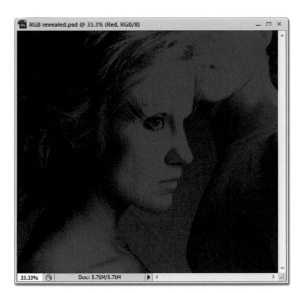

Figure 1-4.

Lest this exercise imply otherwise, note that layers and channels are in no way, shape, or form interchangeable. Layers are separated images that you can move around independently or blend together as you like. Channels are the contents of those layers subdivided into their primary colors. Although layers are extremely powerful, permitting you to create everything from temporary adjustments to elaborate compositions, they're ultimately optional. For example, you can correct the colors of an image without adding a single layer. Channels, on the other hand, are inescapable. By definition, every full-color digital image contains multiple channels.

Figure 1-5.

6. *Make the Green layer visible.* We'll start by blending the Red and Green layers to see how they combine. Click the box to the left of **Green** to wake up its ◉ and make the layer visible. The image now appears only as shades of green, as in Figure 1-6. And were you to switch to the Channels palette, the Green channel would look normal and the Red and Blue channels would be black. In other words, this is the image rendered entirely in Green.

7. *Change the blend mode to Screen.* If you watched the video, you saw how you can combine the Red and Green channels, without Blue, to create an image in which the

Figure 1-6.

Figure 1-7.

lightest color is yellow. In this step, we'll duplicate that effect using our layers. Start by clicking the thumbnail for the **Green** layer to make it active. Then click the blend mode pop-up menu in the top-left corner of the Layers palette and choose **Screen** midway down the list (see Figure 1-7).

The Screen mode mimics what you'd see if you projected both the Red channel and the Green channel onto a single screen (hence the name), which just so happens to be *precisely* the same effect you get when you combine the Red and Green channels in the Channels palette, as shown in Figure 1-8.

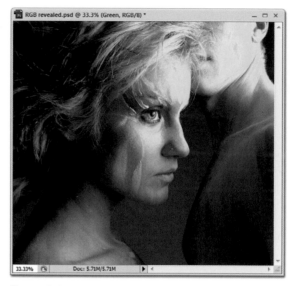

Figure 1-8.

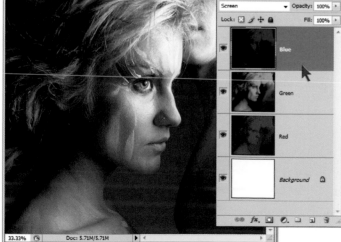

Figure 1-9.

8. *Make the Blue layer visible.* Now it's time to add the Blue layer to the full-color image. So click in the 👁 column in front of the word **Blue** to make the layer visible. You should now see a very dark blue version of the image on screen.

9. *Again change the blend mode to Screen.* Click anywhere on the Blue layer to make it active and then change the blend mode pop-up menu to **Screen**. What were formerly patches of light yellow in the image now blossom into bright white highlights, as in Figure 1-9.

Moral of the story? When working in the RGB mode, luminance information from the Red, Green, and Blue channels builds up to produce ever brighter colors in the full-color photography. Which is why

even very dark shades like those in the Blue channel can have a profound brightening effect on an image. Meanwhile, the underlying mathematical equation used to blend Red, Green, and Blue is identical to that employed by the Screen blend mode.

If this all seems a tad theoretical at this point, have faith that you'll have plenty of opportunity to put this information to practical use as we visit RGB and Screen time and time again throughout the pages of this book.

The Single-Channel Grayscale Image

Between Video Lesson 1 and the previous exercise, you may feel like you've had your fill of RGB color theory. So let's take a break from multichannel blending and see what happens if we reduce an image to a single channel. As you'll learn, the result is luminance with no hint of color in sight.

1. *Open an RGB image you'd like to convert to grayscale.* If it's not already ready and waiting on your screen, open *Painted couple.jpg*, located in the *Lesson 01* folder inside *Lesson Files-PsCM 1on1*. Assuming you set your color settings as directed in the Preface (see Step 6 on page xvi), you should see no difference between this image and the one you built in the previous exercise.

2. *Go to the Channels palette.* Choose **Window→Channels** or click the **Channels** tab in the Layers palette group to bring up the Channels palette. Again you'll see four items: RGB, followed by Red, Green, and Blue.

PEARL OF ⬤ WISDOM

Red, Green, and Blue are channels, but the first item, RGB, is not. Rather, it represents the so-called *full-color composite*, which is the mixture of the color-bearing channels that you see in the image window.

3. *Convert the image to grayscale.* Let's say that you want to create a black-and-white version of the image. I explore all kinds of ways to create custom black-and-white photographs in Lesson 9, "Channel Mixing and Other Tricks." But the simplest is to convert the image to Photoshop's grayscale format. Choose **Image→Mode→Grayscale** to distill the image down to nothing but it's core *luminance levels*, which are the no-color shades of brightness from black to white. The command and the resulting image appear in Figure 1-10 on the next page.

If Photoshop asks if you want to "Discard color information?" first turn on the **Don't show again** check box so the message doesn't appear in the future. And then click the **Discard** button to confirm that you want to convert this image to the grayscale mode.

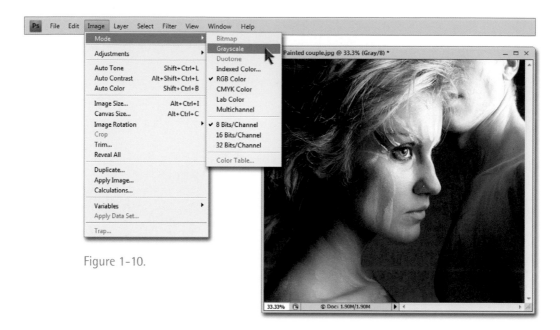

Figure 1-10.

Figure 1-11.

4. *Review the Channels palette.* In converting the RGB image to grayscale, we instructed Photoshop to fuse three channels into one. Therefore, the Channels palette shows a single channel called Gray, as in Figure 1-11. Just like the channels we observed in the RGB image, the Gray channel contains a rich array of luminance levels from black to white. But because this is now the only channel in the image, Photoshop is left with no means for mixing colors. That means no color composite and nothing but black-and-white in the image window.

5. *Undo the grayscale conversion.* Now let's take a look at a different way to go gray that gives you slightly more control over the conversion process. Choose **Edit→Undo Grayscale** or press Ctrl+Z (⌘-Z on the Mac) to restore the RGB image.

6. *Review the individual channels.* Instead of blending the information from all three channels in this RGB image to create a final grayscale image, we'll choose a specific channel to use as our grayscale image. To review the Red, Green, and Blue channels, click each channel in turn in the Channels palette. As Figure 1-12 illustrates, each channel looks different from the automatic grayscale blend produced in Figure 1-10.

7. *Select your preferred channel.* For my money, the Blue channel is best because it captures the otherworldly drama of the image, so I clicked the thumbnail for the **Blue** channel to make it active.

8. *Convert to grayscale.* We're now going to apply the same grayscale conversion we performed in Step 3 but with an important difference: Because the Blue channel is active in the Channels palette, that channel will be used as the sole basis of the final grayscale image. Choose **Image→Mode→Grayscale** to keep Blue and throw away Red and Green.

Even if you selected the Don't show again check box when converting the image to grayscale in Step 3, you'll likely see another message, this time asking if you want to "Discard other channels?" This message differs from the previous one in that you're not just removing color information, you're throwing away whole channels of information. Such is the price for custom black-and-white. Again turn on the **Don't show again** check box and click OK.

The net result is another single-channel image. And as ever, one channel delivers plenty of luminance but nothing in the way of color.

9. *Close the image.* We're finished exploring this particular image, so choose **File→Close** to close the image, and click **No** (or **Don't Save**) when asked if you want to save changes. Alternatively, you can press Ctrl+W to close and N to neglect saving (that's ⌘-W and D on the Mac).

There's just one lesson from this exercise: If you want black-and-white, one channel is fine. If you want color, you need three or more. But they don't have to be RGB. They can be something quite different, as I'll demonstrate in the next exercise.

Working with Lab Color

Photoshop has a long history of embracing the best of imaging technology. And it's support for the Lab color model is no exception. *Lab* (pronounced by some as L-A-B but by me as the way it looks) is a *device-independent color model*. Meaning that it has nothing to do with any piece of hardware, be it a camera or monitor (as in the case of RGB) or a printer (as with CMYK). Rather, Lab is designed to represent an image in a way that's analogous to the way our eyes see and our brains interpret the real world.

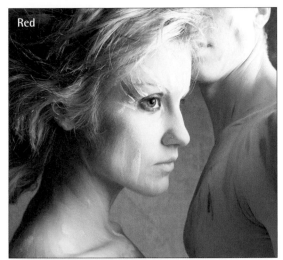

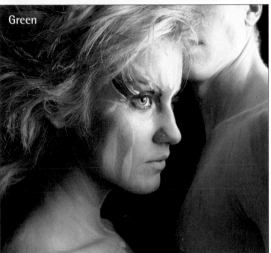

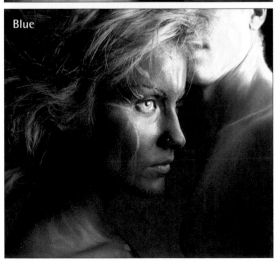

Figure 1-12.

Photoshop's Eight Channel Modes

In Photoshop, *channel modes* are ways of defining how channels are organized in an image, what those channels mean, and how they are blended to form the full-color composite (if indeed there is any). A channel mode may be based on an industry-standard *color model*, which is a set of rules that define how color values are calculated. Or it may employ no color model, blending colors in the digital equivalent of the Wild West. In this sidebar, I'll explain the eight channel modes, in the order they appear in the Image→Mode submenu.

Starting with a grayscale image (explained next), choose Image→Mode→Bitmap to convert all pixels in the image to either black or white with no variation in between. Below we see a bitmapped image printed at 120 pixels per inch with a diffusion dither, which uses random dots to simulate gray values. Bitmapped images result in small files—each pixel consumes just one bit of data—but aren't of much practical use unless you're going for the old-school ImageWriter look.

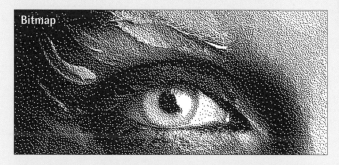

Choose Image→Mode→Grayscale to reduce an image to a single channel. With just one continuous-tone channel, Photoshop is not able to produce color. Hence, the result is what we generally think of as a black-and-white photograph, as appears below. I demonstrate lots of ways to produce great looking grayscale photographs in this lesson and in Lesson 9, "Channel Mixing and Other Tricks."

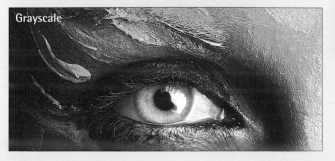

Again armed with a grayscale image, choose Image→Mode→Duotone to enrich a black-and-white image by rendering it in as many as four inks. The result is a more powerful image with darker blacks and more sculptural definition, as represented by the four-ink quadtone below. Note that Photoshop does not give you access to the individual channels in a duotone-style image. Rather, you can edit the channels using the Duotones command or convert the image to multichannel. For complete information, see "Duotones, Tritones, and Quadtones," which begins on page 28.

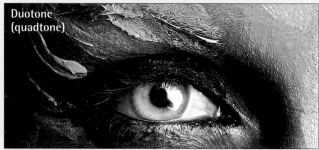

Choose Image→Mode→Indexed Color to render a color image using just one channel. Didn't I just say that wasn't possible a couple of paragraphs ago? Yes, and it isn't, in a continuous-tone image. The Indexed Color command abandons continuous-tone and distills an image down to 256 or fewer colors. The image below contains just 32 colors, meaning only 5 bits of data are devoted to each pixel. The Indexed Color command can be a first step to creating a GIF image for the Web. Do not use it for print.

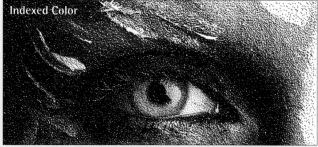

If ever you need to convert an image to RGB (most photographs begin life this way), choose Image→Mode→RGB Color. RGB is an acronym for red, green, and blue, the most common color model in digital imaging. Red, green, and blue represent the primary colors of light, such as those produced by

computer monitors and projectors, as well as those captured by digital cameras and scanners. As the primary colors blend with each other, the composite image grows brighter, which is why RGB is alternately knows as the *additive color model*. The image below demonstrate how the three RGB channels blend together.

Choose Image→Mode→CMYK Color when (and *only* when) preparing an image for offset press printing. CMYK gets its name from the four process-color inks: cyan, magenta, yellow, and the "key" color, black. Inks absorb light, so as they blend together, the composite image grows darker, which is why CMYK is know as the *subtractive color model*. Every figure in this book was ultimately output as a CMYK image. (Though truth be told, I generally placed RGB images into InDesign and let InDesign perform the color space conversion.) Below we see each of the CMY inks mixed with black.

Choose Image→Mode→Lab Color to convert the image to Photoshop's only device-independent color model. In other words, Lab is not beholden to the needs of a piece of hardware, whether it is a screen or camera in the case of RGB or a printer in the case of CMYK. A Lab recipe for orange (L: 75, a: 60, b: 120) always produces orange, regardless of screen or printer. The L in Lab stands for the Lightness channel, which separates the luminance information from the color. The other two channels, *a* and *b*, are perpendicular axes of color. The *a* channel conveys tint from green to pink; *b* conveys temperature from blue to yellow. The image below shows the separated *a* and *b* channels mixed with Lightness.

Choose Image→Mode→Multichannel to release an image from the constraints of a color model without modifying a single pixel, making it a useful way station for moving between color model–based modes. In the example below, I switched a CMYK image to multichannel, swapped the order of the Cyan and Yellow channels, and switched the image back to CMYK. Multichannel also provides direct access to the channels in a duotone, tritone, or quadtone image.

For the student of channels and masks, the bitmap and indexed color modes hold little interest. I'll walk you through how each of the other six modes work—including some great uses for multichannel—in the six exercises in this lesson.

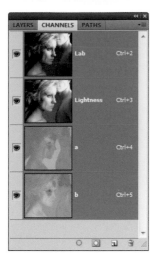

Figure 1-13.

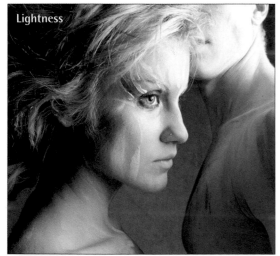

Lightness

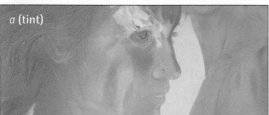

a (tint)

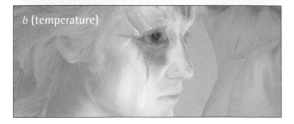

b (temperature)

Figure 1-14.

The three letters in the word Lab hail from its three channels: The capital *L* stands for lightness (or more accurately, luminance). The lowercase *a* and *b* are letter designations assigned to a couple of perpendicular color axes.

Here's how Lab works:

1. ***Open a standard RGB image.*** Open that original *Painted couple.jpg* file, located in the *Lesson 01* folder inside *Lesson Files-PsCM 1on1.*

2. ***Convert the image to the Lab color space.*** Choose **Image→Mode→Lab Color**. The image shouldn't change one iota on screen, but the way Photoshop sees it is entirely different.

3. ***Review the Channels palette.*** Take a look at the **Channels** palette (see Figure 1-13) and you'll see four new items: the composite Lab preview followed by the independent channels Lightness, *a*, and *b*. The Lightness channel stores the luminance information separately from the color information (*a* and *b*), which opens up a variety of possibilities, some of which you'll discover later in this exercise.

4. ***Click the Lightness channel.*** To see just the luminance information—without any color—click the **Lightness** channel, which is essentially a lighter-than-usual grayscale version of the image, as displayed at the top of Figure 1-14.

5. ***Click the a channel.*** Now let's take a look at the channels responsible for conveying the color in the image. Click the **a** channel in the Channels palette. This indistinct, mostly grayish channel (pictured second in Figure 1-14) depicts the colors ranging from green to its theoretical opposite (or *complement*), pink. Anything darker than medium gray is green; anything lighter is pink. In the world of color balance, this *color axis*—by which I mean a line of color drawn straight through the heart of a circle diagram of all colors—is known as *tint.*

6. ***Turn on the Lightness channel.*** To gain a better understanding of the *a* channel, let's view it in combination with the Lightness channel. Click the box to the left of the **Lightness** thumbnail to wake up the 👁 icon and turn on the luminance information. With both the Lightness and *a* channels visible, we can see the greens and magentas communicated by the image, as in Figure 1-15. With just two channels, we are able to communicate the entire luminance range, from black to white, along with two extreme opposites of color.

7. *Click the b channel.* All right, that's *a*. What about *b*? Click the **b** channel in the Channels palette to see yet another incomprehensible smear of intermediate grays (the last image in Figure 1-14). You would hardly know it to look at them, but these are the blues in the dark regions and yellows in the light. Two things to know about *b*: First, if you were to fill a circle with all visible colors, and the *a* axis were a horizontal line right through the center of that circle, the *b* axis would be similarly centered but vertical. Which is to say, *a* and *b* are perpendicular axes. Second, the *b* colors are commonly known as *temperature*, ranging from *cool* on the blue side to *warm* on the yellow.

8. *Again turn on the Lightness channel.* To see the colors from the *b* channel in context, click to the left of the **Lightness** channel to light up its 👁. You can now see luminance and temperature, as in Figure 1-16.

FURTHER INVESTIGATION

Lab might well be Photoshop's least understood and most underappreciated feature. Which is why I devote an entire six-and-a half-hour video series to the topic, *Photoshop CS3 Lab Color.* (Lab hasn't changed since CS3, so that series remains 100 percent accurate.) To review it for yourself, go to *www.lynda.com/dekeps* and start up your 7-Day Free Trial Account (as introduced on page xxv of the Preface). In minutes, you'll be waking up colors you never dreamed existed.

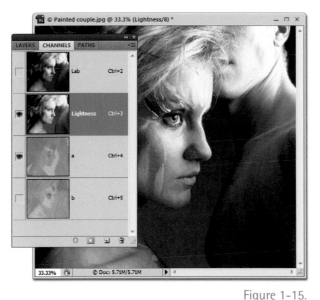

Figure 1-15.

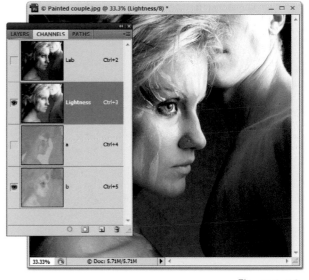

Figure 1-16.

9. *Display the composite Lab image.* The Lab mode offers access to its own teeming world of color modifications. In particular, you have unparalleled control over the intensity, or *saturation*, of your colors. Click the word **Lab** at the top of the Channels palette so you can see your edits applied to the full-color image.

10. *Choose the Levels command.* The most straightforward command for elevating saturation values in a Lab image is Levels. Choose **Image**→**Adjustments**→**Levels** or press Ctrl+L (⌘-L) to bring up the **Levels** dialog box. In Lab, Levels lets you edit just one channel at a time. By default, that channel is Lightness.

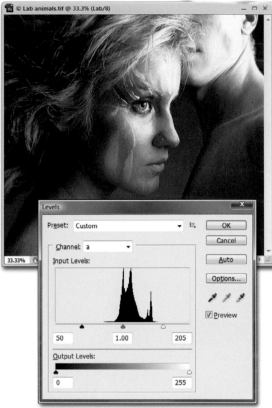

Figure 1-17.

Figure 1-18.

11. *Choose the a channel in the Levels dialog box.* To modify the saturation of an image, we need to focus our energies on the *a* and *b* channels. So choose **a** from the **Channel** pop-up menu. Notice that the *histogram* (the central chart that shows the relative number of pixels at each luminance level) is clustered into a few slim peaks right in the center (see Figure 1-17). Despite this being a vivid image, the histogram tells us that the green-to-pink colors are actually fairly moderate in saturation.

12. *Increase the black point value.* The first **Input Levels** value affects the *black point*, which corresponds to the black triangle under the histogram. Set the black point value to 50 to make the channel darker and thus intensify the greens in the image.

13. *Decrease the white point value.* The third Input Levels value controls the *white point*, not to mention the white slider triangle. We need to balance our adjustment with an equal tweak to the pinks, so decrease the white point value from 255 to 205. This bolsters the pinks by the very same amount as the greens (50 luminance levels), resulting in the predominantly red image pictured in Figure 1-17.

14. *Choose the b channel in the Levels dialog box.* If your goal is to intensify all colors equally (as it is in our case), you need to apply symmetrical changes to both the *a* and *b* channels. So choose **b** from the **Channel** pop-up menu. Not surprisingly, the histogram for the *b* channel is another narrow cluster of peaks, further proof of moderate saturation.

15. *Modify the black and white point values.* We want our saturation adjustment to be uniform for all colors in the image, so set the first **Input Levels** value to 50, which enhances the blues, and the third value to 205, which balances out the yellows. The resulting image appears in Figure 1-18.

One of the great things about performing a saturation boost in the Lab mode as opposed to RGB is that you can make the colors more vibrant without altering the tonality or sacrificing detail. This is possible because Lab keeps all the luminance information in the Lightness channel—which we haven't touched—separate from the color information in the a and b channels.

16. *Choose the Lightness channel in the Levels dialog box.* Just to get a sense for how luminance works in Lab, choose **Lightness** from the **Channel** pop-up menu. Notice the histogram now spans the full width of the available space, indicating that we have a good distribution of luminance levels, all the way from very dark shadows to hot white highlights.

17. *Invert the luminance information.* Purely for the sake of experimentation, let's give the Input Levels the slip this time and try out the Output Levels instead. Where the Input Levels values tell where luminance levels are coming from (in Step 12, for example, we took all levels that had been 50 or darker and made them black), Output Levels specify where they're going to.

By way of an extreme example, let's invert the luminance of the image. Set the first **Output Levels** value to 255, thus sending all blacks to white; then change the second value to 0, making all whites black. This swaps all luminance levels in the image, creating the inverted effect you can see in Figure 1-19. Notice, however, that just the luminance information is inverted; the colors remain the same.

18. *Click the OK button.* If this last effect is not to your liking, restore the original Output Levels values of 0 and 255, respectively. Then click **OK** to apply your adjustment.

Congratulations. You just made quick and effective use of Photoshop's most powerful color model, and you're not even 20 pages into this book. If you want to save your work, choose File→Save As and change the Format setting to either TIFF or Photoshop. (JPEG does not support Lab.) Or just choose File→ Revert to abandon your changes and restore the original RGB image. You'll need it for the next exercise.

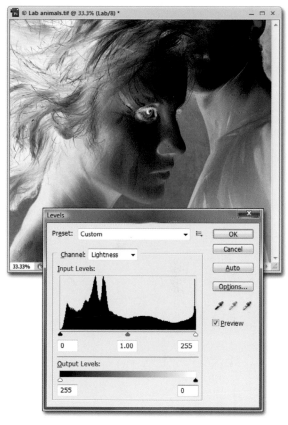

Figure 1-19.

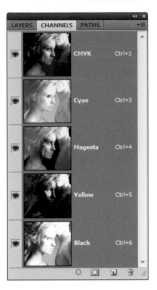

Figure 1-20.

Figure 1-21.

The Mechanics of CMYK Inks

In this exercise, we'll explore the world of CMYK. Designed to suit the needs of commercial offset printing (CMYK is neither necessary nor desirable when printing to an inkjet or other composite-color printer), *CMYK* stands for the four process-color inks: cyan, magenta, yellow, and the "key" color black. CMYK is in many regards the direct opposite of RGB, which I'll demonstrate by once again diagramming how the channels interact using layers.

1. *Open an RGB image.* If it's not already on screen—in its original RGB condition—open *Painted couple.jpg*, located in the *Lesson 01* folder inside *Lesson Files-PsCM 1on1*. Virtually all images begin life as RGB; this one's about to make the transition to CMYK.

2. *Convert to CMYK.* Choose **Image→Mode→CMYK Color**. (If you get a warning, which explains an alternative method for color managing the conversion, ignore it for now and click **OK**.) If you watch closely, you'll see the colors dim slightly. CMYK cannot accommodate bright, highly saturated RGB values. Plus, the Channels palette grows from four items to five, including the composite preview and the four process inks, all on display in Figure 1-20.

The specific nature of the RGB-to-CMYK conversion hinges on the color settings you established in the Preface (Step 6, page xvi). If you want to convert to a different CMYK profile—preferably one provided by your commercial printer—then you would choose Edit→Convert to Profile. That's precisely the message imparted by the warning you saw a moment ago, which is why I did not instruct you to turn on the Don't show again check box. It's no fun to see warnings, but this is a good warning to bear in mind.

3. *Review the CMYK channels.* Each channel in a CMYK image corresponds to a plate of ink applied by the printing press. Anywhere that you see black in a channel represents an area of heavy ink coverage; white represents uninked paper (which is presumably white). Figure 1-21 shows each channel in sequence.

4. *Turn on the channels one at a time.* Where gauging ink coverage or appearance is concerned, seeing grayscale channels is accurate only for Black, which is in fact grayscale. But as shown in Figure 1-22, the CMY channels actually print in

color. In Figure 1-21, the Yellow channel is mostly pitch black. But when substituted for yellow ink, as in Figure 1-22, it's nearly invisible. To see how the channels build up, do the following: In the **Channels** palette, click **Cyan** so that only the first grayscale channel is visible. Then click in the 👁 column for **Magenta**. Suddenly the image springs to life with blues, pinks, and purples. Next add **Yellow** and finally **Black**. As you do, notice how each channel adds more ink and thus more darkness to the image.

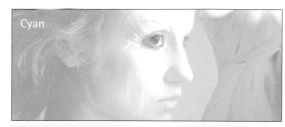

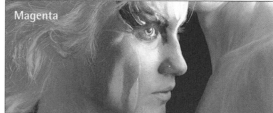

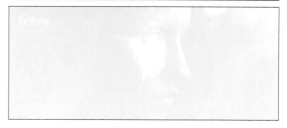

Figure 1-22.

5. *Open the CMYK diagram.* Now open the file called *CMYK revealed.psd*, again located in the *Lesson 01* folder. This is a version of the same image with each of the CMYK channels relegated to an independent layer. Of the color layers, only Cyan is turned on (see Figure 1-23); the Magenta, Yellow, and Black channels appear empty.

6. *Go to the Layers palette.* Switch to the **Layers** palette and note that each of the thumbnails shows a CMYK channel rendered in its corresponding ink, as in Figure 1-23. Again, I hasten to add, channels do not somehow turn themselves into layers automatically. I have constructed this composition to demonstrate the relationship between channel mixing and blend modes in Photoshop.

7. *Turn on and select the Magenta layer.* Click in the 👁 column in front of **Magenta** and then click the Magenta layer to make it active.

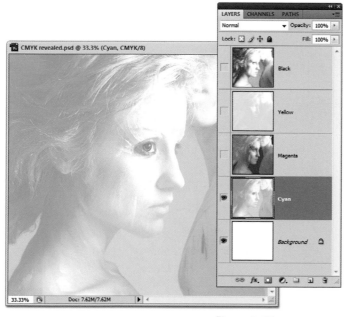

Figure 1-23.

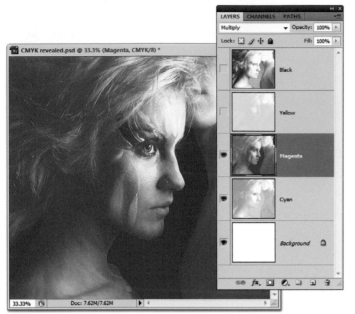

Figure 1-24.

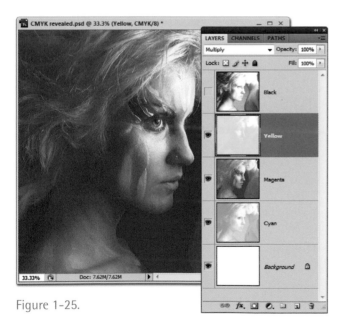

Figure 1-25.

8. *Change the blend mode to Multiply.* High amounts of cyan and magenta ink combine to form a deep blue. To see this combination in action, go to the top-left corner of the Layers palette and set the blend mode to **Multiply**. The result appears in Figure 1-24.

The theoretical opposite of Screen (see page 8), Multiply simulates the effect of mixing a pass of translucent magenta ink over a bed of cyan ink. Meaning that it's exactly the same operation Photoshop uses to combine the CMYK channels in the Channels palette.

9. *Turn on and select the Yellow layer.* Now we'll add the Yellow channel to the mix. Click in the 👁 column in front of the **Yellow** layer to display the hot yellow ink on screen. Then click the layer to make it active.

10. *Change the blend mode to Multiply.* Choose **Multiply** from the blend mode pop-up menu in the top-left corner in the Layers palette. We have now blended all the color information—that is, Cyan, Magenta, and Yellow—to produce the brightly colored image pictured in Figure 1-25.

11. *Turn on and select the Black layer.* By themselves, the CMY channels aren't able to produce deep, rich blacks. (Instead, you get a dark, muddy brown.) Which is why Photoshop offloads the shadow information—noticeably absent from Figure 1-25—to the Black channel. To see the contribution that the K (short for Key) ink makes, click in front of the **Black** layer to wake up its 👁, and then click the layer to make it active.

12. *Change the blend mode to Multiply.* For the last time this time, choose **Multiply** from the blend mode pop-up menu. The finished composition exhibits deep, rich, even lavish shadows, as in Figure 1-26 on the facing page.

In stark contrast to RGB, CMYK inks build up to make darker and darker colors. Frankly, we won't be seeing much CMYK in this book; the choppy edge transitions provided by its channels are poorly suited

to masking. But the knowledge you've gained, particularly as it applies to the Multiply blend mode (which you'll be seeing a *lot*) will serve you well as you continue to learn how to make use of channels.

Editing in the Multichannel Mode

In this exercise, I introduce you to the *multichannel mode*. Unlike the other channel modes we've seen so far, this one is not a color model, meaning it's not intended as a means of describing color. Rather, it's a way of organizing channels into a sort of halfway house, permitting you to switch from one color model to another without recalculating the channels to keep the appearance of the image intact. For example, when you convert an image from RGB to CMYK, Photoshop rewrites each channel—including inventing a fourth K channel—in an attempt to preserve the appearance of the full-color image. Were you to go from RGB to multichannel to CMYK, Red, Green, and Blue would simply *become* Cyan, Magenta, and Yellow; Black would be left empty. The result would be an image that changes dramatically based on a new interpretation of the channels.

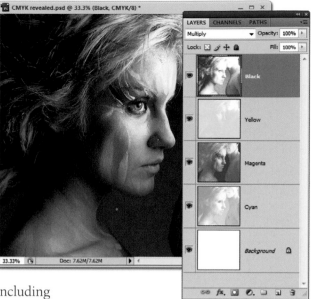

Figure 1-26.

We'll start by simply playing around with an image in the multichannel mode, so you have a better sense of what it is and how it operates. Then I'll guide you through a couple of techniques that employ the multichannel mode to create some highly interesting visual effects.

1. *Open an RGB image.* Yet again, I want you to open *Painted couple.jpg*, located in the *Lesson 01* folder inside *Lesson Files-PsCM 1on1*. I think you'll find it very helpful to have a familiar image by your side as you work your way through this unusual exercise.

2. *Switch to the multichannel mode.* Choose **Image→Mode→ Multichannel** to bust up the relationship between the RGB channels. Switch to the **Channels** palette and you'll see that Photoshop is unclear on what you're trying to accomplish. The image still contains three channels, but they're now named Cyan, Magenta, and Yellow, respectively (see Figure 1-27 on the next page). The content of the channels remains the same, but because the interpretation of the channels has been changed, the image appears quite different. Notice also that we no longer have a composite channel at the top of the Channels palette. This is an image without a rudder.

3. *Switch to the Lab mode.* So far, the image doesn't look right, but it's not far off base. To get a sense of the strange extremes you can achieve with the help of the multichannel mode, let's reinterpret the RGB channels in the Lab mode. Choose **Image→Mode→Lab Color**. The Red channel becomes Lightness, Green becomes *a*, and Blue becomes *b*. Because there's no rhyme or reason to making such a reassignment, the image looks like nothing you would see in the real world, as Figure 1-28 (at the bottom of this page) makes plain.

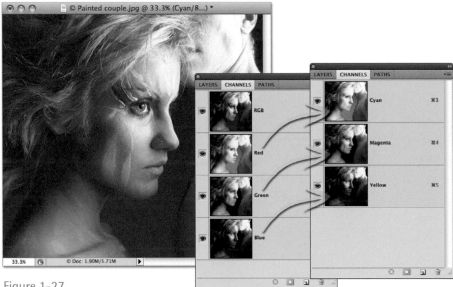

Figure 1-27.

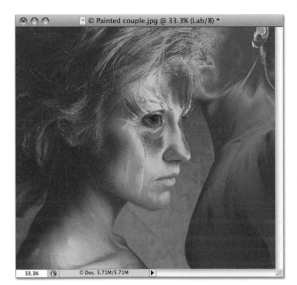

Figure 1-28.

4. *Switch back to the multichannel mode.* Choose **Image→Mode→Multichannel**. Now Photoshop really doesn't have a clue what we're up to and has entirely given up assigning any sort of meaning to the channels. They are now named Alpha 1, Alpha 2, and Alpha 3, which means Photoshop is treating the channels as prospective masks. (I'll tell you all about the term *alpha* in Lesson 2.) And as Figure 1-29 on the facing page demonstrates, Photoshop makes no attempt to create a color image. It merely shows Alpha 1, formerly known as Red.

5. *Return to the RGB mode.* Because we haven't done anything to alter the contents of the channels, the original RGB information remains utterly and completely unharmed. To prove me right, choose **Image→Mode→RGB Color** and see how the channels are at once restored to their former glory as Red, Green, and Blue, complete with a full-color composite preview.

Naturally, Photoshop has no idea *why* we would choose to saunter through a confusing sequence of channel modes only to go right back to where we started. And I'd hazard a guess, neither do you. So enough aimless wandering. In the remaining steps, I'll show you how to use RGB, multichannel, and CMYK to achieve two highly desirable effects.

6. *Again switch to the multichannel mode.* Let's start by fabricating a warm, lustrous sepia tone. Choose **Image→Mode→Multichannel** to release the image from the confining walls of RGB and free yourself to operate outside the box.

7. *Create a new black channel.* Because we started with a three-channel image, the switch to multi-channel mode leaves us with Cyan, Magenta, and Yellow. If we hope to scale up to CMYK, we need to create a fourth channel that will stand in for Black, which we'll create by blending another.

Figure 1-29.

The command that we'll be using, Calculations, is advanced. And while you'll ultimately feel comfortable with this command, we don't actually cozy up to it until Lesson 10, "Calculations (a.k.a. Channel Operations)." So I'm going to ask you to trust me on this one—much as you have throughout this entire lesson—and take the following leap of faith:

- Click the **Cyan** channel in the **Channels** palette to make it the active channel.

- Choose **Image→Calculations** to bring up the **Calculations** dialog box.

- Check that both **Source 1** and **Source 2** are set to the current image (*Painted couple.jpg*).

- Also check that both **Layer** options are set to **Background** and both **Channel** options are set to **Cyan**. If you've never used Calculations before, these should be your defaults.

- Set the **Blending** option to **Multiply**.

- Reduce the **Opacity** value to 50 percent.

- When your settings look like the ones pictured in Figure 1-30 on the next page, click the **OK** button.

You now have a fourth channel that is little more than a darker version of the first.

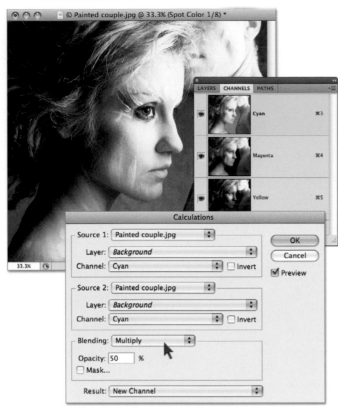

Figure 1-30.

Figure 1-31.

8. **Set the new channel to be the Black channel.** Because we used the Cyan channel as the basis for the new channel, Photoshop assumes that the new channel is yet another variant of cyan. But rather than calling the channel Cyan 2, Photoshop names it Spot Color 1, as you can see in Figure 1-31. (A *spot color* is a custom, premixed ink, available from a variety of vendors through your local commercial printer.) But we don't want a spot color, particularly not one that looks just like cyan.

To clearly identify the channel as Black, do like so:

- Double-click on **Spot Channel 1** to bring up the **Spot Channel Options** dialog box. Notice that the Name option reads Spot Color 1. Don't change this name; Photoshop will change it for us in a moment.

- Click the cyan **Color** swatch to display the **Select Spot Color** dialog box. Direct your attention to the CMYK values in the bottom-right corner of the dialog box.

- Set the **C** (cyan) value to 0 percent.

- Then set the **K** (black) value to 100 percent. The moment you enter the number, the name of the channel in the Spot Channel Options dialog box automatically changes to Black as shown in Figure 1-32 on the facing page.

- Click the **OK** button in the Select Spot Color dialog box to apply the color change.

- Click the next **OK** button you see, the one in the Spot Channel Options dialog box, to accept your changes. The new channel is now for once and for all Black.

9. **Make all channels visible.** To see the effect you've managed to create, turn on all channels by dragging up the column of missing 👁 icons. The result is a warm, somewhat murky, and overly dark version of the image, as shown in Figure 1-33.

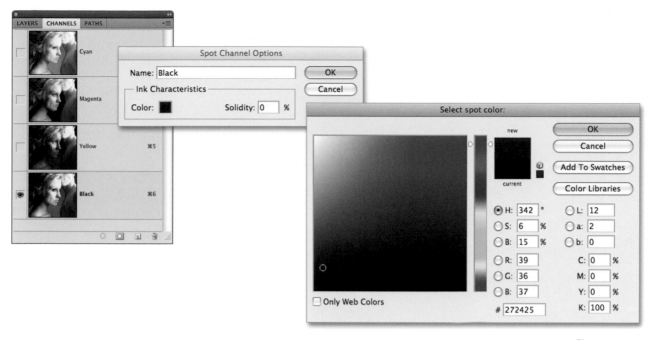

Figure 1-32.

10. ***Fill the Cyan channel with white.*** We can lighten the image
 and lose the cooling influence of the Cyan channel in one fell
 swoop by filling that channel with white. Click the **Cyan** chan-
 nel in the **Channels** palette to make it active. Press the D key
 to ensure default colors (black for foreground and white for
 background). Then press Ctrl+Backspace (or ⌘-Delete) to fill
 the channel with white. The result is the intensely warm and
 deeply shadowed photograph that you see in Figure 1-34.

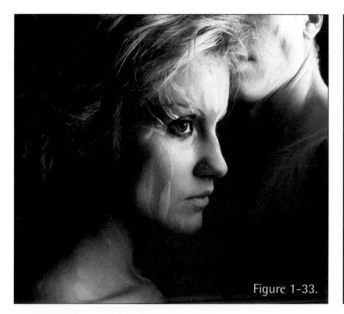

Figure 1-33.

Figure 1-34.

11. *Convert the image to CMYK.* At this point the image lacks a color model, so if you were to try to place it into another program—even an advanced page-layout application like InDesign—the import would fail. To assign the color model that best fits our four channels, choose **Image→Mode→CMYK Color**. The appearance of the image will shift slightly (a function of moving from an unprofiled to a profiled space), but you now have an industry-recognized CMYK image that retains your custom sepia effect.

12. *Save your changes.* We're done exploring this image. If you like, choose **File→Save As** to save your changes. It is a beautiful image, after all.

If you plan to print the image to a photo-grade inkjet printer, you need to first convert it to RGB. Although inkjet printers are indeed equipped with inks—some of which may be cyan, magenta, and the like—every printer employs a different number and mix of inks. So rather than requiring Photoshop to support 100 or so other color models, the printer software is designed to take an RGB image and convert it to the proper mix of inks on-the-fly.

Oh, and when you switch back to RGB, don't use multichannel. That's just for effects. Convert the image the conventional way by choosing **Image→Mode→RGB Color**. You'll want to choose **File→Save** to update your image file on disk as well.

So far we've seen how to go from RGB to multichannel to CMYK and back to RGB. And to beautiful effect. I mean, you're only a few pages into this book and you've already pulled off a feat that none but the absolute upper echelon of Photoshop users know how to do. If you've had enough of such madcap channel wrangling, feel free to move on to the next exercise, "Duotones, Tritones, and Quadtones," which begins on page 28. Then again, if you like the idea of pushing the envelope a bit further as we take an image from CMYK to multichannel to RGB, complete with a special trick for integrating the dangling Black channel, read on.

13. *Open a CMYK image.* Open *Flesh for press.jpg*, located in the *Lesson 01* folder inside *Lesson Files-PsCM 1on1*. This is a CMYK version of the same image we've been spending so much time with in this lesson, and we're going to use it as the basis for an effect that produces high saturation color with no evidence of *clipping* (that is, loss of detail at the darkest or brightest luminance levels) or *banding* (loss of smooth gradations of tone and color).

14. *Switch to multichannel mode.* We again want to exploit the law-less realm of the multichannel mode, so choose **Image→Mode→Multichannel**. Although the Channels palette displays the same base channels as before—Cyan, Magenta, Yellow, and Black—the full-color composite in the image window takes on a slightly different appearance. Being an authentic color model, CMYK is a color-managed environment. There is no such thing as color management in multichannel. We have entered a kind of color no-man's-land.

15. *Switch to RGB mode.* Earlier, I mentioned how RGB is capable of generating brighter, more satu-rated colors than CMYK. Now we're about to see what that means. To map the former CMYK levels to RGB, choose **Image→Mode→RGB Color**. Now look to the **Channels** palette and witness our new channels: Red, Green, Blue, and Black, all on display in Figure 1-35. There is no such thing as an RGBK color model, so were you to output this image, only the composite of the Red, Green, and Blue channels (formerly Cyan, Ma-genta, and Yellow) would print. If you were to import the image into another program, at best the Black channel would be seen as a mask.

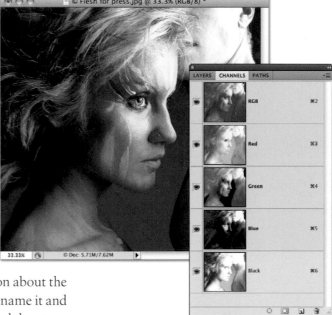

Figure 1-35.

16. *Turn off the Black channel.* To avoid any confusion about the nature of this fraudulent poser of a channel, let's rename it and turn it off. Double-click the channel name, **Black**, and then type "Extra Channel" followed by the Enter (or Return) key. Next, click the 👁 icon for **Extra Channel** to see the RGB image for what it truly is, highly saturated but lacking anything in the way of shadow information.

17. *Reintroduce the Black channel's effect.* The Black channel wasn't contributing anything to the RGB image. But we need its dark luminance levels to achieve the dramatic shadows on display in Figure 1-35. Here's how to integrate those shadows into the RGB image:

- Choose **Image→Apply Image** to bring up the **Apply Image** dialog box.

- Make sure the **Source** is set to *Flesh for press.jpg* (the image we're working on) and that **Layer** is set to **Background**.

- Choose **Extra Channel** from the **Channel** pop-up menu.

- Set the **Blending** option to **Multiply**.

- If you want to tone down the shadows, you can reduce the **Opacity** to, say, 70 percent. But then you'll lose the most intense blacks, so I recommend keeping it at 100 percent, as in Figure 1-36.

- Click **OK** to burn the shadows into the RGB composite.

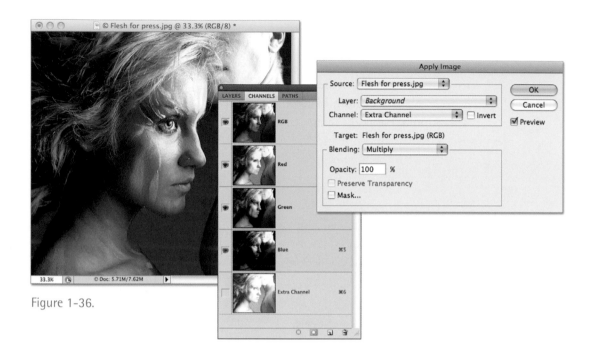

Figure 1-36.

18. *Save your changes.* Two bits of good news: Your image will now print, export, and import just as you see it on screen. And there's no need to convert it to RGB because it is RGB. To save your changes, choose **File→Save As**. To preserve the formerly black Extra Channel, change the Format option to TIFF. And name the new image anything you like.

Duotones, Tritones, and Quadtones

In previous exercises, I showed you how to work with grayscale and multichannel images. In this exercise, I'll show you how to bring these two worlds together as we examine duotones, tritones, and quadtones, which allow you to add depth to your commercially re-produced black-and-white photographs.

Here's the idea: When you send a single-channel grayscale image to a commercial printer, it gets assigned just one ink, black. That would be fine were it not for two problems: First, by itself, black ink is not terribly dark; deep "rich" blacks requires several inks

working together. Second, a single ink can convey only so much information, perhaps 100 levels of luminance in all.

You can solve both problems by adding more inks. A *duotone* has two inks, a *tritone* has three, and a *quadtone,* four. More inks mean more expense (printers charge for extra plates and inks, both of which can be costly), but they also make for darker blacks and a wider range of luminance levels. Here's how to convert a grayscale image to a multi-ink work of black-and-white splendor.

1. *Open a grayscale image.* Open the file *Custom B&W mix.jpg*, located in the *Lesson 01* folder inside *Lesson Files-PsCM 1on1*. This is a custom black and white variation of the Sophia Tsibikaki image that I created using Photoshop's Black & White command. (I'll show you how to use this command in Lesson 9.) Note that you must be working with a single-channel grayscale image to create a duotone, tritone, or quadtone.

2. *Switch to the duotone mode.* To add inks to a grayscale image, choose **Image→Mode→ Duotone**. Photoshop displays the **Duotone Options** dialog box shown in Figure 1-37.

3. *Up the number of possible inks to four.* By default, the Type option is set to Monochrome, which assigns just one ink to an image, rather defeating the purpose. To be able to apply as many as four inks, choose **Quadtone** from the **Type** pop-up menu.

4. *Load a quadtone preset.* You can use the distribution curves and swatches (the two columns of boxes) to infuse color into the image. But it's much easier to start with one of the presets included with Photoshop:

 - Click the ⌸ icon to the left of the **OK** button and choose the **Load Preset** command to bring up the **Load** dialog box.

 - Strangely, there are no presets in the default Duotones folder. So you'll have to manually navigate to a completely different location. Under Windows, go to *C:\Program Files\ Adobe\Adobe Photoshop CS4\Presets\Duotones\Quadtones\ Pantone Quadtones*. On the Mac, press ⌘-Shift-A to go to the *Applications* folder and then navigate to *Adobe Photoshop CS4/Presets/Duotones/Quadtones/Pantone Quadtones*.

Figure 1-37.

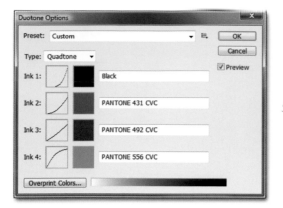

Figure 1-38.

Figure 1-39.

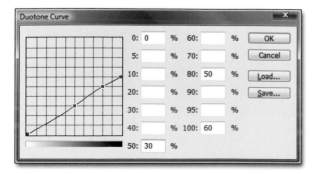

Figure 1-40.

- Select the preset named *Bl 431 492 556.adu* (the third entry alphabetically).

- Click the **Load** button to load the preset and populate the Ink options, as in Figure 1-38.

5. *Change the Ink 2 color to dark orange.* Turn off and on the **Preview** check box and you'll see that the image is looking lush with contour and detail. But it's too dark and too green. We'll solve that by customizing the Ink settings. Start by clicking the color swatch associated with **Ink 2** to bring up the **Color Libraries** dialog box, which offers a list of spot colors from Pantone, the biggest name in premixed inks in the United States. Drag the sliders upward toward the warm colors and select **Pantone 1535 C** from the left-hand list, as in Figure 1-39. Or just type the number "1535" to scroll right to the swatch. Then click **OK**.

6. *Change the Ink 4 color.* The green is way too ghoulish for my tastes. So click the color swatch for **Ink 4** to again bring up the Color Libraries dialog box. This time just type "7404" to select a bright yellow and click **OK** to apply the change.

7. *Change the curve for Ink 2.* The quadtone image is warm as a fire but dark as an oven. We can fix that by adjusting the curve for Ink 2. Click the curve thumbnail to the left of the color swatch for **Ink 2** to bring up the **Duotone Curve** dialog box. Then change three of the numerical values in reverse order as follows:

- Click the number **100** in the bottom-right corner of the dialog box and change the highlighted value to 60 percent. This removes orange from the areas of the image that have been assigned 100 percent black.

- Click **80** and change it to 50 percent.

- Click **50** and change it to 30 percent.

When your graph looks like the one in Figure 1-40 (I've colored the points red so that you can easily make them out), click **OK**.

8. *Change the curve for Ink 3.* Now click the curve thumbnail for **Ink 3**. In the Duotone Curve dialog box, click the number **100**, change the highlighted value to 65 percent. Then click the **OK** button.

9. *Change the curve for Ink 4.* The image is looking much brighter, but that yellow ink is attracting too much attention. I'm looking for something more nuanced. So click the curve for **Ink 4** and change the values as follows:

- Click **100**; make it 70 percent.

- Click **30**; make it 40 percent.

- Click **10**; make it 20 percent.

Click the **OK** button to apply the changes, resulting in the effect pictured in Figure 1-41. Then click **OK** once again to accept your changes and close the Duotone Options dialog box.

Figure 1-41.

10. *Switch to multichannel mode.* The image now contains four inks. But take a look at the **Channels** palette and you'll see just one item, called Quadtone. This is not a channel but rather the composite preview. The missing channels are Photoshop's way of showing you that you can't edit the inks from the Channels palette. Instead, you would choose Image→Mode→Duotone to bring up the very same options we set in the previous steps.

The good news is, you can continue to modify the spot colors and curves from the Duotone Options dialog box. But let's say we'd prefer to gain direct access to the inks in the Channels palette. To break all ties to the Duotone command, choose **Image→Mode→Multichannel**. Photoshop hands you four channels, one each for Black and the three Pantone spot colors (see Figure 1-42). Gone is the composite preview, but because all channels are adorned with 👁s you still see the composite image, with inks merged according to the Multiply blend mode. And now, you can do anything you want to the inks.

Figure 1-42.

One caveat to consider before converting to multichannel: With the Channels palette showing the single item Quadtone, you retain the option of converting the image to RGB or CMYK. (Both options sacrifice the spot colors, but Photoshop will do its best to maintain the basic appearance of the image.) After you go to multichannel, you're back in color limbo with no means to perform conversions. So be aware that there's no turning back (beyond undoing, of course) once you've taken this route with your image. But if you know you want to stick with spot colors, as we do, multichannel is just the ticket.

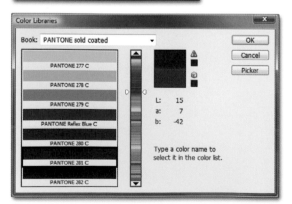

Figure 1-43.

11. *Swap the color for the third channel.* Let's say, on further reflection, that Pantone 492 is too purple for our taste. We want to switch it to a cooler blue color. Here's how:

- In the Channels palette, click the third channel, **Pantone 492 CVC**, to make it active.

- This also hides the other channels. You don't want that, so turn on the 👁s for the other channels to view the full-color composite image.

- Double-click the thumbnail for the active channel to bring up the **Spot Channel Options** dialog box.

- Click the tiny purplish color swatch to bring up the **Color Libraries** dialog box.

- Type "281" to select **Pantone 281 C**, a deep shade of blue. You'll see the preview update in the background, as in Figure 1-43.

- Click **OK** to apply the spot color change you just made in the Color Libraries dialog box.

- Then click **OK** again to close the Spot Channel Options dialog box and apply your new ink.

Regarding the names of the channels, two things I'd like to pass along: First, there's the matter of the letter after the Pantone color number. CVC stands for *computer video coated*, which hails back to the 1990's when Adobe's presets (one of which we loaded in Step 4, page 29) were first created. In 2000, Pantone remixed its screen colors to account for paper stocks. C stands for coated, M is matte, and U is uncoated. Second, if you really want to use these spot colors, I advise you *not* to change the channel names. Even changing the case of the word *Pantone* can result in a miscommunication with another application or with your commercial printer.

12. *Swap the color for the fourth channel.* Now we've gone and made the image a little too green. I want to warm it up a little more. Here's the solution I came up with:

- Double-click the thumbnail for the fourth channel, **Pantone 7404 C**, to bring up the **Spot Channel Options** dialog box.

- Click the color swatch to bring up **Color Libraries**.

- Type "123" to select **Pantone 123 C**, which is more of an orange-yellow. The image grows warmer.

- Click **OK** twice.

Incidentally, if this seems like a lot of busy work, switching out one spot color after another, bear in mind that each ink affects the appearance of the others. That is to say, this kind of back-and-forth work comes with the territory.

13. *Reduce the image to a tritone.* Let's see if we can reduce the number of channels to three. Doing so will save us money when printing the image by cutting out one ink and one plate. So click the 👁 icon for the dark blue channel, **Pantone 281 C** to turn it off. As you can see in Figure 1-44, the color looks pretty great. But the image is too light. My guess it that we can adjust one of the other channels to compensate.

14. *Make the orange channel darker.* We're left with three inks: black, a rich orange, and a bright yellow. Or those, the orange is the only one with enough heft and color to deepen the midtones in this image. So do the following:

- Click **Pantone 1535 C** in the **Channels** palette to make the rich orange channel active.

- Choose **Image**→**Adjustments**→**Levels** or press Ctrl+L (⌘-L) to bring up the **Levels** dialog box.

- See how the luminance levels are concentrated toward the right side of the histogram? To spread them out, change the first **Input Levels** value to 70, as in Figure 1-45 on the next page.

- Click **OK** to apply the change.

15. *Delete the unused channel.* Usually I advocate keeping disabled elements in Photoshop. After all, you never know when you might need an old layer, effect, or alpha

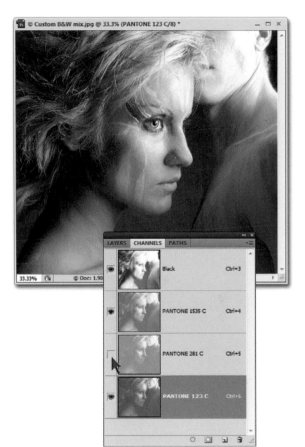

Figure 1-44.

channel. But when working with spot colors, it's too easy for the channel to get turned back on, increasing the cost of the print job, and ruining the final effect. So drag the **Pantone 281 C** channel to the trash can icon at the bottom of the **Channels** palette to make it go away.

16. *Save the image to the DCS format.* As a final step, let's imagine we're going to import this image into a page-layout program. To make it as universally compatible as possible—so it can be placed into InDesign or QuarkXPress— choose **File→Save As**, change the **Format** setting to **Photoshop DCS 2.0**, make sure the **Spot Colors** check box is turned on, and click the **Save** button. In the DCS 2.0 Format dialog box, set the **Preview** option to **TIFF (8 Bits/Pixel)** and click **OK**.

And so ends our introduction to the varied topic of color-bearing channels in Photoshop. If at times the topic seemed a little theoretical or far-afield—how often are you really going to want to perform crazy multichannel manipulations?— remember that we have a big topic ahead of us. Masking relies on some on the oldest, most obscure, and even arcane commands inside Photoshop. The knowledge you gleaned here will help you immensely in later lessons.

Happily, you can anticipate something more down-to-Earth in Lesson 2.

Figure 1-45.

WHAT DID YOU LEARN?

Match the key concept in the numbered list below with the letter of the phrase that best describes it. Answers appear upside-down at the bottom of the page.

Key Concepts

1. Channel
2. Color model
3. RGB
4. Grayscale
5. Luminance level
6. Lab
7. Temperature
8. Histogram
9. CMYK
10. Multichannel
11. Spot color
12. Duotone

Descriptions

A. A chart located inside the Levels dialog box and elsewhere that shows the relative number of pixels at each luminance level from black to white.

B. A no-color brightness value from black to white, with incremental shades of gray in between.

C. An obscure but useful channel mode that lets you to switch from one color model to another without recalculating the channels to keep the appearance of the image intact.

D. Essentially an independent grayscale image, this band of luminance information may describe a primary color in an image, a spot color in a quadtone, or the transparency information conveyed by a mask.

E. This color model employs a single channel that stores nothing more than luminance information, resulting in an image that is devoid of color.

F. A command that assigns two, three, or four inks to a grayscale image, resulting in darker blacks and a wider range of luminance levels.

G. The rules that define how the primary colors in an image are recorded, blended, and converted, forming the basis of channels and masks in Photoshop.

H. In many ways the direct opposite of RGB, this color model employs process-color inks that darken as they blend together on the page.

I. The color information imparted by the *b* channel of a Lab image, ranging from cool blues to warm yellows.

J. The color model that describes the primary colors of light, used by everything from computer screens to digital cameras.

K. This device-independent color model is designed to represent an image in a way that's analogous to the way our eyes see the real world.

L. A custom, premixed ink, available from Pantone among others, that delivers a color that may be beyond the capabilities of CMYK.

Answers

1D, 2G, 3J, 4E, 5B, 6K, 7I, 8A, 9H, 10C, 11L, 12F

LESSON
2

HOW MASKS WORK

NOW THAT you know a thing or two about channels and how they merge to form the colors in a digital image, it's time to move on to their non-color-bearing brethren, *alpha channels*, which allow you to build, modify, and store masks.

We'll start our discussion of alpha channels at an unusual place—at the beginning. I'm not trying to be clever or ironic. It's just that normally with a big, meaty topic like alpha channels, I would start by showing you how they work and come back to how they originated later. This time, however, we're going to start with a very brief look at the origin of the alpha channel. My hope is that this quick peak under the hood will help introduce and demystify the topic.

The alpha channel is named for the Greek letter alpha, or α, which is the variable at the heart of each and every layer's transparency. Figure 2-1 shows the α equation. I realize a lot of people are discouraged by math, and algebra seems to have a particularly bad reputation. My hope is Figure 2-1 and the following story of that figure will rise above any phobias.

Figure 2-1 is a layered image. The clouds and tulips exist on the Background layer. A gradient, starting red at the top and fading down to transparency, floats on a layer above. Imagine a pixel on that layer, the opacity of which is, say, 30 percent. That pixel's name is capital A. The pixel right behind it is named B for background. The opacity is α. Only α is calculated as a decimal, so 30 percent becomes 0.3. Hence, at this one pixel, we see $0.3A + (1-0.3) = 0.7B$. Which is to say, at that one pixel, we see 30 percent red mixed with 70 percent clouds.

tulips and clouds istockphoto.com/JacobH

Equation: Alvy Ray Smith

Figure 2-1.

This lesson examines a few ways to create, preview, modify, combine, and save alpha channels in Photoshop. I'll also show you how to load masks as selections and put them in play to create some simple but effective compositions. You'll learn how to:

- Convert a few selection outlines to masks and
 save both image and masks as a TIFF file page 40

- Load masks as selection outlines and use
 them to build a layered composition page 48

- View mask and image at the same time
 and refine a problem selection outline page 56

- Subtract one mask from another and fill the
 resulting selection with a shaded gradient page 61

Video Lesson 2: The Anatomy of a Mask

Masks tend to intimidate a lot of people. But they're really just the digital equivalent of the traditional stencil. You paint inside the areas that the stencil (or mask) doesn't cover; everything else is protected. The big difference is that the holes in the stencil are white, the protected areas are black, and the stencil in general is a heck of a lot more accurate.

To watch a real-time comparison of stencils and masks—not to mention, learn why masks are so much better—watch the second video lesson. Insert the DVD, double-click the file *PsCM Videos.html*, and click **Lesson 2: The Anatomy of a Mask** under **Channels, Masks, and Selections.** Lasting 9 minutes and 15 seconds, this movie introduces these shortcuts:

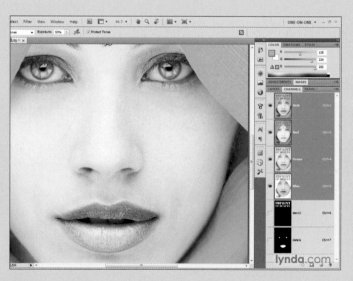

Operation	Windows shortcut	Macintosh shortcut
Brush tool	B	*B*
Release "sticky" blend mode option	Esc	*not necessary*
Change Opacity setting of active tool	1, 2, 3, . . . 0	1, 2, 3, . . . 0
Turn on airbrush option	Shift+Alt+P	Shift-Option-P
Delete selected layers	Backspace or Delete	Delete
Switch to the 1st or 2nd alpha channel	Ctrl+6 or Ctrl+7	⌘-6 or ⌘-7
Hide selection outlines	Ctrl+H	⌘-H
Lift color when brush tool is active	Alt-click	Option-click

That equation was the brainchild of Alvy Ray Smith. He came up with it more than a decade before Photoshop, back in the 1977. In those days, they had digital RGB images, but there was no such thing as transparency. So if you wanted to combine the foreground of one image with the background from another, you had to "pull a matte," which usually involved the creation of a separate image, and then laboriously render foreground with matte into a new background. The way Alvy tells the story on his site (*www.alvyray.com*), his buddy (and fellow cofounder of Pixar) Ed Catmull was grousing that it certainly would be easier if the foreground image contained its own transparency information. Alvy said no problem and had it ready for him the next day. Ed did some more work on it, a couple of guys named Tom further refined the technology a few years later, and in 1996 they all won an Oscar. For the equation in Figure 2-1.

Which goes to show two things: First, Adobe did not invent the alpha channel, it merely had the sense to support it. And second, math is actually wicked cool.

What Are Masks?

In Photoshop, alpha channels are not necessary to convey the overall translucency of a layer. You can accomplish that simply enough using the Opacity value in the Layers palette. You can likewise erase holes in a layer without the help of an alpha channel (though that transparency information is tracked in the background as a kind of alpha channel that Photoshop calls a *transparency mask*).

Rather, an alpha channel is an extra channel that contributes nothing to the color of an image and stores masks for later use. So while most folks use the terms alpha channel and mask interchangeably, technically speaking, the alpha channel is the house and the mask is the thing that lives inside it.

Like other channels in an image file, a *mask* is a grayscale image that subscribes to an additive color metaphor. Meaning? As you may recall from the previous lesson, RGB is an additive color model. In an RGB image, black is the absence of primary color, and thus "off." White is full on primary color, and thus "on." All the other colors are on a kind of dimmer switch between on and off. In a mask, black likewise means off, which may translate to a deselected or transparent pixel. White is on, meaning a selected or opaque pixel. The other luminance levels fill in the various increments on the dimmer switch between off and on, as illustrated in Figure 2-2.

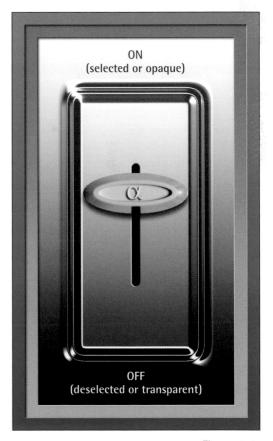

ON
(selected or opaque)

OFF
(deselected or transparent)

Figure 2-2.

In this lesson, I'll show you how alpha channels work, how they accommodate masks, and what masking is all about. Among the highlights, I'll show you how to save and load masks, how you go about combining them, and how you can view them as translucent overlays. By the end of this lesson, you'll know exactly how masks work and how you can work with them.

Creating and Saving Alpha Channels

One of the most common ways to create an alpha channel is to select a portion of an image and then convert that selection to a mask. The advantages of this approach are many: An alpha channel permits you to save a selection for later use. You can see what the selection looks like (beyond the animated outline, which is notoriously inaccurate as we'll learn in time). And you can use the selection-based mask as a jumping-off point for something more complex and more accurate.

In this straightforward and I hope fun exercise, we'll create three separate selection outlines and convert them to three independent masks in three different ways. I'll also show you how to save an image file with all alpha channels intact.

1. *Open an image.* Open *Tool man.jpg*, located in the *Lesson 02* folder inside *Lesson Files-PsCM 1on1*. Although impeccably captured by photographer Aleksandra Alexis of iStockphoto, the image (featured in Figure 2-3) has a certain unfinished quality to it. The scientist guy is looking at a wrench, but he can't possibly see it because his goggles are blacked out. But what really got me is that his cigarette has gone out. It made me realize that what this image needs is to be lit up. Not the cigarette—he'll live longer if we leave that as is—but the stuff around it. And by that I mean lasers blasting out of the guy's goggles and heating up the wrench. In this exercise, we'll define the masks. In the next exercise, we'll put those masks to use.

Figure 2-3.

2. *Get the quick selection tool.* To start with, we need to select the black elliptical regions of the goggles. We're going to use the quick selection tool. So click the quick selection tool in the toolbox, as in Figure 2-4 on the facing page. Or press the keyboard shortcut for the tool, the W key.

3. *Select the black faces of the goggles.* Paint inside one of the two black areas of the goggles with the quick selection tool. A short brushstroke selects everything up to the rims. Then paint inside the second black area. Photoshop automatically adds the second area to the first, as indicated by the selection outlines in Figure 2-5. Note that these outlines are often called *marching ants* for their animated appearance on screen.

Figure 2-4.

Marching-ants-style selection outlines

Figure 2-5.

4. *Save the selection as an alpha channel.* That selection didn't take more than a few seconds to create, so in my normal day-to-day work, I probably wouldn't go to the effort of saving it. (My rule of thumb is, if it takes more than 5 minutes to craft a selection outline, save it.) But because we won't actually put the selection to use until the next exercise, save it we must. Fortunately, it's easy to do:

Figure 2-6.

- Choose **Select→Save Selection** to bring up the **Save Selection** dialog box pictured in Figure 2-6.

- Keep the **Document** option set to the current image, which is the default.

- Leave the **Channel** option set to **New** to instruct Photoshop to make a new alpha channel from this selection.

- Type "Eyes" in the **Name** field. Granted, these aren't really the eyes, but they're where the eyes would appear if we could see them.

- Because this image has no other alpha channel, the **Operation** section offers just one option, **New Channel**. Go with it.

- Click the **OK** button to save the selection.

When you save a selection, it's saved in memory but not to disk. To save the selection as a permanent part of the image file, you have to choose File→Save, a step that we will perform at the end of this exercise.

5. *Deselect the image.* With the selection now safely tucked away as an alpha channel, there's no need to keep it active. So choose **Select→Deselect** or press Ctrl+D (⌘-D on the Mac) to get rid of it. Might seem reckless, but we're fully protected, as explained in the sidebar "The Lossless Translation" (page 44).

6. *View the alpha channel.* Now let's take a look at the alpha channel we just saved:

 - Go to the **Channels** palette. (If it isn't visible on screen, choose **Window→Channels**.)

 - Click the **Eyes** channel to not only switch to that channel but also show it and hide the others. You now see the mask. The areas you selected are white and the areas you did not select are black, as in Figure 2-7.

 - Not all pixels are black or white. If you zoom in and scrutinize the very few gray pixels between the black and white areas, you'll see just how trashy the selection outline is. Alas, that's the quick selection tool for you. We'll see how to get better results from the tool in Lesson 3, "Selection Essentials." But fortunately, the effects we'll be applying are pretty forgiving, so this pair of jagged, aberrant ovals happen to be good enough for our purposes.

Selected (white) Transitional edges (gray)

Deselected (black)

Figure 2-7.

7. *Return to the RGB image.* We're finished reviewing our handi-work, so click the composite **RGB** view in the Channels palette to return to the full-color image.

We'll be switching between channels and composite views a lot in this book, so you may find it helpful to memorize some simple keyboard shortcuts, all of which involve Ctrl (or ⌘) with a number from 2 to 9. For example, you can switch to the full-color composite by pressing Ctrl+2 (⌘-2). When working with an RGB image, the color-bearing channels are Ctrl+3 (⌘-3) for Red, Ctrl+4 (⌘-4) for Green, and Ctrl+5 (⌘-5) for Blue. Ctrl+6 (⌘-6) takes you to the first alpha channel. All shortcuts are listed on the right side of the Channels palette.

8. *Create a selection.* Now let's select the area in which a laser will come blasting out of one of the guy's eyes.

- Still armed with the quick selection tool, paint inside the black area of the near goggle (the one over his right eye) to select it. You now have what I will call an oval selection.

- Select the rectangular marquee tool by clicking its icon in the toolbox or pressing the M key.

- Click the ⬚ icon in the options bar (indicated by the tool tip *Add to selection* in Figure 2-8) to append another selection outline to the existing one.

- Make sure that you can see the far right side of the photograph. Then draw a rectangular mar-quee from the top-center of the oval selection to the far right edge of the image. When the bottom edge of the marquee aligns to the bottom edge of the oval, release to create a selection outline like the one shown in Figure 2-9.

9. *Save the selection as an alpha channel.* Last time (Step 4), we used the Save Selection command. This time we'll try something less obvious but much more convenient. Go to the **Channels** palette and click the ⬚ icon along the bottom of the palette. Photoshop adds a second, unnamed alpha channel.

10. *Rename the alpha channel.* Double-click the name of the new channel, **Alpha 1**, to make it available for editing. This is the forward laser beam, so enter "Front" and press Enter or Return.

Rectangular Marquee Tool (M)

Feather: 0 px Anti-alias Style: Norm

Add to selection

Figure 2-8.

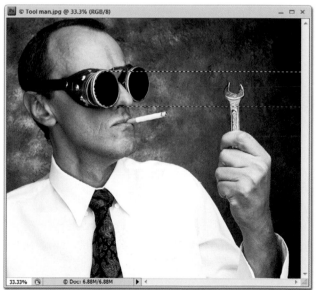

© Tool man.jpg @ 33.3% (RGB/8)

33.33% © Doc: 6.88M/6.88M

Figure 2-9.

The Lossless Translation

We've been fairly liberal about converting selections to alpha channels and then converting them back to selections. Which might cause you some reasonable concern. After all, in Photoshop, the word *convert* is usually code for *change*. When you convert an image to the JPEG file format, Photoshop has to assign new colors to just about every pixel in the image. When you convert from RGB to CMYK, Photoshop changes the colors of *all* pixels (except the white ones).

The loss becomes greater the more times you convert the image. For example, excluding any multichannel tricks, every conversion from RGB to CMYK and back again causes incremental damage to the image.

Such is *not* the case when converting from selection to alpha channel or vice versa. The conversion is *lossless*, meaning that no information is lost in the translation. How is that possible? Photoshop sees each and every selection outline you draw as a grayscale image, with resolution and pixel dimensions and everything. Meaning that every selection—whether it appears as marching ants or alpha channel—is forever and always a mask.

Not convinced? Lucky for you I like a skeptic. Here's my proof: Choose **File→New** to bring up the **New** dialog box. Set the **Width** and **Height** values to, say, 600 pixels apiece, and the **Color Mode** option to **Grayscale**. Then click **OK** to create the document.

Select the elliptical marquee in the toolbox and drag across the image to create a large selection outline. Then press the Shift key and drag a few more times to add smaller outlines that overlap your large one, resulting in something along the lines of the one shown above and to the right. (If yours looks a little different, or even a lot different, no problem. You'll still get your proof in the end.)

Choose **Select→Modify→Feather** to bring up the **Feather Selection** dialog box. Set a **Feather Radius** value of 18 pixels and click **OK**. This blurs the selection outline and

introduces a wide range of grays into our prospective mask. But you wouldn't know it to look at the marching ants. All corners get rounded off, but otherwise the ants are incapable of indicating soft or transitional edges.

For the sake of contrast, let's cut some nonfeathered areas into the selection. Select the rectangular marquee tool from the toolbox, press and hold the Alt (or Option), key and drag to slice a few slim rectangles in the selection outline, as shown in the figure below.

Now let's fill the selection with black so we can see what it looks like. Press the D key to make the foreground color black and press Alt+Backspace (or Option-Delete) to fill the selection with the foreground color, as below.

All right, that's one impression of the selection. To see another, save the selection to an alpha channel. Go to the **Channels** palette. Alt+click (or Option-click) the ⬚ icon along the bottom of the palette, enter "Blob" for the **Name** value, and click **OK** to create the mask. Then press Ctrl+D (⌘-D) to deselect the image.

Now to compare the mask from the Blob channel to the black-filled selection in the Gray channel. Go back to the **Layers** palette and press Ctrl+Shift+N (⌘-Shift-N) to bring up the **New Layer** dialog box. Type "Test" for the **Name** value and click **OK**.

By default, the new layer is transparent. For the sake of our comparison, we need it to be white, which we can achieve by pressing Ctrl+Backspace (⌘-Delete).

Return to the **Channels** palette and Ctrl+click (or ⌘-click) the **Blob** channel to load its selection outline. The selection has now run the gamut from marching ants to alpha channel and back to marching ants. If any degradation

is going to occur, we'll be able to see it in its early stages, however microscopic.

Switch back to the **Layers** palette and make sure the **Test** layer is active. Then press Alt+Backspace (Option-Delete) to fill the selected area with black. And press Ctrl+D (⌘-D) to deselect the image.

You now have two layers, Background and Test. Background represents our original selection; Test is the one that you converted to a mask and back. Click the 👁 icon for the Test layer to turn the layer off and on. You won't see any difference. But your eyes can be fooled, so let's take a more scientific approach.

Turn on the **Test** layer and make sure it's active. Then choose **Difference** from the blend mode pop-up menu in the top-left corner of the Layers palette. The accurately named Difference mode finds the difference between a pixel on the active layer and the pixel directly behind it. If the two pixels are absolutely identical, the colors cancel each other out and the Difference mode shows black. In our case, all pixels in the image are black, meaning there is no difference between the original selection and the one that was saved as a mask and loaded back up again. The conversion is lossless.

11. *Return to the RGB image.* The next step is to retrofit the laser beam selection to the fellow's left eye. We need to see the image to do that. So click **RGB** at the top of the Channels palette or press Ctrl+2 (⌘-2).

12. *Move the selection upward.* We're going to use the existing selection around the front goggle to create a similar selection aligned to the rear goggle. Assuming that the rectangular marquee tool is still selected:

 • Click the first icon in the options bar, ▪, which displays the tool tip *New selection* when you hover over it. It's true that this option lets you make new selections, but it also allows you to modify existing ones.

 • Move your cursor inside the selection and notice that it changes to a hollow arrowhead, showing you that you can modify the selection outline independently of the image. Drag the animated outline straight up—taking care that the right edge of the selection remains aligned to the right edge of the image—until the top of the selection aligns to the top edge of the rear goggle, as it does in Figure 2-10.

Figure 2-10.

13. *Transform the selection.* The selection outline is now in position, but we need to resize it for a better fit:

 • Choose **Select→Transform Selection**, which lets you change the shape of the outline independently of the image.

 • Drag the bottom-left handle up and to the right so the selection aligns with the far eye, as demonstrated in Figure 2-11. You may have to finesse the selection by dragging the bottom and left side handles as well.

 • Accept the transformation by clicking the ✔ icon in the right area of the options bar. Or just press the Enter or Return key.

Figure 2-11.

14. *Create a new channel.* Naturally, we want to save this selection as an alpha channel, but again using a different method:

- Alt-click (or Option-click) the ☐ icon at the bottom of the Channels palette. Having Alt (or Option) down forces the display of the **New Channel** dialog box.

- Enter "Rear" into the **Name** field, inasmuch as this is the selection for the rear eye.

- Click **OK** to create the new channel.

15. *Fill the selection with white.* Our newest alpha channel is unlike the others in that it does not contain a mask of the selection outline. It's just an empty channel, filled entirely with black. To make it a mask, we need to fill the selected area with white:

- Press the D key to make sure the colors are set to their defaults. When working on a mask, that's white for the foreground and black for the background.

- Then press Alt+Backspace (Option-Delete on the Mac) to fill the selection with white. That's a mask.

16. *Deselect the image.* We're done with this selection for the moment, so choose **Select→Deselect** or press Ctrl+D (⌘-D) to deselect it.

17. *Return to the RGB image.* Now that we've created our alpha channels for the three selections in the image (see Figure 2-12), click **RGB** in the Channels palette or press Ctrl+2 (⌘-2) to return to the full-color image.

18. *Save the image.* As I mentioned in Step 4, the selections have been converted to masks. But until we save the image to disk, we could lose them in the event of a system crash or what have you. Unfortunately, the JPEG file format cannot accommodate alpha channels, so here's what you need to do:

- Choose **File→Save As** or press Ctrl+Shift+S (⌘-Shift-S) to bring up the **Save As** dialog box, pictured in Figure 2-13.

- Be sure that the **Alpha Channels** check box is turned on and that you don't see a yellow ⚠ icon so that Photoshop really does save your alpha channels along with the image.

Figure 2-12.

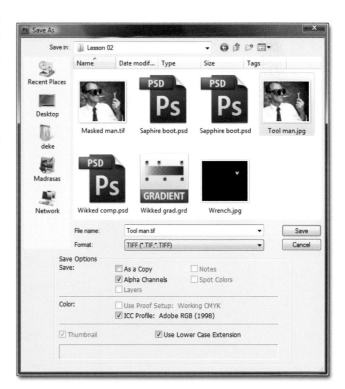

Figure 2-13.

- Both the Photoshop and TIFF file formats support alpha channels. I prefer TIFF for flat files. So choose **TIFF** from the **Format** pop-up menu.

- Enter a new name if you like, or just leave it named *Tool man.tif* as I did back in the figure on the previous page.

- Click the **Save** button to bring up the **TIFF Options** dialog box.

- Set **Image Compression** to **LZW**, which applies lossless compression, especially useful for reducing the file size of masks without harming a single pixel in your image.

- Click **OK** to save your image.

With all the selections you'll need in place, you're now ready to make those laser beams burst from the science guy's goggles.

Loading Masks and Putting Them to Use

Now that you know how to save selections as alpha channels, it's time to learn how to convert the masks to selections so that you can put them in play. (In and of themselves, alpha channels don't do anything. They are merely holding cells for masks that are waiting to be used when and how you see fit.) In this exercise, we'll load the selections and use them to warm up the goggles, create a pair of lasers blasting out of the mad scientist's eyes, and subsequently heat up the wrench.

1. *Open an image.* If you still have the file open from the last exercise, keep it open. Otherwise, open *Masked man.tif*, located in the *Lesson 02* folder inside *Lesson Files-PsCM 1on1*. This is the image we produced in the preceding exercise, complete with the saved alpha channels that we'll put to use in this exercise.

2. *Load the Eyes channel as a selection.* Let's start things off by warming up the goggles. We'll be doing this with the help of an Inner Glow layer effect, which requires an independent layer, which in turn requires us to select the portion of the image that we want to send to the layer. So choose **Select→Load Selection** to display the **Load Selection** dialog box (see Figure 2-14). Choose **Eyes** in the **Channel** pop-up menu, which lists all alpha channels in the active image. Then click **OK** to load the selection just as it was when we saved it. Photoshop selects the portion of the mask that is white and deselects the black.

Figure 2-14.

3. *Jump the selection to a new layer.* To copy the selection to an independent layer, choose **Layer→New→Layer Via Copy**. Or better yet, press Ctrl+J (⌘-J), which you can think of as standing for "jump."

4. *Go to the Layers palette.* Switch to the **Layers** palette by clicking its tab or pressing the F7 key.

5. *Rename the new layer.* Double-click the name of this new layer, **Layer 1**, type "Eyes," and press Enter or Return to rename the layer. The diminutive Figure 2-15 shows the result.

Figure 2-15.

6. *Apply an Inner Glow layer style.* Now to make the eyes glow in a way that's every bit as easy as it is effective:

- Click the *fx* icon at the bottom of the Layers palette and choose **Inner Glow** from the pop-up menu to bring up the **Layer Style** dialog box, shown in Figure 2-16 as it will appear when you finish setting the following options.

- Make sure the **Preview** check box is on so you can see the results of your changes.

- We want our glow to radiate from the center of the eyes, so change the **Source** option in the **Elements** section of the Layer Style dialog box to **Center**.

- Increase the **Size** value to 70 pixels so the glow better fills the goggles.

- Up in the **Structure** section, raise the **Opacity** value to 100 percent to bolster the effect.

- Click the color swatch to bring up the **Color Picker** dialog box. Then dial in the following shade of orange using the HSB (hue, saturation, and brightness) values: Set **H** to 30 degrees, **S** to 75 percent, and **B** to 100 percent. The result is the vivid orange pictured in Figure 2-17. Click **OK** to close the Color Picker dialog box.

- Click the **OK** button to close the Layer Style dialog box and accept the effect, which appears in all its glory in Figure 2-18 at the top of the next page.

Figure 2-16.

Figure 2-17.

Figure 2-18.

7. *Merge the Eyes layer into the Background.* I don't typically like to merge layers. Case in point, merging the glowing eyes back into the image prevents us from ever again tweaking the Inner Glow settings. But the following steps will be considerably easier if we flatten the image, so merge we will. Choose **Layer→Merge Down** or press Ctrl+E (⌘-E on the Mac).

8. *Load the Front channel as a selection.* Now let's use the Front channel to create the effect of lasers blasting forth from the goggles. And just as there are hidden ways to save selections that are more convenient than the Save Selection command, there are hidden ways to load selections that are more convenient than the Load Selection command. Go to the **Channels** palette, press the Ctrl (or ⌘) key, and click the **Front** alpha channel to load it as a selection, as indicated by the pointing-finger cursor in Figure 2-19.

9. *Jump the selection to a new layer.* For the ultimate blasting experience, we need to send the selection to a layer. Switch to the **Layers** palette and press Ctrl+Alt+J (⌘-Option-J) to both jump the selection and display the **New Layer** dialog box. Call the layer "Front Ray" and click the **OK** button.

10. *Load the selection from the layer.* The filter that we'll use to achieve the blast effect, Radial Blur, requires a selection outline to delineate the area that's considered part of the effect. To load just such a selection, Ctrl+click (⌘-click) the thumbnail for the **Front Ray** layer in the Layers palette. You should see the marching ants as in Figure 2-19.

Note: It's very important that you Ctrl-click (or ⌘-click) the layer's thumbnail. If you Ctrl-click (⌘-click) the layer itself, you'll deselect it in the Layers palette, and then the filter will fail entirely. That's because Ctrl-clicking (⌘-clicking) also permits you to select and deselect nonadjacent layers. So remember, do your clicking on the thumbnail to load that selection outline.

Figure 2-19.

11. *Hide the selection outline.* You won't want the marching ants interfering with your ability to see the next effect, so choose **View→Extras** or press Ctrl+H (or ⌘-H) to hide them. Bear in mind, however, that the selection is still very much in effect.

12. *Apply the Radial Blur filter.* Choose **Filter→ Blur→Radial Blur** to bring up the **Radial Blur** dialog box, which spins an image slightly by default. To create a dramatic blast effect:

 • Set the **Amount** value to its maximum, 100 percent.

 • Change the **Blur Method** to **Zoom**.

 • This is a rickety old command, so there is no preview inside or outside the dialog box. Instead, we have the Blur Center box, which shows you a kind of wireframe diagram of the effect. Drag the center of wireframe all the way to the left while keeping it centered vertically, as you see me doing in Figure 2-20.

 Click the **OK** button to apply the blast effect, which also appears in the figure.

Figure 2-20.

13. *Change the blend mode to Screen.* The effect is interesting, but it obscures the wrench and it doesn't look so much like a blast as some sand art that got shaken extremely vigorously. We can fix that with a blend mode. Click the blend mode pop-up menu in the top-left corner of the **Layers** palette and change the blend mode to that great lightening mode that we saw in the previous lesson, **Screen**. Now that's a bright, beautiful laser blasting out of a crazy scientist's eye, as witnessed by Figure 2-21. I mean, I wish I had *those* goggles.

14. *Load the Rear channel as a selection.* Now to repeat this laser effect for the other eye. Of course, we need a selection for that. This time, let's try yet another trick. The Rear channel is our third alpha channel, so you could switch to it by pressing Ctrl+8 (or ⌘-8). But don't do that. Instead, press Ctrl+Alt+8 (⌘-Option-8) to load the mask as a selection.

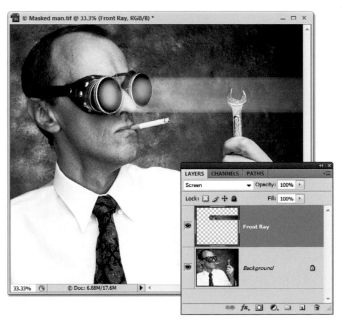

Figure 2-21.

15. *Create a new layer.* Once again, we need an independent layer from the contents of the original image. So return to the Layers palette and click the **Background** layer to make it active. Press Ctrl+Alt+J (⌘-Option-J) to display the **New Layer** dialog box. Name the new layer "Rear Ray" and click **OK**.

16. *Load the selection from the layer.* We need a selection outline to rein in the behavior of the Radial Blur filter, so Ctrl+click (⌘-click) the thumbnail for the **Rear Ray** layer in the **Layers** palette.

17. *Repeat the Radial Blur effect.* To apply the Radial Blur filter to this layer with the same settings we used for the Front Ray layer, choose **Filter→Radial Blur** or press Ctrl+F (⌘-F).

18. *Change the blend mode to Screen.* We want the same lightening effect for this layer as well, so change its blend mode in the Layers palette to **Screen**. Note that the Screen mode has a shortcut: Shift+Alt+S (or Shift-Option-S).

19. *Deselect the selection.* Press Ctrl+D (or ⌘-D) to dispense with the selection outline. The second laser blast is now complete, as shown in Figure 2-22.

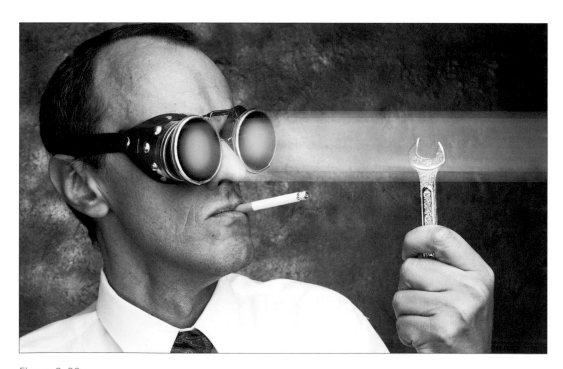

Figure 2-22.

When's the last time you created a layered composition that was this simple and yet looks this good? But while it's great that our guy's got these glowing rays of hot laser weirdness coming out of his eyes, the wrench is just sitting there. It should be glowing, very nearly melting, ready to be refashioned into whatever device the scientist wants to invent next. If you somehow regard fiery tools as a crime against nature, jump ahead to the "Modifying a Mask" exercise on page 56. But if you wished you lived in a world where all tools were on fire, stick with me. You'll even learn a thing or two in the process.

20. *Open another image.* You'll need to select the wrench before you can do anything to it. But that means using one of Photoshop most demanding selection functions, the pen tool, which I don't discuss until Lesson 11. Which is why I went ahead and saved the selection as a mask. Problem is, this image began life as a JPEG file, and JPEGs don't support masks. Which explains why I put the mask in a different file. Go to the *Lesson 02* folder inside *Lesson Files-PsCM 1on1* and open the image *Wrench.jpg.* Shown in its entirety in Figure 2-23, this grayscale image just so happens to contain an outline of the wrench that is perfectly aligned with the wrench in the ongoing layered composition.

Figure 2-23.

In case you're wondering, wait a sec, how is it that JPEGs don't support masks and yet the *Wrench.jpg* file is a mask? Answer: The mask appears in a color-bearing channel that JPEG *does* support, Gray. In other words, JPEG supports masks just fine if they're moved to a separate file and converted to grayscale using Image→Mode→Grayscale.

21. *Make the original image active.* We are going to load the wrench selection into the scientist comp, so switch back to the *Masked man.tif* file.

22. *Load the wrench selection.* Choose **Select→Load Selection** to bring up the **Load Selection** dialog box. The **Document** pop-up menu offers a list of all open images that are the same pixel dimensions as the active one. Change this setting to **Wrench.jpg**, as in Figure 2-24. The image contains just one channel, so **Channel** is automatically set to **Gray**. It's that easy. Click **OK** to load the selection.

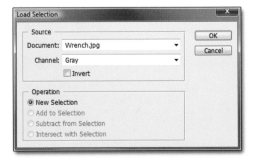

Figure 2-24.

Figure 2-25.

23. *Jump the wrench to a new layer.* We'll heat up the wrench with the help of a couple of layer effects, and layer effects require a layer. Go to the **Layers** palette, click the **Background** layer, and press Ctrl+Alt+J (⌘-Option-J). In the **New Layer** dialog box, enter a **Name** of "Wrench" and click **OK**.

24. *Move the Wrench layer to the top of the stack.* The wrench is getting a little obscured, so let's move it in front of the laser beam layers. Drag the **Wrench** layer to the top of the **Layers** palette, as demonstrated in Figure 2-25.

25. *Apply an Outer Glow effect.* We want the wrench to look as though it's being heated by the laser beams, so we'll apply a couple of layer effects, starting with an Outer Glow:

- Click the *fx* icon at the bottom of the **Layers** palette and choose **Outer Glow** from the pop-up menu to bring up the **Layer Style** dialog box.

- Raise the **Opacity** value to 100 percent.

- Click the color swatch to bring up the **Color Picker** dialog box. Enter an **H** value of 40 degrees for a slightly yellowish orange. Then set the **S** and **B** values to 100 percent each to make the color its brightest. Click **OK** to return to the **Layer Style** dialog box.

- Raise the **Size** value to 25 pixels.

- Set the **Blend Mode** option to **Linear Dodge (Add)** to create an extreme, fiery glow.

All my recommended settings appear in Figure 2-26.

Figure 2-26.

26. *Add a Color Overlay effect.* Now to heat up the interior of the wrench. With the **Layer Style** dialog box still on screen, click the words **Color Overlay** in the left-hand list of effects to switch to the **Color Overlay** panel, turn on the effect, and make the wrench red. Then do as follows:

- Click the color swatch to bring up the **Select Overlay Color** dialog box (which is really just the Color Picker with a different name). Set the **H** value to 20 degrees to infuse the red with some orange. Leave the **S** and **B** values set to 100 percent apiece and click **OK**.

- In the **Layer Style** dialog box, set the **Blend Mode** option to **Vivid Light** to burn the orange into the shadows and make the highlights a bright yellow.

- Ease off the effect by reducing the **Opacity** value to 70 percent.

Figure 2-27 shows our settings. When you have your settings in place, click **OK** to close the Layer Style dialog box and apply both the Outer Glow and Color Overlay effects. Figure 2-28 shows the finished result, complete with glowing eyes, blasting lasers, foundry-hot wrench, and curiously still-cold cigarette.

Figure 2-27.

Figure 2-28.

27. *Save the file* We now have a composition that contains three alpha channels and three layers. Technically, the TIFF file format can accommodate layers, but the native Photoshop PSD format is the industry-accepted standard for layered files. Here's what I recommend:

- Choose **File→Save As** or press the command's keyboard shortcut, Ctrl+Shift+S (⌘-Shift-S).

- Change the **Format** option to **Photoshop**.

- Rename the file if you like and click **OK**.

- If you see an alert message—which will happen only if you did *not* follow my instructions in the Preface—turn off **Maximize compatibility** and click the **OK** button.

So just to recap: When saving a flat image with no layers or alpha channels, JPEG will do, although I recommend maximizing the Quality setting. When an image contains alpha channels but no layers, TIFF is your best bet. And once layers get involved, save to the native Photoshop PSD format.

Modifying a Mask

So far we've had an easy time creating and deploying masks that have perfectly met our needs. Now we'll move on to a more challenging—and realistic—scenario in which we need to view and modify a mask to improve our results.

By way of example, we'll assemble the cover of a fake magazine, *Wikked*. I've set the composition against another photo from Aleksandra Alexis of iStockphoto that features a woman outfitted provocatively in nothing more than a necklace, a bolt of gossamer fabric, and some alarmingly red boots (see Figure 2-29). Our objective is to place the title of the magazine onto the cover, with the forward boot extending in front of the title. And yes, that means we'll be placing the title of the magazine at the bottom of the cover. A bit unorthodox, to be sure, but then this is no ordinary magazine. It's for creatures of the night.

1. *Open an image.* Open *Wikked comp.psd*, located in the *Lesson 02* folder inside *Lesson Files-PsCM 1on1*. In addition to the photograph and the layers of rasterized text (that is, letters converted to pixels), this image contains a couple of alpha channels so you can focus on modifying masks.

Figure 2-29.

2. *Zoom in on the forward boot.* Zoom in on the boot in the bottom-left corner of the image. And just look at it for a moment. I want you to have a clear sense of what this detail looks like: a few wrinkles and puckers, but ultimately smooth as porcelain.

3. *Go to the Channels palette.* Now let's take a look at our masks and decide if they're any good before we put them to use. As you know by now, masks live in the **Channels** palette, so go there.

4. *Switch to the Boot mask.* In addition to the standard RGB channels, we have two alpha channels, one for the title of the magazine (itself titled Nameplate) and another for the forward boot. Click the **Boot** channel to make it active. As shown in Figure 2-30, the edges of the mask are serrated, ragged, and misshapen, a function of having drawn the original selection outline with the magnetic lasso tool (one of the features we'll examine in Lesson 3). Having studied the smooth contours of the boot just two steps ago, it's seems a safe bet that this mask and that boot are not a good fit. The condition of this channel is therefore unacceptable.

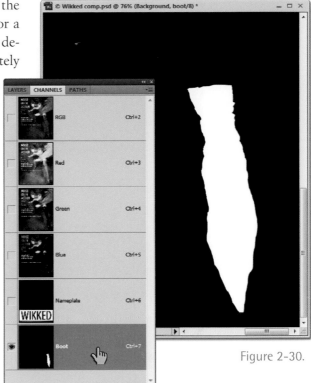

Figure 2-30.

5. *View mask and image together.* So while we can tell the mask and the image don't match, the question is, to what degree? We can't effectively compare mask and image if we can see only one or the other. So let's see both at once.

We're already seeing the mask, as indicated by the 👁 icon to the left of the word **Boot** in the Channels palette. Click in the empty 👁 column to the left of the **RGB** thumbnail (not on the thumbnail itself) to see the image as well.

Note that you can also show or hide the full-color image by pressing the ⌐ (tilde) key, located in the top-left corner (below the Esc key) on American keyboards.

6. *Change the overlay color.* By default the mask appears as a translucent red overlay (see Figure 2-31). You'll sometimes hear this view called the *Rubylith* mode, after a brand of red-colored masking film that was used to composite photographs back in the pre-digital days. Although Photoshop chose the default red coloring to simulate Rubylith, it couldn't be a worse choice for our purposes. Where does the red boot end and the red mask begin?

Figure 2-31.

Figure 2-32.

Figure 2-33.

That's why we're so lucky that we can change the color of the overlay, as follows:

- Double-click the thumbnail for the **Boot** alpha channel to bring up the wee **Channel Options** dialog box, pictured in Figure 2-32.

- Click the color swatch to bring up the **Select Channel Color** dialog box. Change the **H** value to 210 degrees to dial in a sapphire blue. Then click **OK**.

- Reduce the **Opacity** value in the **Channel Options** dialog box to 30 percent. This dialog box could really use a preview option—as it is we're working blind—but it stands to reason that the lower Opacity setting will allow us to better see the image.

- Click the **OK** button to apply the new mask color, which we can see in Figure 2-33.

Note that these settings are specific to the Boot channel. The Nameplate channel remains red; other masks we might create can all be set to different colors. And Photoshop saves those colors as part of the image file.

7. *Select the brush tool.* Now that we can easily distinguish mask and boot, it becomes all the more clear that the original selection used to create the mask was, to be polite, a rough approximation. How do we fix it? Paint away the mistakes using the brush tool. First, let's get the brush tool and set it up:

- Select the brush tool from the toolbox (see Figure 2-34), or press the B key.

- Right-click (or if need be on the Mac, Control-click) in the image window to display a pop-up palette of brushes.

- Choose the 19-pixel hard-edged brush (sixth in the list). Then press Enter or Return to close the palette.

- Press D and then X to make the foreground color white.

PEARL OF WISDOM

When working in the full-color image, the default colors are black for foreground and white for background (the foreground and background colors being those swatches at the bottom of the toolbox). When working on a mask, they're the opposite—foreground: white, background: black— the assumption being that you most likely want to paint in selected regions. When viewing mask and image at the same time, the defaults goes back to foreground: black, background: white, even when the mask is active.

Figure 2-34.

8. **Erase the mask on the right side of the shoe.** Before we can paint in a good edge, we have to erase the bad one. Paint along the right edge of the shoe (the part of the boot that contains the foot) to erase the blue of the mask, as demonstrated in Figure 2-37.

The brush tool always paints with the foreground color, which is currently white. So how in the world does painting with white translate to erasing away blue? Press the ⌐ (tilde) key and you'll see the actual mask. Where you painted white really *is* white. It just appears transparent in the rubylith mode. Meanwhile, were you to paint with black, your brushstrokes would look black when viewing the mask by itself, but they'd appear colored—in our case, blue—when viewing both mask and image together. When your curiosity is satisfied, press ⌐ again to return to the rubylith mode.

9. **Paint a new edge.** Now that we've eliminated the rough edge, we can redraw that section of the mask to better follow the right edge of the boot:

- Zoom in for the closest possible view.

- Press X to swap foreground and background colors, so the foreground color is black.

- In the options bar, make sure the **Mode** setting for the brush tool is **Normal** and both the **Opacity** and **Flow** values are 100 percent.

- I really have no idea how anyone tolerates this type of footwear. (Then again, I spend just about all of my day barefoot.) The front of the shoe forms a sharp point that is distinctly unfoot-like and must place a massive amount of pressure on the lesser toes, more or less grinding them into a kind of monkey fist. But I have to give the model her props. By throwing herself on the altar of fashion, she made this particular area easier to mask. I mean, just look at that right edge— it's straight as a ruler! Painting a straight line to match is a two-step operation: First, click just to the right of the toe to define a starting point for the brushstroke (labeled *First click…* in Figure 2-36).

- Then Shift-click at the "corner" where the point of the shoe transitions into the side of the foot (labeled …*and then Shift-click* in the figure). Photoshop paints a straight line between the first and second clicks.

Figure 2-35.

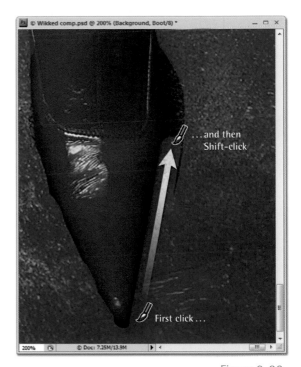

…and then Shift-click

First click …

Figure 2-36.

Figure 2-37.

Figure 2-38.

- The remainder of the right side of the shoe can be described as a series of small straight edges. So keep the Shift key down and continue clicking from one corner to the next.

If you mess up and have to undo—which is altogether likely, by the way—you'll need to reinitiate a starting point for your sequence of straight edges by clicking. Then Shift-click away.

- If any of your corners end up looking too sharp, you can click and Shift-click well outside the corners to create a straight line that ever-so-slightly shaves off that corner and creates a smoother transition.

The result of my labors appears in Figure 2-37. Bear in mind that so far I've limited my edits to the right side of the shoe.

10. *Shave off the tip.* The very tip of the shoe is now a mess. Fortunately, it forms a nearly perfect circle that we can emulate with a single click of the brush. But first, I want you to paint over the tip to cut it in half, as in Figure 2-38. After all, you have to destroy a thing before you can rebuild it (as we will do in Step 14).

11. *Paint along the left side of the shoe.* Having addressed the right side of the shoe, it's time to deal with the left. There's a bit of a gap between the edge of the mask and the toe of the shoe, so nothing to erase there. Just set right in painting with black. Click to the left of the tip that you just cleaved away, and then Shift-click at each corner going up the left side of the shoe. The more straight lines you draw, the smoother the final result.

12. *Clean up the inside of the mask.* As you work your way up, you'll come across a place between the midsection of the foot and the ankle where the blue mask extends into the red shoe. Press the X key to swap the foreground and background colors, making the foreground color white. Then click and Shift-click along the inside edge to clean it up.

13. *Perform any final clean-up work.* Now examine the rest of the blue overlay that represents the mask to look for areas that need work (other than the very tip, which we'll fix next). Any areas that should be masked, paint over with black; areas that should be selected, paint over with white.

For my part, I painted away some of the garbage along the left side of the calf, but I left the right side pretty much alone. Not that there aren't any problems with the boot's right side. But I deemed them unworthy of my attentions.

14. *Fix the tip of the shoe.* The final step in modifying the mask is to reinstate the tip that we shaved off in Step 10.

- To match the size of the tip, right-click (or Control-click) in the image window to display the pop-up palette. Set the **Master Diameter** value to 17 pixels and press Enter or Return to close the palette.

- Press D followed by X to change the foreground color to white.

- Click at the very tip of the shoe to create a nicely tapering, evenly rounded terminus. While still being sharp enough to put your eye out.

Figure 2-39 shows my final Boot channel, still overlayed against the RGB image. We now have a first-rate mask that we can combine with the Nameplate channel in the next exercise.

15. *Save the composition.* After putting so much effort into cleaning up the boot, you owe it to yourself to save the result—but not over the original. Choose **File→Save As** or press Ctrl+Shift+S (⌘-Shift-S) to bring up the **Save As** dialog box. Type the name "Ruby boot.psd" and click **Save** to save the image.

Figure 2-39.

Combining Masks

Thanks to your efforts in the preceding exercise, we now have a layered composition that contains two high-quality masks. We're ready to combine the masks to achieve our final goal of placing a title on the cover of our magazine with the woman's boot extending over the last letter.

1. *Open the image.* If you're continuing on from the previous exercise, keep working on your image, presumably now named *Ruby boot.psd*. Otherwise, open the image I've created for you, *Sapphire boot.psd*, located in the *Lesson 02* folder inside *Lesson Files-PsCM 1on1*. Why "sapphire" when the boot is so very obviously red? Because sapphire is the color that we assigned to the Boot mask back in Step 6 (see page 58).

2. *Switch to the full-color image.* If you're following along with this exercise on the heels of the last one, click **RGB** in the **Channels** palette to switch back to the full-color composite image, and then turn off the 👁 for the **Boot** channel to hide the blue overlay.

3. *Load the Nameplate mask as a selection.* As you may recall, the name of our fake publication is *Wikked*. To achieve an appropriately cool title treatment, I want to paint inside some letters that I've saved as a mask. Go to the **Channels** palette and Ctrl-click (or ⌘-click) the **Nameplate** channel. Or you can press Ctrl+Option+6 (⌘-Option-6). Photoshop loads the mask as a selection, as in Figure 2-40.

Figure 2-40.

4. *Subtract the boot from the selection.* As it is, the Wikked selection runs right over the boot. We want to exclude the boot so it can stride in front of the title. To subtract the Boot mask from the active selection, do either of the following:

- Choose **Select→Load Selection** to bring up the **Load Selection** dialog box. Choose **Boot** from the **Channel** pop-up menu, select **Subtract from Selection** from the **Operation** options, and click **OK**.

- Press the Ctrl+Alt (⌘-Option) keys and click the **Boot** channel in the **Channels** palette.

The selection ants now march around the forward boot, as evidenced by Figure 2-41 on the facing page.

5. *Switch to the Layers palette.* We're ready to fill this selection outline with some beautiful pixels, and I have a layer ready and waiting for you to do just that. Bring up the **Layers** palette by clicking its tab or pressing F7.

YOUR OWN PRIVATE TOUR OF THE EMERALD CITY

WIKKED

magazine of the night

Figure 2-41.

6. *Select the Wikked layer.* Click the **Wikked** layer to make it active. This layer is empty, just waiting for the nameplate.

7. *Select the Gradient tool.* We're going to fill the Wikked selection with a gradient, so select the gradient tool from the toolbox, as you see me doing in Figure 2-42. Or press the G key.

8. *Load a gradient.* Because I have your back—and a specific idea of how I want this effect to look—I've already created a gradient for you in advance:

 • Go to the options bar and click the ▾ arrow to the right of the gradient preview bar, which I've labeled in Figure 2-43 on the next page. This brings up a pop-up palette of predefined gradients that ship with Photoshop.

 • Click the ⊙ arrow in the top-right corner of the palette to display a flyout menu. Choose the **Load Gradients** command to bring up the **Load** dialog box.

 • Navigate to the *Lesson 02* folder inside *Lesson Files-PsCM 1on1*, select the *Wikked grad.grd* file, and click the **Load** button. Photoshop adds one new swatch to the list of predefined gradients in the palette.

Gradient Tool (G)

Figure 2-42.

Click to pop up palette

Click to display menu

My custom gradient

Figure 2-43.

• In the pop-up palette, click the new swatch, which goes by the name **Wikked grad**. Although not much to look at—it goes from gray to red, orange, red, and back to gray—it is going to work out splendidly.

• Press Enter or Return to close the palette.

9. *Fill the selection with a gradient.* Press and hold the Shift key and then draw a horizontal line from the extreme left side of the image to the extreme right side. The Shift key constrains the angle of the gradient to the nearest 45-degree increment, thereby ensuring an absolutely horizontal drag. When you release the mouse button, you'll see the gradient in all its questionable splendor, as witnessed in Figure 2-44.

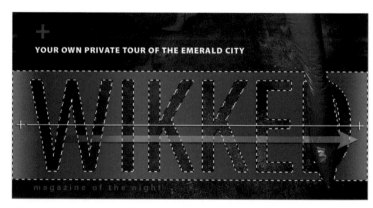

Figure 2-44.

10. *Hide the selection outline.* The gradient serves as a nice foundation, but it's by no means the final effect. To better see what you're doing from this point on, hide the selection outline by choosing **View→Extras** or pressing Ctrl+H (⌘-H on the Mac).

If you ever find yourself missing the marching ants, you can bring them back by choosing the Extras command or pressing Ctrl+H (⌘-H) again.

11. *Add a drop shadow to the nameplate.* Our magazine title will read a little better if we set it off from its background with a drop shadow. So click the *fx* icon at the bottom of the **Layers** palette and choose **Drop Shadow** from the pop-up menu to bring up

the **Layer Style** dialog box. Then apply the following settings (documented in Figure 2-45):

- Click the color swatch to the right of the **Blend Mode** pop-up to bring up the **Select Shadow Color** dialog box.

- Move your cursor out of the dialog box to get the eyedropper. Then click on a dark brown in the left side of the image. (The region under the *m* in *reckless menace* works well.)

- Click the **OK** button to close the Select Shadow Color dialog box.

- Back in the **Layer Style** dialog box, set the **Opacity** value to 100 percent and the **Size** value to 8 pixels.

- Click **OK** to accept your changes.

Figure 2-45.

12. *Paint a shadow behind the boot.* If the letters cast a shadow on the background, it only stands to reason that the boot should cast a shadow on the letters. We can't automate this one with a layer effect, but it's easy enough to paint it in by hand:

- Select the brush tool or press the B key.

- Right-click (Control-click) in the image window to pop up the brush palette. Set the **Master Diameter** value to 50 pixels and the **Hardness** to 0 percent. Press Enter or Return to close the palette.

- Press and hold the Alt (or Option) key to temporarily get the eyedropper tool. Click in the same area you chose for the drop shadow to lift a dark brown as the foreground color. Then release the key to return to the brush.

- Paint along the left side of the boot. Assuming that the selection is still active, your brushstrokes will stay inside the nameplate.

- Paint slightly inside the right edge of the boot to give that shadow a lighter touch. In the end, you should achieve an effect like the one pictured in Figure 2-46.

Figure 2-46.

13. ***Set the Wikked layer to Hard Light.*** To blend the nameplate into its background, choose **Hard Light** from the blend mode pop-up menu in the top-left corner of the **Layers** palette. The grays on either side of the nameplate completely disappear, resulting in fading edges. Meanwhile, the oranges and reds take on a darkly phosphorescent quality, as in Figure 2-47.

Somehow it seems fitting that we were able to complete the nameplate for our "magazine of the night" in 13 steps. Feel free to dismiss the selection outline and save your modifications. Now all you need to do is write some content, maybe shoot a few photographs, and find a publisher, and you have yourself a periodical. I'm telling you, this demographic isn't getting nearly enough attention.

Figure 2-47.

WHAT DID YOU LEARN?

Match the key concept in the numbered list below with the letter of the phrase that best describes it. Answers appear upside-down at the bottom of the page.

Key Concepts

1. Alpha channel
2. Opacity
3. Mask
4. Selection outline
5. Marching ants
6. The ▣ icon
7. Deselect
8. Load Selection
9. Lossless
10. Difference
11. Extras
12. Rubylith

Descriptions

A. More easily invoked by pressing Ctrl+H (⌘-H on the Mac), this command hides the marching ants while leaving the selection intact.

B. The contents of an alpha channel, in which black means deselected or transparent and white means selected or opaque, with other luminance levels representing degrees of selection or translucency in between.

C. Better serviced by the keyboard shortcut Ctrl+D (⌘-D), this command clears any and all selection outlines.

D. A grayscale image element that does not contribute to the overall color of an image but rather enables you to save a selection as a mask and recall the selection for later use.

E. The name given to the animated dashes that cycle endlessly around an active selection outline.

F. Any conversion, translation, or compression process that occurs without changing the color or luminance of so much as a single pixel.

G. Named for a brand of pre-digital masking film, this special mode permits you to see a mask and an image at the same time, with the mask by default shown in red.

H. The degree to which pixels in a layer allow underlying pixels to show through, available as a numerical option in the Layers palette and represented by the Greek letter α in the original alpha channel equation.

I. The boundary that distinguishes the selected pixels from the deselected ones, better represented by a mask.

J. This command converts the contents of an alpha channel—whether found in the active image or another open image with the same pixel dimensions—to a selection outline.

K. This blend mode compares a pixel on the active layer with one on the layer below and delivers black if the two pixels are the same.

L. Located at the bottom of the Channels palette, this option saves a selection outline as a mask inside a new alpha channel.

Answers

1D, 2H, 3B, 4I, 5E, 6L, 7C, 8J, 9F, 10K, 11A, 12G

SELECTION ESSENTIALS

DEPENDING ON your experience level, you might reckon—just from reading the title of this lesson—that the next 50-odd pages are going to be a waste of your time. After all, anyone with the mettle to take on the topic of channels and masks knows how to work with selections. I mean, heck, you know multichannel!

So let me assure you, if I thought for a moment that this lesson was somehow optional, I would have struck it from the book.

But it's here, and here's why: Photoshop's selection functions are your tools of first and last resort when making masks. You can use a selection tool to rough in a mask. You can use it to add or subtract elements that otherwise defy masking. You can even use it when working inside an alpha channel, essentially employing a mask to refine a mask.

And knowing how something as simple as, say, the magic wand tool works—how it *really* works—can go a long way toward helping you make sense of the more sophisticated luminance-analysis functions that go to the heart of masking. Understanding the low-level, ever-present stuff is an essential first step toward understanding the high-level, arcane stuff. Or put more simply, before you can work without thinking, you need to take a moment to think about how you work.

Which is why we're going to spend this lesson scrutinizing the common selection outline as closely as if it were an insect under a magnifying glass (Figure 3-1). I start simply enough, but over the course of this lesson, we'll visit topics that most users comprehend poorly, incorrectly, or not at all. And if that sounds like meager motivation, trust me, you'll be glad you did it when you are done.

Figure 3-1.

69

ABOUT THIS LESSON

This lesson examines the specific behaviors of Photoshop's three automated selection tools—magic wand, quick selection, and magnetic lasso—and shows you how to best exploit each. Along the way, you'll learn how to:

- Select common and adjacent luminance levels . . . page 72

- Compensate for the quick selection tool's habit of selecting too much page 85

- Identify edges on a granular level using the magnetic lasso page 90

- Finesse a selection outline with Refine Edge. page 93

- Add and subtract selection outlines made with different tools page 104

- Transform and intersect selection outlines to make them exactly fit image elements. page 113

Project Files

Before beginning the exercises, make sure you've copied the lesson files from the DVD, as directed in Step 3 on page xv of the Preface. This should result in a folder called *Lesson Files-PsCM 1on1* on your desktop. We'll be working with the files inside the *Lesson 03* subfolder.

Video Lesson 3: Selections, Floaters, and Layers

People often mistake simple tools for simplistic results. But in the hands of a capable and informed artist, Photoshop's relatively mundane selection tools can produce out-of-this-world results.

To prove my point, I walk you through the creation of a fast but furious composition, created using nothing more than three images, a couple of color adjustments, and the two marquee tools, rectangular and elliptical. To see it for yourself, watch the third video lesson. Insert the DVD, double-click the file *PsCM Videos.html*, and click **Lesson 3: Selections, Floaters, and Layers** under the **Channels, Masks, and Selections** heading. This 12-minute, 4-second movie touches on the following shortcuts:

Operation	Windows shortcut	Macintosh shortcut
Move a marquee while drawing it	spacebar	spacebar
Nudge an outline in 1-pixel increments	↑, ←, ↓, →	↑, ←, ↓, →
Fade a floating selection with the image below	Ctrl+Shift+F	⌘-Shift-F
Nudge selected pixels in 1-pixel increments	Ctrl+↑, ←, ↓, →	⌘-↑, ←, ↓, →

The Automated Selection Tools

We'll be spending most of our time in this lesson looking at Photoshop's three automated selection tools: the old-school magic wand, the new-school quick selection tool, and the often-maligned but useful magnetic lasso, all pictured large and in charge in Figure 3-2. Not a single one of them is what I would call outstanding, but each can come in handy when roughing in or refining a mask.

The automated selection tools are often portrayed as functionally equivalent, or worse, gradually improving in quality based on their age, with the wand being the oldest and worst and the quick selection tool the newest and therefore the best. This simply isn't true. They are three very different tools that serve different purposes:

- The magic wand tool selects color ranges according to a Tolerance value that is measured in luminance levels. (More on this shortly.) It's best suited to selecting areas of homogeneous color that lack much in the way of texture, the classic example being a cloud-free sky. It can also be coerced into selecting areas of moderate tonal variation, as you'll see in the first exercise.

- The quick selection tool is the most automated tool of the bunch, meaning that it does what it does without troubling you with the details (good?) or permitting you control over what's going on (bad). But what little it does, it does well: It seeks out *edges*—areas of rapid contrast that distinguish one element of a photo from another—and expands a selection outline to fill in those edges. I find it most useful for selecting areas of subtle contrast that may go unnoticed by other masking techniques.

- The magnetic lasso tool looks for an edge within a narrow proximity to your cursor as you move the cursor around an image element. It can be a puzzling little tool and its options are both mystifying and of little practical use. (Quick selection tool, I take it all back!) Using the tool to define a selection from scratch is generally an exercise in frustration. But it's great for reinstating corners and otherwise augmenting selections.

All of the selection tools are elevated by one of the most powerful automation functions in Photoshop, the Refine Edge command, which let's you modify a selection outline and witness your changes in real time. You can expand or contract the size of a selection, smooth ragged edges, blur or harden a selection outline, and even spread a selection into the naturally occurring details in an image. If you haven't seen this command in action, prepare yourself for a welcome surprise.

Magic wand

Quick selection

Magnetic lasso

Figure 3-2.

Making the Most of the Magic Wand

The magic wand was one of those groundbreaking features that made Photoshop an overnight success when it was introduced in 1990. Just click in an image to select a continuous range of color. (I fondly remember my audience's guaranteed delight when I would intone the words, "'Scuse me while I click the sky.") But unlike Levels, Unsharp Mask, alpha channels, and other mind-blowing Version 1.0 features, the magic wand hasn't aged as well. It's widely regarded as underpowered, incapable of producing decent results, or just plain disappointing.

The wand's bad reputation is not undeserved—the tool invariably results in choppy outlines—but it *is* overstated. If you need to turn around a project quickly or you don't have the bandwidth for an alpha channel "deep dive," the wand can be just what the doctor ordered. As I explain in the sidebar "The Magic Behind the Wand" (page 74), it offers more control than most folks realize. And I use it all the time for selecting just one color—say, white—independently of everything else, which can be quite useful when cleaning up masks.

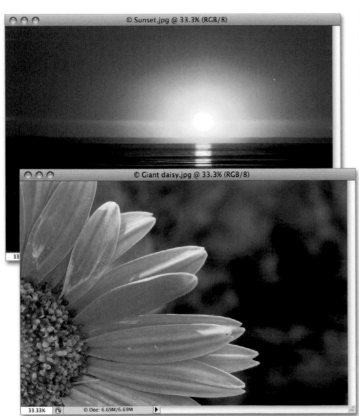

Figure 3-3.

In this exercise, we'll use the wand to select a foreground image and place that image against a different background. And unlike the bad carpenter who blames his tools, we'll use the creaky old wand to achieve impeccable results.

1. *Open a couple of images.* Open both *Giant daisy.jpg* and *Sunset.jpg*, located in the *Lesson 03* folder inside *Lesson Files-PsCM 1on1*. On display in Figure 3-3, both images come to us from James Pauls of iStockphoto. Our task will be to isolate the daisy and composite it against the sunset.

2. *Select the magic wand tool.* Click and hold the quick selection tool (fourth one down in the toolbox) and choose the magic wand tool from the flyout menu, as in Figure 3-4 on the facing page. Or press the W key twice in a row.

3. *Reset all tools to their defaults.* The magic wand tool relies on its own options bar settings, as well as one eyedropper tool setting. So that we will achieve the same results, it's important that we start things off with the

factory defaults. Right-click (or Control-click) on the magic wand icon on the far left side of the options bar to bring up a small pop-up menu. Then choose **Reset All Tools**. When asked to confirm, click **OK**. Now all tools—magic wand, eyedropper, and the rest—will behave just as they did when you first started Photoshop.

When selecting something with the wand tool, start by asking yourself, which is easier to select: the thing or its background? In our case, the flower comprises shades of yellow with green toward the center and lots and lots of detail throughout. The background is green with a wide range of luminance levels, dark to light. Of the two, the background will be easier to select.

4. *Click in the background.* Click anywhere in the background to select a range of colors similar to the one you clicked. Regardless of where you click, you're going to select some of the background but leave most of it behind. To add to the selection, press the Shift key and click again. That selects some more pixels, but by no means all of the background. In fact, as things stand now, it might take you 20 or more Shift-clicks to select everything, and that's just dumb. We need to adjust some settings.

5. *Raise the Tolerance value.* On the left side of the options bar, the Tolerance value decides how many colors are selected at a time, as measured in luminance levels. By default, the wand selects 32 levels lighter and 32 levels darker than the clicked color, for a total of 65 levels (32 + 32 + 1 for the clicked color) per channel. Press the Enter or Return key to highlight the **Tolerance** value; change it to twice its default setting, a full 64 levels; and press Enter or Return to apply your change.

6. *Shift-click again.* Note that there is no immediate change to the selection outline. That's because Tolerance and the other magic wand settings are *static*, meaning that they affect the next selection, not the existing one. So Shift-click in the background to add still more pixels to the selection. But alas, the selection still falls short of the entire background. What to do?

Figure 3-4.

Shift-clicking is a surefire way to add pixels to a selection, but it's tedious. Raising the Tolerance value gets you there faster, but it's easy to push the value too far and bleed over into the foreground. Fortunately, another option samples more colors at a time beyond the single clicked point, but it isn't available to the wand. It's the eyedropper tool's Sample Size.

The Magic Behind the Wand

In its capacity as the grand old man of automated selection tools, the magic wand has received a fair amount of abuse over the years. I mean, it's hard not to be let down by a tool with the word *magic* in its title, especially when the tool isn't the least bit magical. Which may explain why some folks have taken to calling it the tragic wand. (People can be so mean.)

However, once you come to terms with how it works, what it can actually accomplish, and what to expect from it, the wand becomes not just a useful tool but also an important first step toward learning how to mask. This tool generates selections based on luminance levels, which is one of the many ways to see an image as a mask.

So let's take a look at how the magic wand and its small top hat of options work:

Start by opening the file *Gradient demo.psd*, located in the *Lesson 03* folder inside *Lesson Files-PsCM 1on1*. This simple image features two orange gradients divided by a solid blue bar, which as you'll see makes it a perfect test bed for our exploration of the magic wand tool.

If it's not selected already, get the magic wand from the toolbox or press the W key. In the options bar, restore the default Tolerance value of 32. Then click at the middle of the top portion of the gradient to select a range of adjacent colors, as in the figure below. Photoshop selects 32 luminance levels darker and 32 levels lighter than the clicked color, which were this a grayscale image would encompass about one quarter of the gradient. (From black to white, there are 256 levels in all.) The selection is smaller in our colorful gradient because it's calculated on a channel-by-channel basis (see below).

Press Ctrl+D (⌘-D) to deselect the image. Raise the **Tolerance** value to 100. Click where you clicked before and notice that you get a larger selection, this time encompassing 100 luminance levels darker and lighter than the clicked point. Now here's where even the experts get confused. Many texts describe the wand as selecting a total amount of levels *equal to* the Tolerance value. And if you look at the orange gradient below, it could be confused for 100 luminance levels in all. But that's not how the tool works. Rather, the wand calculates independent selections for the Red, Green, and Blue channels (also below) and then creates a composite selection where the three intersect.

We'll skip the next item in the options bar, Anti-alias (which I discuss in the next sidebar, "How Antialiasing Works," page 80) and turn our attention to the item after that, Contiguous, which selects adjacent or nonadjacent pixels. With the check box turned on, the magic wand limits itself to the oranges on just one side of the blue bar. But watch this: Press Ctrl+D (or ⌘-D) to deselect the image. Turn off the **Contiguous** check box. And then click again in that same spot. As shown below, the selection outline jumps the gap and includes areas both above and below the bar. So when you want to select just neighboring pixels, turn on Contiguous. To select *all* pixels that fall within the Tolerance range, regardless of where they fall in the image, turn off Contiguous.

Now for the last check box, Sample All Layers, which causes the wand to see one layer or all layers at a time. Press Ctrl+D (⌘-D) to eliminate the last selection. Then go to the **Layers** palette and wake up the 👁s for the **Thing 1**, **Thing 2**, and **Thing 3** layers to make them visible. These incrementally larger, translucent blue bars interact with the gradient to create a new composite view. Nonetheless, if you click again in the middle of the top gradient, you get the same selection outline you had a moment ago. This is because the Background layer is active, and by default, only that layer is evaluated by the magic wand tool.

But press Ctrl+D (⌘-D), turn on **Sample All Layers**, and click in an exposed area of the orange gradient. This time, the selection includes only those portions of the gradient that are not covered by blue bars, as seen below.

Finally, let's look at the wand's hidden option. Press Ctrl+D (⌘-D) and click the 👁s for the **Thing 1**, **Thing 2**, and **Thing 3** layers to hide them. Press the I key to select the eyedropper tool and note the Point Sample option in the options bar, which controls the number of colors sampled by eyedropper, wand, and a few others. Choose **101 by 101 Average** from the **Sample Size** pop-up. Then return to the magic wand, click in the middle of the top gradient—but close to the blue bar this time—and you'll get a huge selection that includes the bar, as below.

7. *Configure the eyedropper tool settings.* Select the eyedropper tool by clicking its icon in the toolbox (sixth down) or pressing the I key. Then change the **Sample Size** setting from Point Sample, which lifts the color of the single pixel on which you click, to **101 by 101 Average** (see Figure 3-5), which looks at a 101 by 101 block of pixels—more than 10,000 pixels in all—centered on the clicked point. Strange as it may seem, the wand tool sees this setting, treats those 10,000 pixels as one big color sample, and expands the selection from there.

Figure 3-5.

This setting is sticky on the PC. To "unstick" it so you can take advantage of keyboard shortcuts, press the Esc key. (Mac users, don't worry about it—it's a Microsoft thing that frankly drives me nuts.)

8. *Reselect the background with the wand.* Press the W key to return to the magic wand tool. And then do the following:

 • For the sake of demonstration—so you can see the profound contribution made by the eyedropper setting—let's start the selection over from scratch. Press Ctrl+D (⌘-D on the Mac) to deselect the image.

 • Click at the location indicated by my colorful, hand-drawn wand cursor in Figure 3-6. Photoshop looks at the 101-by-101-pixel block, calculates the 129 luminance levels (64 + 64 + 1) surrounding those colors in each channel, and selects the entire background, as illustrated below.

Figure 3-6.

9. *Restore the default eyedropper behavior.* You aren't going to want to leave the eyedropper's sample size messed up like that—as it is, you can no longer use the eyedropper to discover the color of a single pixel—and lest you forget, there's no time like the present to reset the option. So press the I key to get the eyedropper tool. And change the **Sample Size** option back to **Point Sample**. Once again, this is a static setting, so it has no effect on the active selection outline (nor would we want it to).

10. *Reverse the selection.* We've selected the entire background; good for us. But we actually want to select the foreground. So reverse the selection by choosing **Select→Inverse** or pressing Ctrl+Shift+I (⌘-Shift-I). Now the flower is selected and the background is not.

11. *Create an alpha channel.* In the introduction to this exercise (page 72), I mentioned how the wand invariably produces choppy outlines. Now I'm going to show you what I mean. But first, some background.

PEARL OF WISDOM

The wand tool is not a nuanced tool. Either it selects colors or it doesn't. If you're a luminance level and you fall inside the Tolerance range, you're in; if not, you're out. So left to its own devices, the magic wand would always produce jagged, stair-stepped selection outlines. To prevent this, Photoshop applies what it calls *antialiasing*, which smooths the edges slightly. The specific variety of antialiasing applied to magic wand selections doesn't work that well, and so the edges look pretty rough. For the complete lowdown on antialiasing, see the sidebar "How Antialiasing Works," on page 80. To see what it looks like, read on.

To see the choppy outline, we need to make an alpha channel. Go to the **Channels** palette and Alt-click (or Option-click) the ▣ icon to save the selection as an alpha channel. In the **New Layer** dialog box, type the channel name "Flower" and click **OK**.

12. *Inspect the new alpha channel.* Click the **Flower** channel or press Ctrl+6 (⌘-6) to make it active. Then press Ctrl+H (⌘-H on the Mac) to hide the selection outline. Zoom in on a detail in the channel. Figure 3-7 shows the edges of the flower in a wide view on the left with a particularly ratty detail at 1600 percent on the right.

In addition to the white (selected) and black (deselected) pixels, we have a thin line of gray pixels along the perimeters of the petals. These gray pixels were created by the antialiasing.

The gray pixels help smooth out the contours slightly, but their effect is of limited benefit for two reasons:

- First, the grays weren't organically harvested from the image. Rather, they were factored in after the selection was complete. (I'll demonstrate what I mean by *organic harvesting* when we look at the Refine Edge and Color Range commands in later exercises.) So magic wand outlines are no better than those produced by, say, the lasso tool.

- Second, when things go wrong, they tend to go badly indeed. In my case, the wand didn't quite select all the way into the corner that appears magnified in Figure 3-7. In its attempt to antialias this badly selected area, Photoshop has gone and made the problem worse.

So what's the take away? Are we to throw up our hands and swear off the magic wand tool, never to touch it again? No. In fact, this selection is in pretty good shape overall. But it's always good to know the weaknesses in your selection outline before you put it to use.

Figure 3-7.

13. *Return to the full-color image.* Okay, so enough alpha channel analysis already, let's get back to work. Click the composite **RGB** thumbnail in the **Channels** palette or press Ctrl+2 (⌘-2) to return to the full-color image. Then press Ctrl+H (⌘-H) to show the selection outline.

14. *Select the move tool.* Click the move tool icon at the top of the toolbox, as in Figure 3-8. Or press the V key (as in mooV). The move tool lets you move selected pixels within an image or from one image to another.

15. *Make sure you can see both images.* If you're working with floating image windows, resize them so you can see at least part of the sunset image in back of the big daisy. If you're working with tabbed image windows, go to the application bar (below the menu bar on the Mac and to the right of the bar on the PC), click the ▣▾ icon (which reads *Arrange documents* when you hover your cursor over it), and choose the 2-up icon, ▣.

16. *Drag the flower into the sunset.* This operation is a little tricky, so read the next paragraph before you begin.

 Position your cursor inside the daisy so that the cursor appears as an arrowhead with a little pair of scissors. Then drag the flower from the *Giant daisy.jpg* image into the *Sunset.jpg* image. Before you release the mouse button, press and hold the Shift key. Finally, release the mouse button and then release the Shift key.

 If you haven't already, go ahead and perform the step. What you just did was a drag followed by a Shift-drop. By pressing Shift when you dropped the flower, you told Photoshop to register the daisy inside its new background. By *register*, I mean that the flower occupies the same horizontal and vertical location in its new home as it did in its old one, as it does in Figure 3-9.

17. *Rename the new layer.* When you drag a selection and drop it into another image—whether you press Shift or not—Photoshop assigns the dropped selection to a new layer and dispenses with the selection outline. Go to the **Layers** palette. Then double-click the name, **Layer 1**, type "Flower," and press Enter or Return to apply the change.

Figure 3-8.

Figure 3-9.

How Antialiasing Works

Antialiasing is one of the key topics that goes to the very heart of the way Photoshop works. It smooths out what would otherwise be jagged edges by rendering partial pixels as translucent ones. (By *partial pixels*, I mean pixels that would be sliced into pieces if such a thing were possible.) Of the selection tools, only two do not offer an Anti-alias (Adobe's spelling) check box: the rectangular marquee tool, which always selects whole pixels, and the quick selection tool, which uses a variety of antialiasing but does not let you turn it off.

But antialiasing doesn't end there. When printed or rasterized (converted to pixels), type and vector shapes are antialiased. All of the retouching tools—from the healing brush to the dodge and burn tools to the history brush—paint antialiased brushstrokes. *The* difference between the brush tool and the pencil tool is that the brush tool employs antialiasing and the pencil does not.

Let's start by examining the term *antialiasing*, and then I'll show you how it works. Photoshop's eternal dilemma is that it's limited to square pixels arranged in perfect rows and columns, and the real world is not. So how do you render something as simple as a diagonal line with a bunch of Lego-like squares?

Look at the graphic below. It contains just six colors, three blues, a brown, and black and white. All shapes are rendered to the best effect possible using those colors.

A world without antialiasing

Next we see three magnified details from the previous graphic. The circular edge of the cloud exhibits lumps. The serifs on the letters range from one pixel thick to three. The perspective checkerboard dissolves into curve patterns along the outer edges of the horizon. These *rendering artifacts*—by which I mean, pixel patterns coughed up by Photoshop's internal calculations that do not contribute to our understanding of the image—are known as *aliasing*. The job of antialiasing is to make those artifacts go away.

orld without

To understand how antialiasing permits square pixels to represent diagonal lines, curves, and other organic forms, consider the circle. At the top of the facing page, we see the red outline of a perfect circle. Behind it, the circle rendered exclusively in opaque pixels. Photoshop wants to slice the pixels into pieces, but a pixel must always be square so it can't.

Enter antialiasing, which gives Photoshop the option of exchanging partial pixels for translucent ones. If a pixel falls completely inside the path of the circle, then it's opaque. If it falls completely outside the path, it's transparent. If a pixel gets sliced by the path, its opacity is determined by the degree to which it falls inside the

This sort of antialiasing works anytime Photoshop has a geometric pixel-independent object to work from, whether it be a circle, a straight-sided polygon, an elliptical brush, a free-form path, a vector-based shape, or characters of type. The odd man out is the magic wand. The wand isn't drawing a shape; it just selects pixels. So how does it work? When you turn on the Anti-alias check box, the magic wand expands the selection (it always expands) the width of a single-pixel line. The opacity of the pixels in that line are determined by the proximity of their luminance levels to the clicked color. It's sophisticated stuff, but it's a crapshoot—sometimes it works pretty well, other times not at all.

It's tempting to see antialiasing as softening or even blurring. But softening is a separate operation that you can apply using Select→Modify→Feather (among others). The image below shows the result of applying 3 pixels of feathering to the circle.

circle. Halfway in, halfway out? 50 percent opaque. One quarter in, three quarters out? The pixel is 25 percent opaque. And so on. The angle at which the path slices the pixel doesn't matter, as witnessed below.

Antialiasing and softening both play important roles in the creation of accurate, natural-looking selections, as we'll explore in the exercises in this lesson.

18. *Add a Color Overlay effect.* While the perimeter of the flower looks pretty good in some places and exceptionally good in others, the composition in general doesn't come off as particularly credible. The flower is too bright and too yellow. We can improve the flower's appearance by adding a few layer effects, starting with Color Overlay:

- Click the *fx* icon at the bottom of the **Layers** palette and choose **Color Overlay** from the pop-up menu.

- In the **Layer Style** dialog box, click the color swatch to the right of the Blend Mode option to bring up the **Select Overlay Color** dialog box.

- Move your cursor out of the dialog box to get the eyedropper. Click in the band of orange in the sunset background about halfway between the sun and the right edge of the photograph to select an indigenous color for our effect. The **H**, **S**, and **B** values should be somewhere in the neighborhood of 30 degrees, 65 percent, and 90 percent, respectively. Click **OK** to close the Select Overlay Color dialog box.

- Back in the **Layer Style** dialog box, change the **Blend Mode** to **Color** so the effect alters only the color of the flower, not the luminance levels.

- Set the **Opacity** value to 60 percent to blend the orange with the natural flower colors.

Your settings and your flower should look like the ones in Figure 3-10. But don't click **OK** yet. We've more work to do.

Figure 3-10.

19. *Add a Gradient Overlay effect.* The color of the flower better matches the sunset image, but the lighting doesn't look right, so we'll add some shading using a Gradient Overlay effect:

- Click **Gradient Overlay** in the **Styles** list on the left side of the Layer Style dialog box. An opaque gradient immediately appears behind the Color Overlay orange, completely obscuring the daisy.

- Set the **Angle** value to 55 degrees so the gradient flows from the center of the flower in the bottom-left corner of the image up and to the right toward the sun.

- Change the **Blend Mode** option to **Multiply** so the gradient uniformly darkens the daisy.

- Reduce the **Opacity** value to 70 percent.

- Move your cursor out of the dialog box and drag inside the image to manually position the gradient effect. I recommend that you move the gradient down and to the left, as demonstrated in Figure 3-11.

Figure 3-11.

20. *Add an Outer Glow effect.* We have a little color fringing around the perimeter of the flower petals. We could try to fix that with an Inner Glow effect, but that would trace along the straight bottom and left edges of the daisy, which would ruin the composition. So we'll try out an Outer Glow effect instead:

- Click **Outer Glow** in the **Styles** list on the left side of the Layer Style dialog box.

Figure 3-12.

- Click the pale yellow color swatch to bring up the **Color Picker** dialog box.

- Set the **H** value to 30 degrees for orange. Mute the color by lowering the **S** value to 10 percent, then make it very dark with a **B** value of 25 percent. Then click **OK** to close the Color Picker dialog box.

- Back in the **Layer Style** dialog box, change the **Blend Mode** option to **Overlay** to create thin outlines around the petals.

- Decrease the **Opacity** value to 50 percent to make the effect more subtle.

- Raise the **Size** value to 100 pixels to transform the glow into a diffused edge effect.

When your settings look like the ones in Figure 3-12, click **OK** to close the Layer Style dialog box and apply the effects. The result is a much improved composition, as witnessed in Figure 3-13. I'm not buying that this flower was photographed against this background, but I am buying that this is an expertly rendered image pulled off with some of Photoshop's simplest compositing features. We're finished with the image, so feel free to save it as a layered PSD file if you desire.

Figure 3-13.

Using the Quick Selection Tool

Just as clicking with the magic wand tool selects entire areas as if by magic, dragging with the quick selection tool selects entire areas quickly. Or so it might seem on first blush. But just as you eventually learned that the magic wand tool is in fact not the least bit magical, you will come to realize that there's nothing quick about the quick selection tool. Your first drag rarely results in the selection you're looking for. And most selections require several minutes of dragging, whether to add areas that you missed or subtract areas that you don't want to include.

A better name for the quick selection tool would be the "edge brush." You paint inside an image and it outlines the nearest edges it can find. In this exercise we'll take the quick selection tool for a spin and see how its edge-detection abilities fare.

1. *Open an image.* Open *Tentacle.tif*, located in the *Lesson 03* folder inside *Lesson Files-PsCM 1on1*. Pictured in Figure 3-14, this octopus arm—tentacles are for squids, but why change a perfectly good filename just because it's wrong?—comes to us from Kelly Cline of iStockphoto.

2. *Select the quick selection tool.* Both foreground and background are rife with colors and luminance levels, making the quick selection tool a better choice than, say, the magic wand. Assuming you worked through the previous exercise, click and hold the magic wand icon in the toolbox and choose the quick selection tool, as in Figure 3-15. Or press the W key (or Shift+W if you skipped the Preface) to switch between the tools.

Figure 3-14.

Figure 3-15.

3. *Increase the brush size.* Earlier I lamented that you have very little control over the performance of the quick selection tool. One of the few settings you can change is the brush size. A larger brush allows you to select larger areas at a time, a smaller brush let's you get into the nooks and crannies of an image element. Which means you typically start big and work your way down. Go to the options bar and click the ▾ to the right of **Brush** to display a pop-up palette and raise the **Diameter** value to 100 pixels.

Another way to change the brush size is to press the square bracket keys, just to the right of the P key on an American keyboard. Press the ⌊[⌋ key to reduce the brush or the ⌊]⌋ key to enlarge it. If you decide to use this technique, press ⌊]⌋ until the Brush setting in the options bar shows a diameter of 100 pixels.

4. *Paint an initial selection.* We'll get things started with a basic selection, so drag clockwise from the topmost suction cup to the rightmost one, as illustrated in Figure 3-16. The tool automatically generates a selection as you paint. If your selection outline varies a little from mine, don't fret. Just avoid painting into the lettuce. (If you do hit the lettuce, press Ctrl+Z or ⌘-Z and try again.)

Drag from here... ...to here

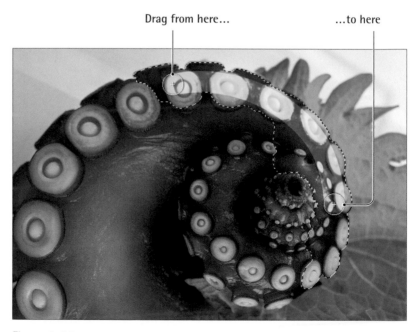

Figure 3-16.

5. *Add to the selection.* In its quest to be that one tool in Photoshop that's actually easy to use, the quick selection tool automatically switches to the add mode (as indicated by the little brush with a plus sign, 🖌⁺, on the left side of the options bar), its wise assumption being that you would now like to add to your selection. Paint over the area highlighted in Figure 3-17 to expand the selection to include the coiled portion of the arm.

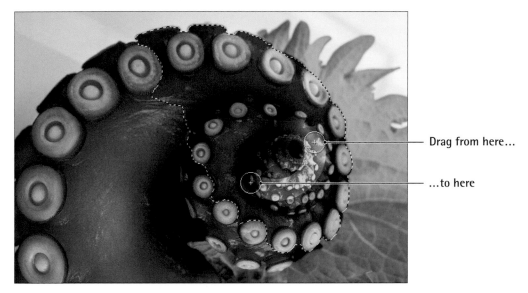

Drag from here...

...to here

Figure 3-17.

6. *Reduce the brush size.* Now to add some of the smaller, less clearly defined areas of the octopus. In anticipation, press the ⊡ key a few times to reduce the brush size to 50 pixels.

7. *Paint in the blurry suctions.* Click once or twice inside each of the out-of-focus suction cups along the bottom of the arm, both labeled in Figure 3-18. For now, don't worry about that small area of green between the suction cups. It ends up getting selected no matter how carefully you paint.

8. *Select the rest of the arm.* We still have an awful lot of octopus to select, and here's where things go haywire: You can paint as carefully as you like in the curled area of the arm, but the second you hit the pink meaty flesh of the animal's biceps (the left area), everything goes kaflooey.

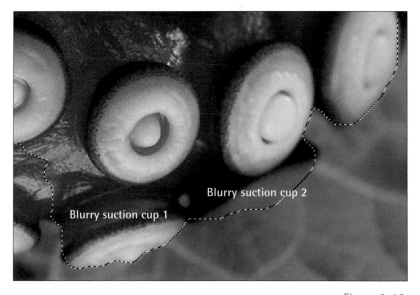

Blurry suction cup 2

Blurry suction cup 1

Figure 3-18.

Case in point: Paint a short line in the pink arm flesh on the left, as illustrated in Figure 3-19. That small brushstroke over an area that's far away from what you and I would call the edges of the arm expands the selection so that it gobbles up not only every visible bit of octopus but also a couple of tiny gaps along the left side of the image and a large area of the lettuce between the two main sections of the arm. All hope that the quick selection tool might live up to its name drifts out to sea.

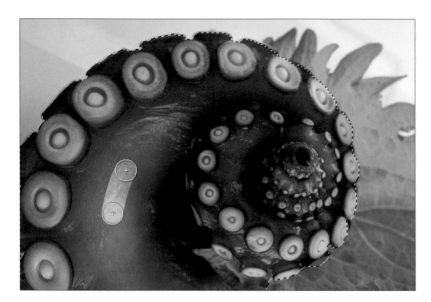

Figure 3-19.

9. *Clean up the selection.* Fortunately, all is not lost. What the quick selection tool gives, it can just as easily take away. Here's how to paint away the bad stuff:

- Click the ⟨icon⟩ icon on the left side of the options bar to tell Photoshop to subtract your next brushstrokes from the existing selection.

- Press the ⟨[⟩ key several times to reduce the brush size to a mere 10 pixels.

- Zoom in on that tiny sliver of background in the bottom-left area of the image.

- Paint inside the pale green fragment. The quick selection tool deselects it.

- Scroll over to the region of lettuce between the two flanks of octopus. Paint all the areas that you want to subtract from the selection. I recommend small, careful brushstrokes. Feel free to further reduce the brush size if need be.

- If you inadvertently deselect two or three suction cups—as you most assuredly will—click the ⟨icon⟩ icon in the options bar to switch back to the add mode, and paint over them.

- Finally, switch back to the ⟨icon⟩ icon and click once in that tiny wedge of green between the blurry suction cups from Figure 3-18 on the previous page spread.

Your final selection outline should look something like the one in Figure 3-20. See? How quick was that?

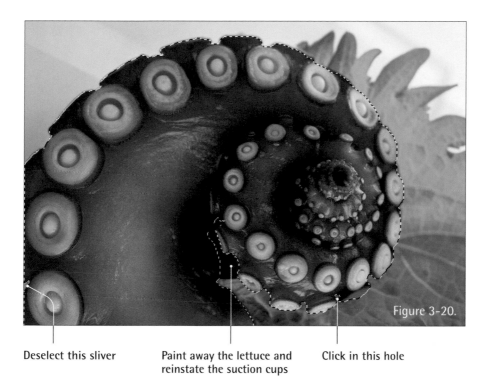

Deselect this sliver Paint away the lettuce and Click in this hole
 reinstate the suction cups

Figure 3-20.

10. *Save the selection.* We'll need this selection later. Switch over to the **Channels** palette. Then press the Alt (or Option) key and click the ⟨icon⟩ icon at the bottom of the palette to bring up the **New Channel** dialog box. Name the channel "QS" for quick selection and click **OK** to make that alpha channel.

11. *Save the file.* The alpha channel isn't permanently saved until you save the image, so choose **File→Save** or press Ctrl+S (⌘-S) to update the file on disk. (Given that we didn't make any changes to the image, and this is a TIFF file, there's no harm in saving over the original.) We'll use the saved selection in a future exercise, in which we put our octopus arm into a fanciful underwater composition.

Using the Magnetic Lasso

Two automated selection tools down, one to go. And this final one, the magnetic lasso tool, is simultaneously the most powerful and most bewildering one in the bunch. But once you come to terms with it, and learn how to make it behave, you may find that it's just the ticket for picking up stray pieces that other masking techniques leave behind.

Like the quick selection tool, the magnetic lasso tool works by detecting edges in an image. But unlike the quick selection tool, which has an annoying habit of finding edges hundreds of pixels away from where you're painting—recall Step 8, top of page 88?—the magnetic lasso keeps it local, by default looking no further than 10 pixels from your cursor. In return, the magnetic lasso requires a keen eye, constant attention, and a bit of patience.

Figure 3-21.

1. *Open an image.* Because the magnetic lasso is the *yang* to the quick selection tool's *yin*—a harder, more aggressive breed of edge-detection technology (Figure 3-21)— we're going to use it to select that same octopus arm that I featured in the last exercise. If you still have it open, press Ctrl+D (or ⌘-D) to deselect the image and you're ready to go. Otherwise, open the image called *A second attempt.tif*, located in the *Lesson 03* folder inside *Lesson Files-PsCM 1on1*.

2. *Select the magnetic lasso tool.* Click and hold the lasso tool in the toolbox and select the magnetic lasso tool from the flyout menu, as in Figure 3-22. Or press the L key (or Shift+L) until the toolbox shows the triangular lasso with the magnet.

3. *Set the basic options.* Turn your attention to the second group of settings in the options bar—Width, Contrast, and Frequency— all of which control how the magnetic lasso tool sees the edges in your image. These options work as follows:

 • You use the magnetic lasso tool by moving your cursor near an edge in the image. The Width value determines how far, in pixels, you can stray from the edge without the lasso losing track of it. Lower values require you to be more careful, but also help you correctly identify edges in tight areas. For now, leave the **Width** set to its default value, 10 pixels, as in Figure 3-23.

Figure 3-22. Figure 3-23.

- The Contrast setting determines how much contrast needs to exist between two neighboring pixels for them to constitute an edge. The default of 10 percent results in too much sensitivity for the purposes of this image (and most others, in my experience), so raise the **Contrast** value to 20 percent.

- The Frequency setting determines how often the magnetic lasso tool lays down the anchor points that define the key points in the selection outline. A high value causes a more precise but potentially jagged selection outline, while a low value means a less precise but smoother outline. We want more precision, so raise the **Frequency** value to 70.

4. *Trace around the octopus arm.* We're now ready to select the octopus with the magnetic lasso tool:

- Click at the point where the top of the arm meets the far left side of the image, labeled *First click here* in Figure 3-24.

- Move your cursor clockwise along the top edge of the arm, taking care not to stray more than 10 pixels from the border between the green background and pink cephalopod. Note that there's no need to *drag* your cursor, just *move* it. By which I mean, don't press the mouse button. Just take the cursor on a stroll.

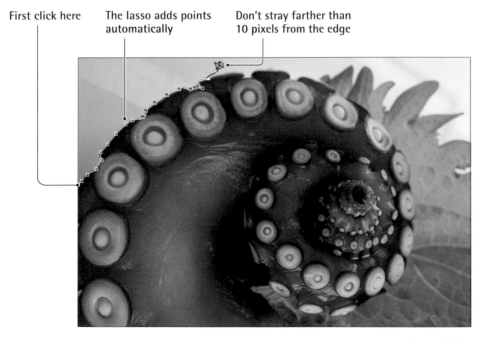

First click here The lasso adds points automatically Don't stray farther than 10 pixels from the edge

Figure 3-24.

- As you trace around the arm, the magnetic lasso automatically lays down square points. To add your own point—to lock down an important corner, for example—click in the image.

If you move the cursor too far away from the edge, the magnetic lasso may place points in undesirable locations. To fix the problem, move the cursor back to the edge just slightly forward of the last correctly placed anchor point. Then press Backspace (or Delete) one or more times to get rid of the unwanted anchor points. (Each keystroke deletes the last anchor point, one point at a time.)

- Continue tracing the edge of the arms, around the area where it spirals, then back down the right side of the big fleshy biceps, until you reach the point where the animal goes outside the canvas at the bottom of the image window. Hold there and await further instructions.

If at any time you need to zoom in or scroll the image, you can take advantage of the standard keyboard tricks. Zoom in by pressing Ctrl+⊞ (or ⌘-⊞). Zoom out by pressing Ctrl+⊟ (or ⌘-⊟). To scroll the image, press the spacebar and drag.

FURTHER INVESTIGATION

If you're having difficulty getting the magnetic lasso to behave—don't worry, you're not the only person to be frustrated by it—you may find it helpful to see the magnetic lasso in action on this very octopus. Go to *www.lynda.com/dekeps* and start up your 7-Day Free Trial Account (as introduced on page xxv of the Preface). Then check out my series *Photoshop CS3 Channels & Masks: The Essentials*, scroll down to Chapter 4, "The Automated Selection Tools," and click the movie called "Using the magnetic lasso tool" (the fifth link from the end of the chapter).

5. *Reduce the Width value.* If you attempt to trace beyond the edge of the canvas, where the base of the arm meets the end of the image, you'll find that the magnetic lasso places anchor points at odd intervals well into the octopus. Fortunately, you can address this problem by minimizing the Width value in the options bar, which you can adjust from the keyboard by pressing the square bracket keys. In this case, press the ⊡ key as many times as it takes to get the **Width** value down to 1 pixel.

6. *Trace beyond the canvas boundaries.* With the Width value set to its minimum, move your cursor out into the gray pasteboard beyond the bottom and left sides of the image. (If you can't get to the pasteboard, move your cursor along the bottom and left edges of the image window.) The magnetic lasso still adds the occasional point a few pixels into the octopus, but the tracing not nearly as bad as it would have otherwise been.

7. *Trace the tiny slivers.* When you reach the tiny sliver of green on the extreme left side of the image, click your way into it to add anchor points manually, as I've done in the circled area in Figure 3-25. You can similarly attempt to click in the itsy-bitsy wedge higher up if you like. Then continue to trace until you return to your starting point.

Figure 3-25.

8. *Complete the selection.* When you've reached the starting point, the cursor changes to include a little O, indicating that a click at this point will bring you full circle and complete the selection. Go ahead and click. You should see a selection outline like the one in Figure 3-26.

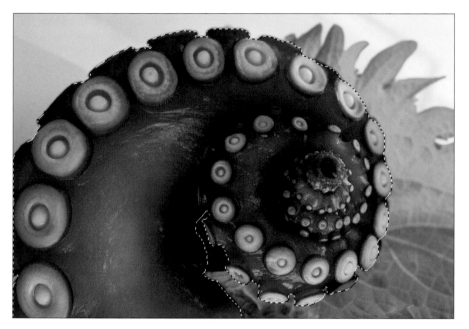

Figure 3-26.

9. *Save the selection.* We'll continue working with this selection in the next exercise, so convert it to an alpha channel by going to the **Channels** palette and Alt-click (or Option-click) the ☑ icon at the bottom of the palette. Enter the name "ML" for magnetic lasso and click **OK** to store the selection.

10. *Deselect the selection.* We're done with the selection outline for the time being, so press Ctrl+D (⌘-D) to deselect the image.

11. *Save the file.* Press Ctrl+S (⌘-S) or choose **File→Save** to update the file on disk. You can now choose from two selections, which will come in handy when we add the mollusk to a lively layered composition in the next exercise.

Refining a Selection Outline

We now have two saved selections, both of which represent the outline of the octopus arm, each with its own problems: The quick selection mask is at once vague and choppy, the magnetic lasso mask is overly geometric with unnaturally sharp corners. Both have done a passable job of distinguishing the cephalopod from its background, but both need refinement.

And that's just what they'll get from the Refine Edge command. One of Photoshop's foremost selection assets, the Refine Edge command turns reasonably good selection outlines into very good ones. (For great selections, you need to move into masking, as we'll begin to do in the next lesson.) Just five numerical options—all of which offer a real-time preview so you can see what you're doing from one adjustment to the next—can cure what ails the automated selection.

In this exercise, you'll get to try out those options for yourself. We'll use Refine Edge to enhance the work of both the quick selection and magnetic lasso tools. And we'll deposit the octopus into an aquatic composition.

1. *Open an image.* If you still have the original *Tentacle.tif* file open with all your work intact, stick with that file. Otherwise, open the image *Both selections.tif*, located in the *Lesson 03* folder inside *Lesson Files-PsCM 1on1*.

2. *Review the alpha channels.* Before we can fix our problems, we need to know what they are. So let's review the alpha channels we created in the previous exercises:

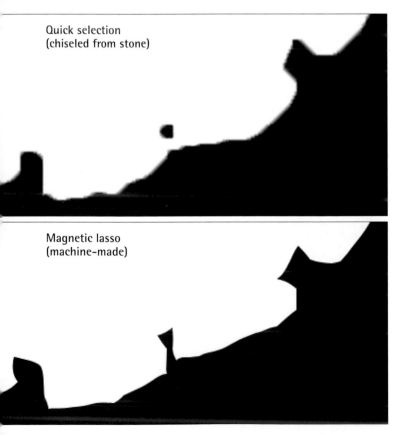

Quick selection
(chiseled from stone)

Magnetic lasso
(machine-made)

Figure 3-27.

- Click the first alpha channel in the **Channels** palette, **QS**, or press Ctrl+6 (⌘-6) to view the mask created with the quick selection tool. Pictured at the top of Figure 3-27, the selection is vague, with indistinct transitions between one suction cup and the next. Plus, the choppy edges contain clusters of gray blocks that make the magic wand's antialiasing look silky smooth. It's like a mask chiseled from soft, crumbly stone.

- Next press Ctrl+7 (⌘-7) or click the **ML** channel, which brings up the magnetic lasso mask (second in the figure). It's razor sharp, with brilliantly rendered antialiasing. But it's all straight or slightly curving edges meeting to form corners, like it was cut by a robot wielding an X-acto knife. There's nothing vague about it, but it's not necessarily more accurate. The edges in the mask vary by as many as four pixels from the edges in our image. And while I'm no marine biologist, last time I checked, octopus arms don't have corners. The mask looks like the work of a machine.

3. *Load a selection.* Of the two, I'd say the ML channel exhibits the most problems. So let's use it as our Refine Edge test case. (Besides, Refine Edge is set by default to correct quick selection outlines, so we have less knowledge to gain from working with the QS mask.) Press the Ctrl (or ⌘) key and click the **ML** thumbnail in the Channels palette to load it as a selection outline.

4. *Return to the full-color image.* Click the **RGB** item in the Channels palette or press Ctrl+2 (⌘-2) to view the full-color image.

5. *Clean up the bottom of the selection.* The base of the selection outline—where it meets the bottom of the canvas—is a mess. But we can easily fix it with the standard lasso tool:

 • Select the lasso tool from the magnetic lasso flyout menu in the toolbox. Or press the L key (or Shift+L).

 • In the options bar, click the second icon, , to add to the existing selection outline.

 • Give yourself some extra gray pasteboard around the image, either by switching to the tabbed window mode (if you loaded my dekcKeys shortcuts back in Step 7 on page xvi of the Preface, you can press Ctrl+Shift+A or ⌘-Shift-A) or pressing F to view the image in the full-screen mode. Then scroll beyond the bottom-left corner of the image.

 • Drag around the bottom-left corner of the octopus arm, well into the pasteboard, as demonstrated by the yellow line in Figure 3-28. Photoshop adds the lassoed area to the mix, thereby cleaning up the selection outline.

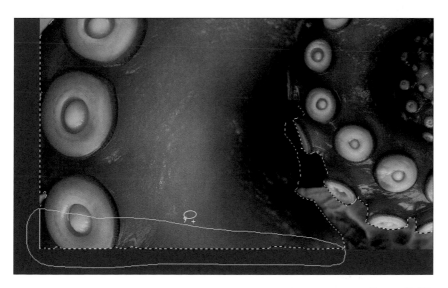

Figure 3-28.

6. **Click the Refine Edge button.** All right, now we're ready to refine. Click the **Refine Edge** button in the options bar. Alternatively, you can choose **Select→Refine Edge** or press Ctrl+Alt+R (⌘-Option-R). However you do it, you'll get the **Refine Edge** dialog box, which lets you edit the selection outline using a series of slider bars and preview the results as you work.

7. **Preview the selection against a white background.** Make sure the **Preview** check box is on so you can see what in the world you're doing. These are some tricky options so you'll want to stay apprised.

Refine Edge offers five ways to preview your adjustments, all represented by the row of "Möbius tube" () icons near the bottom of the dialog box. Click a button (or press the F key) to change the appearance of your selection in the image window. Because the octopus is dark, we'll get the best sense for what our selection needs by previewing it against a white background. So click the -on-white icon as you see me doing in Figure 3-29. The formerly green background goes solid white.

Figure 3-29.

8. **Adjust the slider bar settings.** Our goal is to soften the selection outline to match the naturally out-of-focus suction cups that surround the octopus arm. In the interest of achieving that goal, I'll tell you how each of the five slider bars work and how

I recommend you set them. (You can also find info about an option by hovering your cursor over it and reading the Description item at the bottom of the dialog box.) My suggested values, and the accompanying preview, appear in Figure 4-30.

- The Radius value applies an intelligent blur that spreads the selection according to the luminance levels inherent in an image. Areas of similar brightness blur more easily than areas of high contrast. The upshot is an effect known as *fuzziness* that softens contours and respects details. (Remember that term; we'll visit it again when we discuss the Color Range command in Lesson 4.) To match the natural fuzziness of the octopus, raise the **Radius** value to 10.0 pixels.

- After better molding the selection outline to the image, you can sharpen the outline by raising the Contrast value. If you wanted a nice clean, antialiased selection, you'd raise the value to somewhere in the neighborhood of 25 to 50 percent. But we want blurry edges, so leave **Contrast** set to its default, 0 percent.

Figure 3-30.

- The Smooth option smooths jagged edges in a selection. It's great for removing the effects of noise, film grain, and dust. But it also rounds off corners. Our selection includes lots of corners, some of which are good and some of which are

bad. But Smooth tosses them all out with the bath water. To keep the good corners and suffer the bad, reduce the **Smooth** value to 0.

- Feather applies a uniform blur that's substantially less discriminating than Radius. Usually, I'm not a big fan of this option, but the perimeter of this image is so blurry, it warrants Feather's attention. Increase the **Feather** value to 4.0 pixels, which has the added benefit off dropping out some of the green *color fringing* around the edges.

- A negative Contract/Expand value contracts the selection outline inward, or *chokes* it. A positive value moves the selection outward, or *spreads* it. It's tempting to reduce this value to lose some more of that green fringing, but we'd also lose precious suction cup detail in the process. Best to leave the outline right where it is with a **Contract/Expand** value of 0 percent.

At this point, I usually go ahead and click the -on-black icon (or press Shift+F) to see what the image looks like against solid black, just to make sure I'm comfortable with the selection outline. Ours is showing some light fringing around the top suction cups (see Figure 3-31), but those won't show up in our final composition, so I'm unconcerned.

Figure 3-31.

Assuming all else is okay, as it is, click the **OK** button to apply your changes, whereupon Photoshop returns you to the standard marching-ants-style selection mode.

9. *Open a destination image.* Let's test our refined selection by adding it to a layered composition. Open *Ad comp.psd*, located in the *Lesson 03* folder inside *Lesson Files-PsCM 1on1*. Brought to us by photographer and imaging artist Andrzej Burak of iStockphoto, this bubbly work of fiction (Figure 3-32) will serve as the perfect environment for our dead but yummy looking octopus.

Figure 3-32.

10. *Make sure you can see both images.* Resize your floating windows so you can see at least part of both the octopus and mermaid images. If you're working in the tabbed-window display, click the ▣▾ icon in the application bar and choose the 2-up icon, ▤, to see one image atop the other.

11. *Drag the octopus into its new home.* Click the title bar or tab for *Tentacle.tif* to bring the octopus to the front. Then make it join the mermaid as follows:

- Select the move tool in the toolbox or press the V key.

- Drag the selection and drop it into the *Ad comp.psd* image window. The octopus covers up just about everything in the mermaid image. Not to worry, it's all part of the plan.

- Switch to the **Layers** palette and note Photoshop's automatic addition of a new layer. Double-click the words **Layer 1**, replace them with "Tentacle," and press Enter or Return. Don't worry that it's not really a tentacle. That's part of the plan, too.

- Tap the 5 key to reduce the **Opacity** value in the Layers palette to 50 percent. This permits you to see through the Tentacle layer to the hungry yellow fish below.

- With the move tool still active, drag the octopus so that the larger of the two yellow fish appears to be nibbling at one of the smaller suction cups, as in Figure 3-33.

- Press the 0 (zero) key to restore the **Opacity** value to 100 percent, so the octopus once again covers up the fish.

Figure 3-33.

12. ***Correct the green color cast around the tentacle.*** The octopus looks utterly ridiculous against this background. The focus is way off. Plus, we have some green color fringing from the old lettuce background. Let us remove this fringing as follows:

- Click the *fx* icon at the bottom of the Layers palette and choose **Color Overlay** from the pop-up menu.

- In the **Layer Style** dialog box, reduce the **Opacity** value to 0 percent so we can see the colors in the octopus.

- Click the red color swatch to bring up the **Select Overlay Color** dialog box.

- Move your cursor into the image window and click in a crimson area of the arm just above the bottom row of large suction cups, as indicated by the eyedropper cursor in Figure 3-34.

- Click **OK** to close the Select Overlay Color dialog box.

- Back in the **Layer Style** dialog box, restore the **Opacity** value to 100 percent, coating the octopus in a crimson tide.

- Set the **Blend Mode** option to **Hue**. Photoshop restores the original saturation and luminance information from the Tentacle layer and mixes it with a uniform crimson hue.

- Click **OK** to create the no-fringe octopus, as in Figure 3-35.

Figure 3-34.

Despite the homogeneous colors, the octopus still looks wrong in his new environment. The problem is the impossible depth of field, with the high-focus forward suction cups giving way to a low-focus perimeter, then suddenly resetting to high-focus fish and mermaid in the background. That's just not possible with real-world optics. Which is why we're going to take the larger of the two yellow fish and move it in front of the octopus, where it can feast to its heart's content. If you don't happen to care for feasting fish, you can skip ahead to the next exercise, "Selection Calculations," which starts on page 104. As for the rest of you, stick with me as we learn how to combine the quick selection tool, magnetic lasso, and Refine Edge command to save our watery composition.

Figure 3-35.

13. *Reveal the Background layer.* To select the fish, we have to be able to see it. Click the 👁 icon for the **Tentacle** layer in the **Layers** palette to hide it. Then click the **Background** layer to make it active.

14. *Zoom in on the fish.* Zoom in tight on the bigger fish so that you can focus on it to the exclusion of all else, as in Figure 3-36.

15. *Select the quick selection tool.* The fish contains lots of luminance variation, and eventually fades to blue in its hindquarters. So we'll need to go at this with a couple of tools. Start by selecting the quick selection tool in the toolbox, or by pressing the W key. And increase the brush size to 30 pixels.

16. *Click in the fish.* A single click inside the fish selects its entire body. The selection is far from perfect, missing many of the fine details including the lips, tail, and rear fins (see Figure 3-37), but progress is progress.

Figure 3-36.

Figure 3-37.

Figure 3-38.

Figure 3-39.

17. *Select the magnetic lasso tool.* We'd spend the rest of our lives trying to select those little details with the quick selection tool. But details are exactly what the magnetic lasso excels at. Click and hold on the lasso tool in the toolbox and select the magnetic lasso from the flyout menu, or press the L key (or Shift+L) a few times in a row.

18. *Select (and deselect) the details.* Here's how to get the little fish bits that evaded detection by the quick selection tool:

 • In the options bar, click the second icon, 🖿, to add to the existing selection outline.

 • Click to set a point above the top lip. Then move the cursor and click your way around the lip, eventually working your way back into the fish face, as shown in the top example of Figure 3-38. Double-click to complete the selection.

 • Repeat the process for the bottom lip, as shown in the bottom example of the figure. If you end up selecting a bit of blue water, don't worry about it. We'll fix that with the Refine Edge command.

 • Go back to the options bar and click the third icon, 🖿, to subtract from the selection outline.

 • Scroll to the bottom of the fish and click your way around the area of blue trapped between the bottom and the lowest fin, as you see me doing in Figure 3-39.

If you're really enjoying the magnetic lasso tool, you can try your hand at the rear fins. But we don't need to select them because only the front part of the fish is hidden by the octopus. (As you'll learn over and over throughout this book, one of the ways to get great masking results is to avoid masking as much as possible. ☺)

19. *Refine the selection outline.* The remainder of our work can be done with the Refine Edge sliders. Click the **Refine Edge** button in the options bar to bring up the **Refine Edge** dialog box. Then do like so:

 • Click the 🐾-on-black icon at the bottom of the dialog box to see the fish against a black background.

 • Start by zeroing out all the values (which should involve setting just **Radius** and **Feather** to 0; the other values should already be there). The selection should look nice and tight around the fish.

- Raise the **Radius** value to 3 pixels to give the edges some natural softness. Then sharpen things by raising the **Contrast** value to 10 percent.

- Leave the **Smooth** and **Feather** values set to 0. And choke the selection by reducing the **Contract/Expand** value to –20 percent. The ends of the lips may turn a little bit black, but that's okay. The selection's going to work out nicely.

When your settings match those in Figure 3-40, click **OK** to close the Refine Edge dialog box and accept your changes.

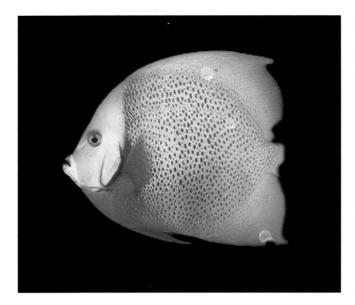

Figure 3-40.

20. *Copy the fish to a new layer.* Selection complete, time to composite. Press Ctrl+Alt+J (⌘-Option-J) to bring up the **New Layer** dialog box, name the layer "Fish," and click **OK**.

21. *Drag the Fish layer up the stack.* We need the **Fish** layer to appear in front of the octopus, so drag it above the **Tentacle** layer in the **Layers** palette.

22. *Turn on the Tentacle layer.* To see the fish nibble at the octopus, click in front of the **Tentacle** layer to wake up the 👁 icon and show that octopus.

23. *Choose the Background layer.* The composition still doesn't look quite right. The culprit is the smaller fish. It's in the background, behind the octopus, so it needs to be blurred. Here's how to make that happen:

- Click the **Background** layer to make it active.

Figure 3-41.

- We'll be applying a modest amount of blur, so a very general selection will work fine. Select the standard lasso tool from the magnetic lasso flyout menu. Or press the L key (or Shift+L).

- Draw a rough selection outline like the one in Figure 3-41. It's perfectly okay if the selection goes into the octopus because that animal exists on a different layer. Just make sure not to select any of the woman's hair.

- Choose **Filter→Blur→Lens Blur** to bring up the **Lens Blur** dialog box. (It's not a fast command, so it may take a moment or two to load on screen.)

- If you've ever used this filter before, you'll need to restore the default settings by pressing the Alt (or Option) key and clicking the **Reset** button, just below OK.

- In the **Iris** area, midway down the list, set the **Radius** value to 8 pixels. Leave all other values set to their defaults. Then click **OK** to apply the blur.

- The fish is now appropriately soft. Press Ctrl+D (⌘-D) to deselect the image.

24. *Finish off the composition.* Go to the **Layers** palette and notice the layer group at the top of the stack. Click in the empty square in front of the **Text & Bar** folder to fire up the 👁 and turn on the group. The final calamari ad appears in Figure 3-42 at the top of the facing page.

Yes, *I* know it's an octopus and *you* know it's an octopus. But seriously, if a consumer will believe this composition, they'll believe anything. For all they know, the mermaid is calamari! As am I, as am you, as am we.

Selection Calculations

It's tempting to dismiss a selection outline as a means to an end, a way of isolating an area or moving an image element from one location to another. But selection outlines are full-fledged objects that can be moved, scaled, rotated, and otherwise modified independently of the image.

These last two exercises give you a sense of what I mean. We'll start by examining ways to combine selections using *calculations*, which are basic arithmetic operations. You can add outlines, subtract them, or toss out everything except where they overlap. (For the full story, read the sidebar "Add, Subtract, and Intersect" on page 108.)

A Message from The Consolidated Calamari Consortium

Figure 3-42.

If these calculations sound hideously theoretical, this exercise demonstrates that they're as practical as grade school. In the following steps, you'll use calculations to select and modify the contents of a tempting cafeteria tray. Even better, we'll be combining the strengths of several different selection tools, thereby demonstrating that it takes many tools to make up a balanced meal.

1. *Open an image.* Open the image *Lunch tray.jpg*, located in the *Lesson 03* folder inside *Lesson Files-PsCM 1on1*. Although bereft of octopus, squid, or cuttlefish (see Figure 3-43), this is another image from food photographer Kelly Cline. So much to select in this image, so little time.

2. *Select the French fries.* I regard myself as something of a French fry connoisseur, and as such, it is my professional opinion that those French fries look horrible. Too much fluffy, downy-soft,

Figure 3-43.

throat-clogging tuber pulp on the inside without nearly enough yummy, salty, super crunchy fried potato on the outside. Those things look like they taste like a box. Let's fry them up:

- Select the magic wand tool from the quick selection tool flyout menu in the toolbox. Or press the W key a couple of times.

- Press the Enter or Return key to highlight the **Tolerance** value and change it to 80 levels.

- Click the French fry at the center of the pile.

- Depending on which pixel you clicked, you may have selected all the fries. If you missed anything, it's probably the bottom fry at the back of the stack. To add it, don't bother with the ⬚ icon in the options bar. Instead, press the Shift key and click the fry. In Photoshop, the Shift key always adds to a selection. You should end up with a selection like the one in Figure 3-44.

Click here —————————

Shift-click here —————————

Figure 3-44.

- Your selection now includes not only fries but also parts of the tray. To correct this, we'll need to subtract from the selection. Again, no need to select the ⬚ icon in the options bar. Instead, Alt-click (or on the Mac, Option-click) in some selected portion of the tray to deselect it. Just as Shift always adds, Alt (or Option) always subtracts.

- That subtracts too much. So press Ctrl+Z (or ⌘-Z) to undo the subtraction. Lower the **Tolerance** value to 30 levels. And then Alt-click (or Option-click) in the tray again.

- This time, you shouldn't deselect any of the fries, but you'll also deselect less of the tray per click. Which means you're going to have to put in a lot of clicks to get the job done. So keep Alt-clicking (Option-clicking) every bit of selection that looks like lunch tray, including the tiny areas between the fries. You should expect to Alt-click (Option-click) between 12 and 20 times in all, until you achieve the selection shown in Figure 3-45.

3. *Refine the selection outline.* Click the **Refine Edge** button in the options bar to bring up the **Refine Edge** dialog box. The default values will work great in this case, so simply click the **Default** button, as you see me doing in Figure 3-46, and then click **OK** to apply the adjustment.

In previewing the selection from the Refine Edge dialog box, you may notice problems with your selection. If you do, click the Cancel button, fix the problems with the magic wand tool, and repeat Step 3.

4. *Copy the selection to a new layer.* We're going to apply a color adjustment to the fries. But before we do, let's go ahead and relegate them to an independent layer. Press Ctrl+Alt+J (⌘-Option-J), name the new layer "Fries," and click **OK**.

 Alt-click (Option-click) all over... ...including in between fries

Figure 3-45.

5. *Apply a Levels adjustment.* I want to toast the fries and spice them up a little, and we'll do that using the Levels command. And rather than walking you through the exact Levels settings—this isn't a color correction title, after all—we will load some settings I created for you in advance:

- Choose **Image**→**Adjustments**→**Levels** or press Ctrl+L (⌘-L) to bring up the **Levels** dialog box.

- Click the 🔀 icon to the right of the **Preset** pop-up menu and choose the **Load Preset** command.

- In the **Load** dialog box, navigate to the *Lesson 03* folder inside *Lesson Files-PsCM 1on1* and choose *Yummy fries.alv.*

- Click the **Load** button to apply the preset in the **Levels** dialog box.

Figure 3-46.

Photoshop offers four *selection modes*: new, add, subtract, and intersect. If these sound somehow obscure or optional, let me assure you of two things: 1) Once upon a time, I thought the same thing, and 2) that opinion could not be further from the truth. These four modes are essential if you want to achieve credible selection outlines in Photoshop.

When any selection tool but the quick selection tool is active (as I'll explain, the QS tool is a slightly special case), the four selection modes are made available as icons on the left side of the options bar. That's great, but once you come to terms with these modes, you'll be using them on a regular basis. And speaking from experience, running to the options bar and clicking an icon every few seconds is a pain in the neck. Which is why Photoshop lets us access each mode from the keyboard.

Where the icons in the options bar are concerned, here's icon number one (enlarged on left). If you hover your cursor over it, it reads *New selection*. And it means just that: When you drag with one of the selection tools, you begin a new selection. Already have a selection in the works? Too bad. It goes away and a new one appears in its place. This is the default behavior for every tool except the quick selection tool.

By the way, when I say *drag*, I'm talking about every tool except the magic wand. When defining selections with the wand, you don't drag, you click. So if you see marching ants, drag inside them to move the selection outline, click outside the ants to abandon that selection and create a new one.

Here's icon number two. Let's imagine you have a selection outline in place. Click this icon in the options bar, drag (or click in the case of the magic wand) with a selection tool, and you'll add to that selection. Better yet,

ignore the icons and press the Shift key. When Shift is down, you can drag or click with a tool to add to the existing selection. This is how we work throughout the "Selection Calculations" exercise. (Only the quick selection tool varies: It's automatically set to add to an existing selection, so there's no need to press Shift.)

Icon number three subtracts. Click it and drag (or click) to subtract the outline you're drawing from the existing selection in the image window. Again, this function is served better by a simple keyboard trick: Press Alt (or Option on the Mac) and drag to subtract from a selection. When using the magic wand, press Alt (or Option) and click. So remember: the Shift key adds, the Alt (or Option) key subtracts. It's that simple.

Click the final icon in the options bar to find the intersection of two selection outlines. In other words, drag with the active selection tool and keep just the portion of the existing selection that falls inside the area within your drag. To get this feature from the keyboard, press both the Shift and Alt keys (Shift and Option on the Mac) and drag with a selection tool.

Two caveats: First, when using the magic wand, press Shift and Alt (or Shift and Option) and click (don't drag) to find the intersection.

Second, there is no intersection option when using the quick selection tool. No icon in the options bar, no keyboard trick. But if you think about it, predicting how that would even work would be extremely difficult.

Shift adds. Alt (or Option) subtracts. Shift and Alt (Shift and Option) finds the intersection. And that logic permeates selections made with channels, layers, and paths, as we'll see in later lessons.

When the fries turn hot and tasty, as they so plainly have in Figure 3-47, click **OK** to apply the Levels adjustment.

Figure 3-47.

6. *Add a drop shadow.* To further enhance our new Cajun fries, we'll add a drop shadow effect. (I know, it doesn't seem like something a bunch of French fries need, but it is.)

- Click the *fx* icon at the bottom of the **Layers** palette and choose **Drop Shadow** from the pop-up menu.

- In the **Layer Style** dialog box, reduce the **Opacity** value to 70 percent.

- Set the **Angle** value to 170 degrees to match the shadows cast by the other objects on the lunch tray.

- Leave the **Distance** set to 5 pixels and raise the **Size** value to 15 pixels.

Click **OK** to apply the effect, which looks like Figure 3-48. See, those fries needed that shadow—helps make the edges look more natural as well.

Figure 3-48.

7. *Switch to the Background layer.* Now to turn our attention to the milk carton. Scroll up and to the right. The milk carton resides on the Background layer, so click the **Background** layer in the **Layers** palette to make it active.

8. *Select the milk carton.* Now let's see how to network different selection tools. The milk carton is made up of straight edges, so we'll start off with another variety of lasso called the polygonal

lasso. It's actually a separate tool available from the lasso tool flyout menu, but I want you to get in the habit of accessing the tool from the keyboard. Here's how:

- Select the standard lasso tool from the flyout menu or press the L key (or Shift+L) a couple of times.

- Press and hold the Alt (or Option) key.

- Click a corner of the milk carton. Notice that the cursor grows little horns, indicating you're now equipped with the polygonal lasso. Keep the Alt (or Option) key down. Then click the next corner and the next. So long as the key stays down, Photoshop connects each corner with a straight segment.

Figure 3-49.

- Continue pressing Alt (or Option) and clicking corners until you've gone all the way around to your starting point.

- Once you arrive back at your starting point, release the Alt (or Option) key to close the selection, as shown in Figure 3-49.

9. *Deselect the letters.* In a few steps, we'll invert the colors in the milk carton. But I don't want you to change the letters that spell *Milk* so we need to deselect them:

 - Select the magic wand tool from the toolbox or press the W key (or Shift+W) a couple of times.

 - Press the Alt (or Option) key and click inside each of the letters spelling *Milk* on both sides of the carton. Note that you'll need to click twice on the letter *K* to deselect both portions of it.

 After ten Alt-clicks (Option-clicks), the selection outline will look like the one in Figure 3-50.

10. *Refine the selection outline.* Click the **Refine Edge** button in the options bar to display the **Refine Edge** dialog box, complete with the default settings you applied in Step 3. Click the **OK** button to apply those settings.

Figure 3-50.

11. *Copy the selection to a new layer.* As usual, it's a good idea to send the selection to an independent layer before working on it. So press Ctrl+Alt+J (⌘-Option-J), name the new layer "Milk," and click **OK**.

12. *Choose the Invert command.* Now to invert the colors. Choose **Image→Adjustments→Invert** or press the shortcut Ctrl+I (⌘-I). Photoshop inverts everything about the layer—luminance and colors—as shown in Figure 3-51.

Figure 3-51.

13. *Change the blend mode.* To constrain the effect to only the color values, change the blend mode in the top-left corner of the **Layers** palette to **Color**. The much improved effect appears in Figure 3-52.

14. *Switch to the Background layer.* Scroll to the left to take in our next victim, the lettuce, which I'd like to turn into cabbage. Once again we need to work on the Background layer, so click **Background** in the Layers palette.

Figure 3-52.

You can switch between layers from the keyboard by pressing Alt (or Option) with a square bracket key. ⬚ moves down the stack, ⬚ moves up the stack. So to switch from the Milk layer to the Background layer, press Alt+⬚ (or Option-⬚).

15. *Select the lettuce.* Let's start this outline with the quick selection tool. Select the quick selection tool from the magic wand tool flyout menu, or press the W key (or Shift+W) a couple of times. Then paint over the lettuce and tomato to create the selection outline pictured in Figure 3-53. Notice that the outline includes portions of the tray outside the lettuce because it reads those areas as being the most significant edges.

16. *Clean up the selection.* The solution is to deselect the tray using that other edge selection tool, the magnetic lasso:

• Select the magnetic lasso tool from the lasso tool flyout menu, or press the L key (or Shift+L) a few times.

Figure 3-53.

Figure 3-54.

Figure 3-55.

- Move your cursor to the approximate location shown at the top of Figure 3-54, up and to the right of the tomato.

- Press the Alt (or Option key) to get the little minus sign next to the cursor and click at this location. You've now told Photoshop to enter the subtract mode. Feel free to release Alt (or Option); its job is done.

- Move the cursor along the edge of the lettuce, clicking to set anchor points at key corners. The bottom example in Figure 3-54 shows the anchor points I used.

- Repeat this process for each area that needs to be subtracted from the selection. You can see me in the process of deselecting a couple of those area in Figure 3-55.

17. *Deselect the tomato.* To turn the lettuce into cabbage, it needs to go from green to violet. But we don't want to change the color of the tomato. So press the W key to switch back to the quick selection tool. Then Alt-drag (or Option-drag) across the tomato. Photoshop deselects it in a flash—finally, this tool does something quickly!

18. *Copy the selection to a new layer.* You know the drill. Press Ctrl+Alt+J (⌘-Option-J), enter "Cabbage" for the **Name**, and click the **OK** button.

19. *Apply a Hue/Saturation adjustment.* Now to make the lettuce violet. Choose **Image**→**Adjustments**→**Hue/Saturation** or press Ctrl+U (⌘-U) to bring up the **Hue/Saturation** dialog box. Change the **Hue** value to –120 degrees to rotate the greens into hot purple territory. Then reduce the **Saturation** value to –60 percent, which settles the colors to a dull cabbage violet, as in Figure 3-56. Click **OK** to apply the change.

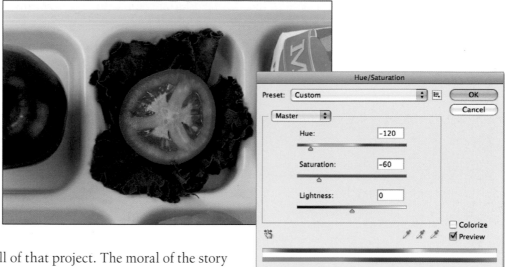

Figure 3-56.

I hope you've had your fill of that project. The moral of the story is this: A selection outline is never done, nor do you ever have to start over from scratch if something goes wrong. You always have the ability to modify the outline by adding to it or subtracting from it, and you can mix and match tools as much as you want. The only selection calculation I didn't demonstrate was intersecting, and that's because I saved it for the next exercise.

Transforming and Warping Selections

Our final exercise is all about the independence of selection outlines from the image that houses them. In addition modifying and refining selection in the many ways we've seen so far, you can move a selection outline to a different location, even to a different image. Plus, you can *transform* an outline—by which I mean scale, rotate, slant, distort, or warp it—without having any effect whatsoever on the pixels in the image.

In the upcoming steps, We'll draw an elliptical marquee and then match it—*exactly* match it—to the contours of an egg. Next we'll paste a face into that egg and make it look like face and egg are as one. It's a silly project, but don't think for a second that these are silly techniques. They are deadly practical, as you're about to learn.

1. *Open two images.* Open *The egg.psd* and *Crazy man.jpg*, located in the *Lesson 03* folder inside *Lesson Files-PsCM 1on1*. Both shown in Figure 3-57, the egg comes to us from an iStockphoto photographer who goes by the handle YinYang, while the utterly captivating man is the work of Alexander Hafemann. Clearly, that man needs to be inside that egg.

Figure 3-57.

Figure 3-58.

2. *Make the egg image active.* We'll start the process by creating a selection for the egg. That way, we'll have something to paste the crazy man's face into. Click the title bar or tab for the egg image to bring it to the front.

3. *Select the elliptical marquee tool.* An egg is an oval form, so the elliptical marquee tool is an obvious place to start. Click and hold on the rectangular marquee tool near the top of the toolbox and choose the elliptical marquee from the flyout menu, as in Figure 3-58. Or press the M key a couple of times.

4. *Create an initial selection.* Drag in the image to create a selection that matches the egg as closely as possible, like the one in Figure 3-59.

As you may recall from Video Lesson 3, "Selections, Floaters, and Layers," you can press the spacebar while drawing with either of the marquee tools to move the selection as you create it, which is especially useful for aligning ellipses.

You won't get a perfect selection at this point—the egg is not a perfect ellipse— but that's okay. Pretty close is good enough for now.

Figure 3-59.

5. *Transform the selection.* Like so many eggs, this one is wider at the bottom than at the top. We therefore need to enlarge its hindquarters by transforming the selection outline:

- Choose **Select→Transform Selection** to modify the selection outline independently of the selected pixels. The selection is surrounded by a bounding box complete with eight square handles.

- Click the ℞ icon toward the right end of the options bar to enter the warp mode. Photoshop adds control handles and a grid to the bounding box, as in Figure 3-60.

Enter warp mode

Control handle

Figure 3-60.

- Try dragging a round control handle and notice how the handle tugs at the grid and bends the selection outline in the background.

- The handles are great, but it's often easier to tug directly on the selection outline. It'll take several drags—as well as a bit of back and forth, given that tugging one portion of the selection outline messes up another area—but eventually you'll arrive at a match, like the one shown in Figure 3-61.

- Click the ✔ on the right side of the options bar or press the Enter or Return key to apply the transformation to the selection.

Figure 3-61.

6. *Switch to the crazy man image.* We're ready to copy the man into the egg image, so click the title bar or tab for the *Crazy man.jpg* image to bring it to front.

7. *Copy the image.* Every Paste needs a Copy. So before you paste the man into the egg, you need to copy him. Choose **Select→All** or press Ctrl+A (⌘-A) to select the image. Choose **Edit→Copy** or press Ctrl+C (⌘-C).

8. *Return to the egg image.* Click the title bar or tab for *The egg.psd* to switch to that image. Or press Ctrl+Tab (or ⌘-`) to switch windows from the keyboard.

9. *Paste the man into the egg selection.* To insert the crazy man into the active selection outline, choose **Edit→Paste Into** or press the shortcut Ctrl+Shift+V (⌘-Shift-V). The man appears exclusively inside the egg, as in Figure 3-62.

Figure 3-62.

10. *Rename the man layer.* As always, Photoshop pastes the image onto a new layer. To help us stay organized, go to the **Layers** palette and double-click the current layer name, **Layer 1**, in the Layers palette. Then type "Man" and press the Enter or Return key.

PEARL OF WISDOM

Notice that your new Man layer sports two thumbnails, one showing the fellow's lunatic grimace and the other showing a white egg shape against a black background. This second thumbnail is the layer mask, which is what keeps the man inside the egg. Layer masks are so infinitely useful that I devote an entire lesson to them, Lesson 7, "Masking Layers." In the meantime, just know that your one-time selection outline has been preserved as a mask.

Figure 3-63.

11. *Move the man.* The man's face would look better centered in the egg, so let's move him. Select the move tool in the toolbox or press the V key. Then drag in the image to reposition the man so his face is frighteningly centered, as in Figure 3-63.

<div align="center">PEARL OF ⬤ WISDOM</div>

If you know anything about layer masks, you'll notice that the mask remains stationary as you move the face. This is thanks to the fact that when you choose the Paste Into command, Photoshop automatically generates a layer mask that is not linked to the layer. So you can move the crazy man as much as you want and his little egg-shaped containment cell will remain unmoved.

12. *Transform the man's face.* Our next task is to distort the man's face so he looks like he's wrapped around the egg rather than visible through an egg cutout:

- To edit the pixels in an image as opposed to the selection outline, choose **Edit→Free Transform** or press Ctrl+T (⌘-T). Welcome to the free transform mode, which allows you to do the following.

When working in free transform, drag one of the eight handles that surround the bounding box to resize the image. Press Shift to scale the image proportionally; press Alt (or Option) to scale the image with respect to its center. Move the cursor outside the bounding box and drag to rotate the image. Press Ctrl (or ⌘) and drag a handle to slant or distort the image. That's a lot to digest in one tip. But I just wanted you to know some of what's in store in the coming steps.

Figure 3-64.

- Press the Shift and Alt (Option) keys and drag a corner of the bounding box inward to scale the crazy man's face proportionately while keeping him centered in the egg. As you scale, keep an eye on the options bar. Reduce the size of the face until the **W** and **H** values read 78 percent.

- Click the ⌇ icon toward the right side of the options bar to enter the warp mode, where even more distortion options are available.

- Drag each of the four corner handles inward to bend his face so it better matches the shape of the egg, as in Figure 3-64.

- Drag directly on the man's face to move it outward. Specifically, drag the top of the visible portion of his face up, drag the man's chin downward out of the frame, and drag his left and right cheeks farther outward to the left and right, respectively. The result is a face that better fills the egg.

- Press Enter or Return to apply the transformation.

13. *Apply the Spherize filter.* The transformation helped, but this very reasonable man's crazy face still needs to bow out more to really look like it's wrapped around the egg. Thankfully, Photoshop offers a filter that does just that:

 - I assume the elliptical marquee is still selected. If not, press the M key to select it.

 - Drag a selection that encompasses a generous margin around the egg, as shown in Figure 3-65. This will give the filter plenty of room to work.

 - Choose **Filter→Distort→Spherize** to bring up the **Spherize** dialog box.

 - Click the minus button below the image preview a few times to reduce the zoom ratio to 20 percent so you can see the man's face in its scary entirety in the preview.

 - Reduce the **Amount** value to 50 percent, as in Figure 3-66.

 When your dialog box looks like mine, click **OK** to apply the effect. The image appears slightly more convex, as if we were admiring this guy on the back side of a spoon.

14. *Deselect the image.* We're finished with the selection outline, so press Ctrl+D (⌘-D) to deselect.

15. *Set the blend mode to Multiply.* We need the texture and shading of the egg to show through the man's face. To make this happen, go to the top-left corner of the **Layers** palette and change the blend mode setting from Normal to **Multiply**, which you can likewise get by pressing Shift+Alt+M (Shift-Option-M). The resulting effect appears in Figure 3-67.

Figure 3-65.

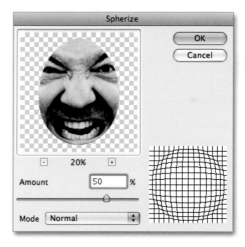

Figure 3-66.

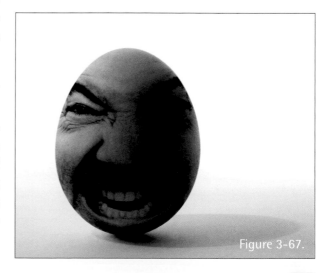

Figure 3-67.

16. *Add the Eggness layer.* It's not easy to make a guy look like he's trapped in an egg, which is why I've included a layer in this file that will help improve the effect. Time to add that layer to the mix. In the Layers palette, click in the 👁 column to the left of the **Eggness** layer to make it visible, and then drag that layer below the Man layer, as in Figure 3-68.

17. *Brighten the teeth.* This guy's getting awfully dark. But rather than brighten him overall, let's focus on a few details, namely the teeth and eyes. We'll start with the teeth:

Figure 3-68.

Figure 3-69.

Figure 3-70.

- Select the lasso tool or press the L key.

- Create a rough selection that includes all the teeth. You don't have to be precise; just drag around the mouth making sure to rope in all the teeth, as in Figure 3-69. You can even Alt-click (or Option-click) to create a polygonal outline if you like.

- Confirm that the Eggness layer is active. Then create a new layer by pressing Ctrl+Shift+N (⌘-Shift-N). Name the new layer "Highlights" and click **OK**.

- Fill the selected area of the **Highlights** layer with white. First press the D key to ensure the default colors, ⬛ at the bottom of the toolbox. Then press Ctrl+Backspace (or ⌘-Delete).

- Press Ctrl+D (⌘-D) to deselect the teeth.

- Press the 5 key to reduce the **Opacity** to 50 percent using the control at the top-right of the palette, producing the result shown in Figure 3-70. Don't worry that the edges look awful; we'll address that problem in a moment.

18. *Brighten the eyes.* Now to bring some of that lightness to the eyes. And this time, I'll be demonstrating that forgotten calculation from the "Add, Subtract, and Intersect" sidebar (remember page 108?), intersection:

- As you'll see more than once, the best tool for selecting eyes is the elliptical marquee. Select it from the toolbox or press the M key.

- Draw an outline that aligns with the top edge of the right eye (his left), without being concerned about where the rest of the outline falls, as indicated by the red-and-white outline in Figure 3-71.

- Press the Shift and Alt (or Shift and Option) keys and draw a selection aligned with the bottom edge of the eye, as indicated by the black-and-white outline in the figure. When you release the mouse button (and the keys), only the area where the two selections intersected remains selected.

- Still on the Highlight layer, press Ctrl+Backspace (⌘-Delete on the Mac) to fill the selected area with white. Then press Ctrl+D (⌘-D) to deselect the image.

- Repeat the process on the left eye (his right). You now have two bright beautiful eyes.

19. ***Soften the edges.*** The teeth and eyes are brighter, but we have some edge problems. Let's fix those using the eraser tool:

 - Select the eraser tool from the toolbox (see Figure 3-72), or press the E key.

 - Click the ▾ to the right of the word **Brush** in the options bar to bring up the pop-up palette. Then set the **Master Diameter** value to 70 pixels and the **Hardness** to 0 percent.

 - Paint just outside the top and bottom edges of the right eye (his left) without painting into it. The other eye is fine.

 - Paint along the top and bottom edges of the mouth to darken the gums.

 - Press the ⬚ key a few times to increase the brush size to 150 pixels and click in each of the corners of the mouth to darken the molars.

 The final effect appears in Figure 3-73. This dude *is* the egg.

...then draw
this outline

First select this
region...

Figure 3-71.

Eraser Tool (E)

Figure 3-72.

20. ***Draw a crack.*** To really sell the egg effect, and the fact that this man is insane, I want to add some cracks. Press the L key to switch back to the lasso. Next, press and hold the Alt (Option) key and, starting above the egg, click multiple times to create a lightning bolt shape, like the one in Figure 3-74.

21. ***Draw more cracks.*** Plainly, we need more cracks. But here's where things get tricky: Now that you have a selection, pressing Alt (or Option) takes you into the subtract mode. But we want to add cracks, so we really need the Shift key. You could switch to the dedicated polygonal lasso tool. (And by all means,

Figure 3-73.

Figure 3-74.

Figure 3-75.

Figure 3-76.

do just that if you'd prefer.) But if you're looking for a sweet but challenging trick, try the following:

- Press the Shift key and click and hold the mouse button. Now release Shift, but keep that mouse button down.

- Press and hold the Alt (or Option) key. Keep the key down as you release the mouse button, and then click, click, click to create more lightning bolt shapes.

My idea of some great cracks appear in Figure 3-75.

22. *Intersect the selection outline with the egg.* Of course, we need to keep the cracks inside the egg. To make that happen, go to the Layers palette, press Ctrl, Shift, and Alt (⌘, Shift, and Option on the Mac), and click the layer mask thumbnail to the right of the **Man** layer. Ctrl (or ⌘) converts the mask to a selection; Shift and Alt (Shift and Option) find the intersection of the cracks and the egg-shaped mask.

23. *Fill the cracks.* Assuming the Highlights layer is still active, press Ctrl+Backspace (⌘-Delete) to fill the selected cracks with white. Press Ctrl+D (⌘-D) to witness the effect in Figure 3-76.

24. *Turn on the text elements.* To finish off the composition, click in the 👁 column in front of the **Text elements** folder at the top of the Layers palette. The end product appears in Figure 3-77. I smell an Emmy.

The true story of a man trapped in an egg. Monday nights at 7:00 pm.

WHAT DID YOU LEARN?

Match the key concept in the numbered list below with the letter
of the phrase that best describes it. Answers appear upside-down
at the bottom of the page.

Key Concepts

1. Edges
2. Magic wand
3. Tolerance
4. Antialiasing
5. Quick selection
6. Magnetic lasso
7. Width
8. Refine Edge
9. The 🔗 icons
10. Selection calculations
11. Transform Selection
12. Warp

Descriptions

A. Identified by the � icon, this special transformation mode lets you distort an image by dragging control handles or even tugging directly on the selection outline.

B. After clicking a color, this tool selects all colors—either adjacent or throughout the image—that fall within a specified luminance range.

C. A value in the options bar that defines the maximum distance, in pixels, that the magnetic lasso tool will search for an edge; the value may be adjusted on-the-fly by pressing a square bracket key.

D. A setting in the options bar that defines the range of luminance levels, darker and lighter than the clicked pixel, that will be included in a magic wand selection.

E. These "Möbius tubes" allow you to change the way Photoshop previews a selection when working in the Refine Edge dialog box.

F. The yang to quick selection's yin, this tool identifies edges by laying down a stream of anchor points as you trace the edges with your cursor.

G. This command modifies a selection outline independently of the pixels inside the outline.

H. When painting with this tool, Photoshop automatically expands the selection outline to the most obvious edge, which may be hundreds of pixels from your brushstroke.

I. This command allows you to adjust the quality of a selection outline and preview the effects of your adjustments as you work.

J. Areas of rapid contrast that may help to distinguish one element of a photograph from another.

K. These arithmetic operations allow you to add, subtract, and intersect areas by pressing a combination of the Shift and Alt (or Option) keys.

L. A means of smoothing selection outlines that expresses partially selected pixels using varying degrees of translucency.

Answers

1J, 2B, 3D, 4L, 5H, 6F, 7C, 8I, 9E, 10K, 11G, 12A

COLOR RANGE AND QUICK MASK

THE BEST SELECTION tool in all of Photoshop isn't a tool at all; it's a command. Found in the Select menu, this much-needed upgrade to the magic wand goes by the name Color Range. It's dynamic; it recognizes gradual organic edges; and it serves as a fantastic introduction to the larger world of masking. In fact, to this day, I can select certain things with the Color Range command that would take way more effort using any other masking technique.

I'll also introduce you to the quick mask mode, which permits you to temporarily dip into a mask, get a sense of what your selection outline really looks like, make a few adjustments, and escape back to the warm embrace of the marching ants, without the additional steps of saving and loading the selection outline. The quick mask mode is particularly well suited to refining selections that you create with Color Range. In fact, the two features go hand in hand, which is why we'll move back and forth between them fairly liberally in this lesson.

Incidentally, I should note that there's nothing inherently quick about the quick mask mode. (That's two for two! Two features that include the word *quick* in their titles— quick selection tool, quick mask mode—and neither is quick. Remember that about Photoshop: *quick* and *magic* just aren't, as documented in Figure 4-1.) The quick mask mode is temporary, and it permits you to conveniently pop back and forth between marching ants and masking. But otherwise, it delivers all the complexity and power of full-blown masking. Which means it requires diligence, attention to detail, and a fair amount of manual labor from you. This is actually a very good thing, as you're about to see.

Figure 4-1.

ABOUT THIS LESSON

Project Files

Before beginning the exercises, make sure you've copied the lesson files from the DVD, as directed in Step 3 on page xv of the Preface. This should result in a folder called *Lesson Files-PsCM 1on1* on your desktop. We'll be working with the files inside the *Lesson 04* subfolder.

In this lesson, we begin our transition from selection outlines into masking. We'll start by looking at the best automated selection function in Photoshop, Color Range, and then examine various means of increasingly powerful refinement. You'll learn how to:

• Use the Color Range command to define an organic, photo-friendly selection outline page 125

• Smooth and rebuild an outline with Refine Edge and the magnetic lasso page 131

• Begin a selection with Color Range and make it right in the quick mask mode page 136

• Stack a background in front of its foreground inside an inverted layer mask page 147

Video Lesson 4: The Quick Mask Continuum

The quick mask mode gets its name from the ease with which you can switch back and forth between a selection outline and an equivalent mask. But it doesn't hasten the pace of building the mask. So if you think of the grand topic of masking as being a swimming pool, and the Channels palette is the deep end, then the quick mask mode is the shallow end. But you're still very much in the water.

To see the quick mask mode in action, watch the fourth video lesson. Insert the DVD, double-click the file *PsCM Videos.html*, and click **Lesson 4: The Quick Mask Continuum** under the **Masking Essentials** heading. Clocking in at 16 minutes and 17 seconds, this movie mentions the following shortcuts:

Operation	Windows shortcut	Macintosh shortcut
Reset a tool to its default settings	Right-click tool in options bar	Right-click tool in options bar
Similar command	Ctrl+Shift+M*	⌘-Shift-M*
Inverse (to reverse a selection)	Ctrl+Shift+I	⌘-Shift-I
Enter or exit quick mask mode	Q	Q
Hide or show RGB image in quick mask mode	⌐ (tilde)	⌐ (tilde)
Drag and drop image, registered into place	Ctrl-drag, Shift-drop	⌘-drag, Shift-drop

* Works only if you loaded the dekeKeys keyboard shortcuts (as directed on page xvi of the Preface.

As Close to Automatic as Masking Gets

But while the quick mask mode offers little in the way of automation, the Color Range command offers lots. In fact, if you were to walk away from this book having learned just one thing, I would want it to be Color Range. Not because it's the best or most reliable or most powerful masking feature—I'm really not sure there is such a thing—but rather because it demands the least from you and delivers the most in return.

Although Color Range is a command, it works much like the magic wand tool. You click in the image to set a base color for the selection. You can also Shift-click to add base colors or Alt-click (on the Mac, Option-click) to subtract them. Only Shift+Alt-clicking (Shift-Option-clicking) does not work.

But while using the Color Range command may seem familiar, it produces much different and usually superior results. For one thing, where the magic wand tool employs a tenuous variety of antialiasing, Color Range responds to the natural ebb and flow of luminance in an image. Plus, you can apply changes dynamically, eliminating the guesswork associated with the wand's Tolerance value.

Color Range is one of the few simple, automated functions that actually produces reliable, high-quality results. And the fact that it has a prosaic name—free of *quicks* or *magics*—speaks volumes. We'll put it and the quick mask mode to great use in this lesson.

Using the Color Range Command

In this exercise, you'll gain hands-on experience with the Color Range command with the intention of replacing an uninteresting sky with a more dramatic one. In the process, we'll see just how powerful the command can be, and why it's typically the better tool to use when you're tempted to reach for the magic wand.

1. *Open two images.* Open *Easter men.jpg* and *Dramatic sky.jpg*, located in the *Lesson 04* folder inside *Lesson Files-PsCM 1on1*. Pictured in Figure 4-2, the Easter Island statues hail from Michal Wozniak, the dramatic South African sky comes from Henk Badenhorst. Both gentlemen are with iStockphoto. Let's make these photos from different lands as one.

Figure 4-2.

2. ***Restore the default colors.*** Just so you and I are on the same page, press the D key to make the foreground color black.

3. ***Choose the Color Range command.*** However we decide to approach this project, we have to start in the Easter Island photo, so click the title bar or tab for the *Easter men.jpg* image to bring it to the front. Then choose **Select**→**Color Range** to display the **Color Range** dialog box, as seen in Figure 4-3.

If you loaded my dekeKeys shortcuts back in the Preface (Step 7, page xvi), then you have a shortcut for this immensely useful command, Ctrl+Shift+Alt+O (or ⌘-Shift-Option-O). My selection of O is for the two O's in Color.

At first glance, the Color Range dialog box looks nothing like a selection function, let alone anything that resembles the magic wand. Here's a bit of preliminary information so you can get your bearings:

In-dialog box preview

Figure 4-3.

- By default, the in-dialog box preview shows the prospective selection outline—that will occur when you click OK—as a mask. (If you see the full-color image instead, click the Selection option below the preview.)

- Color Range uses the foreground color as the initial base color for the selection. The foreground color is black, but very little of the image is black. So just the tiny regions of white in the preview will be selected.

- Measured in luminance levels, the Fuzziness value allows you to expand or contract the selection much like the magic wand's Tolerance value. Except that the Fuzziness value is much better, as we'll see.

- Move the cursor out of the dialog box to get the eyedropper. That eyedropper cursor is your dramatically improved magic wand tool.

4. ***Click in the sky.*** We want to select the statues, but the sky is so much easier to select, and we can always reverse the selection. So move your cursor out into the image window and click the sky. By way of guidance, I recommend you click at the point circled in red in Figure 4-4.

5. ***Confirm the default Fuzziness value.*** Check that the **Fuzziness** value is set to 40, which is the default setting. As with the magic wand's Tolerance value, Fuzziness selects 40 luminance levels lighter and 40 levels darker. But

rather than absolutely selecting pixels, the way the wand does, Color Range's selection gradually declines over the course of the 40 levels, from 100 percent selected at level 0 to not-selected-at-all at level 41. The result is organic selections.

There's plenty of reason to change the Fuzziness value, and were you to do so, you would see the mask preview update on-the-fly. But the default setting of 40 luminance levels suits our purposes just fine. For a detailed explanation of fuzziness (another key concept to understanding Photoshop), read "The Magic Wand on Steroids" sidebar, which starts on page 128.

6. *Expand the selection.* We need to expand our selection so it includes the entire sky. So press the Shift key and click at the location circled in green in Figure 4-4. Then press Shift and drag across the two locations highlighted with yellow arrows in the figure. Yes, that's something else the Color Range command can do that the magic wand can't. Every color over which you drag becomes another base color in the selection, which is great for making quick work of areas that contain many saturation values and luminance levels, like this sky.

Another trick: You can click, Shift-click, or Shift-drag in either the image window or the in-dialog box preview. So if you see any stray areas of gray in what should be a perfectly white sky in the Color Range dialog box, Shift-click on them until they go away.

Figure 4-4.

The Color Range command is best understood in the context of the magic wand tool. In fact, the Color Range command was intended as a replacement for the magic wand tool in Photoshop. In many regards, Color Range is magic wand 2.0, or as I prefer to think of it, a magic wand on steroids. Good steroids, if there are such a thing.

To compare the two, and in the process learn more about the Color Range command, open the image *Gradient demo 2.psd*, located in the *Lesson 04* folder inside *Lesson Files-PsCM 1on1*. A variation of the image we used in the sidebar "The Magic Behind the Wand" (pages 74 and 75), this file features two gradients divided by a solid-color bar, as made so very clear below.

Choose the magic wand tool from the quick selection tool flyout menu in the toolbox. At the far left end of the options bar, right-click (or Control-click) the magic wand icon and choose **Reset Tool** to establish the default settings. Then change the **Tolerance** value to 120 and leave the other settings as is. Click at about the center of the top gradient. Because the Contiguous check box is turned on, the wand selects a wide swath of the top gradient without jumping the gap to the bottom gradient. If we wanted to change that, we could turn off Contiguous, but that would mean clicking again to generate a new selection as well. As it is, this selection is fine.

To get a sense of what this selection outline really looks like, let's save the selection as an alpha channel. Go to the **Channels** palette and Alt-click (Option-click on the Mac) the icon at the bottom of the palette to display the **New Channel** dialog box. Name the channel "Magic Wand" and click **OK**. Then press Ctrl+D (⌘-D) to deselect the image.

Click the **Magic Wand** channel to make it active. We have what appears to be a white rectangle with torn edges against a black background, as shown below. Zoom in on the left or right edge and it's very probable you will see not a hint of gray. In my mask, an investigation of the Histogram palette shows me that there are 1,611 pixels with a luminance level of 253 and 1,143 with a level of 254, both of which are virtually indistinguishable from white. The other 1,751,166 pixels are either black or white. (Your results may vary but only *very* slightly.)

Those numbers are important only in that they shine a stark light on what is ultimately a jagged-edged mask. The Anti-aliased check box is turned on. So where are all the grays?

The wand requires two things to calculate its particular brand of antialiasing: angle and color variation along the edge. This linear gradient has neither—the edge is perpendicular, and the neighboring color is uniform up and down the length of each edge. The wand has failed.

Now let's take a similar approach with the Color Range command. Click the **RGB** item at the top of the **Channels** palette or press Ctrl+2 (⌘-2) to return to the full-color image. Choose **Select→Color Range** or press the dekeKeys shortcut Ctrl+Shift+Alt+O (⌘-Shift-Option-O) to bring up the **Color Range** dialog box. If the **Invert** check box is on, turn it off. Move your cursor into the image window and click at the center of the top gradient. The in–dialog box preview updates to show white pixels where the image will be selected. The preview also shows lots and lots of grays. To see even more, raise the **Fuzziness** value to 120 levels, the same value you applied to the wand's Tolerance, and watch the selection expand on-the-fly. Then click **OK** to create the selection.

To compare this selection to the work of the magic wand, save it as an alpha channel. Alt-click (or Option-click) the ⬚ icon at the bottom of the **Channels** palette, name the channel "Color Range 1," and click **OK**. Press Ctrl+D (⌘-D) and then click the **Color Range 1** channel to look at it. Pictured below, the mask isn't perfectly smooth, but it's a quantum leap better than what the wand came up with. The selection doesn't abruptly end; it gradually declines over the course of the 120 luminance levels to the left and right, darker and lighter, that you set with the Fuzziness value. This is an organic selection based not on object geometry, as with antialiasing, but on continuous tones like those we encounter in photographs.

Also notice that the Color Range selection jumps the gap. By default, it is set to select nonadjacent pixels. In fact, until Photoshop CS4, there was no way to limit your selection to adjacent pixels. Technically, there still isn't, but a new option limits how far a selection can roam.

To check, press Ctrl+2 (⌘-2) to return to the full-color diagram. Choose **Select→Color Range**. Turn on the **Localized Color Clusters** check box, which unlocks a new slider bar called **Range**. Reduce the value to 50 percent to rein in the selection around your clicked point.

Click **OK** and once again save the selection as an alpha channel, this time named "Color Range 2." Click the **Color Range 2** channel to check it out. As witnessed below, the mask resembles a radial gradient with a bar cut through it. And indeed, that's what it is. The Localized Color Clusters option limits the selection to an area (as defined by the Range value) near to and gradually fading away from the points at which you clicked and Shift-clicked. The result is a more click-centric selection.

Two last notes about Color Range: Like the wand, it responds to the eyedropper's Sample Size; any setting but Point Sample will cause Color Range to incorporate more base colors. Second, Color Range sees the composite image, by which I mean a merged picture of all visible layers. The *Gradient demo 2.psd* file includes layers for you to experiment with if you are so inclined.

7. **Double-check the selection outline.** To confirm that you selected everything, choose **Grayscale** from the **Selection Preview** pop-up menu at the bottom of the dialog box. This will show you the mask view of the selection nice and big in the image window. (You can scale this preview using the standard zooming techniques.) If you see stray grays, Shift-click on them. When you're finished, reset the **Selection Preview** option to **None**, which restores the RGB image.

Figure 4-5.

8. **Reverse the selection.** Our goal is to select statues, not the sky, so reverse your selection by turning on the **Invert** check box, which is circled in Figure 4-5. Now the statues appear white and the sky black, indicating that the statues are selected.

From this point on, Shift-clicking will add to the deselected area and Alt-clicking (or Option-clicking) will add to the selection. If you find that confusing (most folks do), then do as we've done here: Wait until you complete a selection to turn on the Invert check box.

PEARL OF ⬤ WISDOM

You might notice that we never did Alt-click (or Option-click), and for a very good reason: Because the Color Range command generates a selection outline dynamically, it has to create a composite of your click, Shift-click, and Alt-click (Option-click) colors when calculating the overall selection. That is a fairly simple calculation from Photoshop's perspective, but it's quite complex from yours. Meaning that's it's nigh on impossible to accurately predict the results of an Alt-click (Option-click). So what do you do if a Shift-click selects too many colors? Press Ctrl+Z (or ⌘-Z). You have one—and only one—undo when working in the Color Range dialog box.

9. **Create the Color Range selection.** Click the **OK** button to close the Color Range dialog box and create the selection outline, as in Figure 4-6.

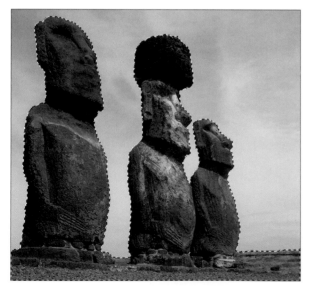

Figure 4-6.

10. **Drag the statues into the dramatic background.** Make sure you can see both images. Or that you're working in a tabbed window. And then do the following:

 • Press the Ctrl (or ⌘) key to get the move tool.

 • Drag the selection into the *Dramatic sky.jpg* image. If you're working in a tabbed window, drag the selection up to the *Dramatic sky.jpg* tab and wait a beat for Photoshop to switch images.

7. *Paint inside the mask.* The quick mask mode was originally envisioned as a way to paint selections, kind of a beginner's masking function. But free-form painting is unwise for two reasons: It involves a lot of manual labor on your part, and it's inexact when compared with other approaches.

To get a sense for what I mean, press the B key to select the brush tool from the toolbox. Then right-click in the image window and set the **Master Diameter** to 80 pixels and the **Hardness** to 100 percent. The foreground color is white, so paint inside, say, the right arm to add to the selection. For now, keep your painting well inside the edges. I've highlighted by brushstroke in red in Figure 4-26.

Figure 4-25.

PEARL OF WISDOM

Working with a Hardness of 100 percent is very important. When painting opaque brushstrokes like this—bereft of any special blend mode, such as Overlay, which we'll employ in Lesson 5—the last thing you want to do is add soft, fluffy edges. Even so, painting free-form like this is precarious. It's easy to add an edge that doesn't exist. And it's so much work. Better to paint inside a selection, as we'll do in the next step.

8. *Select the upper wall.* As we've seen a few times now, the quick selection tool has a unique way of seeing an image, and it performs better than the other selection functions when color contrast is low.

Figure 4-26.

- Select the quick selection tool from the toolbox, or press the W key.

- Press Ctrl+2 (⌘-2) or click the composite **RGB** channel in the **Channels** palette to switch attention to the full-color image. Don't worry, technically we're still in the quick mask mode, but we're now in a position to access and edit the image.

And here I'll sneak in a tip. The next time you have a selection outline active, but you need to do something independent of the selection for a moment and don't feel like saving it as an alpha channel, do this: Press Q, ⌐, Ctrl+2 (or ⌘-2). Now you can work on the image selection-free. When you're done, press Q and, like magic, your selection is back.

- In the options bar, turn on the **Auto-Enhance** check box. Yes, I recommended that you ignore this option back in Lesson 3 (page 95). But in this case, turning it on will eliminate the need of repeatedly visiting the Refine Edge command.

- If you've been following right along with me, your brush size should be 100 pixels, which works well here. Drag across the bricks that are above the hands to create a base selection.

- The top-right region of the farmer's jacket gets selected as well. We don't want that, so press the Alt (or Option) key and drag in the jacket to subtract it.

- If that doesn't quite deselect all the sleeve, press the ⬚ key a few times to reduce the brush size to 70 pixels. Then Alt-click (or Option-click) any portions of the farmer's jacket that are still included in the selection.

- Finally, zoom in on the top-left corner of the farmer's grubby gray cuff and again Alt-click (or Option-click) the tiny bit of excess selection to subtract it.

The final selection appears in Figure 4-27.

9. **Return to the Quick Mask channel.** Press Ctrl+6 (⌘-6) or click the thumbnail for the **Quick Mask** channel in the Channels palette. Then press the ⬚ key or click the 👁 icon in front of **RGB** to hide it and view the quick mask by itself.

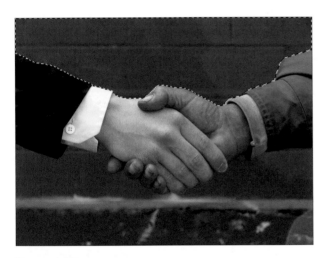

Figure 4-27.

10. **Paint inside the selection.** Now to fill in the selection with black:

- Press the B key or select the brush tool from the toolbox. Then press the X key to make the foreground color black.

- Press the ⬚ key several times to increase the brush size to 175 pixels.

- Paint over the entire selection area to make it black, as shown in Figure 4-28.

Alternatively, you could have pressed Alt+Backspace (or Option-Delete) to fill the selection with black. But I just want you to have a sense of the various ways you can use the brush tool in the quick mask mode.

Figure 4-28.

11. ***Reverse the selection.*** Now we'll turn our attention to the arms and hands, so choose **Select→Inverse** or press Ctrl+Shift+I (⌘-Shift-I).

12. ***Switch the foreground color to white.*** The arms and hands fall inside the selection and therefore need to be white. Press X to swap the foreground and background colors, bringing white to the foreground.

13. ***Paint in the arms and hands.*** Paint in the top portion of the selected area. Keep your brushstrokes near the top of the selection outline because that's your sole area of selection protection. When you finish, only the bottom of the arms and hands will look scruffy, as in Figure 4-29.

Figure 4-29.

PEARL OF WISDOM

Did you catch that? The selection is masking the brushstroke. So for all intents and purposes, you have a mask operating inside a mask. Which is the beauty of masking in Photoshop: Any mask, even a quick mask, permits you to bring the entire weight of the program to bear on the task of creating an accurate selection outline, including other selection outlines and, as we'll see later, alpha channels.

14. ***Return to the full-color image.*** Press Ctrl+2 (⌘-2) or click the **RGB** thumbnail in the Channels palette to switch to the full-color image while still remaining in the quick mask mode.

15. ***Select the lower-right wall.*** The quick selection tool worked so well last time, let's give it another try, this time in the much more intricate lower wall:

- Press Ctrl+D (⌘-D) to abandon the previous selection. Otherwise, the quick selection tool will automatically add to it.

- Press the W key to switch back to the quick selection tool. (When switching between the brush and quick selection tools, I find it's easy to mix them up. When in doubt, take a peek at the toolbox.)

- Paint in the area immediately below and to the right of the farmer's arm. Make it a short stroke. Then paint a bit farther down, into the wide swath of mortar and beyond. If you end up selecting a fingertip or two, no worries; that's to be expected.

Figure 4-30.

Figure 4-31.

Figure 4-32.

- Zoom in on the bottom edge of the farmer's wrist. See that little patch of arm hairs? I show you how to select hair in the next lesson. But head hair, not body hair. Really, what possible contribution will arm hairs make to our final composition? Much easier to give the guy a shave.

- Press ⬚ several times to reduce the brush size to 25 pixels. Click (don't drag) once or twice along the edge of the wrist until the selection outline consumes the hairs.

- Now press ⬚ a few more times to further reduce the brush size, this time to 7 pixels. Click in the small gap between the index and middle finger on the businessman's hand to add the few remaining hairs to the selection.

- Press ⬚ several times to increase the brush size to 40 pixels. Alt-click (or Option-click) in the businessman's index finger and his middle finger knuckle to subtract those areas from the selection.

- If you end up deselecting some of the wall between the fingers (it's almost impossible not to), click in that area to deselect back to the fingers.

Figure 4-30 shows the resulting selection.

16. ***Clean up the bad corner.*** Zoom way in on the businessman's pinky and you'll see a bad corner between his pinky and ring finger. This is an obvious job for the magnetic lasso tool, so select the tool from the toolbox or press the L key. And Shift-click a few times around the corner to select it, as in Figure 4-31.

17. ***Return to the Quick Mask channel.*** Time to deploy the selection in the quick mask mode. Press Ctrl+6 (or ⌘-6) followed by the ⬚ key to see the Quick Mask channel independently of the image.

18. ***Fill the selection with black.*** The selection falls outside the area we want to ultimately select—how's that for crazy?—so press Backspace (Delete) to fill the selection with black, as in Figure 4-32.

19. ***Reverse the selection.*** Of course we need to repurpose this selection for the farmer's arm and hand. So choose **Select→Inverse** or press Ctrl+Shift+I (⌘-Shift-I).

20. **Paint inside the new selection.** Let's once again paint to clean up this area:

 - Press the X key to make white the foreground color. Then press the B key for the brush tool. Finally, press ⬚ to raise the brush size to 200 pixels.

 - Paint along the businessman's fingers and farmer's arm, but only where the selection outline protects the edge. The result appears in Figure 4-33.

 - Press Ctrl+D (⌘-D) to deselect the image.

21. **Select the businessman and the farmer's fingers.** Now for our last major selection outline. (I know, finally!) This time around, we won't be selecting the wall. You know how obsessed the quick selection tool is with smooth forms. The businessman has never done a day of hard labor in his life—even his brief prison stint was cushy—so his hand is silky smooth. Let's select it:

 - Press Ctrl+2 (⌘-2) for the full-color image.

 - Press the W key to get the quick selection tool.

 - You know how you know if you're a he-man? You cannot be selected with one brush of the quick selection tool. Contrast that with the businessman: Paint from his hand, up and down his sleeve, and all the way into his jacket. What a cream puff.

 - One part of the businessman is tough—the bottom of his sleeve. Click to add it. If you get some of the wall, Alt-click (or Option-click) to subtract it.

 - We need the farmer's fingers, too. But he's a he-man so expect some resistance. Press ⬚ twice to raise the brush size to 50 pixels, and carefully drag inside his index finger. You might have to click a few extra times to get the very tip.

 - Then click in each of the other farmer's fingers to finish off the selection, shown in Figure 4-34.

22. **Return to the Quick Mask channel.** And once again, back we go. Press Ctrl+6 (⌘-6) and then the ⬚ key to see the lone Quick Mask channel.

23. **Fill the selection with white.** Check that white is still the foreground color and press Alt+Backspace (Option-Delete) to make the businessman white.

Figure 4-33.

Figure 4-34.

Figure 4-35.

Figure 4-36.

24. **Reverse the selection.** Now we'll clean up the bottom-left portion of the image. Press Ctrl+Shift+I (⌘-Shift-I) to select what wasn't selected and deselect what was.

25. **Paint inside the selection.** To finalize our cleanup work, we'll paint with black.

- Press B for the brush tool and X to swap the foreground and background colors. The foreground color should now be black.

- Paint in the area below the hands and arms on the left side of the image. Make sure to get all the way to the extreme boundaries of the canvas. The result is on display for all to see in Figure 4-35.

26. **Deselect the image.** That's it for this selection. Press Ctrl+D (⌘-D) to bid it a fond farewell.

27. **Refine to your heart's content.** Press the ⌇ key to bring back the RGB image and view the mask as a blue overlay. It's actually in pretty great shape, but there are some minor problems if you care to address them. Figure 4-36 diagrams the trouble spots:

- The pink circles indicate corners that you can fix with the magnetic lasso. (You'll have to switch focus to the RGB image so the magnetic lasso can see the image, and then switch back to the Quick Mask channel to fill your selections with black.

- The yellow circles indicate areas that you can fix by painting with the brush tool. Use a 60-pixel hard brush. If necessary, press X to make white the foreground color. Then paint one click at a time.

28. **Save the mask.** After all that work, you cannot exit the quick mask mode and run the risk of losing the selection. To make the mask a permanent resident of the image, drag the temporary **Quick Mask** channel to the ⬓ icon at the bottom of the Channels palette. Double-click the name of the duplicate channel, **Quick Mask Copy**, type "My Mask," and press Enter or Return.

29. **Exit the quick mask mode.** We've finished refining the selection, so press Q to exit the quick mask mode.

30. **Save the image.** Choose **File→Save As** or press Ctrl+Shift+S (⌘-Shift-S). No layers in this file, so change the **Format** to **TIFF**. And click the **Save** button.

Pasting an Image into a Mask

In the previous exercise, we learned in massive detail just how powerful the quick mask mode is and how quick it is not. We put a tremendous amount of effort into creating a selection that will empower us to make a high-quality composition. In this short exercise, all that hard work—all that grinding, index finger–breaking labor—is about to pay off in sweet country spades.

1. *Open two images.* Open either your image from the previous exercise or the version I created for you, *Final quick mask.tif*, as well as the background image, *Field of dreams.jpg*, both located in the *Lesson 04*. The sublime background image (Figure 4-37) comes to us from an artist with iStockphoto who goes by the handle Kativ.

Figure 4-37.

2. *Copy the background image.* Rather than set the handshake against the pretty background, we're going to place the background in front of the handshake and mask it into place in one operation. Click the title bar or tab for *Field of dreams.jpg* to make it active. Then press Ctrl+A (⌘-A) to select the entire image and Ctrl+C (⌘-C) to copy it to the clipboard. Or choose **Select→All** and then **Edit→Copy**.

3. *Load the selection.* Now bring the handshake image to the front. If you went from the previous exercise directly to this one, your handshake is covered in marching ants, indicating that you have an active selection outline. If you didn't, go to the **Channels** palette, and Ctrl-click (or ⌘-click) the lone alpha channel, called **My Mask**.

Figure 4-38.

4. *Paste into the reverse of the selection.* In the final exercise in Lesson 3, we employed Edit→Paste Into to paste a crazy man into an egg (Step 9, page 115). Were we to use that same command this time around, we would cover the handshake in the background, as in Figure 4-38. That's a lovely Magritte-like effect, but it's not what I'm looking for.

What's needed is a Paste Behind command. I say this because there used to be one. Adobe got rid of it years and years ago, but they left behind the shortcut: Ctrl+Alt+Shift+V (⌘-Option-Shift-V).

So press Ctrl+Alt+Shift+V (or ⌘-Option-Shift-V) to paste the background behind the selection, as in Figure 4-39. Switch to the **Layers** palette and you'll see a new layer with a mask that shows the background as white and the handshake as black, just the opposite of our quick mask.

Figure 4-39.

Figure 4-40.

5. **Name the new layer.** Double click **Layer 1** in the Layers palette, type "Sky," and press Enter or Return.

6. **Select the businessman's sleeve.** That left-hand sleeve is too pink, even for our businessman. In his defense, it's a leftover from his old environment. To fix it, click the **Background** layer in the Layers palette. Press the W key to get the quick selection tool, and paint all parts of the sleeve to select it, as in the first example in Figure 4-40.

7. **Deselect the area outside the sleeve.** If your new selection extends beyond the sleeve, as in the figure, you can remedy the problem by subtracting the Sky's layer mask. Press Ctrl and Alt (or ⌘ and Option) and click the layer mask for the **Sky** layer in the Layers palette. The resulting selection includes only the sleeve, as in the second example in the figure.

8. **Desaturate the sleeve.** To eliminate all color in the sleeve, choose **Image→Adjustments→Desaturate** or press Ctrl+Shift+U (⌘-Shift-U).

9. **Deselect the selection.** Press Ctrl+D (⌘-D). As seen in Figure 4-41, the finished image stands as a proud tribute to powerful features working together in the quick mask mode.

Figure 4-41.

WHAT DID YOU LEARN?

Match the key concept in the numbered list below with the letter
of the phrase that best describes it. Answers appear upside-down
at the bottom of the page.

Key Concepts

1. Color Range

2. Fuzziness

3. Invert

4. Localized Color Clusters

5. Selection Preview: Grayscale

6. Smooth

7. Quick mask

8. Brush tool

9. Q, ⬚, Ctrl+2 (⌘-2)

10. Auto-Enhance

11. Select All

12. Paste Behind

Descriptions

A. Measured in luminance levels, this setting in the Color Range dialog
box determines how far a selection expands from a clicked color before
it gradually fades away.

B. This command—which places the contents of the clipboard into a re-
versed mask of the selection outline—no longer exists in Photoshop, but
still enjoys the shortcut Ctrl+Shift+Alt+V (⌘-Shift-Option-V).

C. The feature that the quick mask mode was designed to accommodate,
but is best used sparingly—with a Hardness of 100 percent, set to an
alternative blend mode, or within the confines of a selection outline.

D. A Color Range option that displays the selection as a mask in the image
window, exactly like a selection stored in an alpha channel.

E. This command selects every pixel in an image and is a necessary pre-
requisite to copying the image to the clipboard.

F. A check box in the Color Range dialog box that reverses the selection
from the pixels you specified to the ones you did not.

G. This check box applies a predefined collection of Refine Edge settings
to an outline drawn with the quick selection tool.

H. This Refine Edge option rounds the edges in a selection outline, which
evens jagged edges as well as rounds crisp corners.

I. This better version of the magic wand tool selects luminance levels based
on their similarity to a clicked color and adjust the results dynamically
before accepting your selection.

J. The secret handshake for editing an image independently of a selection
outline, while keeping the outline safe for later use.

K. New to Photoshop CS4, this check box limits a Color Range selection
to an area near to and gradually fading away from the clicked color.

L. A mode that allows you to see (and modify) a selection as a color overlay
on the image or as a temporary alpha channel.

Answers

1I, 2A, 3F, 4K, 5D, 6H, 7L, 8C, 9J, 10G, 11E, 12B

EVERYDAY CHANNEL MASKING

THERE'S NOTHING IMPRECISE, amateurish, or dishonorable about using the quick mask mode. It's a great tool, and it delivers top-notch results—I use it all the time. But when you hear pro-level users talk about *masking*, they're not talking about quick mask; they mean old-fashioned channel masking. And truly, the Channels palette is where real masking goodness resides.

In this lesson, I'll show you the essential steps required to generate and employ an organic, dependable, photorealistic channel-based mask that you can save with an image and use over and over again. **You'll use the techniques you learn in this lesson** on a regular basis. In fact, if this is as far as you get into masking, consider yourself well served. (And for those of you who have been itching to select some hair, you're about to get your fill.)

As you can appreciate by looking at Figure 5-1, selecting hair represents a big challenge. Very big in this case. The individual strands of hair are tiny and numerous, and to make matters worse, they are translucent. It all adds up to a task that can be intimidating at first glance. Fortunately, with the right tool and techniques, this job doesn't need to be daunting.

Channels provide just such a tool, enabling you to create complicated masks with relative ease. I'm not saying work won't be involved, but as you'll discover in the exercises in this lesson, channels provide an effective means of creating masks that would otherwise be incredibly difficult—if not impossible—to make.

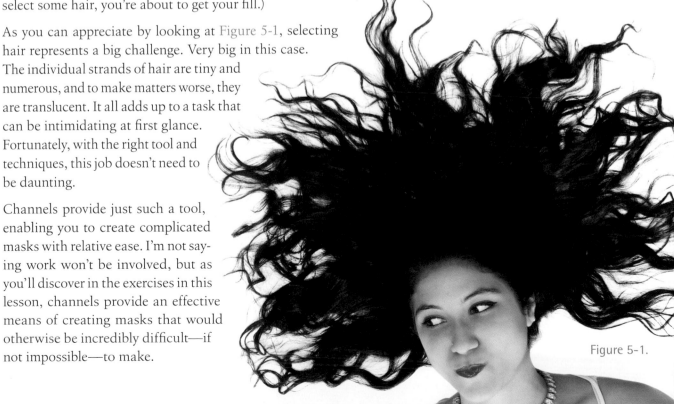

Figure 5-1.

Project Files

Before beginning the exercises, make sure you've copied the lesson files from the DVD, as directed in Step 3 on page xv of the Preface. This should result in a folder called *Lesson Files-PsCM 1on1* on your desktop. We'll be working with the files inside the *Lesson 05* subfolder.

In this lesson, I'll show you how to build a full-blown, intricately detailed mask from beginning to end, and then use that mask to create a graphic silhouette effect and a more traditional layered composition. Over the course of five exercises, you'll learn how to:

- Build a mask from a high-contrast channel using Levels and Overlay paintingpage 154

- Mask the smooth contours using some familiar, and distinctly unfamiliar, selection functions page 160

- Create a spooky, underlit silhouette effect and customize the effect with a handful of actions. . . . page 166

- Composite dark hair against a colorful background with the help of Multiply and edge toasting page 173

- Set the image into an expensive picture frame page 182

Video Lesson 5: Using the Image to Select Itself

Just as you can see the various elements of a photograph, Photoshop can "see" them as well. But the way you and Photoshop see them are different. By understanding how Photoshop sees the elements, you can exploit that vision to create an accurate mask, even when the image contains complicated or intricate details such as hair. It's all about using the image to select itself.

To see what I'm talking about, watch the fifth video lesson. Insert the DVD, double-click the file *PsCM Videos.html*, and click **Lesson 5: Using the Image to Select Itself** under the **Masking Essentials** heading. Over the course of these 18 minutes and 51 seconds of movie goodness, you'll see these shortcuts:

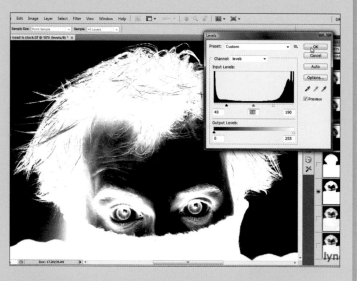

Operation	Windows shortcut	Macintosh shortcut
Invert a mask	Ctrl+I	⌘-I
Levels (with last-applied settings)	Ctrl+L (Ctrl+Alt+L)	⌘-L (⌘-Option-L)
Curves (with last-applied settings)	Ctrl+M (Ctrl+Alt+M)	⌘-M (⌘-Option-M)
Cycle between points in Curves graph	⊞ and ⊟ (plus and minus)	⊞ and ⊟
Brightness/Contrast	Ctrl+Alt+B*	⌘-Option-B*

* Works only if you loaded the dekeKeys keyboard shortcuts (as directed on page xvi of the Preface).

One Big, Hairy Project

No more automated tools and no more automated commands. It's time to put those away and create a mask manually. The best way to select the area you want to mask is to use the image itself, through the power of channels.

The subject for this exercise is Figure 5-2, a woman with hair all over the place (from iStockphoto photographer Lise Gagne). Using a variety of techniques, you're going to select every single strand. It helps that she's set against a homogeneous background. (In later lessons I'll show you how to select complicated foreground images set against complicated backgrounds.) In addition, her hair is very dark and the background is very light, which provides a lot of contrast to work with.

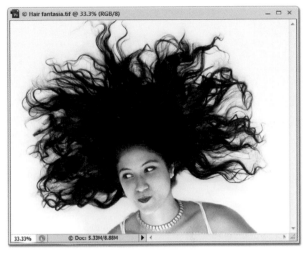

Figure 5-2.

However, if you take a close look at the left cheek (her right) you'll notice that it becomes very light and fades into the background. This creates a challenge, as do her dress straps, her necklace, and other areas where there isn't much in the way of contrast.

In spite of these issues, by the end of the lesson you'll have learned how to select the woman and all that hair and position her against the background shown in Figure 5-3 (an illustration by artist Kativ of iStockphoto). Unlike previous lessons, in this lesson you'll work all the way through on a single project.

Figure 5-3.

I don't think anyone is going to be fooled that some crazy windstorm blasted her hair in all directions while she stood in this bucolic field. However, I hope the good aesthetics of the composition will create a *trompe l'oeil* effect (French for "trick of the eye"). When you use a mask to take an image from one background and position it against a different background in a way that fools the viewer, you can rest assured that you fall on the ethical side of things if people can still tell that they are viewing a photo composite. It makes for a little more fun, however, to do a splendid job, so they don't know exactly where the illusion ends.

Speaking of fun, for our final exercise in this lesson, we'll put this composition inside the widescreen television (from Eva Serrabassa, also of iStockphoto) shown in Figure 5-4 on the next page. We'll

Figure 5-4.

Figure 5-5.

Figure 5-6.

retain all the hair detail and keep a nice strong edge along her face, neck, dress, and straps, as you can see in Figure 5-5. There's no time like the present to create your very first channel mask from scratch.

Making a Mask from a Channel

In this first exercise, I'll illustrate the power of channels by creating a mask from an existing channel. Ultimately, we will get to the point where the mask is white for the woman (and her lovely hair) and black for the background. The great thing about this technique is that the image will do most of the work for us.

1. *Open the image you want to mask.* Open *Hair fantasia.tif*, in the *Lesson 05* folder inside *Lesson Files-PsCM 1on1*. It may be hard to believe, but you're about to expertly produce a mask that allows you to isolate the woman from the background.

2. *Bring up the Channels palette.* If the **Channels** palette isn't visible, choose **Window**→**Channels**. In the palette, shown in Figure 5-6, you can see the individual channels—one for each of the primary colors red, green, and blue—that make up the full-color image. Each channel serves as a potential starting point for our mask.

PEARL OF WISDOM

It is easiest to mask inside an RGB image because you start with three channels—Red, Green, and Blue—all of which contain a wealth of information. If you're working inside a Lab image, only one channel—the Lightness channel—will do you any good. You may think you'd be better off with a CMYK image and its four channels, but the information they provide is subpar compared to RGB; they contain a lot more noise and lack good transitions. If you're starting with an image in CMYK or Lab, create a copy of the image, convert the copy to RGB, and create the mask in your RGB copy. Then bring the mask back into your original image by duplicating the channel.

3. *Make sure the channels appear in grayscale.* If the channels appear in color, change them to a grayscale display. Choose **Edit→Preferences→Interface** (**Photoshop→Preferences→ Interface**) or press Ctrl+K, Ctrl+2 (⌘-K, ⌘-2). Turn off the **Show Channels in Color** option and click **OK**.

4. *Identify the base channel.* Peruse the channels, as shown in Figure 5-7, by clicking the thumbnail for each channel in the **Channels** palette. Identify the channel that has the best contrast between the subject and the background. For this image, the Blue channel is the hands-down winner.

Figure 5-7.

PEARL OF　WISDOM

For portraits, the Red channel is best when the subject is against a dark background, because skin tones—regardless of race, religion, creed, or any of that jazz—appear brightest. When the subject is against a light background, the Blue channel is best because skin tones appear darkest on the Blue channel. The Green channel is where you'll find the most detail and sharpest focus, and it is a good choice for when neither the Red channel nor the Blue channel provides a good basis for a mask.

5. *Duplicate the Blue channel.* Drag the Blue channel to the 🖿 icon at the bottom of the Channels palette to create a copy of that channel (be careful not to accidentally drop the channel on the trash can icon, which will delete the channel). It is important to create the mask from a duplicate channel, rather than working directly on one of the Red, Green, or Blue channels; you don't want to alter the color of the original image.

6. *Rename the duplicate channel.* To keep things organized, rename the duplicate channel. Double-click the name of the duplicate channel in the Channels palette and type a new and more meaningful name, such as "mask."

7. *Invert the channel.* Because you will be selecting the woman and not the background, you want her to be white rather than black. Since she's currently dark against a light background, press Ctrl+I (⌘-I on the Mac) to invert the channel. You can also choose **Image→Adjustments→Invert**. The result is the negative image pictured in Figure 5-8.

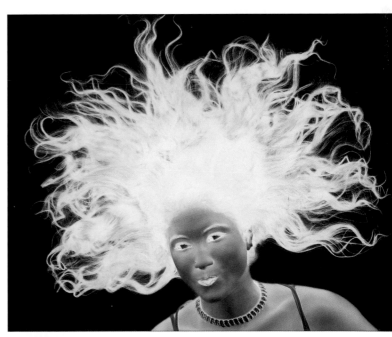

Figure 5-8.

Making a Mask from a Channel　155

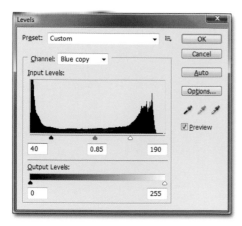

Figure 5-9.

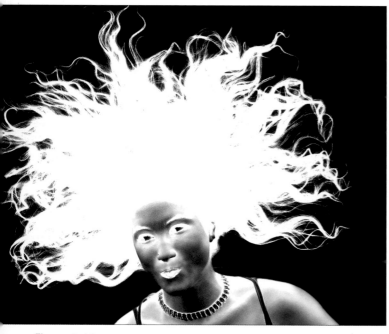

Figure 5-10.

Figure 5-11.

8. **Increase the contrast with Levels.** To define a clear separation between the woman and the background, we need to maximize the contrast—and the best command for increasing contrast is Levels. Choose **Image→Adjustments→Levels** or press Ctrl+L (⌘-L on the Mac) to display the **Levels** dialog box, shown in Figure 5-9. Darken the darkest values in the image by moving the black **Input Levels** triangle below the histogram to the right to a value of 40. (This renders all pixels with a luminosity value of 40 or lower as black.) Then decrease the white **Input Levels** value to 190 either by moving the white triangle or simply typing the new value in the box at the bottom-right of the histogram. (Now all values 190 or higher will be rendered as white.)

9. *Darken the midtones.* Move the middle triangle (the gamma triangle under Input Levels) to the right to darken the midtones in the image. A value of 0.85 produces maximum detail in the hair and a minimum of edge-fringing artifacts. As you can see in Figure 5-10, the Levels values maximize the contrast while retaining high levels of detail in the strands of hair. Click **OK** to apply the Levels adjustments.

10. *Remove highlight detail from the face and shoulders.* The contrast is starting to look good, but no clear edge is defined between the woman and the background. We'll paint away some of the highlight details in the woman's face and shoulders to better define those edges as we continue cleaning up the mask:

 - Click the ✎ tool in the toolbox or press the B key.

 - To get the best results, some of the properties for the brush tool need to be adjusted. In the options bar, click the ▼ arrow to the right of the brush icon to bring up the pop-up palette (see Figure 5-11).

 - We'll use a relatively large brush with a soft edge to make our work a little easier, so set the **Master Diameter** value to 100 pixels and the **Hardness** value to 0 percent.

- We need to protect the areas of the channel that are pure white or black, because they identify the edges that are already well defined. In the options bar, set the **Mode** option to **Overlay** to preserve all the pure black and pure white areas as you paint.

You can quickly switch to the Overlay blend mode by pressing Shift+Alt+O (Shift-Option-O on the Mac). To set the blend mode back to Normal, press Shift+Alt+N (Shift-Option-N). This shortcut works for other commonly used blend modes as well: Substitute the first letter of the blend mode in the keyboard shortcut. Be sure to switch the blend mode back to Overlay for this exercise if you've been experimenting with the keyboard shortcuts.

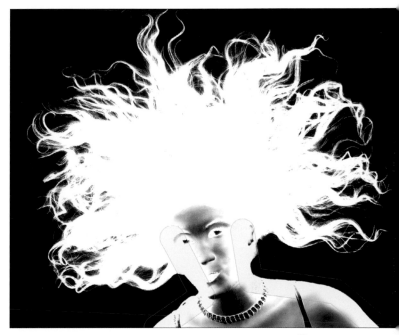

Figure 5-12.

- Press the D key to set the colors to their default values to ensure that white is the foreground color.

- Using the brush tool, paint over the edges of the woman's face to remove as much detail as possible. Release the mouse and paint over areas where the detail is holding on for dear life and one pass doesn't do the trick, such as along the edge of the left cheek (her right). Continue painting to remove highlight detail along the edge of the woman's neck on the right (her left) and her shoulders on both sides so there is good contrast between her and the black background. You'll need to make several passes around the dress straps. Figure 5-12 illustrates the results, with the edges you should paint highlighted.

11. *Remove more highlights from the hair.* While we've dealt with the edges around her body, there are still areas in her hair that are actual highlights, rather than bits of background showing through. These need to be added to the mask.

Start with the hair on the left side. (You might find it helpful to zoom in to see more detail.) Press the ⌐ key, to the left of the 1 key, to toggle on and off the RGB composite, which should help you distinguish between the hair highlights versus the areas of background showing through. Paint away the hair highlights much as you painted away the shoulder and face edge details, but leave the background areas unchanged.

You may find that your brush size is too large to accurately paint inside many of the finer strands of hair without damaging the background area. Rather than going into the brush options and changing the size from the pop-up menu, you can change the brush size by pressing [to decrease the size and] to increase it (adding Shift alters the brush's hardness, rather than size). But there's a better way. New to CS4, you can Alt+right-click (Option–Control-click on the Mac) to dynamically resize the brush on-the-fly. Unlike the keyboard shortcuts, you add the Ctrl key (the ⌘ key on the Mac) to alter the hardness rather than the size.

You may be tempted to leave the RGB composite on while you paint away the highlights—and why not, it's easier to see what you're doing. But if you do, be aware that Photoshop CS4 may swap the foreground and background colors to their pre-mask state; confirm once you toggle on the composite image that your foreground color is still set to white before painting.

12. ***Darken the shadow detail in the hair.*** Now to apply the opposite effect. We need to increase some of the shadow detail in the hair:

- Press the X key to swap the foreground and background colors so that the foreground color is black.

- Increase the **Master Diameter** value for the brush tool to 700 pixels and change the **Opacity** value to 50 percent.

- Starting on one side and moving around the perimeter of the hair, click at the tips of her hair. Don't paint (i.e., drag) because that will cause the hair to get too thin. When you're finished, you will have clicked once on each portion of the hair, as shown in Figure 5-13.

13. ***Select the remaining detail with the lasso tool.*** We need to get rid of the detail that remains in her face and body. To define the area to clean up, create a selection like the one shown in Figure 5-14 on the facing page:

- To clearly see the boundary between the outline of the woman and the detail to get rid of, zoom in on her face and body.

- When making selections that go all the way to the edge of an image, it's helpful to be in full-screen mode. You can then move the image around and see the pasteboard outside the image. Press the F key to switch to full-screen mode.

- In this case you can create a selection comprised of straight lines, so choose the lasso tool and press and hold the Alt (Option) key to constrain your selection so that it contains only straight lines.

- Starting outside the image (the opaque arrow in the lower left of Figure 5-14), click to define anchor points for the selection.

Figure 5-13.

Continue clicking to define a selection near the inside edge of the woman, between the detail to be removed and the background. Once you've made your final click (in the lower right of the figure), release the Alt (Option) key to complete the selection.

- Switch out of full-screen mode by pressing the F key twice.

14. ***Fill the selection with white.*** Now we'll fill the selected area with white to obliterate that detail. Press the X key to swap the foreground and background colors so the foreground color is white. Press Alt+Backspace (Option-Delete) to fill the selected area with the foreground color, then press Ctrl+D (⌘-D) to deselect.

15. ***Paint away the final edge details.*** We're getting close to our final mask, but there are still more areas to clean up. We need to paint away the remaining unwanted detail and produce a clean edge:

- Select the brush tool by pressing the B key.

- Set the blend mode for the brush to **Normal**.

- Reduce the **Master Diameter** value for the brush to 15 pixels so we can work more precisely.

- Set the **Hardness** value to 100 percent to paint with a crisp edge, and reset the **Opacity** to 100 percent.

- Zoom in to the areas that need to be cleaned up, including the woman's neck and shoulders. (Your problem areas may vary, but they'll likely be near where the dress straps were.) Using the brush tool, paint away the remaining detail. Press the X key as needed to swap the foreground and background colors. Be careful as you paint near the edges so you are only getting rid of artifacts and not damaging the shape of the mask. The final result is shown in Figure 5-15.

Figure 5-14.

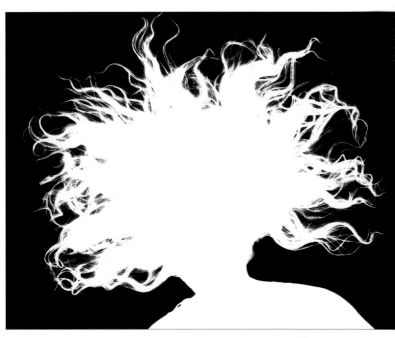

Figure 5-15.

16. *Save the file* We're going to continue working on this image, but now is a good time to save your work as a new file. Choose **File→Save As** or press Ctrl+Shift+S (⌘-Shift-S). Save the file as a Photoshop PSD with a name such as "Hair mid-mask."

Finessing the Smooth Contours

Give yourself a well-deserved pat on the back. You're on your way to having a top-notch mask, and all your hard work will pay off in the exercises to come. Now to make sure our mask is the best it can be, we're going to finesse it with a little trick I call *re-aliasing*. It may sound odd, but you're going to like the results.

Back in Lesson 3 (page 77), I told you about antialiasing, which smooths away jagged transitions. Normally that smoothness is our friend, but not always. When pasting into a mask, for example, the antialiasing results in unwanted artifacts. We therefore want to reintroduce the jagged transitions, as I'll explain in these steps:

1. *Open the image.* If you have the document open from the preceding exercise, great; otherwise you can open *Cleaned up.psd*, in the *Lesson 05* folder. We'll continue working with this image as we fine-tune our mask, which is starting to look pretty good.

2. *Display the image along with the mask.* Take a close look at your mask and you can see that the left cheek and the right side of the neck have ragged edges. To get a better idea of just how rough this area is, select the **Mask** channel and then click in the 👁 column to the left of the RGB composite to display the image along with the mask (or press the ⊡ key).

3. *Change the color of the mask overlay.* The default color for the mask overlay is red, which blends in with the warm skin tones and makes it difficult to see the shape of the mask clearly (note the left side of Figure 5-16). We can fix this by changing the color of the mask display:

 • Double-click the thumbnail for the Mask channel to bring up the **Channel Options** dialog box.

 • Click the **Color** swatch to open the **Select Channel Color** dialog box to select a new

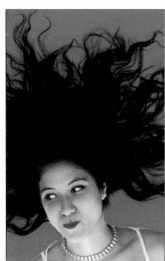

Figure 5-16.

color. Change the values to **H**: 210, **S**: 100, and **V**. 100 to get a nice shade of cobalt blue. Click **OK** to accept the color change.

- In the **Channel Options** dialog box, change **Opacity** to 90 percent, which allows the mask to appear nearly solid, with only minor detail showing through. Click **OK** to close the dialog box, and see the updated results in the right side of Figure 5-16.

4. *Select the problem area of the mask.* Choose the lasso tool from the toolbox (or press the L key) and draw a selection around the edge of the left cheek (her right). Take extra care to include the loop between her shoulder and dress strap. Next, press and hold the Shift key while drawing a selection around the right neck edge to add that area to the existing selection. The selection should include areas where the skin transitions into the background, as well as the adjacent areas of hair and shoulder. Your final result should be similar to that shown in Figure 5-17. (I added the Alt or Option key to constrain my lasso to polygons, but that's by no means necessary.)

Figure 5-17.

5. *Re-alias the selection.* Now we're going to apply the re-aliasing effect to produce a crisp edge along our selection:

- Press Q to enter the quick mask mode. (I know, it's a little crazy to use the quick mask mode when working directly on a mask, but the results are worth it.)

- Click the 👁 icon for both the **RGB** composite and the **Mask** channel to hide them, so you are looking only at the Quick Mask channel.

- Choose **Image→Adjustments→Threshold** to bring up the **Threshold** dialog box, which is Photoshop's antialiasing zapper. This adjustment changes smooth edges back to jagged edges. (By default, the selection tool antialiases its edges, which is precisely what we don't want.) The **Threshold Level** value doesn't matter because we simply want to force all pixels to either black or white, which is exactly what Threshold does. Click **OK** to apply the re-aliasing. As you can see in Figure 5-18, the result is a nice crisp edge.

Figure 5-18.

Figure 5-19.

Figure 5-20.

6. *Copy the selected area from the Blue channel.* Press Q to exit the quick mask mode. Then click the **Blue** channel in the **Channels** palette and choose **Edit→Copy** to copy the selected area of the Blue channel to the clipboard.

You may be asking, "Why are we using the Blue channel again? It gave us problems in these areas the last time, so why should it be different now?" Unfortunately, the Blue channel is still the best of the three for these problem areas. In other instances, it's best to check all channels to see which one has the best data to start from.

7. *Paste the selected area into the mask.* Now it's time to put the area you copied from the Blue channel back into the Mask channel to replace the detail in the problem areas. Click the **Mask** channel to select it (note the selection remains active as you switch channels, which is a wonderful thing). Choose **Edit→Paste** to paste the selection from the clipboard into the Mask channel, as illustrated in Figure 5-19.

8. *Invert the pasted area.* Just as you had to invert the copy of the Blue channel you created in the first exercise of this lesson, invert the information you just pasted into the Mask channel by pressing Ctrl+I (⌘-I).

9. *Increase the contrast.* We want to darken the shadow areas to emphasize some of the detail in the hair and shoulders (we'll deal with the cheek separately). Press Ctrl+Alt+L (⌘-Option-L) to open the **Levels** dialog box with the values you entered previously. These values don't provide quite enough contrast—move the black **Input Levels** triangle to 60 and the white Input Levels to 200, and reset the gamma (middle) value to 1, as in Figure 5-20. Click **OK** to apply the changes.

10. *Paint away the detail.* Now we'll use the same technique from the last exercise to paint away detail, but this time

we need to apply the change only to the shoulder areas—not to the cheek or neck:

- Press Ctrl+H (⌘-H) to hide the selection so it doesn't distract us while we're painting.

- Press the B key to choose the brush tool.

- Set the **Master Diameter** value to 20 pixels.

- Set the **Hardness** value to 0 percent

- Set the **Mode** to **Overlay**.

- Press the X key if necessary to swap the foreground and background colors so that white is the foreground color.

- Zoom in on the woman's shoulder on the left side and paint away the detail. Be sure not to paint into the face area, because we're going to use a different technique there. Take care to retain the black gap in the straps—shown in detail in Figure 5-21. In the strap area, reduce the brush size further and paint carefully. Then move to the woman's left shoulder and paint away the detail, again steering clear of the neck area.

11. *Enhance the shadow details.* We need to emphasize some of the shadow details to improve the accuracy of our mask. As you perform this step, it may seem that you're doing more harm than good. To get to our final mask, we need to enhance the corners, which is exactly what this step will accomplish. (Later I'll show you a method to restore the edges you're about to paint away.)

Figure 5-21.

- Press X to swap the foreground and background colors (the foreground should be black), and set the **Opacity** to 50 percent.

- With the brush still set to 20 pixels, click once at the points on the left side (her right) of the neck where it meets the hair and again where the neck meets the shoulder, to ensure a nice firm corner.

- Increase the brush size to 80 pixels and click a couple of times on the hair where it meets the neck to help emphasize the detail.

- Reduce the brush to 20 pixels and click one more time where the hair meets the neck, producing the result shown in Figure 5-22.

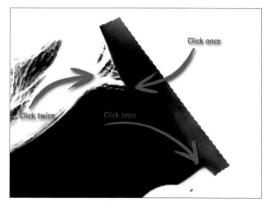

Figure 5-22.

Figure 5-23.

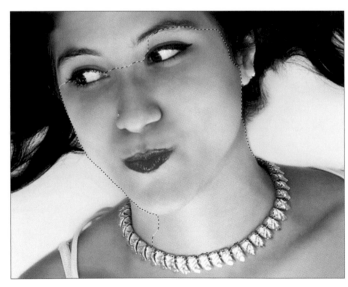

Figure 5-24.

• The right side lacks contrast between the neck and the background, and no amount of painting will produce a nice edge. Instead, increase the brush size to 70 pixels and paint down the edge of the neck, going over it several times to destroy the detail, as shown in Figure 5-23.

• Press Ctrl+D (⌘-D) to deselect.

12. *Create a selection of the neck edges.* Now we need to create a new edge for both sides of the neck using our friend, the quick selection tool:

• Choose the quick selection tool from the toolbox or by pressing the W key.

• Switch to the RGB image by clicking the **RGB** composite in the **Channels** palette.

• Drag down the left side of the face along the cheek.

• If the selection grows beyond the face, you'll need to subtract from the selection by holding the Alt (Option) key and dragging as needed on the area outside the face. Be sure to subtract from the selection under her chin, as you want to avoid selecting any portion of the left side of her neck.

• The quick selection tool will probably expand the selection automatically to include the other side of her face. If not, click a few times along the right edge of her neck. You'll need to refine that side as well—specifically cheating the selection back in to exclude the soft focus edge along her neck by Alt-clicking (Option-clicking) in the white background area. (Minor adjustments like this are better achieved by clicking rather than painting, because you add a smaller area to the selection.) Your final selection should look similar to Figure 5-24.

13. *Refine the selection edge.* We now have a basic selection of the areas of the mask that still need to be cleaned up. But the selection still isn't as good as it could be; Refine Edge is just the tool to improve it.

• Click the **Refine Edge** button in the options bar to open the **Refine Edge** dialog box, which you can use to improve the selection.

- At the bottom of the dialog box, click the 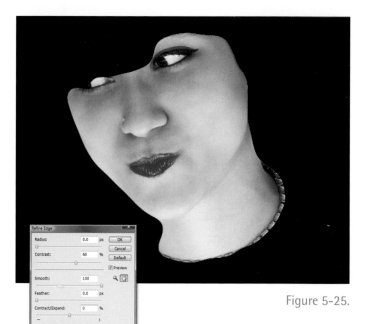-on-black icon to display the selection against a black background; this shows you exactly how poor the selection still is. First, we want no antialiasing of the selection, so set both the **Radius** and **Feather** settings to 0 pixels.

- Next, increase the **Contrast** to 60 percent, which will give us a nice sharp selection outline along the woman's cheeks.

- Unfortunately, that outline wavers in an unpleasant way, so increase the **Smooth** value to its maximum of 100 percent to smooth the edges.

- When your dialog box looks like that in Figure 5-25, click **OK** to apply the refined selection edge.

14. *Paint to finalize the mask.* We are on the verge of a perfect mask for our image, with just a little more painting to wrap things up:

- Go to the **Channels** palette and select the **Mask** channel.

- Press the B key to select the brush tool.

- Set the **Mode** option to **Normal** by pressing Ctrl+Shift+N (⌘-Shift-N on the Mac).

- Set the **Hardness** to 100 percent and press the 0 key to set the **Opacity** to 100.

- Make sure the foreground color is set to white.

- Press Ctrl+H (⌘-H on the Mac) to once again hide the selection edges so you can continue without distraction.

- Paint along the edge of the cheek and neck on both sides of the image to remove the final problem details, revealing a mask edge that is near perfect, as in Figure 5-26. You're almost there!

- Press Ctrl+D (⌘-D).

Figure 5-25.

Figure 5-26.

Figure 5-27.

15. *Eliminate the artifacts.* Switch to the lasso tool by pressing the L key and carefully select the areas (on both sides of the woman's face) that need some touch-up, as shown in Figure 5-27. (You may need to zoom in to select these areas with the necessary precision.) Then fill with white (which should still be set as the foreground color) by pressing Alt+Backspace (Option-Delete). Now zoom out and behold your final mask.

16. *Save the image.* You've put a lot of effort into creating the mask, so now is a good time to save the image. Choose **File→Save As** or press Ctrl+Shift+S (⌘-Shift-S) and save your image under a new name, such as "Final Masks.psd."

Creating a Silhouette Effect

After all that hard work, a it's time test just how good your newly minted mask is. And why not have a little fun in the process? In this exercise, I'll show you how to create a spooky underlit appearance for the image by creating a silhouette effect. If your mask is faring well—and I suspect it is faring very well indeed—the silhouette will look great. To learn how to automate the effect, read the sidebar "Silhouette Actions" on page 170.

1. *Open the image containing your mask.* If you are continuing from the preceding exercise and still have the image open, you can skip to Step 2. Otherwise, open *Final Masks. tif* in the *Lesson 05* folder, which contains the final masks we'll test in this exercise.

2. *Add a gradient background.* We'll create a nice gradient behind our subject to enhance the mood of the final result:

 • Go to the **Layers** palette and click the ◑ icon at the bottom. Choose **Gradient** from the pop-up menu, seen in Figure 5-28.

 • In the **Gradient Fill** dialog box, click the gradient bar to open the **Gradient Editor** dialog box, shown on the right side of Figure 5-29 on the facing page.

 • Click the **Load** button and navigate to the *Lesson 05* folder inside *Lesson Files-PsCM 1on1*. Select the *Cobalt cool.grd* file and click the **Load** button.

 • You'll see a new blue swatch among the others in the Presets section. Click that blue swatch to apply it and then click the **OK** button.

Figure 5-28.

- We want the light to come from the bottom toward the top, so we need to reverse the direction of the gradient. In the **Gradient Fill** dialog box, change the **Angle** to −90 degrees.

- Click **OK** to finalize the creation of the gradient.

Figure 5-29.

3. *Create a selection from the Mask channel.* The Mask channel you created with ever-so-much care in the last two exercises is the basis for our silhouette effect. To put the Mask channel to use, you first need to create a selection from that mask. Go to the **Channels** palette and Ctrl+click (⌘-click) the **Mask** channel. This automatically creates a selection in the shape defined by the Mask channel.

4. *Create a new layer.* When creating an image built from various pieces like this one, it's important to keep each piece separate. We therefore need to create a new layer to hold the gradient we'll add behind the woman:

- Go back to the **Layers** palette.

- Press Ctrl+Shift+N (⌘-Shift-N) to open the **New Layer** dialog box.

- Change the **Name** to "Silhouette" and click **OK**.

- Hide the selection by pressing Ctrl+H (⌘-H).

- Press D to reinstate the default colors, so that black (the color we want for our silhouette effect) is the foreground color.

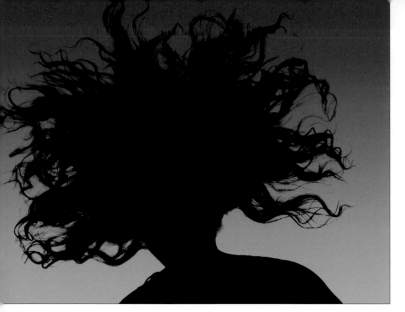

Figure 5-30.

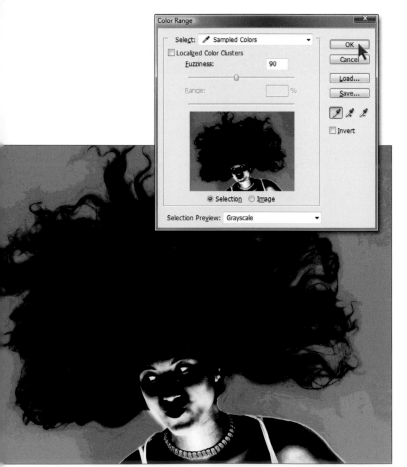

Figure 5-31.

- To fill the selection with the foreground color of black, press Alt+Backspace (Option-Delete). The results are shown in Figure 5-30.

- Press Ctrl+D (⌘-D).

5. *Create a Color Range selection.* To create the spooky underlighting effect, some of the face details need to be restored. We'll select those details using the Color Range command:

- Click the **Background** layer in the **Layers** palette to make it active.

- Press and hold the Alt (Option) key and click the ☻ icon for the Background layer so it will be the only visible layer.

- Choose **Select→Color Range**.

- In the **Color Range** dialog box, make sure the **Localized Color Clusters** check box is turned off, and set the **Selection Preview** option to **None**.

- Click inside the image at the horizontal and vertical center of the strap on the right shoulder (her left).

- Set the **Fuzziness** value to 90 so that the selection will expand into additional areas of the woman's face.

- You can see a better preview of the effect by changing the **Selection Preview** option to **Grayscale**, as shown in Figure 5-31.

- Click **OK** to create the selection.

6. *Smooth the transitions in the selection.* The selection resulted in some noise and rough transitions, as you may have noticed when viewing the Grayscale preview (or in the figure to the left). The noise is easy enough to clean up by working with the selection in the quick mask mode:

- Press Q to enter the quick mask mode.

- Press the ⠃ key to view the mask by itself without the RGB composite.

- Choose **Filter→Noise→Reduce Noise**.

- In the **Reduce Noise** dialog box, set the **Strength** value to 10, and set both the **Preserve Details** and **Sharpen Details** values to 0 percent (see Figure 5-32).

If you want to preserve the Photoshop default settings for Reduce Noise so that your current settings won't replace those defaults, you need to perform a few more steps before clicking OK in Step 7. After applying the settings as desired, click the ⊞ button. Type a new name (for example, "Max noise removal"). Click OK to save the settings. Then choose the settings you just saved from the Settings pop-up menu. At this point you can click OK in the dialog box and the original Photoshop default settings will be preserved. If you don't perform these steps, the default settings will be replaced with these new values.

Figure 5-32.

7. *Click OK.* This applies the Reduce Noise settings. Note how much smoother the image has become.

PEARL OF WISDOM

You may be wondering why I didn't use CS4's new Localized Color Clusters option, which is great for fine-tuning color range selections and reducing banding—I could have eliminated Steps 6 and 7 entirely. Although results using the Localized Color Clusters option are much smoother, they also tend to be flatter, with less contrast throughout the selection. Given the effect we're going for, we want a high-contrast selection. You'll need to experiment with the setting to find which works best for any given image.

8. *Remove the background from the selection.* Because the background in the quick mask isn't black, the current selection will allow much of the background to block part of the beautiful blue gradient we created. Therefore, the next step is to fill that background with black:

- Start with a selection of the background area. Go to the **Channels** palette and Ctrl+click (⌘-click on the Mac) the **Mask** channel. Yes, that's right, we're employing an alpha channel inside the quick mask mode. Totally awesome.

Silhouette Actions

Once you've created a final mask for an image, such as the composition we're creating in this lesson, you're ready to apply it in a variety of ways. Before applying the mask, however, it's good to test it so you can gauge its quality and get a better sense of what it looks like.

To help you test the image you've been working on in this lesson, I've created some actions that will run the mask through a few silhouette scenarios, which is a great way to see your mask in action and evaluate it.

To get started, open the *Final masks.psd* image. This is the image of the woman (and all her hair) with the final mask you created in this lesson saved as part of the file. You'll use that mask as the basis for the tests using the silhouette actions covered here, underscoring the fact that saved masks can always be reused.

I also need you to load the actions used to test the mask. Go to the **Actions** palette (if the palette isn't visible, choose **Window**→**Actions** to display it) and click the ▾≣icon to display the palette menu. Choose **Load Actions** (see below) to bring up the **Load** dialog box. In the dialog box, choose *Black comp.atn*, located in the *Lesson 05*

folder inside *Lesson Files-PsCM 1on1*, and click **Load**. Repeat this process to load *White comp.atn* as well.

The actions I've provided require that your mask is called *hair* and is positioned directly after the Blue channel in the Channels palette, so go ahead and make those changes. In the **Channels** palette, drag the existing **hair** channel to the trash can icon. Then drag your **Mask** channel up into position directly below the Blue channel, double-click the name of the mask, and rename it "hair" (be sure to use all lowercase letters).

Once you've made those changes, you're ready to begin testing your mask. The first action creates a white silhouette effect on a gradient background with your mask as the basis. In the **Actions** palette, choose the *White silhouette* action located in the *White comp* folder and click the ▶ icon at the bottom of the Actions palette. This produces a white silhouette set against a cobalt gradient, as you can see here.

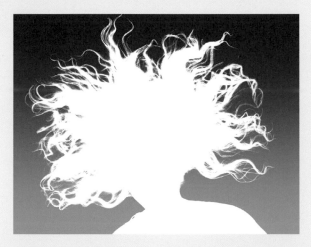

Next you'll run an action that will add the woman's face to the effect utilizing a mask called "face" that I created for you. (All actions in the *White comp* folder should be run sequentially.) Choose **Add face** from the Actions palette and click the ▶ icon at the bottom of the palette. The **face** mask displays a portion of the woman's face and applies an adjustment layer to make her face primarily red. You can see the result of this effect at the top left of the facing page.

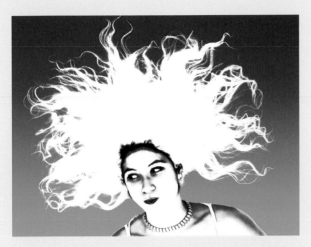

Next, we'll add a simple drop shadow and outer glow effect to the white silhouette layer. These emphasize the silhouette effect and, in the process, allow you to see the detail in the mask more clearly. Choose **Add styles** in the Actions palette and click the ▶ icon to apply the effect, which you can see below.

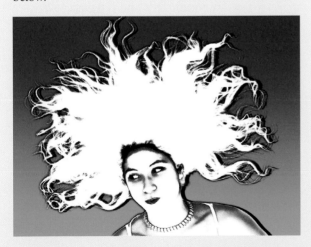

To make things more interesting, I want to add a fire effect to this image. Choose **Fire effect** in the Actions palette and click the ▶ icon. This action triggers a warning from Photoshop indicating that some aspects of effects cannot be reproduced with layers. This isn't a limitation in the Fire effect example, so you can simply click **OK** to dismiss the warning.

The Fire effect action is a bit more elaborate than the other three you've applied thus far, as you can tell by looking at the

result below. It applies a black-to-orange gradient to the image, but then constrains that effect in a clipping group with the silhouette layer so the effect can be seen only along the edges of the woman and her hair. Because it is such a detailed effect, utilizing a gradient along the outer edges of the hair, it really gives you a sense of the quality of your mask. (You can see all the gory details of this action by clicking the ▶ icon next to **Fire effect** to show all of the subactions.)

Finally, run the Black silhouette action found in the *Black comp* folder in the Actions palette. Choose the **Black silhouette** action and click the ▶ icon. You'll quickly recognize the result (shown below) as the same spooky effect you created manually in the "Creating a Silhouette Effect" exercise.

- The selection from the Mask channel includes the woman rather than the background, so choose **Select→Inverse** to invert the selection to include only the background area.

Figure 5-33.

- Now that the background is selected in the quick mask mode, you can fill it with black, our current background color, by pressing Ctrl+Backspace (⌘-Delete).

- Remove the current selection by pressing Ctrl+D (⌘-D).

- Finally, press Q to exit the quick mask mode and return to the normal selection display for the image.

9. *Duplicate the selected area to a new layer.* The face that appears within the selection needs to be at the top of our composite image to be visible. Make sure the **Background** layer is selected in the **Layers** palette and then press Ctrl+Alt+J (⌘-Option-J). In the **New Layer** dialog box (see Figure 5-33), type "Face" as the name for this layer and click **OK**. The new layer will contain only the selected pixels.

10. *Move the Face layer to the top of the stack.* Drag the **Face** layer to the top of the **Layers** palette, so it will appear above all other layers in the final composite image.

11. *Turn on all layers.* Click the empty ◉ column to the left of both the **Silhouette** and **Gradient** layers to complete the effect. You have created a spooky silhouette inside Photoshop using the elaborate hair mask you made from scratch as an alpha channel, as shown in Figure 5-34. In the process, you demonstrated just what a great mask you created too.

12. *Save the image.* After creating such a stunning effect, you'll want to be sure to save your work in a new file. Choose **File→Save As** or press Ctrl+Shift+S (⌘-Shift-S) and use a new name such as "Spooky silhouette.psd."

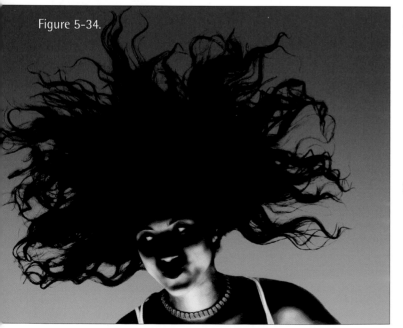

Figure 5-34.

Blending Hair and Sky

All right, after that little detour you're ready to get back to the project I defined at the start of this lesson—namely, putting the woman and her wild hair onto a background with sky and grass. You've done the most difficult part, creating a mask that will serve you well as you assemble the final composite. But even having defined an excellent mask, making a high-quality composite image requires some additional effort. In this exercise, I'll guide you through the process so you can go on to create composite images you'll be proud of.

The following steps work well when compositing a person with dark hair. But never fear, I'll show you a technique that works well with blondes in Lesson 12.

1. *Open the images to be composited.* Open *Final masks. tif* and *Tall grass.psd*, located in the *Lesson 05* folder inside *Lesson Files-PsCM 1on1*. These are the two images you will bring together in one document, using your mask to seamlessly blend the woman into her new background.

2. *Copy a merged version of the background.* We'll start our composite by placing a copy of the *Tall grass.psd* image into the image of the woman. Press Ctrl+A (⌘-A) to create a selection of the entire image. Then copy a merged version of the image (all visible pixels, not just the current layer) to the clipboard by pressing Ctrl+Shift+C (⌘-Shift-C).

Figure 5-35.

Normally I would place the subject into the new background, not the other way around. However, in this case I want to avoid the complication of bringing the saved mask over along with the layer. This way you're moving just one thing, not two.

3. *Paste the background image.* Return to the *Final masks.tif* image, and press Ctrl+V (⌘-V) to paste the background image into place on an independent layer, as you can see in the Layers palette shown in Figure 5-35. Double-click the name for this layer and rename it "Field."

4. *Reposition the Field layer.* I want to drag the Field layer up a little so we can see more of the grass at the bottom of the image. Press Ctrl+Shift (⌘-Shift) while dragging the image up slightly (see Figure 5-36).

Figure 5-36.

Adding the Shift key constrains the movement to vertical when dragging up or down. Because the two layers are the same width, you want to be sure you don't move the Field layer left or right, which would reveal part of the layer below.

5. *Convert the Background layer to a floating layer.* You'll need to be able to move the layer with the woman independently, so double-click the thumbnail for the **Background** layer to open the **New Layer** dialog box. In the **Name** field, type "Woman," and click **OK**.

6. *Create a selection from the mask.* We now want a selection to isolate the woman and copy her to a new layer, and we'll use the mask we created earlier for this purpose. Go to the **Channels** palette, and Ctrl+click (⌘-click) the thumbnail for the **Mask** channel to convert that channel to a selection.

7. *Duplicate the woman to a new layer.* Return to the **Layers** palette and make sure the **Woman** layer is selected. Duplicate the Woman layer to a new layer by pressing Ctrl+Alt+J (⌘-Option-J) to open the **New Layer** dialog box. Change the name for this new layer to "Masked" since it represents the masked version of the woman, and click **OK**.

8. *Move the new layer to the top of the stack.* To have the woman in front of the background, the Masked layer needs to be above the Field layer, so drag the **Masked** layer to the top of the **Layers** palette. Notice in Figure 5-37, however, that the hair isn't blending well. There are weird highlights in various places, and some of the hair seems to have shifted colors. The hair needs to be bolstered a bit to produce a more pleasing result.

9. *Turn off the Masked layer.* We'll use the Woman layer to improve the appearance of the edges of the hair, so for the moment we need to hide the Masked layer. Click the ◉ icon for the **Masked** layer in the Layers palette.

10. *Move the Woman layer above the Field layer.* The Woman layer is currently hidden below the Field layer, so drag the **Woman** layer above the Field layer in the Layers palette.

11. *Set the blend mode to Multiply.* Change the blend mode to **Multiply** for the Woman layer.

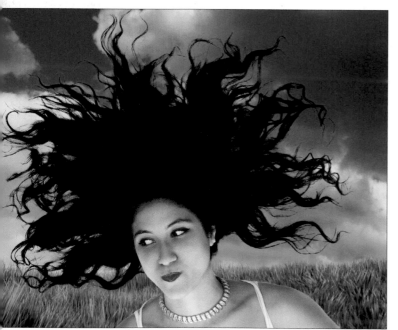

Figure 5-37.

This produces the darkening effect that you can see in Figure 5-38. Notice that the edges of the hair look much better, though we've lost detail in other areas, such as her face, and the color shifting is unacceptable.

12. *Turn on the Masked layer.* Now it's time to bring back the full detail in the woman. Do so by turning on the visibility for the Masked layer by clicking in the 👁 icon column to the left of the layer thumbnail. Suddenly everything looks much better, as you can see in Figure 5-39. All these wonderful layers are working together to create a seamless composition.

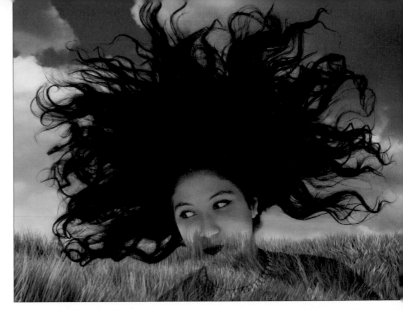

Figure 5-38.

You've produced an excellent composite image, but you can produce an even better result by doing some fine-tuning, particularly to the highlights around the edges of the skin. If you're not worried about the subtle details of the skin, move on to the next exercise, which starts on page 182. But if you want to apply some final adjustments to really make the most of this image, let's get to it.

13. *Create a Multiply layer.* To take this composite image to the next level, I'd like you to employ a technique I call *edge toasting*, which will enables you to darken some of the bright highlights on the skin. For this method, you'll create a new adjustment layer but not apply any adjustment with it. Instead, you'll use it as a vehicle to apply a blend mode to the image:

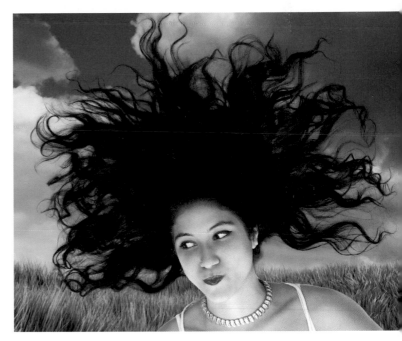

Figure 5-39.

- Start by clicking the thumbnail for the **Masked** layer in the **Layers** palette to make it active.

- Go to the **Adjustments** palette. Press the Alt (or Option) key and click the second icon in the first row, 🔺, to open the **New Layer** dialog box.

- Name this new adjustment layer "Shade" and click **OK**.

- Back in the **Layers** palette, change the blend mode for the **Shade** layer to Multiply. The skin is now "toasted" (darkened to a nice golden brown), but everything else in the

Select Menu Equivalents

You'll probably find yourself using selections as the basis of masks with many of your images, and you might use some of the various commands in the Select menu to modify those selections before creating a mask. I want to show you filters that you can apply to any mask you've already created—filters that will achieve the same effect you might otherwise have applied to the selection before you created the mask. This way, you can modify your masks in ways similar to the Select menu options, even after you've created the mask.

You already know we have an equivalent for the Select→Inverse command. If you want to reverse a mask, you simply apply the Image→Adjustments→Invert command.

But what about the options in the Select→Modify menu? These include Smooth, which smooths the corners of a selection outline; Expand, which moves a selection outline outward a given number of pixels; Contract, which moves a selection outline inward; and Feather, which blurs the selection outline. All four have equivalents where masks are concerned in the Filter menu. (I skipped the Border command because it has no filter equivalent.)

To see the operations in action, draw a rectangular marquee selection on an image, press Q to enter the quick mask mode, and press ⊡ to hide the image so you can see just the mask as an alpha channel (represented to the right). Then try out the following alternatives to the commands in the Select→Modify menu:

- **Smooth:** To produce the same effect as we get with the Select→Modify→Smooth command, choose **Filter→ Noise→Median**. If you increase the Radius value, the corners go from the sharp angles you see in the original mask to the rounded corners with no anti-aliasing as shown here.

- **Expand:** For the Select→ Modify→Expand command we'll substitute **Filter→Other→Maximum**. This filter operates by expanding the maximum luminance level, which is

white. As you increase the value for Radius, the white area of the mask enlarges from its starting point to a larger area as seen here. Note that unlike the Expand command, the Maximum filter retains the sharp corners.

- **Contract:** The Select→ Modify→Contract command is the opposite of Expand, and for this command we'll use **Filter→ Other→Minimum**. This expands the minimum luminance value, which is black. As you increase the value

for Radius, the white area of the mask shrinks from its starting point to a smaller area, as shown here.

- **Feather:** The Select→ Modify→Feather command blurs the selection in the same way as **Filter→ Blur→Gaussian Blur** when applied to a mask. Adjusting the Radius value results in the same effect as using the same value with the Feather command.

image is darkened as well, as you can see in Figure 5-40. The hair is jet black, the sky is too stormy, and the image looks more or less ruined at this point.

14. *Create a selection of the Masked layer.* To repair the image, you need to constrain the darkening effect created by the Shade layer so that it affects only the areas of skin at the outer edge of the woman. The Masked layer already contains all the masking information you created earlier, so Ctrl+click (or ⌘-click) the **Masked** layer to load the selection. This is the same selection you saved in the Hair mask.

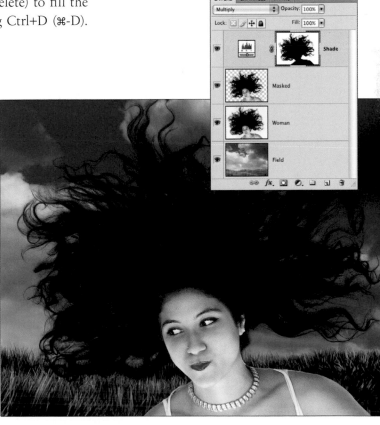

Figure 5-40.

15. *Fill the selection with black.* Fill the current selection with black on the Layer mask for the Shade layer so the effect won't be visible for the Masked layer. (We'll make it visible for just the edges of the woman in a later step.) The background color should be black at this point (if it isn't, press D to set the colors to their defaults). Press Ctrl+Backspace (⌘-Delete) to fill the layer, and then clear the selection by pressing Ctrl+D (⌘-D). The result is shown in Figure 5-41.

16. *Create a clipping mask for the layer.* As you can see, the Shade layer is no longer toasting the woman, but it is still toasting the background. You can remove that by creating a *clipping mask* for the Shade layer based on the Masked layer. With the **Shade** layer selected in the Layers palette, choose **Layer→Create Clipping Mask** or press Ctrl+Alt+G (⌘-Option-G). Note that the Shade layer is now indented with an arrow, indicating that it is masked inside the contents of the underlying layer. (It is also masked by the layer mask you created in the last step, so it isn't affecting the image at all—well, maybe a little around the fringes of the hair).

17. *Create a rough selection of the skin areas.* We now need to create a general selection that defines the skin areas we'll toast.

Figure 5-41.

- To view the area outside the image while creating the selection, enter full-screen mode by pressing the F key..

- If you can't see the area behind the woman (outside the image itself), press the spacebar to access the hand tool and drag the image upward.

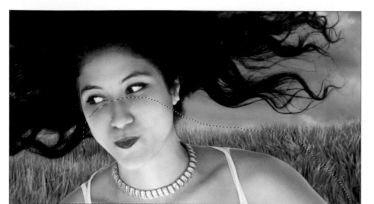

Figure 5-42.

- Choose the lasso tool from the toolbox or press L.

- Draw a selection that includes the woman from about the eyes downward and the background, but none of her hair, as shown in Figure 5-42.

- Feather the selection to give it a slightly soft edge by choosing **Select→Modify→ Feather**. Enter a value of 6 pixels for **Feather Radius** and click **OK**.

- Exit the full-screen mode by pressing F two more times.

18. *Expand the selected region inward.* Next we need to expand the selected region inward using the mask to bring the toasting effect into the edges of the woman. Select **Filter→ Other→Maximum** to bring up the **Maximum** dialog box. Set the **Radius** value to 15 pixels so we have a relatively thin (though abrupt) line around the edges of the skin (see Figure 5-43) and click **OK**.

Figure 5-43.

19. *Blur the mask to soften the edges.* You can see that the edges of the skin are being toasted, but the transition to areas not being toasted is harsh. Blurring the mask will fix this, so select **Filter→Blur→Gaussian Blur** to open the **Gaussian Blur** dialog box. Set the **Radius** value to 12 pixels and click **OK**. Figure 5-44 shows the improvements we've made. You can now remove the selection by pressing Ctrl+D (⌘-D).

20. *Fine-tune the mask with the brush tool.* You've made great progress, but now the woman looks like she smudged a bit of ash on her face—not

Figure 5-44.

too pretty. You can solve that by painting on the mask to block the Multiply effect in those areas.

- Click the ✐ icon in the toolbox or press B.

- Press X to swap the foreground and background colors so that black is your foreground color.

- Set the **Master Diameter** to 100, the **Hardness** to 0 percent, the **Mode** to **Normal**, and the **Opacity** value to 100 percent.

- Click the chin on the left side (her right) and then press and hold Shift and click her cheek on the left side to paint a straight line between those two points, as illustrated in Figure 5-45.

Figure 5-45.

- You might also want to paint a little with white on the right side of the neck (her left) to toast that area a little. You can also do some minor toasting in other areas as you see fit. Go nuts; do whatever you want!

21. *Add an inner glow to the Masked layer.* The shoulder on the right is still looking a little less than ideal, with edge fringing tracing the contours of her shoulders and neck. We can solve this problem easily with an inner glow:

- Click the **Masked** layer to make it active, and then click the *fx* icon at the bottom of the **Layers** palette and choose **Inner Glow** from the pop-up menu.

Figure 5-46.

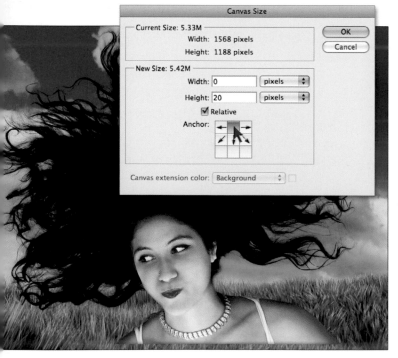

Figure 5-47.

- Click the color swatch to bring up the **Color Picker**.

- You could click inside the image to lift one of the colors, but for this exercise we'll enter specific values. Use **H**: 30, **S**: 75, and **B**: 60 percent. Then click **OK** to apply the color.

- Back in the **Layer Style** dialog box, set the **Blend Mode** to **Multiply** to burn in the effect.

- Bring the **Opacity** value down to 50 percent so we're not overdarkening the edges.

- We want to distribute the effect nicely, so raise the **Size** value to 15 pixels.

- Click **OK** to apply the effect, shown in Figure 5-46.

22. *Increase the canvas size.* Notice how good the blend on the shoulder is looking. That's wonderful, but if you look at the bottom of the image you'll see that Photoshop is adding the inner glow to the edge of the layer all the way around. We can fix that by adding extra pixels at the bottom of the image so that the glow applies outside the canvas area. Start by choosing **Image→Canvas Size**. Turn on the **Relative** check box and set the **Height** value to 20 pixels to add to the image size. Click any square in the top row of the **Anchor** grid (see Figure 5-47) so the new pixels will be added to the bottom of the image. Click **OK** to expand the canvas.

23. *Create a selection of the bottom edge of the image.* Now we can create a selection of the added space at the bottom of the canvas and fill it with pixels to hide the inner glow effect:

- Select the rectangular marquee tool.

- Instead of creating a free-form selection, set the **Style** pop-up in the options bar to **Fixed Size**.

- Set the **Width** to an astronomical value such as 4000 pixels (the selection won't extend beyond the width of the image), and set the **Height** to 20 pixels (the same number of pixels added to the canvas).

- Click below the image (outside the canvas) to create a selection 20 pixels high along the bottom of the image.

24. *Fill the selection with a standout color.* We need to fill this selection with pixels. We want the inner glow to occur outside the actual image area, so we'll fill it with a color that will stand out in case we accidentally reveal this area of the image later.

 - Press I to select the eyedropper tool, and then click a bright area of her lips to get a vibrant red from her lipstick.

 - Press Alt+Backspace (Option-Delete) to fill with red. Notice that the inner glow effect has moved to the pixels we added and is no longer affecting the bottom of the woman.

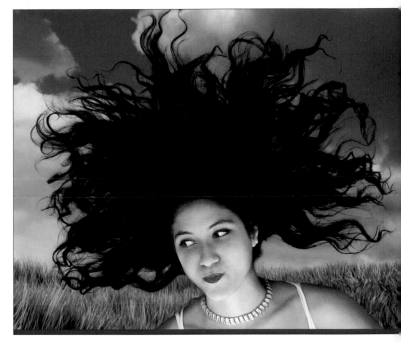

Figure 5-48.

 - Deselect the selection by pressing Ctrl+D (⌘-D). The results are shown in Figure 5-48.

25. *Reduce the canvas size.* Although that solved the inner glow issue, it introduced a new problem with the bright red bar at the bottom of the image. We'll get rid of that bar by reducing the size of the canvas, basically reversing Step 22. Choose **Image→Canvas Size** or press Ctrl+Alt+C (⌘-Option-C). In the **Canvas Size** dialog box (see Figure 5-49) set the **Height** to −20 pixels, turn on the **Relative** check box, click one of the top anchor points, and then click **OK**. Photoshop will whine and warn that you're about to perform some clipping, but that applies only to the Background layer so it isn't an issue for us. Click **Proceed** in the warning dialog box. Problem solved.

26. *Create an Inner Glow layer.* The only other issue I have with this Inner Glow effect is that it traces along her face and gives

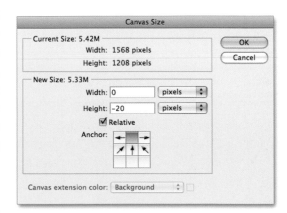

Figure 5-49.

her that dingy look again. You can partially erase the effect by making the Inner Glow effect an independent layer. Right-click (Control-click) the Inner Glow effect in the **Layers** palette and choose **Create Layer**. Photoshop warns you that some effects can't be rendered in layers, but that's not an issue for this effect, so click **OK** to continue. Rename the new layer "Glow."

27. *Erase the unwanted portion of the inner glow.* To erase the Inner Glow effect from portions of the face, select the eraser tool, and set the **Size** value to about 40 pixels and the **Hardness** to 0 percent. Click the chin and Shift-click the cheek to erase on her face in a straight line to get rid of the weird shading. You can use the eraser tool to clean up other areas of the face if you want.

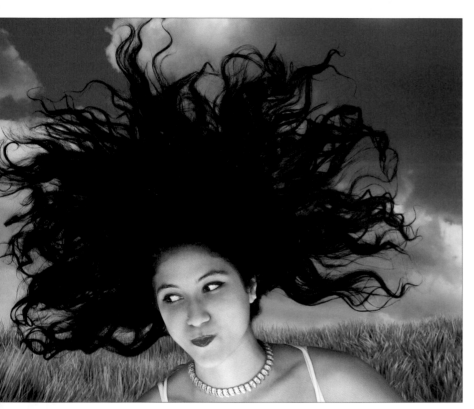

Figure 5-50.

28. *Reduce the Opacity of the Shade layer.* If you feel (as I do) that the shade effect is too strong, select the **Shade** layer and reduce the **Opacity** to about 70 percent. The final composition, shown in Figure 5-50, is stunning in both its smooth transitions and seamless edges.

29. *Save the image.* Congratulations on creating a beautiful composite image! At this point be sure to save your work. Choose **File→Save As** or press Ctrl+Shift+S (⌘-Shift-S) and use a fitting name such as "Mask of beauty.psd."

Setting the Image in a $3000 Frame

You've been working hard and deserve a reward in the form of the next exercise, which offers an easy effect and immediate satisfaction. In this final exercise, we're going to take our composition and

place it inside a high-definition television, effectively giving this bit of digital wizardry a $3000 picture frame. I for one can't imagine a better way to present our composite image.

1. *Open the images.* Open *Big-screen TV.tif*, located in the *Lesson 05* folder inside *Lesson Files-PsCM 1on1*, as well as *Thing of beauty.psd* if you don't still your file open from the preceding exercise. We'll be creating a composite of two images again, but in this case the process will be much easier than the last exercise. Make sure *Thing of beauty.psd* is the active document.

2. *Move the Field layer lower.* It dawns on me that my Field layer is a little high. I don't like seeing so much grass in the background, so select the **Field** layer in the **Layers** palette and press Ctrl+Shift+↓ (⌘-Shift-↓) to move it downward. Press about six or seven times to get the Field layer to the right position, as shown in Figure 5-51.

3. *Copy the composition to the clipboard.* Now to copy the image with the woman set against the grass background into the image of the big-screen television. Press Ctrl+A (⌘-A) to select the entire woman image. You need to make sure you're copying the merged version of the composition, not just the currently active layer, so press Ctrl+Shift+C (⌘-Shift-C).

4. *Create a selection from the alpha channel.* To constrain where the composition will appear in the TV, you need a selection. I've created an alpha channel for you in the *Big-screen TV.tif* image, so go to the **Channels** palette and Ctrl+click (⌘-click) the **Active Display** channel. This creates the selection in the active portion of the television set for you. (To create this selection, I used the rectangular marquee tool and applied a slight amount of softening using the Feather command.)

Figure 5-51.

5. *Paste the composition.* Place your composition into the television by pressing Ctrl+Shift+V (⌘-Shift-V) to paste from the clipboard. This adds a new layer using the existing selection as a mask, as shown in Figure 5-52 on the following page.

Figure 5-52.

6. *Move the composition into position.* Lastly, the composite image with the woman needs to be moved into place without moving the mask you've created for it. Click the thumbnail for the **Woman** layer to make it active. Hold down the Ctrl (⌘) key and drag to position the composition within the confines of the television, making sure the image extends beyond all edges of the area we selected. This is the final version of the effect, shown in Figure 5-53.

Congratulations! You have managed to mask a complicated image with more hair than you will likely encounter in any other image you use. You selected all that hair by yourself from scratch using the existing information in the image. Well done!

Figure 5-53.

WHAT DID YOU LEARN?

Match the key concept in the numbered list below with the letter
of the phrase that best describes it. Answers appear upside-down
at the bottom of the page.

Key Concepts

1. *Trompe l'oeil*
2. Levels
3. Composite
4. Silhouette
5. Overlay
6. Select Menu equivalents
7. Threshold
8. Multiply
9. Clipboard
10. Layer mask
11. Clipping mask
12. Layer style

Descriptions

A. Photoshop's antialiasing zapper, this adjustment converts all pixels inside a selection to pure black or pure white.

B. This blend mode drops out the highlights in the affected layer and burns in the shadows to create a darkening effect.

C. Allows you to constrain one or more layers so that they (or their effects, in the case of adjustment layers) are visible only where the underlying layer they are clipped to is visible.

D. A group of adjustments that can be made to a layer mask, providing the same effects as transformations made to a selection before creating the mask.

E. A visual effect created by combining two or more images together to create the illusion of a seamless, if sometimes implausible, image.

F. A blend mode that causes light areas to lighten the image below and dark areas to darken the layer below. Areas of pure black or white are not affected.

G. An image adjustment that allows you to increase the contrast, especially useful for refining the edge of a mask.

H. The full-color image created by combining the three color channels (or four, for CMYK images).

I. A temporary holding area in memory where you can store image information so it can be pasted elsewhere.

J. A visual effect created by masking away the contents of the foreground to a solid color.

K. An alpha channel that has been applied to a specific layer.

L. An effect applied to a specific layer that changes the appearance of that layer, such as a drop shadow or inner glow.

Answers

1E, 2G, 3H, 4J, 5F, 6D, 7A, 8B, 9I, 10K, 11C, 12L.

BLENDS AND COMPOSITES

IN THE PREVIOUS LESSON, you saw how you can use the Multiply mode to combine dark hair against a light background. That one blend mode did a ton of work for us, which is, of course, the whole idea. Blend modes and the larger world of compositing techniques are great for producing similar results as masking but with much less effort. Blend modes can also make your masked images look better inside their new homes.

In this lesson, I'll show you how to work blend modes even harder to obtain automated, accurate, and infinitely more flexible results. I call the class of features that include blend modes, opacity, and luminance blending (to name a few) *parametric operations* because they're based on numerical parameters and other adjustable settings. Because parametric operations aren't permanent—you can modify them anytime you like—it's impossible to damage your layered composition. And because parametric operations are so powerful, it's easy to do your images an awful lot of good.

When in Doubt, Blend

Selections and masks are amazing tools. But they require time, thought, planning, and—when things get tough—patience. So if you can avoid making a mask, there's a good chance you'll be able to move through a project more quickly and with less frustration. Which is why it's such a great idea to come to terms with blend modes. In many situations, blend modes render masks unnecessary if not downright irrelevant. Consider the self-serving Figure 6-1. I start with a black-and-white scan. Let's say I want to extract the signature from its white background and render the signature in white against a dark background. The tempting but destructive and time-consuming approach: get to work with the magic wand tool. The five second, better-results approach: Invert the scan and apply the Screen blend mode, as I did to achieve the second example in the figure.

Scanned signature

Invert and Screen

pattern istockphoto.com/Bill Noll

Figure 6-1.

ABOUT THIS LESSON

Project Files

Before beginning the exercises, make sure you've copied the lesson files from the DVD, as directed in Step 3 on page xv of the Preface. This should result in a folder called *Lesson Files-PsCM 1on1* on your desktop. We'll be working with the files inside the *Lesson 06* subfolder.

This lesson is all about blend modes and luminance blending, which allow you to avoid masking and make your masked compositions appear credible. Over the course of these exercises, you'll learn how to:

- Add black-and-white artwork to a photograph using Multiply, Screen, and Difference page 190

- Use each of the 25 blend modes available to the Layers palette, including The Fill Opacity Eight . . . page 203

- Weave intricate threads of lightning in and out of a cloud using luminance blending. page 219

- Blend two images that couldn't be more different into a homogeneous composition page 223

Video Lesson 6: The 25 Standard Blend Modes

Depending on how you count them, Photoshop offers upwards of 30 blend modes, some of which are too obscure to mention even in this book. But the most ubiquitous—the ones that show up when using the brush, history, and gradient tools; the Calculations and Apply Image commands; and the Layers Style dialog box—are the 25 standard blend modes available in the Layers palette.

For a brief introduction to these blend modes, watch the sixth video lesson. Insert the DVD, double-click the file *PsCM Videos.html*, and click **Lesson 6: The 25 Standard Blend Modes** under the **Masking Essentials** heading. Over the course of this 10-minute, 33-second movie, I introduce these options:

Operation	Windows shortcut	Macintosh shortcut
Reverse a layer mask	Ctrl+I	⌘-I
Release "sticky" blend mode option	Esc	*not necessary*
Multiply blend mode	Shift+Alt+M	Shift-Option-M
Screen blend mode	Shift+Alt+S	Shift-Option-S
Overlay blend mode	Shift+Alt+O	Shift-Option-O
Difference blend mode	Shift+Alt+E	Shift-Option-E
Luminosity blend mode	Shift+Alt+Y	Shift-Option-Y

For those of you who may be unclear what a blend mode is, allow me to explain. Available from the top-left corner of the Layers palette and elsewhere in Photoshop, a *blend mode*—sometimes called a *composite mode* or *transfer mode*—lets you mix the active layer with the composite view of all the layers below it according to one or more mathematical operations. Or more succinctly put, blend modes combine colors with math. It's not important that you know what that math is. What is worth knowing is the following:

- The Layers palette offers a total of 25 blend modes that it shares with the brush tool and the Calculations command.

- One common misconception is that some blend modes are re-duced Opacity versions of others. This is never the case. Each and every blend mode produces a unique effect.

- You may combine blend modes with the Opacity setting and other blending options to produce still more effects.

- You can switch between blend modes as many times as you like without adversely affecting a single pixel in the image.

- To make them slightly easier to digest, Photoshop organizes blend modes into logical groups, as illustrated in Figure 6-2. For more information on this, as well as explanations of each of the groups and its blend modes, watch Video Lesson 6, "The 25 Standard Blend Modes," as introduced on the facing page.

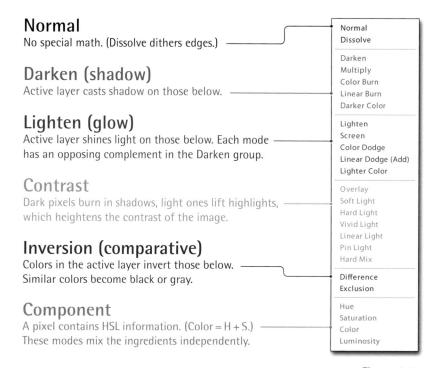

Normal
No special math. (Dissolve dithers edges.)

Darken (shadow)
Active layer casts shadow on those below.

Lighten (glow)
Active layer shines light on those below. Each mode has an opposing complement in the Darken group.

Contrast
Dark pixels burn in shadows, light ones lift highlights, which heightens the contrast of the image.

Inversion (comparative)
Colors in the active layer invert those below. Similar colors become black or gray.

Component
A pixel contains HSL information. (Color = H + S.) These modes mix the ingredients independently.

Normal
Dissolve

Darken
Multiply
Color Burn
Linear Burn
Darker Color

Lighten
Screen
Color Dodge
Linear Dodge (Add)
Lighter Color

Overlay
Soft Light
Hard Light
Vivid Light
Linear Light
Pin Light
Hard Mix

Difference
Exclusion

Hue
Saturation
Color
Luminosity

Figure 6-2.

In this lesson, we'll use blend modes to add a logo to a composition, fuse images together, circumvent masking, and make a masked image better match its new home. In future lessons, blend modes will become part of our shared imaging vocabulary that we'll employ over and over again. We will even use them to combine color-bearing channels to create base alpha channels—a lot. Never were 25 arbitrarily named, enigmatic mathematical operations so much fun.

Blending a Scanned Logo

Let's start things off with an in-the-trenches, work-a-day puzzle: Imagine that you're a designer, and you work for a client who wants you to superimpose his logo onto a photograph to create a branding element.

If your client has an electronic version of the logo—presumably an Illustrator (.ai or .eps) file—then it's a simple matter of choosing Photoshop's Place, after which the logo joins the photo on an independent layer. But it might surprise you what a typical client does and doesn't have. This particular client doesn't know what Illustrator is (a vector-drawing program from Adobe), let alone the whereabouts of the .ai file. The only version of the company name anyone can locate is a scrap of paper that was photocopied, scribbled on, wadded up, and shoved in the back of a filing cabinet for a few years. The electronic illustration—if indeed such a thing ever existed—has disappeared from the database of human memory.

If this sounds like a kooky scenario, let me assure you, it's common as dirt. And just as messy. Which is a problem, right? After all, as the man says, garbage in = garbage out. Fortunately for us, Photoshop realizes that this is the age of recycling. Hence, blend modes to the rescue.

Figure 6-3.

1. *Open two images.* Rescue *Logo scan.tif* and *Shock of yellow.jpg* from the *Lesson 06* folder inside *Lesson Files-PsCM 1on1.* Shown in Figure 6-3, these files include a logo that I printed, crumpled into a ball, threw in the trash, picked back out, and scanned. The bright and vivid photograph comes to us from Satu Hyttilä of iStockphoto. Now to turn grubby logo and dazzling photo into one pristine composition.

2. *Select the logo.* Our first task is to clean up the logo image and make it fit for human consumption. Click the *Logo scan.tif* title bar or tab to make the image active. Then enclose it in a rough selection outline that isolates the logo from the scribblings as follows:

- Press the L key or select the lasso tool from the toolbox.

- Press and hold the Alt key (Option on the Mac) and click around the logo to draw a free-form polygon well outside the boundaries of the MünGrafiks letters. Don't worry about the moon. Release the Alt (or Option) key to complete the logo. Make sure the selection neither cuts into the letters nor includes any of the scribblings, as typified by Figure 6-4.

- Choose the elliptical marquee tool from the rectangular marquee flyout menu. Or press the M key one or more times.

- Shift-drag around the moon to add it to the existing selection. You don't want to scalp away any of the moon's glow, so make sure to give the elliptical outline extra room, as I'm doing in Figure 6-5.

3. *Reverse the selection.* We need to clear away all the gruesome details outside the selection, so choose **Select→Inverse** or press Ctrl+Shift+I (⌘-Shift-I) to surround said details.

4. *Clear the selected area.* Press the D key to confirm the default colors and press Backspace (or Delete) to fill the selection with white, as I've done in Figure 6-6.

Figure 6-4.

Figure 6-5.

Figure 6-6.

PEARL OF WISDOM

By way of a minor FYI: The Backspace (Delete) key fills a selection with the background color—as witnessed here—only when working on the Background layer. (This is a flat file, so the Background layer is all we have.) If you were working on an independent layer, pressing Backspace (or Delete) would clear the pixels and make the selection transparent. To fill a selection with the background color when working on any image layer, press Ctrl+Backspace (⌘-Delete). If you didn't already know that, now you do.

5. *Deselect the image.* We don't need the selection anymore, so press Ctrl+D (⌘-D) to kiss it goodbye.

6. *Increase the contrast for the logo.* The logo should be black on white, not dark gray on rumply light gray. The best way to accomplish that? Choose **Image→Adjustments→Levels** or press Ctrl+L (⌘-L) to bring up the **Levels** dialog box. The spike at the left end of the histogram represents the logo; the hump toward the right is the light gray of the paper. Drag the black triangle to the right of the spike, until the first **Input Levels** value reads 30. Then drag the white triangle to the left of the hump until the third Input Levels value reads 170. When you achieve the effect shown in Figure 6-7, click **OK**.

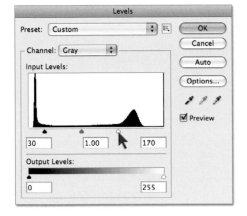

Figure 6-7.

7. *Fix the flakes in the letters.* If you look closely, you'll see a number of small light marks inside the letters—specifically the *ü*, *n*, *r*, *f*, and *k*—where the toner flaked off the paper. Let's get rid of them like so:

- Press the L key to return to the lasso tool.

- Drag around the first of the flakes to lasso it. Then press Shift and lasso the others, producing a selection like the one in Figure 6-8.

- Press Alt+Backspace (or Option-Delete) to fill the selected areas with black.

- Press Ctrl+D (⌘-D) to deselect the image.

Figure 6-8.

Incidentally, no need to worry about the halftone dots around the perimeter of the text. Photoshop will resolve those away automatically when we rotate and scale the logo in future steps.

8. *Fix any schnivels in the background.* Zoom in on the letters and check for any stray *schnivels*—a word my wife coined as an informal synonym for random dust and detritus, which I firmly believe should be a member of the English lexicon—that should be plain white paper. Lasso the schnivels and press Backspace (Delete) to fill them with white.

Don't see anything? Oh, it's there. Try this: Get the magic wand tool. Set the Tolerance to 0 (zero) and turn *off* the Anti-aliased check box (both settings are very important). Then click a white spot in the image. Zoom the image to at least 100 percent and notice all the areas traced by the marching ants. Anything in the area beyond the letters is a schnivel. I've circled the worst offenders in **Figure 6-9**. To select the schnivels and still keep an eye on them, switch back to the lasso tool and then Shift-drag around each area of marching ants that shouldn't be there, taking care not to slice into the letters or halftone dots. (Don't worry about the areas between or inside letters.) Then when everything seems to be selected, press the Backspace (or Delete) key.

Figure 6-9.

9. *Straighten the logo.* Now to rotate the logo so it's horizontal. The best solution is a trick that involves the ruler tool and Image Rotation→Arbitrary:

- Click and hold the eyedropper tool in the toolbox and choose the ruler tool, as shown in Figure 6-10.

- Drag along the bottom of the text to define the baseline that ought to be horizontal. If you like, you can drag the line you just created up to the top of the text to confirm the alignment. If anything's out of kilter, drag one of the endpoints to get the line just right.

- Choose **Image→Image Rotation→Arbitrary**, or if you loaded dekeKeys back in the Preface, press Ctrl+Shift+Alt+R (⌘-Shift-Option-R on the Mac). Photoshop displays the **Rotate Canvas** dialog box, already filled with the angle of rotation required to make the ruler line horizontal, as in Figure 6-11.

- All you have to do is click **OK** and, just like that, Photoshop produces a horizontal logo.

Figure 6-10.

Figure 6-11.

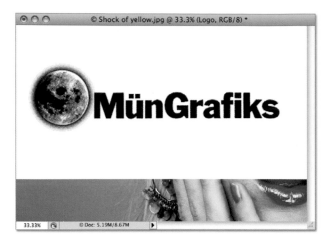

Figure 6-12.

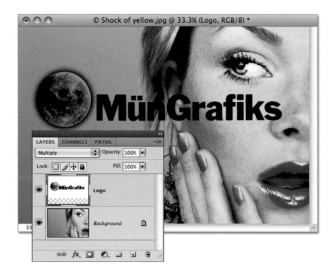

Figure 6-13.

10. *Drag the logo into the yellow photo.* Now that the logo is all cleaned up and straightened out, let's move it into the photograph. Make sure that you can see both images you opened in Step 1 or that you're working in a tabbed window. Ctrl-drag (or ⌘-drag) the entire logo image into the *Shock of yellow.jpg* photo and drop it any old place for now. If you're working in a tabbed window, Ctrl-drag (or ⌘-drag) the logo up to the *Shock of yellow.jpg* tab, wait for Photoshop to switch images, and drop it. Logo and photo now occupy the same composition, as in Figure 6-12.

11. *Name the new layer.* Go to the **Layers** palette, double-click the words **Layer 1**, type the new name "Logo," and press Enter or Return.

12. *Change the blend mode to Multiply.* Right now the logo is obscuring a big chunk of the yellow photograph. To drop out all the whites in the logo layer and have the grays and blacks darken incrementally, go to the top-left corner of the Layers palette and change the blend mode to **Multiply**. The white areas turn transparent, revealing the underlying image, as in Figure 6-13. Keep in mind that this is a nondestructive, parametric adjustment that you can change anytime you like. (For example, to restore the opaque logo, you would set the blend mode to Normal. Don't do it, I'm just telling you.)

When any tool *except* a paint or edit tool—that is, any except those in the second group in the toolbox—is active, you can change the blend mode of a layer by pressing Shift+Alt (or Shift-Option) and a letter key. For example, for Multiply, you press Shift+Alt+M (Shift-Option-M). For Normal, it's Shift+Alt+N (Shift-Option-N).

Out of the 25 blend modes, 23 have keyboard shortcuts. Only the P, Q, and R keys go unused. Some, like those above, make perfect sense. Others make no sense at all. Atop the facing page, Figure 6-14 shows the blend mode pop-up menu with each mode's shortcut letter to the right. (Remember that you press Shift+Alt or Shift-Option with the letter key.) If you're the kind of person who cottons to shortcuts, I recommend you memorize the ones in circles, many of which are thankfully obvious.

Another way to cycle through blend modes from the keyboard is to press Shift+⊡ (plus) to move forward a mode or Shift+⊡ (minus) to back up. It's a great way to experiment. But bear in mind, every change of blend mode is tracked by the history palette and you can burn through your 20 saved history states in nothing flat.

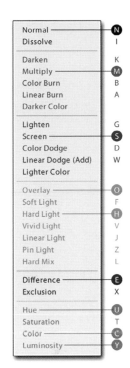

13. *Convert the Logo layer to a smart object.* Obviously, our logo is far too big to fit the composition. So we'll scale it. But just to keep things as flexible as possible, we want to do so in a non-destructive manner. To accomplish this we need to first convert the Logo layer to a *smart object*, which creates a container that allows us to perform modifications without altering the pixel contents of the image.

With the Logo layer active, click the ⛛≡ icon in the top-right corner of the Layers palette and choose the **Convert to Smart Object** command from the flyout menu. Alternatively, if you loaded my dekeKeys shortcuts back in the Preface, you can press Ctrl+⊡ (or ⌘-⊡). Photoshop adds a little 🗗 icon to the Logo layer thumbnail, distinguishing it from other, less smart layers.

Figure 6-14.

PEARL OF WISDOM

By converting the Logo layer to a smart object, you give yourself the latitude to scale, rotate, and otherwise transform the logo as many times as you want without modifying the pixels. Compare this with scaling a standard image layer, which rewrites pixels according to the rules of *interpolation* (that is, pixel averaging). Smart objects come at a price—they increase a file's size by essentially duplicating the layer. But if you so much as think you might want to scale a layer more than once, converting the layer to a smart object—*in advance of scaling it!*—is the only way to go.

14. *Scale the logo.* Choose **Edit→Free Transform** or press Ctrl+T (⌘-T) to enter the free transform mode. Photoshop draws a rectangular bounding box around the logo, complete with eight square handles. Shift-drag one of the corner handles toward the opposite handle to reduce the size of the logo proportionally, as in Figure 6-15. Watch the options bar and reduce the size of the layer until the **W** and **H** values (the ones with the 🔗 between them) read 20 percent or thereabouts. And then press Enter or Return to apply the transformation and smooth out the results.

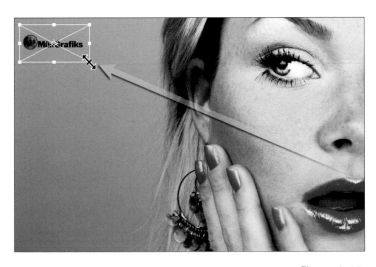

Figure 6-15.

15. *Rescale the logo.* Good news: In reducing the size of the logo, Photoshop has altogether resolved the halftone artifacts around the letters and moon. Bad news: The client's quite reasonable reaction is that the logo is too small. No problem. Just press Ctrl+T (⌘-T) again to revisit the free transform mode. Look to the options bar and notice that the W and H values remember your last settings, which tells you Photoshop is always working from the full-sized original image. Shift-drag the corner handle outward until the **W** and **H** values read 40 percent, and press Enter or Return once again. That's smart objects for you—two transformations in a row and not a pixel harmed in the process.

16. *Move the logo into place.* Ctrl-drag (or ⌘-drag) the logo into a good place in the top-left corner of the image, so that the model's eye directs our attention right to it. Happily, the enlarged logo still looks nice and smooth, even when printed at the relatively low resolution of 244 pixels per inch, as in Figure 6-16.

Figure 6-16.

Figure 6-17.

17. *Open another image.* Let's assume the client loves your work but also wants to be able to set the logo against a photograph with a dark background. No problem. Open the image *Silence in red.jpg*, located in the same *Lesson 06* folder. Gifted to us by Larysa Dodz of iStockphoto, this striking photograph is too dark to accommodate our black logo, as you can plainly see from Figure 6-17.

18. *Drag the logo into the new image.* We can leverage the work we've done so far by moving the logo from the light photo into the dark one. We could do the standard drag-and-drop, but this is an advanced imaging title, so I'm going to show you yet another way:

 • Bring the *Shock of yellow.jpg* image to the front.

- Go to the **Layers** palette and Alt-drag (or Option-drag) the **Logo** layer onto the ▣ icon at the bottom of the palette. Because the Alt (or Option) key was down, Photoshop displays the **Duplicate Layers** dialog box.

- Choose **Silence in red.jpg** from the **Document** pop-up menu. This sends the layer to the newly opened document.

- Click the **OK** button. Then switch to the *Silence in red.jpg* photograph. The Logo layer is ready and waiting, in the same position as it was in the yellow photo, as in Figure 6-18.

Figure 6-18.

19. *Change the blend mode to Screen.* Sure enough, the logo is too dark, so let's make a white version of it. The first step is to change the blend mode. As you know, the Multiply mode causes white pixels in the active layer to disappear and all other colors to incrementally darken the layers below. This time we want an opposite effect—we want to drop out black and make the other colors incrementally lighten. So go to the top-left corner of the Layers palette and change the blend mode to Multiply's opposite, **Screen**. You can likewise press the keyboard shortcut Shift+Alt+S (or Shift-Option-S).

Figure 6-19.

As shown in Figure 6-19, Photoshop makes the logo transparent and the white paper opaque. To get a white logo with transparent paper, we need to invert the logo, as in the next step.

20. *Invert the Logo layer.* Inverting a layer is normally as simple as pressing Ctrl+I (⌘-I). But because the Logo layer is a smart object, we no longer have direct access to its pixels. So we'll need to use an adjustment layer instead:

- Make sure the **Adjustments** palette is up on screen. If it isn't, choose **Window→Adjustments**.

- Click the ▾≡ icon in the top-right corner of the Adjustments palette and check to see if the **Add Mask by Default** command has a check mark in front of it. If it does, choose the command to turn it off. Otherwise, leave it alone.

Figure 6-20.

- Photoshop CS4 arranges its adjustment layers into three rows of icons. Locate the first icon in the third row, ⬚, which represents Invert

- Press the Alt (or Option) key and click the ⬚ icon to bring up the **New Layer** dialog box.

- Change the name of the layer to "Invert" (as opposed to Invert 1 which implies there will be more Invert layers).

- Select the **Use Previous Layer to Create Clipping Mask** check box so the new Invert layer affects the contents of the Logo layer without affecting the Background.

- Click **OK** to create the adjustment layer and invert the Logo layer, producing the result you see in Figure 6-20.

EXTRA ★ CREDIT

If nothing else, you should have a clear idea that Multiply is the blend mode that keeps blacks and drops out whites, while Screen keeps whites and drops out blacks. They are second only to Normal in day-to-day utility, and we'll be seeing them over and over again in all kinds of capacities throughout this book. Those of you who are photographers first and designers second—if at all—may feel like that's enough time spent messing around with a logo, and if so, feel free to skip ahead to "Working with Blend Modes" on page 203. But if do that, you'll rue the day that you missed out on creating a logo that automatically inverts everything behind it. This is where things really gets interesting.

21. *Convert the logo to static pixels.* The technique I'm about to share with you relies on the logo including real transparency, not this phoney baloney transparency created by the Multiply and Screen modes. In other words, the logo has to be opaque and the area around it transparent. That means we have to make a new static version of the logo:

- In the **Layers** palette, click the thumbnail for the **Logo** layer to make it active. Then choose **Normal** from the blend mode pop-up menu or press Shift+Alt+N (Shift-Option-N). The logo appears white on black.

- We need to select the white letters. And the easiest, most accurate way to do that is to—and this may sound strange—convert the entire image to a selection outline. Switch over to the **Channels** palette and Ctrl-click (or ⌘-click) the **RGB** thumbnail. Photoshop selects the highlights and deselects the shadows, as in Figure 6-21. Shortcut enthusiasts can press Ctrl+Alt+2 (⌘-Option-2).

- We've selected the white logo independently of its black background, but we selected a lot of the woman as well. To cut her out of the equation, switch back to the **Layers** palette. Then press Ctrl+Shift+Alt (or ⌘-Shift-Option) and click the thumbnail for the **Logo** layer. Photoshop keeps only that part of the selection that intersects with the Logo layer—which is to say, the white logo and nothing more—as shown in Figure 6-22.

- Click the 👁 icon for the **Logo** layer to hide both the Logo layer and its subordinate Invert effect.

- Still in the Layers palette, click the **Background** layer to make it active. Press Ctrl+Shift+N (⌘-Shift-N on the Mac) to display the **New Layer** dialog box. Name the layer "Reverse Logo" and click **OK** to create the new layer.

- Press Ctrl+Backspace (⌘-Delete) to fill the selection with white.

- Press Ctrl+D (⌘-D) to dismiss the selection.

- You now have a white logo against a photographic background, as you did in Figure 6-20 on the previous page. Why in the world did we go to all this work just to arrive right back where we started? Because now the logo is opaque and the area around the logo is truly transparent, which is the only way to make the logo invert everything behind it.

22. *Change the blend mode to Difference.* Go to the top-left corner of the **Layers** palette once again and change the blend mode to **Difference**, or press Shift+Alt+E (Shift-Option-E). The Difference mode uses the active layer to invert the colors in the layers below. Colors invert proportionally, but white pixels invert absolutely, as shown in Figure 6-23.

Figure 6-21.

Figure 6-22.

Figure 6-23.

Figure 6-24.

23. *Remove the color from the logo.* For this effect to really work right, the logo has to exhibit the highest possible amount of contrast from its background. And that means removing the color and sending most of the logo to black or white. To get rid of the color:

- Go to the **Adjustments** palette and locate the second icon in the second row, ▇, which adds a Hue/Saturation layer.

- Alt-click (or Option-click) the ▇ icon to display the **New Layer** dialog box and name the layer "Desaturate."

- To affect just the Reverse Logo layer and not the Background, turn on the **Use Previous Layer to Create Clipping Mask** check box. Then click **OK**.

- The Adjustments palette now displays the **Hue/Saturation** panel with three sliders, Hue, Saturation, and Lightness. Set the **Saturation** value to –100 percent, as in Figure 6-24.

By all rights, reducing the Saturation value to its absolute minimum should make the logo gray, but it produces no effect whatsoever. That's because Photoshop is desaturating the white logo before applying the Difference mode to it, which is pointless. We want the desaturation to come *after* the Difference mode, as described in the next step.

24. *Turn off Blend Clipped Layers as Group.* Back in the **Layers** palette, double-click the thumbnail for the **Reverse Logo** layer to bring up the **Layer Style** dialog box. Notice the five check boxes in the middle of the dialog box? The second one, **Blend Clipped Layers as Group**, mixes all clipped layers—in our case, the Desaturate layer is clipped inside Reverse Logo—before applying the blend mode, Difference. To bust things up, turn off this check box. Assuming the **Preview** check box is on, the logo immediately turns gray, as in the facing page's Figure 6-25. Click **OK** to accept your change.

25. *Increase the contrast of the logo.* The logo would have more impact if it appeared mostly black or white, with just a few grays in between. We can do that with Levels:

- Click on the **Desaturate** layer to make it active.

- Go to the **Adjustments** palette and click the green ◁ in the palette's bottom-left corner to restore the three rows of adjustment icons. Note the location of the ▲ icon, first row second one in.

- Alt-click (Option-click) the ⛰ icon to display the **New Layer** dialog box. Change the name to "B or W" and turn on the **Use Previous Layer to Create Clipping Mask** check box.

- Click **OK** to create the new Levels adjustment layer.

Figure 6-25.

- The Adjustments palette displays the **Levels** panel. Below the histogram, drag the black triangle to the right of the peak nearest to the middle of the histogram, so the first numerical value reads 185.

- Move the white triangle to the left of the spikes on the right side of the histogram, so the third number reads 235. The MünGrafiks logo turns black-and-white, producing the high-impact inversion effect pictured in Figure 6-26.

Figure 6-26.

Figure 6-27.

Figure 6-28.

26. *Drag the logo around.* Click the **Reverse Logo** layer in the **Layers** palette to once again make it active. To get a sense for how your new reverse logo works, press Ctrl (or ⌘) and drag the logo inside the image window. As demonstrated in Figure 6-27, it might not always look good, but it always inverts the colors of the layer below it.

27. *Move and divide the logo.* For purely aesthetic reasons, I want to split the logo so *Mün* overlaps the red background and *Grafiks* stays inside the model's hair. Ctrl-drag (or ⌘-drag) the logo back to the top-left region of the photo, more or less where it was before. Then do this:

 - Select the rectangular marquee tool.

 - Draw a marquee around the moon and the letters *Mün*. Keep it nice and roomy so you don't cut off anything, as in Figure 6-28.

 - Ctrl+Shift-drag (or ⌘-Shift-drag) the selection to the left so *Mün* resides completely outside the woman's hair.

 - Press Ctrl+D (⌘-D) to release the selection.

 - Press Ctrl (or ⌘) with the arrow keys to nudge the logo into the desired position. Your final result should look something like Figure 6-29.

28. *Save the image.* Press Ctrl+S (⌘-S) and save your altered file to the native Photoshop PSD format with all layers, blend modes, and special blending options intact. Or don't save. Entirely up to you.

Figure 6-29.

Working with Blend Modes

We're almost halfway through the book. And yet, by my reckoning, we've employed just 5 out of the 25 blend modes available from the Layers palette—Normal, Multiply, Screen, Overlay, and Difference. And one, Overlay, we saw only in the context of the brush tool.

It's high time to remedy that oversight. In this only slightly goal-driven exercise, we'll explore all 25 blend modes more or less in the order that they're presented in the blend mode pop-up menu.

We'll be working with the same sample file I showed in Video Lesson 6, "The 25 Standard Blend Modes" (see page 188), and for good reason. I'm hoping that, having witnessed each one of them—albeit in quick succession—they'll seem a little more familiar as you put them to firsthand use. We won't be trying to get much of anything done, mostly just poking around, creating entertaining if transient effects. But you will learn. Over the course of the next 28 steps and 2 sidebars, I'll explain:

Blend mode pop-up menu

- How each of the 25 blend modes works.

- Which modes are essential, which are occasionally handy, and which are just plain frivolous.

- How you might apply a given blend mode in your day-to-day work (if, indeed, the mode has any practical application).

- How some blend modes are calculated.

This last item is somewhat technical. Which is why I've relegated it to a sidebar: "Why Multiply Darkens (Blend Mode Math)" on page 209. If you have a mind for such things, it'll give you a deeper understanding of what's going on. If not, don't worry about it.

That said, here's how to work with blend modes.

1. *Open an image.* Open *Profile with peaks. psd*, located in the *Lesson 06* folder inside *Lesson Files-PsCM 1on1.* You already saw this composition in the video, but here it is again in Figure 6-30. As pictured in the palette, the Background layer contains the woman in profile by the photographer I featured in Lesson 2, Aleksandra Alexis. Above that is the jagged range of icy peaks from Loic Bernard, also of iStockphoto. The peaks are clipped by a layer mask that I created using the pen tool, as I explain in Lesson 11, "The Pen Tool and Paths Palette."

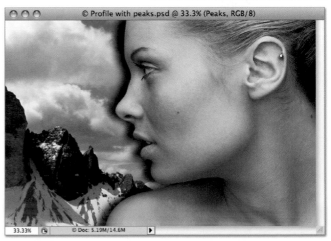

Figure 6-30.

Figure 6-31.

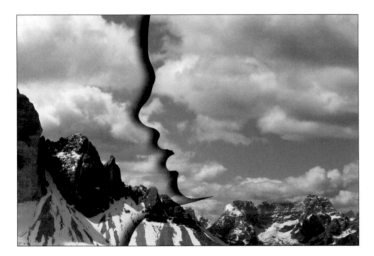

Figure 6-32.

Figure 6-33.

2. *Try out the Dissolve mode.* We know what the Normal mode does. It's not really a mode at all; it merely defers any and all layer interaction to other options such as Opacity and the layer mask. So let's start things off with the next blend mode in the list, Dissolve, which converts translucency to a dot pattern. To see this blend mode at work, we need something blurry, like the shadow beside the face:

- Go to the **Layers** palette. The layer we saw in Figure 6-30 is called Wall, after the fact that the woman casts a shadow onto the peaks, which tells us the peaks must be printed on some kind of wallpaper.

- Make sure the **Wall** layer is expanded, and double-click the **Inner Shadow** effect.

- Near the top of the giant **Layer Style** dialog box, change the **Blend Mode** setting to **Dissolve**. The shadow changes from soft and gradual to what's known as a *diffusion dither pattern*, as in Figure 6-31.

What's it good for? Low-color Web graphics, special effects, little else. We don't want it, so press the Esc key to cancel out.

3. *Turn on the Face layer.* Return your attention to the **Layers** palette and notice that the icy peaks exist on two layers. Another hidden layer called Face covers up the woman's face. Click in the 👁 column to the left of **Face** to turn on that layer, as in Figure 6-32.

4. *Apply the Lighten and Darken modes.* With the Wall layer still active, choose the first of the lighten blend modes, **Lighten**, from the top-left pop-up menu in the Layers palette. Then click the **Face** layer and apply the first of the darken modes, **Darken**. Figure 6-33 shows the result.

Both Lighten and Darken employ shortcuts based on letters from the middle of the words. Lighten is Shift+Alt+G (Shift-Option-G); Darken is Shift+Alt+K (Shift-Option-K).

5. *Compare the two blend modes.* Both Lighten and Darken are either/or modes, meaning that pixels on the affected layers are either left visible or made transparent based on criteria. In the case of Lighten, only those pixels in the Wall layer that are lighter than the pixels in the portrait are visible; with Darken, only those Face pixels that are darker than the pixels below make the cut.

Red Green Blue

Figure 6-34.

PEARL OF WISDOM

The problem with that description is that it doesn't explain what we're seeing in Figure 6-33. Where's that pink in the sky and clouds coming from? Or the vivid green along the woman's jaw? The fact is, Photoshop is applying the blend mode differently to each of the color channels. Focusing strictly on the Face layer, the sky in the Red channel is darker and covers the woman's face, the sky in the Blue channel is lighter so the face shows through, and the Green channel features a little of both. Photoshop takes the independent color channel results shown in **Figure 6-34** and blends them into the full-color composite (Figure 6-33), which exhibits all kinds of unexpected color variations.

6. *Switch to Lighter and Darker Color.* If applying these calculations on a channel-by-channel basis doesn't suit your needs, you can apply them on a composite basis instead:

- With the Face layer active, go to the blend mode pop-up menu and choose the last of the darken modes, **Darker Color**. It is just like the Darken mode, except that it makes pixels visible and invisible on a composite basis, producing more jagged transitions.

- Select the **Wall** layer in the Layers palette and apply the **Lighter Color** blend mode. The result appears in Figure 6-35.

Darker Color and Lighter Color are the only blend modes for which Photoshop does not offer keyboard shortcuts. Small surprise—you'll rarely, if ever, need them.

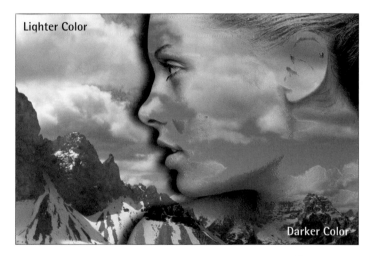

Lighter Color

Darker Color

Figure 6-35.

PEARL OF WISDOM

So far, I haven't offered you much advice for using these blend modes. The simple reason is that, where continuous-tone photographs are concerned, I haven't any. I'll use these modes for fixing screen shots—making a limited range of colors lighter, for example. But there are more effective ways to do this in a continuous-tone image, as we'll see when we discuss luminance blending in the next exercise.

7. *Switch to Screen and Multiply.* Let's migrate our attention to the more useful of the lighten and darken modes, by which I mean Screen, Multiply, and the Dodge and Burn variations.

- Assuming the Wall layer is selected, apply the **Screen** mode or press its by-now familiar shortcut, Shift+Alt+S (Shift-Option-S).

- Select the **Face** layer and set the blend mode to **Multiply**, or press Shift+Alt+M (Shift-Option-M).

- For a cleaner effect, turn off the 👁 icon in front of the word **Effects** assigned to the **Wall** layer (again, in the Layers palette).

At this point, I just want you to sit back and reflect. Prior to this step, we had seen the results of six blend modes in this exercise, five of which —and let's be honest—looked like garbage. Only Normal was any good. Now by way of a refreshing change of pace, we see Screen and Multiply, and they look superb, as evidenced by Figure 6-36.

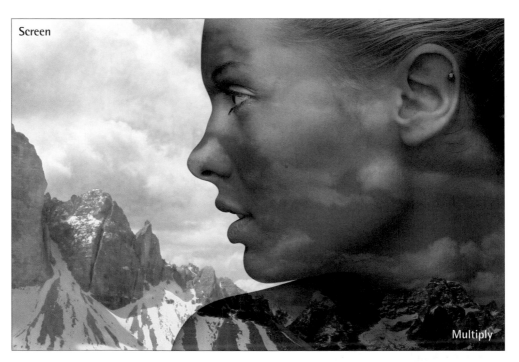

Figure 6-36.

And it's no surprise. Screen and Multiply are designed to provide the smoothest, most organic blends of any of the lighten and darken modes. Some of the other top-performing modes are based on them as well.

Here are a few ways to use and think about Screen:

- Screen is the mode of highlights and glows.

- It shines the light of one image onto another. This is actually literally true. Screen simulates the appearance of two slides placed in two projectors and pointed at the same screen.

- It is the mode used to combine RGB channels—remember Lesson 1?—as well as add one mask to another.

As for Multiply:

- It's the blend mode of smooth, soft, transitional shadows. Both the sun and the moon paint shadows with Multiply.

- Multiply is the blend mode for mixing pigments, which is why it's great for creating ink and marker effects.

- It simulates the effect of taking two transparencies and placing one directly in front of the other on a light table. Two stacked transparencies mean more color for the light to pass through, hence a dimmer and richer composite image.

- Multiply is the mode used to combine CMYK channels as well as subtract one mask from another.

In other words, there's no end to what you can—and what we *will*—do with these blend modes.

8. *Try out Color Dodge and Burn.* Screen and Multiply are circumspect, steadfastly refusing to clip highlights or shadows that weren't already clipped. But there may be times when you want to pull out the stops and go with a mode that delivers more impact. That's when you turn to Dodge and Burn:

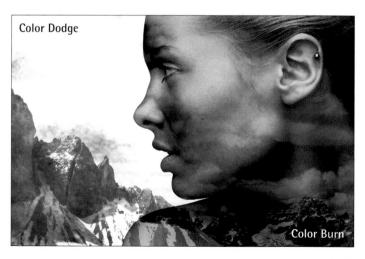

Figure 6-37.

- With the Face layer active, press Shift+⊡ to advance to **Color Burn**. (If the shortcut doesn't work, press Esc and try again.)

- Select the **Wall** layer and press Shift+⊡ for the next lighten mode, **Color Dodge**.

Named for a couple of traditional darkroom techniques, these modes result in hypersaturated, high-contrast blends. Unless one of the images is made up entirely of midtones, you're going to clip colors like crazy. In Figure 6-37, the highlights in the sky have gone stark white, with various areas under the brow, below the jaw, and behind the neck turning pitch black.

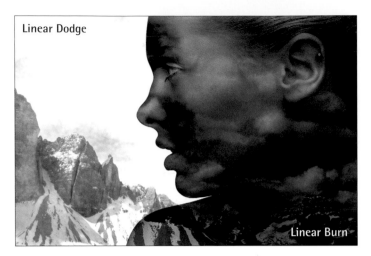

Figure 6-38.

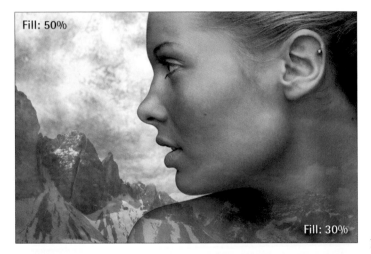

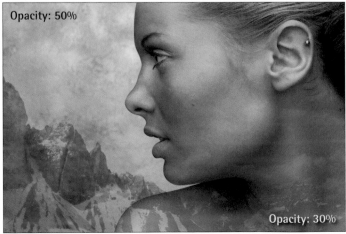

Figure 6-39.

9. **Switch to Linear Dodge and Burn.** For even more radical contrast, but without the overly saturated color values, switch up to the Linear variations of the Dodge and Burn modes:

- The Wall layer is active, so press Shift+⊡ to advance to the next blend mode in the lighten group, **Linear Dodge (Add)**.

- Select the **Face** layer and once again press Shift+⊡ to advance to the next darken mode, **Linear Burn**.

These modes result in still more clipped highlights and shadows. But as shown in Figure 6-38, Photoshop settles the saturation values, so they're more in keeping with those associated with Screen and Multiply. The Linear modes also result in more gradual luminance transitions.

10. **Adjust the fill opacity.** At this point you might assume that the Dodge and Burn modes are about as useful as Lighten and Darken. But these four modes have something special going for them: They respond uniquely to *fill opacity*. Note the Fill value under Opacity in the top-right corner of the Layers palette? Reduce the **Fill** value for the Face layer to 30 percent. Then select the **Wall** layer and make its **Fill** value 50 percent. Figure 6-39 compares the result (top) to those same values applied with the standard Opacity option (bottom). Fill opacity tempers the blend modes while preserving the depth and intensity of the effect. In contrast, Opacity leaves the image looking flat; the effect lacks commitment.

Blend modes are a complex topic and I want to do everything I can to help you make sense of them. Including divulging some of the underlying equations, when they seem of value. When you see one of these equations in this exercise, you're likely to be of one of two minds. It's math, and you just don't get it. Or you're okay with math, but in the process of plugging in your own A and B values, you find that the results just aren't working out right.

If math isn't your thing, forgive the fact that I double-majored in Math and Fine Art in college and skip to the next page. For those of you who are trying to make sense of the equations, I offer this sidebar.

Here's the puzzle: In Step 9, I mentioned how Linear Dodge (Add) lives up to its parenthetical name with its simple equation A+B. Likewise honest is Multiply: A×B. So how is it that adding luminance levels brightens an image but multiplying them darkens the image? Last time I checked, adding numbers makes them bigger and multiplying them makes them bigger still. (See, Mom? My college education paid off after all.)

All blend modes employ simple arithmetic: add, subtract, multiply, and divide. (Most contrast modes include two equations—one for the dark colors and one for the light—but that's as complex as it gets.) As outlined on the right, these operations work out differently depending on how luminance is measured.

If black is 0 and white is 255, division usually produces the smallest results and multiplication the biggest. For example, let's say we have two pixels, a bright one with a luminance level of 204 and a darker one with a level of 76. Were we to divide 204 by 76, we'd get a luminance of about 3, very nearly black. Subtraction would result in 128, medium gray. Addition would deliver 280, which would clip to 255, white. And multiply would produce a level of 15,504, *way* off the charts. Given these number, an image set to Multiply should be very nearly completely white except for the darkest shadows.

But behind the scenes, Photoshop rarely calculates levels from 0 to 255. Instead, it *standardizes* the numbers, keeping black as 0, converting white to 1, and scaling the other levels to decimals in between.

When standardized, a level of 204 becomes 204/255=0.8; 76 becomes 76/255≅0.3. As documented below, multiplication now delivers the smallest result, 0.24, which is a level of 61, darker than either of the contributing pixels. Not surprisingly, that's exactly how Multiply behaves. Subtraction gives us 0.5, or 128 levels. Addition is next, resulting in 1.1, which clips to white. Division delivers the brightest result, 2.67, again clipping white.

Among the blend modes available to the Layers palette, the closest thing to a straight subtraction mode is Difference, which finds the absolute value (positive result) of A−B. So even if we put the darker pixel on top, so that 0.3−0.8=−0.5, Difference lops off the negative sign and calls it 0.5, or level 128. (The Calculations command offers a Subtract mode which does not calculate the absolute value, which we'll learn about in Lesson 10.)

There are no straight divide modes, but a few use division in their equations. Color Dodge is B÷(1−A). Applying Color Dodge to our pixels results in 0.3÷(1−0.8), which is 0.3÷0.2=1.5. That would be 382 levels. Such a thing is not possible, so Photoshop clips it to white.

HOW ADD OUT-BRIGHTENS MULTIPLY

When working with values greater than 1
division usually delivers the smallest results, then subtraction, then addition, ending with multiplication as top dog.

For example:
Let's say we have a couple of numbers, 204 and 76:

DIVIDE	SUBTRACT	ADD	MULTIPLY
204÷76=2.68	204−76=128	204+76=280	204×76=15,504(!)

But blend modes are standardized
meaning that black is 0, white is 1, and 50 percent gray is 0.5.

In the tiny realm from 0 to 1
multiplication and subtraction decrease, division and addition increase.

For example:
Our standardized levels are 0.8 and 0.3:

MULTIPLY	SUBTRACT	ADD	DIVIDE
0.8×0.3=0.24	0.8−0.3=0.5	0.8+0.3=1.1	0.8÷0.3=2.67

Figure 6-40.

The primary purpose of the Fill value is to permit you to access the content of a layer independently of its layer effects. In **Figure 6-40**, for example, I added Inner Shadow and Bevel and Emboss effects to some live text and then reduced the Opacity value to 0 percent. As a result, the letters disappear but the effects remain. Of the 25 blend modes, 17 respond to Fill in exactly the same way as Opacity. I call the others The Fill Opacity Eight. The eight modes respond differently—I would argue better—to the Fill setting than to Opacity. These include the four Dodge and Burn modes, as well as Vivid Light, Linear Light, (the most obvious example) Hard Mix, and Difference. We'll see how each is affected as we come to it.

For those wondering why I call it *fill opacity*, it goes by just that name in the Layer Style dialog box. The option is abbreviated in the Layers palette.

Just as you can change the Opacity value by pressing a number key, you can change the Fill value by pressing Shift with a number. Shift+1 changes Fill to 10, Shift+2 to 20, Shift+0 to 100. (If the blend mode is stuck on, first press Esc.) Press Shift with a two-number sequence for greater control. The only value you have to enter manually is 0.

11. *Revert the image.* We now move from the darken and lighten modes to the contrast modes, each of which uses a pair of equations to lighten the lightest colors and darken the darkest ones. To get a sense for how they work, you'll need to reset the Fill values and reinstate the drop shadow. Simpler just to go to the **File** menu and choose **Revert**, or press the F12 key.

12. *Switch both layers to Overlay.* Reverting the image selects the Wall layer. Choose **Overlay** from the blend mode pop-up menu in the Layers palette or press the shortcut Shift+Alt+O (or Shift-Option-O). Then make the **Face** layer visible, select the layer, and apply **Overlay** to it as well. A shadow divides the two identically blended layers, as in Figure 6-41.

Overlay

Overlay

Figure 6-41.

As we saw in the previous lesson, Overlay is a fantastic blend mode, capable of enhancing contrast without steamrolling over detail. It works by evaluating the luminance of a pixel on the Background layer, the one with the portrait on it. If that pixel is darker than 50 percent gray, Photoshop applies a half-strength Multiply to it. Otherwise, it applies a half-strength Screen.

(Naturally, this happens on a channel-by-channel basis, as is the case with everything we've seen except the Lighter and Darker Color modes.) The "half-strength" component ensures a seamless meeting of the light and dark halves of the image, which happens throughout Figure 6-41, not at the shadowed seam.

13. *Switch to Soft and Hard Light.* The Overlay effect is at once overwhelming the Face layer and insufficiently serving the Wall layer. Fortunately, Photoshop provides more conservative and more aggressive effects in the forms of the Soft Light and Hard Light modes:

 • With the Face layer active, change the blend mode setting to **Soft Light** or press Shift+Alt+F (Shift-Option-F).

 • Select the **Wall** layer and change its blend mode to **Hard Light**, which is Shift+Alt+H (Shift-Option-H).

 The result appears in Figure 6-42. So you have a sense of what you're looking at, the stronger mode, Hard Light, runs the same equation as Overlay, but it decides whether to half-Multiply or half-Screen a pixel based on its brightness in the active layer (not the Background, as with Overlay). That puts the active layer in charge of the effect, hence the Wall layer grows more dominant. Soft Light similarly favors the active layer, but its equation favors gradual transitions, resulting in a more subtle effect.

Figure 6-42.

Vivid Light

Linear Light

Figure 6-43.

Figure 6-44.

Vivid Light
Fill: 60%

Linear Light
Fill: 40%

Opacity: 60%

Opacity: 40%

Figure 6-45.

14. *Switch the Face layer to Vivid Light.* The next two blend modes are combinations of the Dodge and Burn modes, and both produce over-the-top effects. Select the **Face** layer and choose **Vivid Light** from the blend mode pop-up menu. Photoshop applies the equivalent of half-strength Color Burn to the darkest colors and half-strength Color Dodge to the lightest, as Figure 6-43.

15. *Switch to Linear Light.* Press Shift+⊡ to advance to the next blend mode, **Linear Light**. (If the keystroke doesn't work, press Esc, try again.) This is the only contrast mode that does not require two equations; instead, Linear Light halves the darkening power of Linear Burn and doubles its brightening power. (Linear Burn is $A+B-1$; Linear Light is $2A+B-1$, FWIW.) The result is fewer aberrant colors than Vivid Light but slightly more contrast, as in Figure 6-44.

16. *Adjust the fill opacity.* Both Vivid Light and Linear Light are members of The Fill Opacity Eight, which means you may have some success scraping your composition off the ceiling by adjusting the Fill value. Press Shift+4 to reduce the **Fill** value for the Face layer to 40 percent. Then select the **Wall** layer and press Shift+6 to make its **Fill** value 60 percent. Figure 6-45 compares the result (top) to those same percentages expressed as Opacity values (bottom). As in Step 10, Fill preserves the dramatic contours, Opacity flattens the image.

17. *Revert the image.* Touring every single blend mode takes a bit of back-and-forthing. We've moved forth for five steps, now it's time to go back again. To start with another clean slate, press F12 to revert the image.

18. *Switch to Pin Light and Hard Mix.* With the Wall layer active, choose **Pin Light** from the blend mode pop-up menu. Then wake up the **Face** layer's 👁 icon, click on the layer to make it active, and set the blend mode to **Hard Mix**. Figure 6-46 shows the result.

All right, so this is unlike anything we've seen before. Here's what's going on: The Pin Light mode blends the brightest highlights and the darkest shadows from the active layer with the Background using equations that look a lot like Linear Light. The difference is that the wide range of midtones in between go transparent. As with Lighten and Darken, the transitions would be jagged were it not for the crossover between the three color channels. (In many ways, Pin Light is a Lighten/Darken combo.)

Hard Mix interweaves the darkest and lightest details from the active layer and Background to create a black-and-white bitmapped image in each of the three color channels. The channels merge to form the six color primaries—red, yellow, green, cyan, blue, magenta. Black, white, and six primaries—that's all you've got.

19. *Adjust the fill opacity.* Pin Light is an obscure mode that can be useful (on rare occasion) for masking and image analysis. Hard Mix, on the other hand, is the clown prince of The Fill Opacity Eight. If you're working on a PC, press the Esc key to deactivate the blend mode option. Then with the Face layer still selected, press the Shift key and type "35" to change the fill opacity to 35 percent. Figure 6-47 compares the result of a 35 percent Fill to a 35 percent Opacity value. Is that not the biggest transformation you've ever seen? The Fill option makes Hard Mix useful!

20. *Open an alternate image.* Time for a completely different set of blend modes, the inversion modes. For aesthetic reasons, we need a different version of this composition, with the layers in reverse order and the layer effects on the Face layer. Rather than making you do the work, I've done it for you in advance. Open the file called *Face in back.psd*, also found in the *Lesson 06* folder. You'll see the woman's silhouette rendered in clouds, peaks, and sky.

Figure 6-46.

Figure 6-47.

Figure 6-48.

Figure 6-49.

21. *Switch to Difference.* The Face layer should be active. Assuming it is, go to the blend mode pop-up menu in the Layers palette and choose **Difference**, or press Shift+Alt+E (Shift-Option-E). Then make the **Wall** layer visible, select it, and change it to **Difference** as well. The psychedelic result appears in Figure 6-48.

Here's how this mode works:

- The active layer inverts the luminance levels of the layers below it, on a channel-by-channel basis. White inverts all the way, black not at all, and the grays invert to varying degrees in between.

- Any place where a pixel of one color overlaps a pixel of that same color, the two pixels cancel each other and become black. Similar pixels become very dark.

- Any place where the Background layer is very dark, the active layer shows through unscathed. Which is why you can see the original blue sky and clouds in the drop shadow in Figure 6-48.

Obviously, Difference is swell for making groovy space art. But it's even more useful in masking and image analysis. For an example of the latter, read the sidebar "Unearthing JPEG Artifacts with Difference" on page 216.

22. *Switch to Exclusion.* For the sake of comparison, let's swap the region outside the profile for the other inversion mode, Exclusion. With the Wall layer selected, choose the **Exclusion** blend mode, or press Shift+Alt+X (Shift-Option-X).

- As before, the colors on the active layer tend to invert those in back of it.

- The most obvious change: Where a pixel overlaps a pixel of the same color, the composite pixel becomes gray. Press Ctrl+Z (⌘-Z) a couple of times to see the darkest colors change to gray, as in Figure 6-49.

It's easy to write Exclusion off as a tepid, icky-looking stepchild of Difference. But under the hood, the two are very different. Difference's equation is |A–B|, meaning subtract one pixel from another and take the *absolute value*—that is, if the number goes negative, switch it back to positive, which is why you get the radical swings in color pictured in Figure 6-48. Exclusion's equation, (A+B–2AB), is actually more similar to Screen's (A+B–AB). Try this: Press Shift+Alt+S (Shift-Option-S) for Screen and then Ctrl+Z (⌘-Z) to return to Exclusion. The darkest colors change only slightly; the light colors double-back to create an inversion effect.

By the way, I don't expect you to remember a lick of this math. It's all incidental to understanding blend modes. If you get it, great. If not, let it wash over you and be done with it.

23. *Adjust the fill opacity.* Exclusion is not a member of The Fill Opacity Eight, but Difference is. Select the **Face** layer. And then press Shift+4 to lower the **Fill** value to 40 percent. Figure 6-50 compares a 40 percent Fill to the same value rendered as Opacity. For readers of Cormac McCarthy's Pulitzer Prize-winning *The Road*, this is what that world must look like.

Figure 6-50.

One of the great technical uses for the Difference blend mode is finding the difference between two similar images. For example, in creating the figures in this book, sometimes I wanted to separate a selection outline from a screen capture. I'd shoot one image with the outline and another without, and then apply the Difference blend mode, and everything *except* the outline turned black.

In this sidebar, I'll show you how to compare an image saved with high-quality JPEG compression to one saved with low-quality compression. Open *Shock of yellow.jpg* and *Low quality JPEG.jpg*, both located in the *Lesson 06* folder inside *Lesson Files-PsCM 1on1*. I saved the first with Photoshop's highest quality setting, 12 (which is how I saved all but one of the JPEG files included with this book) and the second with a low Quality setting of 4 (that's the exception). Such a low setting makes the file much smaller on disk. It's hard to see any difference between the two, even when zoomed in to the most obvious detail in the image, the eye. In print in particular, the two images are indistinguishable (below). But the low-quality image is compromised in ways that will become very apparent if you sharpen or otherwise modify the image in earnest.

JPEG Quality 12

JPEG Quality 4

Let's say you're painfully aware of the downsides of low-quality JPEG compression and you're trying to impress upon a client to stop using it. But he's skeptical. I mean, if you can't see the difference in high-end commercial output between a setting of 12 and 4, what's with all the whining?

Here's what you do. Use the move tool to drag one image onto the other. Difference is a *symmetrical mode*, meaning it doesn't matter who's on top. However, it's very important that you Shift-drop the image into place so the two photographs are perfectly aligned.

In the **Layers** palette, change the blend mode to **Difference**, or just press Shift+Alt+E (Shift-Option-E). At first glance, it may appear that the image has gone completely black, which would indicate no differences whatsoever. The differences are there; they're just dim. Go to the **Adjustments** palette and click the 🔺 icon in the first row to add a **Levels** adjustment. Change the third value under the histogram to 20 levels to dramatically expand the range, and then press Shift+Tab to back up to the second value and change it to 2.00. Press Enter or Return. The result appears below. Only those pixels that are completely black have not changed. The light pixels have changed the most. According to the Histogram palette, more than 84 percent of the pixels in this image have changed, and all for the worst.

If your client remains unimpressed, say something pithy like, "Oh for Pete's sake, grow a brain!" But say it with your inside voice. That kind of charming repartee doesn't always win you repeat business.

24. *Switch images and revert.* Time for a completely different set of blend modes, the component modes. Switch back to the *Profile with peaks.psd* image. And then press the F12 key to return to base camp.

25. *Switch to the Hue mode.* Select the **Face** layer and make it visible. (For the moment, we'll leave the Wall layer as is.) Then choose **Hue** from the blend mode pop-up menu, or press its shortcut, Shift+Alt+U (Shift-Option-U). Figure 6-51 shows what it looks like to mix the hues from the Face layer with the saturation and luminance of the Background layer. Bear in mind that the Face layer actually contains colors from the peaks image, hence the sky blues. Meanwhile, the underlying profile image is intensely saturated, hence the low-saturation clouds suddenly bursting with yellow and orange. And, of course, the luminance of the woman shows through. Hue is great for covering up wandering skin tones, as we'll see in a later lesson.

Figure 6-51.

26. *Switch to the Saturation mode.* To see that other critical ingredient of color, choose the **Saturation** blend mode or press Shift+Alt+T (Shift-Option-T). The vivid flesh we're seeing in Figure 6-52 is a function of the highly saturated colors in the sky; the grays are a gift from the low-saturation clouds. Between you and me, Saturation is the least of the component modes. But remember that it's there; you may find a use for it every blue moon.

Figure 6-52.

Figure 6-53.

FURTHER INVESTIGATION

To learn still more minutia about blend modes—including how to combine the effects of multiple blend modes, adjust the appearance of clipped layers, and assign blend modes to smart filters—go to *www.lynda.com/dekeps* and start up your 7-Day Free Trial Account. Of special interest is Chapter 10, "Advanced Blending," in my exhaustive series *Photoshop CS3 Channels and Masks* (which is equally applicable to Photoshop CS4).

27. *Switch to the Color mode.* Choose the **Color** mode or press Shift+Alt+C (Shift-Option-C). If you're wondering where this mode fits into the HSL model, *color* is the combined effort of hue and saturation working together. Which means we see the vivid blues of the sky and the low-saturation grays of the clouds mixed with the luminance levels of the woman's face, as in Figure 6-53. Color is the mode for taking the detail from one image and imbuing it with the color of another, and unlike so many of the other blend modes—which have narrow purposes—it nearly always produces attractive results.

28. *Change the Wall layer to Luminosity.* Let's wrap things up with the last of the 25 blend modes, Luminosity. Select the **Wall** layer and choose the **Luminosity** mode or press Shift+Alt+Y (Shift-Option-Y—hey, it's the last mode so it gets the last letter of the blend mode's name). The exact opposite of Color, Luminosity blends the peaks from the Wall layer with the beige of the Background, as in Figure 6-54.

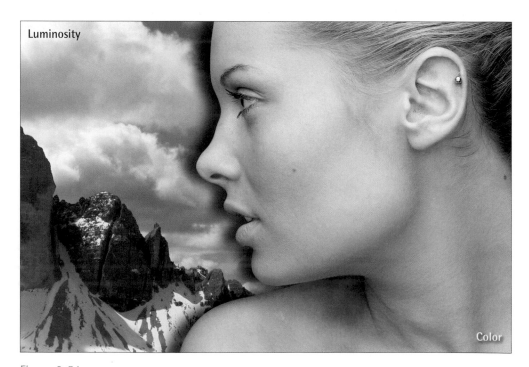

Figure 6-54.

Luminance Blending

Not all blending is a function of blend modes. And not all masking requires a selection outline or an alpha channel. A case in point is *luminance blending*, which allows you to drop out luminance levels in the active layer or force the display of levels from the composite view of the layers below. If that was a bit much to absorb in one sentence, think of it this way: Luminance blending gives you specific control over the visibility of shadows and highlights in a layer.

In this exercise, I'll show you how to make several hundred tendrils of lightning burst forth from a roiling cloud formation, all without a single visit to the Channels palette or quick mask mode. I should mention that this particular technique is the brainchild of artist Greg Vander Houwen, based on a contribution he made years ago to my now out-of-print *Photoshop Studio Secrets*. Although you can employ luminance blending in countless ways, this remains the best demonstration I've seen. I hope you agree.

1. *Open two images.* Open *Big cloud.jpg* and *Lightning.jpg*, both located in the *Lesson 06* folder inside *Lesson Files-PsCM 1on1*. Shown in Figure 6-55, the clouds come to us from Don Wilkie; the lightning is a detail from a much larger image from a designer who goes by the name Soubrette. Both photographers are with iStockphoto. Whatever our names and whoever we're with, our job is to lace the lightning into the clouds in a way that makes you swear it was shot that way.

2. *Copy the lightning.* We've been doing so much dragging and dropping in this book, you might think I have an aversion to the clipboard. I don't, and just for the sake of variety, I say let's use it. Bring the image *Lightning.jpg* to the front. Then press Ctrl+A, Ctrl+C (⌘-A, ⌘-C) to copy the entire image to the clipboard.

3. *Paste the lightning.* Switch over to the *Big cloud.jpg* image and press Ctrl+V (⌘-V) to paste the lightning into this image. Pasting into a deselected image produces the same effect as Shift-dropping an image with the move tool—that is, it either centers the image or registers it. These two images have the same pixel dimensions, so the lightning precisely aligns to its new environment.

Figure 6-55.

4. *Rename the lightning layer.* Double-click the words **Layer 1** in the **Layers** palette, replace them with "Lightning," and press Enter or Return.

5. *Apply the Screen blend mode.* If you've been absorbing the information so far, you might have a sense of what our first blending step should be. The lightning is bright, the reddish sky is dark. We want to keep the lightning and drop out the sky. So press Shift+Alt+S (Shift-Option-S on the Mac) to apply the **Screen** mode.

 Pictured in Figure 6-56, the result is good but by no means perfect. The lightning is showing up quite nicely. But Screen lightens *everything*, light and dark colors alike. Only absolute black goes completely transparent. So the dark red sky results in a hazy ambient fog. To make matters worse, Screen has enhanced the color banding already evident in the sky. The other lighten modes will either make the effect look choppier or brighter still. Screen is the best first step, but it needs help from luminance blending.

Figure 6-56.

6. *Bring up the Layer Style dialog box.* In Photoshop, luminance blending takes the form of the This Layer and Underlying Layer slider bars in the Layer Style dialog box. Double-click the **Lightning** layer to bring up the **Layer Style** dialog box. Or if you prefer to work by command, click the *fx* icon at the bottom of the Layers palette and choose **Blending Options** from the pop-up menu.

7. *Drop out the dark sky colors.* We're interested in the two gradient slider bars at the bottom of the dialog box. The first one, This Layer, permits you to make the darkest or lightest colors in the layer transparent. We want to drop out the dark colors of the sky, so drag the black **This Layer** slider triangle to the right. As you do, watch the darkest colors in the sky fade away. Keep dragging until the first value above the slider bar reads 175. This tells Photoshop to make all pixels with luminance levels of 175 or darker transparent, as in Figure 6-57.

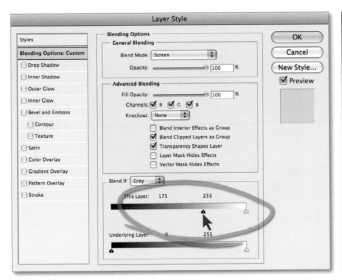

Figure 6-57.

8. *Soften the transitions.* If you zoom in on the image, you'll see the fatal flaw with our implementation so far. As seen in Figure 6-58, the edges of the individual lightning bolts contain all varieties of fringing, and they're jagged as all get out.

In the old days, the equivalent of this dialog box offered a Fuzziness value. It worked just like the one in the Color Range dialog box, permitting you to introduce into the edges naturally occurring softness between opacity and transparency. Now that feature is addressed in a better but hidden fashion. Look closely at the black and white slider triangles. Notice the tiny vertical line in the middle, as if the triangle might be broken in half. Alt-drag (or Option-drag) on either side of the line to pull the two halves of the triangle apart.

Figure 6-58.

For the lightning, I want you to Alt-drag (Option-drag) the left half of the black triangle to the left until the first This Layer value reads 85/175. Now anything darker than a level of 85 is transparent, anything lighter than 175 is opaque, and anything inside that range gradually fades between the two extremes. The result is a much smoother transition, as in Figure 6-59.

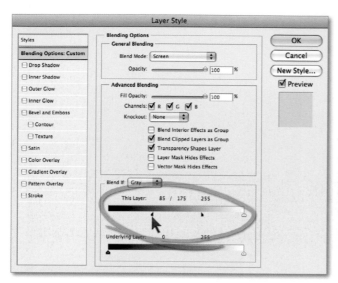

Figure 6-59.

9. *Force through the cloud colors.* The luminance blending sliders allow you to not only drop out colors in the active layer but also reveal colors in the underlying layers. Try dragging the black **Underlying Layer** slider triangle to the right and watch the darkest colors from the cloud image, which also exist in the sky, cut their ways through the lightning.

That turns out not to be the effect we want, so return the black triangle to 0. Then drag the white triangle to the left until the second Underlying Layer value reads 160. The lightest portions of the clouds begin to envelope the lightning.

10. *Soften the transitions.* Press Alt (or Option) and drag the right half of the white triangle to the right until the second Underlying Layer value splits to 160/185, as in Figure 6-60.

11. *Apply your modifications.* Click **OK** to close the Layer Style dialog box. The resulting composition—complete with threads of lightning finer than strands of hair, wandering in and out of the clouds and even appearing to cast light on a few of the cloud's roiling surfaces—appears like a mighty storm in Figure 6-61 atop the facing page.

Figure 6-60.

Figure 6-61.

12. *Save the image.* If it was possible to save over the original image, I'd tell you to do it. After all, you haven't made a single permanent change to the Lightning layer. Everything you've done you can undo or modify any time you like just by revisiting the Layer Style dialog box. But this is a JPEG file. So press Ctrl+S (or ⌘-S) to display the **Save** dialog box, make sure **Format** is set to **Photoshop**, name your new image "Electric storm.psd," and click the **Save** button. Who'd have guessed something this elaborate could be pulled off so easily?

Using Blending to Reconcile Images that Really Don't Go Together

So far we have seen a variety of ways to create layered compositions and bypass masking using blend modes and other blending functions. But blend modes and masking are in no way mutually exclusive. In fact, the two become more powerful when they combine forces.

In the last exercise of this lesson, we'll employ yet another combination of blending options to take a young woman from a stock photo and place her against an image I shot of my own backyard. I'll also

introduce you to the Match Color command, which lets you match the color of one image to that of another. With any luck, you'll be amazed and inspired by the final composition.

1. *Open two images.* Open both *PhotoSpin girl.tif* and *Backyard blur.jpg*, located in the *Lesson 06* folder inside *Lesson Files-PsCM 1on1.* Courtesy of the good folks at the PhotoSpin image library, the first image features a young woman set against a colorful but indistinct background. The second is an intentionally blurry photo shot by yours truly. How'd I get that amazing out-of-focus effect? By shooting the image out of focus. Both images appear in Figure 6-62.

Figure 6-62.

By now, you've probably come to recognize my obsession with showing you new ways to accomplish the same darn thing. I do it for the sake of variety and so you can explore as much of Photoshop in the little time we have together as possible. In the next few steps, we'll see yet another way to combine two images into a single composition that enables us to express an alpha channel as a flexible layer mask. Make sure the photograph of the young woman is in front, and let's begin.

2. *Load the mask as a selection.* The only way to move image and mask in one operation is to combine them before sending them on their way. So go to the **Channels** palette and notice that I've included an alpha channel called Model. I created this mask in the very same way I made the one in Lesson 5—by duplicating a color-bearing channel (in this case Blue), enhancing the contrast with Levels, and painting with the brush tool set to the Overlay mode. To assign this mask to the image, you need to convert it to a selection outline. So Ctrl-click (or ⌘-click) the **Model** channel to load up the ants.

3. *Convert the flat image to a layer.* Go to the **Layers** palette. I'd like you to click on the ▢ icon at the bottom of the palette, but it's dimmed because you can't assign a mask to the Background layer. To convert the image to a layer, double-click the Background layer, name the layer "Girl," and click **OK**.

4. *Add a layer mask.* Now you can assign the mask to the layer by clicking the ▢ icon at the bottom of the Layers palette. Photoshop converts the selection outline to a layer mask, thus turning everything but the model transparent, as in Figure 6-63.

5. *Copy the young woman into the blurry background.* Now to move layer and mask into their new home:

- Right-click (or Control-click) in the empty portion of the **Woman** layer to the right of the mask thumbnail and choose **Duplicate Layer** from the shortcut menu to bring up the **Duplicate Layer** dialog box.

- Choose **Backyard blur.jpg** from the **Document** pop-up menu. Photoshop automatically resets the layer name from Girl Copy to Girl.

- Click **OK** to close the Duplicate Layer dialog box and add the layer to the photo of my backyard.

6. *Switch to the backyard photo.* Click the title bar or tab for *Backyard blur.jpg* to bring that image to the front. Sure enough, the composition now contains the Girl layer and mask, as in Figure 6-64.

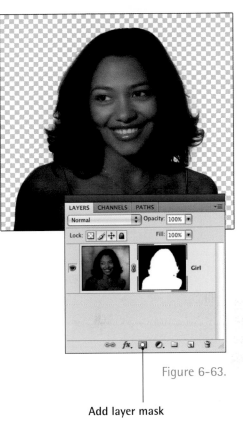

Figure 6-63.

Add layer mask

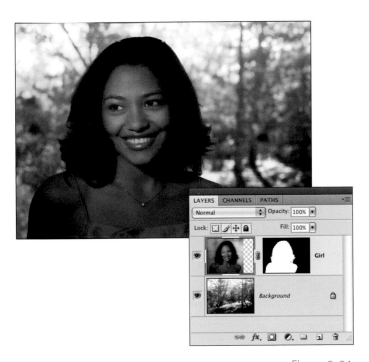

Figure 6-64.

7. *Match the young woman to her background.* It's one thing to have independent foreground lighting; photographers use strobes and light kits when shooting outdoors all the time. But it's another to have a teen with a disco purple color cast set against a natural amber backdrop. To make the images match up, choose **Image→Adjustments→Match Color**, which displays the **Match Color** dialog box. Available strictly as a

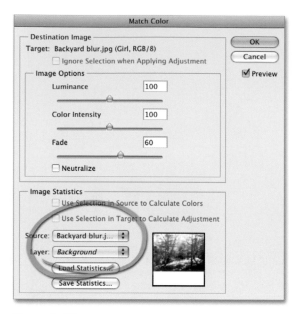

Figure 6-65.

static color adjustment, this command lets you bring the colors in one layer in line with those in another. Here are my recommended settings:

- Photoshop needs a destination and a source for its color modification. The destination is the image you want to change, the source is the image you want to match. Photoshop already knows the young woman is the destination because it was active when you chose Match Color. But you have to tell it a source. Click the **Source** option in the bottom-left corner of the dialog box and choose **Backyard blur.jpg**, the very image you're working on.

- Next set the **Layer** to **Background**, as circled in Figure 6-65. This tells Photoshop to gather the source colors from the amber backdrop. Suddenly, a whole new color scheme takes over our young lady.

- Increase the **Fade** value to 60 percent to create the ideal mix of foreground and background colors.

- Click the **OK** button to invoke your changes.

8. *Fix the remaining aberrant colors.* The girl matches her background very nicely, but I would still like to finesse a couple of colors. The blue cast in the whites of her eyes don't look right. And I want to shift the colors of her top, which are currently too magenta.

- Choose **Image**→**Adjustments**→**Hue/Saturation** or press Ctrl+U (⌘-U) to bring up the **Hue/Saturation** dialog box.

- Notice the 🖑 in the bottom-left corner of the dialog box? New to Photoshop CS4, this *target adjustment tool* allows you to edit colors directly by dragging inside the image window. Click it to make it active.

- You can now drag on a representative color in the image window to change the saturation of that group of colors. Drag to the right to increase the saturation values, drag to the left to decrease them. In this specific case, I want you to click in the blue area of the eye and drag to the left. Inside the Hue/Saturation dialog box, the unnamed pop-up menu below the Preset option should show that you're modifying Cyans. (If not, press Ctrl+Z or ⌘-Z and try again.) Drag until the **Saturation** value descends to −100 percent, as illustrated in Figure 6-66 on the facing page. The whites of the eyes become a neutral light gray.

- The target adjustment tool has another behavior that lets you modify the hue assigned to a range of colors. Press the Ctrl (or ⌘) key and drag inside a magenta area of her top. This time, drag to the right until the **Hue** value reaches +35 degrees. Photoshop warms the colors, making the blouse more of a rose color.

- Once you feel like you've sufficiently mastered the target adjustment tool and everything it has to offer, click the **OK** button to accept the revised colors.

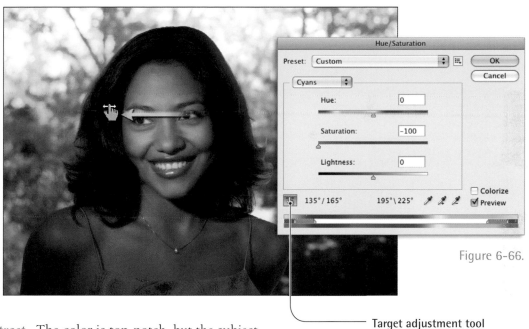

Figure 6-66.

Target adjustment tool

9. *Increase the contrast.* The color is top-notch, but the subject lacks the contrast of her background. We need her to rise to the occasion and be an active member of this composition. Here's how to make that happen:

- Choose **Image**→**Adjustments**→**Levels** or press Ctrl+L (⌘-L) to bring up the **Levels** dialog box.

- Drag the black point slightly to the right so the first value under the histogram is 5. Move the white point to the left until the third value becomes 235.

- To finish things off, click in the middle option below the histogram. And press the ↑ key a few times to nudge the value up to 1.04. The warmer, stronger foreground image appears in Figure 6-67 on the next page.

- Click **OK** to accept the enhanced image.

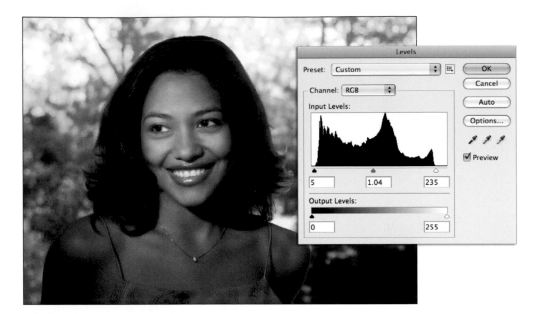

Figure 6-67.

Figure 6-68.

Figure 6-69.

Now that we've matched the colors inside the girl to her background, we need to work on the edges—the perimeter where the foreground meets the background. We'll address the edges using a series of transitional layers that takes us from the background to the foreground in stepped phases. Specifically, we'll create three versions of the Girl layer, each with a different blend mode and a slightly adjusted layer mask.

10. *Apply the Multiply blend mode.* We'll begin with the first transitional layer. As in the previous lesson, this model has dark hair. Assuming a selection tool is active, burn the hair into the background by pressing Shift+Alt+M (Shift-Option-M). Or choose the **Multiply** blend mode. The perimeter of the hair blends naturally with its background, as in Figure 6-68.

11. *Rename the layer according to its function.* To help keep track of this and the coming layers, double-click the word **Girl** and change its name to "Multiply."

12. *Create a Luminosity layer.* It's one thing to blend into your background, it's another to be a chameleon. What's needed is an in-between layer that reestablishes the luminance levels in the skin and face. Press Ctrl+Alt+J (⌘-Option-J) to bring up the **New Layer** dialog box. Enter "Luminosity" for the **Name**, change the **Mode** option to **Luminosity**, and click **OK** to produce the result shown in Figure 6-69.

13. *Select the layer mask.* In restoring the good luminance information, we've also brought back the bad edges. The trick is to integrate the multiplied edges into the restored composition by choking the layer mask.

First we need to make the mask active. Click the mask thumbnail for the **Luminosity** layer or press Ctrl+⌷ (⌘-⌷) to select the layer mask.

14. *Choke the layer mask.* To scoot the edges of the layer mask inward, you need to expand the minimum luminance level, black. And you do that by choosing **Filter→Other→Minimum**. Set the **Radius** value to 10 pixels and click **OK** to reveal 10 pixels of the Multiply layer, as in Figure 6-70.

Figure 6-70.

15. *Blur the layer mask.* No one's going to buy that sudden transition between the Luminosity and Multiply layers. To soften it away, choose **Filter→Blur→Gaussian Blur**. (If you loaded my dekeKeys shortcuts in the Preface, you can press Shift+F7 as well.) Set the **Radius** value to 20 pixels—twice the Minimum Radius value—and click **OK**. The result appears in Figure 6-71.

Figure 6-71.

16. *Fix the halo around the woman.* If you zoom in on the teen's shoulders, you may notice that in addition to blurring the edges inward, we've also blurred them outward. The result is a *bounce*, which is an unintended region of brightness that extends from the image like a dim corona. (Think big diffused halo.) It's one of those things that may not be obvious at first—perhaps you can just make it out in Figure 6-72?—but could turn into a dead giveaway in the final composition.

We're going to kill the bounce by loading the original layer mask and using it to clip the edge. Here's what I want you to do:

- Ctrl-click (or ⌘-click) the thumbnail for the layer mask associated with the **Multiply** layer to load that mask as a selection outline.

Figure 6-72.

Figure 6-73.

Figure 6-74.

- Press Ctrl+Shift+I (⌘-Shift-I) to reverse the selection so the region outside the girl is selected and the girl herself is not.

- Confirm that the layer mask for the Luminosity layer is still active. Then press the D key to make the background color black.

- Press the Backspace (or Delete) key to fill the selected area of the layer mask with black. This blocks the portion of the Luminosity layer responsible for the bounce effect, as in the magnified Figure 6-73. It's subtle, I know, but I'm telling you, it'll make a positive difference in our final blended photograph.

- Press Ctrl+D (⌘-D) to abandon the selection.

17. *Create a Normal version of the layer.* We have now successfully implemented two transitional layers. But transitional layers are nothing more than supporting actors in the final composition. We still need to regain the natural, organic colors associated with the foreground image (or at least the natural, organic colors that we modified so naturally and organically with the Match Color, Hue/Saturation, and Levels commands).

To bring back those oh-so-natural, organic-as-all-get-out colors, press Ctrl+Alt+J (⌘-Option-J), enter "Normal" for the **Name** value, change the **Mode** option to **Normal**, and click the **OK** button. The reinstated normalcy appears in Figure 6-74.

18. *Select the layer mask.* Each new version of the layer brings with it the positive contribution of restored color and luminance information as well as the negative contribution of bad old edges. And again, the solution is to edit the layer mask. Click the mask thumbnail for the **Normal** layer or press Ctrl+⬚ (⌘-⬚) to activate the mask.

19. *Blur the layer mask.* No need to choke the mask this time around. A simple blur should do the trick quite nicely. Assuming you haven't gone and chosen some other filter while I wasn't looking, Gaussian Blur is

now listed as the first command in the Filter menu. (You can confirm that fact or just take my word for it.) To revisit that first command, press Ctrl+Alt+F (⌘-Option-F on the Mac). Photoshop displays the **Gaussian Blur** dialog box, complete with your last Radius value of 20 pixels. Change the **Radius** to 40 pixels and click the **OK** button to further blur the already blurry edges around the Normal layer.

20. *Fade the Gaussian Blur effect.* Guassian Blur is an equal-opportunity blurrer. That is to say, it blurs both inward and outward. As was the case for the Luminosity layer, blurring the layer mask for the Normal layer has resulted in a brightness bounce, but this time one more pronounced than before, as witnessed in Figure 6-75.

Figure 6-75.

But while the problem is worse, the solution is more straightforward. Prior to the previous step, the mask had the edges we needed to prevent the bounce. All we need to do is bring those edges back:

- Choose **Edit→Fade Gaussian Blur** or press Ctrl+Shift+F (⌘-Shift-F) to bring up the **Fade** dialog box.

- We want to blur inward but not outward. That means blurring into the white area of the mask and not the black area. In other words, we want Gaussian Blur to darken the mask and not lighten it. So set the **Mode** option to the when-in-doubt darken blend mode, **Multiply**.

- You should notice the brightness surrounding the young woman drop precipitously. Which is a good thing, as evidenced in Figure 6-76. To accept your modification, click **OK**.

So why didn't we just fade the Gaussian Blur filter the time before instead of going through the load-and-reverse process documented in Step 16? Because in the case of the Luminosity layer, we applied two filters, Minimum and Gaussian Blur. The Fade command can accommodate just one operation, hence it could have reduced the effects of Gaussian Blur but not Minimum; we needed both.

Figure 6-76.

Without Multiply

Without Luminosity

Without Normal

Figure 6-77.

21. *Test the layers.* To get a sense for how the layers in your composition are working together, hide each layer and then turn it back on. Figure 6-77 shows a detail from the image with one of each of the transitional layers turned off. Without the Multiply layer, the edges disappear. Without Luminosity, we lose detail and the edges grow too dark. And without Normal, we lose the important color information. All three layers are required to produce the final effect.

And what is the final effect? If Figure 6-78 is any indication, a young lady who looks like she's spent her whole life growing up against her new background. A little bit of masking and a whole lot of blending add up to a credible composition.

Feel free to save your finished artwork to the native PSD format. And welcome to the exclusive realm of people who know more than they ever wanted to about blending and compositing in Photoshop.

Figure 6-78.

WHAT DID YOU LEARN?

Match the key concept in the numbered list below with the letter of the phrase that best describes it. Answers appear upside-down at the bottom of the page.

Key Concepts

1. Parametric operations
2. Blend mode
3. Schnivel
4. Smart object
5. Interpolation
6. Blend Clipped Layers as Group
7. Dodge and burn
8. Standardized levels
9. The Fill Opacity Eight
10. Luminance blending
11. Target adjustment tool
12. Transitional layers

Descriptions

A. This internal mechanism for expressing luminance—where 0 is black, 1 is white, and shades of gray are decimals—is necessary to calculate blend modes.

B. A class of features based on numerical parameters and other settings that you can apply and modify anytime you like.

C. When turned on, this check box prevents a blend mode assigned to a layer inside a clipping mask from affecting anything outside the mask.

D. Multiple copies of a single image, subject to different blend modes and masks, for the purpose of creating a credible composition.

E. The destructive averaging of pixels that occurs when you scale, rotate, or otherwise transform a static image.

F. A means for hiding and revealing pixels based on their brightness using the This Layer and Underlying Layer slider bars.

G. A silly word for a serious problem that confronts scanned line art and is best cleaned up with the help of the magic wand.

H. Best exemplified by the Hard Mix mode, these blend modes are uniquely affected by a little-known option that's designed to make a layer transparent while keeping its effects opaque.

I. New to Photoshop CS4, this tool allows you to modify the saturation and hue of colors by dragging directly inside the image window.

J. This setting mixes the active layer with the composite view of all the layers below it according to one or more mathematical operations.

K. Based on traditional darkroom techniques, these are the names given to features that lighten and darken, respectively, throughout Photoshop.

L. This container allows you to perform certain kinds of modifications without altering the contents of a layer, thereby delivering nondestructive results.

Answers

1B, 2J, 3G, 4L, 5E, 6C, 7K, 8A, 9H, 10F, 11I, 12D

MASKING LAYERS

WHILE THE POWER of masking is quite impressive, you don't realize its full potential until you combine it with a more common function in Photoshop: layers. Layers are a critical component of the incredible flexibility of Photoshop. They enable you to mix and match a variety of images—not to mention adjustment layers—to change the appearance of your images.

Every layer carries with it a *transparency mask*, which defines the boundaries of the layer—that is, which pixels are opaque and which are transparent. You can't see or edit transparency masks directly in Photoshop, but they are always there, ready for you to use as another way to mask elements of an image. By way of example, you can load the transparency mask of any layer as a selection at any time—just press Ctrl (⌘ on the Mac) and click a thumbnail in the Layers palette.

The Many Kinds of Layer Masks

Transparency masks are just the beginning, however. You also have *layer masks*, which allow you to mask away portions of a layer on-the-fly or control the area affected by an adjustment layer. A layer may include up to two masks, a conventional pixel-based layer mask as well as a path-based *vector mask*. (For more information on the latter, see Lesson 11, "The Pen Tool and Paths Palette.") You can use a *clipping mask* to house the contents of one or more layers inside another layer. And you can use *knockouts* to bore temporary holes inside layers. With the exception of transparency masks, these various layer-based masks are temporary, so you always have access to your original pixels. As diagrammed in Figure 7-1, layer, thy name is flexibility.

In this lesson we'll focus exclusively on the many ways to mask layers. After all, layer masks are where much of the power of masking resides. Along the way you'll employ a variety of techniques for masking layers,

Start with these images...

...and through the use of layers, layer masks, and clipping masks...

...arrive at these results.

the jellybricks boltback

Guy's back istockphoto.com/Brainsil, rusty rivets istockphoto.com/Fitzer

Figure 7-1.

ABOUT THIS LESSON

This lesson is all about the various ways to assign masks to specific layers, whether for the purpose of mitigating an effect or color adjustment, introducing translucency, or bringing different people into a common scene. You'll learn how to:

Project Files

Before beginning the exercises, make sure you've copied the lesson files from the DVD, as directed in Step 3 on page xv of the Preface. This should result in a folder called *Lesson Files-PsCM 1on1* on your desktop. We'll be working with the files inside the *Lesson 07* subfolder.

- Use a layer mask to simulate the appearance of rapid and decisive movementpage 237

- Mask a pair of adjustment layers to hone in on the background and highlights in an image page 243

- Introduce translucency to create a natural interaction between foreground and background. page 249

- Align and combine people in a group shot.page 258

- Combine the effects of multiple masks assigned to a single layer with a knockout mask.page 267

Video Lesson 7: Introducing Layer Masks

Photoshop CS4 introduces a new palette called the Masks palette. While not essential to the task of creating and editing layer masks, it can be quite helpful, permitting you to apply powerful selection functions, such as Color Range and Refine Edge, to layer masks as well as make temporary modifications. And the Masks palette happens to be exclusively applicable to layer masks.

To learn how to work with the new feature, watch the seventh video. Insert the DVD, double-click the file *PsCM Videos.html*, and click **Lesson 7: Introducing Layer Masks** under the heading **The Lighter Side of Masking**. This 14-minute, 25-second movie touches on the following shortcuts:

Operation	Windows shortcut	Macintosh shortcut
Color Range	Ctrl+Shift+Alt+O*	⌘-Shift-Option-O*
Mask Edge/Refine Mask	Ctrl+Alt+R	⌘-Option-R
Hide marching ants from inside dialog box	Ctrl+H	⌘-H
Add a layer to a clipping mask	Ctrl+Alt+G	⌘-Option-G
Switch between image and layer mask	Ctrl+2, Ctrl+⌐ (backslash)	⌘-2, ⌘-⌐ (backslash)

* Works only if you loaded the dekeKeys keyboard shortcuts (as directed on page xvi of the Preface).

both to fill your head with knowledge and provide you with a better perspective on which techniques to use in a given situation. By the time you complete the exercises in this lesson, you'll not only be singing the praises of layers and layer masks but also putting them to full use in your images for the best results possible.

Creating a Jet of Motion Blur

About a decade ago, a buddy of mine—Greg Vander Houwen, the same guy who innovated the lightning clouds in Lesson 6—shared a cool technique that will form the basis of this exercise. I've enhanced the procedure to make it more functional, but at its heart, it's the same astoundingly simple, fetchingly dramatic, and solidly practical technique that it was when layer masks were first added in Photoshop 3.

The approach involves appending a unidirectional speed trail to a fast-moving object, such as the jet in Figure 7-2. Adding the appearance of motion is easy: just apply the Motion Blur filter. But Motion Blur is bidirectional, so any speed trail you make with it will flow both in front of and behind the object. A layer mask allows you to steer the trail in a single, more decisive direction.

Figure 7-2.

1. *Open an image.* Open *Jet on blue sky.jpg*, located in the *Lesson 07* folder inside Lesson *Files-PsCM 1on1*. This jet was captured by iStockphoto photographer Christoph Ermel.

2. *Convert the Background to a normal layer.* To make your work easier, I want you to rotate the image before applying the motion blur, and that's more easily accomplished if you convert the Background layer to a normal (unlocked) layer. Double-click the thumbnail for the **Background** layer in the **Layers** palette to bring up the **New Layer** dialog box, name the layer "Plane," and click **OK**.

3. *Rotate the Plane layer.* Now you can rotate the plane image to be precisely horizontal:

 • Choose the ruler tool from the ✐ tool flyout in the toolbox.

 • Drag along the main axis of the jet, from the tip of the nose to the base of the tail, as I did in Figure 7-3.

Figure 7-3.

Figure 7-4.

Figure 7-5.

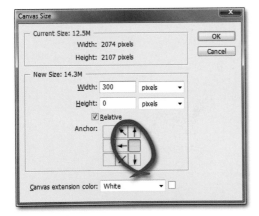

Figure 7-6.

- Choose **Image→Image Rotation→Arbitrary** to bring up the **Rotate Canvas** dialog box. Note in Figure 7-4 that the rotation direction and angle are filled in automatically based on the line you drew with the ruler tool (your rotation value may be slightly different from mine). Click **OK** to apply the rotation.

- Because the line you drew with the ruler tool was closer to vertical than horizontal, Photoshop assumes that you want that line to become vertical. It assumes wrongly, however, so choose **Image→Image Rotation→90° CCW** to rotate the image 90 degrees counterclockwise. The result is shown in Figure 7-5.

4. *Increase the canvas size.* It will be helpful to have a little bit of extra space in front of the plane so that you'll have room to apply your blur; choose **Image→Canvas Size** to bring up the **Canvas Size** dialog box. Confirm that the **Relative** check box is selected, change the **Width** pop-up to **Pixels** and enter a value of 300. Then in the set of nine directional buttons, click the middle button in the right column to add the extra space to the left side of the image. When your settings match those in Figure 7-6, click **OK**.

5. *Duplicate the Plane layer.* We want to apply the motion blur effect to a duplicate of the Plane layer, rather than the original layer itself. Press Ctrl+Alt+J (⌘-Option-J) to "jump copy" the Jet layer. (An easy mnemonic: *J* for *jump*.) This copies the layer and its contents to a new layer and brings up the **New Layer** dialog box. Change the name to "Blur," and click **OK**.

6. *Stretch the Blur layer.* The motion blur operates bidirectionally, creating the appearance of shrinking the object we're blurring. To counteract the shrinking, we need to stretch the plane before we apply the blur:

- At the top-right of the **Layers** palette, change the **Blur** layer **Opacity** to 50 percent (or press the 5 key) so you can see through this layer as you resize it relative to the Plane layer. Then press F to enter the full-screen mode.

- Choose **Edit→Free Transform** to enter the transform mode. Press the Alt (Option) key and drag the left edge of the transform bounding box around the image to resize the width evenly in both directions to a total of roughly 140 percent, seen as the **W** value in the options bar.

7. *Skew the Blur layer.* Now we need to align the wings on the Blur layer with the layer underneath:

 - Drag the image (which affects just the Blur layer since it is still being affected by the Free Transform command) so the lower wing's front corner (where the wing meets the tip tank, the oblong structure at the outside end of the wing that holds the fuel) aligns with the same point on the Plane layer below, as shown in Figure 7-7.

 - Move the transformation center point to the front tip of the wing where you aligned the two layers, circled in Figure 7-7.

 - Mash down on Ctrl+Shift+Alt (or ⌘-Shift-Option) and drag the top-center handle of the transform box to the left so the corner of the upper wing on the Blur layer aligns with the same point on the Plane layer, as in Figure 7-8. Press Enter (Return) to apply the transformation.

 - Press F twice to return to the normal view mode.

 - Return the **Opacity** for the **Blur** layer to 100 percent by pressing the 0 key.

Figure 7-7.

Figure 7-8.

8. *Apply a motion blur.* Now to apply the motion blur to our Blur layer. Choose **Filter→Blur→Motion Blur** to bring up the **Motion Blur** dialog box. Make sure the **Angle** value is set to 0. The Distance default setting of 10 pixels is laughably subtle for our purposes, so raise the **Distance** value to 300 pixels (see Figure 7-9). Click **OK** to produce a radical effect that is the visual equivalent of *whoosh!*

Figure 7-9.

9. *Mask part of the motion blur effect.* As you can see, the motion blur effect is extending in front of and behind the plane. We want the effect only behind the plane to produce the impression of forward motion. We'll use a layer mask to block the effect from the front portions of the plane:

- In the **Layers** palette, reduce the **Opacity** value of the **Blur** layer to 50 percent so we can see through to the Plane layer as we work.

- Switch to the **Masks** palette, and click the ▢ icon to add a pixel layer mask to the Blur layer.

- Press the B key to choose the brush tool from the toolbox. Then press the D key to set the colors to the default values of black and white, and press the X key to swap the foreground and background colors so black is the foreground color.

- Right-click (Control-click) the image to bring up the brush pop-up palette. Set the **Master Diameter** value to 175 pixels, the **Hardness** value to 0 percent, and press Enter or Return.

- Paint along the front edges of both wings and the fuselage (the body of the plane in which the passengers sit) in front of the wings. Also paint all the blurred areas in front of the plane. The result should look like that shown in Figure 7-10.

- Press the X key to change the foreground color to white. Then press 🔲 several times to reduce the brush size to 125 pixels.

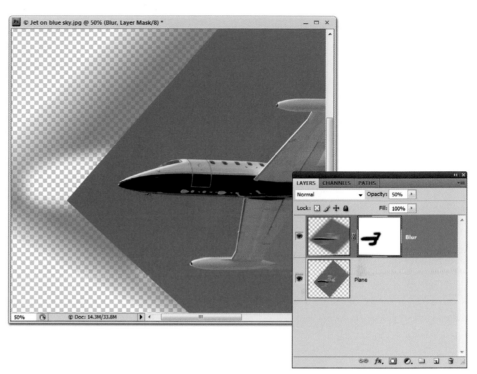

Figure 7-10.

- Paint within the fuselage in front of the wings to bring back the blur effect, being careful not to paint all the way to the edge of the fuselage.

- Click the thumbnail for the **Blur** layer (not the layer mask) in the **Layers** palette to make it active.

- Return the **Opacity** value for the Blur layer to 100 percent. You can see the final effect in Figure 7-11.

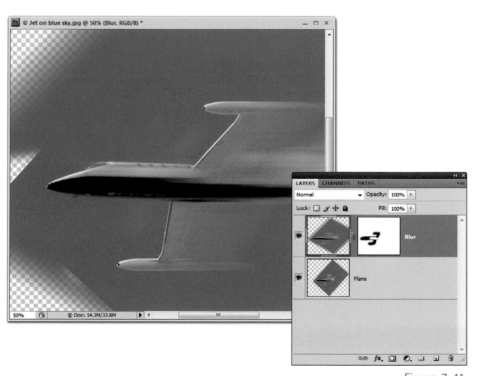

Figure 7-11.

Figure 7-12.

If you see any additional motion blur residue at this point, click the layer mask for the Blur layer in the Layers palette, press the X key to swap the foreground and background colors so black is the foreground color, and paint in those areas to block them.

10. *Rotate the plane to its original orientation.* Choose **Image→Image Rotation→90° CW** to rotate the plane to vertical. Then choose **Image→Image Rotation→Arbitrary** to bring up the **Rotate Canvas** dialog box. Note the Angle value from Step 3 is filled in automatically, so all you need to do is choose the **°CCW** option to rotate the image counter-clockwise. Then click **OK**, producing the result you see in Figure 7-12.

11. *Crop the image.* At this point you can crop the image to eliminate the extra space we added in Step 4. Choose the crop tool from the toolbox (or press C), and drag to define a box that matches the original image dimensions (see Figure 7-13). In the options bar, check the **Hide** option to preserve the pixels you're cropping just in case you need them later. Press Enter (Return) to accept the crop.

Figure 7-13.

PEARL OF WISDOM

If you're having trouble aligning the crop box to the edges of the original image because Photoshop is "helpfully" trying to snap to the now blurred layer edges, you can turn off Snap by pressing Ctrl+Shift+⌘ (⌘-Shift-⌘ on the Mac). Also, as with the marquee tool, you can press the spacebar key at any time as you're drawing the crop box to move it rather than resize it. If you still have some transparent fringing around the edges after you accept the crop, reduce the canvas size by pressing Ctrl+Alt+C (⌘-Option-C), enter −6 pixels for both the width and height, make sure the Relative check box is selected, and press OK. (Photoshop's warning about clipping does not apply to layered files, only to the locked Background layer—if it exists—or flattened images.)

12. *Reduce the Opacity for the Blur layer.* To make the motion effect blend more seamlessly, I think we should let more of the nonblurred plane show through. Change the **Opacity** value for the **Blur** layer in the **Layers** palette to

85 percent. The final image is shown in Figure 7-14.

13. *Save the image.* You've combined filters and layer masks, along with a few other techniques, to produce a cool image that deserves to be saved. Choose **File→Save As**. Name the file something like "Screaming jet" and click **Save**.

Our first foray into layer masking is now complete. Using only Free Transform, Motion Blur, and a layer mask, you've taken a static snapshot and given it a punch of energy—I half expect to hear a sonic boom as I look at this photo.

Figure 7-14.

Masking an Adjustment Layer

When you apply a change using an adjustment layer, you don't actually change the pixel values in the image, making it a flexible approach. Considering the fact that you can use layer masks with adjustment layers—most commonly to limit the area affected by the adjustment layer—you will see that there are no bounds to the control you can exercise over your images.

1. *Open an image.* Open *Complementary colors.tif,* located in the *Lesson 07* folder inside *Lesson Files-PsCM 1on1.* This image comes to us from iStockphoto photographer Alex Nikada (see Figure 7-15).

Figure 7-15.

2. *Confirm your Adjustments palette settings.* Take a moment to confirm that your Adjustments palette settings are in line with mine. Click the ▾≣ in the **Adjustments** palette, and make sure that **Add Mask by Default** is turned off (no check mark) in the palette menu.

Figure 7-16.

Figure 7-17.

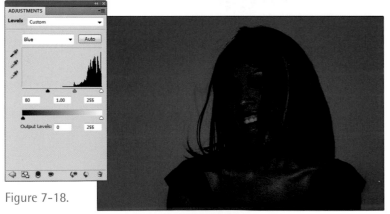

Figure 7-18.

3. **Add a Levels adjustment.** The first thing I want you to do is enrich the sky in the background, which we'll accomplish with the Levels adjustment:

- Alt-click (Option-click) the ⛰ icon at the top of the Adjustments palette.

- In the **New Layer** dialog box, name the layer "Sky," and click **OK** to create the adjustment layer. (For now, the adjustment will affect the entire image, something we'll fix in the next few steps).

- In the **Adjustments** palette, choose the **Red** option from the pop-up menu above the histogram to switch to the Red channel—or use the keyboard shortcut, Alt+3 (Option-3 on the Mac). Set the black slider triangle directly below the histogram to 45. Set the white **Output Levels** slider triangle to 100, producing the effect shown in Figure 7-16. This adjustment robs the image of much of the red, boosting the cyans in the background, because cyan is the complementary color to red.

- Switch to the Green channel by pressing Alt+4 (Option-4). Set the black triangle directly below the histogram to 60. Set the white **Output Levels** triangle to 170. This creates the effect you see in Figure 7-17.

- Choose the Blue option by pressing Alt+5 (Option-5). Set the black slider triangle under the histogram to 80 (see Figure 7-18).

4. **Evaluate the channels.** The background is now fully saturated, but our model has been unacceptably darkened. We need a selection to start a mask for the adjustment layer. As you saw in Lesson 5, it is often possible to use a channel as the basis of a selection, which we'll do the here. First, click the 👁

icon in front of the **Sky** layer to hide it. Then, in the **Channels** palette, click the thumbnails for the **Red**, **Green**, and **Blue** channels in turn (all shown in Figure 7-19). The Blue channel offers the most contrast between the woman and the background, and thus is your best starting point for the selection. Click the **RGB** thumbnail to show the composite image again.

5. *Load a selection.* Press the Ctrl (⌘) key and click the **Blue** channel thumbnail to load a selection based on the luminosity values in that channel.

6. *Create a starting mask for the Sky layer.* Start by switching back to the **Layers** palette and clicking in the 👁 column in front of the **Sky** layer to make it visible again. Then, switch to the **Masks** palette by choosing **Window→Masks** and click the ▣ icon. This adds a pixel layer mask based on the current selection—you'll immediately see the model's colors brighten, as seen in Figure 7-20. Still, the mask could certainly use some more work.

7. *Create a second window for the image.* To refine the layer mask for the Sky layer so it doesn't affect the woman, we'll need to apply an adjustment directly to the Sky layer mask. You could perform the adjustment while looking directly at the mask or the full-color image, but why would you when you can see both at the same time? To create a second window, choose **Window→Arrange→New Window for Complementary colors.tif**. You now have two windows showing the same image, and you can set the viewing options independently as you make adjustments to the layer mask.

8. *Tile the image windows.* Choose **Window→Arrange→ Tile** to rearrange the windows to see both.

A word of warning: If your views are in tabs, rather than in separate windows, you need to choose Window→Arrange→Float All in Windows before you choose the Tile command.

9. *Adjust the zoom settings for each window.* To get the most benefit from both views, adjust each one to display the image differently:

 • Click the title bar for the image window on the left to make it active. Set the zoom at the bottom-left to 100 percent and

Red

Green

Blue

Figure 7-19.

Figure 7-20.

Figure 7-21.

press Enter or Return. Press the spacebar to temporarily access the hand tool and drag the image so you can see the hair on the left side of the image (her right).

- Make the image on the right active by clicking its title bar. Set the zoom to 50 percent and press Enter or Return.

- Press the Alt (Option) key and click the layer mask for the **Sky** adjustment layer in the **Layers** palette to view the layer mask for this image. The result is shown in Figure 7-21.

10. *Apply a Levels adjustment.* Press Ctrl+L (⌘-L) to bring up the **Levels** dialog box. Set the black **Input Levels** triangle to 20 and the white **Input Levels** value to 160 to increase the contrast in the mask, and click **OK**. In Figure 7-22, you can see changes in both the full-color image and the layer mask.

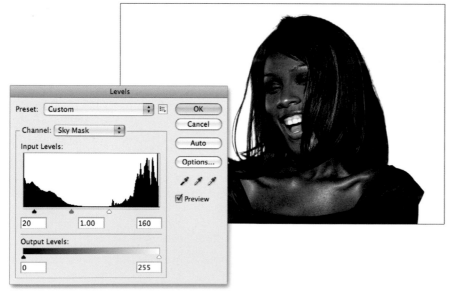

Figure 7-22.

11. *Paint in the mask.* The Levels adjustment made a big improvement in the layer mask, but we still have to clean up the mask so it affects only the sky in the background:

- Choose the brush tool from the toolbox. Right-click (Control-click) inside the image to bring up the brush pop-up palette. Set the **Master Diameter** to 250 pixels and the **Hardness** to 0 percent. Press Enter or Return.

- In the options bar, set the **Mode** option to **Overlay**, or press Shift+Alt+O (Shift-Option-O on the Mac).

- Press the D key to set the colors to their defaults. Press the X key to swap the foreground and background colors so black is the foreground color.

- Paint over most of the woman, but don't get too close to the hair on the left (her right) or you'll damage the edges. If necessary, press the spacebar to access the hand tool and move the mask image to paint into the shoulders. At this point your mask should look like mine in Figure 7-23.

Figure 7-23.

- Using the lasso tool from the toolbox, press and hold the Alt (or Option) key and draw a selection around the areas that still show white, such as her teeth and a few other features. Press Alt+Backspace (Option-Delete) to fill the selection with black (the current foreground color). Your mask should now look like Figure 7-24.

- Press Ctrl+D (⌘-D) to deselect.

12. *Close the second window.* We've finished with this mask, so go ahead and close the second image window but leave the original window open.

13. *Create a Color Range selection.* The sky in the background looks much improved, so now it's time to turn your attention to removing the color cast on (and brightening) the teeth and other highlights. This time, we'll create a selection first, and then apply the mask automatically to the adjustment layer:

Figure 7-24.

- Click the thumbnail for the **Background** layer in the **Layers** palette to make it active.

- Choose **Select→Color Range** to bring up the **Color Range** dialog box. Set the **Selection Preview** option to **None**.

- Click one of the teeth to set that area as the basis of the selection. Increase the **Fuzziness** setting to 120. When your settings match Figure 7-25, click **OK**.

14. *Create a Levels adjustment layer.* We have the Color Range selection, and now we need to create an adjustment layer to do the brightening and color correction:

Figure 7-25.

- Make the **Background** the active layer by clicking it in the **Layers** palette.

- Hold Alt (Option) and click the ♨ icon at the top of the **Adjustments** palette, which brings up the **New Layer** dialog box. Change the name of the layer to "Teeth," and click **OK** to create the new adjustment layer. Note that the layer is created with a layer mask automatically built from your selection.

- In the **Adjustments** palette, choose the **Red** option from the pop-up menu above the histogram to select the Red channel. Set the white value below the histogram (the input level) to 240.

- Choose the **Green** option from the pop-up menu and set the white input level value to 210.

- Next choose the **Blue** option from the pop-up menu and change the white input level value to 195. As you can see in Figure 7-26, the teeth look much better, as do the other highlights.

15. *Save the image.* The contrast in this image is now quite striking and the colors much more vivid. If you want to save the result, choose **File→Save As**, name the file "Vibrant portrait," and set the **Format** option to **Photoshop**. Click **Save**.

Figure 7-26.

Masking Translucent Objects

In this exercise you'll assemble via masking a mock magazine cover—
but not just any magazine cover. This one will incorporate glass. Spe-
cifically, you'll be masking glass against a textured background. Unlike
masking hair and most details, masking glass is a matter not of select-
ing edges but of balancing highlights and shadows, as you'll see.

1. *Open two images.* Open *Background & text.psd* and
Water in glass.jpg, located in the *Lesson 07* folder in-
side *Lesson Files-PsCM 1on1.* The first features an ab-
stract green design created by the iStockphoto artist known as
Andhedesigns, shown in Figure 7-27. I applied some adjustments
to the image, then rasterized it (converted it from vector artwork
to pixels). I also added a few rasterized text layers (which are not
currently visible) that we'll employ later in this exercise. The sec-
ond image, seen in Figure 7-28, is by iStockphoto photographer
Izabela Habur and features a glass of water that we'll place onto
the green background.

Figure 7-27.

Figure 7-28.

2. *Copy the glass image into the new background.* Get things started by copying the glass image into the green background image:

- Click the title bar (or tab, if you're using tabbed views) for *Background & text.psd* to make it active.

- In the **Layers** palette, click the thumbnail for the **Background** layer to make it active, so our duplicated layer will appear directly above it.

- Click the title bar for the *Water in glass.jpg* image.

- In the Layers palette click ▾≡ at the top-right and choose **Duplicate Layer** from the pop-up menu.

Figure 7-29.

- In the **Duplicate Layer** dialog box, type "Glass Shadows" for the **As** field. We'll use this layer initially to isolate the shadows in the glass image. In the **Document** pop-up menu, choose the **Background & text.psd** option (see Figure 7-29) and click **OK**.

- Choose **File→Close** to close the *Water in glass.jpg* image.

- Click the title bar for the *Background & text.psd* image. Note in Figure 7-30 that the new layer has been added to the Layers palette, and the glass image is now covering the background.

Figure 7-30.

3. *Set the blend mode to Linear Burn.* As much as you might wish that a single Photoshop blend mode would perfectly mold the highlights and shadows of the glass to the background layer, it is not to be. We need to work on the shadows and highlights independently to manage the challenges of masking glass. We'll start with the shadows. In the Layers palette, change the Glass Shadows layer blend mode to **Linear Burn**. As you can see in Figure 7-31 on the facing page, this blend mode does an excellent job of dropping out all the highlights and preserving the shadow details.

4. *Duplicate the Glass Shadows layer.* Now it's time to turn your attention to the highlights. Press Ctrl+Alt+J (⌘-Option-J) to jump copy the Glass Shadows layer and bring up the **New Layer** dia-

log box. Name the layer "Highlights" and change the **Mode** to **Normal**. Click **OK** to create a new copy of the glass image.

5. *Select the highlights.* To isolate the highlights in the Highlights layer, you may be tempted to use a blend mode (perhaps the Screen blend mode from the previous lesson comes to mind). But for this particular image, a blend mode won't work well because of the overhighlighting at the top of the image. Instead, we need to create a layer mask. We'll use a Color Range selection as the basis for that mask:

- Choose **Select**→**Color Range** to bring up the **Color Range** dialog box. Make sure the **Selection Preview** option at the bottom of the dialog box is set to **None** so you can see the full-color image.

- Click the highlight along the right edge of the glass to set the base color value for the Color Range selection. (You may need to zoom in on the image to select the precise area.) Increase the **Fuzziness** setting to 140, as shown in Figure 7-32. Click **OK** to create the selection.

6. *Add a layer mask.* Using the selection, you can now mask the Highlights image so that only the brightest areas are visible. Switch to the **Layers** palette and click the ▣ icon to add a layer mask based on the selection.

7. *Apply a gradient to the mask.* Only the brightest areas of the Highlights layer are visible, but that includes areas at the top-right that are too bright. I recommend we resolve that by applying a gradient to the layer mask:

- Select the ▣ tool from the toolbox or press the G key.

- In the options bar, click the ▾ button next to the gradient bar and choose the second option from the left (foreground to transparent) from

Figure 7-31.

Figure 7-32.

Masking Translucent Objects 251

the pop-up menu. Next, click the ▭ icon (the second of the five gradient style icons) to make the gradient a radial gradient. Make sure the **Mode** option is set to **Normal**, and reduce the **Opacity** value to 70 percent. Finally, turn on the **Reverse** check box so the gradient will go from transparent to the foreground color. These options are all shown in Figure 7-33.

Figure 7-33.

- Confirm that the foreground color is set to black.

- Press the F key to switch to the full-screen view so you can see some of the pasteboard outside the image.

- Drag from the center of the glass to just outside the top-right corner of the image, as illustrated in Figure 7-34.

- Press the F key twice to return to the normal display mode. The resulting image is shown in Figure 7-35.

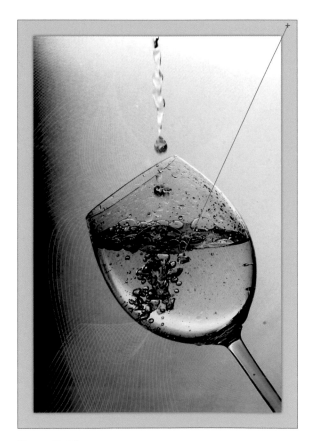

Figure 7-34.

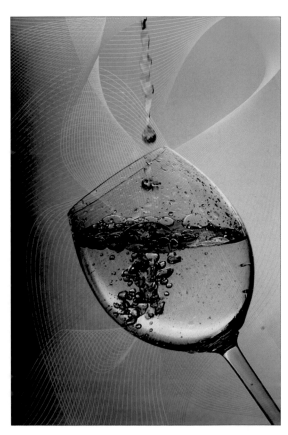

Figure 7-35.

8. *Move the Highlights layer down.* After applying the gradient to the layer mask, the Highlights layer is much improved, but still a little too bright for my tastes. Drag the **Highlights** layer below the **Glass Shadows** layer in the Layers palette to allow the shadows to have more impact and to tone down the highlights, as you can see in Figure 7-36.

9. *Change the blend mode.* Moving the Highlights layer down helped, but it muted the highlights too much. To strengthen the effect slightly, change the blend mode for the **Highlights** layer to **Linear Dodge (Add)**, creating the much improved Figure 7-37.

10. *Turn on the text layers.* With the glass blended expertly into the background texture, it's time to apply some finishing touches to our magazine cover. In the Layers palette, click the empty box in the ◉ column in front of both the **Lead Story** and **Text Elements** layers to make the rasterized text visible, shown in Figure 7-38.

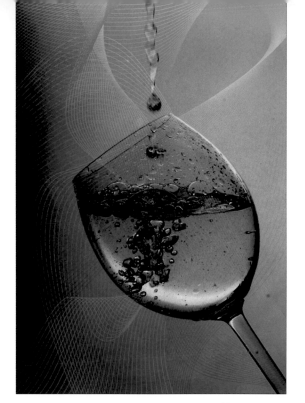

Figure 7-36.

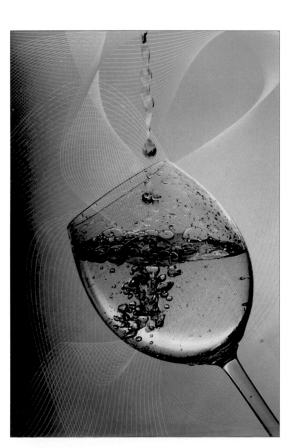

Figure 7-37.

Figure 7-38.

The text layers we're using have been rasterized only because you might not have the fonts I used. Rest assured that the methods presented in this exercise work just as well using text layers as they do when using the rasterized layers in the sample files.

11. *Create a copy of the glass layer.* As you may have noticed, the text headline near the bottom left is overlapping the glass of water. To fix this distraction, we'll create a layer mask for this text. The first step is to make a copy of the Glass Shadows layer to use for the selection. Click the thumbnail for the **Glass Shadows** layer and press Ctrl+Alt+J (⌘-Option-J) to bring up the **New Layer** dialog box. Name the layer "Dummy," change the **Mode** to **Normal**, and click **OK**.

Figure 7-39.

12. *Move the Dummy layer up.* To create our selection, we need to see the layer we just created. Drag the **Dummy** layer to the top of the stack in the **Layers** palette, or press Ctrl+Alt+⦆ (⌘-Option-⦆).

13. *Make a Color Range selection.* Once again we'll use the Color Range command to create a selection of the glass, but this time the shadows will get our attention, since that's where the text overlaps the glass:

 • Choose **Select→Color Range** to bring up the **Color Range** dialog box.

 • In the composite image, click the bottom left of the glass in the blue shadow area above the stem. Then press the Shift key and click a little farther up in the shadow area on the left side of the glass, as indicated in Figure 7-39.

 • Finally, back in the dialog box, reduce the **Fuzziness** value to 115, turn on the **Invert** check box, and click **OK** to create the selection.

14. *Hide the Dummy layer.* We've made our selection, so we no longer need the **Dummy** layer. Click the 👁 icon in the **Layers** palette to hide the layer. Even though we won't be using the Dummy layer again, it's a good idea to keep it with the image in case you want to revisit this image later.

15. *Add a layer mask to the Lead story layer.* Now to mask the text to blend it better with the glass. Click the thumbnail for the **Lead Story** layer in the Layers palette, and then click the ▢ icon to add a layer mask based on the active selection. (Conversely, you could click the ▢ icon in the **Masks** palette.) The results of the mask can be seen in Figure 7-40. The effect is good overall but too heavy-handed, especially with the shadows creeping in from the left.

Figure 7-40.

16. *Modify the layer mask.* The layer mask needs to be refined to bring back the left edge of the text. Here's how:

- Alt-click (Option-click) the layer mask for the **Lead Story** layer to make it active and view it by itself.

- Choose the elliptical marquee tool from the flyout for the rectangular marquee tool in the toolbox.

- Create a selection that follows just outside the left edge of the glass, as I did in Figure 7-41.

- Choose **Select→Modify→Feather** to bring up the **Feather Selection** dialog box. Set the **Feather Radius** to 9 pixels and click **OK**.

- Choose **Select→Inverse** or press Ctrl+Shift+I (⌘-Shift-I) to invert the selection.

- Press the D key to ensure that the foreground color is set to white, and press Alt+Backspace (Option-Delete) to fill the selected area with white.

- Press Ctrl+D (⌘-D) to deselect the image.

Figure 7-41.

Figure 7-42.

Figure 7-43.

17. *Clean up the mask.* The mask is nearly complete, but there's still a hint of a shadow outside the lower-left edge of the glass. You can get rid of it by painting with white, as you have in earlier exercises:

- Press the B key to switch to the brush tool.

- Set the **Diameter** to 50 and the **Hardness** to 0 percent. Press Shift+Alt+O (Shift-Option-O) to set the blend mode to **Overlay**.

- Paint outside the glass to remove the light gray shadow, taking care not to paint over any of the black edges of the glass itself.

- Restore the full composite view of the image by Alt-clicking (Option-clicking) the layer mask thumbnail. The results of your work are shown in Figure 7-42.

18. *Move the text slightly.* I'd like to move the text down a little so the top of the *S* in *it's* isn't blocked quite so much by the glass. Click the thumbnail for the **Lead Story** layer. Then click the 🔗 icon between the Lead Story layer and the layer mask to unlink the mask, allowing the text to be moved independently of the mask. Press Ctrl (⌘ on the Mac) to access the move tool and drag the text down slightly, as shown in Figure 7-43.

EXTRA ⭐ CREDIT

Our mock magazine cover looks great. All your hard work has certainly paid off. To add a fun element to the composition, I'm going to put a goldfish into the glass of water. If you'd rather move on to the "Assembling the Perfect Group Photo" exercise, which starts on page 258, by all means feel free to do so. Otherwise, stick with me and learn a few more tricks.

19. *Open an image.* Open *Goldfish.jpg*, located in the *Lesson 07* folder inside *Lesson Files-PsCM 1on1*. This image of—you guessed it—a goldfish (see Figure 7-44) was photographed by Lise Gagne of iStockphoto. We will ever so delicately place this goldfish into the glass of water to put the finishing touch on the magazine mock-up.

20. *Copy the goldfish into our composition.* Before we can do anything, we need to place the fish into the composition to start blending it into the final result. Click the ▾≡ icon at the top of the **Layers** palette and choose **Duplicate Layer** from the pop-up menu.

Figure 7-44.

In the resulting dialog box, enter the name "Fish" and change the destination to **Background & Text.psd**, as shown in Figure 7-45. Click **OK**, and then close the file *Goldfish.jpg*.

Figure 7-45.

21. *Adjust the position of the goldfish layer.* The goldfish will blend best if it is directly on top of the Glass Shadows layer. In the Layers palette, drag the **Fish** layer so it is just above **Glass Shadows**.

22. *Convert the Fish layer to a smart object.* We're going to resize the Fish layer so that it fits the composition better. But to preserve the original pixels in the process, it's best to convert a layer to a smart object. Click the ▾≡ icon at the top of the Layers palette and choose **Convert to Smart Object** from the pop-up menu.

PEARL OF ⬤ WISDOM

Smart objects are the way to go if you have multiple transformations you want to apply to a layer. By converting the layer to a smart object, you preserve all the original pixels in the layer, regardless of what transformations you later put the object through. Using smart objects in this way gives you astonishing flexibility to later undo those changes.

23. *Resize the Fish layer.* Choose **Edit→Free Transform** or press Ctrl+T (⌘-T) to enter the transform mode. Press Shift to constrain the proportions, and drag one corner of the transform bounding box inward to reduce the size of the Fish layer. Then move the fish into position. Press Enter or Return, creating the result shown in Figure 7-46.

Figure 7-46.

24. *Change the blend mode to Multiply.* By now you probably know which blend mode we need to use to drop out the white in the Fish layer and blend the fish into the composition. Go ahead and change the blend mode for the Fish layer to **Multiply** by pressing Shift+Alt+M (Shift-Option-M). As you can see in Figure 7-47, the fish seems to be swimming in the glass.

25. *Add a Color Overlay effect.* Have you ever seen a goldfish looking so happy swimming in a glass of water? But I want to make one final change. I think the fish would look better if it were green:

Figure 7-47.

- Click the *fx* icon at the bottom of the Layers palette and choose **Color Overlay** from the pop-up menu.

 - In the **Layer Style** dialog box, click the color swatch to bring up the **Select Overlay Color** dialog box. Change the **H** value to 120, **S** to 80, and **B** to 30. (Or click in the image to choose a shade of green.) Click **OK**.

 - A solid block of color doesn't quite cut it. In the Layer Style dialog box, set the **Blend Mode** to **Color** so the effect will change only the color of the fish rather than making the entire layer solid green. That's much improved, but there's still an artifact of the blend modes—the rectangle of color showing up around the fish.

 - On the left of the Layer Style dialog box, click **Blending Options: Custom** to switch to the Blending Options panel, as seen in Figure 7-48. Turn on **Blend Interior Effects as Group** to apply the Color Overlay effect before using the layer's Multiply blend mode. This eliminates the color rectangle, blending the fish seamlessly with the background.

 - Click **OK** to close the Layer Style dialog box.

26. *Save the image.* You've leveraged blending modes, layer masks, and much more to create an incredible composition, seen in Figure 7-49. Choose **File→Save As**, change the file name to "Magazine cover," and click **Save**.

Figure 7-48.

Figure 7-49.

Assembling the Perfect Group Photo

If you've ever tried to assemble a multiperson photograph, you know it can be an ordeal. So many people to please, so many egos to feed, so much to go wrong. Even if you shoot a thousand images, finding that one gem that properly captures each and every personality can prove elusive. Fortunately, Photoshop's understated but highly practical Auto-Align Layers command distorts selected layers so that their backgrounds align, thus allowing you to mix and match foreground elements with relative ease.

My video producer, Max, and I grabbed a quartet of young, hip staff members at the Ventura, California–based lynda.com and trundled them off to a nearby public beach. Inspired by such opaquely named pop bands as My Chemical Romance, Clap Your

Hands Say Yeah, ...And You Will Know Us by the Trail of Dead, and everyone's favorite, Panic! at the Disco (all real), I chose the excruciatingly clever name Tumult! at the Aviary. Never mind that only one of my models can play an instrument. As is so often the case, image is everything.

In keeping with the band's name, I wanted to capture the models in flight. After blocking the shot, I directed the group's members to jump in the air, as high as they could, without showing the slightest hint of exertion or emotion on their placid faces. (They are, after all, morbidly serious, angst-ridden artists.) Max yelled, "1-2-3-jump!" over and over as I recorded one shot after another. In this exercise, we'll combine four photos—one for each of the four musicians—into a single photo that features all of them at their best.

1. **Open four images.** Open *Jumpers-1.jpg*, *Jumpers-2.jpg*, *Jumpers-3.jpg*, and *Jumpers-4.jpg*, all located in the *Lesson 07* folder inside *Lesson Files-PsCM 1on1*. Because of my generosity (exceeded only by my humility), I've selected the best images for you. As you can see in Figure 7-50, each represents a shot that is good for one of the four but not necessarily as good for the other three in the photo. However, after blending all four, we will have the perfect group photo.

Figure 7-50.

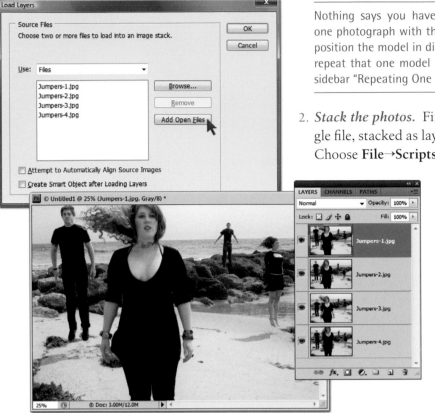

Figure 7-51.

Nothing says you have to stick with replacing one person in one photograph with that same person in another photo. If you position the model in different locations during a shoot, you can repeat that one model again and again, as I'll show you in the sidebar "Repeating One Person Many Times," on page 264.

2. *Stack the photos.* First we need all four images in a single file, stacked as layers, so we can blend them together. Choose **File→Scripts→Load Files into Stack** to bring up the **Load Layers** dialog box. Click the **Add Open Files** button and then click **OK** to combine the files into a single composition, with each image assigned to its own layer, as seen in Figure 7-51.

3. *Close the original photos.* Now that we have a single document containing the four photos of the band composition, close the four original jumper images. We'll work exclusively with this layered file from here on out.

4. *Align the layers.* Just because the images are stacked doesn't mean they're aligned. In fact, if you captured your images sans tripod, as I did, you can bet they aren't aligned. (And even a tripod is no guarantee.) To see this for yourself, Alt+click (Option-click) the 👁 icon in front of the bottom layer, **Jumpers-4.jpg**, and then press Alt+⬚ (Option-⬚) to cycle through the various layers. Notice how the background, as well as the models, are jumping around wildly. Were I to mask one model next to another, the surf, sand, and jetty would shift along the border, thus betraying my digital modifications. Needless to say (but I'll say it anyway), that just won't do, so we will align the images next:

 • Select all the layers by pressing Ctrl+Alt+A (⌘-Shift-A). Choose **Edit→Auto-Align Layers** to bring up the **Auto-Align Layers** dialog box, pictured in Figure 7-52 on the facing page.

 • Select the **Auto** option, which tells Photoshop to distort the images so that the most identifiable elements morph into alignment. This usually results in stationary objects—the rocks and other background stuff—fusing in place, and the

moving elements—in this case, the people—being allowed to drift.

- Click **OK** to perform the alignment, which will take a few seconds as Photoshop figures out how to distort each image to produce the best alignment for all selected layers. As you can see by viewing each layer, the rocks and horizon line in particular are aligned for each image, with the people (who were moving through the air as the photos were being taken) in different positions in each photo. You'll see a little bit of transparent background peeking through around the edges, but we'll crop that away near the end of the exercise.

Figure 7-52.

5. *Rename the layers.* To make it easier to follow along in the next few steps, rename each layer according to the person it best captures. My band members are (from left to right) Jehf, Melody, Paavo, and Megan. So, Jumpers-1.jpg becomes Paavo, Jumpers-2.jpg becomes Jehf, Jumpers-3.jpg becomes Megan, and Jumpers-4.jpg becomes Melody. Double-click the name of a layer in the **Layers** palette, type the person's name, and press Enter or Return. Repeat this for each layer.

6. *Confirm the order of the layers.* Assuming your layers opened in the same order as mine, shown in Figure 7-51, we should have the same layer order. If not, drag the thumbnails in the Layers palette so that the layers are ordered, from top to bottom, as Paavo, Jehf, Megan, and Melody (see Figure 7-53).

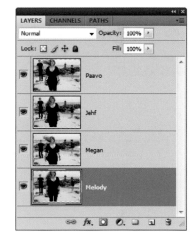

Figure 7-53.

7. *Turn off all but the rearmost layer.* It's best to start from the bottom of the Layers stack and work upward. While pressing the Alt (Option) key, click the 👁 icon for the rearmost layer in the Layers palette, the **Melody** layer (the woman at the center of the photo), to make only that layer visible.

8. *Turn on the next layer.* Now it's time to add the next person to the composition. Click in the empty 👁 column to the left of the next layer, **Megan**, to make it visible again, then click the thumbnail for that layer to make it active.

9. *Add a layer mask.* You want only a small part of the Megan layer (Megan herself) to show, so we need to add a layer mask. Initially, the layer mask should block the entire layer. Switch to the **Masks** palette by choosing **Window→Masks**, and while pressing Alt (Option), click the 🔲 icon at the top of the palette to create a new layer mask filled with black, thus hiding the layer.

10. ***Paint in Megan.*** We can now paint back the person by adjusting the layer mask:

- Choose the brush tool from the toolbox. Press the D key to set the foreground color to white.

 - Right-click (Control-click) the image to bring up the brush pop-up palette. Set the **Master Diameter** to 250 pixels and the **Hardness** to 0 percent for a soft-edged brush. Press Enter or Return.

 - In the options bar, make sure the **Mode** option is **Normal** and the **Opacity** setting is 100 percent.

 - Paint over the area to unmask the image of the person you're working on, revealing the better version housed on the current layer. If you reveal something you didn't intend to reveal, press the X key to swap the colors and paint the mask back in. The result for Megan is shown in Figure 7-54.

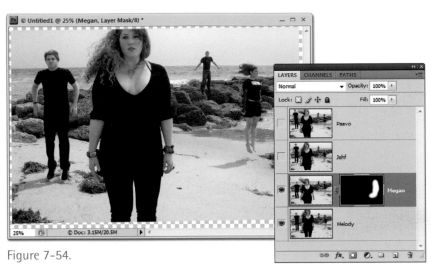

Figure 7-54.

11. ***Paint in Paavo.*** Repeat Steps 8 through 10 for the **Paavo** layer (the top layer). We're saving the Jehf layer for last because it is more challenging than the others. After painting in Paavo, the result will look like Figure 7-55.

12. ***Paint in Jehf.*** Adding the best Jehf is a little trickier. Although Jehf and Melody were nearly 20 feet apart, their bodies practically overlap in the flat space of the frame. To mask the Jehf layer in and out of visibility, you'll put both soft and hard brushes to work.

- Click in the empty 👁 column to the left of the **Jehf** layer to make it visible, then click the thumbnail for the Jehf layer in the **Layers** palette to make it active.

- Switch to the **Masks** palette, and then Alt-click (Option-click) the 🔲 icon at the top of the palette.

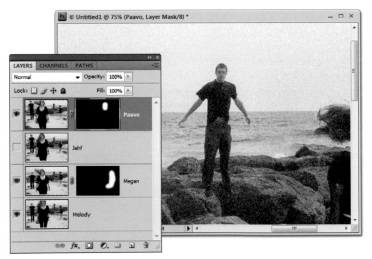

Figure 7-55.

- As best you can, paint over Jehf as you did with the previous models to unmask the better version of him into the photo. You'll likely end up with some duplication and ghosting of Melody, due to the brush being so soft around Jehf and revealing some of Melody in the Jehf layer.

- Zoom in to the space between Jehf and Melody to see the fine details better.

- Right-click (Control-click) the image to bring up the brush pop-up palette. Reduce the **Master Diameter** to 90 pixels and increase the **Hardness** to 75 percent for a brush that isn't quite as soft. Press Enter or Return. Then press the X key to swap the colors so black is the foreground color.

- Paint along the left side of Melody (her right) to eliminate any duplication, and also paint to clean up the water between Melody and Jehf. Be careful not to paint too far away from the water or you'll reveal the previous version of Jehf. (If that happens, swap colors and repaint him.) Your result should look like Figure 7-56.

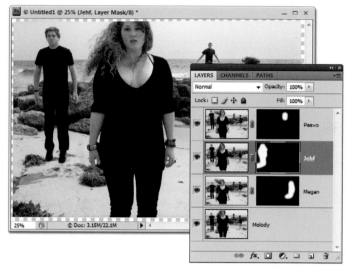

Figure 7-56.

13. *Open the text image.* Open *Tumult text.psd*, located in the *Lesson 07* folder inside *Lesson Files-PsCM 1on1*. This image contains some text and other elements we'll add to our composition to create a poster for the band.

14. *Duplicate the text to our composition.* Right-click (Control-click) in an empty area of the **Text & So Forth** layer in the **Layers** palette (not the thumbnail or the layer name), or click the ▾≡ icon at the top of the palette. Choose **Duplicate Layer** from the menu to bring up the **Duplicate Layer** dialog box. Choose **Untitled 1** (or whatever your main document happens to be named) from the **Document** pop-up and click **OK**. Then close the *Tumult text.psd* image.

15. *Reposition the text layer.* Duplicating a layer from one composition to another does not typically position the new layer very well (unless, of course, the images are identically sized). We need to adjust the Text & So Forth layer to get it into the best position. Press the Ctrl (⌘) key to access the move tool and drag the **Text & So Forth** layer so it aligns with the top of the image window and nicely frames the group (making sure all

Figure 7-57.

Repeating One Person Many Times

Employing many of the same techniques used for assembling the perfect group photo, you can create a surreal group photo by repeating the same person multiple times in the composition. Start by capturing the scene (preferably from a tripod) with the subject in the frame, then capture additional images with the same subject in different locations. Finally, blend the best of these images for a truly unique portrait.

By way of example, open *Jumpers-3.jpg*, *Jumpers-5.jpg*, *Jumpers-6.jpg*, *Jumpers-7.jpg*, and *Jumpers-8.jpg*, all located in the *Lesson 07* folder inside *Lesson Files-PsCM 1on1*. These represent the best views of Megan, as well as another image to provide some additional background area.

Choose **File→Scripts→Load Files into Stack** to bring up the **Load Layers** dialog box, shown below. Click the **Add Open Files** button to add the open files to the list of images to be processed. Then turn on the **Attempt to Automatically Align Source Images** check box and click **OK**. The images are processed and placed into a new image, with each image on a separate layer. You can now close the original images.

Drag the thumbnails up or down as needed in the **Layers** palette to reorder the layers from top to bottom as follows: Jumpers-7.jpg, Jumpers-3.jpg, Jumpers-8.jpg, Jumpers-5.jpg, Jumpers-6.jpg. The layers could be in any order, but this order ensures we're on the same page (or layer, as the case may be).

Alt-click (Option-click) the 👁 icon for the **Jumpers-6.jpg** layer in the Layers palette to make it the only visible layer, and then click in front of the **Jumpers-5.jpg** layer in the 👁 column to turn on that layer. Click the thumbnail for the **Jumpers-5.jpg** layer in the Layers palette to make it active. Switch to the **Masks** palette, and hold the Alt (Option) key while clicking the 🔲 icon at the top of the palette to add a layer mask filled with black to the Jumpers-5.jpg layer.

Choose the brush tool from the toolbox, and press the D key to set the colors to their defaults so the foreground color is white. Right-click (Control-click) in the image to bring up the brush pop-up palette and set the **Master Diameter** to 150 pixels and the **Hardness** to 25 percent. Then press Enter or Return. Next paint over the model at the far left of the image to reveal Megan in that location. You'll likely reveal parts (namely arms) of the other models, which we'll

fix in a moment. If the horizon line is slightly out of alignment, hold the Ctrl key (⌘ key) and press the ↑ key once to nudge the layer upward into alignment.

Back in the **Layers** palette, click the empty square next to the **Jumpers-8.jpg** layer to wake the 👁 up, and then click the thumbnail to make the layer both visible and active. Alt-click (Option-click) the ⬛ icon at the top of the **Masks** palette to add a layer mask, again filled with black. Carefully paint in the background area between the front Megan and the left Megan to clean up the extra arms that were revealed in that area.

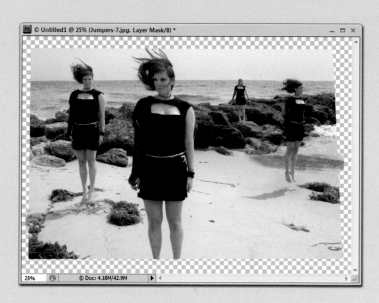

Repeat the preceding steps for the **Jumpers-3.jpg** layer. Paint over the rightmost model to reveal Megan in that area. Then, if your horizon is out of alignment (as I suspect it might be), hold Ctrl (⌘) and press the ↑ key a few times to nudge the layer upward until the horizon line is seamless. You may also encounter blending issues with the wet sand behind her; if necessary, press the X key and go back to paint in areas of the mask.

Finally, repeat the steps to activate and mask the **Jumpers-7.jpg** layer. Paint over the most distant model to reveal Megan there, as shown in the top image on this page.

To complete the composition, choose the crop tool from the toolbox by pressing the C key and drag a marquee around the image. Make sure all four sides are within the actual image area.

Then press Enter or Return, and as you can see to the right, your quite unbelievable portrait is in fact a reality—using all the same techniques you learned in the group composite exercise.

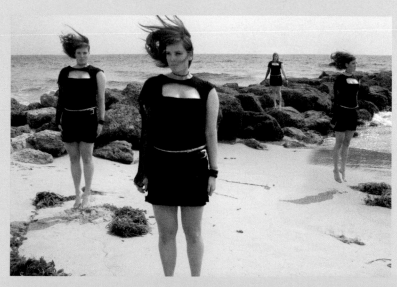

four edges of the border are within the image area), as shown in Figure 7-58.

16. *Crop the image.* We can now crop the composition to finalize our band poster:

 - From the **View** menu, make sure the **Snap** item is checked.

 - Choose the crop tool from the toolbox (or press the C key). Drag from one corner of the bounding box in the Text & So Forth layer to the opposite corner. With Snap turned on, the bounding box automatically snaps to the edge of this layer.

 - In the options bar, set the **Cropped Area** option to **Hide** so you're hiding (not deleting) the pixels outside the area defined for the crop. Press Enter or Return to apply the crop. The final version of our image is shown in Figure 7-59.

17. *Save the image.* You'll want to save this composition so you can print thousands (millions?) of posters for the band's big debut. Choose **File→Save As** and name your image "Band Poster," set the **Format** option to **Photoshop**, and click **Save**.

Figure 7-58.

Figure 7-59.

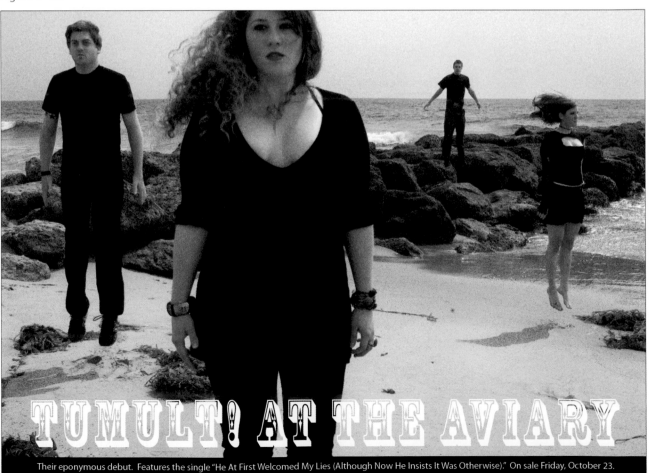

Their eponymous debut. Features the single "He At First Welcomed My Lies (Although Now He Insists It Was Otherwise)." On sale Friday, October 23.

Employing a Knockout Mask

One of the limitations of Photoshop is that while a single layer can contain multiple channels of information, a single channel cannot contain multiple layers. With the exception of transient floating selections, channels are always flat.

This limitation means that changes made to masks (which are channel-based functions) are permanent. In the final exercise in this lesson, we're going to use a gradient as a layer mask. But instead of permanently altering an existing layer mask, we will create a separate layer that holds our gradient to mask away the adjustment layer below it, serving as a *knockout layer* (a mask that isolates a particular subject or area of a photo).

Figure 7-60.

1. *Open an image.* Open *Ancient doorway.psd*, located in the *Lesson 07* folder inside *Lesson Files-PsCM 1on1*. This image contains two layers, shown in Figure 7-60. The Background layer is a photo I took at Stonehenge, and the Sky layer features a beautiful sky by the iStockphoto photographer Kativ.

2. *Transform the Sky layer.* To match the size of the Stonehenge image, the Sky layer needs to be resized, and (as always) we need to do so nondestructively. We'll use a smart object version of the layer:

 • Click the thumbnail for the **Sky** layer in the **Layers** palette to make it active. Click the ▾≡ icon and choose **Convert to Smart Object** to create a smart object from the Sky layer.

 • Press Ctrl+T (⌘-T) to enter the free transform mode.

 • Press Shift+Alt (Shift-Option) to constrain the aspect ratio of the image and have it grow outward from the center point. Drag the bottom-right corner below the horizon in the Stonehenge image and just outside the pasteboard.

 • Press Enter or Return to apply the transformation, producing the result shown in Figure 7-61.

Figure 7-61.

3. *Load a selection.* I've included an alpha channel in the *Ancient doorway.psd* image that you can use to mask the sky into the background. Go to the **Channels** palette, press the Ctrl (⌘) key, and click the thumbnail for the **Sky Mask** alpha channel to load it as a selection.

Figure 7-62.

Figure 7-63.

4. *Add a layer mask.* With the selection active, we can now mask the Sky layer so it appears only in the selected area. In the **Masks** palette, click the ⬚ icon to create a new layer mask based on the active selection. The result looks like Figure 7-62.

5. *Blur the sky.* Our new sky is in focus, but the trees in the background of the Stonehenge image are not, which makes the sky appear out of place. Click the thumbnail for the **Sky** layer in the **Layers** palette, and then choose **Filter→Blur→Gaussian Blur**. In the **Gaussian Blur** dialog box, set the **Radius** value to 4 pixels and click **OK** to apply the blur. (See the results in Figure 7-63.)

Because the layer was converted to a smart object, the filter is applied as a *smart filter*. We can revise our filter settings by double-clicking the name of the filter we want to modify (in this case, Gaussian Blur) in the Layers palette.

6. *Create a new layer.* There are some rough edges in the transition from the new sky and the Stonehenge image. Let's fix that by adding a knockout layer to the image. Using a knockout enables you to apply a gradient effect to the layer mask without directly altering that mask, meaning you can adjust each mask independently. To get started, press Ctrl+Shift+N (⌘-Shift-N) to bring up the **New Layer** dialog box, type "Knockout" for the **Name**, and click **OK**.

7. *Add a gradient to the Knockout layer.* We'll now add a gradient to the Knockout layer, which we'll ultimately use to constrain the mask for the Sky layer:

 • Select the gradient tool from the toolbox or press the G key.

 • Select the second option (foreground to transparent) from the ▾ drop-down menu next to the gradient in the options bar, or press Ctrl+⁐ (⌘-⁐) and then the ⁏ key.

The foreground color used to create this gradient can be any color you like. This technique utilizes the transparency of our Knockout layer rather than the specific foreground color you choose.

- Choose the ■ icon (the linear gradient option) from the set of five gradient style icons in the options bar. Make sure the **Reverse** check box is turned off and set the **Opacity** to 100 percent.

- While pressing Shift to constrain your direction to vertical, drag a gradient from just below the horizon to a point about halfway up the gap between the rocks where the sky shows through, as shown in Figure 7-64.

8. *Change the blending options for the Knockout layer.* Right now the gradient in the Knockout layer is simply covering up the image, but that can be remedied by adjusting the blending options for the layer:

- Double-click the thumbnail for the **Knockout** layer in the **Layers** palette to bring up the **Layer Style** dialog box.

- In the **Advanced Blending** section, choose the **Shallow** option from the **Knockout** pop-up menu. The Knockout layer will now knock out layers beneath it.

Figure 7-64.

Because this layer isn't inside a layer group, both the Shallow and Deep options accomplish the same thing. When layers are grouped, Shallow affects only those layers in its group, while Deep affects all layers down to the Background layer.

- Reduce the **Fill Opacity** value to 0 percent. This instructs Photoshop to not display the pixels in this layer. The final settings are shown in Figure 7-65. Click **OK**.

You now have a layer of transparency that operates as an independent mask on the adjustment layer beneath it. That's right, you have two masks—a layer mask and a knockout layer—working in tandem on a single layer. To see the full glory of your double mask in action, turn off the **Background** layer temporarily by clicking the 👁 icon next to the layer. You'll see your gradient-faded sky, as shown in Figure 7-66 on the next page.

Figure 7-65.

Figure 7-66.

You can even nudge the Knockout layer up or down to increase or decrease your fade. Be sure to turn on the Background layer before you go to the next step.

9. *Refine the Sky layer mask.* If you look very closely, you'll see some problems in the transitions between the Stonehenge formation and the new sky—specifically under the crossbeam at the top, as shown in the drastically zoomed top half of Figure 7-67.

In previous years, I might have directed you to blur the mask to create smoother transitions, then asked you to apply a Levels command to restore sharpness to the edges and choke them in towards the stone. And while that does still work, why jump through all those hoops when CS4 provides us with the Masks palette to do precisely the same sorts of operations?

Switch to the **Masks** palette, and press the **Mask Edge** button to bring up the **Refine Mask** dialog box, shown in Figure 7-67. (I find it easiest to work with the quick mask preview mode, but it's really a matter of preference.) Enter a **Contrast** of 25 percent, which helps to resharpen the edges being feathered by the 1.0 **Feather** value.

Figure 7-67.

Finally, set the **Contract/Expand** value to 50 percent to choke in the edges—any higher and you may start to see some strange artifacts. Once your values look like mine, click **OK**. The amazing results are shown in the lower half of Figure 7-67.

Cheers! You've learned yet more ways to bend Photoshop's masking capabilities to your will. Save or discard the file as you see fit.

WHAT DID YOU LEARN?

Match the key concept in the numbered list below with the letter of the phrase that best describes it. Answers appear upside-down at the bottom of the page.

Key Concepts

1. Transparency mask
2. Canvas size
3. Jump copy
4. Masks palette
5. Adjustments palette
6. Adjustment layer
7. Auto-align layers
8. Knockout mask
9. Shallow
10. Deep
11. Fill opacity
12. Refine mask

Descriptions

A. A command that changes the dimensions of a document without resizing the image or layers contained in that document.

B. A mask used to bore holes nondestructively in an image layer.

C. An option for the Knockout control in the Advanced Blending options that causes a knockout layer to affect all layers between it and the background layer.

D. New to CS4, this palette provides easy creation and adjustment of layer masks.

E. An option for the Knockout control in the Advanced Blending options that causes a knockout layer to affect only layers within its layer group (if a layer group exists).

F. New to CS4, this palette provides quick access to Levels, Curves, Hue/Saturation, and other image adjustments.

G. A specific type of layer that alters the layers below; it may or may not have an associated mask.

H. A mask carried by every layer in an image that defines the opacity or translucency of all pixels in that layer; it cannot be directly edited.

I. A command that duplicates a layer and its contents to a new layer, so nicknamed because its shortcut is Ctrl+Alt+J (⌘-Option-J).

J. A command that attempts to automatically align multiple layers of the same general subject based on composition.

K. A command that provides dynamic adjustments of the contrast, smoothness, and edges of layer masks.

L. An Advanced Blending option that specifies the transparency of pixels within a layer style, used most commonly in knockout masks.

Answers

1H, 2A, 3I, 4D, 5F, 6G, 7J, 8B, 9E, 10C, 11L, 12K

SPECIALTY MASKS

WHEN I MENTION the word mask, at least where Photoshop is concerned, your mind probably goes straight to that perfect alpha channel or selection outline that allows you to take a foreground image from one background and move it seamlessly into another. But in reality, unless you're doing an inordinate amount of collage and composition—in which case, more the power to you—more of your time will likely be spent using masks in subtler ways.

For example, you might use a mask to correct the colors in one portion of an image independently of another. Or you might want to selectively adjust the focus of the edges in an image while leaving more delicate areas alone. Or you may want to blur just the background to emulate a shallow depth-of-field.

Figure 8-1 illustrates the process of using a very basic mask to correct the shadow details in the woman's hair as well as deepen the too-hot colors in the flesh. I document this entire process in Video Lesson 8: "Working with 'Found Masks'," introduced on page 274.

In this lesson, we explore a coterie of masks designed for day-to-day image adjustments. Or more specifically, designed to ensure that your day-to-day adjustments appear precisely where you want them and leave the rest of the image alone. In these cases, the adjustment itself helps define the kind of mask you need and how you go about creating it. The masks that I describe—luminance, corrective, color, density, depth, and edge masks—all fall into a category I like to call *specialty masks*. Whatever you call them, they are for the most part easy to create and surprisingly powerful.

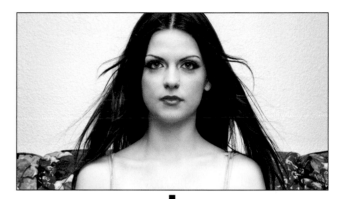

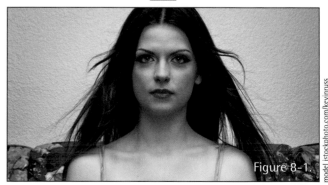

Figure 8-1.

model istockphoto.com/kevinruss

ABOUT THIS LESSON

Project Files

Before beginning the exercises, make sure you've copied the lesson files from the DVD, as directed in Step 3 on page xvii of the Preface. This should result in a folder called *Lesson Files-PsCM 1on1* on your desktop. We'll be working with the files inside the *Lesson 08* subfolder.

This lesson shows you how to create and use each of the six specialty masks identified on the facing page. In fact, I devote exactly one exercise to each of the specialty masks, in the very order I introduced them. In completing these exercises, you'll learn how to:

- Use a luminance mask to apply a layer of diffused digital makeup to a portrait shot page 276
- Correct wandering skin tones with an adjustment layer and a corrective mask page 283
- Change a piece of clothing to a completely different color, without affecting the rest of the photo page 287
- Use a density mask and a knockout layer to sharpen the darkest edges of a photo page 296
- Create a depth-of-field effect with a depth mask . . page 300
- Sharpen an archival photo without enhancing grain, dust, or scratches, an edge mask page 304

Video Lesson 8: Working with "Found Masks"

In my experience, most artists associate masks with arduous, multistep procedures that involve a certain level of technical expertise and a whole lot of painstaking brushwork. We've already seen how that's not always the case, but now we'll *really* see it. Because in this video, we take a look at what I call "found masks," which are masks that are just sitting there inside your image waiting to be used.

To see the two best examples of found masks—luminance and density masks—insert the DVD, double-click the file *PsCM Videos.html*, and click **Lesson 8: Working with "Found Masks"** under the **The Lighter Side of Masking** heading. A mere 9 minutes and 20 seconds long, this movie offers these shortcuts:

Operation	Windows shortcut	Macintosh shortcut
Convert a color channel to a selection	Ctrl-click on the channel	⌘-click on the channel
View the layer mask on its own	Alt-click layer mask thumbnail	Option-click layer mask thumbnail
Reverse a luminance selection	Ctrl+Shift+I	⌘-Shift-I
Hide all but one layer	Alt-click 👁 in Layers palette	Option-click 👁 in Layers palette

Six Specialized Selectors

The six masks that I cover in this lesson aren't by any means the only kinds of specialty masks you might employ or even invent, but they are the ones that I've identified as the most helpful in the widest range of circumstances. Here's how each of the six works:

- The *luminance mask* is nothing more than one of the color-bearing channels repurposed as a mask, often exactly as is. The luminance mask selects the highlights in an image and deselects the shadows, making it great for modifying the brightest colors in a photo. Figure 8-2 begins with a luminance mask taken from the Green channel.

- Next is the *corrective mask*, which is my name for a quickly assembled mask—usually made with the Color Range or Curves command—that allows you to focus a color adjustment on a specific area of an image. The second example in the figure shows a corrective mask for the woman's skin.

- Then comes the *color mask*, which allows you to alter the hue and saturation values of clothing or other specific objects in an image, while leaving the rest of the photograph unharmed.

- Pictured third in Figure 8-2, a *density mask* is nothing more than an inverted luminance mask. So named because it selects the areas of highest ink density in the printed version of the image, a density mask selects the shadows, making it great for certain kinds of sharpening operations.

- A *depth mask* allows you to modify the perceived depth-of-field in an image by defining which areas will be in focus and which will be blurred, as determined by the Lens Blur filter.

- Last but not least is the *edge mask*, which selects the areas of sudden luminance variation in the image, as shown in the final example in the figure. We'll use an edge mask to sharpen an archival photograph.

In the exercises, I show you how to create and apply these masks to great effect. If you ever thought masking was tedious, this lesson proves it can be—dare I say?—fun.

Luminance mask

Corrective mask

Density mask

Edge mask

Figure 8-2.

Smoothing with a Luminance Mask

We'll start things off with a look at luminance masks, which are simply masks built from luminance data found inside the image. When you create a luminance mask, you're basically just taking one of the color channels, Red, Green, or Blue, and repurposing it as a mask. And even though creating luminance masks can be insanely easy, they can also be very powerful, as we'll see in this exercise. We'll start by using a common for retouching portraits, a digital make-up effect, which we'll then refine with a luminance mask created from the image's Red channel information.

The initial effect, which involves the use of the Gaussian Blur filter set to the overlay mode, is, as I mentioned, a fairly common method for portraits that not only evens out the skin tone and smooths the surface but also enhances the contrast and color of the image. Of course, you don't always want to smooth everything in a portrait, so the luminance mask will help limit the effects of this useful modification to only the appropriate areas.

Figure 8-3.

1. ***Open an image.*** Open *Close-up.jpg*, located in the *Lesson 08* folder inside *Lesson Files-PsCM 1on1*. As you can see in Figure 8-3, this image from photographer Sharon Dominick of iStockphoto is a wonderful straight-on portrait with beautiful lighting. But there is a slight color mottling in the subject's skin that will benefit from a judicious application of Gaussian blur.

2. ***Convert the Background layer to a smart object.*** To apply the Gaussian Blur filter in a nondestructive way and allow for the application of blending options, you need to first convert the image to a smart object (which then allows the application of a smart filter). Click the ▾≡ icon at the top-right of the **Layers** palette and choose **Convert to Smart Object**, or press Ctrl+⬚ (⌘-⬚). Then double-click the name of the layer, rename it "Make-up," and press Enter or Return.

3. ***Apply a Gaussian Blur.*** To create the smoothing effect, start by choosing **Filter→Blur→Gaussian Blur** to bring up the **Gaussian Blur** dialog box. (If you loaded my dekeKeys shortcuts, you can alternately press Shift+F7.) Set the **Radius** to 20 pixels, as I've done in Figure 8-4, and click **OK**.Don't be disturbed by the initial effect, we're going to be working on this.

4. ***Change the blending option of the smart filter.*** Obviously, as you can see in Figure 8-4, the blur effect obliterated not only all the surface detail in the image but also rather important things like her eyes, nose, and lips. We'll pull back the effect by adjusting the blend mode of the filter. In the **Layers** palette, double-click the ⚏ icon to the right of the **Gaussian Blur** filter to bring up the **Blending Options** dialog box. Set the **Mode** option to **Overlay**, which increases the contrast but mitigates the blur effect, as you can see in Figure 8-5. Click **OK**.

5. ***Turn off the smart filter.*** The image is looking smoother, but we have lost too much of the detail in the process. The luminance mask we'll create during this exercise will constrain the blur effect so it applies only to the highlight areas, smoothing the skin textures without sacrificing details such as her hair.

To create that mask, however, we need to use the channel information of the original image (before we applied the filter). So click the 👁 icon to the left of **Smart Filters** in the **Layers** palette to temporarily disable the effect of your Gaussian Blur filter application, as shown in Figure 8-6.

Figure 8-4.

Figure 8-5.

Figure 8-6.

Figure 8-7.

Figure 8-8.

6. *Load a selection from a channel.* Go to the **Channels** palette and click the thumbnails for the Red, Green, and Blue channels in turn to evaluate them. As you might expect since you're working in a portrait, the Red channel looks like the best candidate for a luminance mask because it has the most contrast (lighter skin, darker hair and background) and the smoothest texture. Ctrl-click (⌘-click) the thumbnail for the **Red** channel to load its luminance data as a selection. Then click the thumbnail for the **RGB** composite to make sure you return to the full-color image as shown in Figure 8-7.

7. *Replace the Smart Filters layer mask.* Now let's use that Red channel selection to create a layer mask for the smart filter effect:

 • Switch back to the **Layers** palette and click to the left of the **Smart Filters** thumbnail to turn on the 👁 icon and restore the effect of the Gaussian Blur filter.

 • Click the layer mask associated with the **Smart Filters** layer. Press the Alt (Option) key and click the trash can icon at the bottom of the palette to delete the layer mask. Pressing the Alt (Option) key prevents Photoshop from asking if you're sure you want to delete the mask. You're sure.

 • Right-click (Control-click) the **Smart Filters** effect layer and choose **Add Filter Mask** from the pop-up menu. This adds a layer mask to the filter effect based on the selection you had loaded, so that the blur is now relegated to only the highlights in the image, as you can see in Figure 8-8.

8. *Make a selection of the left eye.* Although the skin looks smoother, the filter effect has had some negative impact on certain parts of the portrait, like the eyes and hair. Let's start with the eyes. This calls for first carefully selecting the eyes:

We're going to use the Intersect with Selection feature of the marquee tool to manually select the eyes, so we have to treat them separately.

- Choose the elliptical marquee tool from the rectangular marquee tool flyout in the toolbox.

- Drag a selection that aligns with the top of the left eye (the woman's right), holding the spacebar as needed to move the selection as you create it.

- Press Shift+Alt (Shift-Option) to access the **Intersect with Selection** option and draw a selection that aligns with the bottom half of the left eye (her right). Again, hold the spacebar as needed to reposition the selection while you're creating it. Where the two ellipses intersect, you have a selection that traces her eye, as in Figure 8-9.

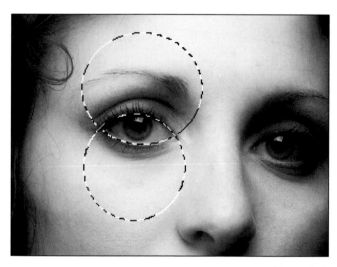

Figure 8-9.

PEARL OF WISDOM

Rather than use an adjustment layer to fix the effect on the eyes, you could carve out eye areas in the luminance mask. To do this, you would Alt-click (Option-click) on the filter mask and make the eyes black, which would reveal the original eyes through the Gaussian Blur filter. But, in general, I tend to avoid destructive edits to masks when possible. A knockout layer, like I discussed in Lesson 7, isn't available when you're in a smart filter stack either. So an adjustment layer is my suggested way to go.

9. **Add a Levels adjustment layer.** We're going to create the levels adjustment for the eye on the left first before we select the second one:

- In the **Adjustments** palette, Alt-click (Option-click) the ▲ icon (top row, second from the left). In the **New Layer** dialog box, name the layer "Eyes" and click **OK**.

- In the **Levels** panel, set the pop-up menu above the histogram to **Red**. Set the white **Input Level** by moving the white triangle below the histogram to 245.

- Press Alt+4 (Option-4) to switch to the **Green** channel, and press Shift+↓ three times to set the white **Input Level** to 225.

- Then press Alt+5 (Option-5) to switch to **Blue** and move the white triangle to 215 by pressing Shift+↓ four times. The net effect of each of these adjustments is to return her eye to a more neutral color from the warm effects of the filter.

- Finally, set the pop-up above the histogram to **RGB**. For Input Levels click in the box under the gray triangle and press Shift+↑ to raise the gamma value to 1.1. Since this adjustment lightens the pupil a bit, raise the black triangle below the histogram to 10.

As you can see in Figure 8-10, the Levels adjustment has brightened the eye considerably.

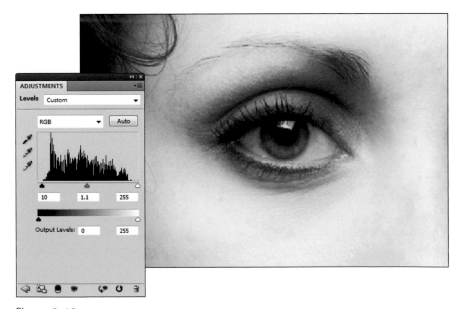

Figure 8-10.

10. ***Paint to adjust the mask.*** We don't want that levels adjustment from the last step to give hard edges to the fleshy inside corner of her eye:

- Make sure the Eyes layer is active.

- Grab the brush tool, and right-click (Control-click) inside the image to bring up the brush pop-up palette. Set the **Master Diameter** to 20 pixels and the **Hardness** to 0 percent. Press Enter or Return.

- Make sure **Opacity** is set to 100 percent and the **Mode** is set to Normal.

- Press D to set the colors to their defaults of black and white. Then press X to switch the foreground and background colors so black is the foreground color.

- Paint the inside corner of the eye to adjust the layer mask and block that area from being affected by the adjustment.

11. ***Add the other eye to the layer mask.*** Now we can modify the layer mask so the adjustment will affect the other eye, but first we need to create a selection for that eye:

- Choose the elliptical marquee tool from the toolbox, or press the M key.

- Drag a selection that follows the top arc of the inner part of her eye. Because the eyelid overlaps the eye, you won't be able to follows the top arc in one selection.

- Pressing Shift+Alt (Shift-Option), drag another elliptical selection overlapping the first, this time following the top arc of the eyelid down the outer edge. You'll end up with a combined arc on the top that is flat on the inner eye and rounder on the outer, as in Figure 8-11).

- Again, press Shift+Alt (Shift-Option) and drag one more elliptical selection that lines up with the bottom of the eye, producing the final selection you see in Figure 8-12.

12. ***Fill the selection with white.*** The layer mask for the Levels adjustment is still active, so we'll use the current selection to modify the mask. Press Ctrl+Backspace (⌘-Delete) to fill the selected area of the layer mask with white. Then press Ctrl+D (⌘-D) to abandon the selection.

Figure 8-11.

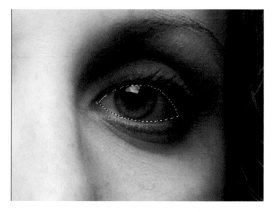

Figure 8-12.

13. ***Paint to add to the mask.*** We weren't able to get the selection to go into the inside corner of the eye, so add a small portion of that area to the layer mask. Switch your foreground color is white. Press the B key to get the brush tool and press ☐ twice to reduce the brush size to 10 pixels. Fill in any missing parts of the inside corner of the eye, within the eye itself, without painting over the fleshy area.

14. ***Modify the mask for the blur effect.*** The adjustments we've been adding to this image are extremely flexible. So we can fine-tune the areas affected by the Gaussian Blur filter even more by applying a Levels adjustment to the filter mask to further protect the hair from the effects of the blur:

 • Click the layer mask associated with the **Smart Filters** layer in the **Layers** palette to make it active.

 • Press Ctrl+L (⌘-L) to bring up the **Levels** dialog box. In the **Input Levels** area, drag the black triangle below the histogram to 60 and drag the white triangle to 225. Click **OK** to close the dialog box.

 As you can see in Figure 8-13, the effect of the Levels adjustment darkened the mask in the hair area, helping to retain more detail, and brightened the mask for the face, applying more smoothing to that area.

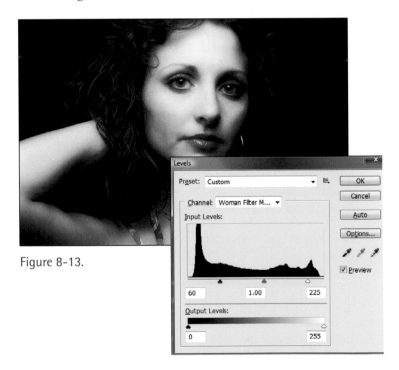

Figure 8-13.

15. ***Refine the Levels adjustment.*** After adjusting the mask for the Smart Filters layer, I think we should remove some of the red from the eyes. We can do that by altering the Levels adjustment associated with the Eyes layer mask:

- Click the thumbnail for the **Eyes** adjustment layer.

- In the **Levels** panel of the **Adjustments** palette, change the Input Levels by moving the black triangle below the histogram to 20 and the white triangle below the histogram to 245. Increase the gamma value (the gray triangle) to 1.30.

- Choose the **Red** option from the pop-up menu above the histogram, as circled in Figure 8-14. Move the white triangle under the histogram to 255 to reduce the amount of pink in the eyes.

16. ***Apply feathering to the Levels layer mask.*** The transition for the Levels adjustment we applied to the eyes is a little harsh. Click the layer mask associated with the **Eyes** layer to make it active. Switch to the **Masks** palette (which is grouped with the Adjustments palette by default, if it's not there choose **Window→Masks**), increase **Feather** to 2 pixels. This setting smooths the transition for our adjustment, producing the result shown in Figure 8-15.

17. ***Save the image.*** If you want to save the final result, press Ctrl+Shift+S (⌘-Shift-S) to bring up the **Save As** dialog box. Name the file "Luminous Smoothing," make sure the **Format** is set to **Photoshop** (to preserve your layers), and click **Save**.

Adjusting Skin Tones with a Corrective Mask

Another specialized way to use masks is with what I call a corrective mask. Simply put, this type of mask focuses the color correction to specific areas inside the image that needs help.

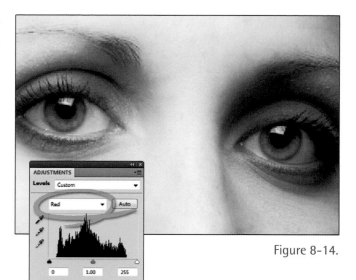

Figure 8-14.

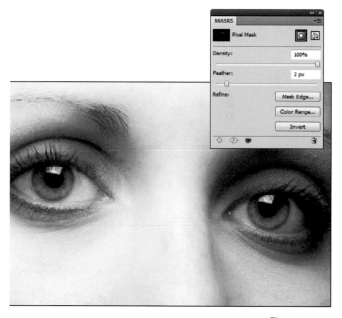

Figure 8-15.

In this exercise, we'll use the corrective mask to wrangle some wayward color hues in the skin tones of an image. As you'll see, this technique provides an easy method for correcting blotchy or uneven tones while leaving other areas in the image safely untouched.

Figure 8-16.

Figure 8-17.

1. *Open an image.* Open *Average hue.tif*, located in the *Lesson 08* folder inside *Lesson Files-PsCM 1on1*. I shot this photo of my son Max, shown in Figure 8-16, years ago. You'll be glad to know that this scary mix of crimson and yellow is not a function of my son's actual skin but rather of the low-end camera I used to take the photo. The corrective mask will help balance these colors with relative ease.

2. *Create a copy of the Red channel.* We need to create a mask so we can apply an adjustment that will affect only the face, and in this case the Red channel happens to have the best contrast between the face and surrounding areas. Go to the **Channels** palette and drag the **Red** channel thumbnail to the ▣ icon at the bottom of the palette to create a copy of it. Double-click the name of the channel, type "Mask," and press Enter or Return.

3. *Apply a Curves adjustment to the mask.* Next, we'll apply a curves adjustment to increase the contrast between the face and the rest of the image. Curves will give us better control than the Levels command we used in the previous exercise:

 • Press Ctrl+M (⌘-M) to bring up the **Curves** dialog box.

 • Drag the black triangle to the right until the **Input** value is 64, darkening the shadow areas of the mask.

 You can set curves in this dialog box in two ways: by setting points or by drawing directly. If you don't see any triangles beneath the graph, make sure you're set to use points by clicking the button in the upper left that looks like a graph rather than the one that looks like a pencil.

 • Click at about the midpoint of the curve line and drag until the anchor point reaches an **Input** value of 115 and an **Output** value of 140 to brighten the midtones. You can nudge the values by moving the anchor point with the arrow keys or you can simply type the values manually.

 • Click **OK**.

 As you can see by the graph in Figure 8-17, the contrast in the mask has already increased quite a bit.

4. ***Clean up the neckline area.*** There are a couple of areas to clean up before we use this mask to control the color correction. We'll use a combination of techniques to cover a few problem areas around the neckline:

- Press the B key to choose the brush tool. In the options bar, set the **Master Diameter** to 90 pixels, the **Hardness** to 0 percent, and the **Mode** option to **Overlay**.

- With white as the foreground color, paint over the two small areas where the skin on the neck is showing through to brighten them, indicated by arrows in Figure 8-18.

- Press X to change the foreground color to black. Reduce the size of the brush to 50 pixels by pressing the ⬚ key four times. Paint in the areas over the zipper and collar to turn them black as I've done in Figure 8-18 as well.

- Using the lasso tool, drag to define a selection that includes all the areas aside from those two skin patches, as shown in Figure 8-19. Press Alt+Backspace (Option-Delete) to fill the selection with black, our current foreground color. Then press Ctrl+D (⌘-D) to abandon the selection.

Figure 8-18.

5. ***Establish the boundary around the face.*** We want the color correction filter to focus on the face, so before we apply our correction, clean up the boundary between the face and the rest of the image:

- Press the B key to choose the brush tool. Press the ⬚ key nine times to increase the brush size to 200 pixels. Make sure the brush **Mode** in the options bar is still set to **Overlay**, and paint around the perimeter of the face just outside the ears and face.

- Press the L key to get the lasso tool. (If you've used a lasso variation, you may have to click the L key a few times.) Draw a selection around the face that includes all the areas of skin without including any of the lighter spots in the black area outside the face. Press Ctrl+Shift+I (⌘-Shift-I) to reverse the selection, as I've done in Figure 8-20.

- Press Alt+Backspace (Option-Delete) to fill with black and then deselect by pressing Ctrl+D (⌘-D).

Figure 8-19.

Figure 8-20.

Adjusting Skin Tones with a Corrective Mask **285**

Figure 8-21.

Figure 8-22.

6. *Load a selection from the mask.* Now that the mask defines just the face, as you can see in the final mask in Figure 8-21, we can use it to create a selection that will constrain the color fix to just that face area. Go to the **Channels** palette, and Ctrl-click (⌘-click) the **Mask** channel to load it as a selection.

7. *Convert the Background layer to a smart object.* Once again, we'll be using a filter effect, so create a smart filter, we need to apply the filter to a smart object. In the **Layers** palette, click the ▾≡ icon to bring up the flyout menu, and choose **Convert to Smart Object**. Then, double-click the layer name and rename the layer something useful like "Max." Press Enter or Return.

8. *Apply an average blur.* Now we're ready to apply the actual adjustment. To even out the variable color values in the face, choose **Filter→Blur→Average**. As you can see in Figure 8-22, this filter converts the selected area that's defined by the mask to a single color based on an average of all the tones in the image, including the various skin tones, the green jacket, the blue blanket, and so on. It's obviously not what we're looking for in terms of the final effect, but we'll fix that in the next step.

9. *Change the blending options for the smart filter.* Double-click the ☰ icon to the right of the **Average** filter effect in the Layers palette to bring up the **Blending Options** dialog box. Change the **Mode** option to **Hue** so the filter effect will alter only the hue of the skin tones without affecting the saturation or luminosity values. The image now has a nice even skin tone while still keeping all of my boy's cute detail. Reduce the **Opacity** value to 70 percent to soften the effect slightly, as you can see Figure 8-23, and then click **OK**.

Figure 8-23.

10. *Save the image.* We've now taken what was a fairly hideous mottled skin tone and turned it into a nice even one with the help of an Average Blur filter effect constrained by a mask that limited the correction to just where we needed it. To save your work, press Ctrl+Shift+S (⌘-Shift-S), name the file "Blotchiness Corrected," set the **Format** to **Photoshop**, and click **Save**.

Changing the Color of an Image Element with a Color Mask

As you've already seen in the previous two exercises, the specialized masks I'm showing you provide a handy way to constrain your adjustments to specific areas of an image. In this next exercise, we'll work with a color mask to isolate one particular object, to change the color of that object without affecting similarly colored items in the image.

Veteran Photoshop users will know that the easiest way to change the color of an object in a photo is to use a Hue/Saturation adjustment to turn one color into another. The problem with using Hue/ Saturation arises when the color of the object you want to change is similar to colors you don't want to alter. In this exercise, for instance, changing the reds in the model's shirt risk unfavorably altering the red tones in her skin. By using a color mask, you can isolate the color shift to just the area you want to change.

1. *Open an image.* Open *Dry dandelion.jpg*, located in the *Lesson 08* folder inside *Lesson Files-PsCM 1on1*. This photo of a woman holding—as you might have guessed—a dry dandelion in Figure 8-24 is by Bobbie Osborne of iStockphoto. Your mission is to change the woman's coral-colored shirt to a muted yellow. The challenge is that the color in her top is similar to the colors in her cheeks, lips, nose, forehead, and elsewhere in her skin tones, so we need to constrain the Hue/Saturation adjustment using a mask that's actually based on the color itself.

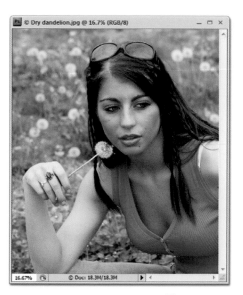

Figure 8-24.

2. *Apply a Hue/Saturation adjustment.* We are going to shift the hue of the model's shirt from coral to banana. We'll dive right in to the Hue/Saturation adjustment, and deal with the undesirable side effects in steps to follow.

These kinds of color shifts are often used by fashion catalogs to show the variety of colors that might be available for a garment, without having to reshoot a model in six different shirts. Hence, my rather romantic descriptive names of the colors we'll be working with.

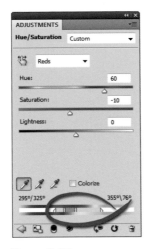

Figure 8-25.

- In the **Adjustments** palette, Alt-click (Option-click) the icon, which is second from the left in the second row of icons. In the **New Layer** dialog box, name your new layer "Yellow" and click **OK**.

- In the **Hue/Saturation** panel, shown in Figure 8-25, you want to switch from adjusting the entire image to adjusting just the red tones in her shirt. So press Alt+3 (Option-3) to change the pop-up menu to the right of the icon from Master to **Reds.**

- In the row of eyedroppers at the bottom of the panel, select the icon on the left, then click inside the model's shirt to establish the base color for your adjustment. You can see the range of your affected colors indicated in the gray area between the two color bars at the bottom of the panel. In this case, we're operating on a range that goes from purplish-magenta to orangish-red.

- Increase the **Hue** setting to 60 to shift the reds toward a somewhat yellow-orange color, and move the **Saturation** setting to –10 to reduce the saturation of the colors we're adjusting.

- To fine-tune the range of colors being affected, drag the triangle thingie on the left side of the gray range indicator bar to 295 degrees, the left vertical bar to 325 degrees, the right vertical bar to 355 degrees, and the right triangle to 76 degrees, as circled in Figure 8-25. Although the color values are expressed in numbers for your reference, there's no way to type the numbers directly in this panel. Dragging the sliders is the only way to adjust the range of affected colors.

You can see in Figure 8-26 that we've changed the shirt color successfully, but with dire consequences to her skin tone.

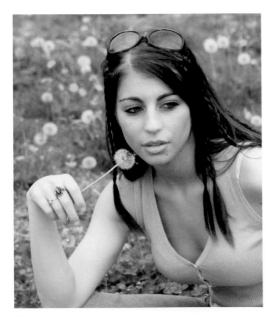

Figure 8-26.

3. *Turn off the Yellow adjustment layer.* The adjustment changed the color of the shirt but unfortunately changed the color of almost everything else as well, just as we'd feared. Fortunately, the color mask will fix that. We want to build our mask based on channel information in the original image, so in the **Layers** palette, click the 👁 icon for the **Yellow** adjustment layer to temporarily turn off its visibility.

4. *Create an initial selection of the shirt.* We're going to use the Color Range command to start the mask, but first we want to give Color Range a little help by defining the area upon which to make its assessment. In the Layers palette, click the thumbnail for the **Background** layer to make it active. Press the L key to get the lasso tool and then Alt-click (Option-click) to draw a selection that very generally defines the area of her shirt and about 10-20 pixels beyond, as shown in Figure 8-27. Be sure to avoid her lips because they are so close in color to the shirt, then return to your first point to create the selection.

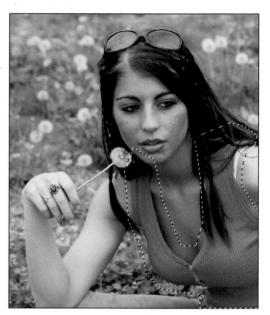

Figure 8-27.

PEARL OF WISDOM

If we were interested in changing the color of her denim jeans instead of her shirt, the target adjustment tool, (a feature new to CS4 that you learned about in Lesson 6) would be the tool of expedient choice. At this stage, if you clicked the 👆 icon in the Hue/Saturation panel and Ctrl-dragged (⌘-dragged) across that small section of her jeans at the bottom of the image, you could easily give the jeans a green or crimson wash without affecting anything else. The target adjustment tool works beautifully on her jeans because no other area in the image is affected by an adjustment to the blues. If you tried the same technique on the shirt, however, and dragged to the left to turn the shirt yellow, you'd end up with a jaundiced model because all the red tones in her skin would come along for the adjustment ride, much as they've done here.

5. *Create a Color Range selection.* Now that we've given the Color Range command a generalized area to work with, we'll use it to refine the area of her shirt:

- Choose **Select→Color Range** or, if you loaded my dekeKeys shortcuts, press Ctrl+Alt+Shift+O (⌘-Option-Shift-O). In the **Color Range** dialog box, shown in Figure 8-28, choose **None** from the **Selection Preview** pop-up menu to see the full-color image as you work (with the normal grayscale preview in the Color Range dialog box). Set **Fuzziness** to 100.

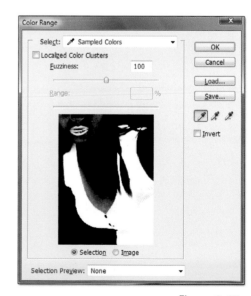

Figure 8-28.

- Click inside the blouse in the image window, and then Shift-drag throughout most of the blouse. Be sure to drag close to the edge of the fabric near the background, but watch out for the areas at the top of the shoulders, which, if you click too close, will take things too far. Keep your eye on the Color Range preview to see if you've missed any noticeably large areas.

If you want to ensure that your Color Range selection is exactly the same as mine (which may make things smoother throughout the rest of this exercise), click the **Load** button in the Color Range dialog box. In the **Load** dialog box, choose the *Coral blouse.axt* file, located in the *Lesson 08* folder inside *Lesson Files-PsCM 1on1*, and click the **Load** button to load the settings I've created for you.

- Click **OK** to close the Color Range dialog box.

6. *Create layer mask for the Yellow adjustment.* Once the selection is created, we want to apply it to the Yellow adjustment layer. In the **Layers** palette, click to select the **Yellow** layer and click in the space to the left of the adjustment thumbnail to wake up the 👁 and make the layer visible. Click the ▢ icon at the bottom of the Layers palette to add a new layer mask based on the active selection The adjustment layer will now affect only the selected area, as you can see in Figure 8-29.

7. *Paint away mask edge details.* Although she's no longer sickly green, our model does have an odd sunburn where our rough mask edges show. There are some other obvious flaws as well, all of which we'll clean up with the tried-and-true overlay brush:

 - Press the Alt (or Option) key and click the layer mask for the **Yellow** adjustment layer in the Layers palette to see it in the image window.

 - Press the B key to get the brush tool. Right-click (Control-click) to bring up the Brush settings menu, and set the **Master Diameter** to 300 pixels and the **Hardness** to 0. Set the **Mode** option to **Overlay** using the pop-up menu in the options bar. Make sure the foreground color is set to black.

 - Paint along the edges of the shirt and along the neckline, shoulders, and sides, but be careful not to paint into the hair or the strap at the top-right of the image (on the model's left shoulder).

Figure 8-29.

- Press the X key to swap the foreground and background colors. Press the ⊡ key three times to reduce the brush size to 175 pixels.

- Carefully paint away any texture in the fabric of the shirt, including the ribbed texture and the stitches near the neckline. Do not paint over the buttons on the shirt or the slight gap near the lower button that appears dark. Your result should look like Figure 8-30.

8. *Use the magic wand to check accuracy.* You can use the magic wand to help judge the accuracy of your mask and to aid in cleaning up the remaining details:

- Choose the magic wand tool from the quick selection tool flyout menu in the toolbox.

- In the options bar, set the **Tolerance** to 0, turn off the **Antialias** and **Sample All Layers** check boxes, and turn on the **Contiguous** check box.

Figure 8-30.

- Click in the black area between the shoulder straps to create a selection which will reveal any stray areas that appeared solid black during our painting but weren't actually solid.

9. *Paint away the defined areas.* Paint away the areas defined by the magic wand selection to clean up your mask:

- Press Ctrl+Shift+I (⌘-Shift-I) to reverse the selection so it includes the shirt and the dark (but not quite black) areas around the shirt.

- Press the B key to get the brush back. Set the foreground color to black, and press the ⊡ key to increase the brush size to 200 pixels.

- Paint in the black areas along the edge of the shirt where the dark pixels are included in the selection, including the hair at the top of the shoulder strap on the right (the woman's left), but not the hair that hangs down the front of the shirt.

- Press Ctrl+D (⌘-D) to abandon the selection.

10. *Create another reference selection.* Now let's use the same technique to clean up the inside of the shirt. Choose the magic wand tool from the toolbox and click a white area of the shirt. Press Ctrl+Shift+I (⌘-Shift-I) to reverse the selection so it includes the nonwhite areas of the shirt that you might have missed in Step 7.

Figure 8-31.

Figure 8-32.

Figure 8-33.

11. ***Paint in selected areas of the shirt.*** Press the B key to return to the brush tool. Press the X key to change the foreground color to white. Paint within all the selected areas of the shirt except where it contacts the hair (because we don't want to damage the transitions around the hair). When you're done, abandon the reference selection by pressing Ctrl+D (⌘-D). The result is shown in Figure 8-31.

12. ***Clean up the V of the shirt.*** Some areas around the edges are suffering from fringing. The first one we'll address is the V of the shirt:

 • In the Layers palette, Alt-click (Option-click) the layer mask for the **Yellow** adjustment layer to return to the full-color image.

 • Press L to get the lasso tool. Alt-click (Option-click) around the V of the shirt to draw a triangle shape that catches that problematic fringing, as shown in Figure 8-32.

 • Press Backspace (Delete) to fill the selection with black, our current background color which will mask that fringe, and press Ctrl+D (⌘-D) to toss away the selection.

13. ***Paint away the red color fringing.*** Next we'll fix the color fringing between the shirt and background on the left side (her right). Note that if you turn off the yellow layer (by toggling the 👁 on and off, little happens to the background behind her right side. This means we can extend the mask to cover the red fringed area without compromising the background.

 • Press B to grab the brush tool. Change the **Master Diameter** setting to 40 pixels. For a soft-edge brush, change the **Hardness** setting to 0 percent. Set the **Mode** to **Normal**.

 • Paint along the edge of the blouse on the left side (circled in Figure 8-33) to remove the color fringing. Be careful not to paint into her hair.

14. ***Clean up the color fringing on the right side.*** We'll use a different approach to remove the color fringing on the right side of the shirt (her left):

 • Press the M key for the rectangular marquee tool, then drag to define a selection that includes the visible color fringe on the right of the strap on the right shoulder (her left). Extend that selection all the way to the right edge below where the shirt goes outside the image area, as in Figure 8-34 on the next page.

- Adjust the zoom percentage to 50 percent.

- Press Ctrl+Alt+↓ (⌘-Option-↓) to move a copy of the selected area of the mask downward. Press ↓ (without the modifier keys) one more time to nudge the selected area down once more. We're basically cloning a few pixels at a time. Then abandon the selection by pressing Ctrl+D (⌘-D).

The result, with that green fringing removed, is shown in Figure 8-35.

15. *Smudge away the final details.* Even after the adjustments to the mask in the preceding step, we still have some fringing near the strap. I don't often use the smudge tool, which shifts the position of pixels in a small area of an image or a layer mask, but it actually happens to be the tool of choice here:

- Choose the smudge tool from the blur tool flyout menu in the toolbox, shown in Figure 8-36. In the options bar, change the **Master Diameter** setting to 175 pixels and increase the **Strength** setting to 100 percent. This means we'll move pixels rather than smear them.

- Drag down from the top of the spike in the color fringe where the strap first appears from behind the shirt. Drag down only a few pixels.

- Drag downward again as needed to eliminate the color fringing in this area of the shirt, but be sure to use very short brushstrokes. If you get fringing in the opposite color, you've gone too far.

Figure 8-34.

Figure 8-35.

Figure 8-36.

Figure 8-37.

Figure 8-38.

16. *Create a selection for fixing the hair.* We have some residual issues with our model's hair. Both the red and the greenish fringing that we saw on the shirt edges are present in her dark brown tresses. To get things started, create a selection to constrain our efforts to the hair:

• Press the L key to get the lasso tool.

• In the options bar, set **Feather** to 0 pixels. We want to create a selection with jagged edges, so turn off the **Anti-alias** check box.

• Alt-click (Option-click) to define the outline of a selection that includes only the edge areas of the hair on the right side (her left) where the ends of her braids rest against her shirt. Draw a polygonal selection that includes the problematic ends of the hair and extends down into her shirt, like the one in Figure 8-37. Click your starting point when you return to it.

17. *Turn off the Yellow adjustment layer.* Time to temporarily turn off the effect of the Yellow adjustment layer, so that you can create a selection based on the Red channel of the original image. In the **Layers** palette, click the 👁 associated with the **Yellow** adjustment layer to hide its effect.

18. *Create a copy of the Red channel.* We'll use the details in the Red channel to improve the hair. Still in the Layers palette, click the **Background** layer to make it active. Then switch to the **Channels** palette, and click the **Red** channel thumbnail to make it active. Press Ctrl+C (⌘-C) to copy the selected area to the clipboard. Press Ctrl+2 (⌘-2) to return to the full-color image.

19. *Paste the details into your mask.* Now we'll paste the copied information into the Yellow adjustment layer mask:

• Return to the **Layers** palette and click the square on the left of the **Yellow** adjustment layer to wake up the 👁.

• Click the thumbnail for the **Yellow** adjustment layer mask to make it active.

• Alt-click (Option-click) the layer mask for the **Yellow** adjustment layer to display the mask.

• Press Ctrl+V (⌘-V) to paste the contents of the clipboard to the layer mask, and then press Ctrl+H (⌘-H) to hide the selection outline, as in Figure 8-38.

- Alt-click (Option-click) the layer mask for the **Yellow** adjustment layer to return to the full-color image. As you can see in Figure 8-39, the edges of the hair look better already. Of course, the surrounding shirt and skin are out of whack, with a slightly red cast in the newly pasted area.

20. *Apply a Levels adjustment to the mask.* To improve the mask, we'll increase the contrast for the pasted area and its Red channel information. Press Ctrl+L (⌘-L) to bring up the **Levels** dialog box. For the **Input Levels,** move the white triangle under the histogram to 190 and move the black triangle to 50. Click **OK**. As you can see in Figure 8-40, the transitions of the hair are better.

Figure 8-39.

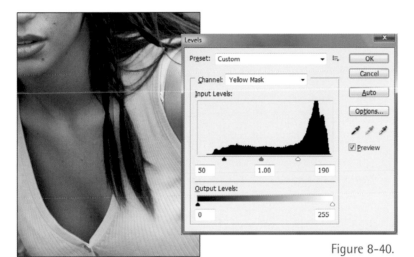

Figure 8-40.

21. *Paint additional mask modifications.* Now we'll paint the final modifications to fix the last of the bad transitions:

- Press the B key to select the brush tool. Change the **Master Diameter** to 175 pixels and the **Hardness** to 0 percent. Set the **Mode** option to **Overlay** and reduce the **Opacity** setting to 70 percent.

- With your foreground color set to white, paint between the two braids hanging in front of the shirt, along the right side, and in the wispy strands of hair farther up on the shoulder. The final result is shown in Figure 8-41.

If your adjustments are too strong while painting, press Ctrl+Z (⌘-Z) to undo the last paint stroke and reduce the Opacity setting before painting again.

Figure 8-41.

22. **Save the image.** There you have it. The model's shirt has gone from coral to banana and yet the rest of the image remains unscathed by the color change. We're going to use this image in the next exercise, so press Ctrl+Shift+S (⌘-Shift-S), name your file "Now Available in Yellow," and click **Save**.

Sharpening with a Density Mask

We're going to continue working with the image from the preceding exercise, this time using a combination of a high pass layer and a density mask (an inverted luminance mask) to apply targeted sharpening to the image. The right amount of sharpening in the right place can really increase the impact of your image. Yes, you could try the Smart Sharpen filter, but in this exercise, we're going for some professional-grade sharpening, which requires a bit of finesse.

Rather than uniformly sharpening the image—a dangerous thing to do with a portrait because no one wants sharp pores!—we're going to sharpen only the details that really benefit from sharpening. Then we'll curtail the effect with a knockout mask. The net result will mean sharp eyes, dandelions, and hands, but not sharpened pores, blemishes, and moles.

1. **Open an image.** If you're still working on your image from the last exercise, skip to the next step. If not, open *The final color mask.psd,* located in the *Lesson 08* folder inside *Lesson Files-PsCM 1on1.* This is, of course, the same image by photographer Bobbie Osborne of iStockphoto.

2. **Create a copy of the Background layer.** We want to apply a sharpening effect without harming our original pixels, so we'll make the modifications to a copy of the background. (For reasons I'll explain later, we can't use a smart filter.) Click the **Background** layer thumbnail in the **Layers** palette to make it active. Press Ctrl+Alt+J (⌘-Option-J) to bring up the **New Layer** dialog box. Type "Sharpen" for the **Name** and click **OK** to create the new layer.

3. **Move the Sharpen layer to the top of the stack.** We need the Sharpen layer to be at the top so that it applies a sharpening effect to the entire image. Press Ctrl+⬚ (⌘-⬚ on the Mac), or drag the **Sharpen** layer thumbnail to the top of the **Layers** palette. As you can see in Figure 8-42, the color change applied to the shirt in the previous exercise disappears, but we'll fix that shortly.

Figure 8-42.

4. *Apply the High Pass filter.* We're going to use the High Pass filter for our initial sharpening effect. Choose **Filter→Other→High Pass** to bring up the **High Pass** dialog box. (I think High Pass is useful enough that I've assigned it a dekeKeys shortcut of Shift+F10.) The initial result, as you can see in Figure 8-43, doesn't seem particularly appealing, but it soon will. Set **Radius** to 3 pixels and click **OK** to close the dialog box.

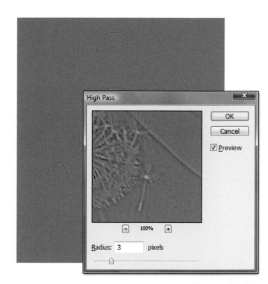

Figure 8-43.

| PEARL OF | | WISDOM |

The High Pass filter turns the image gray. The lower the radius value you use, the more gray you're going to get. It's like the image is sent through a funnel and its colors turn grey as it passes through. The edges, meanwhile, are hanging on for dear life. The low Radius value defines the thickness of what those remaining edges are. Less thick edges equals more gray. So most of the image will go to gray but the most important edges will remain.

5. *Change the blend mode to Overlay.* As you'll recall from previous lessons, the Overlay blend mode drops neutral colors (gray) and increases contrast (edges), which is exactly what we want. Change the blend mode for the **Sharpen** layer by setting the **Mode** to **Overlay** in the pop-up menu. You can see the result in Figure 8-44.

6. *Increase the contrast for the Sharpen layer.* I said I would explain why we couldn't apply our sharpening effect as a smart filter, and this step is the reason why. We want to increase the contrast of this layer to strengthen the sharpening effect. If we had used a smart filter, we wouldn't have the flexibility to alter the mask for the Sharpen layer or to use a knockout layer to constrain the areas affected by sharpening.

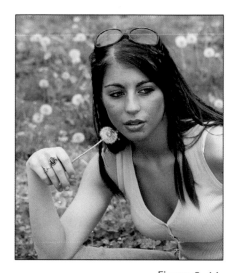

Figure 8-44.

Since we sacrificed file size and doubled the background to be able to put the filter on its own layer, we can now start this increased contrast quest with a Levels adjustment. Press Ctrl+L (⌘-L) to bring up the **Levels** dialog box, shown in Figure 8-45. For **Input Levels**, set the black triangle below the histogram to 100 and the white triangle to 155. Click **OK**.

7. *Make only the Background layer visible.* To enhance the dark areas of the image, we will create a density mask (the opposite of a luminosity mask, which enhances bright areas). The first step is to make only the Background layer visible. Press Alt (Option) and click the 👁 for the **Background** layer in the **Layers** palette so it is the only visible layer.

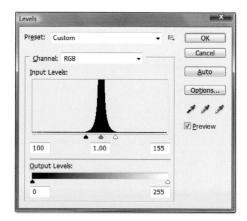

Figure 8-45.

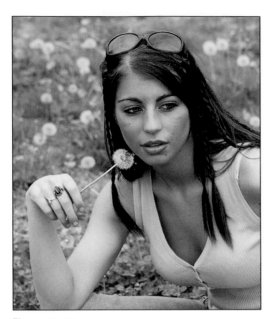

Figure 8-46.

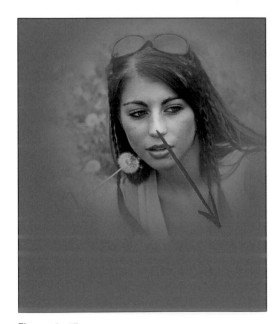

Figure 8-47.

8. *Create a density mask.* To constrain the Sharpen layer to only the darkest areas of the image, we'll use the Red channel as the basis of a density mask because it has the best contrast:

- In the **Channels** palette, press Ctrl (⌘) and click the **Red** channel thumbnail.

- Go to the **Layers** palette. We need the **Yellow** and **Sharpen** layers visible, so click in the space to wake up both of the 👁 icons. Make sure the **Sharpen** layer is active.

- Alt-click (Option-click) the ▢ icon at the bottom of the **Layers** palette to add a mask based on the inverse of the current selection. We now have a layer mask for the Sharpen layer that is an inverted version of the Red channel. As you can see in Figure 8-46, we are applying our sharpening effect to only the edges within the image.

9. *Create a new layer.* A knockout mask will help mitigate a few of the problems that came along with our sharpening effect, including some compromising effects to our earlier color shift from the last exercise. To begin, press Ctrl+Shift+N (⌘-Shift-N) to create a new layer and bring up the **New Layer** dialog box at the same time. Type "Knockout" for the **Name** and click **OK**.

10. *Apply a radial gradient.* Now we'll surround the woman's face in much the same way we surrounded the glass of water in the "Masking Translucent Objects" exercise in Lesson 7, to constrain the sharpening:

- Choose the gradient tool from the toolbox.

- Change the foreground color to something obvious so you can see what you're doing. Start by clicking the foreground color swatch in the toolbox. In the **Color Picker** dialog box, set the **H** value to 210 degrees and the **S** and **B** values to 100 percent each. Then click **OK**.

- In the options bar, set the gradient option so that it goes from your foreground color to transparent by pressing Ctrl+ ⌐ (⌘-⌐) and then the ⌐ key. Choose the radial gradient option by clicking the ▭ icon (second from the left of the five gradient style icons). Turn on the **Reverse** check box so we'll be creating a gradient that goes from transparent in the center to opaque at the outside.

- Drag from the center of the woman's face down to about the tips of her braids to produce the gradient shown in Figure 8-47.

11. *Group the Knockout and Sharpen layers.* We are going to use the Knockout layer to knock out the sharpening effect in the layer below, and the first step is to group our layers:

- Click the **Knockout** layer in the **Layers** palette.

- Shift-click the **Sharpen** layer. Click the ▾≡ icon in the Layers palette and choose **New Group From Layers** from the pop-up menu.

- In the **New Group From Layers** dialog box, type "Knockout Group" for the name and click **OK**.

The two selected layers collapse into the new layer group.

12. *Change the blending options for the Knockout layer.* We'll now adjust the blending options for the Knockout layer so it will serve as a clipping mask for the Sharpen layer:

- In the **Layers** palette, click the triangle to the left of the **Knockout Group** layer group to reveal its contents.

- Double-click the **Knockout** layer thumbnail to bring up the **Layer Style** dialog box, shown in Figure 8-48. In the **Advanced Blending** area, set the **Fill Opacity** to 0 percent to hide the visibility of the gradient pixels.

- We want the knockout effect to affect only the next layer down, so choose the **Shallow** option from the **Knockout** pop-up menu.

- Click **OK** to close the Layer Style dialog box.

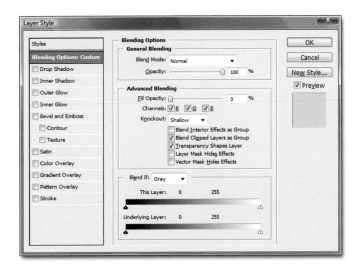

Figure 8-48.

Figure 8-49.

13. **Reveal the sharpening in other areas.** The Knockout layer has limited the effect to the model's face, but there are some details beyond her face that would benefit from sharpening:

- Choose the eraser tool from the toolbox or press the E key. Then Right-click (Control-click) in the image to bring up the brush pop-up palette. Set the **Master Diameter** to 900 pixels and the **Hardness** to 0 percent, and press Enter or Return.

- Click once on the hand to erase the gradient in that area and reveal the sharpening.

- Press the ⬚ key five times to reduce the brush size to 400 pixels. Paint over the model's sunglasses, the dandelion she's holding, and any other details you think need sharpening. My final result is shown in Figure 8-49.

14. **Save the image.** To save your sharpened masterpiece, press Ctrl+Shift+S (⌘-Shift-S) to bring up the **Save As** dialog box. Name it something appropriate such as "Professionally sharpened" and click Save.

Blurring a Background with a Depth Mask

Photographers produce evocative effects in their images by intentionally adjusting the depth of field. That might mean keeping everything in a scene in tack-sharp focus for a realistic rendition, or softening everything but a primary subject to create a stylized portrait. In this exercise, we'll use the power of Photoshop to blur the background of an image and exaggerate a narrow depth of field.

Figure 8-50.

The Lens Blur filter permits you to blur specific areas of an image, and using a depth mask, you can limit that blur to the focal length you desire.

1. **Open an image.** Open *In the grass. tif,* located in the *Lesson 08* folder inside *Lesson Files-PsCM 1on1.* As you can see in Figure 8-50, this portrait of our same model, another by photographer Bobbie Osborne of iStockphoto, already has a narrow depth-of-field effect. The grass that serves as the model's background is in high focus in front of her but quickly turns blurry as it goes on behind her. We're going to exaggerate that effect.

2. *Create a copy of the Background image layer.* To apply our blur effect without harming the original image, create a copy of the Background layer. (Photoshop doesn't allow the Lens Blur filter to be applied as a smart filter.) Go to the **Layers** palette and press Ctrl+Alt+J (⌘-Option-J) to create a new layer and bring up the **New Layer** dialog box. Name the new layer "Lens Blur" and click **OK**.

3. *Apply the Lens Blur filter.* We'll use the built-in features of the Lens Blur filter to fine-tune how the blur is applied:

 - Choose **Filter→Blur→Lens Blur** to bring up the **Lens Blur** dialog box. Make sure **Preview** is set to **Faster** or you'll be here all day.

 - In the **Depth Map** section, set the **Source** pop-up to **Field**. Note that any alpha channel or layer mask you had available would appear in this pop-up menu selection. I made the Field channel for you.

 - This mask constrains the blur so that it applies only to the grass areas in the image. Make sure the **Blur Focal Distance** option is set to 0. This option maps the blur effect to the tones in the image. Black represents areas that will remain in focus and white represents areas that will be blurred, so in our case the option will blur all the grass area.

 - Increase the **Radius** setting to 45 to apply a strong blur to the image. Note that you can change the blur effect with a variety of options, intended to simulate specific lenses, but we can leave those set to their defaults, as shown in Figure 8-51. Click **OK** to apply the blur.

Figure 8-51.

4. ***Create a new layer.*** The background grass has a nice soft blur, but unfortunately so does the foreground grass (except of course for the dandelions that I convinced you to ignore if you were creating the mask yourself). We'll once again use the knockout method to control which areas of grass are affected by the blur effect. Press Ctrl+Alt+N (⌘-Shift-N) to create a new layer, name it "Knockout" in the **New Layer** dialog box, and click **OK**.

5. ***Apply a gradient.*** We'll use a gradient for our knockout layer so that the transition to out-of-focus emulates what would happen with actual depth-of-field conditions:

 • Choose the gradient tool from the toolbox. Pick a color that's easy to see color by clicking the foreground color swatch in the toolbox to bring up the **Color Picker** dialog box. Change the **H** value to 210 degrees and the **S** and **B** values to 100 percent each. Click **OK**.

 • In the options bar, select the foreground-to-transparent gradient by pressing Ctrl+⬚ (⌘-⬚) and then the ⬚ key. Choose the linear gradient style by clicking the ▨ icon (the first of the five style options). The **Opacity** should be 100 percent and the **Mode** set to **Normal**. Turn off the **Reverse** check box.

 • In the image window, Shift-drag upward from the top of the white dandelion to the right of her head to almost the top of her head. The Shift modifier keeps you moving at a right angle perpendicular to the horizon, producing the gradient you see in Figure 8-52.

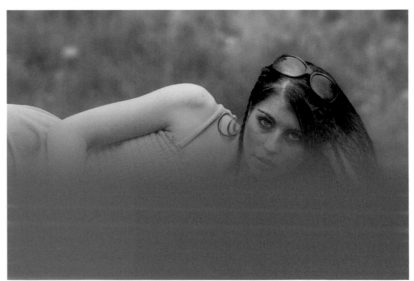

Figure 8-52.

6. *Change the blending options.* With the gradient created in the Knockout layer, we can now change the blending options to use this layer as a knockout layer:

- Double-click the thumbnail for the **Knockout** layer in the **Layers** palette.

- In the **Advanced Blending** area of the **Layer Style** dialog box, shown in Figure 8-53, set the **Fill Opacity** to 0 percent so that the blue isn't visible and change the **Knockout** option to **Shallow** so that this layer knocks out only the Lens Blur layer below it.

- Click **OK** to apply the knockout.

Figure 8-53.

One of the advantages of the Knockout layer is that we can adjust the location of the effect at any time. If you want your blur to start a little farther back, for instance, just use the move tool to slide the gradient upwards. Hold the Shift key while you move to constrain the angle of your movement to vertical. Just be warned that you may have to fill in the bottom of the gradient with the rectangular marquee if you move the gradient back so far that there's a gap in the front section.

7. *Apply a Screen blend mode.* To add a more dreamy effect to the image (and further exploit the flexibility of the knockout layer), click the thumbnail for the **Lens Blur** layer and change the blend mode to **Screen** using the pop-up at the top of the **Layers** palette. The result is shown in Figure 8-54.

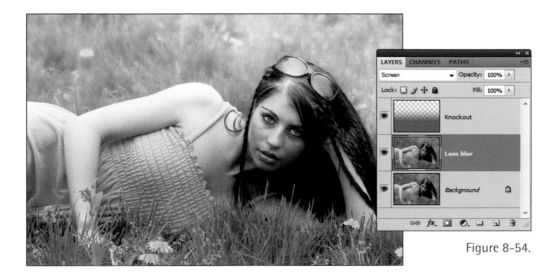

Figure 8-54.

Figure 8-55.

8. *Mask the Screen effect.* The Screen effect has spilled over into the model. To solve this, mask the Lens Blur layer so it affects only the grass:

- In the **Channels** palette, Ctrl-click (⌘-click) the **Field** channel to load it as a selection.

- Return to the **Layers** palette and click the thumbnail for the **Lens Blur** layer to make it active.

- Click the ⬜ icon to create a layer mask based on the current selection. As you can see in Figure 8-55, the blur effect is now visible only in the grass areas, with a smooth transition from the woman to the full background of the photo.

9. *Save the image.* To preserve all the effort you've put into the depth mask for this image, save it by pressing Ctrl+Shift+S (⌘-Shift-S), naming your file "Field of blur," and clicking **Save**.

Correcting an Archival Photo with an Edge Mask

I this final exercise, I'll show you what is possibly the most useful specialty mask of all: the edge mask. An edge mask helps you identify the true edges of objects in the image, ruling out the garbage. Creating an edge mask always follows the same basic pattern of steps, which I'll explain here.

An edge mask is great for sharpening any kind of photograph, but it's especially good for archival photographs. Photographs from the pre-digital age, especially those fifty years or older, tend to contain grain, dust, and scratches. In this lesson, we'll work on a 90-year-old photograph that features not only my maternal grandmother, but a lot of weathering from its 90-year existence that make standard Unsharp Masking out of the question.

PEARL OF ⬤ WISDOM

How out-of-the-question is the use of Unsharp Mask? I've set up a couple of example layers that feature Unsharp Mask filter treatments in your sample file. The numbers in those layer names indicate the Amount/Radius/Threshold settings I used for the filter for each layer. You can toggle the layer visibility by waking up the 👁 on the left of each layer in turn to see the effects. Pretty nasty looking case of measles if you ask me.

1. **Open an image.** Open *Plains dwellers.psd*, located in the *Lesson 08* folder inside *Lesson Files-PsCM 1on1*. As I mentioned, this is a family photo that I've scanned from an old print. Our goal is to enhance the good detail without emphasizing the bad. The woman on the far right of Figure 8-56 (the only one smiling, interestingly enough) is my maternal grandmother. The years have caused some damage, including dust and scratches—all of which is especially noticeable (and distracting) on the faces of my ancestors.

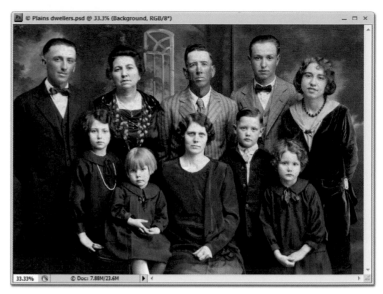

Figure 8-56.

2. **Duplicate the best channel.** We need to identify which channel is the best for our edge mask, and then duplicate that channel:

 • Go to the **Channels** palette. Click the thumbnail for the Red, Green, and Blue channels in turn, and identify which one has the best edge detail. Because the source is a monochrome image, there isn't much difference, so we'll use the "when in doubt" channel, Green.

 • Drag the thumbnail for the **Green** channel to the ⊟ icon at the bottom of the Channels palette to make a copy. Double-click the name of the **Green Copy** channel, type "Edge Mask," and press Enter or Return.

3. **Increase the contrast in the Edge Mask channel.** This channel has dust spots and other clutter, so we'll perform a basic cleanup by increasing the contrast with a Levels adjustment, which is generally speaking always your first step when creating an edge mask:

 • Press Ctrl+L (⌘-L) to bring up the **Levels** dialog box.

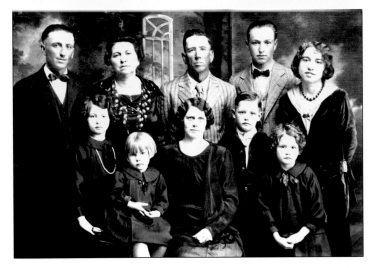

Figure 8-57.

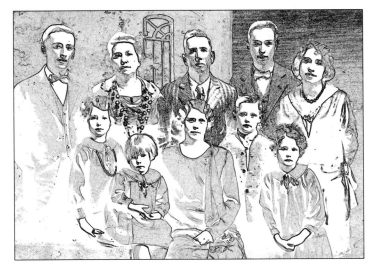

Figure 8-58.

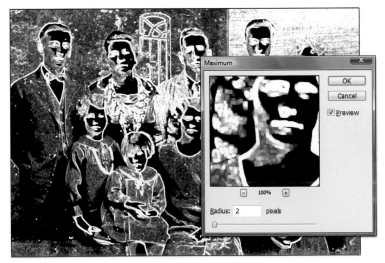

Figure 8-59.

- For **Input Levels**, move the white slider triangle under the histogram to the left to 170. This gets rid of much of the pockmark effect in the skin areas.

- Set the black slider triangle to the right to 60.

- Click **OK** to close the dialog box.

As you can see in Figure 8-57, the contrast has been enhanced considerably, helping to clean up some of the garbage in the image.

4. *Apply the Find Edges filter.* Our next step is to find the edges of the image. Choose **Filter→Stylize→Find Edges**. That's it, there's no dialog box. Photoshop just jumps right in and defines the edges in your image. The alpha channel now clearly defines the edges in the photo, complete with soft edge transitions. But also, as is revealed by Figure 8-58, complete with five-o'clock shadows on everyone, including the children.

5. *Invert the mask.* We need our edge mask to define the edges, but all the edges are currently black. Press Ctrl+I (⌘-I) to invert the Edge Mask channel, leaving white where the edges are, thus allowing them to be adjusted without affecting the rest of the image.

6. *Apply the Maximum filter.* Next we'll expand the edges in our mask so they cover a larger area along the edge borders in the photo. Choose **Filter→Other→Maximum**, set the **Radius** to 2 pixels, and click **OK**. The filter thickens the edges, as you can see in Figure 8-59.

If you want to extrapolate this technique to your own family heirlooms, you need to decide the setting for the Maximum filter on a case-by-case basis. After this step, however, the instructions I give you are directly related to the setting you entered here for any similar project.

7. *Apply the Median filter.* The edges, being determined by square pixels after all, are a bit blocky. We can mitigate that square appearance with the Median filter. The Median filter takes neighboring pixels, averages their luminance levels, and—when all is said and done—rounds off sharp corners. Choose **Filter→Noise→Median** to bring up the **Median** dialog box (see Figure 8-60). We need to apply the *same* setting for Median that we did for Maximum, so set the **Radius** to 2 and click **OK**.

Figure 8-60.

8. *Blur the edges slightly.* The edges of our mask have some transition, but they need more. Choose **Filter→Blur→Gaussian Blur** (or if you've loaded my dekeKeys shortcuts, you can press Shift+F7) to bring up the **Gaussian Blur** dialog box, shown in Figure 8-61. You always want the Gaussian Blur Radius to be 2 times the number of pixels you set during the Maximum/Median stages, so change the **Radius** to 4 pixels and click **OK** to apply the blur.

9. *Return to the Layers palette.* Now that we've built our edge mask, we can sharpen the image with the mask in place to constrain the effects. Press Ctrl+2 (⌘-2) to return to the RGB composite and switch to the **Layers** palette.

Figure 8-61.

10. *Duplicate the Background layer.* We're going to use the same sharpening technique we used in the density mask exercise earlier in this lesson. Click the thumbnail for the **Background** layer to make it active. Then press Ctrl+Alt+J (⌘-Option-J) to bring up the **New Layer** dialog box, name the layer "High Pass" (because that's the filter we'll apply), and click **OK** to create a copy of the Background layer.

11. *Apply High Pass sharpening.* Choose **Filter→Other→High Pass** (or my dekeKeys shortcut Shift+F10) to bring up the **High Pass** dialog box. Set the **Radius** to 3 pixels and click **OK**. In the **Layers** palette, change the blend mode for the **High Pass** layer to **Overlay** using the pop-up menu. You can see in Figure 8-62 that at this point the effect is not particularly strong.

12. *Enhance the sharpening effect with Levels.* We'll enhance the sharpening effect by increasing the contrast with an adjustment layer:

Figure 8-62.

- Alt-click (Option-click) the ⛰ icon in the Adjustments palette (second from the left in the top row.)

- In the **New Layer** dialog box, name the layer "Amount" (because we're going to adjust the amount of sharpening).

- Turn on the **Use Previous Layer to Create Clipping Mask** check box so this adjustment layer will affect only the layer directly below (the High Pass layer). Click **OK** to create the new Levels adjustment layer.

- In the **Levels** panel, move the black triangle below the histogram to 100 and the white triangle to 155. As you can see in Figure 8-63, we have considerably enhanced the sharpening effect.

Figure 8-63.

13. *Desaturate the sharpening effect.* The sharpening effect is actually enhancing some of the unwanted color variations in the image, so we need to desaturate the effect:

- Click the thumbnail for the **High Pass** layer in the **Layers** palette to make it active.

- Alt-click (Option-click) the ▬ icon in the Adjustments palette (second from the left in the second row).

- Set the layer name in the **New Layer** dialog box to "Desaturate," and click **OK**.

- In the **Adjustments** palette, reduce the **Saturation** setting to −100 to completely desaturate our High Pass layer. You'll

notice in Figure 8-64 a faint pinkish glow along the right sides of the subject faces (among other places) is now gone.

14. ***Load the edge mask as a selection.*** Now that we've created it, we can load the edge mask as a selection. Go to the **Channels** palette, and Ctrl-click (⌘-click) the thumbnail for the **Edge Mask** channel to load it as a selection.

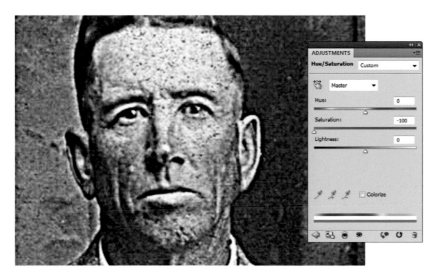

Figure 8-64.

15. ***Add a layer mask.*** We can now use this selection to constrain the sharpening effect. In the **Layers** palette, click the thumbnail for the **High Pass** layer to make it active. Then click the ▢ icon to add a layer mask to the High Pass layer based on the active selection.

16. ***Make the edge mask active.*** Fine-tuning the sharpening effect calls for adjusting our edge mask. Click the layer mask thumbnail (not the image thumbnail) associated with the **High Pass** layer in the **Layers** palette to make it active.

At this point, if you're curious, turn on the USM 350/3/25 layer and see just how much better the edge mask technique worked compared to unsharp mask. Just promise to turn it off again quickly. Shiver.

17. ***Fine-tune the sharpening effect.*** R the sharpening effect with a Levels adjustment applied directly to the edge mask:

- Press Ctrl+L (⌘-L) to bring up the **Levels** dialog box.

- To minimize the edges included in the edge mask (so fewer areas are sharpened), drag the black triangle under the histogram to the right to about 70.

- To maximize the edges included in the edge mask (so more areas are sharpened), drag the white triangle under the histogram to the left to about 190.

- Click **OK** to apply your changes and close the Levels dialog box.

- Reduce the sharpening effect by pressing the 7 key to reduce the Opacity setting for the **High Pass** layer to 70 percent. Figure 8-65 reveals the final restored family treasure.

18. *Save the image.* If you want to save this old photo in its new improved digital form, press Ctrl+Shift+S (⌘-Shift-S) to bring up the **Save As** dialog box, name your image "Sharp dwellers," and click **Save** to save the image.

There you have it. Six handy masks, created simply from properties inside the images themselves, which serve to constrain powerful effects to just the areas where you need them.

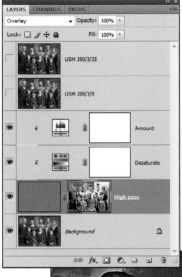

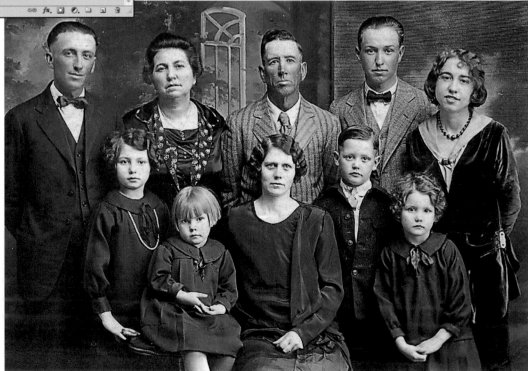

Figure 8-65.

WHAT DID YOU LEARN?

Match the key concept in the numbered list below with the letter of the phrase that best describes it. Answers appear upside-down at the bottom of the page.

Key Concepts

1. Luminance mask
2. Corrective mask
3. Color mask
4. Density mask
5. Depth mask
6. Edge mask
7. Blending Options
8. Filter mask
9. Hue
10. Smudge
11. Median
12. Find Edges

Descriptions

A. A mask based on the density information of a channel in an image, which is the opposite of luminance information.

B. A layer mask that constrains the effect of a filter to specific areas of an image.

C. A filter that neighboring clusters of pixels and averages their luminance levels, effectively rounding off sharp corners..

D. A blend mode that causes the underlying hue to be changed, without altering the saturation or brightness of the image.

E. A mask used with an adjustment layer to apply changes to specific areas of an image.

F. A filter that locates the areas of highest local contrast in an image.

G. A mask defined based on high-contrast edges within the image.

H. A mask utilized for adjusting colors in a specific area of an image.

I. A mask based on luminance information from a single channel in the image.

J. A tool that allows you to shift the position of pixels in a small area of an image or a layer mask.

K. A control that adjusts the blend mode and opacity of an effect applied to a layer.

L. A mask for making adjustments to an image based on the distance of objects from a lens, simulating a depth-of-field effect.

Answers

1I, 2E, 3H, 4A, 5L, 6G, 7K, 8B, 9D, 10J, 11C, 12F

CHANNEL MIXING AND OTHER TRICKS

REMEMBER WAY BACK in Lesson 1, when we discussed how Photoshop blends the luminance levels in each of the color-bearing channels—Red, Green, and Blue in the case of most of our images—to create a composite view of all the colors in a given image? In this lesson, we're going to look at ways to do some of our own custom blending. And we won't be creating alpha channels; we'll modify the color channels themselves. The results will be a series of black-and-white conversions, professionally tinted photographs, and extreme colorization effects. I'll even show you how to correct red-eye with a degree of control no other approach can match.

Mixing the contents of color-bearing channels might seem outside the normal range of acceptable behavior. After all, if you mess with the Red, Green, or Blue channel, you mess up the colors in your image. But channel mixing is both powerful and commonplace. In Figure 9-1, for example, I started with the red chair in the top-left corner and used Hue/Saturation to create all the others. The command shifted the hues by transferring luminance information from one channel to another. And thanks to adjustment layers, it all happened without altering a single pixels in the original photograph.

Figure 9-1.

Project Files

Before beginning the exercises, make sure you've copied the lesson files from the DVD, as directed in Step 3 on page xv of the Preface. This should result in a folder called *Lesson Files-PsCM 1on1* on your desktop. We'll be working with the files inside the *Lesson 09* subfolder.

In this lesson, we'll take a look at ways to mix color-bearing channels with each other to create high-impact, black-and-white images, and colorize those images on a luminance-by-luminance basis. Over the course of these exercises, you'll learn how to:

- Mix your own custom duotone photograph using a Channel Mixer adjustment layer page 316
- Create an even better duotone using a Black & White adjustment layer page 322
- Simulate infrared photography with the Channel Mixer and colorize with Gradient Map page 325
- Use Channel Mixer to correct extreme red eye created by a point-and-shoot camera. page 337

Video Lesson 9: Five Ways to Gray

Photoshop gives you a total of five ways to mix a grayscale image from an RGB (or otherwise colored) photograph. Three are automated but limited. The other two take a little more work, but they're customizable and nondestructive. The automated methods involve choosing the Grayscale command when viewing one or more channels; the nondestructive—and thus preferable—methods involve Channel Mixer and Black & White adjustment layers.

To see every one of them in action, insert the DVD, double-click the file *PsCM Videos.html*, and click **Lesson 9: Five Ways to Gray** under the **The Lighter Side of Masking** heading. Lasting 12 minutes and 54 seconds, this movie shows these shortcuts:

Operation	Windows shortcut	Macintosh shortcut
Scroll multiple open images simultaneously	Shift+spacebar-drag	Shift-spacebar-drag
Show or hide the Effects palette	Shift+F10	Shift-F10
Switch to the Green channel	Ctrl+4	⌘-4
Switch to the Lightness channel	Ctrl+3	⌘-3
Create and name an adjustment layer	Alt-click Adjustment icon	Option-click Adjustment icon
Brighten skintones from Black & White	drag right in skin with ✋ tool	drag right in skin with ✋ tool
Darken eyes from Black & White	drag left in eyes with ✋ tool	drag left in eyes with ✋ tool

Channel Mixer, I Am Your Father

We won't be using anything so mundane as Hue/Saturation. No, instead we'll start things off with a command that I wrote years ago and Adobe stole from me. In the early 1990s, Photoshop 3 (the current version is technically Photoshop 11, so a while back) introduced a feature called the Filter Factory that let you design your own filters. Industrious Photoshop tinkerer that I was, I used the Filter Factory to create a little thing I called Channel Mixer. It let me mix custom amounts of the Green and Blue channels into the Red channel, Red and Blue into the Green, and Green and Red into the Blue. Figure 9-2 shows the code used to create the filter followed by the filter as it appeared to the user. (Forgive the appearance of the dialog boxes; these are very old screen captures that originally appeared in ancient editions of my *Photoshop Bible*.)

Fast-forward a few years. Adobe discontinued the Filter Factory, citing "lack of interest." My Channel Mixer no longer works. But lo and behold, in Photoshop 5, Adobe released its own command cleverly called Channel Mixer that lets you mix custom amounts of the Green and Blue channels into the Red channel, Red and Blue into the Green, and Green and Red into the Blue. Sound familiar? What next, Adobe? A feature that provides full-color step-by-step tutorials with accompanying video lessons?

So now you know, Channel Mixer is my long-lost love child. But really, who can blame Adobe? It's a great feature any Photoshop parent would be proud to claim as its own. The Channel Mixer is particularly useful when it comes to creating custom black-and-white conversions that outperform anything you can create inside the camera. Using a combination of my estranged child Channel Mixer and its BFF Gradient Map, I was able to turn the full-color photograph at the top of Figure 9-3 into the monochromatic masterpiece below.

You can also use the Channel Mixer in more extreme ways to radicalize an image. And mixing channel information can be a good first step to reducing the red-eye effect produced by point-and-shoot cameras. Of course, like any tool, Channel Mixer has its issues—it was ripped from me when it was still a baby—but I'll show you how to get beyond them during the course of this lesson.

Figure 9-2.

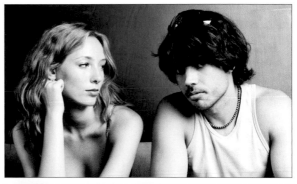

good-looking couple istockphoto.com/Mlenny

Figure 9-3.

Mixing a Custom Black-and-White Image

Mixing information from the color-bearing channels is a useful and easily controlled way to create grayscale versions of color images . In this exercise, we'll use the Channel Mixer command (which Adobe of course now takes credit for) and use it to mix information from the channels to create a custom black-and-white version of a color composite, like the one shown in Figure 9-4.

Figure 9-4.

Figure 9-5.

1. *Open the full-color image of the lovely couple.* Open the cleverly named file *YSM.psd*, located in the *Lesson 09* folder inside *Lesson Files-PsCM 1on1*. The portrait comes to us from photographer Alexander Hafemann of iStockphoto. YSM is an acronym for "You're smushing me," which you can imagine is what the woman might be thinking because the man is taking up more than his fair share of the frame.

2. *Create a Channel Mixer adjustment layer.* The Channel Mixer is accessible from the new Adjustments palette. (If the palettes is not visible, choose **Window→Adjustments**.)

 • From the main panel of the **Adjustments** palette, Alt-click (Option-click) the 🔵 icon (which, as you can see in Figure 9-5, is on the far right in the second row of icons) to create a Channel Mixer adjustment layer.

- In the **New Layer** dialog box, which appears because you held the Alt (Option) key, name the new layer "B&W" and click **OK**.

- In the **Channel Mixer** panel, turn on the **Monochrome** check box, circled in Figure 9-6. This creates a black-and-white version of the image based on Photoshop's default mix of 40 percent Red, 40 percent Green and 20 percent Blue.

3. *Adjust the color mix to the "industry standard" grayscale formula.* Increase the **Green** setting to 50 percent and decrease the **Blue** setting to 10 percent. Leave **Red** set to the default of 40 percent. The result, shown in Figure 9-7, is a close approximation of how we would see the world without color.

Figure 9-6.

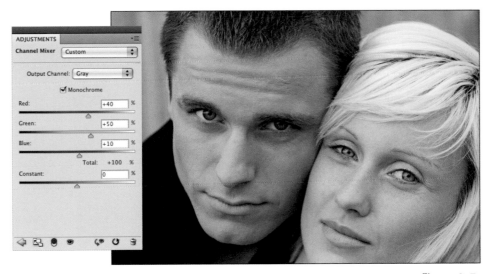

Figure 9-7.

PEARL OF WISDOM

This particular combination of channel information (40 percent Red, 50 percent Green, 10 percent Blue) is more or less what most applications use to convert from RBG to grayscale. (Photoshop throws in a little color management too, so it's not an exact equation.) This formula actually hails from the days of black-and-white television and is based on the way the human eye is constructed: We have more red and green cones in our eyes, so we don't see as much blue light when we're looking at the world.

4. *Display the expanded view of the Histogram palette.* The histogram will help you keep track of luminance levels as you make adjustments. (If the Histogram palette isn't already visible, choose **Window→Histogram**.) Click the ▾≡ icon at the top-right of the **Histogram** palette and choose **Expanded View** from the flyout menu.

Figure 9-8.

Figure 9-9.

As you can see in Figure 9-8, the histogram display expands so that 256 pixels are now devoted to the width of the histogram, 1 pixel for each of the 256 luminance levels in our 8-bit-per-channel image.

5. *Refine the Channel Mixer settings to create a greater contrast.* The standard black-and-white conversion we created in the earlier step produces an adequate result, but let's use the Channel Mixer to create an adjustment that really pops:

- Go to the **Channel Mixer** panel in the **Adjustments** palette, and increase the **Red** setting to 60. (Adjusting reds in a portrait has a direct effect on the skin tones.)

- Update the cached information in the **Histogram** palette by clicking the ⚠ icon that appears above the display on the right. Notice in Figure 9-9 that the histogram runs up against the right edge, indicating a loss of highlight detail.

- Return to the **Channel Mixer** in the **Adjustments** palette, tab down to the **Green** value, and reduce the setting to 0. Then click the ⚠ indicator in the **Histogram** palette to refresh the display again, and notice that we now have no bright highlights on the right side. This is affirmed by the fact the image, shown in Figure 9-10, is quite muted.

Figure 9-10.

- Back in the **Adjustments** palette, increase the **Blue** value to 70, taking the total luminance value up to 130 percent. Refresh the display in the **Histogram** palette by clicking the warning indicator. In Figure 9-11, as you'd expect, taking the total value up past 100 has meant losing a considerable amount of highlight detail.

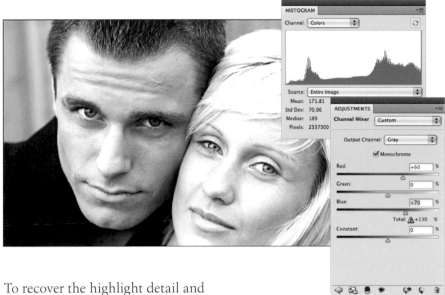

Figure 9-11.

- To recover the highlight detail and bring the sum of the channel contributions closer to 100 percent, return to the **Channel Mixer** and Shift-Tab to the **Green** value. Press Shift-↓ to reduce the Green value to −30. Yes, you can actually use negative values when blending channels.

- Although the total value of the channel mix is 100 percent, which would seem to indicate a luminance-balanced image, the histogram still favors the shadows, as you an see in Figure 9-12. Tab to the **Blue** value and use the ↑ key to nudge the Blue value up until the histogram spreads out over the right side of the graph. A Blue value of 76 percent should be exactly sufficient to restore the highlights.

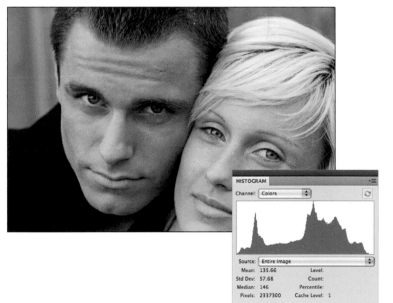

Figure 9-12.

Shooting for a total of 100 percent contribution from the channels is a good place to start, but ultimately it's how the image looks that matters. In this case, a value of 106 percent gives nice highlights to our subjects' skin, eyes, and hair.

6. *Add a Curves adjustment for increased contrast.* Click the ⇦ arrow in the bottom-left corner of the Adjustments palette, and then Alt-click (Option-click) the 🔲 icon to create a new Curves adjustment layer.

 • In the **New Layer** dialog box, name your new layer "Contrast" and click **OK**.

 • In the **Curves** panel, shown in Figure 9-13, click at the quarter point in the lower-left quadrant to anchor the darks on the curve line. Setting this point will hold the shadows in place when we adjust the highlights.

 • Add another point a quarter of the way down from the upper-left corner. Drag this anchor point upward slightly so that the **Output** value is at 209.

 The result is increased contrast that further enhances the pop of the black-and-white conversion.

7. *Apply a sepia tone effect.* *Sepia* is an old-school darkroom technique that creates a monochromatic image with a warm brownish tint. To imbue our custom grayscale image with a

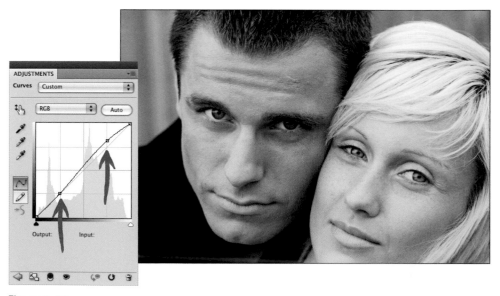

Figure 9-13.

sepia tone, we'll create a dynamic fill layer and establish the custom color:

- Alt-click (Option-click) the ⊘ icon at the bottom of the **Layers** palette, and choose **Solid Color** from the pop-up menu. In the **New Layer** dialog box, name the layer "Sepia" and click **OK**.

- In the **Pick a solid color** dialog box, set **H** to 30, **S** to 45, and **B** to 80. The result is a light orangish tan. Click **OK**.

- Change the blend mode for the Sepia layer to **Multiply** using the pop-up menu at the top of the **Layers** palette. As you can see in Figure 9-14, the Sepia layer colorizes the entire image.

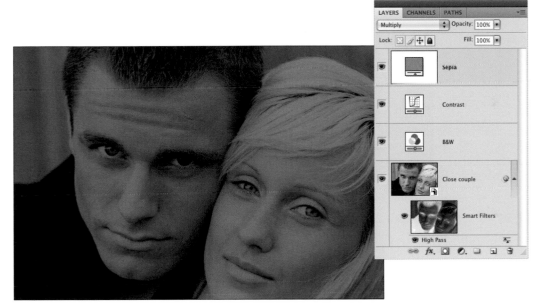

Figure 9-14.

8. *Fine-tune the sepia effect with a density mask.* To make the sepia effect a little more subtle—so that it primarily effects the shadows and has some impact on the midtones but leaves the highlights relatively unchanged—we'll need to create a density mask:

- You actually already have a density mask in the image, assigned to the High Pass smart filter in the Close Couple layer. In the Layers palette, Ctrl-click (⌘-click) that mask's thumbnail to load it as a selection outline.

- Make sure the Sepia layer is active, then click the ⬚ icon to convert the selection to a mask. The result is a subtly applied, professional-grade sepia tone, as you can see in Figure 9-15.

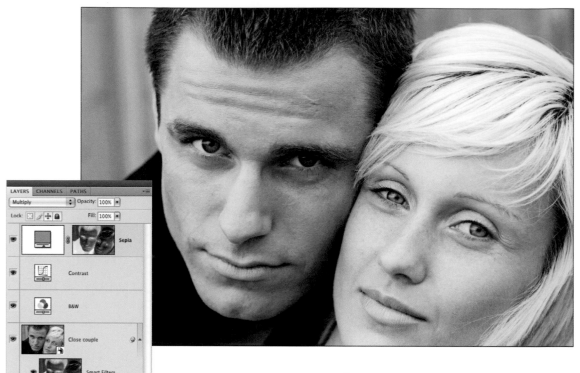

Figure 9-15.

9. *Save the image.* We'll continue working with this image in the next exercise, so press Ctrl+Shift+S (⌘-Shift-S) to bring up the **Save As** dialog box. Name the layered image "Channel Smushin.psd," and click **Save**.

Swapping Channel Mixer for Black & White

The Channel Mixer adjustment we used in the last exercise to create a beautiful black-and-white image from a color original looks terrific, especially with its sepia tone effect on top of that conversion. But what if you want a little more control over certain parts of the image during the conversion to grayscale? The answer is, you'd swap the Channel Mixer adjustment layer for a Black & White adjustment layer, and fortunately you can do this without disturbing the sepia layer. In this exercise, we'll do just that, and in the process, we'll get more control over key details such as the eyes and lips in our portrait without compromising the pleasant effect of the sepia tone.

1. *Open an image.* If you're still working on your image from the preceding exercise, you're ready to go. If not, open *Sepia smushin.psd* from the *Lesson 09* folder inside *Lesson Files-PsCM 1on1*. This is the same portrait we used in the previous exercise, but with the beautiful sepia tone effect applied.

2. *Hide the B&W layer.* In this exercise, I'm going to have you replace the B&W layer you created with the Channel Mixer, with a Black & White adjustment layer. Rather than delete the layer, click the 👁 icon associated with the **B&W** layer in the **Layers** palette to hide the effect of that adjustment layer.

3. *Create a Black & White adjustment layer.* Click the thumbnail for the **Close Couple** layer in the Layers palette to make it active. In the **Adjustments** palette, Alt-click (Option-click) the ◰ icon, which is fourth from the left in the second row of icons. In the **New Layer** dialog box that appears, name the layer "Better B&W" and click **OK**.

 Instead of the three channels you saw in the Channel Mixer, the Black & White panel contains six sliders: Reds, Green, and Blues, as well as Yellows, Cyans, and Magentas, as you can see in Figure 9-16. You can move these sliders to adjust the amount of information that each color is contributing to the final black-and-white image, giving you greater control than you had in the Channel Mixer.

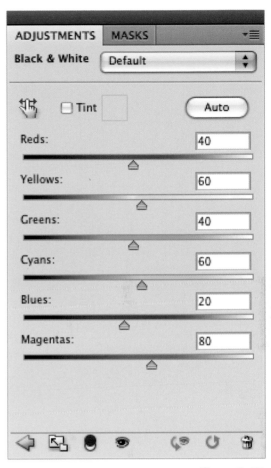

Figure 9-16.

Two more advantages to Black & White: You can't clip highlights the way Channel Mixer can, regardless of how high you set a value. And you can lighten levels by dragging directly on them with the target adjustment tool. Click the 👆 icon in the top-left corner of the palette and drag in the image window to try it out.

4. *Adjust the Black & White settings.* Now you can replace the earlier Channel Mixer monochrome conversion with a more fine-tuned conversion:

 - In the **Adjustments** palette, increase the **Reds** setting to 50 percent and increase the **Yellows** setting to 80. These adjustments will help boost the skin tones in the image.

 - Increase the **Cyans** setting to its maximum of 300 percent to primarily boost the reflection in the eyes.

 - The **Blues** setting doesn't have much of an effect on this image (since there aren't many areas with blue color), but go ahead and increase it to a value of 60.

- Reduce the **Magentas** setting to 20, which will darken the lips slightly. Leave **Greens** at the default value of 40. The result of our adjustment in shown in Figure 9-17.

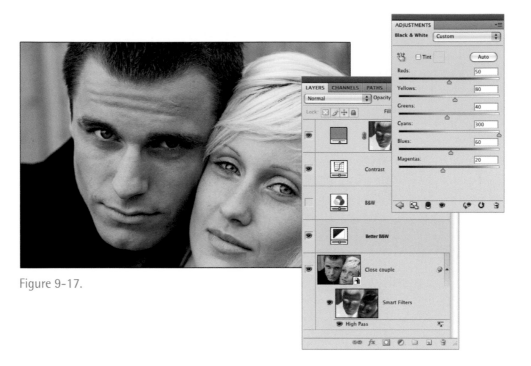

Figure 9-17.

PEARL OF WISDOM

The Black & White adjustment includes an option to apply a tint to your image, but it isn't nearly as powerful as adding the dynamic fill layer as we did in the last exercise. Since our Sepia layer is still intact at the top of the stack in the Layers palette, there's no reason to use the inferior Tint option in the Black & White panel.

Figure 9-18.

5. *Increase the contrast adjustment.* The original Contrast layer that we created with the Curves adjustment is still intact, and now that we've altered the black-and-white conversion the image could use more contrast to boost the highlights. Let's revisit the Curves adjustment.

- Double-click the thumbnail for the **Contrast** adjustment layer in the **Layers** palette.

- In the **Adjustments** palette, drag the anchor point you added at the three-quarter point (near the white end of the curve) upward so that the **Output** is about 221 and the **Input** is 191, as shown in Figure 9-18, to brighten the highlights.

Be judicious, because pushing either the Curves or the B&W adjustment too far can lead to rough transitions, or *posterization*, where what should be a gradual transition from one tone to another divides into visible clumps or bands of separate tones.

6. *Save the image.* Compared to the earlier work we did with the Channel Mixer, you can see in Figure 9-19 that our final image contains more detail in some areas of the image, particularly the nice bright eyes and darker details in the lips. To save the file, choose **File→Save As,** name the file "Refined Smushin," and click **Save**.

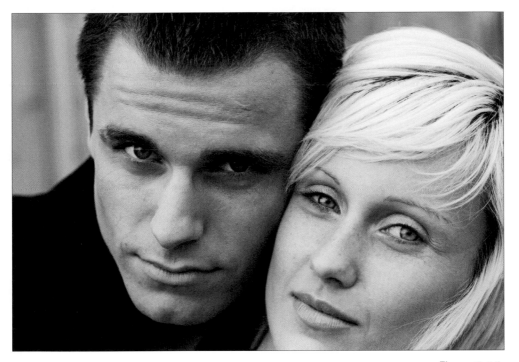

Figure 9-19.

Extreme Channel Mixing

Lest you think that the Channel Mixer is good only for custom grayscale conversion, in this exercise I'll show you what I like to call extreme channel mixing. We'll take an ordinary image of young urban professionals holding a meeting on the roof of their office building and apply an effect that's worthy of their obvious coolness. In this case, we'll be emulating *infrared photography*, where objects that reflect infrared radiation, such as people and foliage appear very bright, while other areas such as the sky appear very dark.

1. *Open an image.* Open the file *TCFTB.psd*, located in the *Lesson 09* folder inside *Lesson Files-PsCM 1on1*. This image, also by photographer Alexander Hafemann of iStockphoto, features a couple of young urban executives who are too cool for the boardroom, as you can see in Figure 9-20. If these kids are so cool that they need to hold meetings on the roof, let's see what the Channel Mixer can whip up for them in terms of special effects.

Figure 9-20.

When you open the image, you'll see that I've already created a layer group called Sharpen Set, which includes a High Pass filter effect for sharpening the overall image, a density mask to limit the sharpening to just the darkest features, a clipped levels adjustment, and a knockout layer to tone down the sharpening on the woman's face (since she's bearing the brunt of the focus in the image). Since you've already learned about these techniques in earlier lessons, I won't walk you through them now, but if you'd like to better understand what the individual layers are doing to the image, feel free to explore the contents of the layer group. When you're finished, be sure to collapse the layer group by clicking the arrow to the left of the folder thumbnail in the Layers palette so the additional adjustments you add in this exercise won't inadvertently end up inside that layer group.

2. ***Add a Channel Mixer adjustment.*** We'll start in now-familiar territory by converting the image to black and white with a Channel Mixer adjustment layer:

- In the **Layers** palette, click the thumbnail for the **Background** image layer to make sure it's active.

- Alt-click (Option-click) the ⬤ icon in the **Adjustments** palette (second row, last on the right). In the **New Layer** dialog box, name the layer "Infrared" and click **OK**.

- To create the infrared effect, you generally want to send the Red and Green channels in a positive direction and employ a negative Blue value. If you start trying to do that at this point, you'll get extreme colors all right, but not necessarily the good kind of extreme. So, first turn on the **Monochrome** check box to change the image to a black-and-white version.

- Set **Red** to 110 percent, **Green** to 190 percent, and reduce **Blue** down to –200 percent. You should see something like Figure 9-21.

Figure 9-21.

Note that even though the total value of the three channels is 100 percent, clipping is still present. (That's okay in this case because we're going to merge this adjustment with the original photo, but I wanted you to note that it was possible. Even with a total of 100 percent you still have to be aware of clipped highlights.)

3. ***Add a density mask to the Infrared layer.*** The effect at this point is over the top, so we'll start reining it in by applying a density mask that will focus the effect only on the shadow areas of the image:

- In the **Layers** palette, Alt-click (Option-click) the 👁 icon for the **Background** image layer so it will be the only layer visible.

- Switch to the **Channels** palette, shown in Figure 9-22. You'll notice that the Blue channel has the highest amount of contrast and does the greatest job of isolating the shadows (her hair and his sunglasses), which makes it best-suited for a density mask. Ctrl-click (⌘-click) the **Blue** channel to load it as a selection outline.

- Return to the **Layers** palette and Alt-click (Option-click) the 👁 icon associated with the **Background** image layer so all layers are visible again.

- Click the thumbnail for the **Infrared** layer to make sure it is active.

- Alt-click (Option-click) the ⬜ icon at the bottom of the Layers palette, which will both convert the selection to a mask and invert that mask, so that the shadows are white and the highlights are black. The result is that the infrared effect will now be isolated to the dark shadow areas, as you can see in Figure 9-23.

Figure 9-22.

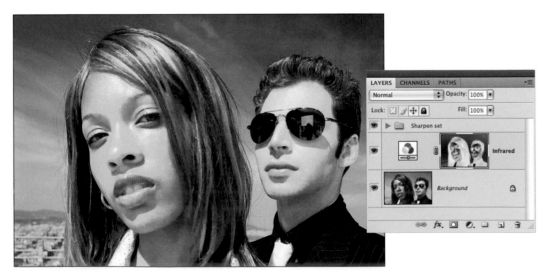

Figure 9-23.

4. *Set an extreme blend mode for the Infrared layer.* The effect looks fairly ridiculous, but we can fix that with a blend mode. In the Layers palette, change the blend mode for the **Infrared** layer to **Linear Burn**, which creates a fairly over-the-top effect initially. But we can scale back some of those clipped shadows by pressing the 5 key to reduce the opacity to 50 percent. This creates a much better result for the hair and other shadow details, as you can see in Figure 9-24.

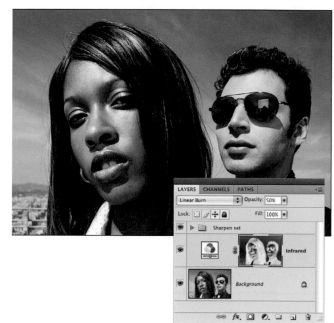

Figure 9-24.

5. *Create a Channel Mixer adjustment for highlights.* Next we'll give the highlights their own extreme treatment, once again using a Channel Mixer adjustment layer:

 • Press the ⤺ to return to the main panel of the **Adjustments** palette. Alt-click (Option-click) the 🔵 icon. When the **New Layer** dialog box appears, name the layer "Highlights" and click **OK**.

 • Turn on the **Monochrome** check box in the **Channel Mixer** panel. Change the values to **Red**, 50 percent; **Green**, 90 percent; and **Blue**, –90 percent. These values add up to only 50 percent, not the 100 percent we usually aim for, because we are using this layer to boost the highlights (as you can see in Figure 9-25) and don't want to take the values too high and wind up with excessive clipping.

6. *Add a luminance mask for the Highlights layer.* This time we're going to create a luminance mask to limit the effect of our adjustment to only the brightest highlights:

 • In the **Layers** palette, Alt-click (Option-click) the 👁 icon for the **Background** layer so that it's the only visible layer.

 • Switch to the **Channels** palette, and Ctrl-click (⌘-click) the **Blue** channel thumbnail to load it as a selection. Because there's very little highlight in the flesh tones, using this the Blue channel will help limit the effect of the adjustment.

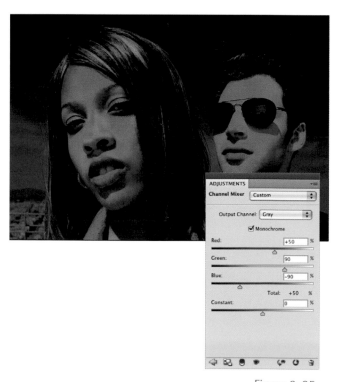

Figure 9-25.

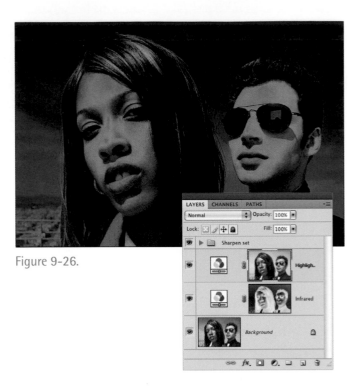

Figure 9-26.

Figure 9-27.

• Go back to the **Layers** palette and Alt-click (Option-click) the 👁 icon associated with the **Background** layer again to make all layers visible. Click the thumbnail for the **Highlights** layer in the Layers palette to make it active.

• Click the ▢ icon at the bottom of the Layers palette to add a luminance layer mask to the Highlights layer based on the active selection. The rather silly result is shown in Figure 9-26.

7. *Change the blend mode to Color Dodge.* To mitigate the odd results, change the blend mode for the **Highlights** layer to **Color Dodge**. If you look at the Histogram (you may have to update it by clicking the ⚠ icon in the Histogram palette), you'll see that the Red channel has some clipping, but the Blue and Green have enough information to make up for it, as you can see in Figure 9-27.

8. *Desaturate the image.* We'll need to apply yet another adjustment layer to convert the image to black and white. Because the shadows and highlights are already the way we want them, we don't want to apply yet another Channel Mixer adjustment. The Hue/Saturation tool will work nicely instead. Press the ◁ icon to return to the main panel of the **Adjustments** palette.

• Alt-click (Option-click) the ▤ icon, which is the second icon from the left in the second row. In the **New Layer** dialog box, name the adjustment layer "Desaturate" and click **OK**.

• In the **Hue/Saturation** panel, reduce the **Saturation** setting all the way down to –100. Although this is a fairly unsophisticated method of robbing an image of color, it's perfect for our current needs.

As you can see in Figure 9-28, you have produced a black-and-white image with extreme contrast while still retaining detail.

9. *Add a Channel Mixer adjustment for the sky.* The sky still looks a little too everyday, so we'll add yet another adjustment to make it more appropriate for our extreme subjects:

- Click the **Infrared** layer thumbnail in the **Layers** palette to make it active. You want to place the new layer you're going to add directly above it.

- Press the ⇦ in the **Adjustments** palette, and then Alt-click (Option-click) the 🔵 icon. In the **New Layer** dialog box, name your layer "Deep Sky" and click **OK**.

- In the **Channel Mixer** panel of the Adjustments palette, turn on the **Monochrome** check box and set the **Red** value to 80 percent, the **Green** value to 40 percent, and the **Blue** value to −60 percent to produce the dramatically dark sky shown in Figure 9-29.

10. *Use the gradient tool to mask the Deep Sky layer.* The Channel Mixer adjustment is affecting the entire image, rather than just the sky. A gradient will allow us to add yet more drama:

- In the **Layers** palette, click the ▢ icon to create a layer mask for the Deep Sky layer.

- Press the D key to ensure that the colors are set to their defaults. Set black as the foreground color (press the X key if necessary to swap foreground and background colors). Press Alt+Backspace (Option-Delete) to fill the layer mask for the **Deep Sky** layer with black.

Figure 9-28.

Figure 9-29.

- Select the gradient tool from the toolbox (or press the G key). Press the X key to swap the foreground and background colors so white is the foreground color.

- You want a white-to-transparent setting for the gradient, so press Shift+⊡ which selects the first in the list from the gradient picker. Then press the ⊡ key to move one to the right, which is where you want it: moving from white on the right to transparent on the left.

- In the options bar, make sure the gradient style is set to linear by pressing the ■ icon which is the first of the five style icons. **Mode** should be set to **Normal**, the **Opacity** to 100 percent, and the **Dither** and **Transparency** check boxes should be turned on.

- Press F to switch to the full-screen view so that you can work in the pasteboard. Zoom out or move the image as needed so you can see the area above the image as well as both sides of the image.

- Drag from several spots along the sides and top of the image all the way in to the face of each model to reveal the Deep Sky layer, as shown in Figure 9-30.

Figure 9-30.

This process reveals some nice striations in the sky that give a dramatic effect. Press F twice more to return to normal view.

11. *Mask away any darkening in the faces.* Clean up any areas where the gradient encroached on the faces by painting on the layer mask associated with the **Deep Sky** layer:

 - Press the B key to get the brush tool. In the options bar, set the **Master Diameter** to 200 pixels, and change the **Hardness** to 50 percent. Make sure the **Mode** is set to **Normal** and the **Opacity** is set to a value of 100 percent.

 - Press X to swap the foreground and background colors so black is the foreground color. Paint inside both models to mask the darkening effect applied by the Deep Sky layer. The result is shown in Figure 9-31.

12. *Apply a Gradient Map to colorize the image.* Unlike the subtle sepia tone we used to tint the image in the last exercise, we're looking for something a little more suitable for our super cool executives. Gradient Map, which maps luminance levels to an assigned gradient, is perfectly suited for this task:

 - Click the **Desaturate** layer thumbnail in the **Layers** palette to make it active. We want the new layer we're adding to be placed at the top of the layer stack.

 - In the **Adjustments** palette, press the ◁ icon to return to the main panel. Then Alt-click (Option-click) the ▬ icon (bottom row, fourth from the left, as you can see in Figure 9-32.) In the **New Layer** dialog box, name your layer "Color Gradient" and click **OK**.

 - In the **Gradient Map** panel, click the preview of the gradient in the pop-up menu to bring up the **Gradient Editor** dialog box.

 - Click the **Load** button, as shown in Figure 9-33 on the next page. Navigate to the *Lesson 09* folder inside *Lesson Files-PsCM 1on1*, choose the *The Gmap Eight*.grd file, and click **Load**. Eight custom gradients I've created for you appear in the gradient preview list.

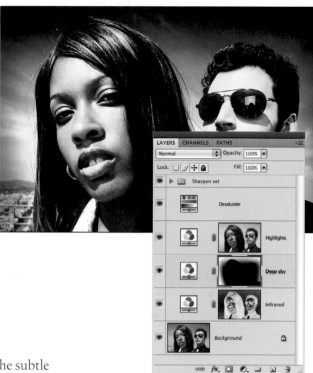

Figure 9-31.

Figure 9-32.

- Choose the Badtones gradient, which is the last of the gradients previewed in the pop-up menu. Click **OK** to close the Gradient Editor dialog box.

In both the gradient preview box of the Adjustments palette and the regular gradient preview in the options bar, you can set the list of preset gradients to be viewed as text only, small or large thumbnails, or small or large lists (thumbnails with text). Click the ● to the right of the gradient preview to reveal a flyout menu with the five choices.

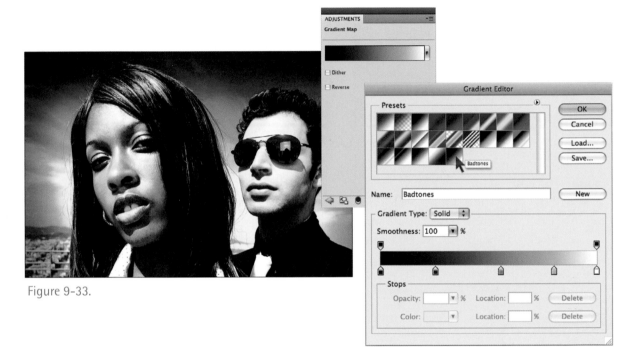

Figure 9-33.

13. *Change the blend mode to Color.* The gradient map, while certainly jazzing up the color, is causing some posterization. To minimize this problem, change the blend mode for the **Color Gradient** layer to **Color** so that the layer affects only the color in the image, not the luminosity values.

14. *Add a density mask to the Color Gradient layer.* To put the finishing touch on the Gradient Map effect, we'll apply a luminance mask to the Color Gradient layer. The density mask you've already created for the Infrared layer will do nicely. Alt-drag (Option-drag) the layer mask thumbnail associated with the **Infrared** layer to the **Color Gradient** layer to duplicate the density mask. As you can see in Figure 9-34 on the facing page, this has the desired result of toning down the color effect.

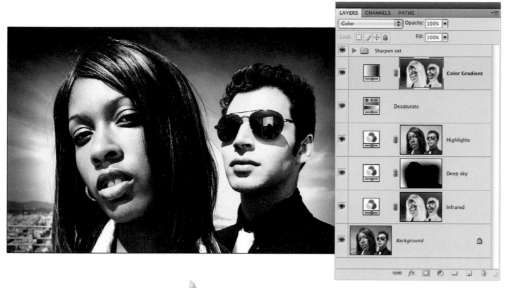

Figure 9-34.

EXIRA ★ CREDIT

You've already given our rooftop denizens a much more dramatic flair by applying some extreme channel effects. If you've had enough of this power-coolness, jump ahead to "The Professional's Approach to Red-Eye," starting on page 337. But if you'd like to add yet another episode of extremity, rendering our sky practically radioactive with the deployment of an opposing colorization scheme, continue with our too-cool executives.

15. *Create another Gradient Map adjustment layer for the sky.* To add an opposing color element to the sky, we'll start with another Gradient Map adjustment layer:

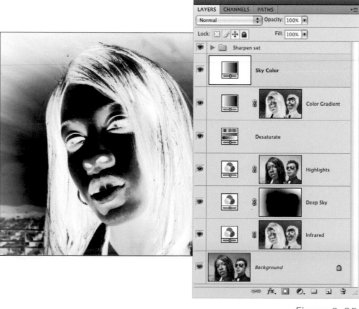

 • In the **Adjustments** palette, click the ◁ to return to the main panel. Then, Alt-click (Option-click) the ◼ icon. In the **New Layer** dialog box, name your layer "Sky Color" and click **OK**.

 • In the **Gradient Map** panel, click the arrow to the right of the gradient preview to bring up your collection of gradient presets. Choose the X-ray invert gradient, which is the second-to-last preview in the pop-up menu, which goes from white to dark green diagonally. (The gradient should have been loaded in Step 12.) The alarming result is shown in Figure 9-35, but click press Enter or Return anyway.

Figure 9-35.

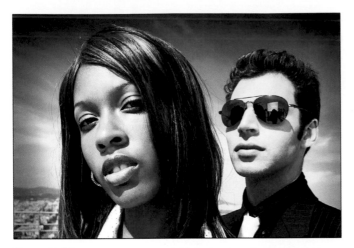

Figure 9-36.

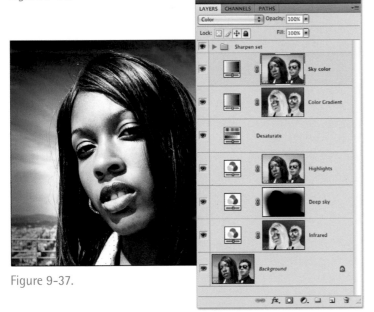

Figure 9-37.

16. *Change the blend mode to Color.* We want the Gradient Map to affect only the color, not the luminance, of the underlying image. So in the **Layers** palette, set the blend **Mode** of the Sky Color layer to **Color** in the pop-up menu. The image should now look like Figure 9-36.

17. *Mask the Sky Color layer.* To limit the possibly radioactive green to just the sky, we need to duplicate and then invert the layer mask associated with the Color Gradient adjustment layer and apply it to the Sky Color layer. Alt-drag (Option-drag) the layer mask thumbnail associated with the **Color Gradient** layer to the **Sky Color** layer to duplicate it, then select the new layer mask and press Ctrl+I (⌘-I) to invert it. You can see the result of adding this luminance mask in Figure 9-37.

18. *Increase the contrast for the Sky Color layer mask.* The Sky Color gradient is still affecting some areas of the couple. We'll resolve that by simply increasing the contrast for the layer mask associated with the Sky Color layer. Press Ctrl+L (⌘-L) to bring up the **Levels** dialog box. Drag the black **Input Levels** value to 140 and the white **Input Levels** value to 220. Click **OK**. As you can see in Figure 9-38, we've constrained the Sky Color adjustment layer so it predominantly affects only the sky.

19. *Reduce the opacity of the Color Gradient layer.* After applying a colorization to the sky, it seemed to me that the colorization of the models was too strong. To tone it down, click the thumbnail for the **Color Gradient** adjustment layer in the **Layers** palette to make it active and reduce the **Opacity** setting to 70 percent.

Figure 9-38.

20. *Save the image.* We've come a long way from our simple rooftop board meeting, as you can see in the final image shown in Figure 9-39. To see what you've accomplished in this exercise, Alt-click (Option-click) the 👁 icon of the **Background** layer to see the original image. Then Alt-click (Option-click) there again to bring the 👁 back and restore your extreme effects. To save this striking new version, press Ctrl+Shift+S (⌘-Shift-S) to bring up the **Save As** dialog box, name your file "Colorization Coolness," and click **OK**.

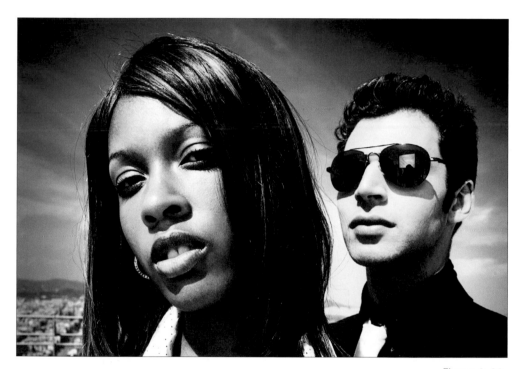

Figure 9-39.

The Professional's Approach to Red-Eye

Red-eye, as I'm sure you've encountered if you've ever taken or even seen a snapshot of a child taken with a flash, is the effect of the light from a flash reflecting the reddish interior of the subject's eyeball. This effect is common particularly with small compact cameras, because the flash sits very close to the camera lens, and thus the lens is at a perfect angle to capture this creepy reflection. Add to that the fact that the light is dim (hence the need for a flash in the first place), the subject's pupils are dilated, the lenses of children's eyes are unclouded by age, and voila: you get the ideal recipe for creating demon-spawn from the purest angelic souls, in this case my children.

Photoshop includes a red-eye correction tool for fixing this problem, but as is the case with many easy, automatic fixes, it doesn't always work. In this exercise, we'll take a look at the simple, if unsatisfactory, approach to fixing red-eye before we dive into a channel-mixing technique that yields much better results.

1. *Open an image.* Open *TSSOTBLH.psd*, located in the *Lesson 09* folder inside *Lesson Files-PsCM 1on1*. The filename is an acronym for "the sun sets on their blonde little heads," because these are my boys, all spiffed up and handsome for a wedding. Unfortunately, as you can see in Figure 9-40, this photo suffers from an extreme case of red-eye.

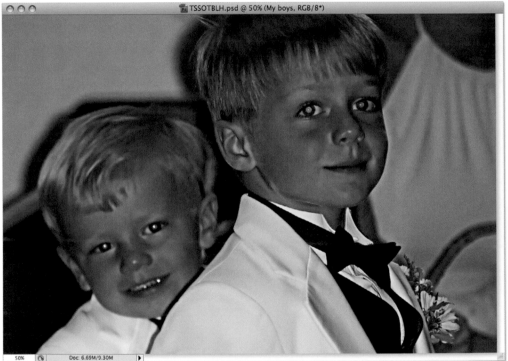

Figure 9-40.

Figure 9-41.

2. *Select the red-eye tool from the toolbox.* The red-eye tool is located in the healing-brush flyout menu. You'll notice in Figure 9-41, if you loaded my dekeKeys shortcuts, I've deemed this tool useless enough to remove from the default rotation for the J key so that you don't have to bother with it.

3. *Make the smart object editable.* The file I've given you contains a smart object with some smart filters applied to address other issues in this photo, (which you are welcome to explore on your own of course). Since the red-eye tool operates at the pixel level, you can't use it directly on a smart object.

In the **Layers** palette, double-click the thumbnail in the **My Boys** layer to enter the smart object. If you haven't dismissed it permanently before, you'll get a warning message that tells you how to update a smart object. Click **OK**.

4. *Click one of the pupils with the red-eye tool.* My older son Max's right pupil is a good place to test the red-eye tool's usefulness. Place the crosshair cursor over the left pupil (his right) in the image window and click. The result, as you can see in Figure 9-42, is that we've now traded red-eye for gray-eye. Not what we're looking for. Neither of the items in the options bar for this tool, increasing the Pupil Size or the Darken Amount, can help with the basic issue, which is that the pupil ends up lighter than the iris around it. Press Ctrl+W (⌘-W) to close the window, and click **No** (**Don't Save** on the Mac) when Photoshop asks if you want to save your changes. We'll return to our starting point. Clearly, we need another approach.

Figure 9-42.

PEARL OF WISDOM

In the title of this section, I refer to this technique as "The Professional's Approach to Red-Eye," but the truth is, professional photographers know that the best way to fix red-eye is to avoid it. That's why a professional photographer will mount a handheld flash so that it's bracketed away from the body of the camera. Putting distance between the flash and the lens offsets the angle of the light, so that the red from the subject's retina isn't bouncing back into the camera. In a studio session, strobe (studio lights that flash) can be set at a more suitable angle even farther off to one side. I suppose the professionals I'm referring to in the title of this exercise are professional retouchers who end up tasked with fixing issues caused by small cameras and amateur shooters.

5. *Select the pupils.* Start by creating a selection of the pupils to isolate the red-eye. Normally, pupils are fairly easy to select with the elliptical marquee tool, but I know you've already created similar selections several times in this book, so I've included an alpha channel in this file for you to use for eye selection. Go to the **Channels** palette and Ctrl-click (⌘-click) the thumbnail for the **Pupils** channel to load it as a selection (see Figure 9-43).

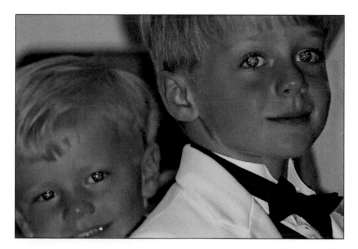

Figure 9-43.

Note that in this mask I've made the pupil areas slightly larger than the actual pupils. Also, because Max was in sharper focus, I added some blur to the selection for his pupils. In the back, my younger son Sammy is already in a little bit softer focus.

6. *Add a Channel Mixer adjustment.* In the **Layers** palette, make sure the **My Boys** layer is selected, then:

- Alt-click (Option-click) the 🔵 icon in the **Adjustments** palette. In the **New Layer** dialog box, name the layer "Red-eye" and click **OK**.

- In the **Channel Mixer** panel, set the **Output Channel** to **Red** (which is the default), set the **Red** value to 0 percent, (we know there's nothing useful in the Red channel.) Set the **Green** value to 76 percent, and the **Blue** value to 16 percent. As you can see in Figure 9-44, these settings do a good initial job of removing the red from the pupils. Switch the **Output Channel** to Green, and set the **Green** value to 102 percent.

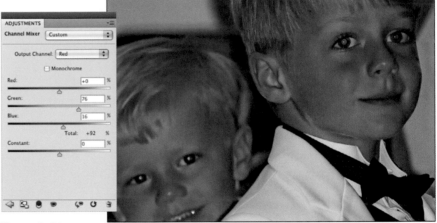

Figure 9-44.

- Next, press Alt+5 (Option-5) to switch to **Blue** for the Output Channel, and then set the **Green** value to 57 percent and the **Blue** value to 37 percent. As you can see in Figure 9-45, this change helps offset a slight color shift, producing relatively neutral pupils (though with a slight amount of green that helps match the appearance of the irises).

These values are a general range that you would use to fix red-eye: put blue and green in the red channel, put some green in the blue channel, and generally leave green alone. The numbers will need tweaking for each image, but they should get you fairly close to neutral. In a perfect world, we would be finished at this point, after removing red and replacing it with green and blue information in the pupil area. But unfortunately the Green and Blue channel information was not enough to compensate for the tragic Red channel in this image. So, in this example we need to apply some additional adjustments to complete the red-eye fix.

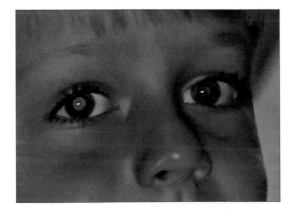

Figure 9-45.

7. *Select Sammy's pupils.* We need to adjust the pupils for each boy independently since each set of red-eyes requires a different approach. Start by creating a selection of Sammy's pupils (my younger son in the background of this photo):

- Ctrl-click (⌘-click) the layer mask associated with the **Red-eye** adjustment layer in the **Layers** palette to load a selection from that mask.

- Zoom in on Sammy, who's in much softer focus, in the background.

- Press the M key to get the rectangular marquee tool, then Shift+Alt (Shift-Option) while dragging a rectangular selection that captures Sammy's pupils. By pressing the modifier keys, you're selecting an intersection, so when you release the mouse button, only his pupils will be selected.

8. *Add a Multiply layer.* The eyes need to be darkened considerably, and as you'll recall from previous lessons, the Multiply blend mode is perfectly suited to that task. First we'll need a "dummy" adjustment layer to which we can then set the Multiply blend mode.

- Press the ◁ arrow in the **Adjustments** palette to go back to the main panel. Alt-click (Option-click) the ☼ icon, which is the first one in the top row. (Any of the adjustment types that you can leave in a neutral position—i.e. evoke the adjustment but not actually have to make any change—would work.) Name the layer "Sam" and click **OK**.

- In the **Layers** palette, change the blend mode for the **Sam** adjustment layer to **Multiply**. Applying the blend mode to this blank layer basically has the effect of blending the image with itself without the need to duplicate the entire image again. As you can see in Figure 9-46, we've darkened Sammy's pupils significantly.

9. *Apply luminance blending.* Sam's pupils no longer exhibit red-eye, but we've also eliminated all the charming highlights. To bring them back, apply luminance blending:

- Double-click an empty area of the bar for the **Sam** adjustment layer in the **Layers** palette (not on the thumbnail or the name of the layer) to bring up the **Layer Style** dialog box.

- Drag the white triangle for **This Layer** in the **Blend If** section to 145.

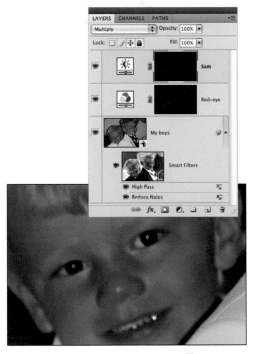

Figure 9-46.

- Alt-drag (Option-drag) the left half of the white triangle for **This Layer** left to a value of 15. As you can see in Figure 9-47, this allows the brightest areas of the underlying layer to show through, revealing the highlights in Sammy's eyes. Click **OK** to close the Layer Style dialog box.

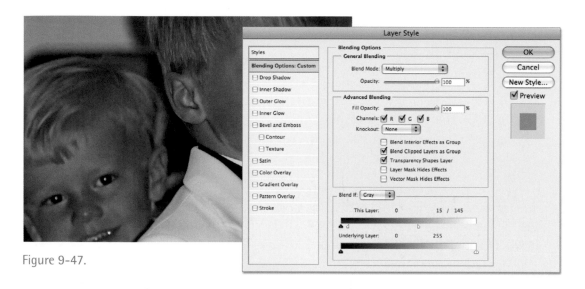

Figure 9-47.

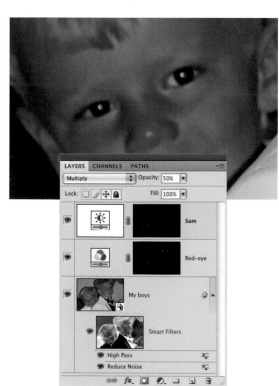

Figure 9-48.

10. *Reduce the Opacity for the Sam layer.* I think Sammy's eyes will look better (and more natural) if we tone down the effect of our Multiply blend mode. Press the 5 key to reduce the **Opacity** setting for the **Sam** adjustment layer to 50 percent. You can see the final results of Sammy's red-eye reduction in Figure 9-48.

11. *Select Max's right pupil.* Because Max's pupils don't match, we need to work on each eye separately. Press Shift+M to switch to the elliptical marquee tool. Zoom in on the left eye (Max's right) and drag to define a selection that includes the dark corona around the pupil, as shown in Figure 9-49 on the facing page.

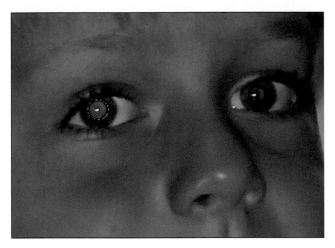

Figure 9-49.

12. *Add a Multiply layer.* We'll again darken the pupil with a layer using the Multiply blend mode. Press the ⬦ icon on the bottom of the **Adjustments** palette, then Alt-click (Option-click) the ☼ icon once again. Type the name "Max" for the **Name** value and click **OK**. Then change the blend mode at the top-left of the **Layers** palette to **Multiply**. This darkens the pupil, as you can see in Figure 9-50.

13. *Create a layer effect.* The pupil is looking quite good, but the dark corona around it have gotten worse. We'll fix that with some layer effects:

- Click the *fx* icon at the bottom of the **Layers** palette and choose **Inner Glow** from the pop-up menu.

- In the **Layer Style** dialog box, shown in Figure 9-51, change the blend mode to **Normal**. Then increase the **Opacity** value to 100 percent, the **Noise** to 10 percent, and the **Size** to 6 pixels.

- Click the color swatch to bring up the **Color Picker** dialog box. Set the **H** value to 110, **S** to 10, and **B** to 23. (These numbers correspond to the approximate color of the iris in this photo. Each photo will need different values. The eyedropper is useless for sampling here because Photoshop can only "see" the black and white of the layer mask at this moment.) When you've made the changes, click **OK**.

Figure 9-50.

Figure 9-51.

Figure 9-52.

- Click **Outer Glow** from the list of effects on the left side of the **Layer Style** dialog box (see Figure 9-52). Click the color swatch to bring up the **Color Picker** dialog box. Again set **H** to 110, **S** to 10, and **B** to 23 and then click **OK**.

- In the **Layer Style** dialog box, change the blend mode to **Normal**. Next, set the **Opacity** to 80 percent and the **Noise** to 10 percent. Change the **Technique** pop-up option to **Precise** since we want it to be a fairly firm line and reduce the **Size** to 3 pixels. When you're finished, click **OK** to close the Layer Style dialog box.

The left pupil (Max's right) is looking pretty good, as you can see in Figure 9-53. So good, in fact, we're going to steal the work we've done on that eye to fix the right (his left).

Figure 9-53.

14. *Duplicate the adjustment to the other eye.* Max's other eye has an irregularly shaped pupil, so I want to duplicate the effect we created for the left eye (his right) to the other eye by copying a portion of the layer mask:

- Make sure the **Max** layer is still selected.

- With the elliptical marquee tool, create a wide selection around the entire left eye (Max's right), as shown in Figure 9-54, on the next page.

Figure 9-54.

- Press Ctrl+Alt (⌘-Option) and drag the selection toward the other eye. You'll be able to see the darkening effect move as you drag. Drop it in place on the other pupil. This effect is slightly larger than the left pupil (Max's right), but in this case I think it works relatively well, as you can see in Figure 9-55. Press Ctrl+D (⌘-D) to abandon the selection.

Figure 9-55.

Figure 9-56

15. *Adjust the pupils to match.* The equal adjustments to each of Max's eyes don't produce matching pupils, because the red-eye effect was slightly different in each eye. We can resolve this by toning down the effect in the right eye (his left):

- Using the elliptical marquee tool, create a selection that includes only the eye on the right (Max's left).

- Press Ctrl+L (⌘-L) to bring up the **Levels** dialog box. Drag the white **Output Levels** triangle to 215, as shown in Figure 9-56. This reduces the white in the layer mask for the left eye to a shade of gray. In turn we've reduced the effect for this pupil so that it matches Max's other pupil Click **OK** and then Ctrl+D (⌘-D).

16. *Save your image.* As you can see in Figure 9-57, we've taken my offspring from devil children to charming angels with the help of some careful manual manipulation. Save the file by pressing Ctrl+Shift+S (⌘-Shift-S). In the **Save As** dialog box, name the file "Angelic Eyes" or something equally appropriate, and click **Save**.

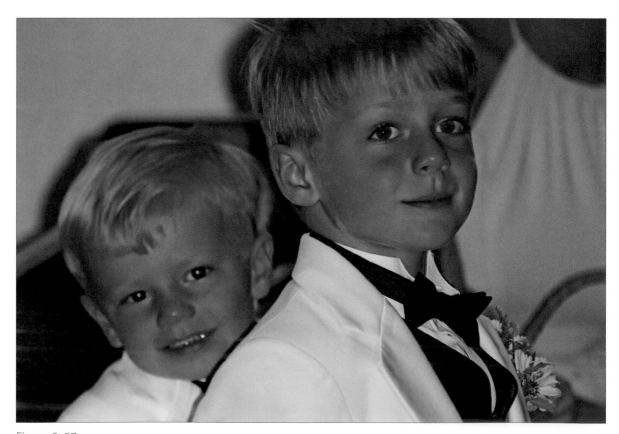

Figure 9-57.

WHAT DID YOU LEARN?

Match the key concept in the numbered list below with the letter of the phrase that best describes it. Answers appear upside-down at the bottom of the page.

Key Concepts

1. Channel Mixer
2. Monochrome
3. Histogram palette
4. Sepia
5. Black & White
6. Posterization
7. Infrared
8. Linear Burn
9. Gradient Map
10. Red-eye
11. Strobe
12. Outer Glow

Descriptions

A. An effect that places a color around the outside of an area of the image based on a mask.

B. An effect where what should be a gradual transition from one tone to another divides into visible clumps or bands of separate tones.

C. An adjustment that provides excellent flexibility in blending multiple channels into a single monochrome result.

D. An option in the Channel Mixer adjustment that allows you to produce a black-and-white conversion.

E. A photographic light that flashes.

F. An adjustment that adds color to an image based on luminosity values in the image.

G. The result of the flash from a camera reflecting on the back of the eyes.

H. An orangish-brown tint traditionally used to colorize photographs.

I. A palette that displays a live graph of the luminosity information in the image.

J. An effect in which skin tones and other areas that reflect infrared light are bright and other areas such as the sky are dark.

K. A blend mode that produces a dramatic effect in the image, which can help heighten an infrared effect.

L. A command that allows you to blend the contents of multiple channels within a single channel.

Answers

1L, 2D, 3I, 4H, 5C, 6B, 7J, 8K, 9F, 10G, 11E, 12A

CALCULATIONS (A.K.A. CHANNEL OPERATIONS)

BY THIS POINT in the book, we've approached (and avoided) masks in more ways than I'm interested in counting. But since Lesson 5, most of our techniques have involved copying a single color channel and using it as the basis for a mask. We sometimes bring in elements of other channels, but the one base channel is always doing the heavy lifting.

If you think about it, that's a pretty narrow philosophy. In any given RGB image, we have three unique grayscale images. But more often than not, they see the image from perfectly reasonable, albeit different, perspectives. That reasonable difference goes to the heart of this lesson. If at least two channels are of sound quality, provide good contrast between foreground and background, and reveal the photograph in different ways, might we not get a better view of the image by combining them? If two heads are better than one, surely so are two channels.

Enter *calculations*, which permit you to blend one channel with another, even inside the confines of a third channel that serves as a mask. While significantly more complicated than duplicating a single color channel (as we did in Lesson 5), performing a calculation expands your range of options. With some experience, you can build a better base alpha channel, complete the mask more quickly, and approach any masking job with more confidence of success.

Consider the example of Figure 10-1. The RGB image clearly shows a warmly colored woman against a cool background. But a review of the color channels shows her hair to be always darker than the background and her skin tones to be lighter or nearly identical. And yet, notice how well the Red channel and an inverted version of the Blue channel compensate for each other. The inverted Blue levels are brightest where the Red levels need the most help. Blend the two using the Linear Dodge (Add) mode, increase the contrast with the Levels command, and we're most of the way to a mask.

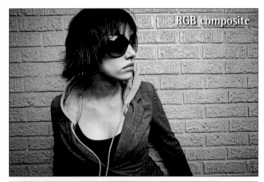

woman against wall istockphoto.com/kevinruss

Figure 10-1.

ABOUT THIS LESSON

Project Files

Before beginning the exercises, make sure you've copied the lesson files from the DVD, as directed in Step 3 on page xv of the Preface. This should result in a folder called *Lesson Files-PsCM 1on1* on your desktop. We'll be working with the files inside the *Lesson 10* subfolder.

In this lesson, we look at reasons and ways to blend two channels to create an alpha channel. We'll also examine the roles of the Calculations and Apply Images commands in masking. When the dust settles, you'll have learned how to:

- Mask a classic blue-screen image and nondestructively address edge fringing page 352

- Apply the Add and Subtract blend modes, which are unique to Calculations and Apply Image page 365

- Refine a mask using the Curves command in concert with the dodge, burn, and brush tools . . . page 374

- Employ Apply Image and other commands to apply a controlled, directional blur to a mask page 389

Video Lesson 10: Calculations versus Apply Image

Photoshop devotes two commands to channel blending, Calculations and Apply Image. Of the two, Calculations is the more practical, not to mention the more utterly and completely indispensable. Now I won't sugarcoat it, Calculations is not easy—in fact, it might be Photoshop's single most difficult feature to master. But it is *the* command that's going to increase the quality of your masks.

To introduce yourself to these powerful functions, watch the tenth video lesson. Insert the DVD, then double-click *PsCM Videos.html*, and click **Lesson 10: Calculations versus Apply Image** under **Calculations, Paths, and Arbitrary Maps**. Lasting 13 minutes and 40 seconds, this movie mentions these shortcuts:

Operation	Windows shortcut	Macintosh shortcut
Switch between the RGB channels	Ctrl+3, Ctrl+4, Ctrl+5	⌘-3, ⌘-4, ⌘-5
Switch back to the RGB composite image	Ctrl+2	⌘-2
Load the highlights as a selection	Ctrl-click color channel	⌘-click color channel
Hide the selection outline	Ctrl+H	⌘-H
Deselect and invert	Ctrl+D, Ctrl+I	⌘-D, ⌘-I
Save and name an alpha channel	Alt-click the ◻ icon	Option-click the ◻ icon
Apply the Levels command	Ctrl+L	⌘-L

You perform calculations using Image→Calculations and, less commonly, Image→Apply Image. Both commands let you blend channels but with different results: Calculations blends two channels into a new alpha channel; Apply Image blends one channel—or even the full-color composite—into the active channel.

Figure 10-1 showed the Calculations command at work. Figure 10-2 shows a few applications of Apply Image. For the sake of comparison, the figure begins with the untreated RGB image. Then I took the same inverted Blue channel as before and merged it with the Red channel subject to the Overlay mode, producing some red highlights in the hair and shadows. The last two examples show me rerunning the experiment with the Linear Dodge (Add) and Difference modes.

Depending on your design sense, there's a lot of fun to be had with these features. But I'll be sticking to practical masking applications in the upcoming exercises.

The Lore of the Chop

If you were around during the early days of Photoshop, you may recall a time when calculations were held in almost mythical esteem. An entire branch of Photoshop activity was devoted to them. Calculation devotees even had a special name for their craft: channel operations, or *chops* for those in the know.

There were channel operation chat forums, where artists traded their favorite formulas. There were Lords of the Craft, whose latest techniques (most of which resulted in drop shadows) were met with grateful anticipation. There was even a book that bore the famously repetitive title *Channel Chops*, best known for attracting high bids on eBay long after it was out of print.

The advent of layers all but eliminated the need for old-school channel operations. Layer effects streamlined techniques like glows, bevels, and embossed text, which previously entailed 20-step chops. Chops might still have a few die-hard fans, but for the most part, they're just elaborate ways of creating effects that you can achieve more simply and with better results using layers. In other words, chops are dead.

Original RGB photo

Blue (invert) into Red, Overlay

same, Linear Dodge (Add)

same, Difference

Figure 10-2.

But while chops are dead—and I do mean stone-cold, pushing-up-the-daisies, beyond-all-hope-of-cloning dead—the Calculations command endures. Its unique ability to blend two channels to create a base alpha channel makes it a fantastic tool for distilling masks. Which is why I'm devoting an entire lesson to the topic. So long live Calculations and the modern-day masking operations it affords. *Mops* may not sound a sexy as *chops*, but they're much more practical.

Blue Screen Calculations

In this exercise I'll introduce you to one of the oldest commands in all of Photoshop—as well as one of the most powerful. The Calculations command allows you to blend any two channels. The channels can be color-bearing channels or alpha channels, and you can blend them together to create a new alpha channel. Among other things, Calculations enables you to create better masks, as you'll see in this exercise.

1. *Open an image.* Open *Model on blue.jpg*, located in the *Lesson 10* folder inside *Lesson Files-PsCM 1on1*. Pictured in Figure 10-3, this photograph from Klaas Lingbeek-van Kranen of iStockphoto features a woman set against a blue screen just waiting to be moved onto a new background. But while she and her background share few common colors, her luminance levels are another matter. In each and every channel, the woman is alternately lighter and darker than the blue screen, rendering a single-channel mask useless.

Figure 10-3.

2. *Peruse the color channels.* It's one thing to have the channels explained to you, it's another to see them for yourself. Bring up the **Channels** palette. Then press Ctrl+3, +4, +5 (⌘-3, -4, -5 on the Mac) to take in each of the color channels. On display in Figure 10-4, they break down like this:

- The Red channel does a great job of separating the skin tones, but (at least from a masking perspective) the hair is a disaster.

- The Green channel is useless to us.

- The Blue channel does a halfway decent job of distinguishing the hair from the background, but the slight shadows around the shoulders are fragile.

In a pinch, we could probably make that Blue channel work, but we'd have to spend a lot of time filling in the skin tones. Fortunately, there's a better way.

3. *Choose the Calculations command.* When confronted by two channels that might work but not well enough, think calculations. Like right now: choose **Image→Calculations**. Up comes the **Calculations** dialog box and its daunting array of inscrutable options. The sheer number of Source 1 and Source 2 selections makes this a flexible command for seasoned experts. But when trying to learn the command, a lot of it just gets in the way. Which is why Figure 10-5 shows two views of the Calculations dialog box—the way it actually appears on the left and the way I want you to imagine that it appears on the right. In the second version, I've grayed out the options that you will rarely, if ever, employ. We'll be seeing some of these functions later in the book, but for now, we have two pairs of Source options, Blending and Opacity, and that's it.

Figure 10-4.

Figure 10-5.

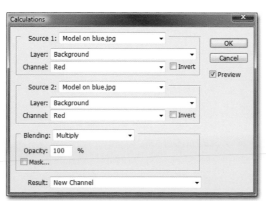

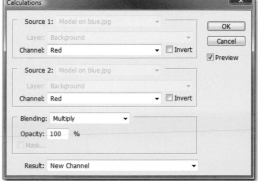

Now that you have a sense for the options that we'll be working with, here's what they do:

- Use Source 1 and Source 2 to define the channels that you want to mix. Don't worry about the image or layer names. We have just the one flat image, so the first two options in each group will be set to Model on blue.jpg and Background. Your job is to set the Channel and decide whether to turn Invert on or off.

- The Blending and Opacity settings determine the blend mode and translucency of the Source 1 image. In other words, if the two channels were layers, Source 1 would be in front and Source 2 is the background, just as their order in the dialog box implies.

- The Mask check box merges one channel with another using a third channel. I'll show you how it works in Lesson 12, "Masking the Tough Stuff," but for now, leave it turned off.

- Because channels don't support layers, you need a place to put the merged result of your settings. The Result option lets you put it in a new channel, put it in an entirely new document, or deliver it as a selection outline.

4. *Specify the channels you want to mix.* Our first task is to decide which color channels we want to mix to create our base alpha channel. And here I have some advice:

Figure 10-6.

PEARL OF ⬤ WISDOM

The toughest decisions to make inside the Calculations dialog box are which channels to use, whether to invert, and which blend mode will produce the best blend. We'll be spending a lot of time on the invert and blend mode decisions. But where the channels are concerned, the optimal solution is to mix the two channels that 1) might independently serve the best as masks and 2) do the best job of complementing each other. Or, more simply put, select your favorite channel, and then look for the channel that will best make up for your favorite channel's weaknesses.

With that in mind, my thinking is this: Our best channel is Blue, because the shoulders are moderately defined and the hair looks great. The Red channel provides some great shoulder detail, so it's nicely suited to help out. And the Green channel is nobody's friend. Figure 10-6 is there to refresh your memory and tell the story.

Here's how I want you to set the two Source options:

- The best channel should serve as the base. Which is why I usually start things off by setting Source 2, the background channel, first. In this case, set the **Channel** option for **Source 2** to **Blue**.

- Next set the **Channel** for **Source 1** to **Red**.

Remember, we're not interested in the first two pop-up menus in each group, which should be left set to **Model on blue.jpg** and **Background**, respectively.

5. *Invert the Blue channel.* Now comes the question, do we invert? The answer ultimately depends on the blend mode. But for now, let's keep things simple and just imagine our final mask. We want the woman light and the background dark. Things are already that way in the Red channel, but it's the other way around in the Blue channel. As shown in Figure 10-7, inverting the Blue channel would bring things to right. So turn on the **Invert** check box for **Source 2** (and, of course, leave it off for Source 1).

Figure 10-8 shows the settings as they exist so far. The result is nothing like what we want, but that's because, by default, the blend mode is set to an evenhanded darken mode, Multiply. We need a radical lighten mode, as you're about to learn in the next step.

Figure 10-7.

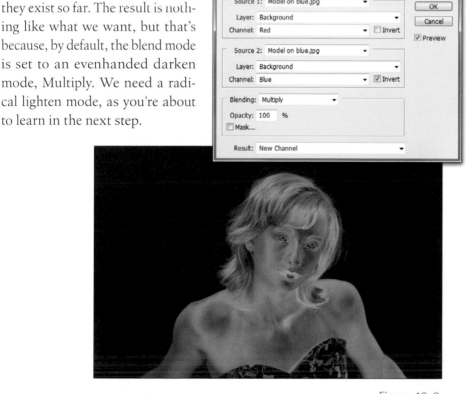

Figure 10-8.

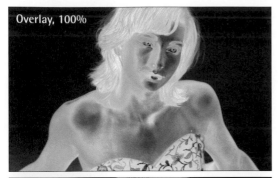

Overlay, 100%

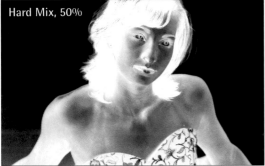

Hard Mix, 50%

Figure 10-9.

6. ***Apply a blend mode from the lighten group.*** Any darken mode is going to leave the dress too dark. Of the contrast modes, Overlay favors the rear image enough to produce a decent result. The same can also be said of Hard Mix set to a reduced Opacity value, although the hair comes off as too blurry. Both modes appears in Figure 10-9.

I don't work with reduced Opacity values very often. More often than not, they don't temper the effect; they dilute it. When I do use Opacity, I tend to use it only with The Fill Opacity Eight, those eight blend modes from Lesson 6 that respond differently to the Fill value than to the Opacity value (see page 210). Perhaps confusingly, the Opacity value in the Calculations dialog box is actually fill opacity. Which is why the second image in Figure 10-9 looks the way it does.

The better solution for this mask is going to be one of the lighten modes. You can experiment, or you can take a gander at Figure 10-10 in which I've laid them all out, starting with the moderate lighten modes on the left, the extreme modes in the middle, and the extreme modes at reduced opacity values (because both Dodges are part of The Fill Opacity Eight) on the right. Lighten is too jagged and Screen is too tepid. Meanwhile, reducing the Opacity values isn't getting us anywhere. That leaves us with the two Dodge modes at 100 percent.

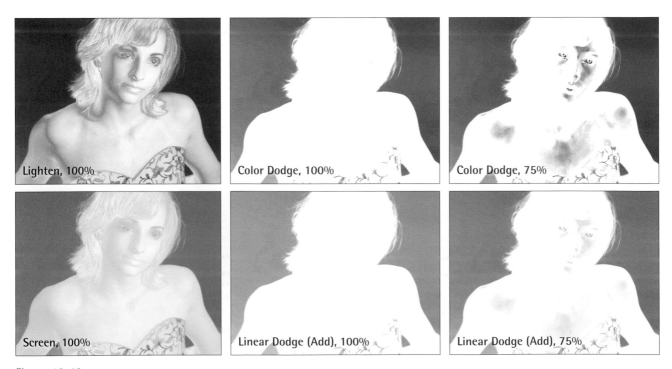

Lighten, 100% Color Dodge, 100% Color Dodge, 75%

Screen, 100% Linear Dodge (Add), 100% Linear Dodge (Add), 75%

Figure 10-10.

After all that, here's what I want you to do: Set the **Blending** option to the Dodge mode that offers slightly better contrast, **Color Dodge**. (Were you working on your own blue screen image, you'd want to test both Dodge modes to see which one works better for you. You might also want to try out Add, which I'll explain in the next exercise.) And leave the **Opacity** value set to 100 percent.

For those of you wondering what happened to the fifth lighten mode, Lighter Color, it servers no purpose here. For whatever reason—because they're composite effects? because they're lame?—Lighter Color and its pal Darker Color produce the same effect as Normal, showing the Source 1 image and hiding the Source 2 image. You can ignore them.

7. *Click the OK button.* Leave the **Mask** check box off and leave **Result** set to **New Channel**. Then click **OK**. Photoshop creates a new alpha channel in the Channels palette.

8. *Rename the alpha channel.* For the sake of tidiness, double-click **Alpha 1**, rename it "Mask," and press Enter or Return.

9. *Clean up the eyes.* If you look closely, you'll see some very light leftover details around the eyes, which we can clean up right away. Press the M key to get the rectangular marquee tool. Draw a selection around the eyes and press Alt+Backspace (Option-Delete) to fill the selection with the foreground color, white. Then press Ctrl+D (⌘-D) to deselect the image.

10. *Increase the contrast with Levels.* The Color Dodge mode has produced an image in which the darkest color has a luminance level of 86, which is about 33 percent in the world of ink density. Suffice it to say, we need something much darker:

 - Choose **Image→Adjustments→Levels** or press Ctrl+L (⌘-L) to bring up the **Levels** dialog box.

 - Set the black point value below the histogram to 110 to darken the background without losing detail in the hair. Then set the white point value to 235 to brighten the lightest areas slightly.

 - When your settings look like those in Figure 10-11, click the **OK** button to enhance the mask.

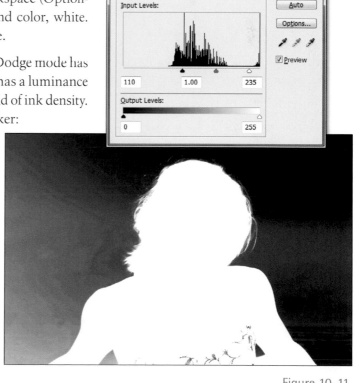

Figure 10-11.

11. *Paint with the Overlay mode.* Now to clean up the mask by painting with the brush tool set to the Overlay mode:

- Press the B key to select the brush tool.

- Right-click (or Control-click) the image window to bring up the brush pop-up palette. Set the **Master Diameter** to 300 pixels and the **Hardness** to 0 percent. Then press Enter or Return to dismiss the palette.

- Choose the **Overlay** option from the **Mode** pop-up in the options bar. Or just press Shift+Alt+O (Shift-Option-O).

- Press the 5 key to reduce the **Opacity** value in the options bar to 50 percent. (If that doesn't work on the PC, press Esc and try again.) This will help protect the hair, which is in a fragile condition at the present.

- Press the X key to swap the foreground and background colors and make the foreground color black.

- Paint along the edges of the hair on both sides of her head to darken the background while retaining as much of the white hair detail as you can. You'll have to paint a few brushstrokes to darken the background enough to make it black.

- Press the ⬚ key several times to reduce the brush size to 70 pixels. Then paint away any stray pieces of hair that are all by themselves and might otherwise look like mistakes.

- Once you're done with the hair, you can move through the image a little more quickly. Press ⬚ several times to increase the brush size to 200 pixels. Press the 0 (zero) key to increase the **Opacity** value to 100 percent. Then paint along the outside edges of the arms and shoulders, being careful not to paint into the hair. You may have to paint two or three brushstrokes along each arm.

- Click two or three times under the arm on the left side of the image to darken that area. Click once under the arm on the right side to darken it as well.

- Press X to make the foreground color white and paint away the fabric details in the dress. Again, this will require two or three brushstrokes.

Your result should look something like Figure 10-12 on the facing page.

Figure 10-12.

12. *Clear away the background.* By now the boundary between woman and background should look just right, fading from white to black over the course of just a few edge pixels. But the dark gray background needs to go pitch black as well. Press the L key to select the lasso tool. Draw a selection outline around the background without getting close to the woman, as in Figure 10-13. Then press the Backspace (or Delete) key to fill the selection with the background color, which should be black. Press Ctrl+D (⌘-D) to deselect the image.

Figure 10-13.

13. *Apply any finishing touches.* Clean up any remaining bad transitions or stray pixels with the lasso and brush tools. These may be bits of patterning in her bodice or not-quite-black areas around the hair. If you decide to paint around the hair some more, be sure to reduce the Opacity setting for the brush tool. And try to keep your brush as much in the background and out of the hair as possible. My finished mask appears in Figure 10-14.

Figure 10-14.

Figure 10-15.

14. *Open another image.* Now that we have a mask, let's use it to place the woman against a new background. Open the file titled *Rays of light.jpg*, located in the *Lesson 10* folder inside *Lesson Files-PsCM 1on1*. This underwater image by photographer Tammy Peluso will provide a nice tranquil background. The original photo included a scuba diver, but I cropped him out, as evidenced by the complete and utter lack of scuba diver in Figure 10-15.

15. *Convert the woman to a masked layer.* As ever, we need to bring the woman, *avec masque*, into the new background. We've seen how to do this a dozen or more times now, but I am duty-bound to document the task for your rereading enjoyment:

 • Click the title bar or tab for the *Model on blue.jpg* image to bring it to the front.

- In the **Channels** palette, Ctrl-click (or ⌘-click) the **Mask** channel to load it as a selection outline.

- Switch to the **Layers** palette (remember F7!) and double-click the thumbnail for the **Background** layer. In the **New Layer** dialog box, name the layer "Model" and click **OK**. You now have an independent layer, with which you can do anything you please. (Uh, within the limits of what Photoshop can do, of course.)

- Click the ▣ icon at the bottom of the Layers palette to convert the active selection outline to a layer mask, as demonstrated in Figure 10-16.

We now have layer and mask ready and waiting to be placed into another backdrop.

Figure 10-16.

16. *Copy the masked woman into the aqueous photograph.* Now to blend old foreground with new background:

- Click the ⌄≡ in the top-right corner of the Layers palette and choose **Duplicate Layer** from the pop-up menu. In the ensuing dialog box, choose **Rays of light.jpg** from the **Document** pop-up (which automatically changes the layer name to Model) and click **OK**.

- Switch to the *Rays of light.jpg* image. The woman now appears against the underwater background.

And for nothing more than a mask and a drag-and-drop, it looks remarkably good. Great, in fact. I totally buy that she was captured against that background—except that really she'd be wet and drowning, of course. Is it possible that blue screens are everything they're cracked up to be? Or that Calculations is the masking command we've all been waiting for? Or that our technique was impeccable?

Figure 10-17.

Or did we simply luck out?

17. *Invert the background.* To simulate a situation where any vestige of old-home color doesn't blend in so well with the new, we'll temporarily invert the colors in the background:

- Click the **Background** layer to make it active.

- Go to the **Adjustments** palette and Alt-click (or Option-click) the first icon in the third row, ▣, to display the **New Layer** dialog box.

- Name the new layer "Color Invert," set the **Mode** option to **Color**, and click **OK**.

Photoshop reverses the colors of the Background layer to produce a bright orange backdrop. And sure enough, the hair is rife with bluish color fringing, as in Figure 10-18.

Figure 10-18.

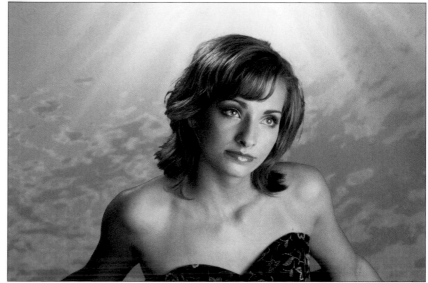
18. *Add a new layer.* Back in the **Layers** palette, click the **Model** layer to make it active. Then press Ctrl+Shift+N (⌘-Shift-N) to bring up the **New Layer** dialog box and name the new layer "Fringing." To keep your brushstrokes inside the hair, turn on the **Use Previous Layer to Create Clipping Mask** check box. Then change the **Mode** option to **Color** and click **OK**.

19. *Paint a color correction.* With our new Fringing layer, we can now paint in corrections to fix the color fringing.

- Press the B key to select the brush tool.

- Press the ⊡ key a few times to reduce the size of the brush to 100 pixels.

- Press the Alt (or Option) key to get the eyedropper tool on-the-fly. Then click on a nice auburn area of the hair to make that color the foreground color.

- Paint around the perimeter of the hair to paint away the fringing. If the color doesn't work for you, eyedrop a different one and paint over your old stuff. If you go too far, you can always erase.

You may also want to lift some skin tones and paint around her shoulders and arms. Throughout, the brushstrokes affect the Model layer and not the background. My finished effect appears in Figure 10-19.

Figure 10-19.

20. *Paint an underwater effect.* The model looks good, but I liked her better underwater. In fact, I want to make her appear *really* underwater. Here's how:.

- Click the 👁 icon in front of **Color Invert** in the **Layers** palette to turn the adjustment off and return the original blue.

- Press Alt (or Option) to get the eyedropper and click in the water to assign a shade of blue to the foreground color.

- Press the ⬚ key several times to increase the brush size to 300 pixels or so. Then paint all over the woman to make her blue as all get out.

- That's too much blue, so press the M key to select the rectangular marquee tool. And press the 5 key twice in a row to reduce the **Opacity** value for the layer to 55 percent. The completed result appears in Figure 10-20.

21. *Save the image.* If you want to keep your work, press Ctrl+S (⌘-S) to display the **Save** dialog box. Set the **Format** to **Photoshop**, name the file "Oceanic angle.psd" or something equally dreamy, and click the **Save** button.

And that is how you extract an image shot against a blue screen using the Calculations command. Shooting against a green screen instead? Take every mention of the Blue channel in this exercise and replace it with Green. Such a flexible technique!

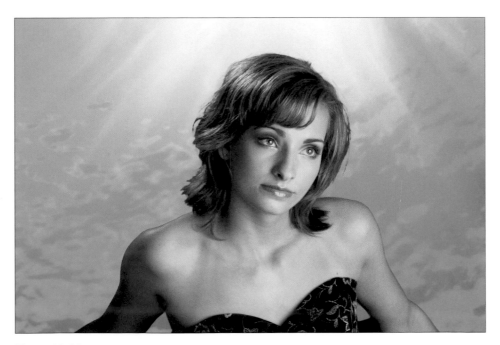

Figure 10-20.

Using the Add and Subtract Modes

Now that you have a sense for how the Calculations command works, it's time to introduce you to the two blend modes that are unique to it and the Apply Image command, Add and Subtract. Both modes do exactly what they say: Add adds luminance levels (S2+S1, where S2 is Source 2 and S1 is Source 1); Subtract subtracts them (S2−S1). And as we'll see, these very simple equations make Add and Subtract exceedingly useful masking functions.

Why are Add and Subtract absent from the Layers palette? Functionally, it would be difficult to include them. For reasons outlined back in the sidebar "Why Multiply Darkens (Blend Mode Math)" (page 209, Lesson 6), Add and Subtract are powerful operations that can clip enormous quantities of light or dark colors, respectively. To help mitigate the clipping, both blend modes offer additional numerical operators that have no home in the Layers palette. Which is why, when Add was added to the Layers palette some years back, it was stripped of its numerical operators and renamed Linear Dodge.

To learn all about the underlying mechanics of Add, Subtract, and their numerical operators, read the sidebar, "How Add and Subtract Work," which starts on page 366. To see these blend modes in action, continue with this exercise.

1. *Open an image.* If you're of a certain age, you may remember the classic days of analog comic books, in which squeaky-clean cape-wearing characters were rendered as having such jet-black, perfectly manicured, meticulously polished bouffants that their hair would actually reflect blue—presumably sky blue, even at night. Robin the Boy Wonder comes to mind. It was as if no wavelengths other than blue were a match for the light-absorbing powers of Robin's coiffure.

 Open *Superhero hair.tif*, located in the *Lesson 10* folder inside *Lesson Files-PsCM 1on1*, and be reminded of those vintage Boy Wonder days, care of Chris Schmidt of iStockphoto and Figure 10-21. Captured at the peak of his form, this guy possesses hair so blue, his super capabilities must number well into the few, if not the several. Better still, this guy is the same color as his background, his hairs are out of focus but to varying degrees, and there is no distinction between the top of this fellow's head and his background. This is a mask-unfriendly image. So let's mask it.

Figure 10-21.

How Add and Subtract Work

To fully understanding masking in Photoshop, you have to come to terms with the Calculations command. And to fully understand Calculations, you have to come to terms with the two blends modes that it shares only with Apply Image: Add and Subtract. Both Add and Subtract provide two numerical options, Offset and Scale. I explain how Add, Subtract, Offset, and Scale work in this sidebar.

I'll start with two channels, one an ellipse that I call The Shadow and another a circle I call The Sun. Both are fuzzy, white shapes against black backgrounds. In all cases, The Shadow is set to Source 1 (or S1 in the figures below) and The Sun is Source 2 (or S2). The two shapes overlap. The degree of overlap is shown in the final figure below. The Shadow is cyan and The Sun is magenta. So that cyan crescent is an area that's black in The Shadow channel and white in The Sun.

Now let's try our hand at blending these two channels, starting with the Add mode. The simple equation for Add is $S2+S1$. Meaning that we start with the luminance levels for the Source 2 channel, which is the base channel at the bottom of the stack, and we add the levels from Source 1. So if an S2 pixel has a level of 100 and the corresponding S1 pixel is 40, the combined level is 140. Meaning that Add is a member of the lighten group.

But what if an S2 pixel has a level of 200 and the S1 pixel is 160? The result is now 360, or 105 levels beyond the maximum value 255. Which is not unusual. Anything that was formerly a midtone gets blasted through the roof. That's where the Scale and Offset values come in. To temper the effect, you can divide the result by the Scale value and subtract or add Offset. Scale may vary between 1 and 2—a small range to be sure, but in 0.001 increments; Offset varies from −255 to +255

Consider the example below. I've used the Add mode to combine The Shadow and The Sun channels. Scale and Offset are set to 1.00 and 0, respectively, as by default. Whenever you divide something by 1 or add 0, you get the same number, so these values have no effect. But the Add mode certainly does. The area where the two images overlap is extremely light, mostly clipping to white. Only the areas of limited or no overlap are allowed to remain gray.

Compare that to dividing the resulting levels by the maximum Scale value, 2. Now if we were talking about an S2 level of 200 and an S1 level of 160, we would get $360 \div 2 = 180$, which falls well under the 255 maximum. Shown at the top of the next column, the result is not only a darker composite, it's also every bit as soft and fuzzy as the original source images. If you want to mitigate the effects of Add and keep the transitions nice and soft, Scale is the solution.

(S2+S1) ÷ 2.00 + 0

Now let's take a look at what it means to rein in the effects of Add with the Offset value. In the figure below, I reset the scale value to 1 and I lowered the Offset to –128, roughly half the 255 maximum. (Take note of the minus sign; a positive Offset value would add brightness to an already overly bright Add effect.) The result: a smaller Sun+Shadow combo, effectively choking the mask. Plus, it's quite crisp. Offset is great for increasing the contrast and sharpening the edges of a mask.

(S2+S1) ÷ 1.00 – 128

From Add, let's move to Subtract. Here, the equation is S2–S1. So in our case, we take The Sun, our base channel, and we subtract The Shadow from it. To cite a previous example, if S2 is 100 and S1 is 40, then the combined level is 60. The brighter the S1 pixel, the darker the result, which is how a white ellipse (S1) can turn into a shadow, as below.

(S2–S1) ÷ 1.00 + 0

The Subtract mode is in every way the opposite of Add. Just as Add is a member of the lighten group, Subtract is a member of the darken group. So where Add benefits from a negative Offset value, Subtract benefits from a positive one. In the example below, I raised the Offset value to 128. (You don't need a plus sign because Offset is automatically configured to add.) The bright levels become exceedingly bright, beyond the 255 maximum. What were formerly blacks become medium grays. And in only those areas where I subtracted bright levels in The Shadow channel from black ones in The Sun channel do we see dark remnants. In other words, only ultra-blacks stay black. And as with Add, the result is choked and sharp.

(S2–S1) ÷ 1.00 + 128

If you want to bring back some of the softness from the Source channels, raise the Scale value. Below, we see the result of raising the Scale to its maximum of 2 while keeping the Offset at 128. For extra credit, compare this image to the Add example with a Scale value of 2 in the top-left corner of this page. Everything that was black or white in the Add mask becomes gray in the Subtract mask, and what was gray in Add becomes black or white in Subtract. In other words, you can use Subtract to turn Add's interior into edges, and vice versa.

(S2–S1) ÷ 2.00 + 128

That's enough brain bending for now. To see a practical application of Add and Subtract, complete the exercise.

2. *Evaluate the channels.* Go to the **Channels** palette and click each of the three channels or press Ctrl+3, +4, +5 (⌘-3, -4, -5) to evaluate them. On display in Figure 10-22, the Red and Green channels offer the most contrast, so you might think those are the ones we should go with. But the better choices are Green and Blue, and here's why:

- The Red channel is a mess. The face is completely clipped, and the background is exceptionally noisy. Something has quite obviously been done to this channel, and the effects of that something are profound. (I wouldn't be surprised if Apply Image were involved.) Lest you think I'm pronouncing judgement, perish the thought. I think this image looks great or I wouldn't have selected it. But whatever the success of the effect, the Red channel was a casualty. We can't trust its content for something as important as a mask.

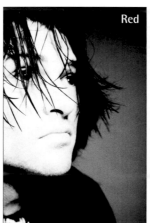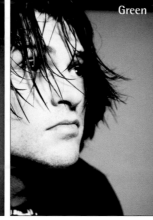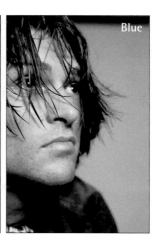

Figure 10-22.

- The Green channel is in solid shape. Excellent contrast.
- Like Red, the Blue channel has seen its fair share of conflict and has the battle scars to prove it. In particular, review the framed details in Figure 10-23. The edge artifacts along the whiskers of the chin and the rough patches in the shoulder are the most obvious examples. But the artifacts rise up the side of his face and into his irises as well. So why am I suggesting we use this channel? Because of the low contrast in the hair. If that sounds strange—admittedly, it runs counter to what I've taught you so far—bear in mind that one of our struggles will be to maintain the naturally soft focus and tenuous existence of the hair, all of which is most evident in the Blue channel. The softness of the Blue channel will help balance the sharpness of the Green.

When you've finished reviewing the channels, press Ctrl+2 (⌘-2) or click **RGB** to return to the composite RGB image.

3. *Choose the Calculations command.* Choose **Image→ Calculations** and establish the following settings:

- Confirm that the first and second pop-up menus for both Source 1 and Source 2 are **Superhero blue.jpg** and **Background**. (The chances of them being otherwise are nil, but it's always a good idea to check.)

- After speaking so highly of the Blue channel, it only seems right to make it our base channel for the calculation. Set the **Channel** option under **Source 2** to **Blue**.

- Green is our designated support channel, so set the **Channel** option under **Source 1** to **Green**.

- In both channels, the hair is darker than the background. To select the hair, it needs to be lighter. So turn on *both* **Invert** check boxes.

Assuming your blend mode is set to Linear Dodge (Add), the result looks like that in Figure 10-24. Don't click **OK**—we have another step to go.

Figure 10-23.

Figure 10-24.

4. *Apply the Add mode.* This time around, rather than select an ideal blend mode and be done with it, we're going to experiment with two different modes, Add and Subtract, and see how they can be made to produce remarkably similar results. Let's start with Add:

- Set the **Blending** option to **Add**. If Linear Dodge (Add) was previously active and Offset and Scale are set to their defaults (0 and 1), the image preview will not change in the slightest.

- Click inside the **Offset** value. Press Shift+↓ and watch the medium and dark colors grow darker, even as the whites remain stubbornly white. Those whites that stay white are the luminance levels that are through the ceiling, in the 300 to 500 realm, far beyond the 255 maximum. Keep reducing the Offset to −90 to sink the darkest colors to black.

- As explained in the "How Add and Subtract Work" sidebar, shifting the Offset value increases the contrast and sharpens the edges of a mask. To soften the transitions and further darken the background, increase the **Scale** value to 1.4. The result is softer transitions along the edges of the hair and less noise in the background, as in Figure 10-25.

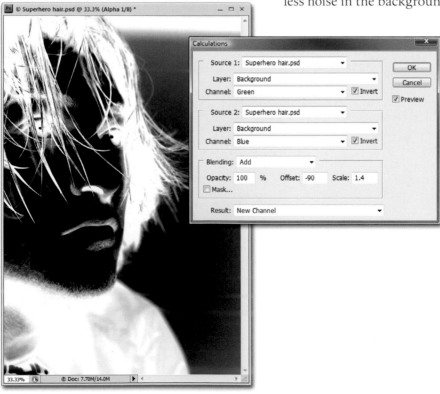

Figure 10-25.

5. *Rename the alpha channel.* Click **OK** to accept the new alpha channel and close the **Calculations** dialog box. Then back in the **Channels** palette, double-click the name of the new channel, **Alpha 1**. Change the name to "Add, –90, 1.4"—just to keep things straight—and press Enter or Return.

6. *Choose the Calculations command.* Now let's take a swing at building a base mask using the Subtract mode. Press Ctrl+2 (⌘-2) or return to the **RGB** composite. Choose **Image→Calculations** to bring up the **Calculations** dialog box, which displays the same settings we applied in the previous step. (Had you not switched back to the RGB image, all the Source settings would be messed up.) Which is great, because we'll be making just a few modifications.

7. *Apply the Subtract mode.* Leave all the Source information the same as it was before and change the **Blending** setting to **Subtract**. The result is the very dark image shown in Figure 10-26. How can it possibly be so dark when the hair, for example, is so light in the inverted sources? Well, here's how it works: Because the equation for Subtract is $S2-S1$, a bright pixel in the S2 channel contributes brightness to the resulting composite, which makes perfect sense. But the fact that S1 gets subtracted means that a bright pixel in the S1 channel drags the S2 level down. Consider the extreme examples:

- S2 white minus S1 white is $255-255=0$, or black.

- S2 white minus S1 black is $255-0=255$, or white.

So if we want the hair to stay nice and white, we need to make it white in the Source 2 channel and black in the Source 1 channel.

8. *Turn off Invert for the Green channel.* How to make the S1 hair black? Go to **Source 1**, which is set to Green, and turn off the **Invert** check box. Just like that, the mask takes on a more reasonable appearance, as seen in Figure 10-27.

Here's what I hope is a simple rule. When using the Add mode, invert the S1 channel as needed for brightness. When using Subtract, invert for darkness. Either way, invert the S2 channel for brightness.

Figure 10-26.

Figure 10-27.

9. *Set the Offset and Scale values.* I'm very happy with the results we got out of the Add mode; let's see if we can duplicate them with Subtract. For starters, we'll mimic the Offset and Scale values:

- Set the **Offset** value to −90.

- Set the **Scale** to 1.4.

The grayish result is obviously wrong. It's not the Scale value that's at fault—by dividing the effects it lessens the impact, lightens the luminance, and softens transitions, which are all good. Our problem is that we're using the Offset value to subtract levels when we should be adding them. And all you have to do to remedy that problem is get rid of the minus sign, making the **Offset** value 90, as in Figure 10-28.

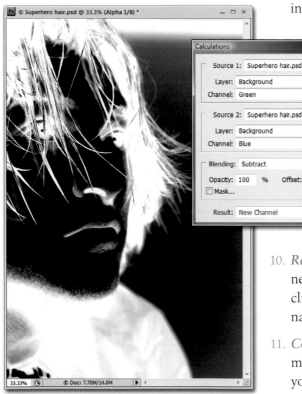

Figure 10-28.

10. *Rename the alpha channel.* Click **OK** to accept the channel and close the dialog box. To keep things tidy, double-click the words **Alpha 1** in the **Channels** palette. Enter the name "Subtract, 90, 1.4" and press Enter or Return.

11. *Compare the Add and Subtract masks.* At this point, you may have already noticed an amazing phenomenon, and you're just waiting for me to point it out. You'll notice it even more if you switch between the **Add, −90, 1.4** and **Subtract, 90, 1.4** alpha channels. The two channels appear not so much similar as utterly and completely identical. Not entirely a surprise, thanks to our effective combination of opposite settings with opposite blend modes. But there are a few minor differences. Let's hunt them down and learn something new in the process.

12. *Run a Difference comparison.* While looking at either the Add or Subtract channel, choose **Image→Calculations**. Then run this difference calculation:

- Set the **Channel** option for **Source 1** to either the **Add** or **Subtract** channel, doesn't matter which. (I explain why below.) Then set the **Channel** option for **Source 2** to the other one.

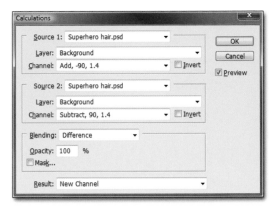

Figure 10-29.

- Set **Blending** to **Difference**. The image preview goes entirely black, suggesting no differences. But they're there, and we'll reveal them in a moment.

- When your settings look like those in Figure 10-29 (Add and Subtract can be swapped), click the **OK** button to close the Calculations dialog box.

- Rename the new channel "What's the diff?"

PEARL OF WISDOM

Difference is what's known as a *symmetrical blend mode*, meaning that it doesn't matter which order you blend the channels. (Whether you take the absolute value of, say, 200–125 or 125–200, you still get positive 75.) Other symmetrical modes include Add, Multiply, Screen, Linear Dodge, and Hard Mix. The *asymmetrical modes*—the ones that produce different effects depending on blend order—include Normal, Overlay, all the Light and HSL modes, Color Dodge and Burn, and Subtract. Changing the Opacity of a channel or layer is also asymmetrical, the one exception being 50 percent. I don't expect you to memorize any of this, but I've found it helpful over the years so it's here if you ever want to come back to it.

13. *Mine the differences with Levels.* We are confronted with what appears to be an all-black channel. But a Levels adjustment reveals the true story:

- Choose **Image→Adjustments→Levels** or press Ctrl+L (⌘-L) to bring up the **Levels** dialog box.

- Drag the white triangle under the histogram all the way to the left so the third **Input Levels** value becomes 2. Those pixels that remain resolutely black represent areas where Add and Subtract produced identical effects. The areas of biggest difference occur primarily around the edges, as indicated by the white areas in Figure 10-30. (Yeesh, you think it'll be the pretty pictures that sell this book?)

- Click **OK** to apply the Levels adjustment.

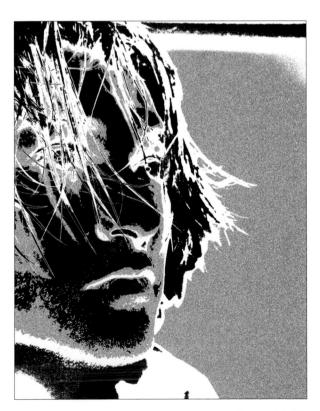

Figure 10-30.

Can we draw some sort of qualitative conclusion based on this image? Not likely. The real point is this: While not absolutely identical, Add and Subtract can be made to produce roughly equivalent calculations. Which blend mode you choose to use for a given job is largely up to you. You may find it more straightforward to develop a masking workflow around Add or Subtract, or you may prefer to mix and match.

14. *Save the image.* We'll be working with this same image throughout the next two exercises. So take a moment to save your work. The good news is, you haven't modified a pixel in the image, you've just added a few alpha channels. So press Ctrl+S (⌘-S on the Mac) to update the *Superhero blue.tif* file.

Curves, Dodge, Burn, and Paint

Thus far, we have a base mask. And like any base mask, it requires refinement. But because of the special challenges associated with this image—varying levels of focus, a preponderance of noise, and the vague distinction between hair and background along the top of the image—we'll need to up our game. So instead of the standard combination of the Levels command and Overlay painting, we'll be employing the more powerful Curves command, Apply Image, and the dodge and burn tools. In the end, we'll have a mask that will trace every blurry, noisy, vaguely defined edge in this image.

1. *Open an image.* If your *Superhero blue.tif* image is still open, stick with it. Otherwise, you can open my version of the file, titled *Vive la difference.tif*, located in the *Lesson 10* folder inside *Lesson Files-PsCM 1on1.*

 Thus far, we've managed to create two base masks that are very similar if not pixel-for-pixel identical. We have to choose one to develop—well, we could develop both, but what's the point?—so I'm going to flip a coin and say Subtract. You can work with the Add channel if you prefer, but if you do, you may get slightly different results.

2. *Copy the Subtract channel.* Because all changes made to channels are static, I like to save my steps by creating copies. So go to the **Channels** palette. Press the Alt (or Option) key and drag the **Subtract, 90, 1.4** channel onto the ▢ icon at the bottom of the palette. Name the new channel "Curves Modification" and press Enter or Return.

3. *Choose the Curves command.* Now comes the step where we increase the contrast of the base mask, a step normally well accommodated by the Levels command. But this mask is unlike the ones we've encountered before. Most of the blacks and whites that we would clip with Levels are already clipped. We need a command that offers more control, and that command is Curves. So choose **Image→Adjustments→Curves** or press Ctrl+M (⌘-M) to bring up the **Curves** dialog box.

4. *Draw a curve with the pencil tool.* A typical application of the Curves command—as explained in the Pearl of Wisdom on the right—involves the use of the point tool, which lets you set points on the curve. The point tool creates a *spline curve*, in which neighboring points network with each other to produce highly regulated smooth transitions. That's fine for correcting continuous-tone photographs. But when adjusting masks, I prefer to take a more free-form approach:

- Click the pencil icon in the top-left corner of the dialog box, as labeled in Figure 10-31.

- Just to get a sense for how the tool works, try drawing a spiky zigzag across the graph, like a rising stock chart. Notice how it introduces a series of weird luminance transitions into the image. Such a free-form curve is known as an *arbitrary map*, and while it may look weird now, it can be extremely effective.

- Press Alt (or Option) and click **Reset** (formerly Cancel) below the OK button to restore the diagonal line.

- Now to get some real work done: Drag a horizontal line from the bottom-left corner of the graph (where the Input and Output values both read 0) to the right, keeping the cursor along the bottom edge and stopping when you reach an **Input** value of 30 or thereabouts. (The **Output** value should be 0 throughout.)

- Move your cursor to the top of the graph and a bit to the right, to a point where the **Input** and **Output** values read 100 and 255, respectively. Then, press the Shift key and click at that point. Photoshop draws a straight line from the bottom to the top of the graph, as in Figure 10-31.

- Move the cursor to the top-right corner of the graph, where both the **Input** and **Output** values read 255, and Shift-click again. The result is a horizontal line across the top of the graph.

For those unfamiliar with the Curves dialog box, start by noticing that it includes a central graph with an inset gray histogram. Assuming default settings, you have a horizontal black-to-white gradient ramp under the graph, with black and white slider triangles that work just like they do in Levels. The diagonal line inside the graph is the curve itself. Click on that line to set a point. Click high on the line to control the bright luminance levels in an image; click low to control the dark ones. Drag a point to introduce curvature to the diagonal line. Drag down to darken the selected levels, drag up to lighten them. In this way, the Curves command gives you specific control over the brightness of an image.

Pencil tool

Figure 10-31.

- Such a polygonal curve results in some harsh transitions in the mask. So to soften things up a bit, go to the top-right corner of the dialog box and click the **Smooth** button. That smooths out the curve a little bit. To go even further, click Smooth again. Both the Smooth button and softened mask appear in Figure 10-32.

Be forewarned: You can click Smooth as many times as you like, but it's not undoable. If you go too far, you'll have to redraw the curve. So in our case, click the button twice and no more.

When you get the graph and the mask shown in the figure, click the **OK** button to apply your adjustment.

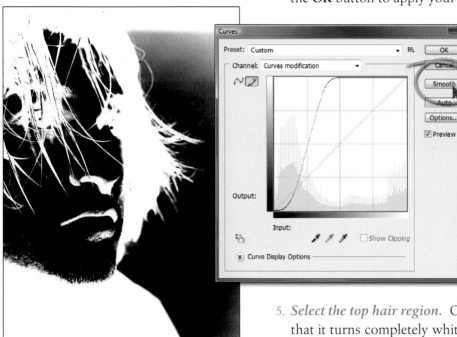

Figure 10-32.

5. *Select the top hair region.* One big problem with our mask is that it turns completely white at the top. We'll attempt to re-build the detail in this area using the Apply Image command, which brings detail from one channel into another channel subject to a blend mode. But first, we need to select the area that we want to work on.

- Press the L key to get the standard lasso tool.

- Press and hold the Alt (or Option) key and click around the general region enclosed in the selection outline in Figure 10-33. Be sure to get all the way to the top of the image, as well as midway down the very prominent loop of hair above the kid's eye.

- Release the Alt (or Option) key to complete the selection.

Figure 10-33.

6. *Refine the selection in the quick mask mode.* I'm generally satis-fied with my selection outline. It incorporates the areas that lack sufficient contrast or any detail whatsoever. But it's too sharp. We could easily end up with an obvious patch of edited pixels. Let's use the quick mask mode to create a more gradual transition:

- Press the Q key to enter the quick mask mode. You'll now see a red quick mask superimposed on a red alpha channel, which is Photoshop's way of showing you that you've piled one mask onto another.

- To better see the masks, go to the **Channels** palette and double-click the thumbnail for the **Curves Modification** channel.

- In the **Channel Options** dialog box, click the red color swatch. Change the **H** value to 210 degrees. Then click **OK** twice to apply the new color.

- Press the G key to select the gradient tool.

- You'll need the foreground color to be black. Press the D key to make it so.

- Right-click the gradient tool icon on the left side of the options bar and choose **Reset Tool**. Then press the ⊡ (period) key a couple of times to advance to the black-to-transparent gradient style.

- Click the temporary **Quick Mask** channel at the bottom of the Channels palette to make it active. (Otherwise you'll edit the wrong channel.)

- Click at the bottom of the selection and drag upward to just above the highest visible loop of hair, as il-lustrated in Figure 10-34.

- That one gradient is all we need. The other edges will go completely black or white, so we needn't fuss over them. Press the Q key to exit the quick mask mode and return to the Curves Modification channel.

Draw a vertical gradient

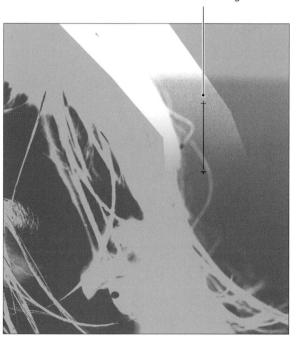

Figure 10-34.

7. *Choose the Apply Image command.* Now to bring in some new channel information. We could copy and paste pixels between the channels as we did in the Lesson 5 exercise "Finessing the Smooth Contours" (page 160), but that would result in undesirable edge artifacts and limit our options. Better to choose the Apply Image command, which mixes channels much like Calculations but de-livers the result into the active channel rather than creating a new alpha channel.

Let's start things off by choosing **Image→Apply Image** to display the **Apply Image** dialog box. And then do the following:

- The Green channel is still our best bet for bolstering the edges. So set the **Channel** option in the **Source** section to **Green**. If the **Invert** check box is on, turn it off.

- Choose **Subtract** from the **Blending** pop-up menu. The Apply Image and Calculations commands work in lock-step, so the Scale and Offset values should still be 1.4 and 90, respectively. Leave the **Scale** value unchanged. Reduce the **Offset** value to 70 to darken things up a bit. The result is a more pronounced contrast toward the bottom of the selection, as in Figure 10-35.

- Click **OK** to apply your settings. Then press Ctrl+D (⌘-D) to deselect the image.

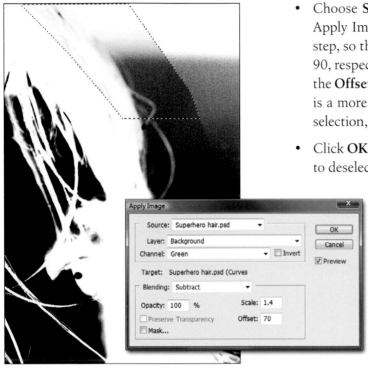

Figure 10-35.

Figure 10-36.

8. *Select the very top region.* The top of the image is still unacceptably low in detail. This time, we'll bring in the Blue channel. Press the L key to return to the lasso tool. And then Alt-click (or Option-click) around the area that I've selected in Figure 10-36.

9. *Add another gradient edge in the quick mask mode.* Again we have to soften the transitions along the bottom of the selection. And we'll do it in the same way as before:

- Press the Q key to enter the quick mask mode.

- Press the G key to get the gradient tool. Then press D to establish the default colors. Otherwise, everything should still be set the way it was in Step 6.

- Draw a vertical gradient from the bottom of the selection to about midway up, as shown in Figure 10-37.

- Press the Q key once again to exit the quick mask mode and rejoin the marching ants.

10. *Choose the Apply Image command.* We'll once again use Apply Image to fill in the selection, but this time we'll call upon the one

channel that might do us any good in this area, Blue. Now that I've given away most of the plot, choose **Image→Apply Image** to bring up the **Apply Image** dialog box. Set the **Channel** option in the **Source** section to **Blue** with **Invert** off. And set the **Blending** option to—wait for it—**Normal**. Why Normal? Because the selected area is almost entirely white. What the heck do we have to blend? We've got nothing; let's just replace it. Figure 10-38 shows the settings and the effect. Click **OK** to apply.

11. *Apply a Levels adjustment.* Naturally, this could use some contrast enhancement. So choose **Image→Adjustments→Levels** or press Ctrl+L (⌘-L). In the **Levels** dialog box, drag the white slider triangle to the left until the third value under the histogram reads 160, as in Figure 10-39. And then click **OK**.

The selection has served its purpose, so press Ctrl+D (or ⌘-D) to give it the slip. At this point, you might be thinking, "This looks terrible!" And you'd be right. While the bottom 95 percent of the image (yes, I measured it) is ready and waiting for refinement, the top 5 percent—the part you just deselected—is little more than a vague suggestion of a mask. Never fear, we'll make it work.

Draw another gradient

Figure 10-37.

Figure 10-38.

Figure 10-39.

12. *Create a copy of the mask.* Our next task will be to refine the mask by painting with the dodge and burn tools. But before we start, let's create a backup of our work so far. Alt-drag (or Option-drag) the **Curves Modification** channel to the 🔲 icon at the bottom of the **Channels** palette. Name the new channel "Dodge and Burn" and click **OK**.

Over the course of the next few steps, we'll be increasing the contrast of our mask on a selective basis—darkening the darkest colors and lightening the lightest ones—by painting inside the image. In Lesson 5, I showed you a technique that involved painting with the brush tool set to the Overlay mode. Problem is, the details in this image are too fragile to hold up to the Overlay mode at full opacity. And were you to lower the Opacity value, you would get less work done at a time and be forced to visit and revisit areas over and over again. The smarter approach is to use the dodge and burn tools.

PEARL OF ⬤ WISDOM

If you know anything about Photoshop CS4, you may be aware that the dodge and burn tools have been enhanced so that they better accommodate the retouching of continuous-tone photographs. It's an excellent improvement, and it makes dodge and burn far more valuable than they've been in the past. But when working in a grayscale image, such as a mask, the dodge and burn tools behave the same way they always have. Which is just fine, thank you very much. The classic dodge and burn behavior has always suited masking quite nicely.

13. *Create a history snapshot.* Anytime you paint inside an image, you tend to rack up a lot of brushstrokes, which makes changing your mind very difficult. By default, the History palette—which tracks your undoable actions—holds 20 states. Meaning that after painting 20 times, your oldest brushstrokes start rolling off the palette, never to return. You can raise the number of history states, but that can lead to memory problems once you switch from brushstrokes back to larger whole-image operations. Better instead to take a snapshot of the image as it exists right now, before you embark on your dodge and burn adventure:

 • Bring up the **History** palette, which you can get by choosing **Window**→**History**.

 • Alt-click (Option-click) the middle icon at the bottom of the palette, 📷, to create a snapshot of the image in its current state. Name the snapshot "Last Good State"—because who knows where things are going from here—and click the **OK** button.

- Click the box to the left of the **Last Good State** snapshot at the top of the palette to mark it with a ✍ icon, which designates the snapshot as the source state for the history brush, as labeled in Figure 10-40.

14. *Burn the background to make it black.* Now we're ready to use the dodge and burn tools to lighten and darken specific areas of the mask. On a side note, here's how the tools work.

History brush source

Create snapshot

Figure 10-40.

Figure 10-41.

Figure 10-42.

Like the Dodge and Burn blend modes that we reviewed in Lesson 6, the dodge tool lightens and the burn tool darkens. (If you have trouble remembering, you have to be light on your feet to dodge things, and when you burn toast—or just about anything else—it gets dark.) But while the dodge and burn tools share their names with some radical lighten and darken modes, their behavior is more in keeping with Screen and Multiply, which is to say, they lighten and darken uniformly. You can limit the luminance range affected by either tool. Normally, they affect the midtones—the middle luminance levels—which is what you most likely want when retouching color images. But when working in a mask, you want the dodge tool to lighten just the highlights and the burn tool to darken just the shadows.

Here's how to send the dark areas of the mask to black without harming the fragile light hairs:

- Choose the burn tool from the dodge tool flyout menu in the toolbox, as shown in Figure 10-41.

- In the options bar, set the **Range** option to **Shadows** or press the shortcut Shift+Alt+S (Shift-Option-S).

- On the PC, press Esc. On either platform, press the 3 key to reduce the **Exposure** value to 30 percent.

- Press the ⬛ key a few times to increase the brush size to 80 pixels.

- Click and paint in the background to darken it and enhance its contrast with the hair.

Feel free to adjust the brush size as you work. You may need to shrink the brush to get into some of the tighter areas. Take care to eliminate as few hairs as possible (although some will have to go). And be sure to get the background nice and black. It'll probably take 20 or so brushstrokes to get everything just right. Figure 10-42 shows the results of my darkening efforts.

15. ***Dodge the hair as needed.*** The hair requires a very different approach than the background. Rather than paint in large generalized areas, we need to brighten a few key strands:

- Choose the dodge tool from the burn tool flyout menu in the toolbox.

If you followed by instructions in the Preface, you can switch back and forth between the dodge and burn tools—known collectively as the toning tools—by pressing the O key. My dekeKeys shortcut reassigns the other toning tool, the sponge (which is of no use when masking), to the N key.

- In the options bar, set the **Range** option to **Highlights** or press Shift+Alt+H (Shift-Option-H).

- If necessary, press Esc to deactivate the Highlights option. Then press the 5 key to set the **Exposure** value to 50 percent, as by default.

- Press the ⬚ key several times to reduce the brush size to a scant 15 pixels. Then zoom in and paint over any of the thick strands of hair that you think need brightening.

If a brushstroke leaves a hair looking unnaturally brittle, press Ctrl+Z (⌘-Z) to undo the effects of the dodge tool. You may be able to restore such hairs with better success using the history brush, as I'll show you in a moment.

16. ***Fill the remaining background with black.*** At this point, most of the background around the hair should be black. Anything other than black will result in partially selected pixels that will diminish the accuracy of your mask. To test your progress, press the W key one or more times to select the magic wand tool. We want to select black and only black, so go to the options bar and set the **Tolerance** value to 0 and turn off the **Anti-aliased** check box. The **Contiguous** check box should be on. Then click in the background. Your next move depends on the character of the selection outline:

- If the selection falls short of covering a large area of the background within a few pixels of the hair, press Ctrl+D (⌘-D) to abandon the selection, switch to the burn tool, and paint in the places that still need darkening. After you finish hitting the weak spots, repeat this step.

- If the selection more or less covers the area encircled in marching ants in Figure 10-43, you're in good shape. Zoom

Figure 10-43.

out and enlarge the window so you can see some of the gray pasteboard around the image. Press the L key to switch to the lasso tool. Then press the Shift key and begin dragging around the area on the right side of the image that still needs to be made black.

If you want to take advantage of the polygonal lasso function, here's what you do: After beginning to drag with the lasso tool, keep your mouse button down, release the Shift key, and press and hold Alt (or Option). Then with Alt (or Option) down, click around the area you want to select. After you incorporate the area shown in Figure 10-43 on the previous page, release Alt (or Option) to complete your selection.

Finally, press the D key to establish the default colors. And press the Backspace (or Delete) key to fill the selection with black. Press Ctrl+D (⌘-D) to deselect the image.

17. *Bring back some of the lost hairs.* Now it's time to bring back a few hairs that are going to help to really sell your mask and, by association, your final composition. You've done all you can with the dodge tool; better to reinstate the hairs with the history brush:

- Select the history brush from the toolbox, as in Figure 10-44. Or press the Y key.

- The blurry hairs contain a lot of noise. So let's bring them back with a noisy brush. Press the F5 key to bring up the **Brushes** palette. And turn on the **Noise** check box in the second section of the left-hand list. Then press F5 again to hide the palette.

- Press the 5 key to lower the **Opacity** value in the options bar to 50 percent. This allows you to paint in the hairs incrementally.

- The perfect brush size is 15 pixels with a Hardness of 0 percent. Assuming default settings, this means pressing the ⌷ key twice.

- You already set the source state for the history brush back in Step 13 (page 380), so you're ready to work. Paint along the hairs that you want to bring back to life. The yellow arrows in Figure 10-45 point to the six hairs that are most in need of your attention.

Figure 10-44.

Figure 10-45.

You may need to paint along some of the hairs more than once. And don't feel like you need to paint along an entire length of hair. Very short brushstrokes and even single clicks of the tool may do quite nicely.

18. *Change the order of the alpha channels.* To figure out what's what, we're going to need to jump back and forth between the RGB image, the color channels, and the Dodge and Burn alpha channel. The easiest way to do that is from the keyboard. Problem is, the Dodge and Burn channel is so far down the list, it doesn't get a shortcut. So move it up the list. In the Channels palette, drag the **Dodge and Burn** channel to the fifth position, between the Blue and Mixer channels. Photoshop now awards it a keyboard shortcut of Ctrl+6 (⌘-6 on the Mac).

19. *Examine the important details at the top of the image.* Zoom in on the top of the guy's hair. (A zoom ratio of 200 percent should work well.) Then press Ctrl+2 (⌘-2) to view the full-color image. Trace the top of the fellow's hairy head with your eyes and get a sense for how it slopes. I've gone ahead and traced a white line across that edge in Figure 10-46. Now press Ctrl+5 (⌘-5) to switch to the Blue channel. Here we see a fragile hair set against a dark gray background, also labeled in the figure. The hair doesn't show up at all in the Red and Green channels, but we've managed to capture it in our mask, so I reckon it's worth preserving.

20. *Mask the fragile hair.* Press Ctrl+6 (⌘-6) to return to the Dodge and Burn channel. Then restore the fragile hair as follows:

 • Press the M key to get the rectangular marquee tool.

 • Draw a marquee that more than encompasses the hair, starting at the very top of the image and ending at the point where the dark background gradually begins to brighten, like the one in Figure 10-47.

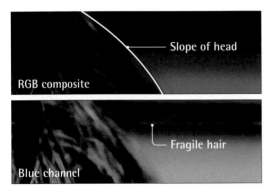

Figure 10-46.

Figure 10-47.

- Press the O key once or twice to select the dodge tool.

- Press the ⬚ key to increase the brush size to 20 pixels, and paint along the hair once to lighten it. You may be tempted to paint more than once, but don't. In this case, less is more.

- Press the O key again to switch to the burn tool.

- Set the brush size to about 40 pixels. And then paint around the hair while avoiding the hair itself. Naturally, you want to make that background black.

- Don't worry about painting into the slope of the large head of hair. We'll resolve that independently in a moment. I ended up with the result in Figure 10-48.

- Press Ctrl+D (⌘-D) to dismiss the selection.

Figure 10-48

21. *Burn away the false hair.* If you compare the mask to the full-color RGB image, you'll see that it contains a "false" hair, which I've circle in orange in Figure 10-48. (I says false in quotes because it's every bit as real as the hair we just saved and we did enhance it as recently as Step 17. But when push comes to shove, it's incomplete and trying to restore it doesn't justify the effort.) Assuming that the burn tool remains active, paint that hair and the area around it to black. Also paint between the looping hairs to enhance the contrast in those regions. The result appears in Figure 10-49.

22. *Establish a black background.* All right, gang. We've come to the end of the road. Simply put, we've run out of salvageable detail. Our only recourse is to paint in the slope of the head manually with the brush tool. But before we do, let's get rid of everything that's not part of the guy's hair with the rectangular marquee:

Figure 10-49.

- Press the M key to select the rectangular marquee tool.

- Drag and Shift-drag around everything that should be black to enclose it in a selection outline. Figure 10-50 shows my selection. Notice that I've gone too far into what I'm calling the slope of the head, and that's very much on purpose. This way, when it comes time to use the brush tool, we can just paint with white—no back-and-forth required. And needless to say, I'm taking care to avoid selecting any of the hairs.

- Press D to confirm the default colors. And then press the Backspace (or Delete) key to fill the selection with black.

Figure 10-50.

For the umpteenth time, press Ctrl+D (or ⌘-D) to jettison the selection outline.

23. *Paint in the missing details.* Now comes the moment of truth, the moment when we leave the warm embrace of the dodge and burn tools and go at the image unassisted with the brush tool. But as usual, I have a heretofore unpublished technique for you that I call *blind brushing*. Here's how it works:

 • Press the B key to select the brush tool.

 • Right-click (or Control-click) in the image window to bring up the pop-up palette. Then change the **Master Diameter** value to 40 pixels and the **Hardness** to 0 percent. Press Enter or Return to dismiss the palette.

 • In the options bar, set the **Mode** to **Normal** and raise the **Opacity** value to 100 percent.

 • Press the F5 key to bring up the **Brushes** palette. Once again turn on the **Noise** check box in the left-hand list, which will help us simulate the natural noise inherent in the mask.

 • Press the ⌐ (tilde) key to view the RGB image and the mask at the same time. Unfortunately, thanks to what seemed like a good idea at the time (Step 6, page 377), the mask is set to blue. Which means we have blue on blue, heartache on heartache. We'll address that in just a moment.

 • But first, go to the **Channels** palette and click the ☉ in front of the **Dodge and Burn** channel to turn it off. Now you have an unfettered view of the photo even though the alpha channel is still active. Wouldn't it be great if you could paint in the alpha channel without seeing it? That way, you could trace the edge exactly as you see it. But alas, Photoshop never lets you paint on a hidden layer or channel. Hence the cursor changes to a ⊘ when in the image window.

 • But where there's a will, there's a way. Double-click the **Dodge and Burn** channel to display the **Channel Options** dialog box. Click in the **Color** swatch, change the **H** value back to 0 degrees for red, and click **OK**. Back in the Channel Options dialog box, reduce the **Opacity** value to 0 percent. Click **OK** again.

 • Now click in front of the **Dodge and Burn** channel to re-awaken the ☉. Because you set the Opacity to 0, the mask is invisible. And yet, the brush cursor is now available, ready and waiting for you to paint.

- Press the X key to swap the foreground and background colors and make the foreground color white. Then carefully paint along the edge of the hair, starting in the middle of the loopy hair above the eye and continuing in an arc to the top of the image. I've illustrated the path of my drag in orange in Figure 10-51. The path of your drag will of course be invisible.

- Again press the ⌀ key to hide the RGB image and reveal the mask with the new white brushstroke. Now paint away all the gray areas inside the head. If necessary, you can also take this moment to smooth away any uneven transitions, so as to keep the contour of the hair nice and rounded, as in Figure 10-52.

To see how the mask compares to the image, double-click the **Dodge and Burn** channel in the Channels palette. Raise the **Opacity** value to 50 percent and click **OK**. Now press the ⌀ key to view the RGB image. As you can see in Figure 10-53, the mask now appears as a traditional rubylith overlay, which works beautifully for this image.

Figure 10-51.

Figure 10-52.

Figure 10-53.

24. ***Duplicate the alpha channel.*** In the interest of keeping each major step intact in case we ever need to come back, I'd like you to once again duplicate the mask in progress. Alt-drag (or Option-drag) the **Dodge and Burn** channel to the 🔲 icon at the bottom of the Channels palette. Enter the name "Final Mask" and press Enter or Return. Then drag the new **Final Mask** item up the list and drop it between Blue and Dodge and Burn to assign it the Ctrl+5 (⌘-5) keyboard shortcut.

25. ***Select the guy's face and fill it with white.*** With the hair and background refined to perfection, it's time to wipe out all the details inside the face with the help of a selection:

Figure 10-54.

- Press the W key to select the magic wand tool. Check that your settings from Step 16 remain in place: **Tolerance**, 0; **Anti-aliased**, off; and **Contiguous**, on. Then click inside a white portion of the hair and Shift-click in the shoulder to select the white pixels in the image.

- Press the L key to switch to the lasso tool. Press the Shift key and begin dragging around the top of the head to add the region inside the young man's face to the selection.

- With your mouse button down, release the Shift key, press and hold Alt (or Option), and then click to set points connected by straight lines.

- For the most part, the gray and black regions of the mask are separated by a wide canyon of white. The exception is the chin. Rather than trying to accurately select the chin, cheat inward as indicated by the circled area in Figure 10-54.

- When you've surrounded the area illustrated by the polygonal boundary in Figure 10-54, release the Alt (or Option) key to complete the selection outline.

- Press the D key to confirm that the foreground color is white. Then press Alt+Backspace (or Option-Delete) to fill the selection with white.

26. *Paint away the chin.* Just one more step stands between us and finishing this mask, and that's the twenty-something's chin:

- Press the B key to select the brush tool.

- Right-click (or Control-click) in the image window to bring up the pop-up palette. Change the **Master Diameter** value to 25 pixels and the **Hardness** to 50 percent.

- Press Ctrl+D (or ⌘-D) to deselect the image.

- Zoom in on the place where the head meets the shoulder and carefully paint away the black and gray pixels that should fall inside the chin.

That's it. Zoom out and admire your work. Pictured in all its glory in Figure 10-55, this is likely to be one of the most complicated, labor-intensive masks you will ever create. The good news is, having completed it, you'll be that much better prepared to take on masks such as this in the future.

27. *Save the image.* As in the previous exercise, this one ends with your original image fully intact and a few alpha channels richer. So press Ctrl+S (or ⌘-S) to update the *Superhero blue.tif* file (or whichever file you happen to be working on).

Multiply, Minimum, Blur, and Apply Image

In this final exercise, we'll test the quality of our mask by using it to composite the guy with the blue hair against a different background. Along the way, I'll show you how to create a controlled feather effect using a combination of the Minimum and Gaussian Blur filters. And we'll use the Apply Image command to blend layer masks.

1. *Open an image.* If you're still working in your modified *Superhero blue.tif* image, stick with it. Otherwise, you can open the file I created for you, *Our hero masked.tif*, found in the *Lesson 10* folder inside *Lesson Files-PsCM 1on1*.

2. *Combine image and mask.* In a moment, we'll composite this fellow against a new background. But first let's combine him with his mask for easy transport:

- Press F7 to bring up the **Layers** palette and double-click the **Background** layer. In the **New Layer** dialog box, type "Blue Haired Boy" and click **OK**.

Figure 10-55.

Figure 10-56.

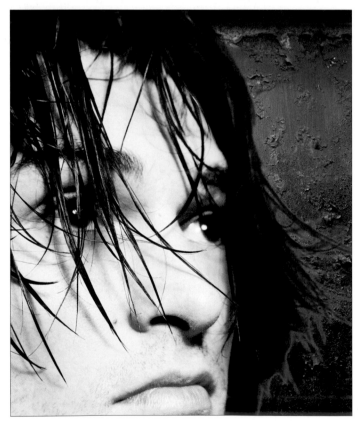

Figure 10-57.

- Switch to the **Channels** palette and Ctrl-click (⌘-click) the **Final Mask** channel to convert the mask to a selection outline. Alternatively, you can bypass the Channels palette and press the shortcut Ctrl+Alt+6 (⌘-Option-6).

- Return to the **Layers** palette and click the ▣ icon along the bottom of the palette to convert the selection outline to a layer mask for the Blue Haired Boy layer.

3. *Open a background image.* From the *Lesson 10* folder, open another image called *Painted metal.psd*. On display in Figure 10-56, this industrial background comes to us from Daniel Brunner, also of iStockphoto.

4. *Commute the kid into the rusty background.* By this point in time, we've seen more than a dozen ways to move a layer from one image into another. If you don't know how to do it without my help, I'm the worst teacher on the planet. So, please, don't disappoint me. On your own volition, duplicate the **Blue Haired Boy** layer into the *Painted metal.psd* image. And do it quickly. Step 5 isn't getting any younger.

5. *Align layer and background.* Back inside the *Painted metal.psd* composition, press the V key to switch to the move tool and drag the fellow so the top-left corner of his oversized head snaps into alignment with the top-left corner of the background, as in Figure 10-57.

6. *Resize the dude to fit his new home.* The guy's head is way too jumbo for its new surroundings. Here's the most straightforward way to size him to fit:

- Press Ctrl+T (or ⌘-T) to enter the free transform mode. You can likewise choose **Edit→ Free Transform** if you prefer.

- On the far left side of the options bar, click the top-left square in the reference point matrix—so it looks like ▦—to scale the layer with respect to its top-left corner.

- Click the ⚷ icon between the W and H values to lock down the proportions of the image. Then change the **W** value to 72, which changes both W and H in kind.

- Press Enter or Return twice to apply the transformation and shrink the guy to better fit his environment.

7. *Change the blend mode to Multiply.* Not surprisingly, the hair possesses a considerable amount of blue fringing. We'll remedy this problem by sandwiching a couple of layers set to different blend modes:

- Press Shift+Alt+M (or Shift-Option-M) to change the blend mode to **Multiply**, which burns the guy into the metal background.

- Press the 7 key to reduce the **Opacity** value to 70 percent. He appears to be tattooed onto the paint-flecked metal, as in Figure 10-58.

8. *Duplicate the layer.* As in the past when creating such blend mode sandwiches, we need to reinstate the normal version of the image. Press Ctrl+Alt+J (⌘-Option-J) to display the **New Layer** dialog box. Name the layer "Opaque," change the **Mode** setting to **Normal**, and increase the **Opacity** value to 100 percent. Then click **OK**. The effect of the previous layer is now blocked by this new one, but only temporarily.

9. *Choke the layer mask with Minimum.* We need to contract the mask for the newest layer to reveal the dark edges from the Blue Haired Boy layer below:

- Click the layer mask thumbnail for the **Opaque** layer or press Ctrl+⬡ (⌘-⬡) to make the layer mask active.

- Choose **Filter**→**Other**→**Minimum** to bring up the **Minimum** dialog box.

- Change the **Radius** value to 50 pixels, which expands the black area of the mask, thus choking the image as in Figure 10-59. Click the **OK** button to apply the change.

Figure 10-58.

Figure 10-59.

Figure 10-60.

Figure 10-61.

10. *Feather the layer mask with Gaussian Blur.* The Minimum filter returns shockingly blocky results, especially at high Radius values. To soften the mask, choose **Filter→Blur→Gaussian Blur**. Inside the **Gaussian Blur** dialog box, set the **Radius** value to 100 pixels—twice what we used in the Minimum dialog box—and click **OK**.

11. *Display the layer mask.* As witnessed in Figure 10-60, the Gaussian Blur filter is an equal-opportunity feathering filter, displacing the edges both inward and outward. To get a full sense of what I mean, Alt-click (or Option-click) the layer mask thumbnail for the **Opaque** layer to see the amorphous layer mask on its own. We need to constrain this blurry blob inside the original mask boundaries.

12. *Merge the two layer masks.* Here's how to make Apply Image do one of the things it does best, use one layer mask to rein in another:

 - Choose **Image→Apply Image** to bring up the **Apply Image** dialog box.

 - Leave the first **Source** option set to the active image, **Painted metal.psd**.

 - Choose **Blue Haired Boy** from the **Layer** pop-up menu.

 - Set the **Channel** option to **Layer Mask**.

 - And finally, change the **Blending** option to **Multiply**. As shown in Figure 10-61, Photoshop captures the active layer mask inside the confines of the mask assigned to the layer below.

 Click the **OK** button to apply your changes. Then press Ctrl+2 (⌘-2) to restore the full-color image. The fellow no longer casts a glow onto his background.

13. *Select the guy's face.* But while the hair looks good, the face does not. Get a load of the flecks of metal below the man-boy's lip. That's a function of the layer mask bleeding into his face. We need to eliminate that problem right now.

And here's how:

- In the **Layers** palette, Shift-click the layer mask thumbnail for the **Opaque** layer to turn it off and reveal the original RGB image.

- Choose our old chum, **Select→Color Range**, to bring up the **Color Range** dialog box.

- If you want to watch your mask develop (and I say you do), choose the **Grayscale** option from the **Selection Preview** pop-up menu.

- Click in the dude's face. Then Shift-click and Shift-drag elsewhere in the face, taking care to hit the highlights and avoid the shadow detail.

- Increase the **Fuzziness** value to 100 levels. Figure 10-62 shows the final Color Range selection. Don't worry that the selection extends outside the guy's face. We'll fix that in a moment.

- Click **OK** to generate the selection outline.

14. *Add the selection to the layer mask.* Here's how to use the Color Range selection to protect the opacity of the chin and face details and nothing more:

- In the **Layers** palette, press Ctrl+Shift+Alt (⌘-Shift-Option) and click the layer mask thumbnail for the Blue Haired Boy layer. This finds the intersection of selection and mask and clips away the portions of the outline that fall outside our superhero's hairdo.

- Click on the layer mask thumbnail for the **Opaque** layer to turn on the mask. Then click that same thumbnail to make it active.

- Press the D key to confirm the default colors. Then press Alt+Backspace (or Option-Delete) to fill the selected area with white.

Press Ctrl+D (⌘-D) to dispense with the selection. (You must deselect for the next step to work.) As you can see in Figure 10-63, the chin and other portions of the face become fully opaque.

Figure 10-62.

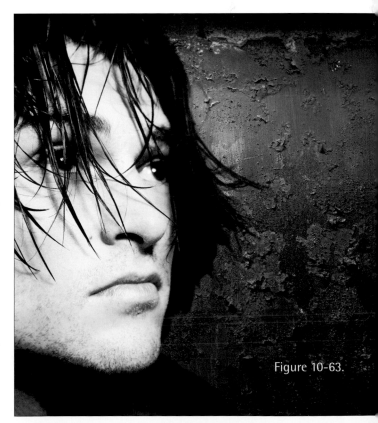

Figure 10-63.

15. *Finish off the composition.* The comp's in good shape. But I'd like it to look better. From here on out, everything we're about to do is an aesthetic decision:

- In the Layers palette, click the blank area to the left of **Smart Filters** below the **Metal** layer to wake up the 👁 and turn on the Gaussian Blur effect.

- Double-click the ⇄ icon to the right of the words **Gaussian Blur** to bring up the **Blending Options** dialog box.

- Set the **Mode** option to **Exclusion** and click **OK**.

- Now click the **Opaque** layer. Go to the **Adjustments** palette and Alt-click (or Option-click) the last icon in the second row, ⬤, to add a Channel Mixer layer. Name the layer "Rusty Hair" and click **OK**.

- In the first panel, set the **Red** value to 0 percent and the **Blue** value to 100 percent.

- Press Alt+4 (Option-4) to switch to the **Green** channel. Then change the **Red** value to 50, **Green** to 0, and **Blue** to 50.

- Press Alt+5 (Option-5) to move on to the **Blue** channel. Once again, change the values to **Red**: 50, **Green**: 0, and **Blue**: 50.

The final effect appears in Figure 10-64.

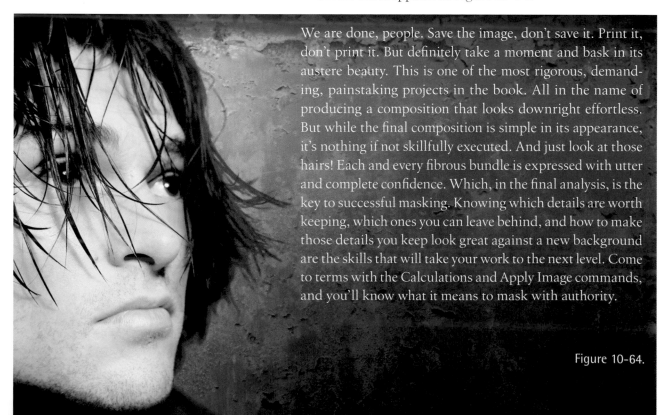

We are done, people. Save the image, don't save it. Print it, don't print it. But definitely take a moment and bask in its austere beauty. This is one of the most rigorous, demanding, painstaking projects in the book. All in the name of producing a composition that looks downright effortless. But while the final composition is simple in its appearance, it's nothing if not skillfully executed. And just look at those hairs! Each and every fibrous bundle is expressed with utter and complete confidence. Which, in the final analysis, is the key to successful masking. Knowing which details are worth keeping, which ones you can leave behind, and how to make those details you keep look great against a new background are the skills that will take your work to the next level. Come to terms with the Calculations and Apply Image commands, and you'll know what it means to mask with authority.

Figure 10-64.

WHAT DID YOU LEARN?

Match the key concept in the numbered list below with the letter
of the phrase that best describes it. Answers appear upside-down
at the bottom of the page.

Key Concepts

1. Calculations
2. Apply Image
3. Chops
4. Source 2
5. Add
6. Subtract
7. Offset
8. Scale
9. Symmetrical blend mode
10. Spline curve
11. Snapshot
12. Burn tool

Descriptions

A. Old-style, multistep channel mixing operations that passed into peaceful obsolescence with the advent of layers, to be replaced by the less catchy but infinitely more practical masking operations (or *mops*).

B. Available only in the Calculations and Apply Image dialog boxes, this blend mode yields the difference between two luminance levels.

C. This command merges the contents of two channels—according to a blend mode and an Opacity value—to form a new alpha channel.

D. A saved history state that remains available at the top of the History palette for as long as an image is open.

E. A calculation that produces the same effect when two layers or channels are reversed; examples include Add, Multiply, Screen, Hard Mix, and Difference.

F. The base channel at the bottom of a Calculations blend, as well as the one favored by many blend modes.

G. This option allows you to add or subtract luminance to the result of the Add or Subtract blend mode, which has the effect of increasing contrast and sharpening the edges of a mask.

H. Identical by default to Linear Dodge, this blend mode delivers the sum of two luminance levels.

I. This brush darkens areas of an image and is particularly useful for refining masks when the Range option is set to Shadows.

J. Slightly less useful than Calculations, this command merges the contents of a single channel or even the composite image into the active channel or image.

K. A line in which neighboring points network with each other to produce smooth transitions, employed by default in the Curves dialog box.

L. This option divides the result of the Add or Subtract blend mode by as much as 2 to rein in the luminance and produce softer transitions.

Answers

1C, 2J, 3A, 4F, 5H, 6B, 7G, 8L, 9E, 10K, 11D, 12I

THE PEN TOOL AND
PATHS PALETTE

I'VE SAID THAT masking is the art of using the image to select itself, and that's generally true. But this lesson is an exception. I'm going to show you how to use the pen tool to draw meticulous, painstaking outlines, one point and control handle at a time. The pen is unlike just about everything else in Photoshop in that it doesn't modify, or even acknowledge, pixels. Instead, it creates and edits vector outlines, just as in Adobe Illustrator. In fact, except for some tiny differences, Photoshop's pen and Illustrator's pen are one and the same.

So what good is the pen tool, and why are we discussing it in a channels and masks book? Because it enables you to trace outlines that no other function in Photoshop can see. You can draw organic paths that look super sharp, super smooth, and super precise, with every edge exactly where it should be. Then you can convert that path to a selection outline, complete with the best antialiasing in all of Photoshop, while leaving the path intact for further refinement.

Imagine trying to separate one of the tempting apples in Figure 11-1 from its nearly matching background using one of the traditional methods we've covered so far in this book. Your eye can pluck your desired apple without difficulty, but Photoshop can't—just look at those color channels! The pen tool lets your human eye and its minion, your hand, show Photoshop where the curves of the apple are and capture them precisely enough to honor the smooth skin of your subject.

I'll be honest: The pen is tough to master. It's a little tricky to control, there are no shortcuts, and you have to hand-position each and every anchor point and control handle. If you have experience with Illustrator's pen, you're in good shape. If you're a photographer who hates to draw, well, your learning curve will be steeper. But the results are well worth the effort.

RGB

Red channel

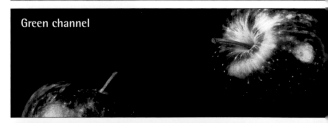
Green channel

Blue channel

Figure 11-1.

ABOUT THIS LESSON

Project Files

Before beginning the exercises, make sure you've copied the lesson files from the DVD, as directed in Step 3 on page xv of the Preface. This should result in a folder called *Lesson Files-PsCM 1on1* on your desktop. We'll be working with the files inside the *Lesson 11* subfolder.

This lesson examines the many ways you can apply transparency to text blocks, paths, and imported images inside Photoshop. Over the course of these exercises, you'll learn how to:

- Create corner points and free-form polygons, as well as edit paths with the arrow tool page 400

- Add and delete interior points and endpoints page 404

- Convert a path outline to either a selection outline or a mask page 408

- Work with control handles, smooth points, and cusp points page 411

- Combine path outlines to build vector masks and shape layers page 414

- Edit text outlines with the convert point tool page 422

Video Lesson 11: Drawing a Path, One Point at a Time

The pen is a singular tool inside Photoshop. Unlike just about everything we've seen so far, it doesn't detect, or "see," anything about an image. In fact, so far as the pen tool is concerned, the image doesn't exist. But no other tool is so flexible. You can draw sharp corners combined with fluid curves—you can draw *any* shape with the pen tool. But that's the rub: you have to draw. The pen tool disdains automation.

To see the pen in action, watch the eleventh video lesson. After opening the *PsCM Videos.html* file on the DVD, click **Lesson 11: Drawing a Path, One Point at a Time** under the **Calculations, Paths, and Arbitrary Maps** heading. Clocking in at 15 minutes and 27 seconds, here's what you don't want to miss:

Operation	Windows shortcut	Macintosh shortcut
Select the pen tool	P	P
Save a Work Path in the Paths palette	Double-click on it	Double-click on it
Delete a path in progress	Backspace twice	Delete twice
Draw a smooth point	Drag with pen tool	Drag with pen tool
Draw a cusp point	Alt-drag existing smooth point	Option-drag smooth point
Access the arrow tool on-the-fly	Ctrl	⌘

Vector-Based Shapes

When you use the pen tool to trace an image, you're leveraging the power of vectors inside Photoshop. A *vector* has no content of its own but rather is a mathematically defined outline, or *path*, and controls pixels but isn't controlled by them. When you draw a path—whether it be with the pen or another shape tool—you can manifest that vector outline as a shape layer or a path. You can likewise convert that path into a marching ants–style selection, thus allowing you to marry masking with the smooth, precise, infinitely scalable quality of a mathematically derived path.

Let's temporarily put aside the admittedly complicated pen tool, and get a sense of the difference between shape layers and paths using something more familiar. When you use the rectangle tool—not the marquee, the shape tool near the bottom of the toolbox—you have three options on the left side of the options bar. We're concerned with the first two.

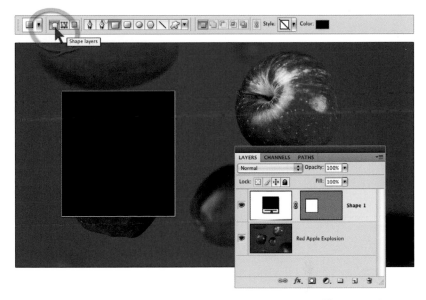

Figure 11-2.

- The ⬚ icon, circled in Figure 11-2, gives you a shape outline on an independent layer. When you draw the shape, you create a dynamic fill layer (filled here with black) with a vector mask designated by the shape. While this may be useful for some purposes, it's not particularly helpful for selecting because what you're trying to select is obscured by the fill color. We can't even see our apple underneath that black square.

- If you select the ⬚ icon, circled in Figure 11-3, you get the outline but no shape layer is created. Instead, this path outline lives in the Paths palette, where it functions independently of any pixels on any layer. The photograph is not obscured so it remains traceable. Because paths are editable, you can be extremely precise with the right drawing tool.

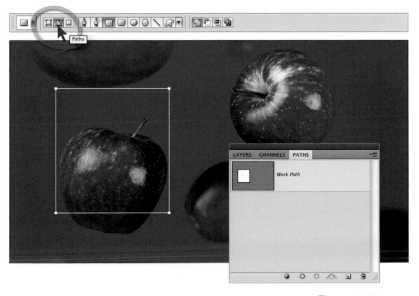

Figure 11-3.

Figure 11-4.

If you create a path by simply grabbing the pen tool and drawing with it, Photoshop creates a Work Path entry in the Paths palette for you, as shown in Figure 11-3. The name is italicized to indicate that the path is temporary. This means if you draw a new path, you will delete the old one. When you want to save a path, double-click its name in the Paths palette to open the Save Path dialog box, shown in **Figure 11-4**. Then give your path a name and click OK. The path is now protected from harm. Even better is to use the method I'll describe in the first exercise.

Drawing a Free-Form Polygon

In this lesson, we're going to work through a single project in which we leverage the selection power of the pen tool to mask away the earth-toned background from the profile of the woman in Figure 11-5. (Lesson 6 enthusiasts may recall this Aleksandra Alexis image, and that I promised to show you how I masked it so precisely.) In the process, we'll reveal a background of oncoming fish by iStockphoto photographer Tammy Peluso, shown in Figure 11-6. Since model and background share similar colors, the techniques you've learned so far in this book won't deliver good results. The pen tool, however, can produce dead-on accurate outlines, making it perfect for manually tracing the edges of her face and allowing us to remove her from the background while retaining the clean lines of her profile.

We'll start this exercise by creating the most basic of pen tool paths, the free-form polygon. In subsequent exercises, we'll continue building this project, using the more sophisticated features available with the pen tool to refine our selection, turn it into a vector mask, and even make adjustments to some text.

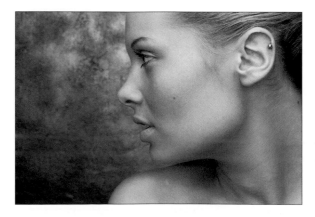

Figure 11-5.

Figure 11-6.

1. *Open the layered image with both photographs.* Let's start by opening *Photographs & paths.psd*, located in the *Lesson 11* folder inside *Lesson Files-PsCM 1on1*. I've set up some preliminary layers for you, including the two photographs central to creating our visual girl-meets-fish tale.

2. *Examine the Profile layer.* In the **Layers** palette, click next to the **Profile** layer where the 👁 normally appears to make it visible, and then click the layer itself to make it active, as in Figure 11-7. We want to get rid of the boring background of the Profile layer to expose the model to those menacing creatures in the Barracuda layer.

Figure 11-7.

3. *Create a new path in the Paths palette.* As I mentioned, once you start drawing a path, Photoshop automatically creates a temporary Work Path in the Paths palette that you can rename to make the path a permanent member of the image file. But there's a better way to work: First create a new entry in the Paths palette so that it can house your work as you create it.

 • Switch to the **Paths** palette, which lives with Layers and Channels by default. If you can't find it, choose **Window→Paths**. Figure 11-8 shows the Paths palette for our sample image; you can see I've already created some paths for you.

 • Alt-click (Option-click on the Mac) the ⬜ icon at the bottom of the palette to bring up the **New Path** dialog box. Name your path "Free-Form Polygon" and click **OK**. At this point, any path you draw will live in this new entry.

Figure 11-8.

4. **Set up the pen tool.** Get the pen tool by clicking the ◊ icon in the toolbox (as in Figure 11-9) or by pressing the P key. Then confirm the following settings in the options bar:

- Create a path by clicking the ⬚ in the first group of icons. This is wisely the default setting in Photoshop CS4.

- Turn on the **Auto Add/Delete** check box.

- Check that either ⬚ or ⬚ is active in the last icon group. The preferred settings appear in Figure 11-9 below.

Figure 11-9.

PEARL OF WISDOM

If you click and hold the pen tool, you'll see five options: the standard pen tool, something called the free-form pen tool, and a trio of tools for manipulating anchor points. At first blush, that second item, the free-form pen, seems infinitely easier to use than the standard pen tool. You just scribble a path. But the end result is roughly as useful as something drawn with the lasso; you sacrifice *all* control. With the exception of the magnetic pen tool variation, which I examine in Video Lesson 12, "Complex Foreground, Busy Background," the free-form pen is useless.

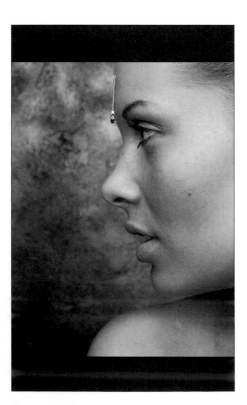

Figure 11-10.

5. **Place the first anchor point on her forehead.** The paths created by the pen tool are designated by points. Click with the pen tool on the edge of the model's forehead to create a square-shaped dot known as an *anchor point*.

6. **Make another point to draw a segment.** Click again a little farther down her forehead to make another anchor point, as in Figure 11-10. See how Photoshop draws a line, called a *segment*, to connect the two points. Technically, these are *corner points* because they define sharp intersections between straight segments.

7. **Continue creating corner points down her profile.** Place clicks every so often along the model's profile. It's very much like Alt-clicking (Option-clicking) with the standard lasso tool. Photoshop performs a basic connect-the-dots operation between your points.

8. *Continue the path into the pasteboard.* For the next steps, you'll need a generous amount of gray pasteboard visible around your image. One way to accomplish that is to zoom out, but then you can't see your image in sufficient detail to trace it. (I generally like to be zoomed in to 100 percent.) Better to work in a tabbed window, which if you loaded dekeKeys, you can get to by pressing Ctrl+Shift+A (⌘-Shift-A). Or press the F key to enter full-screen mode. Now you can scroll and expose the pasteboard as you like. When you get to the bottom of the model's shoulder, click in the pasteboard to extend the line, as in Figure 11-11.

9. *Close the path.* Set points way out there below and to the right of the canvas, above and to the right, and then above the model's forehead, as in Figure 11-12. Then come back into the image and hover over your first point. Your cursor sprouts a circle, as in ◊₀, just as you see in the figure. Click that point to create a closed shape. After you do, the anchor points go away, revealing a continuous free-form polygon.

10. *Save your work.* That's it for our first brief exercise. Press Ctrl+Shift+S (⌘-Shift-S) or choose **File→Save As**, name your file "My aqua project.psd," and click **OK**. You can use this file in the next exercise or work with the one I created for you.

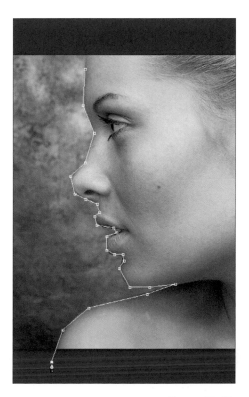

Figure 11-11.

Figure 11-12.

Adding and Deleting Anchor Points

We have a rough outline of the model's profile, but we've barely begun to scratch the surface of the pen tool's power. In this exercise, I'll show you how to move, add, and delete points to refine your thus far primitive path.

1. *Open an image with the path you want to refine.* For this exercise, you can either pick up where you left off with the file you created in the preceding exercise, or open a file I've created for you, *Free-form polygon.psd* in the *Lesson 11* folder. To see the path we're going to work on, click the **Free-Form Polygon** entry in the **Paths** palette. You'll see line segments but no anchor points, as in Figure 11-13.

Figure 11-13.

To display the points, you have to select the path. Located directly below the pen tool in the toolbox are two tools for selecting and editing paths. Photoshop calls these tools the selection tool and the direct selection tool. I find these names confusing because the tools have nothing to do with the pixel-selection tools discussed in Lesson 3, including the similarly named quick selection tool. So I call them by what they look like, the black arrow tool and the white arrow tool.

Why two arrow tools? Because they serve different purposes. The black arrow tool selects and moves entire paths at a time. The white arrow tool lets you select an element of a path, such as an anchor point, a segment, or a collection of points and segments.

2. *Select the path with the black arrow tool.* Select the ↖ icon in the toolbox or press the A key to get the black arrow tool. Then click the path outline and you'll see the anchor points. All points appear as solid squares to show that they're selected.

3. *Move an anchor point to adjust your path.* Switch to the white arrow tool by pressing the A key (or Shift+A if you skipped the Preface). Then do this:

 • Click anywhere off the path outline to deselect the path and all its points.

 • Click a segment in your path. When you do, you'll again be able to see the anchor points, but they are now open squares, indicating that they are not selected.

 • Select a point you'd like to move by clicking it with the white arrow, as in Figure 11-14. The point becomes solid, showing it's selected.

You can now drag the selected point to move it or use the arrow keys to nudge it a screen pixel in any direction. Move each of the points along the path as you'd like, refining the outline to more closely follow the model's profile.

4. *Delete the anchor points in the pasteboard.* Let's say we want the segments in the pasteboard to all be perpendicular—no special reason, just for the sake of doing it. You could try to drag the points into position, but short of setting up guidelines, there's no way to ensure that the segments would be exactly parallel to the canvas boundaries. Instead, it's easier to delete the segments and draw new ones.

Begin by selecting the top-right point with the white arrow key. Shift-click the top-left and bottom-right points as well, all circled and selected in Figure 11-15. Press Backspace (or Delete) to remove both the points and their neighboring segments.

Figure 11-14.

Figure 11-15.

Figure 11-16.

Figure 11-17.

5. **Redraw the pasteboard segments.** To redraw those segments, you need to reactivate the path. Start by selecting the pen tool. Note that if you move the cursor into the image window but away from the path outline, the cursor gets a little × next to it, like this: ✎ₓ. This means if you were to start clicking, you'd draw a new path and it would appear as a subpath in your Free-Form Polygon entry in the Paths palette. Don't do that. Instead:

- Move the cursor over the open anchor point, called an *endpoint*, below the shoulder of the model until you get the ✎ₒ cursor. (That tiny square with the two nodes is supposed to be a path going into and out of an anchor point.)

- Click on the endpoint to activate the path and make it ready to receive more points.

- Hold down the Shift key and click below and to the right of the image. With Shift still down, click above and right, then above the forehead. Finally, close your shape by clicking the anchor point on her forehead, just as you did back in Step 9 of the previous exercise. Figure 11-16 shows the result.

6. **Add a point to the path.** Reselect your path with the white arrow tool. But don't switch outright to the tool; when using the pen, you can get it on-the-fly by pressing the Ctrl (or ⌘) key. So Ctrl-click (or ⌘-click) anywhere on the path to select it. Then click and hold the pen tool in the toolbox and choose the add anchor point tool from the flyout menu. Let's add a point to smooth the line that goes over the woman's bottom lip. When you hover over the segment, your cursor changes to ✎₊ (as in Figure 11-17) to indicate that you'll be adding points. Add as many points as you like to further smooth the profile.

7. **Delete a point from the path.** Click and hold the pen tool in the toolbox and choose the delete anchor point tool from the flyout menu. Then hover over an anchor point you don't want. Your cursor changes to ♦, as in Figure 11-18. Click the point and watch it disappear.

Figure 11-18.

Note that the delete anchor point tool works differently than selecting a point and pressing the Backspace (or Delete) key. Rather than opening the path and leaving a hole, the tool adds a segment between the points in either direction and keeps the closed path closed.

8. **Add and delete points with the pen.** As nifty as the add and delete anchor point tools are, you don't need them. Press the P key to return to the pen tool. Then hover your cursor over any part of the path outline. Because you confirmed that the **Auto Add/Delete** check box was turned on in the options bar back in Step 4 of the previous exercise, the pen tool is poised to add and delete points as needed:

- When you hover over an existing anchor point, you get the ♦ cursor, which means you can click to delete that point.

- Hover over an existing line segment and you see the ♦ cursor, which invites you to click to create a new point.

When you add a point, Photoshop also adds a pair of control handles on either side of the point, which smooth your path by adding curvature to the neighboring segments. I'll show you how control handles work in a later exercise.

If you need to move an anchor point, remember that you can hold down the Ctrl (or ⌘) key to temporarily get the white arrow tool and drag the point to a new position. Or Ctrl-click (⌘-click) a point to select it and then nudge it by pressing the ↑, ↓, ←, or → key. Each press of an arrow key moves the selected point one screen pixel, so the tighter you're zoomed in, the more precision you get. Press Shift with an arrow key to move the point 10 image pixels, regardless of the zoom ratio.

9. **Continue to refine the line, and then save your work.** After you lay down as many points as you need to roughly trace the profile, save your work for the next exercise by choosing **File→Save** or by pressing Ctrl+S (⌘-S). In the next exercise, we'll convert this path to a selection and use it to mask out the background of our profile.

Converting a Path to a Selection or a Mask

In this exercise, I'll show you three ways to deploy your carefully created path outline, first as a standard selection, then as a layer mask, and finally as a vector mask. In doing so, we'll be able to let our heroine face her fishy foe head on.

1. *Open the file with the polygonal path.* If you're working along with me on the heels of the previous exercises, make sure your *My aqua project.psd* file is open and in front of you. If you're just jumping in, choose my predrawn path file called *Ready to mask.psd,* located in the *Lesson 11* folder of *Lesson Files-PsCM 1on1.* In this file, I followed my earlier suggestion and added some additional points to the original path to more closely follow the profile of the model.

2. *Select the polygon path.* Go to the **Paths** palette and click the **Free-Form Polygon** path to select it.

3. *Convert the path outline to a selection.* As with a layer or channel, you can convert a path to a selection outline to put the path in play. Choose from one of these methods:

 * Click the ▾≡ in the top-right corner of the Paths palette and choose Make Selection from the flyout menu. In the ensuing dialog box, you skip feathering, say yes to antialiasing, and click OK. Not my favorite method, but there it is.

 * The second option is to click the ◌ icon at the bottom of the Paths palette to load the path as a selection.

 * My preferred method is to press the Ctrl key (⌘ key) and click the **Free-Form Polygon** path entry in the Paths palette. This is the same way you've learned to load channel and layer mask selections throughout this book. Consistency is cool.

4. *Copy your selection to a layer.* Switch to the **Layers** palette and click the **Profile** layer to make sure it's active. And then:

 * Press Ctrl+Alt+J (⌘-Option-J) to display the **New Layer** dialog box, name the new layer "Face Only," and click **OK.** Because the face was selected, Photoshop jumps the face and only the face to a new layer.

 * To reveal the barracudas in the background, click the 👁 in front of the **Profile** layer to turn it off. Zoom in to check the edges. As you can see in Figure 11-19 on the facing page, my tracing is not half bad, but it's not great either.

Figure 11-19.

5. *Delete the new layer.* I know, we just got done creating the layer. But I want to show you a couple of better ways to work. So press the Backspace (or Delete) key to throw away the layer. Let's try something that will give us more flexibility.

6. *Recreate your selection outline.* Return to the **Paths** palette and Ctrl-click (⌘-click) the **Free-Form Polygon** path to convert it to a selection. Note that by using this shortcut, you don't need to first select the path entry. Another plus for my favorite method.

7. *Turn the selection into a layer mask.* Back in the **Layers** palette, click in front of the **Profile** layer to wake up its 👁. Then click the ▢ icon at the bottom of the palette to create a new layer mask based on your path outline. Alt-click (Option-click) the layer mask thumbnail to take a closer look. As Figure 11-20 shows, this is a pixel-based mask, nicely antialiased, which in some situations might be just what you want. But in our case, the edges are too geometrical. Obviously, we're going to need to put some more work into smoothing that path outline.

8. *Delete the layer mask.* We're not ready to give up our vectors by accepting this layer mask, so Alt-click (Option-click) the trash can icon to remove it from the layer.

Figure 11-20.

9. *Create a vector mask from the path.* Switch back to the **Paths** palette, and this time click the **Free-Form Polygon** path to make it active. Go back to the **Layers** palette and confirm that the **Profile** layer is active. Then choose **Layer→Vector Mask→Current Path** to turn the path into a vector mask.

Alternately, you can convert a path outline to a vector mask (or make a new vector mask) by Ctrl-clicking (⌘-clicking) the ☐ icon at the bottom of the Layers palette. Or, if a layer mask already exists, you can just click the ☐ icon.

The vector mask thumbnail appears beside the Profile layer in the Layers palette. Where the mask is white, the layer is opaque; where the mask is gray, the layer is transparent. A *vector mask* has two big advantages compared to the layer mask we deleted earlier. First, it maintains the editable path outline. If you click the path with the black arrow tool, you'll see that all the anchor points are still there, as in Figure 11-21. Second, you can scale this image and the edges of the mask will retain their sharpness regardless of the image's revised dimensions.

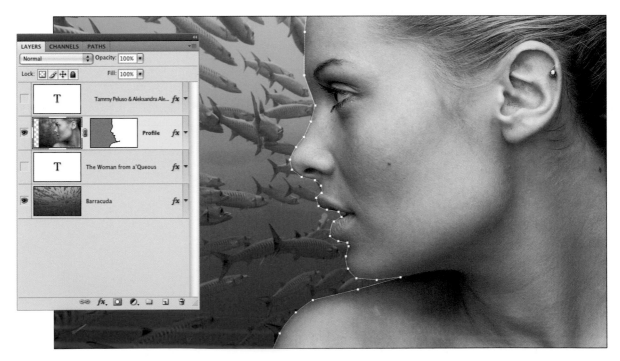

Figure 11-21.

You can hide the path outline by clicking the vector mask thumbnail in the Layers palette. Click again to bring it back. You can also toggle the outline on and off when the pen tool, either of the arrow tools, or one of the shape tools is active by simply pressing the Enter or Return key.

10. *View your vector mask in the Paths palette.* Switch to the **Paths** palette and notice that Photoshop has made an entry for your vector mask. The fact that it's italic, as in Figure 11-22, shows that it's temporary—not that it won't be saved with the file but that it's there only as long as the Profile layer is active, Meanwhile, your Free-Form Polygon path is still there as well. Any edits you make to one path are independent of the other.

11. *Save your file.* You've now successfully created an editable mask that exposes the profile to the oncoming barracudas. Save your work by choosing **File→Save As** and naming the file "Pretty good vector mask.psd." In the next exercise, I'll show you how to make your vector mask look even better.

Figure 11-22.

Control Handles, Smooth Points, and Cusps

Okay, admittedly, the path we created in the last exercise was a good practice run for using the pen tool, and we were able to see how to turn the path into a vector mask. But we have yet to tap into the real power of the pen tool. In this exercise, we'll use the pen tool's power features—control handles, smooth points, and cusps—to smooth out the Profile layer's vector mask so it accurately follows the organic curves our model's face.

1. *Open a file.* For this exercise, I want you to resume your project with the file you saved in the last exercise, *Pretty good vector mask.psd.* Or use the file I created for you called *Polygonal vector mask.psd,* in the *Lesson 11* folder of *Lesson Files-PsCM 1on1.* Both files include a handful of predefined paths that we'll be using in this exercise.

2. *Delete the vector mask in the Layers palette.* We ultimately want our vector mask to be based on a meticulously drawn path that we're about to create, so ditch the one from the previous exercise. Go to the **Layers** palette, click on the vector mask thumbnail for the **Profile** layer, and Alt-click (Option-click) the trash can icon at the bottom of the palette.

3. *Select the Face path.* Switch to the **Paths** palette and click the second path that I've created for you, **Face**. Select the black arrow tool from the toolbox (or press the A key a couple of times) and click the path outline in the image window to see its anchor points. Figure 11-23 shows just how smooth and accurate the profile outline can be when rendered with smooth points, cusps, and control handles.

Figure 11-23.

Click and hold here...

...and drag to here

Figure 11-24.

Figure 11-25.

4. *Create an entry for your shoulder path.* But enough looking at the Face path that I drew. The only way you're going to get a sense for how the pen tool works is to use it yourself. Your task is to trace the woman's shoulder, point by careful point. To prepare the soil, Alt-click (Option-click) the ⬓ icon in the Paths palette and name your new path "New Shoulder." (Because I already have a backup Shoulder path for you, just in case, at the top of the palette.) Click **OK**.

5. *Set the first smooth point in her neck.* Get the pen tool from the toolbox. Click and hold at the point in the woman's neck where you see my square anchor point in Figure 11-24 and then—in one motion— drag to the left. Photoshop creates a pair of round *control handles* that sit on a slightly inclined seesaw-style lever through the anchor point. These handles will attract and repel the segment in a magnet-like way as you adjust them, allowing you to manipulate the curvature of your path outline.

Before you release the mouse button, try twirling the control handles around. See how they move symmetrically about the point? This is a function of a *smooth point*, which guides the path outline through a continuous, even arc. Release the mouse button when your handles are in the positions shown in Figure 11-24.

6. *Create a second point on her shoulder and drag to the left.* Click and hold to make your next anchor point below the left end of the chin, roughly where I did in Figure 11-25. Again, drag to the left, releasing your mouse button when you reach the location of the pen tool cursor in the figure. Try to curve your segment slightly inside the edge between the woman's shoulder and her background.

Now that you have a complete line segment, you can begin to see how its curvature is affected by the handles. See how the segment begins and ends at an anchor point and bends toward each of the opposing control handles? The path has no choice but to pass through each and every anchor point—hence the word *anchor*. In contrast, the path approaches but never touches the control handles. The points demand, the handles attract.

You can adjust an anchor point or a control handle while drawing a path by pressing the Ctrl (or ⌘) key and dragging with the white arrow tool. You'll want to err on the side of keeping the path inside the edge of the model's shoulder. This will help to avoid fringing when we turn the path into a mask.

Figure 11-26.

7. *Click and drag to make the next two segments.* Now that you've established a counterclockwise direction to your path, keep it going. Click near the end of her shoulder, just before the bottom of the canvas, and drag down and to the left. Then click in the pasteboard and drag downward, as in Figure 11-26. If necessary, use the white arrow tool to reposition the control handles or anchor points to achieve an accurate, organic curve. (You can always check my Shoulder path in the Paths palette to compare your path against mine.)

8. *Lop off the last control handle.* There are no organic curves to trace in the pasteboard, so we might as well stop drawing curves for a moment and make our way over to the right side of the shoulder with a straight line. That means lopping off the last control handle so it doesn't pull at the segment.

Still armed with the pen, press the Alt (Option) key and hover your cursor over the last anchor point. Your pen cursor displays a tiny caret symbol, as in ♦ₐ, to show that it's poised to convert the point from a smooth point to a *cusp point*, which joins one or more curved segments at a corner. With Alt (or Option) down, click the point. The lower control handle disappears, as in Figure 11-27.

Figure 11-27.

9. *Draw a horizontal segment.* Staying inside the pasteboard, move your cursor directly to the right, to where the base of the neck would be if you could see it, and Shift-click. This should result in a horizontal segment, like the one in Figure 11-28.

10. *Add a control handle to the new corner point.* To add a control handle to the corner point, click it with the pen tool and drag away. In this case, drag up and slightly to the right to start building your final curve, as in Figure 11-28.

Figure 11-28.

Figure 11-29.

11. **Close the path by clicking the first point.** Now to join up with the first point and come full circle around the shoulder. The first point is a smooth point, so you might think you should drag on it, but that could mess up the curvature of the path. Much wiser to just click on that first point. Figure 11-29 shows me doing just that with my tell-tale ♉ cursor. Photoshop maintains the smooth point, keeps the angle of the control handles, and closes the path.

12. **Adjust the path and save your work.** If need be, use the white arrow tool to adjust anchor points and control handles to suit your taste. Then choose **File→Save As** and name your file "My very own shoulder.psd." In the next exercise, we'll combine this path with others to make a flawless vector mask.

Vector Masks, Shape Layers, and Layer Masks

In this exercise, we'll load those carefully constructed paths to create the final super smooth vector mask for our project. We'll also use paths to create a couple of shape layers, and combine a vector mask with a pixel-based layer mask on a single layer.

1. **Open an image.** You're welcome to either continue with the document that you saved in the previous exercise or open my *Two smooth paths.psd*, which is located in the *Lesson 11* folder of *Lesson Files-PsCM 1on1*. Either file you use will have several paths available to you in the Paths palette. Now that the paths are refined and ready to go, we're going to combine them into one glorious fish-defying vector mask.

2. **Turn the Shoulder path into a vector mask.** The Paths palette lets you select just one entry at a time. Because the paths tracing the shoulder and face are stored as independent entries, we'll need to assemble the pieces of our layer mask in steps.

 • Assuming that the **Paths** palette is front and center (or at least down and to the right), select the first path, **Shoulder**.

 • Go to the **Layers** palette and select the **Profile** layer.

 • Ctrl-click (⌘-click) the ◻ icon at the bottom of the palette to convert the path to a vector mask. The result? A headless shoulder and some well-fed brain-eating fish, as in Figure 11-30 atop the facing page. Let's fix that.

The profile layer includes a drop shadow that nicely suits the composition and appears in the figures. To turn it on, expand the **Profile** layer by clicking the ▼ arrow on the far right. And then click in front of the word **Effects** to wake up the ◉. Hey, the drop shadow is optional, but it looks great.

Figure 11-30.

3. *Add the Face path to the vector mask.* Here's how you combine the shoulder and face inside one vector mask, and automatically assign everything into place:

- Go back to the **Paths** palette and click the second path, **Face**, to display it in the image window.

- Select the black arrow tool from the toolbox (or press A one or more times) and click the barely visible path outline in the image window to select it. You have to click right on the outline to get it.

- Press Ctrl+C (⌘-C) to copy the path.

- Now return to the **Layers** palette, click the vector mask thumbnail for the **Profile** layer to make it active, and press Ctrl+V (⌘-V) to paste—in place, no less!

4. *Fix the gap by adding the paths.* By default, the two subpaths are set to merge by excluding any overlapping areas. As a result, a sliver of a gap exists between the bottom of the jaw and the top of the shoulder. You can change how the subpaths interact by selecting a different *compound shape mode* in the options bar, which includes the four buttons circled in Figure 11-31. The final icon, ▣ (or exclude), is selected. To marry face and shoulder, click the ▣ button to add the paths. The tiny gap fills with flesh.

Figure 11-31.

5. *Fill in the back of her head.* We're missing the back of the model's head, which you can fill in with the plain old rectangle tool. In the toolbox, click and hold the shape tool icon below the arrow tool and choose the rectangle tool from the flyout menu. With the vector mask still active, select the ⬜ icon in the options bar or just tap the ⊞ (plus) key to add to the mask. Then draw a rectangle around all the missing parts of our model, as shown in Figure 11-32.

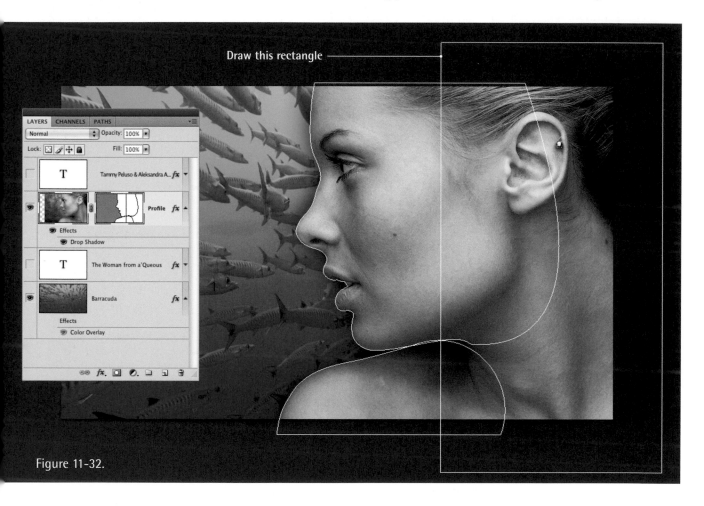

Draw this rectangle

Figure 11-32.

If you skipped the Preface, I need you to switch out a setting before performing Step 6: Click the ▾≡ in the top-right corner of the Layers palette to display the flyout menu, and choose **Panel Options**. At the bottom of the ensuing dialog box, turn off the **Use Default Masks on Fill Layers** check box and click **OK**. This prevents Photoshop from adding a mask to the dynamic fill layer, which messes up this project—and is a bad idea in general.

6. *Color the model with a dynamic fill layer.* We want our model to look like an underwater creature, so we'll add a layer of solid color to cool off her warm skin tones. Make sure the **Profile** layer is active. Press the Alt (or Option) key, click and hold the ⬤ icon at the bottom of the Layers palette, and choose **Solid Color** from the pop-up menu. Because you had Alt (or Option) down, you'll get the **New Layer** dialog box. Name your layer "Blue 1." Turn on the **Use Previous Layer to Create Clipping Mask** check box, and set the **Mode** to **Multiply**. Then click **OK** to display the **Pick a Solid Color** dialog box.

7. **Set the color to an underwater blue.** In the color picker, set the **H**, **S**, and **B** values to 215 degrees, 100 percent, and 50 percent, respectively, as in Figure 11-33. Click **OK** and our model turns a lovely deep blue.

8. **Ease up with luminance blending.** On second thought, that might be too much blue. Our intention is to give her an underwater cast, not make her a Smurf. We need to bring back some of the natural skin tones using luminance blending:

 - In the Layers palette, double-click an empty area to the right of the words **Blue 1** to bring up the **Layer Style** dialog box.

 - Go to the **Underlying Layer** slider bar at the bottom of the dialog box and drag the white triangle to the left until the value above it reads 210. Any pixel from the Profile layer with a luminance level of 210 or lighter shows through the blue.

 - To soften the transitions, Alt-drag (or Option-drag) the left half of the white triangle all the way to the left until the value says 0/210.

 Click **OK**. Her face exhibits an eerie underwater calm, as seen in Figure 11-34.

9. **Create a border for her costume.** By all rights, this woman should be wearing a super suit. We'll create one for her using two more layers of blue. Copy the Blue 1 layer to a new layer by pressing Ctrl+Alt+J (⌘-Option-J). Name the layer "Blue 3," because it's actually the border of the suit. Turn on the **Use Previous Layer to Create Clipping Mask** check box so that the border is constrained to her face and doesn't extend into the water. Then set the **Blend Mode** to **Hard Light** and click **OK**.

Figure 11-33.

Figure 11-34.

10. **Add a vector mask to cut out the border.** Return to the **Paths** palette and select the third path, **Costume Hem.** (It's a border, it's a hem—what do I know about undersea fish-woman apparel?) Now go back to the **Layers** palette and Ctrl-click (⌘-click) the ⬛ icon to create a vector mask that constrains the Blue 3 color to just the border. In Photoshop, a dynamic fill clipped by a vector mask is called a *shape layer.*

11. **Modify the luminance blending.** The border's colors look pretty awful. Why? Because our luminance blending settings from the Blue 1 layer are still at work. Double-click an empty area in the **Blue 3** layer to bring up the **Layer Style** dialog box. Go down to the **Underlying Layer** slider and drag the left half of the white triangle to 120. (You may have to move the black triangle out of the way first and then drag it back to 0.) Move the right half of the white triangle all the way right to 255. Click **OK.** The border now looks like the one in Figure 11-35.

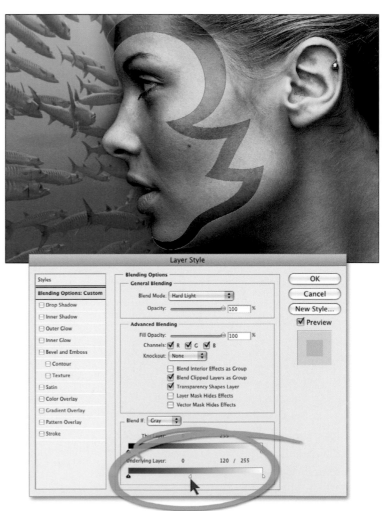

Figure 11-35.

12. *Add a fill layer for the super suit.* Now for the super suit, which requires another blue fill layer that covers our model from the border backward:

- Again select the **Blue 1** layer. Press Ctrl+Alt+J (⌘-Option-J) and name the layer "Blue 2."

- Turn on the **Use Previous Layer to Create Clipping Mask** check box and set the **Mode** to **Hue**.

- Click **OK** to see your new layer sandwiched between Blue 1 and Blue 3, thus revealing the genius behind my clever naming system.

- To enliven the color, double-click a blank area in the **Blue 2** layer, which brings up the **Layer Styles** dialog box. Go to the **Underlying Layer** slider and set the black triangle to 0 and both halves of the white triangle to 255. Click **OK** to achieve the effect pictured in Figure 11-36.

Figure 11-36.

13. *Mask the blue away from her face.* To cut the suit away from her face—it's hard enough to breathe underwater—we'll use the various paths at our disposal to craft a unique layer mask:

- In the Layers palette, Ctrl-click (or ⌘-click) the vector mask thumbnail for the **Profile** layer to convert it to a selection outline.

- Ctrl+Alt+click (⌘-Option-click) the vector mask thumbnail for the **Blue 3** layer to subtract the border from the selection.

Figure 11-37.

- With the **Blue 2** layer still active, click the ▣ icon at the bottom of the palette to change your selection to a layer mask. Alt-click (Option-click) the layer mask thumbnail to see it independently of the image, as in Figure 11-37.

- Press the L key or select the lasso tool from the toolbox. Draw a lasso around that nicely separated area of white that traces her face. Then press Backspace (or Delete) to fill the selection with black.

Press Ctrl+D (⌘-D) to abandon the selection and Ctrl+2 (⌘-2) to restore to the full-color image. The completed super suit appears in Figure 11-38.

Figure 11-38.

Thus far, you've seen how to use the pen tool to create masks that are smooth, scalable, and flexible. You've also learned how you can use those paths to create vector and layer masks alike. If you feel like you've spent enough time in the murky depths of vector-based masking, swim along to the next lesson, starting on page 422. But if you choose to stick around this underwater wonderland, I'll show you how to apply both a vector mask and pixel-based layer mask to a single layer, and why in the world you'd want to.

14. *Create a white layer to embellish her suit.* Confirm that the **Blue 2** layer is selected in the **Layers** palette. This identifies where the next layer should land. Then press the Alt (or Option) key and click and hold the ⊘ icon. Choose **Solid Color** from the top of the pop-up menu. In the **New Layer** dialog box, name the layer "Whiteness," again turn on the **Use Previous Layer to Create Clipping Mask** check box, and click **OK**. In the **Pick a Solid Color** dialog box, click white in the extreme top-left corner of the color field, or simply set the **R**, **G**, and **B** color values each to 255. Click **OK**.

15. *Mask the white layer with the Waves path.* Move over to the **Paths** palette and select the fourth entry, **Waves**, which I've drawn for you using one of the presets available to the custom shape tool, which we'll use in the next exercise. Return to the **Layers** palette, and click the ▢ icon at the bottom to add a blank layer mask, which we'll use in a moment. Then click the ▢ icon a second time, and Photoshop automatically gives you a vector mask as well. You can see the white waves in Figure 11-39.

Figure 11-39.

16. ***Cut off the vector mask at the border.*** Notice that the wavy lines spill over onto the deep blue costume border. To clip them to the border:

- Select the **Blue 3** layer and click its vector mask thumbnail to see the path outline in the image.

- Press the A key to get the black arrow. Then click on the path around the blue border in the image to select it. Press Ctrl+C (⌘-C) to copy the shape.

- Select the **Whiteness** layer and make its vector mask active. Then press Ctrl+V (⌘-V) to paste the hem subpath into the Whiteness vector mask.

- With the subpath still selected, click the 🗗 icon in the options bar or just tap the ⊟ (minus) key.

- Click the vector mask thumbnail for the **Whiteness** layer again to turn it off so you can see the full effect, shown in Figure 13-40.

Figure 11-40.

17. ***Apply a gradient mask.*** I want the wavy lines to fade to transparency as they undulate their way to the right side of the composition. Which is an effect we can achieve with a gradient mask. Click the empty thumbnail that represents the layer mask you added to the **Whiteness** layer in Step 15. Press the G key to select the gradient tool. To confirm that the tool is set for default behavior, right-click (Control-click) the gradient tool icon on the far left end of the options bar and choose **Reset Tool**. Then Shift-drag to draw a horizontal line, starting and ending at the points labeled in Figure 11-41.

18. ***Make the wave translucent.*** Press the M key to return to our base tool, the rectangular marquee tool. Then press the 7 key to reduce the **Opacity** value in the Layers palette to 70 percent. On the next page, Figure 11-42 shows how vector masks, layer masks, and various blending options work together to create the final costume.

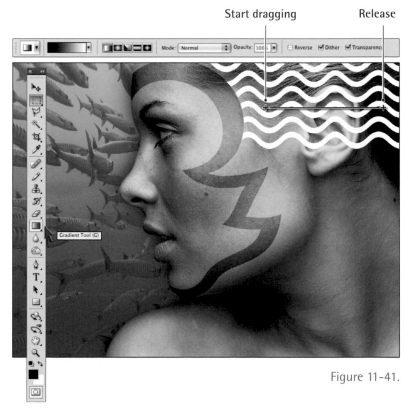

Figure 11-41.

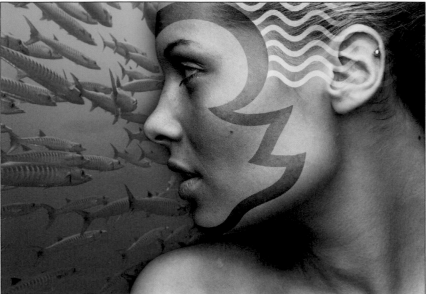

Figure 11-42.

19. *Save your file.* You've now turned this beautiful creature into a suitable match for those ferocious fish. Save your file by pressing Ctrl+Shift+S (⌘-Shift-S) and naming it "Super suit.psd." In the next exercise, we'll finish this project by using a few vector manipulations to put the final touches on some text layers.

Editing Character Outlines as Paths

One of Photoshop's lesser-known features is that it lets you convert characters of text to path outlines and then edit those characters with the pen and arrow tools. In this exercise, we'll do just that. Our job will be to turn this familiar composition into the cover for a coffee table book, complete with customized type treatments.

1. *Open a file.* The layers you'll need for this last exercise are in the file you saved in the last exercise. If that file is still open, great. If not, open my *All but the text.psd* found in the *Lesson 11* folder of *Lesson Files-PsCM 1on1*.

As mentioned at the outset of this lesson, these sample files use fonts that come with the complete Creative Suite 4 but may not ship with the standalone or educational versions of Photoshop CS4. If you get a font warning, click OK to open the image. Then look for the layers with yellow ⚠ icons in their big **T** thumbnails. Select these layers and switch them out for fonts on your system. The text will look different, but otherwise, the exercise will work the same.

2. ***Convert the letters to shapes.*** Our first task is to take the title of the book and convert it to a shape layer, including a dynamic fill and an editable vector mask. In the **Layers** palette, click in the 👁 column in front of the text layer **The Woman from a'Queous** to make it visible. Click on the layer to select it. Then do one of the following:

- Choose Layer→Type→Convert to Shape.

- The trickier but more convenient alternative is to right-click (or Control-click) anywhere on the layer *except* the thumbnail and choose Convert to Shape from the shortcut menu. (Right-clicking the thumbnail produces a list of different commands.)

This renders the characters of text into editable path outlines, as you can see in Figure 11-43.

After you convert your text to shapes, you can no longer edit it with the type tool. So if you encounter a typo, for example, you may be faced with the proposition of creating the type all over again. Which is why I usually go ahead and duplicate my text before I convert it. Then I click the 👁 icon to hide the original text and convert the duplicate. Or you can do what we'll be doing in this exercise—back up your original text by saving the converted shapes under a different filename.

Figure 11-43.

Figure 11-44.

Figure 11-45.

Figure 11-46.

3. **Delete the tail from the uppercase Q.** Zoom in on the area around the uppercase Q so that you have some room to alter the tail (the thorn jutting out of the O part). For aesthetic purposes, I'd like to get rid of that spike and replace it with something with a little more curvature. We'll start by deleting the existing tail:

- Press the A key a couple of times (or Shift+A if you skipped the Preface) to get the white arrow tool.

- Click somewhere on the Q path to make it active. Then draw a marquee around the two points on the very end of the Q's thorny tail, as shown in Figure 11-44.

- Press the Backspace (or Delete) key and off comes the very thing that makes a Q a Q.

4. **Redraw the tail with the pen tool.** Press the P key to switch to the pen tool. Draw the left side of the tail as follows:

- Click the lower of the two endpoints on the outer path of the Q and drag down and to the right as shown in the first example in Figure 11-45. This is a cusp point.

- Click to create an anchor point the same distance again down and to the right and drag at a slightly more shallow slope, as in the second example in the figure. The result is a slightly waving segment that defines the underside of the tail.

- To make the bottom point a cusp point, Alt-click (Option-click) on the anchor point you just drew.

5. **Draw the top side of the curly Q tail.** We're just one anchor point and two segments away from a new tail:

- Click slightly up and to the right to create a corner point joined to the previous cusp by a straight segment, as in the first example in Figure 11-46.

- Drag from that same point up and to the left to create a control handle roughly halfway up the new tail.

- Finally, position your pen cursor over the other endpoint, so you get the ♀₀ cursor. Then drag from that point up and to the left. End your drag in the lower-right center of the Q, with the control handle extending in the opposite direction, as in the second example in Figure 11-46.

The result is a new curly tail for the Q.

6. *Select the custom shape tool.* I want to create a new apostrophe that we'll extract from a predefined shape that ships with Photoshop. To get to it, select the custom shape tool, �, from the shape tool flyout menu in the toolbox. If you loaded dekeKeys, you can just press the U key.

7. *Select a campfire shape.* Go to the options bar and click the ▾ arrow to the right of **Shape** to bring up a palette of ornaments. Click the ⊙ in the top-right corner of the palette and choose **All** from the menu so that you can see every custom shape included with Photoshop, as in Figure 11-47. Select the campfire (🔥) shape near the bottom of the list, which I've circled in the figure.

8. *Set the shape tool to add to the vector mask.* Click the ⬚ icon in the options bar to add the campfire to the active vector mask. Or tap the ⚌ key.

9. *Delete the old apostrophe.* Press the Ctrl (or ⌘) key to temporarily get the black arrow tool and click on the path that represents the apostrophe between the *a* and the *Q*. Then release Ctrl (or ⌘) and press Backspace (or Delete) to delete it.

10. *Draw a new apostrophe with the campfire shape.* This isn't hard, but it is intricate, so let's break it into baby steps:

 • Draw with your custom shape so that the right flame of the campfire is positioned to become the new apostrophe, as I've highlighted in Figure 11-48.

 • As you draw, press and hold the Shift key to constrain the proportions of the campfire. You can also press the spacebar to move the shape on-the-fly. Release the spacebar when you get the shape properly positioned, as in the figure. But keep Shift down until after you release the mouse button.

 • Press the A key to select the white arrow tool.

Figure 11-47.

Figure 11-48.

If this underwater adventure with the pen has left you wanting to explore the depths of this fabulous tool, you may want to learn more about the program that started it all, Adobe Illustrator. My video series *Adobe Illustrator CS4 One-on-One*, available at lynda.com, will not only make you adept at using the pen but also show you features you never knew existed. For immediate access, go to *www.lynda.com/dekePS* and sign up for your 7-Day Free Trial Account. Then again, if books are your preferred means of deep-dive investigation, keep an eye out for *Adobe Illustrator CS4 One-on-One* (Deke Press/O'Reilly Media, 2009) on a retail bookshelf near you.

- Alt-click (or Option-click) and then Alt+Shift-click (Option-Shift-click) on each of the five subpaths in the campfire other than the right flame. Be careful not to select points on the outline of the lowercase *a* or the *Q*. Press Backspace (or Delete) to delete those non-apostrophe paths.

11. ***Deselect the vector mask and save your file.*** Click on any other layer in the Layers palette so you can accurately see your creation. Turn on the **Tammy Peluso & Alexandra Alexis** text layer to pay homage to our fabulous photographic contributors. Finally, press Ctrl+Shift+S (⌘-Shift+S), name the file "a'Queous composition.psd," and click the **Save** button.

Six mesmerizing exercises later, Figure 11-49 reveals our final nautical creation. The lesson file includes two bonus effects, including a drop shadow for the Profile layer (that I mentioned earlier) and a color overlay for the Barracuda that ironically makes the fish flesh-colored. Turn them on and off at your discretion. But here's something you can't turn off: your experience with using the pen tool to draw highly precise and supremely editable shapes, layer masks, and vector masks in Photoshop.

Figure 11-49.

The Woman from a'Queous

Tammy Peluso
& Aleksandra Alexis

WHAT DID YOU LEARN?

Match the key concept in the numbered list below with the letter
of the phrase that best describes it. Answers appear upside-down
at the bottom of the page.

Key Concepts

1. Vector
2. Path
3. Pen tool
4. Anchor point
5. Segment
6. Corner point
7. Path entry
8. Vector mask
9. Control handle
10. Smooth point
11. Cusp point
12. Shape layer

Descriptions

A. An outline created using a vector-based drawing tool that comprises a network of points connected by segments.

B. This hybrid anchor point joins one or more curved segments—or a curved segment and a straight one—to form a corner.

C. This pixel-independent occupant of the Layers palette lets you assign an editable path outline to a layer.

D. Created by clicking or dragging with the pen tool, this square-shaped dot in a path outline functions as a fixed point through which a path must move.

E. A mathematically defined outline that exists entirely independently of the pixels in an image or a layer, and yet can control them.

F. This infinitely scalable and adjustable layer is ultimately the combination of a dynamic fill clipped by a vector mask.

G. This round path element attracts and repels a segment like a magnetic force, allowing you to manipulate the curvature of your path outline.

H. An anchor point that lacks control handles, and therefore results in straight segments and free-form polygons.

I. An anchor point that includes two symmetrical control handles and guides the path outline through a continuous, even arc.

J. Although difficult to learn and demanding to use, this feature enables you to trace outlines that no other function in Photoshop can see.

K. An item in the Paths palette that may contain a single path, multiple subpaths, or no path at all.

L. In the grand dot-to-dot puzzle that is a vector-based path outline, these are the lines that Photoshop automatically draws to connect the dots.

Answers

1E, 2A, 3J, 4D, 5L, 6H, 7K, 8C, 9G, 10I, 11B, 12F

MASKING THE TOUGH STUFF

Throughout this book, we've spent a significant amount of our time extracting intricate foregrounds from reasonably homogeneous backgrounds. And frankly, that's the most sensible, no-tears way to work. Whenever you're in control of the photography process, and you intend to composite a model or other subject against a different background, you should do your best to include a plain screen, wall, or sky in your shot. But you're not always in control, and even when you are, your best laid plans may go differently than you expected.

Take Figure 12-1. It starts off with an opaque foreground set against a plain background. Even so, the mask entailed a fair amount of work. I had to select the hand and pen in separate passes. Then there were the matters of accounting for variations in focus, refining the edges, and reintroducing the natural cast shadow. And if that's difficult, what are we to do if the subject contains the same colors as the background? What if the subject is translucent, as in the case of, say, a flame? What if the subject is wildly colorful, with elaborate ruffles or fringes, and set against a busy multicolored background?

In this lesson, those what ifs are going to give you what for. Fortunately, I'll show you a few techniques that will make your job easier. And while I can't show you each and every masking curveball that might get thrown your way, I will cover blonde hair, flames, feathers, and weird bushy puffballs. The techniques in this final lesson, combined with everything you've diligently mastered so far, will enable you to face those less-than-desirable to downright scary masking situations armed to the teeth and calling the shots.

Figure 12-1.

ABOUT THIS LESSON

In this lesson, we'll use the Calculations, High Pass, and Curves commands—along with a host of functions from previous lessons—to separate a couple of complex images from similarly colored or cluttered backgrounds. You'll learn how to:

- Combine alpha channels with Calculations and bring in a new background with Apply Image page 432

- Mask and enhance a bright, translucent object . . . page 442

- Separate an image from an intricate background using a sequence of advanced calculations page 445

- Turn an image into a meticulously detailed coloring book using the High Pass filter page 449

- Build a complete mask from a series of arbitrary maps drawn with the Curves command page 452

Project Files

Before beginning the exercises, make sure you've copied the lesson files from the DVD, as directed in Step 3 on page xv of the Preface. This should result in a folder called *Lesson Files-PsCM 1on1* on your desktop. We'll be working with the files inside the *Lesson 12* subfolder.

Video Lesson 12: Complex Foreground, Busy Background

Now that you understand everything from the fundamental concepts of masking to the advanced principles of channel blending, it's time to get out the big guns and take on those jobs that seem nigh on impossible. And by big guns, I mean such recondite but powerful features as the magnetic pen variation, arbitrary maps, and the High Pass filter.

To see all three of these functions applied to one of the images we'll be using in this lesson, insert the DVD, double-click the file *PsCM Videos.htm*, and click **Lesson 12: Complex Foreground, Busy Background** under the **Calculations, Paths, and Arbitrary Maps** heading. Lasting a full 19 minutes and 25 seconds, this movie mentions these essential shortcuts:

Operation	Windows shortcut	Macintosh shortcut
Delete anchor point when pen is active	Ctrl-click on point, Backspace	⌘-click on point, Delete
Curves	Ctrl+M	⌘-M
Reset the curve to a diagonal line	Alt-click Reset button	Option-click Reset button
High Pass	Shift+F10*	Shift-F10*
Levels	Ctrl+L	⌘-L

* Works only if you loaded the dekeKeys keyboard shortcuts (as directed on page xvi of the Preface).

Calculations, High Pass, and Arb Maps

When it comes to the tough stuff, there is no single solution. As you work your way through the exercises in this lesson, you'll find that you often need to use a lineup of tools against a host of particularly challenging masking scenarios. We'll consider three main approaches in this lesson:

- The first is to apply multiple passes of the Calculations command, which provide you with precise distinctions between channels that you can mix and match as you see fit. I'll be showing you a few ways to employ calculations, including a couple of techniques that combine two calculations to produce a third.

- The second approach uses a filter called High Pass to create an intricate series of black-and-white outlines that you can then manually—not to mention tediously—fill in like a coloring book.

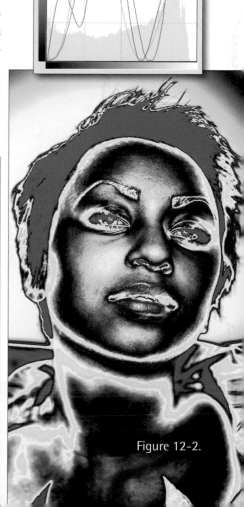

- The final approach employs *arbitrary maps*, which allow you to reassign luminance levels on a level-by-level basis. Figure 12-2 shows a creative use of arbitrary maps. Starting with the untreated photograph on the left, I applied a Gradient Map adjustment to replace the luminance levels, from black to white, with the colors in a gradient. The result is the center image, with gradient on the top. The other arb map function is Curves, which lets you assign unique free-form curves to each channel, as illustrated in the third example. We'll be focusing on Curves because it's the more useful of the two for masking. To see how this three-layer file was put together, go to the *Lesson 12* folder inside *Lesson Files-PsCM 1on1* and open *David Politi.psd*, named for the photographer.

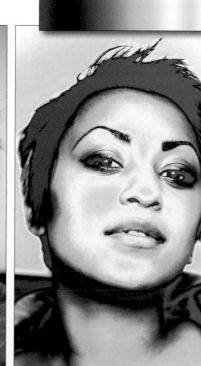

Figure 12-2.

Each of these methods has advantages and disadvantages, as you'll discover over the course of this lesson. And each delivers results that need to be further refined using old favorites, such as Levels, dodging and burning, plain old lassoing and filling in, and even painting with the brush tool.

In the second half of this lesson, we'll employ each of the three approaches on the same cluttered image, and you can decide for yourself which ones are and aren't for you. Out in the Wild West of masking, each job you encounter will require you to make decisions about what combination of techniques to use, based on your time, patience, and the needs of the particular image.

Masking and Compositing Light Hair

We haven't had any shortage of hair to mask in this book. But it's all been dark. Masking a model with light hair—whether blonde, sandy, white, or gray—presents new and difficult challenges. You can't simply switch your strategy from using the Multiply blend mode (which works so well for dark hair) to Screen and expect it to work in the same way. After all, light hair does not cast a glow onto its background. But with the assistance of a few powerful masking tools, we'll be able to remove the blonde model in Figure 12-3 from her red background and place her in a whole new world.

This image will be familiar to readers of my general Photoshop book, *Adobe Photoshop CS4 One-on-One*. But thanks to the extended knowledge of masking you've acquired in this book, our approach in this exercise will be more sophisticated and deliver better results.

Figure 12-3.

1. *Open an image with a light-haired model.* Start by going to *Lesson 12* in the *Lesson Files-PsCM 1on1* folder and opening *Woman with flame.jpg*. This image from photographer Andrzej Burak of iStockphoto poses three masking challenges: the warm skin tones of the subject set against the deep red background, the platinum blonde hair, and the translucent flame (the last of which we'll deal with in the next exercise).

2. *Compare the channels.* Go to the **Channels** palette and cycle through the color channels either by clicking them or pressing Ctrl+3, Ctrl+4, and Ctrl+5 (⌘-3, ⌘-4, and ⌘-5 on the Mac). The Blue channel is pretty to look at, but it's dark, low on contrast, and the flame is all but absent. Meanwhile, the Red and Green channels are quite promising in their own unique ways. As evidenced in Figure 12-4, the Red channel displays a strong flame, good contrast along the right side the face (her left), and nice shoulder detail—albeit with a bright, banded background. The Green channel is the Blue channel brightened up a few notches, with good contrast between hair and background all around. The flame is weak and the shoulders are dim, but hey, that's why we have the Red channel.

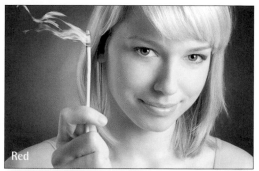

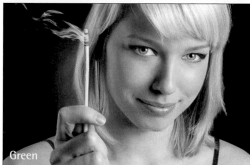

3. *Establish a base mask by adding Green and Red.* Press Ctrl+2 (or ⌘-2) to reinstate the full-color image. Then choose **Image→ Calculations** to blend the channels like so:

 • Green is our best channel. So set the **Channel** option for **Source 2** to **Green** and the one for **Source 1** to **Red**.

 • In both channels, the woman is brighter than her background, so turn the **Invert** check boxes off.

 • Set **Blending** to **Add** to add the luminance levels.

 • Darken the background with an **Offset** value of –70. Keep the transitions sharp with a **Scale** value of 1.0. Otherwise, leave everything as you see in Figure 12-5.

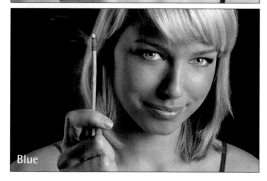

Click **OK** to create the new alpha channel. In the **Channels** palette, double-click **Alpha 1** and rename it something descriptive, such as "G+R, Add, –70."

Figure 12-4.

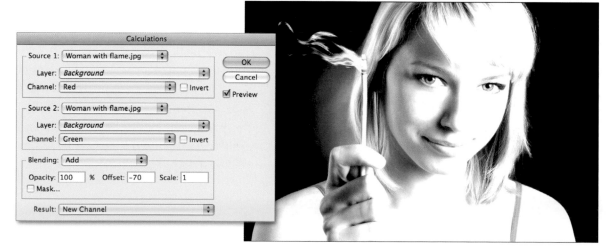

Figure 12-5.

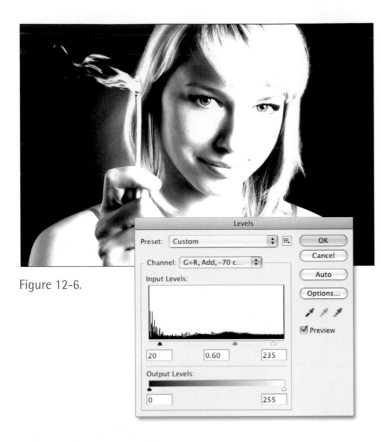

Figure 12-6.

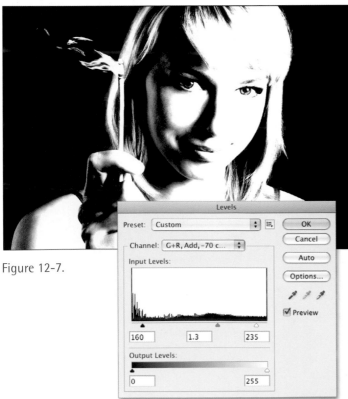

Figure 12-7.

4. *Copy the alpha channel.* Let's consider this a significant stage in the development of our mask and keep it safe from future edits. That is to say, drag the **G+R, Add, −70** channel to the ⊡ icon at the bottom of the Channels palette to duplicate it.

5. *Increase the contrast with Levels.* Press Ctrl+L (⌘-L) to bring up the **Levels** dialog box. Then do the following:

 • Increase the first value under the histogram to 20 to sink a handful of the darkest luminance levels into blackness.

 • Reduce the third value by 20, to 235, to clip 20 levels to white.

 • That area of gray behind the woman's head needs to be darker. Select the central (gamma) value and press Shift+↓ a few times to reduce it. As shown in Figure 12-6, 0.60 is about as low as we can go without harming the fine hairs.

 • Click **OK** to accept your edits. Now that we know what values we used, double-click the name of the duplicate channel and rename it "20/0.60/235."

6. *Copy the channel again and try a different adjustment.* The only way to blacken the background is to harm the hairs, which means we need an alternate channel. Once again, grab the **G+R, Add, −70** channel and drag it to the ⊡ icon. Press Ctrl+L (⌘-L) to bring up the **Levels** dialog box. This time, I want you to set the three values under the histogram to 160, 1.3, and 235. As shown in Figure 12-7, the background drops to black, but so do the shoulder, hand, and finger; and the hair becomes fragile and crunchy. Not a problem, we have a backup, so click **OK**. Double-click the channel name and rename it "160/1.3/235." Now we have two variations on the image that we can merge together to create a perfect base mask.

7. *Select the area where the channels will merge.* Before we can merge the two results of the Levels command, we need to identify the area that works better for one channel than the other. Click the lighter of the two channels, **20/0.60/235**, to make it active. Press L to get the lasso tool and draw a general boundary around the problem area of the background, as in Figure 12-8.

Now click the **160/1.3/235** channel and locate any areas that you want to exclude from your selection because they looked better in the previous channel. Alt-drag (Option-drag) with the lasso tool around any of these areas to establish the best boundary between the two channels. As you can see in Figure 12-9, I subtracted the area around the side of the knuckle, which enjoys better contrast and detail in the 20/0.60/235 channel.

To finish the selection, choose **Select→Modify→Feather**. In the **Feather** dialog box, set the **Radius** to 6 pixels and click **OK**.

8. *Save the selection as an alpha channel.* Alt-click (or Option-click) the 🔲 icon at the bottom of the **Channels** palette, name the new channel "Iteration Boundary," and click **OK**.

9. *Merge the two Levels variations together.* Now to perform the merge. Click the **20/0.60/235** channel so it's active, and choose **Image→Calculations**. In the **Calculations** dialog box, leave the **Channel** option for **Source 1** set to **20/0.60/235**. Set the **Channel** for **Source 2** to the **160/1.3/235** channel and then change the **Blending** option to **Normal**.

The key to making this calculation work is to turn on the **Mask** check box under the Opacity value. The dialog box will expand to request information for a third **Channel** option, which you should set to **Iteration Boundary**. (If your selection is still active, you can choose **Selection** as well; same diff.) Photoshop places the Source 1 channel inside the mask, which is just the opposite of what we want. No problem: Just turn on the **Invert** check box at the bottom of the dialog box. The all-important options appear circled in Figure 12-10.

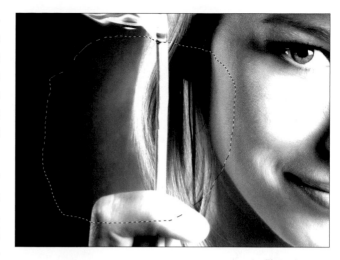

Figure 12-8.

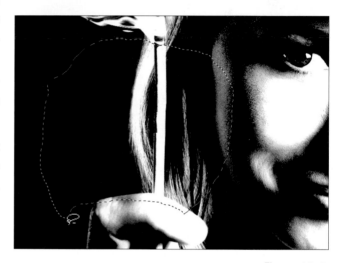

Figure 12-9.

Figure 12-10.

10. *Name and move the new channel.* Click **OK** to create yet another alpha channel. Double-click the channel name and rename it "Iteration Merge." This channel will serve as the basis for our final mask, so you might as well move it to a position of authority. Drag the **Iteration Merge** channel to just below the Blue channel. Photoshop automatically assigns the channel a keystroke of Ctrl+6 (⌘-6). Press Ctrl+D (⌘-D) to turn off your selection.

Figure 12-11.

11. *Refine the mask with the dodge and burn tools.* Now that we've done what we can with Levels and Calculations, it's time to address the undesirable gray areas on a selective basis. The background is mostly black, so we'll start by painting away the larger problem, the highlights:

• Press the O key to select the dodge tool. Make sure that the **Range** and **Exposure** options are set to **Highlights** and 50 percent, respectively. Also turn on the airbrush tool in the options bar. A brush size of about 200 pixels works well. Paint over her hair, the edges of her knuckle, and along her shoulder on the left side of the image. Paint away the strap on the right shoulder (her left) as well.

• Press O or Shift+O to switch to the burn tool. Set the **Range** to **Shadow** and the **Exposure** to 50 percent. Paint away the light flare above the knuckle as well as any light spillover you may have caused with the dodge tool.

12. ***Clean up the interior of the woman with the lasso.*** Once you've finished dodging and burning the edges—don't overdo it—press the L key to switch the lasso tool. And then press the Alt (or Option) key and click around the inner border of the white area to select the interior, as in Figure 12-12. Don't worry about the flame for the time being.

Figure 12-12.

Press the D key to confirm the default colors and Alt+Backspace (or Option-Delete) to fill the selection with white. Then press the usual Ctrl+D (⌘-D) to bid the selection adieu.

13. ***Select the problem area with the pen tool.*** After the intense dodging required to lighten the finger and knuckle, we're left with a problem area at the point where the knuckle meets the hair. As circled in Figure 12-13, the hair doesn't make sense, appearing to grow both downward and upward. The best solution? Enclose the area with a smooth outline care of the pen tool:

- Press Ctrl+2 (⌘-2) to return to the full-color image so you can see what you're tracing.

- Press the P key to select the pen tool. Make sure the 🖋 icon is active in the options bar and switch to the **Paths** palette.

Figure 12-13.

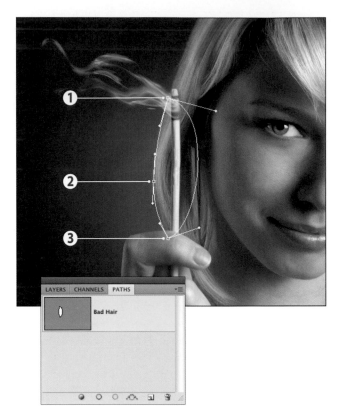

Figure 12-14.

Figure 12-15.

- Click at the spot labeled ❶ in Figure 12-14 to place the first anchor point and then drag downward to draw out a control handle.

- Click at the spot labeled ❷ in the figure and drag down to draw a smooth curve along the left side of her hair. Note that you're not trying to outline individual hairs; that would I think reasonably drive you insane. Rather, you're trying to draw a line that mimics the way hair naturally falls. If you're worried that you'll make the hair look artificial or stiff with hair spray, don't. It'll look great.

- Next, click and drag down and to the right from the point marked ❸ in the figure. When you get the opposite handle positioned as shown in Figure 12-14, press and hold the Alt (or Option) key and drag the now-severed handle to the right.

- With the Alt (or Option) key still down, click and drag from the first point, ❶, to close the path.

- When the path is complete, double-click the **Work Path** entry in the Paths palette; rename it "Bad Hair."

- Finally, Ctrl-click (⌘-click) the **Bad Hair** thumbnail in the Paths palette to convert the path to a selection.

14. *Fill in the hair.* Go back to the **Channels** palette and make sure the **Iteration Merged** channel remains selected. Then do the following:

 - The hair has a little bit of softness associated with it. So choose **Select→Modify→Feather**, enter a value of 1.2 pixels, and click **OK**.

 - Assuming the default colors, press Alt+Backspace (or Option-Delete) to fill the selection with white.

15. *Clean up the excess hairs.* Look closely at the black background behind the knuckle and the hair, and you'll see that we still have a few white hair remnants. The best way to clean them up is to select that part of the background and paint inside it:

 - Press Ctrl+Shift+I (⌘-Shift-I) to reverse the selection.

 - Press the L key to switch to the lasso tool. Then press Shift+Alt (Shift-Option) and drag carefully around the rough area above the knuckle, as in Figure 12-15, to select the intersection of these two outlines.

- It's tempting to fill the selection with black. But if you do, you'll introduce divots at the points where the lasso and pen outlines intersected. It's an abstruse by-product of working with a blurry selection, but the solution is easy: Press the B key to select the brush tool. Press D and then X to make the foreground color black. Click with a big, soft brush in the bottom-right corner of the selection.

The bad hairs put to rest, our mask is complete. To celebrate, double-click **Iteration Merge** in the Channels palette and rename the channel "Final Mask."

16. *Convert the alpha channel to a layer mask.* Now to composite the woman against a new background in yet another new and different way. Press Ctrl+2 (or ⌘-2) to return to the full-color image. Switch to the **Layers** palette and do the following:

 - Double-click the **Background** layer to display the **New Layer** dialog box. Name the layer "WWF" (the universal acronym for Woman with Flame) and click **OK**.

 - Press Ctrl+Alt+6 (⌘-Option-6) to load the Final Mask channel as a selection. Then click the ▣ icon at the bottom of the **Layers** palette to convert the selection to a layer mask.

17. *Open a background image.* Open the file called *Valley of Fire.jpg*, also located in the *Lesson 12* folder. Captured in Nevada's sublimely picturesque Valley of Fire, this photo comes to us from . . . me.

18. *Apply the background to the composition.* Return to the *Woman with Flame.jpg* image and proceed like so:

 - Ctrl+Alt-click (⌘-Option-click) the ▣ icon to create a new layer *below* the active layer. (These tricks are unending!) Name the new layer "VOF" and click **OK**.

 - Choose **Image→Apply Image**. In the **Apply Image** dialog box, set the **Source** to **Valley of Fire.jpg**. The sky and rocks magically drop into the background, as in Figure 12-16.

 - Set **Blending** to **Normal**. The other settings can be left at their defaults. And then click the **OK** button to deliver the Valley of Fire to the flame.

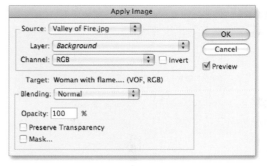

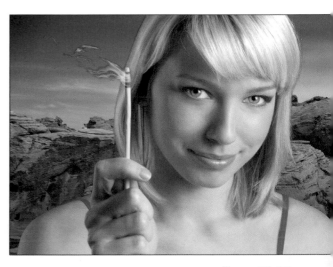

Figure 12-16.

Figure 12-17.

19. ***Tweak the hair to remove the dark edge.*** On the whole, the composition looks pretty darn good, except for the subtle line of darkness that surrounds the hairs and shoulders, most evident in the circled region in Figure 12-17. As I mentioned, we can't apply the Screen mode in any of the ways we used Multiply in previous lessons because light hair doesn't magically cause things behind it to become lighter. However, some lightening is clearly in order. The trick is to use Screen in a very controlled way, as I'm about to explain:

- Click the **WWF** layer to make it active. Then set the blend mode in the top-left corner of the **Layers** palette to **Screen**. The result is a ghostly effect that will provide us the foundation we need to create a seamless composition.

- Jump the WWF layer to a new layer by pressing Ctrl+Alt+J (⌘-Option-J). In the **New Layer** dialog box, name the layer "Normal," turn on the **Use Previous Layer to Create Clipping Mask** check box, set the **Mode** option to **Normal**, and click **OK**.

- Pictured in Figure 12-18, the result doesn't look any different than it did a moment ago. The problem is that the blend mode of the clipped layer is subordinate to the base layer. To correct this, double-click the thumbnail for the **WWF** layer to display the **Layer Style** dialog box. Then turn off the check box, circled in Figure 12-19 on the facing page. This tells Photoshop to calculate the blend mode for each layer separately. Click the **OK** button to restore the opaque version of the woman and her flame.

Figure 12-18.

- To lighten the edges slightly more, click the layer mask thumbnail for the **Normal** layer. Go to the new **Masks** palette, which you can get by choosing **Window→Masks**. And raise the **Feather** value to 3 pixels. Photoshop applies a live blur effect to the mask, revealing a bit more of the underlying WWF layer. And because the Normal layer is clipped inside WWF, the blur does not even remotely exceed the boundaries of our foreground subject.

Figure 12-19.

Pictured in Figure 12-20, the composition now more closely resembles the effect that blonde hair would actually produce when set against a richly colored background. To see before and after views, click the **WWF** layer and change it to the **Normal** mode. That's before; now press Ctrl+Z (⌘-Z) for after.

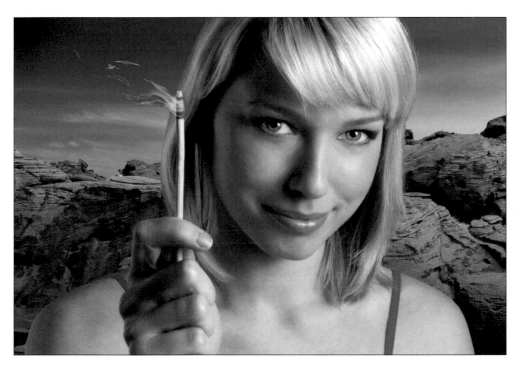

Figure 12-20.

20. *Save your file.* We'll continue with this image in the next exercise, in which we concentrate our efforts on the last remaining obstacle, the flame. Save your work by pressing Ctrl+Shift+S (⌘-Shift-S). Make sure the **Format** is set to **Photoshop** and that all check boxes except As a Copy are on. Name your file "Soft manageable hair.psd" and click **Save**.

Capturing and Enhancing a Flame

What could be more elusive than blonde hair? How about the gaseous flame being wielded by said blonde? Our flame is darkening its background and in some places turning the blue sky to orange, which is not what flames do in reality. The Screen mode will be handy, but we can't blend one part of a layer independently of another. So the flame will need a layer of its own:

1. *Open a layered composition.* If you saved your work in the last exercise, you can continue right where you left off. To jump in at this spot, open *Bad flame.psd*, located in the *Lesson 12* folder inside *Lesson Files-PsCM 1on1*.

The *Bad flame.psd* file includes a live Feather setting care of the Masks palette, which requires Photoshop CS4. If you're using Photoshop CS3 or older, open the file called *CS3 flame.psd* instead, which includes a layer mask that was softened with the Gaussian Blur filter set to a Radius of 3 pixels. The live Feather option and Gaussian Blur produce identical effects.

2. *Examine the channels for the best flame mask.* We should be able to set right in using the Calculations command on the Normal layer. But while Calculations can see an independent layer, it applies the layer mask as well, which messes up everything. So go to the **Layers** palette. Alt-click (Option-click) the horizontal line between the **Normal** and **WWF** layers to turn off the clipping mask. Then Shift-click Normal's layer mask thumbnail to turn it off.

3. *Subtract the Blue from Red.* If you were to peruse the channels, you'd see that the flame is brightest in the Red channel and darkest in the Blue channel. Then again, you could probably figure that out if you crawled in a cave and put a bag on your head. With that in mind, choose **Image**→**Calculations** and set these parameters:

 - Set **Source 1** and **Source 2** to **Bad flame.psd**. Change both **Layer** options to **Merged.**

 - Our best bet is to subtract Blue from Red, so set the **Channel** option for **Source 2** to **Red** and **Channel** for **Source 1** to **Blue.**

 - Select **Subtract** from the **Blending** pop-up menu, and give it an offset value of −20 to darken the image. If the **Mask** check box is on, turn it off. And then click **OK.**

Figure 12-21 shows a scary looking model and her dimly lit flame. But it's more than enough contrast to make a mask. Rename the channel "Flame" and drag it up the stack so that it gets the shortcut Ctrl+6 (⌘-6).

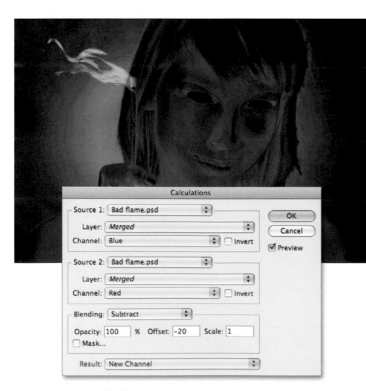

Figure 12-21.

4. **Adjust the contrast.** Press Ctrl+L (⌘-L) to bring up the **Levels** dialog box. Drag the black triangle under the histogram to 30 and the white triangle to the left for a value of 135, as in Figure 12-22. Then click **OK**.

5. **Refine the flame.** Now we'll use the burn, dodge, and lasso tools to refine the mask.

 - Press the O key to select the burn tool. In the options bar, make sure **Range** is set to **Shadows** and **Exposure** is set to 50 percent. Also turn on the airbrush icon. Set the brush size to something small enough to give you good control. I recommend starting at 20 pixels and adjusting as necessary to navigate the flame outline. Brush around the flame carefully, taking care to avoid the flame itself. Expect to take 20 or so brushstrokes in all.

 - Press the O key again to switch to the dodge tool, and brush over the flame area to brighten it. Feel free to use a larger brush for this task.

 - When you've dodged and burned the flame to your liking, press the L key to get the lasso tool and encircle the flame, taking care to draw the outline through the black areas. Press Ctrl+Shift+I (⌘-Shift-I) to reverse the selection and press the Backspace (or Delete) key to fill the area beyond the flame with black. Press Ctrl+D (⌘-D) and you end up with something like Figure 12-23.

6. **Blur the flame to make it pop.** Choose **Filter→Blur→Gaussian Blur**, or if you loaded my dekeKeys shortcuts as instructed in the Preface, press Shift+F7. In the **Gaussian Blur** dialog box, set the **Radius** value to 8 pixels and click **OK**. To bring back some of the original flame, choose **Edit→Fade Gaussian Blur** or press Ctrl+Shift+F (⌘-Shift-F). In the **Fade** dialog box, reduce the **Opacity** to 80 percent and click **OK**.

7. **Brighten the flame with the Levels command.** Blurring the flame has darkened it. To bring back the whites, press Ctrl+L (⌘-L). In the **Levels** dialog box, drag the white-point triangle to 125, as in Figure 12-24, and click **OK**. The result is something that looks vaguely like a glowing steer's skull, but will serve us fantastically well as a mask.

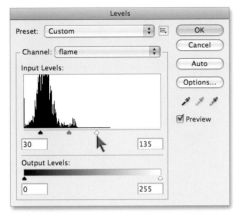

Figure 12-22.

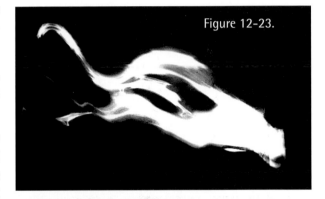

Figure 12-23.

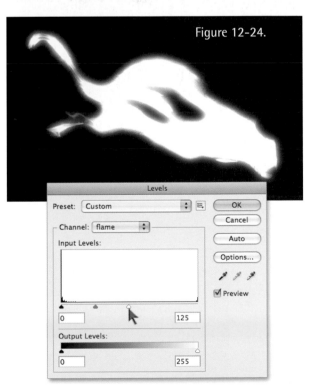

Figure 12-24.

Figure 12-25.

8. *Amplify the flame.* Press Ctrl+2 (⌘-2) to return to the full-color image, bring up the **Layers** palette, and do the following:

- We need to reassemble the layered composition. Alt-click (or Option-click) the horizontal line between the **WWF** and **Normal** layers to restore the clipping layer. Then Shift-click the layer mask thumbnail to turn it back on.

- With the top layer active, press Ctrl+Alt+6 (⌘-Option-6) to load the Flame channel as a selection.

- Press Ctrl+Alt+J (⌘-Option-J) to copy the flame to its own layer. Name the new layer "Flame," set the **Mode** to **Screen**, and click **OK**. Your layers should look like those in Figure 12-25.

9. *Bolster the flame with one final adjustment.* The flame has grown brighter, but it wants to be brighter still. Go to the **Adjustments** palette and Alt-click (or Option-click) the first icon, ☼, to add a Brightness/Contrast layer. Name the layer "x2," turn on the **Use Previous Layer to Create Clipping Mask** check box, and set the **Mode** to **Screen**. Click **OK**. If the flame now appears a little too hot, cool it down by pressing the 7 key to reduce the **Opacity** value to 70 percent. The result is a bright beautiful flame against a richly saturated blue sky, as in Figure 12-26.

10. *Save your file.* Press Ctrl+Shift+S (⌘-Shift-S) and assign your image a more appropriate filename, such as "Truly outstanding flame.psd." This is another masking challenge met with a versatile combination of artistry and math.

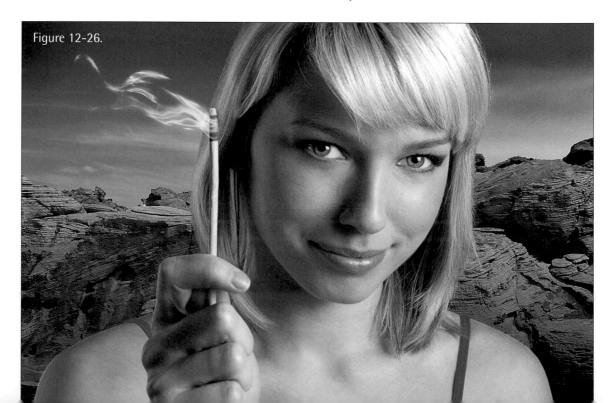

Figure 12-26.

Mastering Advanced Calculations

The easiest way to select a difficult subject against a difficult background is to avoid the situation entirely by shooting against plain, complementary colored backgrounds. But the fact that I've called this lesson "Masking the Tough Stuff" is my way of acknowledging that avoidance is not always possible. So permit me to introduce you to your final opponent, the feathery and frightening macaw in Figure 12-27, photographed by iStockphoto's Kriss Russell.

Admittedly, this background isn't the most complex thing on Earth. Surely, I could have found a peacock strolling through a junk yard outfitted with scaffolding, piles of wicker furniture, and a few tumbleweeds for good measure. But while this background is happily free of reticulated palm fronds, it does offer several difficulties. All the colors found in the background also occur in the foreground. The luminance levels are all over the place. And the perimeter of the bird shifts in and out of focus. But more to the point, this is as complex as an image needs to be to present you with a full-on masking challenge. Any worse than this, and the task does not become more difficult, it becomes more tedious. Proficiency, not tedium, is the goal of this book. (I dare say you can find plenty of tedium on your own time.)

In all, we'll examine three "big guns" that you can turn to when the going gets tough—advanced calculations, the High Pass filter, and arbitrary maps. Because calculations are the most familiar, we'll start with them. Only this time we'll see how to use the results of initial calculations to produce still more calculations that get us closer and closer to our goal.

1. ***Open the dreaded beast.*** Start by opening *Military macaw.jpg*, located in the *Lesson 12* folder inside *Lesson Files-PsCM 1on1*.

2. ***Peruse the channels.*** Go to the **Channels** palette and click through the Red, Green, and Blue channels to find the channels with the best complementary information. The areas around the eyes and beak change

Figure 12-27.

little from one channel to another. The red tuft appears lightest in the Red channel. (No surprise there.) The Green channel reveals the feathers as light and the Blue channel shows them dark. Feathers consume the biggest mass of image, so let's start with Green and Blue.

3. *Find the difference between Green and Blue.* Choose **Image→ Calculations**. In the **Calculations** dialog box, set the **Channel** option for **Source 1** to **Green** and the **Channel** for **Source 2** to **Blue**. (Throughout these steps, don't worry about the Image and Layer pop-up menus; they'll always be Military macaw.jpg and Background, respectively.) To find the areas of difference between the two channels, set the **Blending** option to **Difference**. Assuming that **Opacity** is 100 percent and **Mask** is off, click **OK**. Shown in Figure 12-28, the result is a terrific beginning in which the greenish feathers are expressed as light and the rest of the bird is dark. Rename your new channel "Green Stuff."

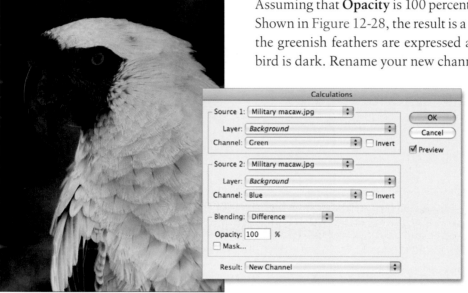

Figure 12-28.

4. *Increase the contrast of the Green Stuff mask.* Press Ctrl+L (⌘-L) to bring up the **Levels** dialog box. Change the values below the histogram so they read 20, 1.00, 90, which slightly darken the background and lighten the feathers like crazy. (The middle gamma value of 1.00 leaves the midtones to fall where they may.) Click **OK** to accept the result.

5. *Find the difference between Green and Red.* Now let's create another difference mask for the red tuft of feathers above the bill. Press Ctrl+2 (⌘-2) to return to the **RGB** image and again choose **Image→Calculations**. We still want **Blending** set to **Difference**. Leave the **Channel** for **Source 2** set to **Green** and change the **Channel** for **Source 1** to **Red**. Assuming that the Preview check box is on, you'll see the difference calculation hone in on that patch of red. Click **OK** and rename the new channel "Red Stuff."

6. *Use Levels to increase the contrast of the tuft.* Press Ctrl+L (⌘-L) to again display the **Levels** dialog box. Set the values below the histogram to 25, 1.00, and 90 to isolate the red tuft, as in Figure 12-29. Then click the **OK** button to accept your changes.

7. *Combine the two alpha channels.* Now we're going to combine these two calculations to make yet a third channel that will accumulate all the work we've done so far. Here's how:

 • Choose **Image→Calculations** a third time.

 • Set the first **Channel** option to **Green Stuff**; leave the second one set to **Red Stuff**.

 • Change the **Blending** setting to **Screen** to merge the brightest aspects of both channels into one. That's a good 75 percent of the bird, as in Figure 12-30.

 Click **OK**. Rename that channel "G+R."

8. *Clean up the new mask.* With the new **G+R** channel selected, use your now-familiar bevy of tools to clean up the mask:

 • Get the dodge tool, set it to **Highlights** and 50 percent, and paint to smooth out the seam between the bird's red crest and the back area of the head.

 • Switch to the burn tool, make sure it's set to **Shadows** and 50 percent, and clean up the edges along the top and back of the bird's head.

 • Now get the lasso tool and use it to select the stray flecks of black inside the white body of the bird. As long as you're there, you might as well select anything that obviously belongs inside the bird, such as the region around the eye—without venturing too far into the beak, that is.

 • Make sure white is your foreground color, and fill the selection with white by pressing Alt+Backspace (or Option-Delete), as in Figure 12-31.

 • When you're finished, press Ctrl+D (⌘-D) to deselect the New World parrot.

The big remaining element is the beak. This is a tough item for calculations, but let's see what we can do.

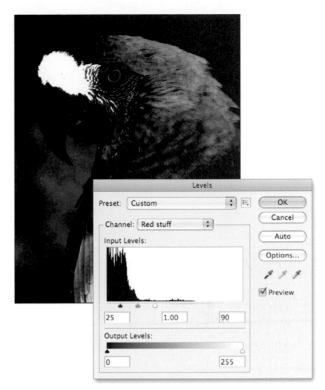

Figure 12-29.

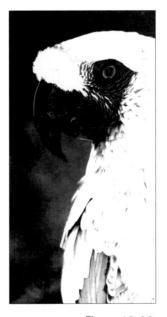

Figure 12-30.

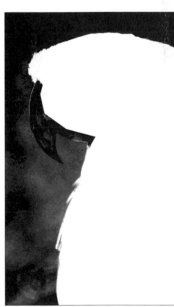

Figure 12-31.

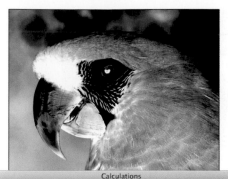

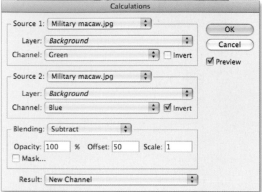

Figure 12-32.

Figure 12-33.

Figure 12-34.

9. *Select the beak with a more complex calculation.* Let's zero in next on the beak area. If you flip through the channels, you'll see that the beak doesn't change much from one channel to the next, so the Difference mode is not going to be the way to go. Instead we'll use Subtract:

 • Choose **Image→Calculations**. In the **Calculations** dialog box, set the **Channel** for **Source 1** to **Green** and the **Channel** for **Source 2** to **Blue**, since that worked out so wonderfully in Step 3.

 • Change the **Blending** setting to **Subtract** (which as you may recall from Lesson 10, is Difference without the absolute value). Restore the default **Offset** and **Scale** values of 0 and 1, respectively.

 • That turns the image pretty much entirely black. So try turning on and off the Invert check boxes. As shown in Figure 12-32, turning on **Invert** for the **Blue** channel works best. Then raise the **Offset** value to 50 to produce the result shown in that very same figure, and click **OK**. Name your new channel "Beak."

10. *Refine the beak with your arsenal of tools.* The beak section is particularly challenging and our calculation doesn't yield much on its own. We'll need a variety of tools to clean it up:

 • Get the lasso tool and select the general area around the top beak. Be sure to slice through the intersection of the two beaks, as in Figure 12-33. Press Ctrl+I (⌘-I) to invert the pixels. Press Ctrl+L (⌘-L) to bring up the **Levels** dialog box and set the values under the histogram to 100, 1.00, and 180. Then click **OK**.

 • Switch to the burn tool and, using the standard settings (**Shadows**, 50 percent), burn away the dark grays in the background. This tactic works well for the left and right sides of the beak. However, avoid using the burn tool around that black tip. Figure 12-33 shows the result.

 • Now get the brush tool, set it to the **Normal** blend mode, and press Shift+⬜ several times to make the brush its hardest. With the foreground color set to white, paint the interior of the beak, adjusting your brush size as needed. You may find that you get better control if you Shift-click from one point in the beak to the next. The tip of the bill is tricky, so zoom in and use a very small brush, as you see evidence of me doing in Figure 12-34.

- After you finish painting in the entire tip of the beak—it's actually not that hard; the beak even helpfully ends in a small, brush-shaped circle—press Ctrl+D (⌘-D). Then switch to the dodge tool and paint away the bottom beak.

- Finally, return to the burn tool and go back over the background areas around the beak. In the end, you should have a white beak against a black background.

11. ***Combine the beak with the G+R mask.*** Get the lasso tool and draw a general selection outline around the portion of the beak that you want to add to the otherwise beakless G+R mask. Then choose **Image→Calculations** and do like so:

- Set the first channel to **G+R** and the second to **Beak**.

- Change the **Blending** option to **Normal**.

- Turn on the **Mask** check box. Then set the newly created **Channel** option to **Selection**. That's the reverse of what we want, so turn on the **Invert** check box.

- When the settings and your resulting alpha channel look like those in Figure 12-35, click **OK**.

12. ***Save your file for comparison to other techniques.*** By now, you have a sense for how calculations can accommodate an image and how they require distinctions between channels to succeed. To save your work, press Ctrl+Shift+S (⌘-Shift-S), set the **Format** to **TIFF**, and name your file "Calculated bird.tif."

Creating a High Pass Mask

Another solution for tough masking situations is the High Pass filter, which results in an elaborate coloring book that you then color in by hand. It's tedious, but it's also brain-dead easy.

1. ***Open an image.*** Feel free to stick with your file from the previous exercise. But just so's you know, we're not going to use the alpha channels you've made so far. If you think those extra channels might prove confusing, open the pristine *Military macaw.jpg* file in the *Lesson 12* folder.

2. ***Duplicate the Green channel.*** If there is one when-in-doubt, high-detail, low-noise channel, it's Green. So much so that without looking at it, you can safely say that Green is the channel best suited for High Pass. In the **Channels** palette, drag the **Green** channel to the 🔲 icon to duplicate it. Then double-click the words **Alpha 1** and rename the channel "High Pass."

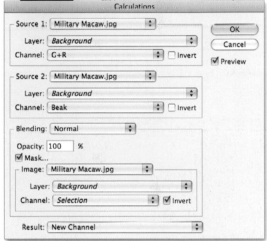

Figure 12-35.

PEARL OF WISDOM

Two things you should know about creating a High Pass mask: First, it's 1 percent automation and 99 percent perspiration. That is to say, it requires lots and lots of painting. If you're the kind of person who likes to turn on some news or music and get in the zone, you may like it. I mean, what artist doesn't like to paint? But if you want results fast, look elsewhere. Second, while it may invoke adjectives like meticulous, laborious, and slow, it *always* works. I'm here to tell you, one way or other, you can always make a High Pass mask work. It is *the* technique of last, hopeful resort.

3. ***Apply the High Pass filter.*** Choose **Filter→Other→High Pass**, or if you loaded dekeKeys back in the Preface, press Shift+F10. This enormously useful filter immediately sends all non-edges in the bird to gray, with the edges doing their best to hang on for dear life. Not only does that make it useful for sharpening, as we saw in Lesson 8, but it also lends itself to tracing. In the **High Pass** dialog box, set the **Radius** to 10 pixels and click **OK**.

PEARL OF 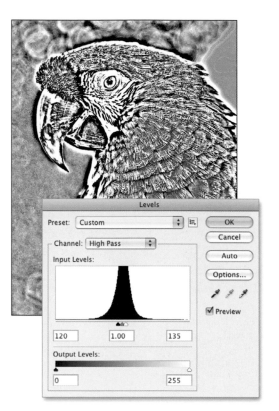 WISDOM

High Pass is that weird filter that produces a bigger effect at lower values. So if you want an insanely accurate tracing that will take you all day to paint, enter a low value like 3 pixels. If you want a highly generalized tracing—the masking equivalent of a coloring book for preschoolers—then enter a high value like 50 pixels. In my younger days, I used to get off on seeing how low I could go. Nowadays, I find a Radius value in the neighborhood of 10 to 20 pixels produces a reasonable compromise between time and labor.

Figure 12-36.

4. ***Bolster the outlines with the Levels command.*** Press Ctrl+L (⌘-L) to bring up the **Levels** dialog box. High Pass has turned the histogram into a towering volcano, with all the luminance levels compressed toward the center. To spread those levels out—*way* out—change the values below the histogram to 120, 1.00, and 135. Note that these values represent a symmetrical modification, meaning that we are darkening by the same amount we're lightening. (The white point value of 135 is 255 minus the black point value, 120.) This is very important—anything other than a symmetrical modification will push your edges inward or outward from their true location. Click **OK** to render the poorly photocopied macaw pictured in Figure 12-36.

5. ***Invert the outlines where necessary.*** If you scrutinize your tracing, you'll notice that High Pass varies its treatment of the edges, sometimes placing its thick black lines outside the bird and other times placing them inside. We want black outside and white inside, so invert any areas that run counter to that.

In Figure 12-37, I've selected an area around the bottom beak with the lasso tool. (I added the colors so you can see the darn thing; marching ants don't stand out very well against a High Pass background.) The arrows point to the black interior against a white exterior. Invert this area by pressing Ctrl+I (or ⌘-I). Select other such areas—around the tuft above the beak and near the back of the head—and invert them as well.

Figure 12-37.

6. **Fill the non-edges with black or white.** Lest you think, "This tracing is so detailed, it'll take me the rest of my life to fill in!" remember that where masking is concerned, all we care about is the edges. Alt-click (Option-click) with the lasso tool all around the interior, close to the outer edge of the bird but leaving a safe margin for your later edits. Press the D key to confirm the default colors, and then press Alt+Backspace (Option-Delete) to fill the shape with white. Then do the same with the outside, selecting the large, easily identifiable outside-the-mask areas and pressing Backspace (Delete) to fill them with black. You should end up with all but the edges filled in, as in Figure 12-38.

7. **Set your view for accurate painting.** To get a sense for which edges you need to paint black and which to paint white, you really need to see both the mask and the image at the same time. Press the ⌑ (tilde) key or wake up the 👁 in front of **RGB** in the **Channels** palette to display the RGB image along with the rubylith mask overly. But if the High Pass mask was confusing before, it's even worse now. You can't tell what the heck's going on. To resolve this problem:

Figure 12-38.

- Double-click the **High Pass** thumbnail to bring up the **Channel Options** dialog box. Click the color swatch, change it to black (just change the **B** value to 0), and click **OK**. If Photoshop tries to rename the channel Black, change it back to "High Pass." Then set the **Opacity** to 100 percent and click **OK**. You now see black mask lines against a macaw background, as in Figure 12-38.

- From here on out, you can toggle the full-color bird in and out of view by pressing the ⌑ key.

8. **Zoom in and paint, paint, paint.** Now it's time to color inside the lines. Press B to get the brush tool. I recommend a brush size of about 40 pixels at full hardness so you don't end up introducing new edges. Paint with black and white as appropriate to fill in the areas near the edges. Paint black to hide the bird; paint with white to reveal it. For long straight passages, click at a point and then Shift-click at another to draw a line between them. Yes, it's slow. Yes, it can be maddening. Yes, I've been known to refer to this technique as "padded-cell masking." But if you have the patience, it's darn well accurate.

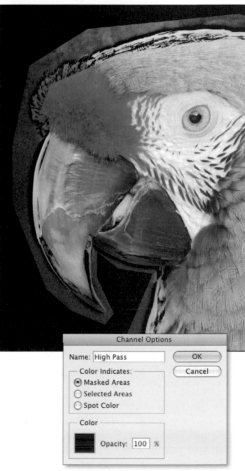

As you toggle in and out of the RGB view, Photoshop may switch the foreground and background colors. Keep an eye on the toolbox to see which color is in which position and have Ctrl+Z (⌘-Z) ready to undo.

Figure 12-39.

9. *Save your file.* I told you up front that you only have to finish the mask once, in the final exercise. So keep working as much as you like, quit working any old time, but save your changes because you may want to come back. Press Ctrl+S (⌘-S) to display the **Save As** dialog box. Set the **Format** to **TIFF** and name the file "High Pass.tif." Later, you may want to compare it against the results of the next and final exercise, which explores the less tedious method of working with arbitrary maps.

Masking with Arbitrary Maps

The third method for masking this tough bird involves arbitrary maps, or *arb maps* for short. In Lesson 10, I introduced you to the notion of drawing custom curves in the Curves dialog box using the pencil tool. Now we're going to take that technique to the extreme, not merely increasing the contrast of a mask but actually developing the mask from a color channel. In fact, we'll need to employ several arb maps working in combination with each other to free this intricate chicken from its complex background.

1. *Open an image.* Let's begin with a clean slate by once again opening *Military macaw.jpg*, located in the *Lesson 12* folder inside *Lesson Files-PsCM 1on1*.

2. *Create a starter mask from the Blue channel.* By now, you know the drill. Press Ctrl+3, +4, +5 (⌘-3, -4, -5) to sift through the channels for the one with the best contrast information. In this image, the Blue channel, despite some noise and posterization, is our best jumping-off point. In the **Channels** palette, Alt-drag (or Option-drag) the **Blue** channel to the 🔲 icon. Name the channel "Arb Map" and click **OK**.

3. *Apply an arbitrary map.* Press Ctrl+M (⌘-M) to bring up the **Curves** dialog box. From the top-left corner of the dialog box, select the pencil tool and follow these instructions:

 - Drag inside the image with the eyedropper cursor. Photoshop adds a bouncing ball to the graph, the position of which represents the luminance level under your cursor. Use the bouncing ball to identify levels, such as those inside the stork, which rank among the darkest in the image.

 - In the Curves dialog box, drag along the top of the graph from the top-left corner to an **Input** value of about 59—as in Figure 12-40—to send much of the interior of the duck to white. Don't drag outside the box or you won't be able to see the Input and Output values.

Seeing as how I'm tired of saying the *bird* or the *macaw* over and over again, and in honor of the arbitrary nature of arbitrary maps, I'm going to switch out the name of this bird for the name of another bird, arbitrarily, every time I mention it. See if you can spot all eighteen.

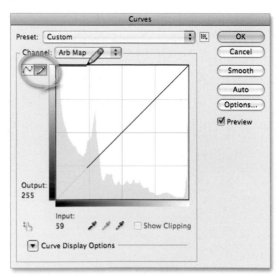

Figure 12-40.

- At the bottom of the graph, click at an **Input** of 60 and drag to the right until you reach 82 to make the area to the left of the seagull black.

If you're wondering why I mention just Input values and not Output ones, it's because the Output values have less variety, either changing to 0 for black or 255 for white.

- Return to the top of the graph and drag from an **Input** level of 83 to 128. The tops of the feathers become white.

- Finally, return to the bottom of the graph and drag from an **Input** value of 129 all the way to the right, ending at 255.

- Click the **Smooth** button just twice to achieve the result pictured in Figure 12-41. Then click **OK**.

4. *Again duplicate the Blue channel.* The result is close to what we want, but by no means perfect. What we need is several arb maps working together, each serving a different part of the image: the back of the magpie's head, the top including the red tuft, the beak, and the feathers along the puffin's tummy. To accomplish this, we'll once again start with the Blue channel, so Alt-drag (Option-drag) **Blue** onto the ▣ icon, name it "Mask" (to indicate this is the big one), and click **OK**.

5. *Apply an arbitrary map to the back of the head.* Using the marquee tool, draw a rectangular selection around the top-right region of the image, where the contrast is highest, as indicated by the orange outline in Figure 12-42. Press Ctrl+M (⌘-M) to bring up the **Curves** dialog box. The pencil tool should still be selected. Drag across the top of the graph from an Input value of 0 across three columns to an **Input** of 186. Then drag along the bottom of the fourth column, from 187 to 255. Click the **Smooth** button three times to connect the curve and click **OK**. The result is a custom adjustment that precisely masks the feathers along the back of the barn owl's head.

6. *Select the top of the head.* To make your next selection align flawlessly with the existing one, first press Ctrl+Shift+I (⌘-Shift-I) to reverse the marquee. Then, still armed with the marquee tool, Shift+Alt+drag (or

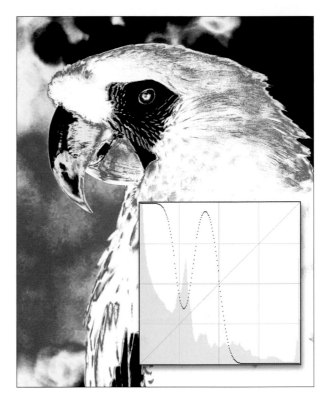

Figure 12-41.

Figure 12-42.

Figure 12-43.

Figure 12-44.

Figure 12-45.

Shift-Option-drag) around the top quarter of the image. Try to align the bottom of your rectangular selection with the intersection of the bottom of the tuft and the top of the beak, as in Figure 12-43.

7. **Apply another arbitrary map.** Press Ctrl+M (⌘-M) to bring up the **Curves** dialog box again. This time we'll take advantage of the Curve command's ability to load preset maps, which I've created for you in advance.

 - Click the ≡ icon to the far right of the **Preset** option and choose **Load Preset**.

 - In the **Load** dialog box, navigate to the *Macaw arb maps* folder in the *Lesson 12* folder. Select the *Top of Head.amp* file and click the **Load** button.

 > If you're working in Windows, you'll need to set the **Files of Type** pop-up menu to **Map Settings (*.AMP)** to see arbitrary maps drawn with the pencil tool.

 - Now click **OK** to apply the Curves adjustment. And press Ctrl+D (⌘-D) to deselect the image.

 - Clean up the light patches in the background with the burn tool. Don't worry about the highlights; we'll hit them in the next step.

8. **Fix the whites along the top of the head.** The light area at the very top of the flamingo's head is an absolute mess. Here the arbitrary map failed us, but the good old dodge tool is about to ride (or is it fly?) to the rescue:

 - Switch back to the rectangular marquee tool. Then press Ctrl+5 (⌘-5) to return to the **Blue** channel and draw an outline around the very top of the head, as indicated by the circled marquee in Figure 12-44.

 - Press Ctrl+C (⌘-C) to copy it.

 - In the **Channels** palette, click the **Mask** channel and press Ctrl+V (⌘-V) to paste the selection, as in Figure 12-44.

 - Press Ctrl+I (⌘-I) to invert your selection. Then use a little bit of the burn tool and a whole lot of the dodge tool to clean it up so that it looks more or less like Figure 12-45.

- Deselect the image by pressing Ctrl+D (⌘-D). Grab the lasso tool, select the other problem areas, and fill them with the foreground or background color as required.

9. ***Apply an arbitrary map to the forward beak.*** Using the rectangular marquee tool, select the region outlined in orange in Figure 12-46. Press Ctrl+M (⌘-M) to bring up the **Curves** dialog box. Click the ≣ icon in the top-right corner of the dialog box and choose **Load Presets**. Still in the *Macaw Arb Maps* folder, select *Forward bill.amp* and click **Load**. Then click **OK** to apply the arb map, which makes the dark midtones black and leaves everything else white. As shown in the figure, it does a good job of darkening the background but leaves much of the beak dark as well.

Figure 12-46.

10. ***Use a path to better select the beak.*** Nothing says you have to use a single technique to mask an image. In fact, you shouldn't. So far, this darn beak has done its best to thwart every advanced masking function we've thrown at it. But it can't best the pen tool. As you'll recall from the previous lesson (as well as earlier in this one), the pen is a great choice for tracing smooth, organic shapes, and our kookaburra's beak is no exception. If you're interested in drawing your own path outline—for the experience—then by all means do so. Or just use the one I've created for you in advance. To take advantage of the latter, switch to the **Paths** palette and Ctrl-click (or ⌘-click) the **Bill Outline** path to load it as a selection. Assuming the default masking colors, press Alt+Backspace (or Option-Delete) to fill the selection with white. The exceedingly satisfying result—complete with that slight jag midway down the front of the beak—appears in Figure 12-47. Honestly, come to terms with the pen and there is no masking scenario that will prove too challenging for you.

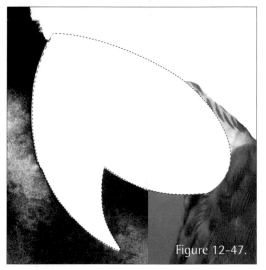

Figure 12-47.

11. ***Make the area around the beak black.*** Press Ctrl+Shift+I (⌘-Shift-I) to reverse the selection outline. That selects too much of the image, of course. So grab the lasso tool, press Shift+Alt (or Shift-Option), and draw an ample selection that starts at the top of the beak and ends at the woodpecker's "chin," as illustrated by the orange outline in Figure 12-48. Photoshop calculates the intersection of the two selections, keeping just the region of the background in front of and below the beak. Press the Backspace (or Delete) key to fill that selection with black (presuming it's your background color), as in the figure on right.

Figure 12-48.

Figure 12-49.

12. *Clean up the stray patches of bird and background.* Using the lasso tool, select any stray bits of darkness in and around the kingfisher's head and beak and press Alt+Backspace (or Option-Delete) to fill your selections with white. Then switch to the marquee tool, draw one or two big rectangular selections across the body of the animal, and fill them with white as well. Next select any areas of the background on the top and left sides of the image that need work and fill them with black by pressing the Backspace (or Delete) key. Keep working until the only area that remains to be masked is the one containing the problematic feathers on the meadowlark's belly, as shown in Figure 12-49.

13. *Apply an arbitrary map to the belly.* From a masking perspective, the tummy feathers represent the most troublesome part of the image. To see what I mean, use the rectangular marquee tool to draw a selection down the front of the albatross. (You'll probably have to Shift-drag a couple of times to select the area in passes and avoid the beak.) Then press Ctrl+M (⌘-M), click the ≣ icon, choose **Load Preset**, and open the file called *Bottom feathers.amp* from the *Macaw arb maps* folder. Then click the **Load** and **OK** buttons. Shown in Figure 12-50, the results are less than ideal, but as usual, we can make things better by requesting some assistance from another channel.

Figure 12-50.

14. *Select the middle tummy.* The belly of the sinister toucan breaks into three areas, two of which are satisfactory as is, and one of which is not. The areas closest to the top and bottom are good, the large middle region is bad. Press Ctrl+D (⌘-D) to abandon the current selection. Then, still armed with the rectangular marquee, select the area that I've outlined in orange in Figure 12-51 below.

15. *Replace the selection with the Green channel.* Given that the feathers along the sparrow hawk's belly are green, we should be able to find some excellent belly detail in the Green channel. With the selection still active, choose **Image→Apply Image**. You have just two options to modify: Change the **Channel** setting to **Green** (with **Invert** off) and the **Blending** to **Normal**. Assuming that the **Opacity** value reads 100 percent, click the **OK** button to fill the selection with the contents of the Green channel.

16. *Apply one last arbitrary map.* Now it's time to make the transplanted Green pixels blend with the others. Press Ctrl+M (⌘-M) to bring up the **Curves** dialog box. You can load yet another of my presets (*Green addition.amp*). Or get the pencil tool and draw it yourself. Make a line at the bottom of the graph from **Input** 0 to 100 and another line at the top from **Input** 101 to 255. Click the **Smooth** button once and then click **OK**. You'll get the result shown in Figure 12-52.

17. *Refine the mask.* Press Ctrl+D (⌘-D) to deselect the image. You'll see a couple of bad seams. Here's how to fix them and finish the mask:

 • Get the lasso tool and select all the blacks and grays inside the body of the majestic eagle. You should be able to get close enough to the edges to eliminate any need to resort to the dodge tool. Press Alt+Backspace (Option-Delete) to fill your selections with white.

 • Use the burn tool to send the background to black. A few brushstrokes should be enough to do the trick.

FURTHER INVESTIGATION

If you'd like to explore any of these techniques in more detail—without the arbitrary birds—keep in mind that I document everything covered in this lesson and more at the lynda.com Online Training Library. Go to *www.lynda.com/dekeps* and start your 7-Day Free Trial Account (as introduced on page xxv of the Preface). Then check out my series *Photoshop CS3 Channels & Masks: Advanced Techniques* and watch the more than 30 movies that make up Chapter 16, "Masking the Tough Stuff," for which this lesson was named. A CS4 series may be coming one day, but in the meantime, little has changed since CS3.

Figure 12-51. Figure 12-52.

- Three problems are likely to remain: The seam at the bottom of the marquee you made in Step 14, the seam at the top of that marquee, and the black spot at the top of the neck. Get the brush tool, press F5 to open the Brushes palette, and turn on the **Noise** check box. Then right-click in the image window and set the **Master Diameter** to 35 pixels and the **Hardness** to 75 percent. Now paint with white to brush away the seams. The final mask should look like the one in Figure 12-53.

I wouldn't dream of doing anything at this point to dissuade you from saving your work. Press Ctrl+S (or ⌘-S) and give the file a fresh name like "Arbitrary Masks.tif" so you can compare these results against the ones from the previous two exercises. If you want to see *my* final mask, check out the file called *The masked macaw.tif*, found inside the usual *Lesson 12* folder.

And then take a load off. You deserve it. You just completed some 450-odd pages of material on what is easily the most arcane, mysterious, and powerful collection of features in all of Photoshop. You know what channels are (Lesson 1), where alpha channels come from (Lesson 2), how to work the core selection tools (Lesson 3), how to assemble basic masks (Lessons 4 and 5), the inner workings of layer blending (Lesson 6), how to exploit layer masks to the hilt (Lesson 7), how to employ masks to correct images (Lesson 8), how to blend channels to produce effects (Lesson 9) and masks (Lesson 10), how to draw precise, detail-independent outlines with the pen tool (Lesson 11), and the names of a random and seemingly endless collection of birds (Lesson 12). My sincere hope is that, by the end of all this, you aren't merely sitting on a collection of factoids and tricks but have a real working knowledge of how to create exceptional imagery—literally anything you want—inside the world's most powerful image editor. And if that's not mastery, then what is?

If you'd like to share your thoughts about this book, the sorts of problems or solutions you've encountered, what you'd like to see in the future, or anything else for that matter, drop by *www.deke.com* and let us know. The site has turned into a bustling hub of activity, and the more minds the better.

Oh, and feel free to close the bird. So far as I'm concerned, this is one dodo that can be safely put to rest. Forever.

Figure 12-53.

WHAT DID YOU LEARN?

Match the key concept in the numbered list below with the letter
of the phrase that best describes it. Answers appear upside-down
at the bottom of the page.

Key Concepts

1. Arbitrary map

2. Light hair

3. Iterations

4. The path outline

5. Use Previous Layer to
 Create Clipping Mask

6. Edit→Fade

7. The "big guns"

8. Difference mask

9. High Pass

10. Smooth

11. AMP file

12. Jackdaw

Descriptions

A. The one point-for-point, manual-selection element that, when all else
 fails, has your ever-loving back.

B. This filter not only lets you sharpen an image (as we saw in Lesson 8),
 but may also turn a channel into a kind of coloring book that you fill
 in to make a mask.

C. When the masking gets really tough, you can rely on these powerhouses:
 advanced calculations, the High Pass filter, and arbitrary maps.

D. Any operation that allows you to reassign luminance levels on a level-
 by-level basis, offered by the Gradient Map command and (more help-
 fully where masking is concerned) the Curves command.

E. Because channels do not support layers, it pays to save these variations
 on masks as independent channels that you can revisit and repurpose
 as you please.

F. A button in the Curves dialog box that rounds off radical luminance
 transitions and fills in the extremes of a broken curve.

G. When turned off, this check box tells Photoshop to calculate the blend
 mode for each layer separately.

H. This calculation allows you to compare two channels and exploit their
 distinctions in the name of establishing a base alpha channel.

I. Recognized by its black plumage and bright white irises, this diminutive
 (~35 cm) species of European crow is, like so many of Earth's amazing
 and varied creatures, not a macaw.

J. Unlike its dark cousin—which can be argued to darken its surround-
 ings—this variety of head covering does not cast a glow on its back-
 ground and must therefore be approached in a unique manner.

K. Although of limited use when correcting continuous-tone photographs,
 this command is of inestimable value when editing alpha channels,
 which do not support layers.

L. A saved arbitrary map that you can load into the Curves dialog box.

Answers

1D, 2J, 3E, 4A, 5G, 6K, 7C, 8H, 9B, 10F, 11L, 12I

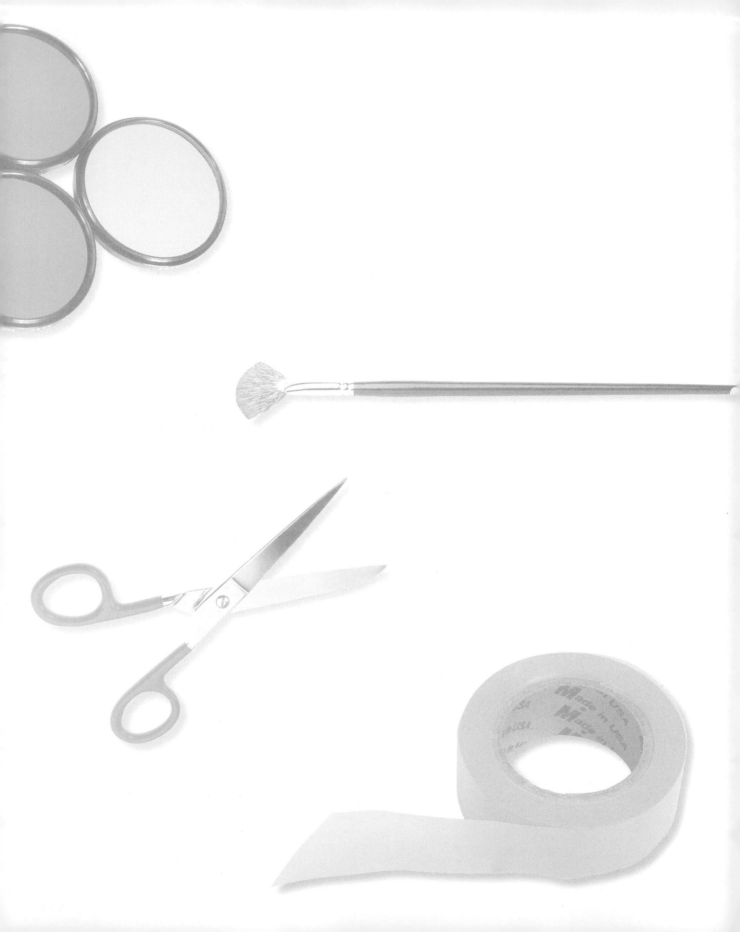

INDEX

Symbols

90° CCW command, 238

A

Actions palette, 170–171
 Fire effect, 171
Add and Subtract modes, 365–374
 applying Add mode, 370
 applying Subtract mode, 371
 comparing Add and Subtract
 masks, 372
 Difference comparison, 373
 how they work, 366–367
 simple rules, 371
Add Filter Mask, 278
additive color model, 13
Add Mask by Default, 197, 243
add selection mode, 108
adjustment layers
 Levels adjustment layer, 280
 masking, 243–248
Adjustments palette, 175, 197
 Add Mask by Default, 243
 adjusting Black & White settings,
 323
 Hue/Saturation panel, 200
Adobe Garamond Italic font, 401
Advanced Blending section, 269
advanced calculations, 445–449
 difference mask, 446
airbrush option, 38
Alexis, Aleksandra, 40, 56, 203, 400
alpha channels, 37, 183
 changing order, 384
 converting to or from selection,
 44–45
 creating and saving, 40–48
 duplicating, 388

 quick mask mode, 169
 renaming, 43, 371
 saving and naming, 350
 saving selection as, 41
 selections, 77
 switching to 1st or 2nd, 38
 TIFF, 48
 viewing, 42
Alpha Channels check box, 47
.amp files, 454
anchor points, 402
 adding and deleting, 404–407
 with pen tool, 407
 adding to path, 406
 deleting, 405
 deleting from path, 407
 displaying, 404
 moving, 407
 tools for manipulating, 402
 (*see also* control handles; cusp
 points; smooth points)
Andhedesigns, 249
Animated Zoom check box, xviii
antialiasing, 77
 how antialiasing works, 80–81
Apply Image command, 377, 378
Apply Image dialog box, 27
Arbitrary command, 193
arbitrary maps, 375, 431
 masking with, 452–458
Arrange documents, 79
arrow tools, 405
 on-the-fly, 398
artifacts, eliminating, 166
asymmetrical modes, 373
Attempt to Automatically Align Source
 Images check box, 264
Auto-Align Layers command, 258
Auto-Align Layers dialog box, 260

Auto-Enhance, 142
Average blur, 286

B

background
 aligning layer and, 390
 color, 191
 default color, 58
 inverting, 362
Background layer
 converting to normal layer, 237
 converting to smart object, 286
Backspace (Delete) key, 191
Badenhorst, Henk, 125
banding, 26
Bernard, Loic, 203
Best Workflow CS4, xvi
Bitmap command, 12
black-and-white conversion
 greater contrast, 318–320
 mixing custom, 316–322
black arrow tool, 405
Black channel, 23, 27
black point value, 16
Black silhouette action, 171
Black & White adjustment layer, 323
Black & White Adjustment tool,
 322–325
 increasing contrast adjustment, 324
Blend Clipped Layers as Group check
 box, 200
blending images that don't really go
 together, 223–232
Blending Options, 220, 277, 394
blending scanned logo, 190–202
Blend Interior Effects as Group, 258
blend modes
 Darker Color, 205
 Difference, 45

blend modes (*continued*)
 Dissolve, 204
 Exclusion, 214–215
 explained, 189
 Hard Light, 66
 keyboard shortcuts, 194
 Lighter Color, 205
 Linear Dodge (Add), 54
 math behind, 209
 Multiply, 20, 27, 117
 Screen, 7–8, 51
 keyboard shortcut, 52
 working with, 203–218
blind brushing, 386
blue screen calculations, 352–364
Border options, xviii
bounce, 229
Browse in Bridge command, xvi
Brunner, Daniel, 390
Brushes palette, Noise check box, 383
brush tool, 38
 adjusting size, 158
 fine-tuning masks, 178
 foreground color, 59
 selecting, 58
Burak, Andrzej, 99, 432
burn tool, 380, 381
 refining mask, 436

C

calculations, 104–113, 349–395
 Add and Subtract modes, 365–374
 applying Add mode, 370
 applying Subtract mode, 371
 comparing Add and Subtract
 masks, 372
 Difference comparison, 373
 how they work, 366–367
 simple rules, 371
 advanced, 445–449
 difference mask, 446
 blue screen, 352–364
 clearing away background, 359
 converting to masked layers, 360
 Curves dialog box, 375
 Smooth button, 376
 Curves, Dodge, Burn, and Paint,
 374–389
 defining channels that you want to
 mix, 354
 inverting channels, 355
 Levels dialog box, 379

masks, increasing contrast,
 380–382
Multiply, Minimum, Blur, and
 Apply Image, 389–394
Overlay mode, 358
quick mask mode, 377
 gradient edge, 378
underwater effect, 364
Calculations command, 369, 371
 applying multiple passes, 431
Calculations dialog box, 23, 353
 Blending and Opacity settings, 354
 Mask check box, 354, 357
 which channels to use, 354
Canvas Size, 180, 181
 increasing canvas size, 238
Catmull, Ed, 39
challenging masking scenarios,
 431–459
 advanced calculations, 445–449
 difference mask, 446
 applying multiple passes of
 Calculations command,
 431
 arbitrary maps, 431, 452–458
 capturing and enhancing flame,
 442–444
 amplifying flame, 444
 refining flame, 443
 High Pass filter, 431, 449–452
 masking and compositing light
 hair, 432–441
 refining mask with dodge and
 burn tools, 436
 rectangular marquee tool, 456
channel masks, 151–185
 alpha channel in quick mask mode,
 169
 artifacts, eliminating, 166
 blending hair and sky, 173–182
 copying selected areas, 162
 Create Clipping Mask command,
 177
 creating from RGB versus CMYK
 images, 154
 final edge details, 159
 fine-tuning masks with brush tool,
 178
 Gaussian Blur filter, 178
 grayscale, 155
 identifying base channel, 155
 Inner Glow filter, 179
 making, 154–160
 Multiply layer, 175

refining edge selections, 164
removing highlight detail, 156–157
selecting problem areas, 161
shadow details
 darkening, 158
 enhancing, 163
silhouette effect, 166–172
 Actions palette, 170–171
 Color Range dialog box, 168
 creating selections from mask
 channel, 167
 Localized Color Clusters option,
 169
 Reduce Noise dialog box, 169
 removing background from
 selection, 169
 smooth contours, 160–166
Channel Mixer adjustment layer, 316
channel mixing, 315–347
 Black & White Adjustment tool,
 322–325
 Channel Mixer command, 316–322
 infrared photography, emulating,
 325–337
 mixing custom black-and-white
 image, 316–322
 red-eye, correcting, 337–346
channel operations (*see* calculations)
Channel Options dialog box, 58, 377
channels, 5
 alpha (*see* alpha channel)
 black, 23
 color-bearing, 5
 creating, 47
 Cyan channel, filling with white, 25
 defined, 5
 defining channels that you want to
 mix, 354
 deleting, 33
 duplicating, 155
 evaluating, 368
 how they work, 3–35
 identifying base channel, 155
 inverting, 155, 355
 making all visible, 24
 mixing (*see* calculations)
 naming, 32, 46
 Photoshop's eight channel modes,
 12–13
 reviewing CMYK channels, 18–19
 reviewing individual, 10
 switching between channels and
 composite views, 43
Channels & Masks palette, xvii

Channels palette, 4, 154
 Auto-Enhance check box, 142
 composite preview, 31
 opening, 6
 reviewing channels, 19
character outlines
 editing as paths, 422–426
 letters, converting to shapes, 423
choking layer mask, 229, 391
Cline, Kelly, 85
clipping, 26
clipping highlights, 323
clipping masks, 177, 235
closing images, 11
CMYK, 18
 converting from RGB, 18, 21, 44
 converting images to, 13, 26
 creating masks, 154
 mechanics of, 18–21
 reviewing channels, 18–19
CMYK Color command, 13, 18, 26
color
 changing objects with color masks, 287–296
 lifting color when brush tool is active, 38
color axis, 14
color-bearing channels, 5
 keyboard shortcuts, 43
Color blend mode, 218
Color Burn blend mode
 keyboard shortcut, 207
Color Dodge blend mode, 330
 keyboard shortcut, 207
color fringing, 98
Color Gradient adjustment layer
 reducing opacity, 336
color information, discarding, 10
colorizing image, 333
Color Libraries dialog box, 30, 32
color masks, 275
 changing color of object with, 287–296
 Color Range dialog box, 289
 Hue/Saturation adjustment, 288
 Levels adjustment, 295
 painting away mask edge details, 290
Color Overlay filter, 55, 82, 100
Color Picker dialog box, 49, 54, 84
Color Range, 123–136, 168, 221, 247, 251, 254, 393
 cleaning up bright corners, 134

color masks, 289
context of magic wand tool, 128–129
 dekeKeys shortcut, 126
 expanding selection, 127
 Fuzziness value, 126, 247
 Invert check box, 130
 Localized Color Clusters, 137
 only one undo, 130
 restoring defaults, 137
 smoothing edges and remaking corners, 131–135
 using, 125–131
color space conversion, 13
complement, 14
composite mode, 189
composite preview, Channels palette, 31
composite views, switching between channels and, 43
composition, 3
compound shape mode, 415
Contract (Modify menu), 176
contrast
 increasing, 162, 227
 increasing with Levels, 156
control handles, 411, 412
 corner points, 413
 lopping off, 413
 one-third rule, 412
controlled feather effect, 389
conversion, lossless, 44–45
Convert to Shape command, 423
Convert to Smart Object, 195, 257, 276
corner points, 402
corners, cleaning up, 134, 144
corrective masks, 275
 adjusting skin tones, 283–287
 applying Curves adjustment, 284
Create Clipping Mask command, 177
crop tool, 242
Ctrl-clicking layers, 50
Cursors, xix
Curves dialog box, 375
 calculations, 375
 Smooth button, 376
cusp points, 411, 413
 drawing, 398
custom shape tool, 425

D

Darken blend mode, 204
Darker Color blend mode, 205
DCS format, 34
Deep option from Knockout menu, 269
dekeKeys shortcuts
 Color Range command, 126
 Convert to Smart Object command, 195
 dodge and burn tools, 382
 full-screen mode, 95
 Gaussian Blur filter, 229, 443
 installing, xvi
 red-eye tool, 338
 sponge tool, 382
density masks, 275, 321, 328, 334
 grouping layers, 299
 High Pass filter, 297
 sharpening with, 296–300
depth masks, 275
 blurring background with, 300–304
 Lens Blur filter, 301
 Knockout layer, 302–303
 Linear Gradient style, 302
 Screen blend mode, 303
Desaturate command, 148
desaturating image, 330
Deselect command, 42
deselecting selection, 52
device-independent color model, 11
Difference blend mode, 45, 199, 214–215
 unearthing JPEG artifacts with, 216
Difference comparison, 373
difference masks, 446
diffusion dither pattern, 204
discarding color information, 10
Discard other channels message, 11
Dissolve blend mode, 204
dodge tool, 380, 381
 refining mask, 436
Dodz, Larysa, 196
Dominick, Sharon, 276
dragging and dropping image, 124
drop shadows, 64, 109
 Select Shadow Color dialog box, 65
Duotone command, 12, 29
Duotone Curve dialog box, 30
Duotone Options dialog box, 29

duotones, tritones, and quadtones, 28–34
 multichannel mode, 31
 quadtone preset, 29
Duplicate Layers dialog box, 197, 225, 250, 263
dynamic fill layer
 preventing Photoshop from adding a mask to, 416

E

"edge brush," 85
edge masks, 275
 correcting archival photo, 304–310
 desaturating sharpening effects, 308
 Find Edges filter, 306
 fine tuning sharpening effect, 309
 High Pass filter, 307
 inverting, 306
 Maximum filter, 306
 Median filter, 307
 sharpening with Levels, 307
edge toasting, 175
elliptical marquee tool, 114, 191
Enable Flick Panning check box, xviii
Enable Version Cue check box, xix
endpoints, 406
Ermel, Christoph, 237
Exclusion blend mode, 214–215
Expand (Modify menu), 176
Export Clipboard check box, xviii
Extra Channel, 27
Extras command, 51
eyedropper tool
 configuring settings, 76
 restoring default behavior, 77

F

Fade Gaussian Blur command, 231, 443
Feather command, 81
Feather (Modify menu), 176, 178
Feather Selection dialog box, 44, 255
File Handling, xix
Fill Layers check box
 Use Default Masks, 416
fill opacity, 208, 210, 212, 213
filters
 Color Overlay, 55
 Lens Blur, 104

 Outer Glow, 54
 Radial Blur, 51, 52
 Spherize, 117
Find Edges filter, 306
Fire effect (Actions palette), 171
flame, capturing and enhancing, 442–444
 amplifying flame, 444
 refining flame, 443
Float All in Windows command, 245
font warnings, 401, 422
foreground color
 brush tool, 59
 default, 58
free-form pen tool, 402
free-form polygon, drawing, 400–403
Free Transform command, 116, 195, 239
free transform mode, 196, 390
full-color composite, 9
full-screen mode, 95
fuzziness, 97

G

Gagne, Lise, 153, 256
Gaussian Blur filter, 178, 231, 268, 277, 392, 394
 dekeKeys shortcut, 229
glass, masking, 249–258
 adding fish to composition, 256–257
 applying gradient to mask, 251
 Color Range dialog box, 251, 254
 Feather Selection dialog box, 255
 Linear Burn blend mode, 250
 Linear Dodge (Add) blend mode, 253
Gradient Editor dialog box, 166, 333
Gradient Fill dialog box, 135, 166
Gradient Map, 333, 335
gradient masks, 421
Gradient Overlay, 83
gradients
 adding, 135
 applying to mask, 251
 filling selection with, 64
 knockout masks, 268
 Load Gradients command, 63
 Reverse check box, 252
gradient tool, 63, 331
grayscale
 before converting to multichannel, 32

 channels, 155
 converting to, 11, 12
 converting to multi-ink image, 29–34
 single-channel, 9–11
 Undo Grayscale command, 10
Grayscale command, 9, 12
 JPEG mask support, 53
group photo, assembling, 258–266
 surreal group photo, 264–265

H

Habur, Izabela, 249
Hafemann, Alexander, 113, 316, 326
hair
 creating mask, 153–154
 masking and compositing light hair, 432–441
Hard Light blend mode, 66, 211
Hard Mix blend mode, 212
highlight detail, removing, 156–157
High Pass filter, 326
 challenging masking scenarios, 431
 creating mask, 449–452
 density masks, 297
 edge masks, 307
histogram, 16, 33
Histogram palette, 317
History palette, 380
HSL (hue-saturation-luminance) components., 217
Hue blend mode, 217
Hue/Saturation adjustment, 112, 288
Hue/Saturation dialog box, 226
Hue/Saturation panel, 200
Hyttilä, Satu, 190

I

images
 closing, 11
 converting flat image to layers, 224
Indexed Color command, 12
infrared photography, emulating, 325–337
 adding Channel Mixer adjustment, 327
 adding density mask, 328
 adding luminance mask, 329
 Color Dodge blend mode, 330
 Color Gradient adjustment layer reducing opacity, 336

colorizing image, 333
density mask, 334
desaturating image, 330
Gradient Map, 335
gradient tool, 331
increasing contrast, 336
masking darkening in faces, 333
Inner Glow filter, 179
red-eye, correcting, 343
Inner Glow layer style, 49
Inner Shadow effect, 204
Input Levels, 16–17, 33
Interface command, 155
intersect selection mode, 108
Intersect with Selection option, 279
Inverse command, 77, 144, 172, 191
Invert command, 155
keyboard shortcut, 111
inverting channels, 355
Iteration Boundary, 435

J

JPEG
converting to, 44
Lab color, 17
mask support, 53
unearthing JPEG artifacts with
Difference blend mode,
216

K

Kativ, 147, 153, 267
keyboard shortcuts
adding new layer, 118
airbrush option, 38
alpha channels, switching to 1st or
2nd, 38
arrow tool on-the-fly, 398
assigning large thumbnails to
palettes, 4
blend modes, 194
brush tool, 38
changing Opacity setting of active
tool, 38
closing images, 11
collapsing palette group, 4
color-bearing channels, 43
Color Burn blend mode, 207
Color Dodge blend mode, 207
Create Clipping Mask command,
177

Curves dialog box, 375
cusp point, drawing, 398
Darken blend mode, 204
deleting anchor point when pen is
active, 430
deleting path in progress, 398
deleting selected layers, 38
Desaturate command, 148
deselecting, 350
deselecting selection, 52
Difference blend mode, 188
dragging and dropping image, 124
Extras command, 51
fading floating selection with the
image below, 70
File Info dialog box, 4
filling selected area with white, 119
hiding selection outlines, 350
High Pass filter, 430
Hue blend mode, 217
interface preferences, 4
Inverse command, 77, 124
Invert command, 111
inverting, 350
Layers palette, 7
Levels command, 350, 430
lifting color when brush tool is
active, 38
Lighten blend mode, 204
loading highlights as selection, 350
loading selection from layer, 52
Luminosity blend mode, 188
moving marquee while drawing, 70
Multiply blend mode, 188
New Layer dialog box, 52
nudging outline in 1-pixel
increments, 70
nudging selected pixels in 1-pixel
increments, 70
Overlay blend mode, 188, 210
Paste Behind command, 147
Paste Into command, 115
pen tool, 398
quick mask mode, 124
quick selection tool, 40, 85
Range option to Shadows, 381
recreating selection outline, 409
Refine Edge command, 132
release "sticky" blend mode option,
38
releasing "sticky" blend mode
option, 188

resetting curve to a diagonal line,
430
resetting tool to its default settings,
124
reversing layer mask, 188
RGB image in quick mask mode,
124
Save As, 56
saving and naming alpha channels,
350
saving Work Path in Paths palette,
398
Screen blend mode, 52, 188, 197
Similar, 124
smooth point, drawing, 398
switching back to full-color
composite, 4
switching between channels, 4
switching between channels and
composite views, 13
switching between layers, 111
switching between RGB channels,
350
Undo command, 86
(see also dekeKeys shortcut)
Knockout layers, 302–303
knockout masks, 267–270
adding gradients, 268
knockouts, 235
Kranen, Klaas Lingbeek-van, 352

L

Lab
acronym, 14
how it works, 14
Lightness channel, 14–15
saturation boost, 17
Lab Color, 11–17, 13, 14, 22
converting images to, 13
JPEG, 17
modifying saturation, 16
Photoshop, 17
TIFF, 17
lasso tool, 383
layered compositions
adding selections to, 99
layer masks, 235–271
adding selection to, 393
assembling perfect group photo,
258–266
aligning layers, 260
Load Files into Stack, 260

layer masks, (*continued*)
 blurring, 230
 choking, 229, 391
 clipping masks, 235
 creating jet of motion blur, 237–243
 cropping image, 242
 masking part of motion blur
 effect, 240
 Motion Blur filter, 240
 skewing Blur layer, 239
 deleting, 409
 displaying, 392
 knockout masks, 267–270
 adding gradients, 268
 knockouts, 235
 masking adjustment layers,
 243–248
 applying Levels adjustment, 246
 Color Range dialog box, 247
 creating Levels adjustment, 244,
 247
 New Window for command,
 245
 masking glass, 249–258
 adding fish to composition,
 256–257
 applying gradient to mask, 251
 Color Range dialog box, 251,
 254
 Feather Selection dialog box,
 255
 Linear Burn blend mode, 250
 Linear Dodge (Add) blend
 mode, 253
 merging, 392
 surreal group photo, 264–265
 turning selection into, 409
 types, 235–237
 vector masks and shape layers,
 414–422
layers
 adding new, 118
 aligning, 260
 aligning background and, 390
 converting flat image to, 224
 copying selections to, 408
 Ctrl-clicking, 50
 deleting selected layers, 38
 duplicating, 391
 duplicating selection to new, 172
 Merge Down command, 50
 renaming, 49
 switching between, 111

Layers palette
 Convert to Smart Object, 276
 keyboard shortcut, 7
 reviewing CMYK channels, 19
 Smart Filters
 disabling effect, 277
Layer Style dialog box
 Advanced Blending area, 303
 Advanced Blending section, 269
 Blend Clipped Layers as Group
 check box, 200
 Blending Options, 220
 Blend Interior Effects as Group,
 258
 Blend Mode to Color, 82
 Blend Mode to Hue, 100
 Blend Mode to Multiply, 83
 Blend Mode to Overlay, 84
 Color Overlay, 82, 100
 Gradient Overlay, 83
 Inner Glow, 49
 Outer Glow, 83
 Preview check box, 200
 Vivid Light, 55
Layer Via Copy command, 49
Lens Blur filter, 104, 300
 applying, 301
lessons, video (*see* training DVD)
letters, converting to shapes, 423
Levels adjustment, 244, 247
 refining, 283
Levels adjustment layer, 280
Levels command, 15, 192, 350
 black point value, 16
 white point value, 16
Levels dialog box, 33, 156, 227, 346, 379
 bolstering outlines, 450
 Difference comparison, 373
 increasing contrast, 357, 447
 Input Levels, 16–17
 Lightness channel, 17
 loading preset, 107
 Output Levels, 17
Levels variations, merging two, 435
Lighten blend mode, 204
Lighter Color blend mode, 205
Lightness channel, 14–15
 Levels dialog box, 17
Linear Burn blend mode, 208, 250
Linear Dodge (Add) blend mode, 54,
 208, 253
Linear Gradient style, 302
Linear Light blend mode, 212

Load Files into Stack, 260, 264
Load Gradients command, 63
Load Layers dialog box, 260, 264
Load Preset command, 29, 107
Load Selection dialog box, 48
Localized Color Clusters check box,
 129, 137, 169
logo
 blending scanned logo, 190–202
 converting to static pixels, 198–199
 removing color from, 200
lossless conversion, 44–45
luminance, 5
luminance blending, 219–223, 341, 417,
 418
luminance level, 9, 10, 16, 17
 clipping, 26
 wider range, 29
luminance masks, 275, 329
 refined smoothing, 276–283
Luminosity blend mode, 218, 228

M

magic wand tool, 71, 72–84, 110, 382
 checking mask accuracy with, 291
 Color Range command, 128–129
 Contiguous check box, 75
 how options work, 74–75
 resetting defaults, 72
 Sample All Layers check box, 75
 Tolerance value, 73–75, 106
magnetic lasso tool, 71, 90–93, 102
 cleaning up selection, 111–112
 Contrast setting, 91
 Frequency setting, 91
 frustrations with, 92
 saving selection, 93
 setting basic options, 90
 tracing with, 91–93
 Width value, 90
 reducing, 92
marching ants, 41
masked layers, converting to, 360
masking glass, 249–258
 adding fish to composition,
 256–257
 applying gradient to mask, 251
 Color Range dialog box, 251, 254
 Feather Selection dialog box, 255
 Linear Burn blend mode, 250
 Linear Dodge (Add) blend mode,
 253

masking layers (*see* layer masks)

masks
 changing overlay color, 160
 cleaning up, 60
 combining, 61–66
 keyboard tasks, 62
 converting path to selection or
 mask, 408–411
 copying, 380
 creating from RGB versus CMYK
 images, 154
 defined, 5, 39
 erasing, 59
 fine-tuning masks with brush tool,
 178
 how masks work, 37–67
 increasing contrast, 380–382
 inverting, 306
 JPEG mask support, 53
 loading, 48–56
 making from channels, 154–160
 modifying, 56–61
 painting inside, 141, 145, 146
 preventing Photoshop from adding
 a mask to the dynamic fill
 layer, 416
 redrawing, 59
 saving, 146
 seeing independently of image, 138
 selecting problem areas, 161
 selection tools, 69
 sharp corners, 60
 switching to specific mask, 57
 transparency, 39
 viewing mask and image together,
 57
 (*see also* challenging masking
 scenarios)
Match Color command, 224, 225
Maximize compatibility, 56
Maximize PSD and PSB File
 Compatibility, xix
Maximum dialog box, 178
Maximum filter, 306
Median filter, 307
Merge Down command, 50
Minimum dialog box
 choking layer mask, 391
Modify menu, 176
 Feather, 178
Monochrome check box, 317
Motion Blur filter, 240
 bidirectional, 237

move tool, 79, 390
multichannel, before converting to, 32
Multichannel command, 13, 21, 22, 27
multichannel mode, 12
 duotones, tritones, and quadtones,
 31
 editing, 21–28
 RGB to multichannel to CMYK, 21
Multiply blend mode, 20, 27, 117, 174,
 194, 198, 206, 228, 391
 red-eye, correcting, 341, 343

N

naming channels, 32
Neuva Standard Regular font, 401
New Channel dialog box, 89
 naming channels, 46
New Group From Layers dialog box,
 299
New Layer dialog box
 Channel Mixer panel
 Monochrome check box, 317
 keyboard shortcut, 52
 Use Previous Layer to Create
 Clipping Mask check box,
 198, 200, 201, 363, 416, 419,
 420, 440
New Path dialog box, 401
new selection mode, 108
New Window for command, 245
Nikada, Alex, 243
Noise check box, 383
Normal blend mode, 198, 379

O

One-on-One
 installation and setup, xiv–xx
 requirements, xiii
one-third rule, 412
Opacity setting, 336
 changing Opacity setting of active
 tool, 38
 reducing, 342
Open Documents as Tabs, xix
organic harvesting, 78
Osborne, Bobbie, 287, 296, 300
Outer Glow, 83
Outer Glow filter, 54
Output Levels, 17
Overlay blend mode, 157
 keyboard shortcut, 210

overlay color, changing, 57
Overlay mode
 painting with, 358

P

parametric operations, 187
Paste Behind command shortcut, 147
Paste Into command, 115
path entries, selecting, 406
path outlines
 converting to selection, 408
 converting to vector mask, 410
 hiding, 410
paths
 adding anchor points, 406
 adjusting, 405
 closing, 403
 converting to selection or mask,
 408–411
 creating vector mask from, 410
 deleting anchor points, 407
 deleting path in progress, 398
 editing character outlines, 422–426
 selecting, 405
Paths palette
 creating new path, 401
 path entries, selecting, 406
 saving Work Path in, 398
 viewing vector masks, 411
 Work Path entry, 400
Pauls, James, 72
Peluso, Tammy, 400
pencil tool, drawing curve with, 375
pen tool
 adding and deleting anchor points,
 407
 keyboard shortcut, 398
 options, 402
 setting up, 402
photo-grade inkjet printer, 26
Photoshop
 eight channel modes, 12–13
 Lab color, 17
Photoshop DCS 2.0, 34
Pin Light blend mode, 212
Pixels, xix
polygonal lasso tool, 109, 383
preference settings
 Animated Zoom check box, xviii
 Border options, xviii
 Cursors, xix
 Enable Flick Panning check box,
 xviii

preference settings (*continued*)
 Enable Version Cue check box, xix
 Export Clipboard check box, xviii
 File Handling, xix
 Maximize PSD and PSB File
 Compatibility, xix
 Open Documents as Tabs, xix
 Pixels, xix
 Show Crosshair in Brush Tip check
 box, xix
 Units & Rulers, xix
 Use Shift Key for Tool Switch check
 box, xviii
 Zoom Resizes Windows, xviii
Preview check box, 200
printing to photo-grade inkjet printer,
 26

Q

quadtones (*see* duotones, tritones, and
 quadtones)
quick mask mode, 123, 124
 alpha channel, 169
 changing color, 139
 cleaning up area, 140
 exiting, 146
 gradient edge, 378
 painting inside masks, 141, 145, 146
 refining selection, 377
 refining selection with, 136–146
Quick Mask Options dialog box, 139
quick selection tool, 40, 71, 85–89, 101,
 164
 adding to selection, 87
 Auto-Enhance, 95
 cleaning up selection, 88
 increasing brush size, 86
 keyboard shortcut, 85
 reducing brush size, 87
 saving selection, 89
QuickTime, xxiii

R

Radial Blur filter, 51, 52
rasterized layers, 254
re-aliasing effect, 160, 161
rectangular marquee tool, 456
red-eye, correcting, 337–346
 adding layer effects, 343
 adjusting pupils to match, 346
 luminance blending, 341

Multiply blend mode, 341, 343
 reducing Opacity setting, 342
red-eye tool, 338
Reduce Noise command
 preserving defaults, 169
Reduce Noise dialog box, 169
Refine Edge command, 71, 94, 96,
 102–103, 107, 110
 Contract/Expand value, 98, 103
 Contrast value, 97
 Feather value, 98
 keyboard shortcut, 132
 Radius value, 97, 103
 Smooth option, 97
 ways of previewing adjustments, 96
Refine Edge dialog box, 164
repeating one person many times,
 264–265
Reselect command, 132
Reset tool, 421
Reverse check box, 252
Revert command, 210
RGB, 6
 color-bearing channels
 keyboard shortcuts, 43
 converting images to, 12
 converting to CMYK, 18, 21, 44
 converting to multichannel to
 CMYK, 21
 mechanics of RGB primaries, 5–9
 switching between RGB channels,
 350
RGB Color command, 12, 22, 26, 27
RGB images
 creating masks, 154
 Quick Mask mode, 124
Rotate Canvas dialog box, 193, 238,
 242
rotating images, 193
Rubylith mode, 57
Russell, Kriss, 445
Russ, Kevin, 137

S

saturation, 15
 modifying, 16
Saturation blend mode, 217
saturation boost in Lab, 17
Save As, 47
 keyboard shortcuts, 56
Save Selection dialog box, 41
Schmidt, Chris, 365

schnivels, 192
Screen blend mode, 7–8, 51, 198, 206,
 220
 depth masks, 303
 keyboard shortcut, 52, 197
segments, 402
 redrawing, 406
selection modes, 108
selection outlines
 hiding, 38, 51, 64, 350
 nudging outline in 1-pixel
 increments, 70
 recreating, 409
 refining, 93–104, 102, 107, 110
 restoring, 132
Selection Preview pop-up menu
 Grayscale option, 393
selections, 69–121
 adding to layered composition, 99
 alpha channels, 77
 calculations (*see* calculations,
 selection)
 cleaning up with magnetic lasso
 tool, 111–112
 converting path to selection or
 mask, 408–411
 converting to or from alpha
 channels, 44–45
 copying to layer, 408
 copying to new layer, 111
 creating, 43
 creating from mask channel, 167
 duplicating to new layer, 172
 expanding selection with Color
 Range command, 127
 eyedropper tool
 configuring settings, 76
 fading floating selection with the
 image below, 70
 filling selected area with white, 119
 filling selection with background
 color, 191
 filling with gradients, 64
 Intersect with Selection option, 279
 jumping to new layer, 50
 Layer Via Copy command, 49
 loading, 95
 loading from layer, 50
 Load Selection dialog box, 48
 nudging selected pixels in 1-pixel
 increments, 70
 previewing against white
 background, 96

quick mask mode, 377
Refine Edge dialog box, 164
Refine Edge (*see* Refine Edge command)
refining selection with quixk mask mode, 136–146
saving as permanent part of file, 42
Shift-clicking, 73
Subtract from Selection, 62
transforming, 113–120
Transform Selection command, 46
turning into layer mask, 409
warping, 113–120
selection tools
automated, 71
elliptical marquee tool, 114
magic wand tool (*see* magic wand tool)
magnetic lasso tool (*see* magnetic lasso tool)
masks, 69
move tool, 79
polygonal lasso tool, 109
quick selection tool (*see* quick selection tool)
Refine Edge command, 71
Select menu equivalents, 176
Select Overlay Color dialog box, 55, 82, 100
Select Shadow Color dialog box, 65
Select Spot Color dialog box, 24
sepia tone, 23, 320
Serrabassa, Eva, 153
shadow details
darkening, 158
enhancing, 163
Shallow option from Knockout menu, 269
shape layers
defined, 418
vector masks and layer masks, 414–422
sharpening
density masks, 296–300
smart filters, 297
Shift-clicking
selections, 73
Show Channels in Color option, 155
Show Crosshair in Brush Tip check box, xix
silhouette effect, 166–172
Actions palette, 170–171
Color Range dialog box, 168

creating selections from mask channel, 167
Localized Color Clusters option, 169
Reduce Noise dialog box, 169
removing background from selection, 169
Similar command, 124
skin tones, adjusting in corrective mask, 283–287
smart filters, 268
changing blending options, 277, 286
sharpening, 297
turning off, 277
Smart Filters, 394
Add Filter Mask, 278
disabling effect, 277
replacing layer mask, 278
smart objects, 257
converting from Background layer, 286
converting layer to, 195
making editable, 338
Smith, Alvy Ray, 39
Smooth button, 376
smooth contours, 160–166
Smooth (Modify menu), 176
smooth point, drawing, 398
smooth points, 411, 412
softening, 81
Soft Light blend mode, 211
Soubrette, 219
specialty masks, 273–311
color masks, 275
changing color of object with, 287–296
Color Range dialog box, 289
Hue/Saturation adjustment, 288
Levels adjustment, 295
painting away mask edge details, 290
corrective masks, 275
adjusting skin tones, 283–287
applying Curves adjustment, 284
density masks, 275
grouping layers, 299
High Pass filter, 297
sharpening with, 296–300
depth masks, 275
blurring background with, 300–304

Knockout layer, 302–303
Linear Gradient style, 302
Screen blend mode, 303
edge masks, 275
correcting archival photo, 304–310
desaturating sharpening effects, 308
Find Edges filter, 306
fine tuning sharpening effect, 309
High Pass filter, 307
inverting, 306
Maximum filter, 306
Median filter, 307
sharpening with Levels, 307
luminance masks, 275
refined smoothing, 276–283
Spherize filter, 117
spline curve, 375
Spot Channel Options dialog box, 24, 32, 33
spot color, 24
standard pen tool, 402
Subtract from Selection, 62
Subtract mode (*see* Add and Subtract modes)
subtract selection mode, 108
surreal group photo, 264–265
symmetrical blend mode, 373
symmetrical mode, 216

T

target adjustment tool, 226, 227
temperature, 15
text
converting to shapes, 423
rasterized layers, 254
Threshold dialog box, 161
TIFF
alpha channels, 48
Image Compression, 48
Lab color, 17
Tile command, 245
tint, 14
tools, shifting from keyboard, xviii
training DVD, xx–xxiii
QuickTime, xxiii
Video Lesson 1: The Channels Palette
Bayer pattern
camera data

training DVD (*continued*)

Channels command
Channels palette
color filter array
enlarging thumbnails
File Info command
full color composite
Grayscale mode
Masks palette
Preferences dialog box
RGB colors
Show Channels in Color

Video Lesson 2: The Anatomy of a Mask

air brushing
alpha channels
burn tool
changing brush size
channels
dodge tool
Extras command
how masks work
limiting retouching
Load Selection command
Multiply blend mode
Overlay blend mode
retouching tools
stencils

Video Lesson 3: Selections, Floaters, and Layers

dragging and dropping selection to new image
elliptical marquee tool
Fade command
Feather Selection
Ignore Selection when Applying Adjustment
Invert command
Match Color
rectangular marquee tool
Use Selection in Source to Calculate Colors

Video Lesson 4: The Quick Mask Continuum

Image Rotation
Inverse command
lasso tool
magic wand tool
quick mask mode
quick selection tool
resetting tools
rubylith compositing

saving mask as permanent alpha channel
select quick mask color
Similar command

Video Lesson 5: Using the Image to Select Itself

Anti-alias check box
Brightness/Contrast command
brush tool
clipping highlights and shadows
Curves command
darkening midtones
increasing contrast
Insert command
lasso tool
Levels command
target adjustment tool

Video Lesson 6: The 25 Standard Blend Modes

Color blend mode
Difference blend mode
Exclusion blend mode
Hard Light blend mode
Hue blend mode
Linear Light blend mode
Luminosity blend mode
Normal blend mode
Overlay blend mode
Saturation blend mode
Screen blend mode
Vivid Light blend mode

Video Lesson 7: Introducing Layer Masks

adjustment layer
Channels palette
clipping masks
Color Range
eyedropper tool
Hue blend mode
Invert button
Layer Mask Display Options
layer masks
Mask Edge
Masks palette
Refine Mask dialog box
vector masks

Video Lesson 8: Working with "Found Masks"

adjustment layers
channels
density mask
found masks
Inverse command
Levels command

lossless conversion
luminance masks
Multiply blend mode

Video Lesson 9: Five Ways to Gray

Adjustments palette
Black & White command
Channel Mixer command
filter mask
Grayscale mode
High Pass filter
Histogram palette
Lab Color mode
smart filter
smart objects

Video Lesson 10: Calculations versus Apply Image

Add blend mode
Apply Image command
blending channels together
Calculations command
channel mixing commands
Difference blend mode
Linear Dodge (Add) blend mode
Subtract blend mode

Video Lesson 11: Drawing a Path, One Point at a Time

adding ponts to path
anchor points
control handles
cusp points
direct selection tool
drawing fluid curves
drawing paths
Paths option
pen tool
selection outlines
Shape option
smooth points

Video Lesson 12: Complex Foreground, Busy Background

arbitrary map
calculations
Curves command
direct selection tool
freeform pen tool
High Pass filter
Levels command
magnetic variation of freefrom pen tool
masking complicated images
Paths palette
pen tool
target adjustment tool

transfer mode, 189
transforming selections, 113–120
Transform Selection command, 46, 114
transitional layers, 228, 230
transparency mask, 235, 39
tritones (*see* duotones, tritones, and
 quadtones)
trompe l'oeil, 153
Tsibikaki, Sophia, 6, 29

U

underwater effect, 364
Undo command, 86
Undo Grayscale command, 10
Units & Rulers, xix
Unsharp Mask, 304
Use Default Masks, 416
Use Previous Layer to Create Clipping
 Mask check box, 198, 200,
 201, 363, 416, 419, 420, 440
Use Shift Key for Tool Switch check
 box, xviii

V

vector-based shapes, 399–400
vector masks, 410
 converting path outline to, 410
 creating from path, 410
 cutting off at borders, 421
 deleting, 426
 setting shape tool to add to, 425
 shape layers and layer masks,
 414–422
 viewing in Paths palette, 411
vector shapes, 80
video lessons (*see* training DVD)
viewing mask and image together, 57
Vivid Light blend mode, 212
Vivid Light layer style, 55

W

warping selections, 113–120
white arrow tool, 405, 413
white point value, 16
White silhouette action, 170
Wilkie, Don, 219
Work Path entry (Paths palette), 400
Wozniak, Michal, 125

Y

YinYang, 113

Z

Zoom Resizes Windows, xviii

dekePOD ™

Uncensored, Unregulated, and Frankly Unwise

deke.oreilly.com

www.deke.com

Author Deke McClelland has been unleashed in dekePod, his new video podcast series on the topics of computer graphics, digital imaging, and the unending realm of creative manipulations. New podcasts are posted every two weeks. Drop by deke.oreilly.com to catch the latest show or to browse the archives for past favorites, including: "Don't Fear the LAB Mode," "Buy or Die: Photoshop CS4," and "101 Photoshop Tips in 5 Minutes."

Don't miss an episode when you subscribe to dekePod in iTunes

O'REILLY®

Learn from a Master

Boundless enthusiasm and in-depth knowledge…

DVD-ROM features over 4 hours of lynda.com
video hosted by Deke McClelland

Adobe
Photoshop CS4
one-on-one™

deke
PRESS
O'REILLY®

DEKE McCLELLAND

That's what Deke McClelland brings to *Adobe Photoshop CS4*. Applying the hugely popular full-color, One-on-One teaching methodology, Deke guides you through learning everything you'll need to not only get up and running, but to achieve true mastery.

- **12 self-paced tutorials** let you learn at your own speed

- **Engaging real-world projects** help you try out techniques

- **Over four hours of video instruction** show you how to do the work in real time

- **Nearly 1,000 full-color photos, diagrams, and screen shots** illustrate every key step

- **Multiple-choice quizzes in each chapter** test your knowledge

Also out now or coming soon:

- *Adobe InDesign CS4 One-on One*, ISBN 9780596521912
- *Adobe Illustrator CS4 One-on-One*, ISBN 9780596515928

DVD-ROM features over 4 hours of lynda.com
video hosted by Deke McClelland

Adobe
InDesign CS4
one-on-one

deke
PRESS
O'REILLY®

DEKE McCLELLAND
WITH DAVID FUTATO

DVD-ROM features over 4 hours of lynda.com
video hosted by Deke McClelland

Adobe
Illustrator CS4
one-on-one

deke
PRESS
O'REILLY®

DEKE McCLELLAND
WITH DAVID FUTATO

deke
PRESS
O'REILLY®

digitalmedia.oreilly.com

ENJOY a Free Week
of training with Deke!

Get 24/7 access to every training video published by lynda.com. We offer training on Adobe® Photoshop® CS4 (and the entire CS4 Suite!) and hundreds of other topics—including more great training from Deke!

The lynda.com Online Training Library™ includes thousands of training videos on hundreds of software applications, all for one affordable price.

Monthly subscriptions are only $25 and include training on products from Adobe, Apple, Corel, Google, Autodesk, Microsoft, and many others!

To sign up for a free 7-day trial subscription to the lynda.com Online Training Library™ visit **www.lynda.com/dekeps**.

lynda.com